Muybridge's
COMPLETE
HUMAN AND ANIMAL
LOCOMOTION

Muybridge's
COMPLETE HUMAN AND ANIMAL LOCOMOTION

All 781 Plates from the 1887
Animal Locomotion

BY
EADWEARD MUYBRIDGE

VOLUME II
containing original volumes

5: MALES (Pelvis Cloth)

6: FEMALES (Semi-Nude & Transparent
Drapery) & CHILDREN

7: MALES & FEMALES (Draped) &
MISCELLANEOUS SUBJECTS

8: ABNORMAL MOVEMENTS, MALES
& FEMALES (Nude & Semi-Nude)

DOVER PUBLICATIONS, INC.
New York

Published in Canada by General Publishing Company, Ltd., 30 Lesmill
Road, Don Mills, Toronto, Ontario.
Published in the United Kingdom by Constable and Company, Ltd., 10
Orange Street, London WC2H 7EG.

This Dover edition, first published in 1979, is an unabridged republication
of the eleven-volume work *Animal Locomotion; an electro-photographic
investigation of consecutive phases of animal movements,* originally published
under the auspices of the University of Pennsylvania, Philadelphia, in 1887;
together with the *Prospectus and Catalogue of Plates,* published separately
by the University earlier in the same year. A new Introduction has been
written specially for the present edition by Anita Ventura Mozley.

Book design by Carol Belanger Grafton

International Standard Book Number: 0-486-23793-1
Library of Congress Catalog Card Number: 79-51299

Manufactured in the United States of America
Dover Publications, Inc.
180 Varick Street
New York, N.Y. 10014

CONTENTS

Volume 5
MALES (PELVIS CLOTH)
pages 631–775

Volume 6
FEMALES (SEMI-NUDE & TRANSPARENT
DRAPERY) & CHILDREN
pages 777–935

Volume 7
MALES & FEMALES (DRAPED) &
MISCELLANEOUS SUBJECTS
pages 937–1079

Volume 8
ABNORMAL MOVEMENTS, MALES & FEMALES
(NUDE & SEMI-NUDE)
pages 1081–1139

LOCATION OF PLATES IN THE PRESENT DOVER VOLUME

As in the original edition of *Animal Locomotion,* the numbering of the 781 plates corresponds to that of the *Prospectus and Catalogue of Plates* (reprinted at the end of the third volume of the present edition). However, the plates do not occur in a continuous numerical order within the eleven original volumes (the sequence of which is followed here), so that the following breakdown will be helpful.

VOLUME 5, *Males (Pelvis Cloth),* contains Plates 3, 8, 9, 26, 31, 59–61, 152, 153, 157–163, 317, 324, 329–342, 349–361, 365, 366, 368, 371–375, 378–381, 405, 505–507, 510–512, 523.

VOLUME 6, *Females (Semi-Nude) & Children,* contains Plates 35, 37, 39, 41, 50, 53, 55, 56, 71, 72, 97, 105, 143, 146, 170, 172, 174, 175, 179, 181, 185, 187–194, 205, 206, 214–216, 229, 232, 233, 242, 246, 248, 253, 265, 267, 271, 305, 306, 417, 420, 421, 423, 459, 461–463, 465–469, 471–481, 494–497, 502, 503, 513, 515, 524.

VOLUME 7, *Males & Females (Draped),* contains Plates 36, 38, 44, 45, 48, 49, 52, 57, 95, 100, 107, 134, 135, 139–142, 148, 156, 169, 173, 197–200, 207–212, 217, 230, 231, 234, 240–242, 250, 295–299, 386, 403, 404, 422, 424, 437, 438, 454–458, 460, 464, 470, 483, 484, 487, 504, 516–518, 532–536.

VOLUME 8, *Abnormal Movements,* contains Plates 186, 537–562, 19, 268.

A full concordance of plate numbers with their page numbers in the Dover edition will be found in the first Dover volume.

Volume 5

MALES
(Pelvis Cloth)

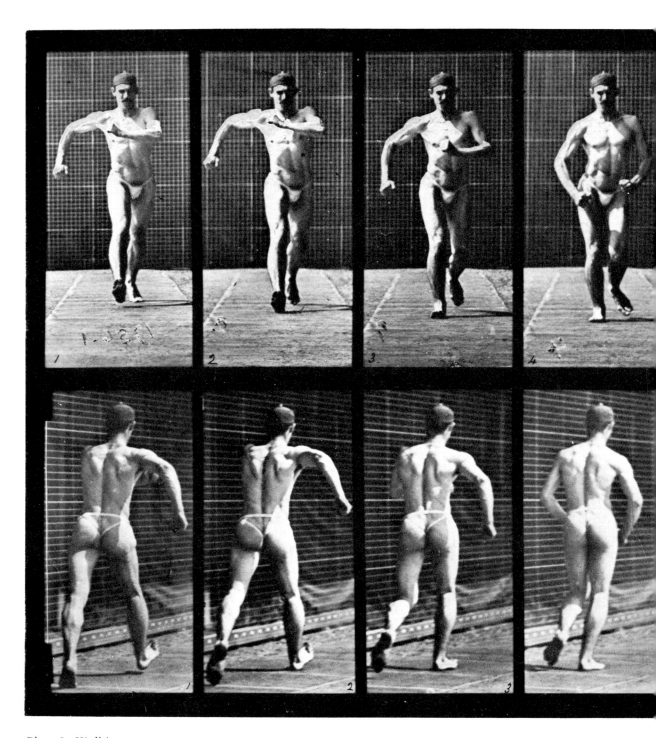

Plate 3. Walking.

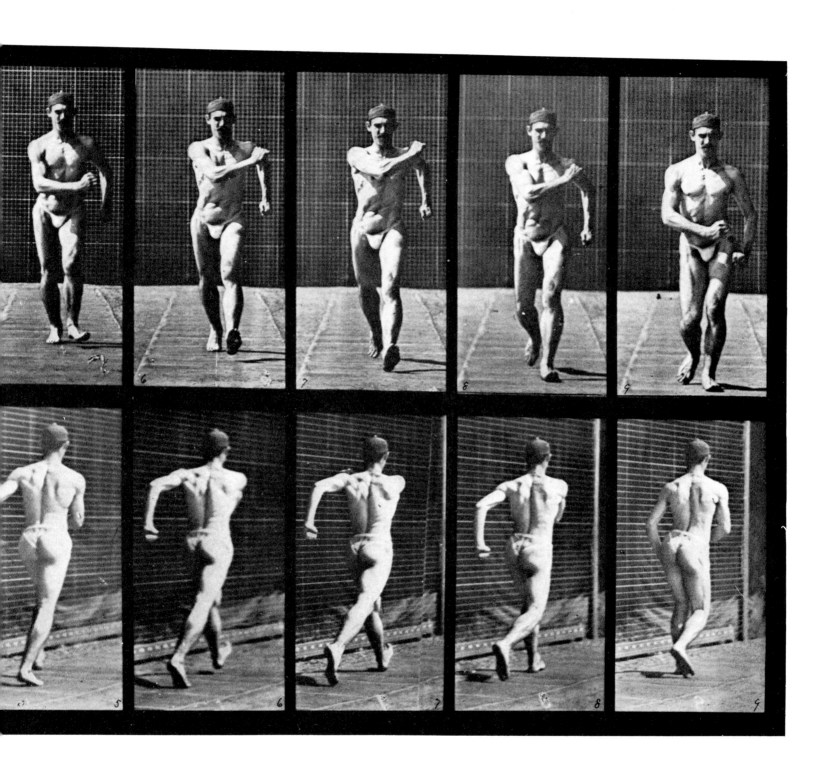

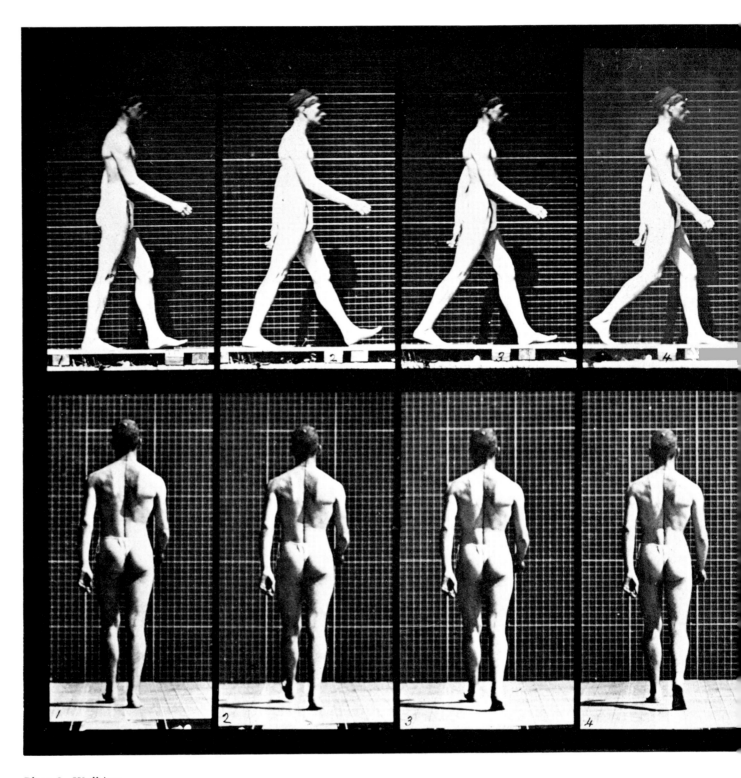

Plate 8. Walking.

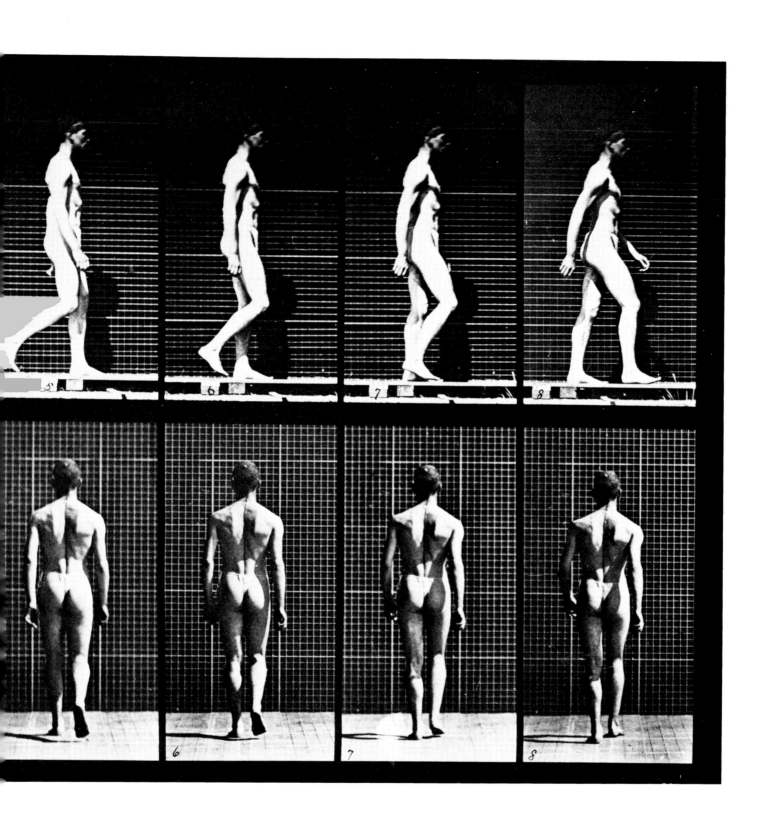

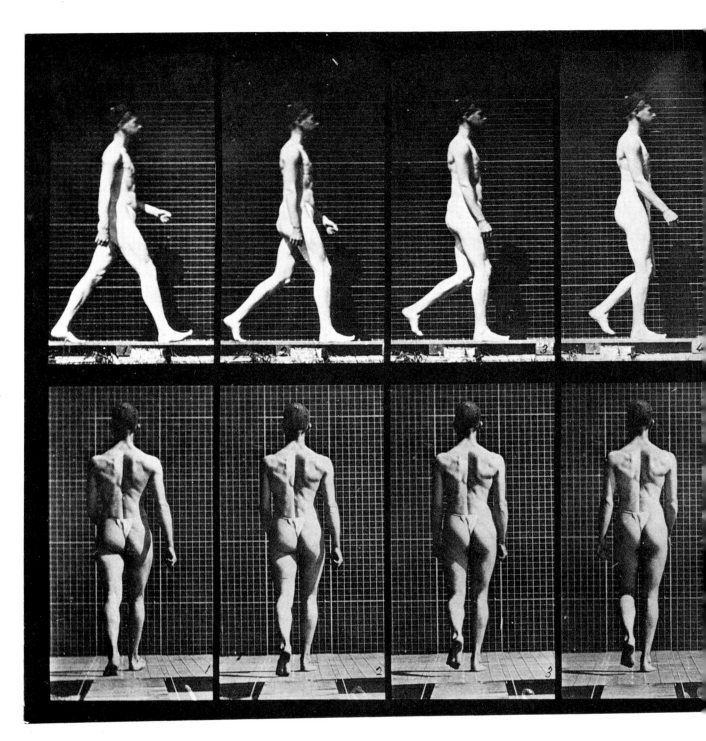

Plate 9. Walking.

636 MALES (PELVIS CLOTH)

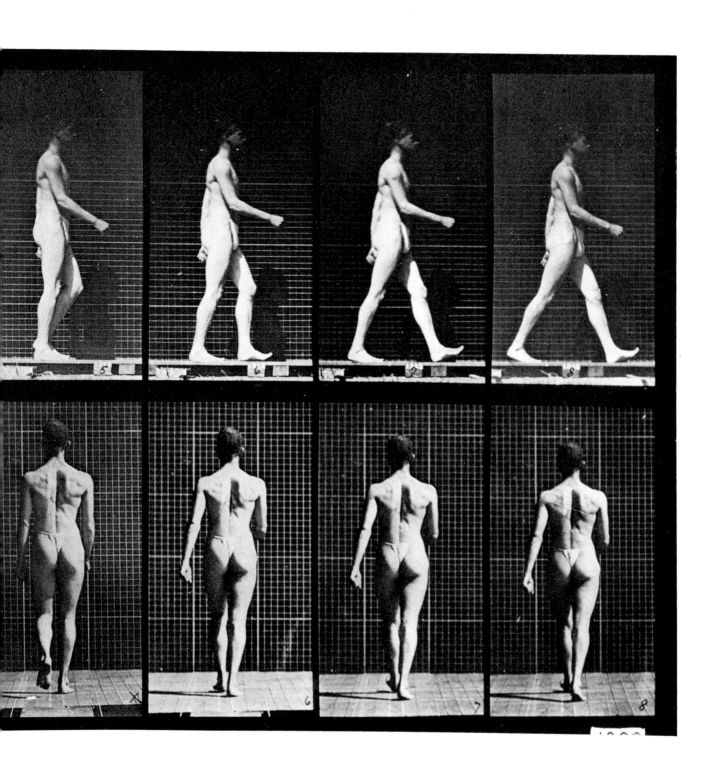

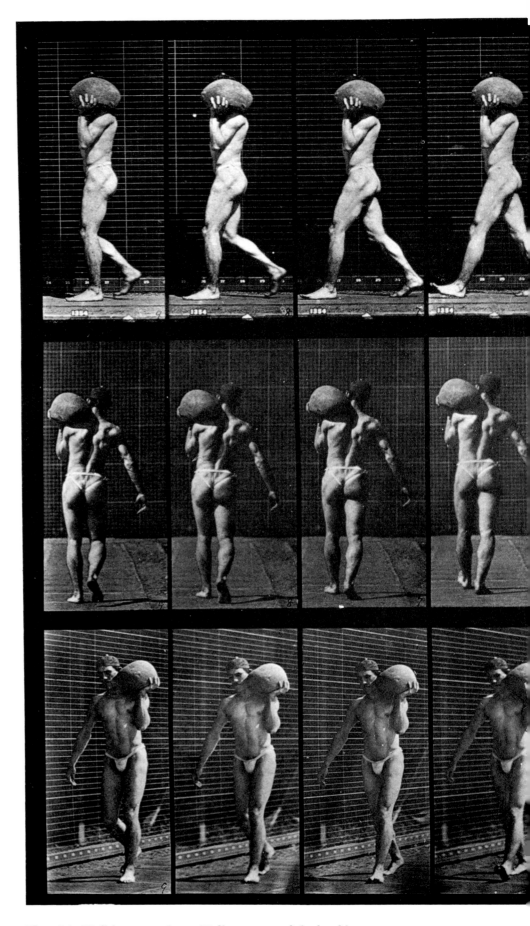

Plate 26. Walking, carrying a 75-lb. stone on left shoulder.

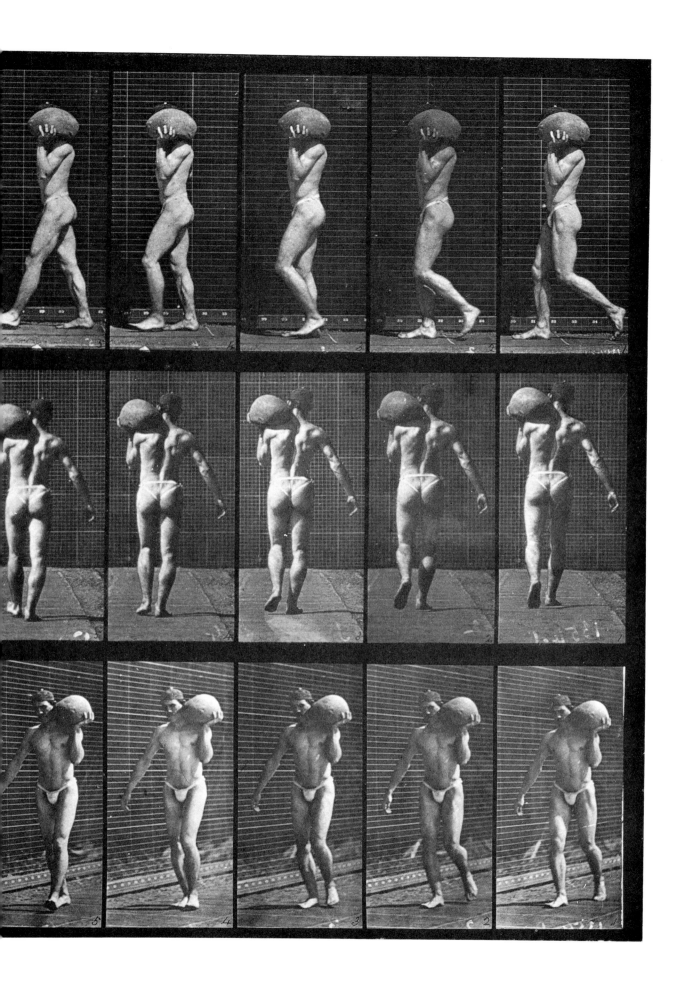

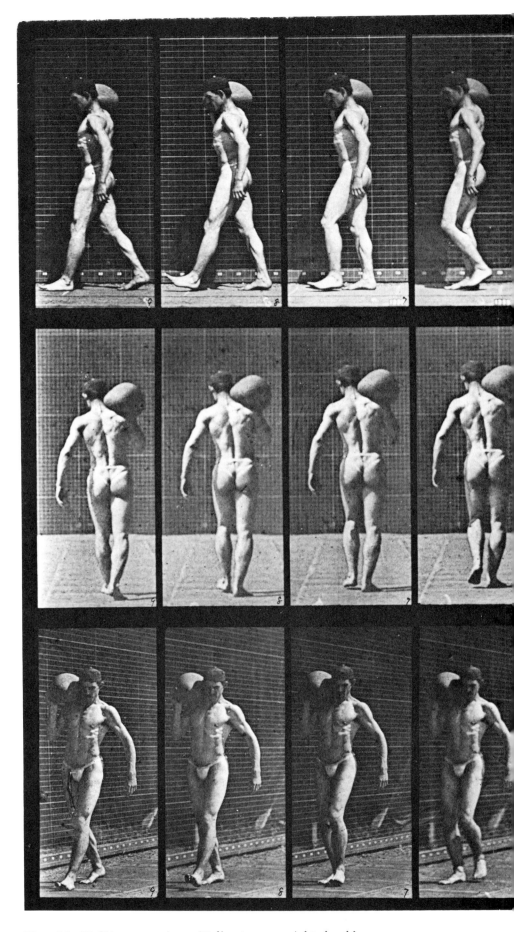

Plate 31. Walking, carrying a 75-lb. stone on right shoulder.

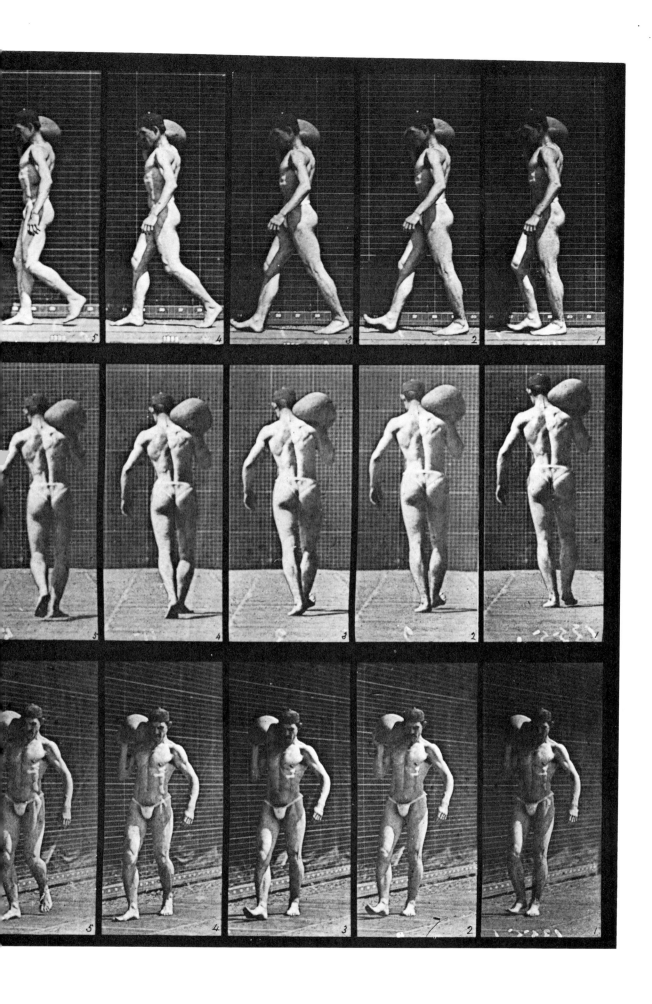

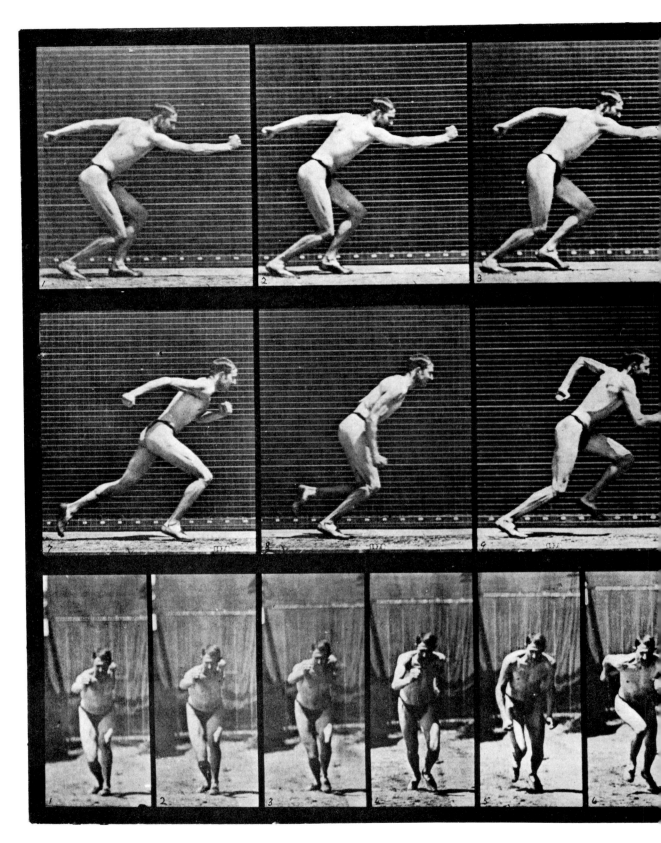

Plate 59. Starting for a run.

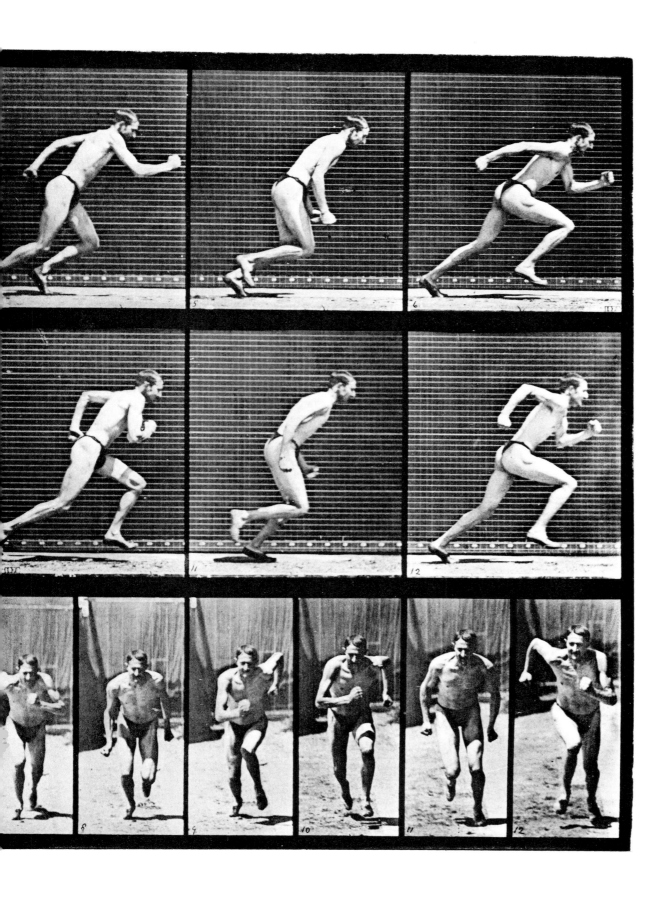

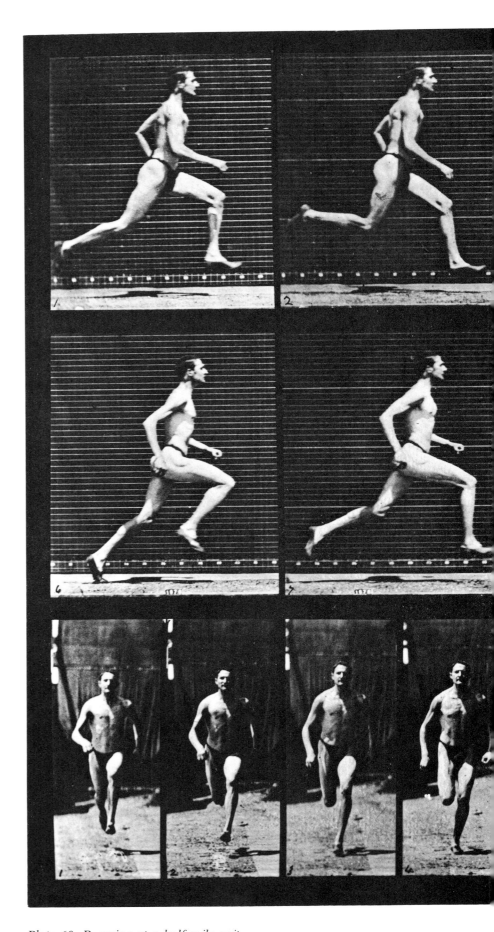

Plate 60. Running at a half-mile gait.

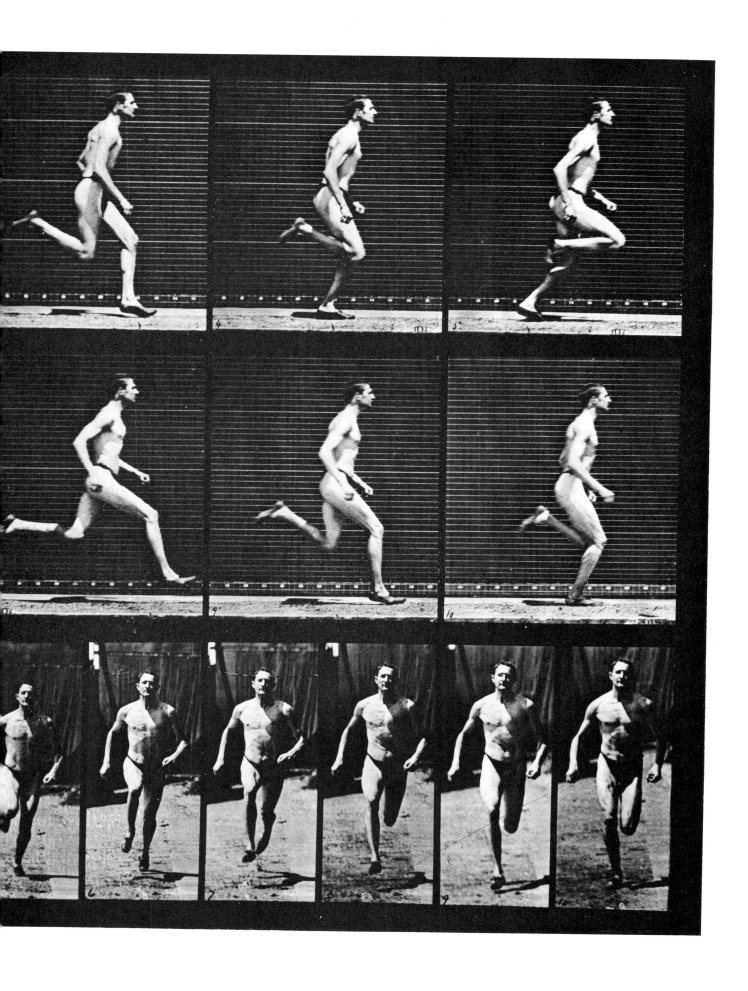

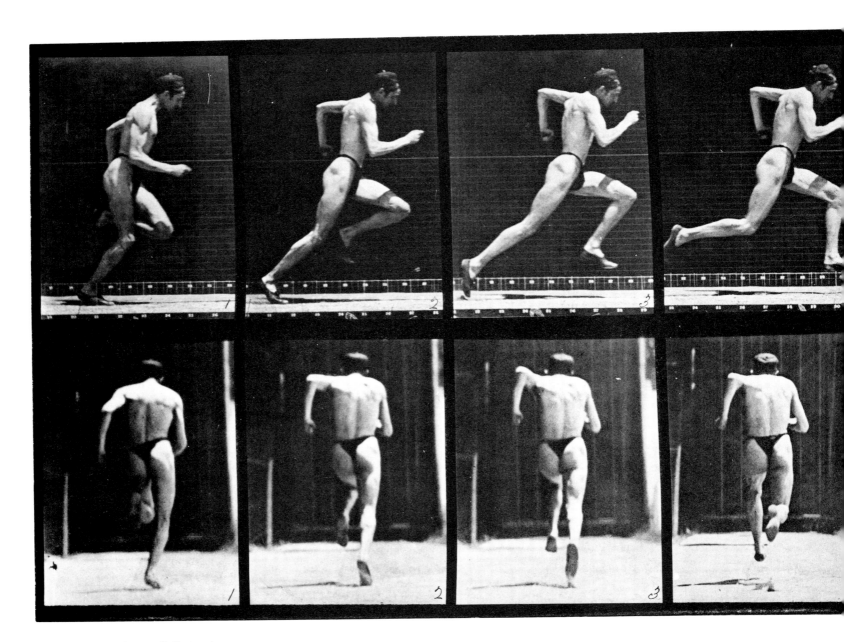

Plate 61. Running at full speed.

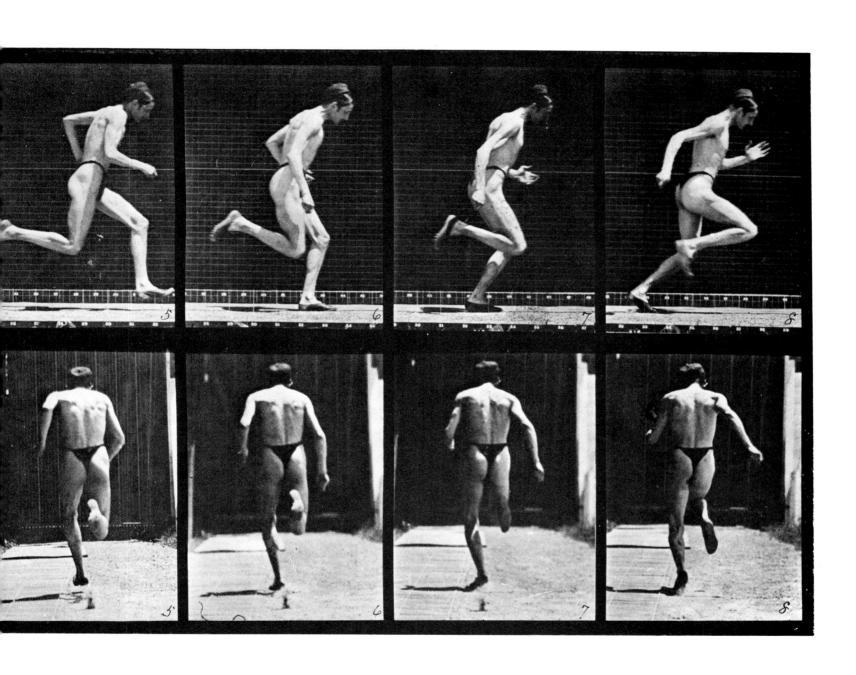

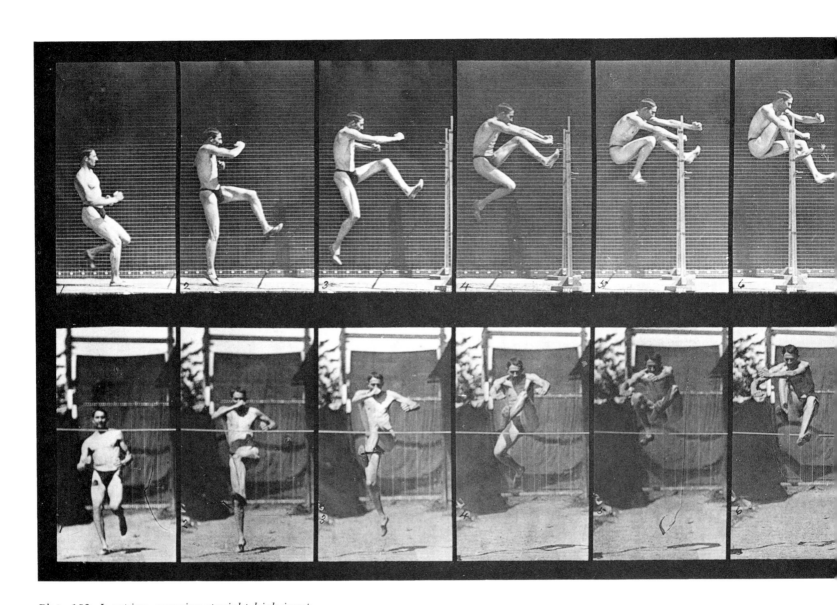

Plate 152. Jumping, running straight high jump.

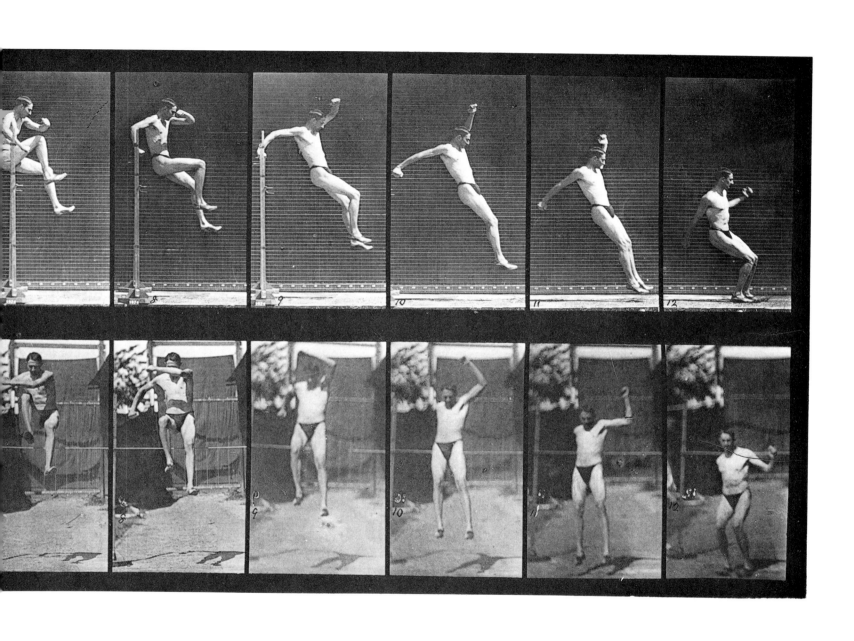

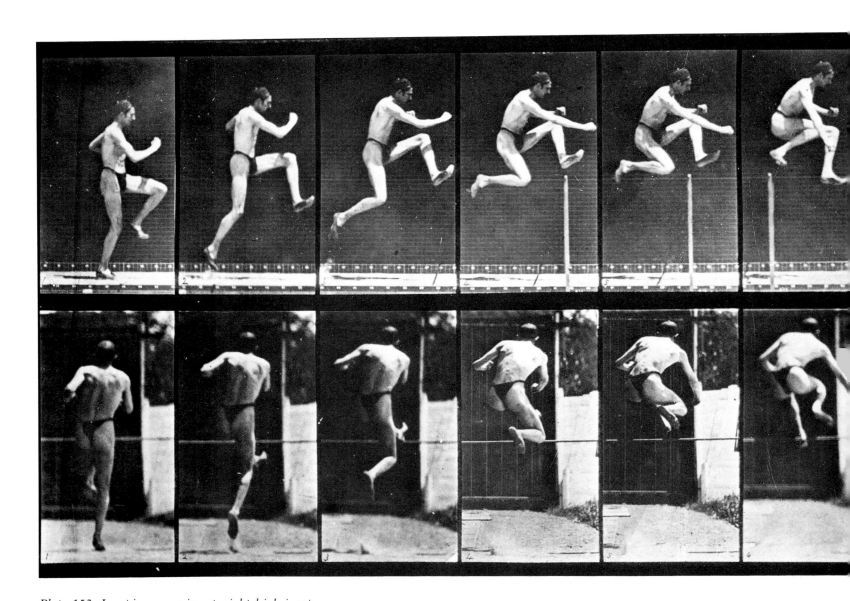

Plate 153. Jumping, running straight high jump.

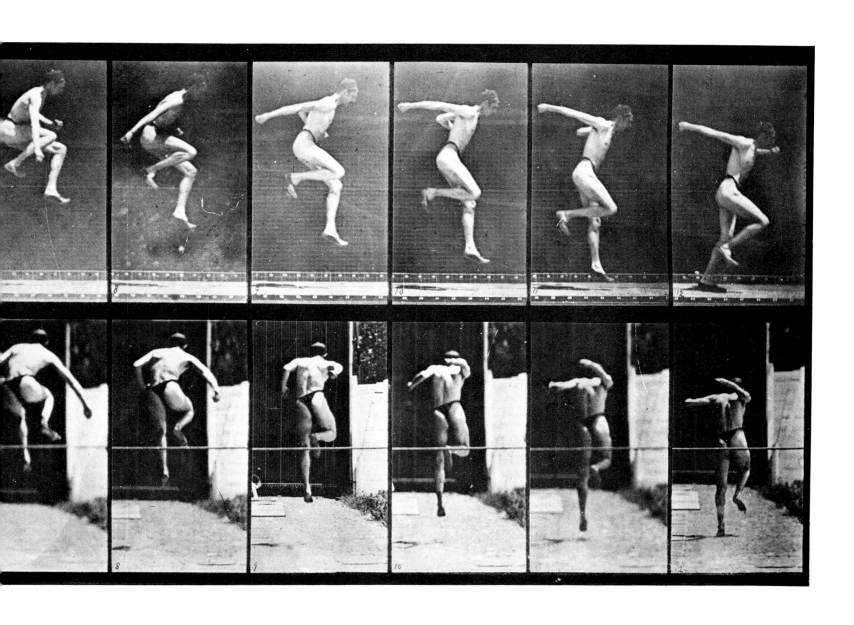

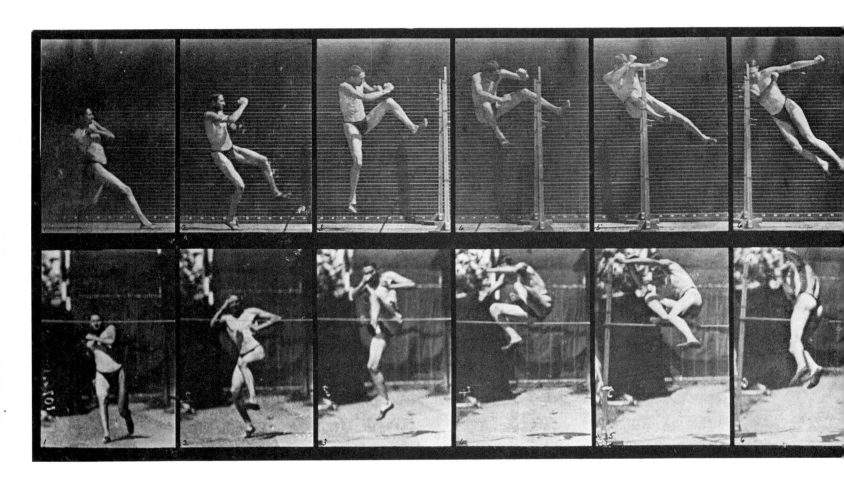

Plate 157. Jumping, running twist high jump.

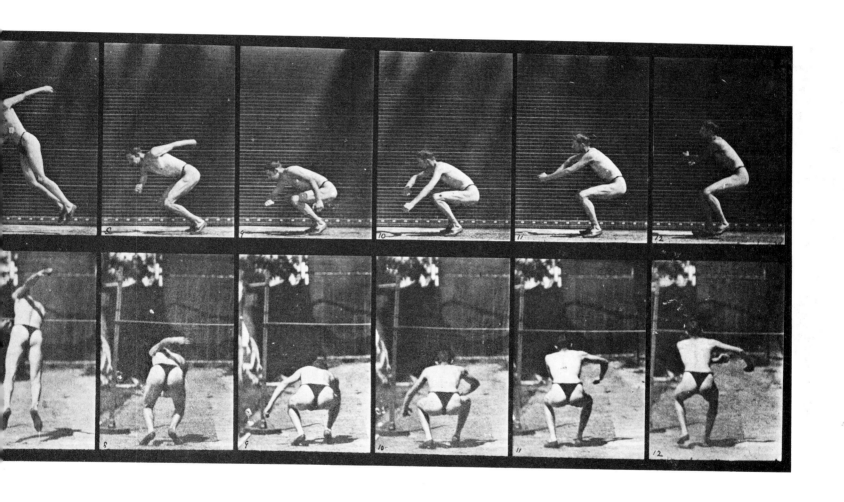

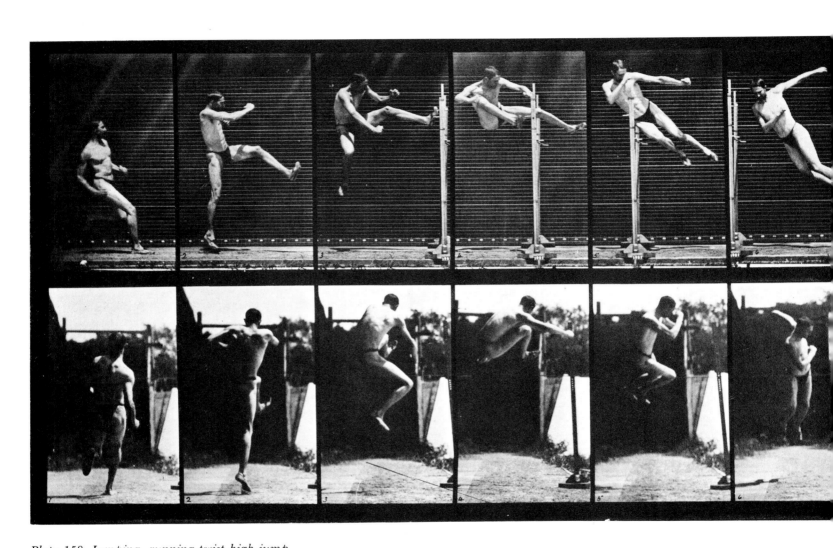

Plate 158. Jumping, running twist high jump.

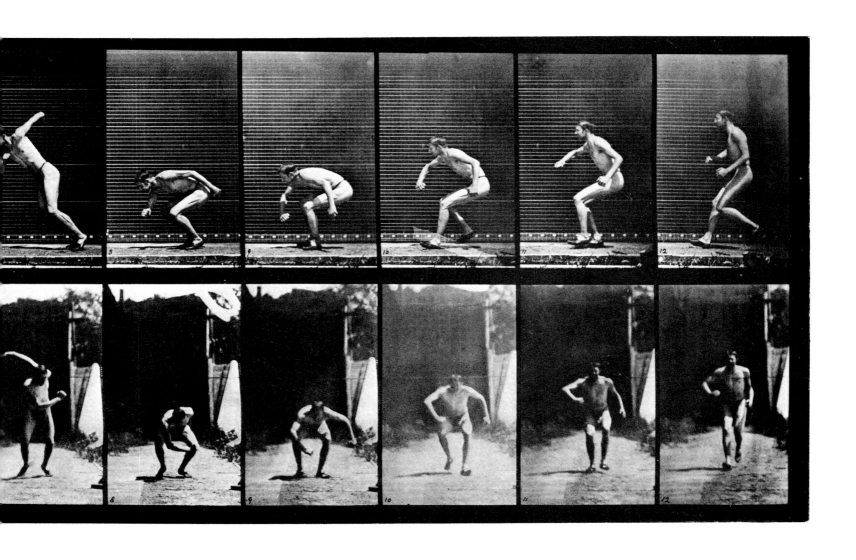

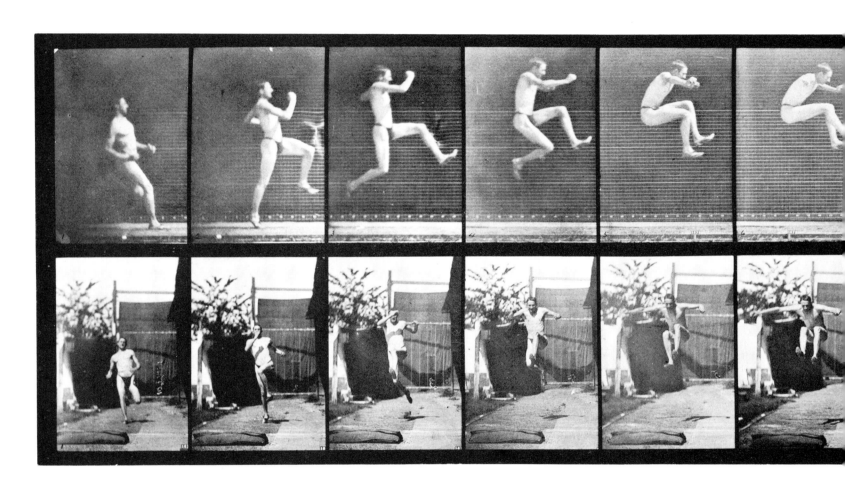

Plate 159. Jumping, running broad jump.

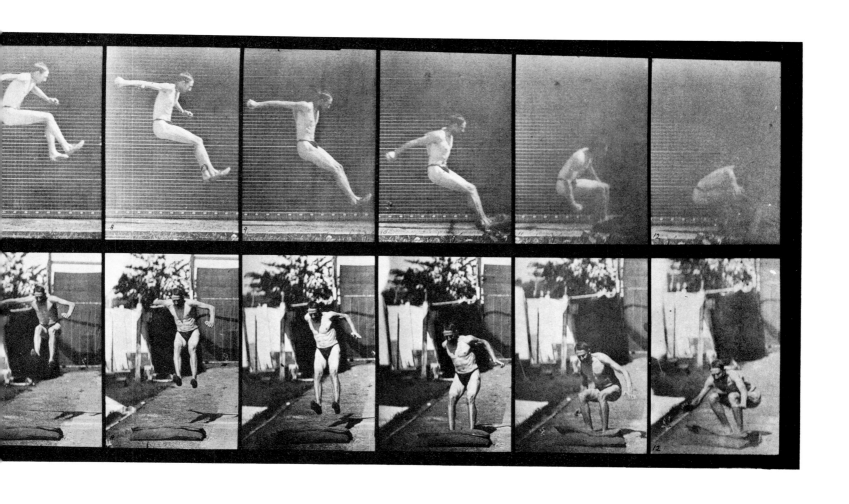

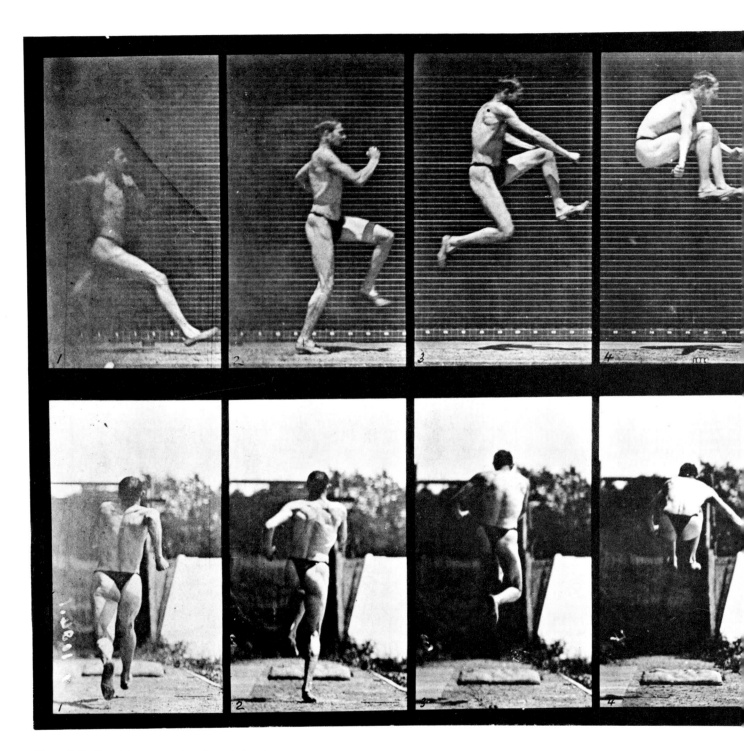

Plate 160. Jumping, running broad jump.

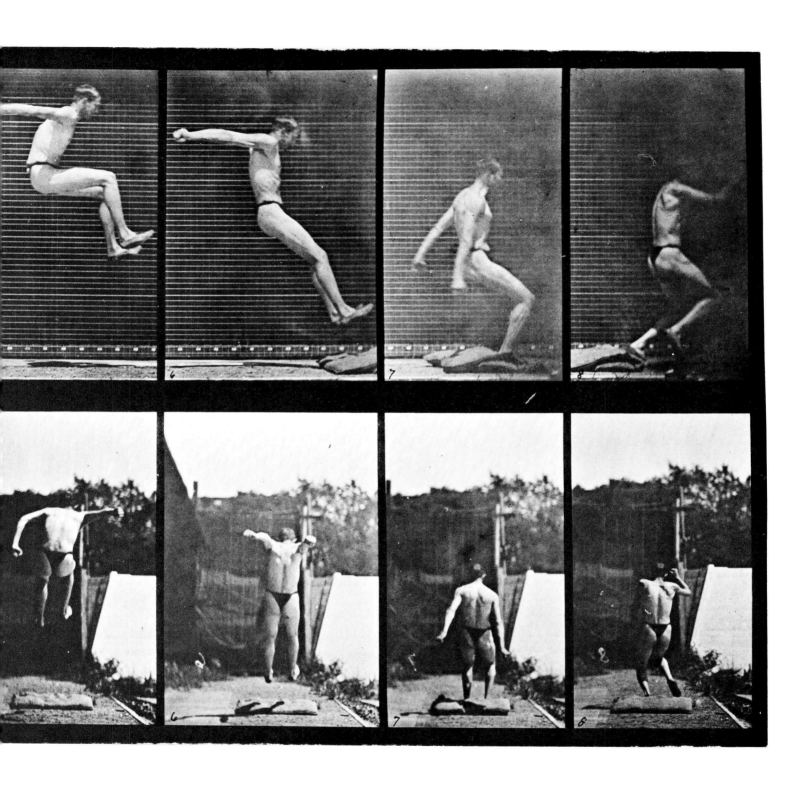

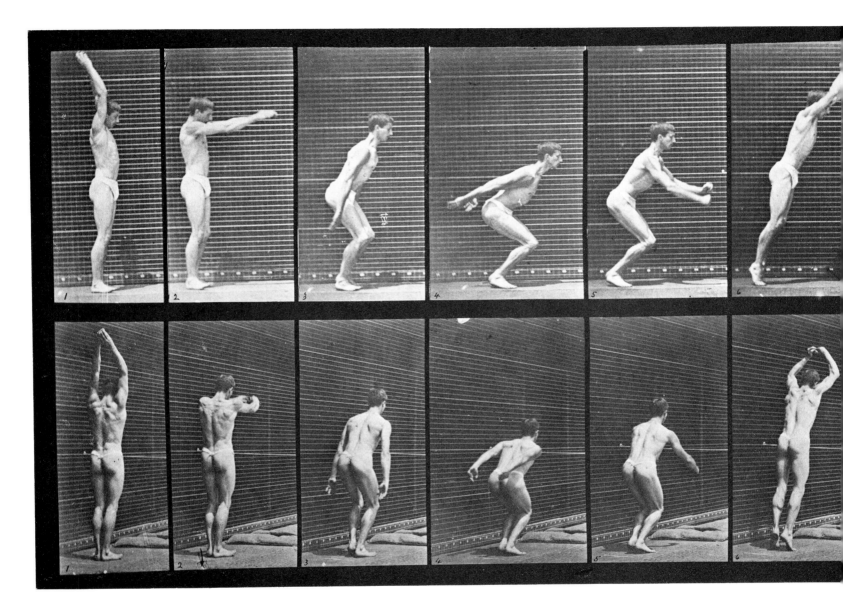

Plate 161. Jumping, standing high jump.

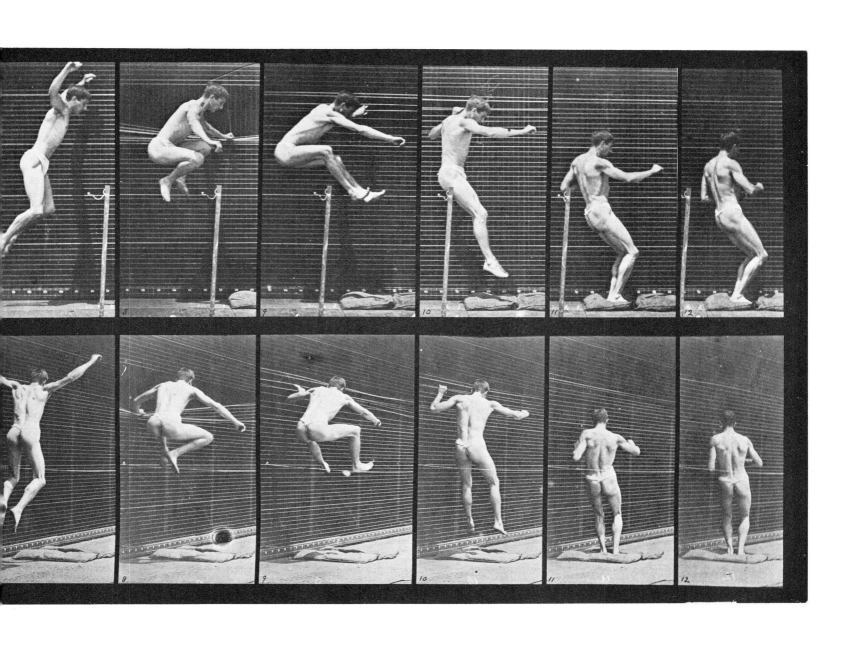

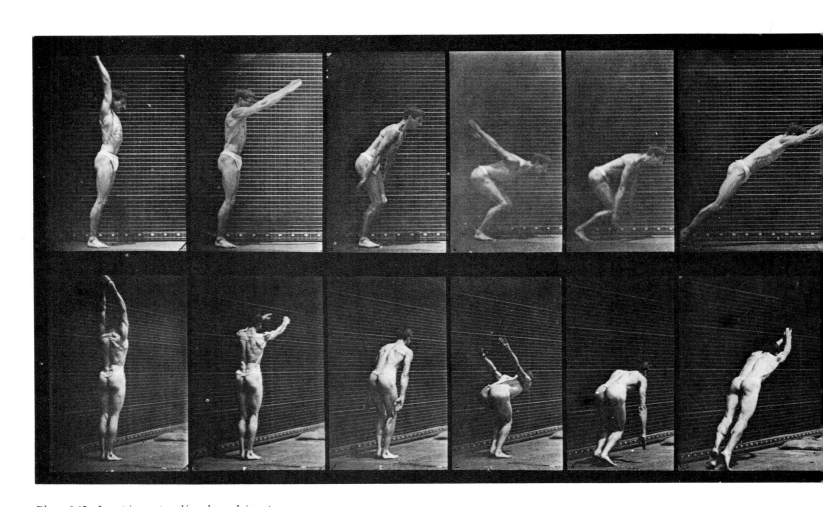

Plate 162. Jumping, standing broad jump.

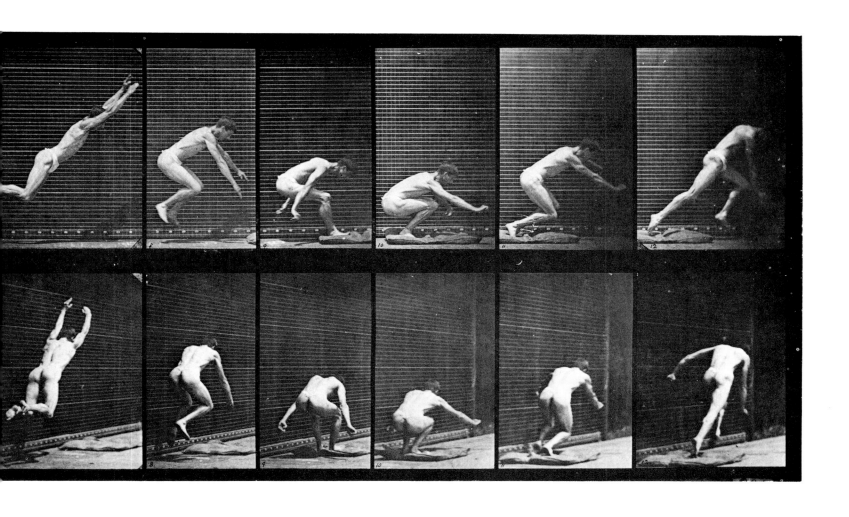

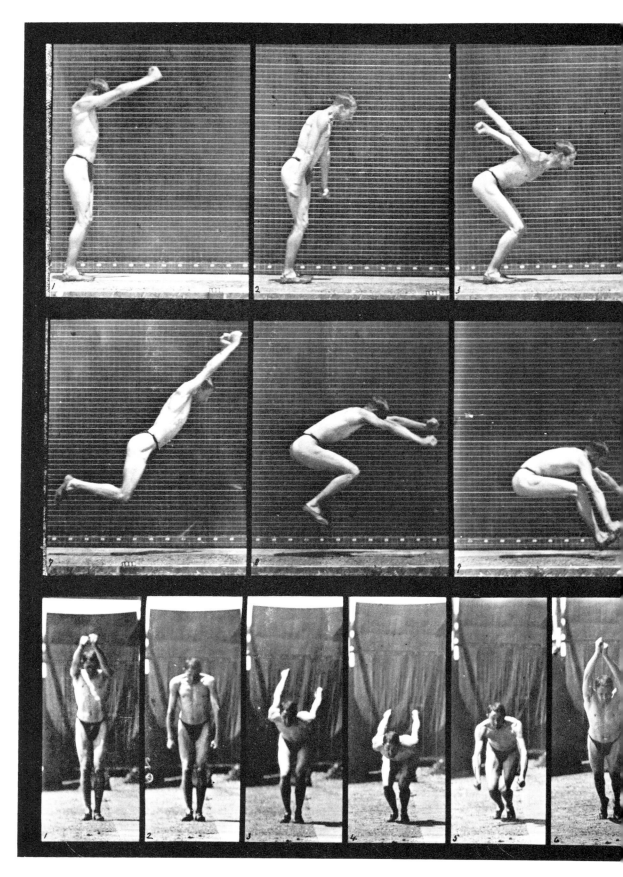

Plate 163. Jumping, standing broad jump.

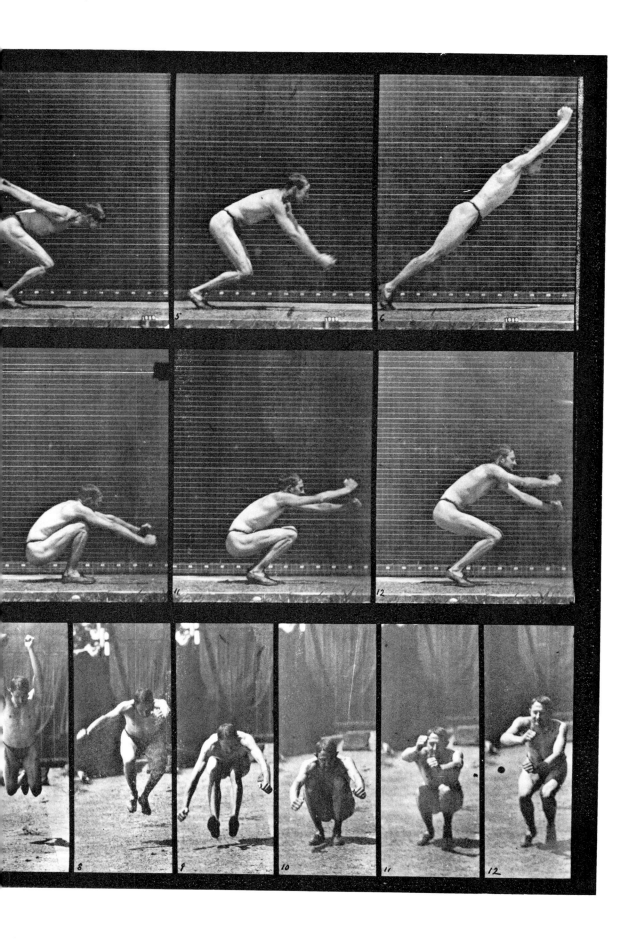

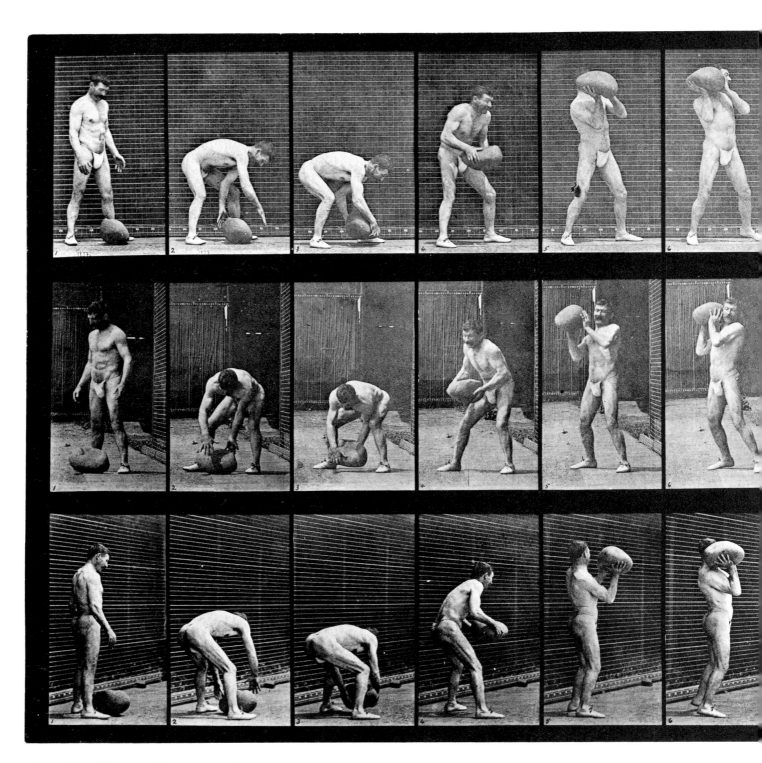

Plate 317. Lifting and heaving a 75-lb. rock.

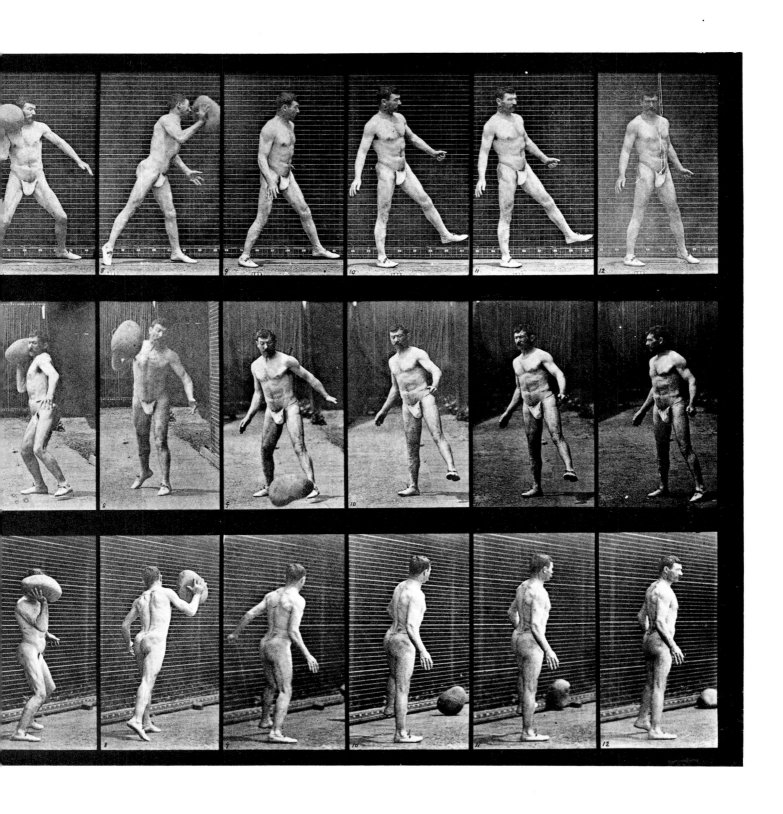

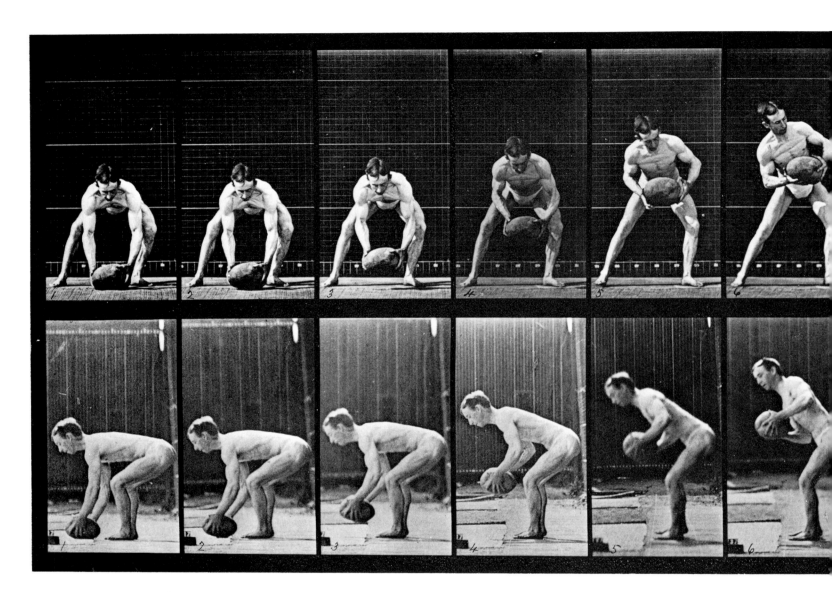

Plate 318. Lifting a 75-lb. rock.

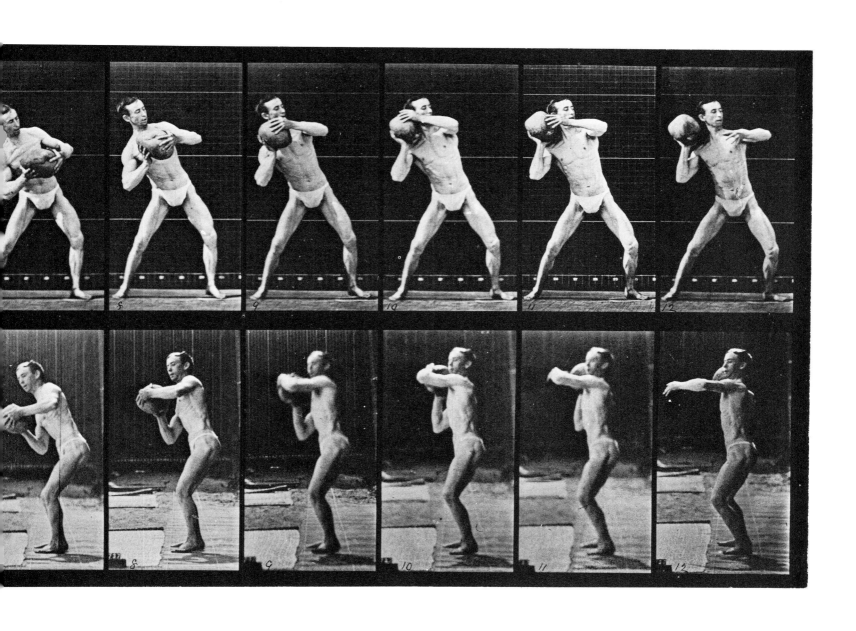

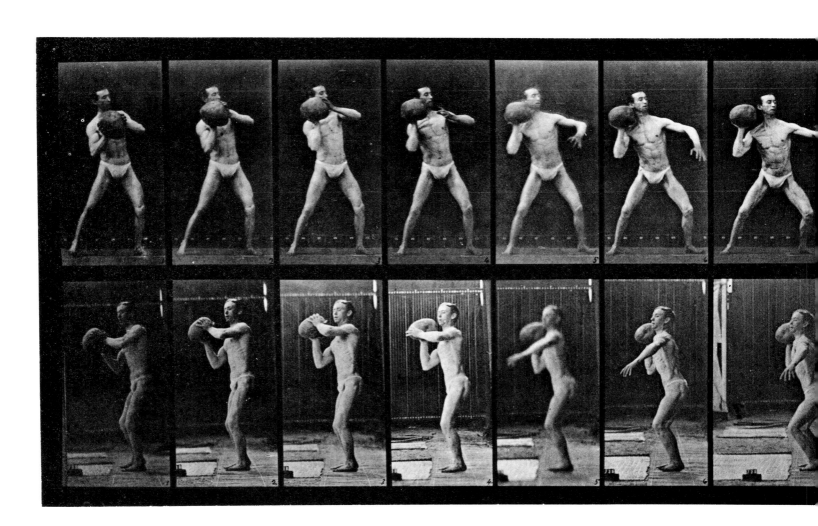

Plate 319. Heaving a 75-lb. rock.

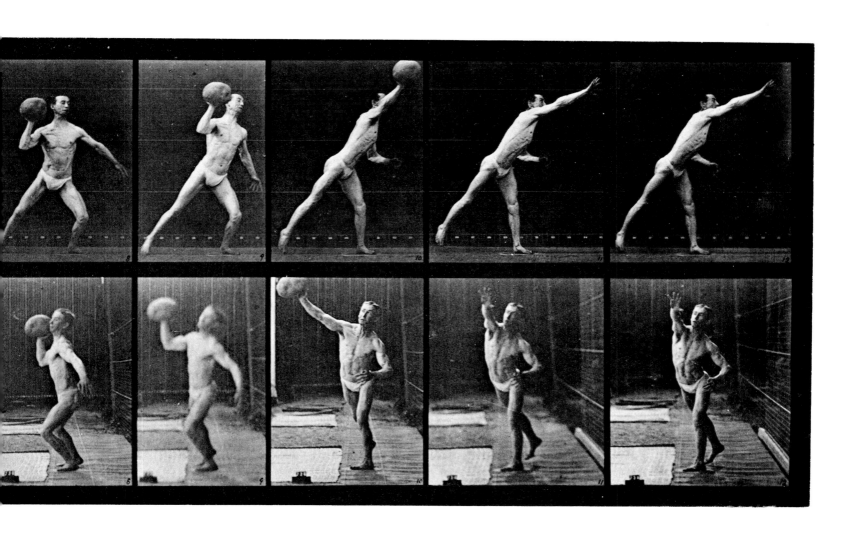

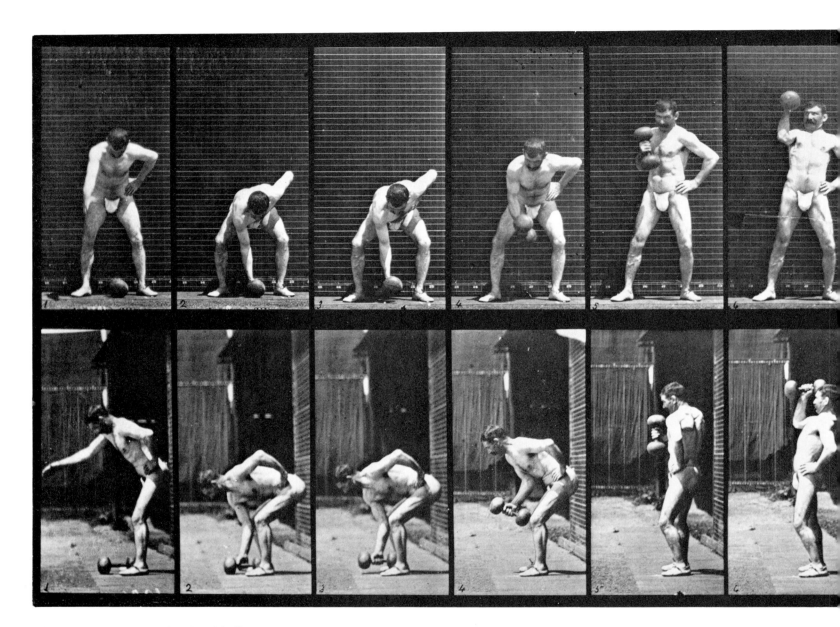

Plate 320. Lifting a 50-lb. dumbbell.

672 MALES (PELVIS CLOTH)

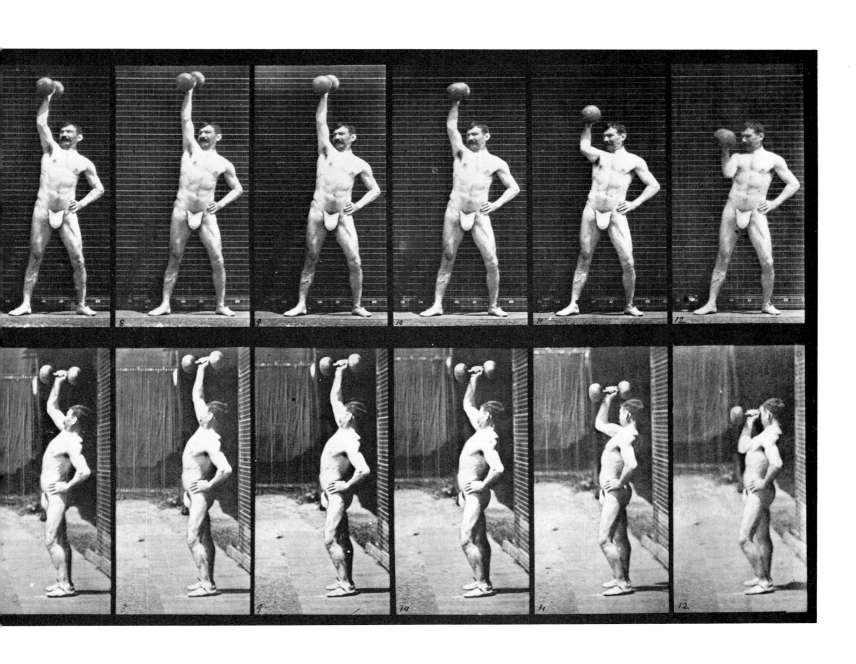

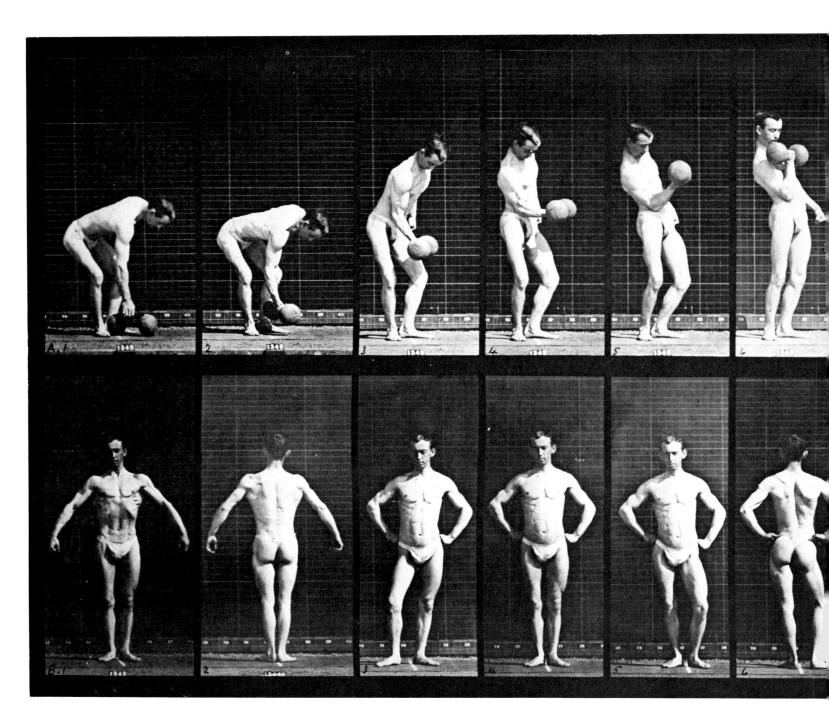

Plate 321. A: Lifting a 50-lb. dumbbell. B: Posing.

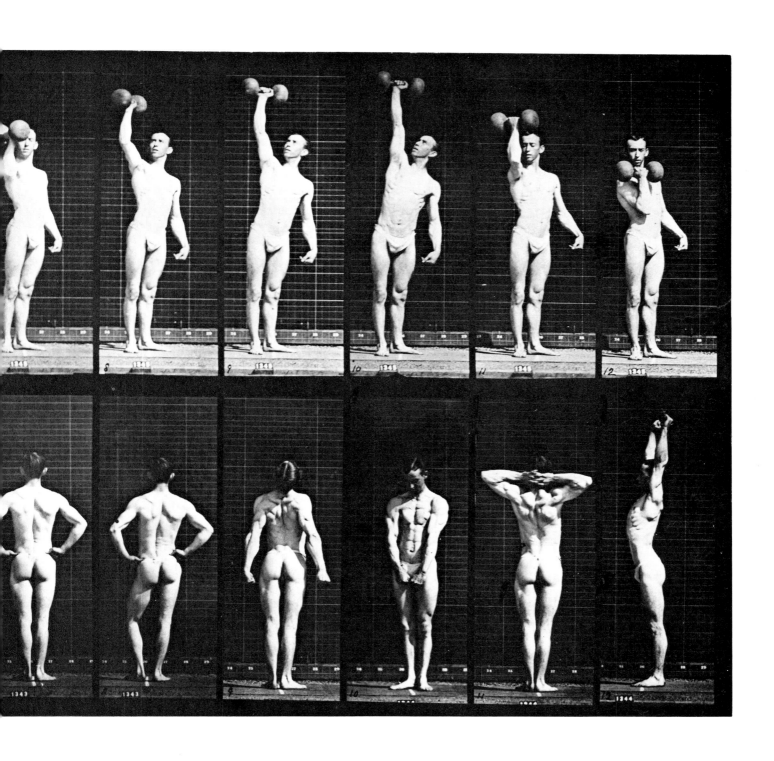

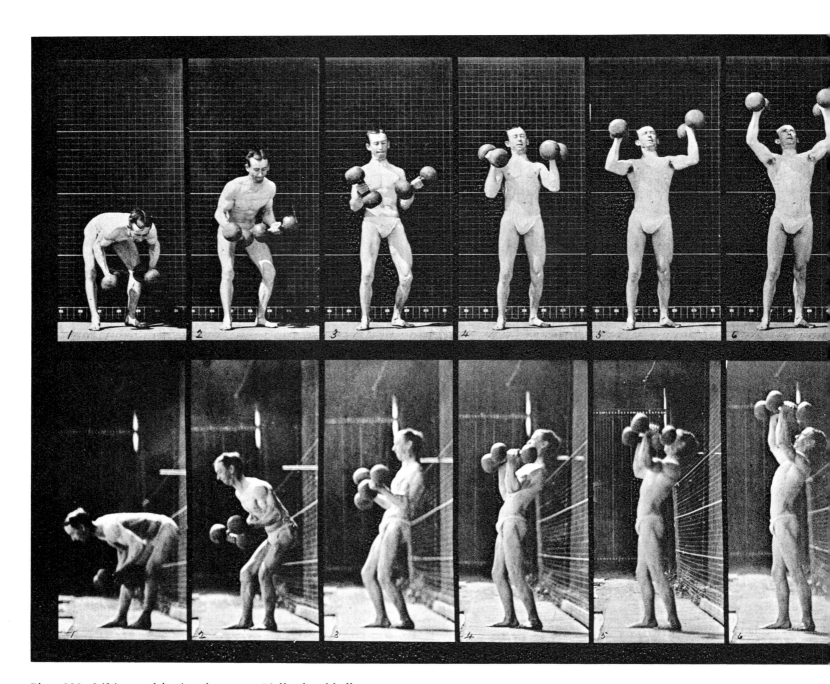

Plate 322. Lifting and letting down two 50-lb. dumbbells.

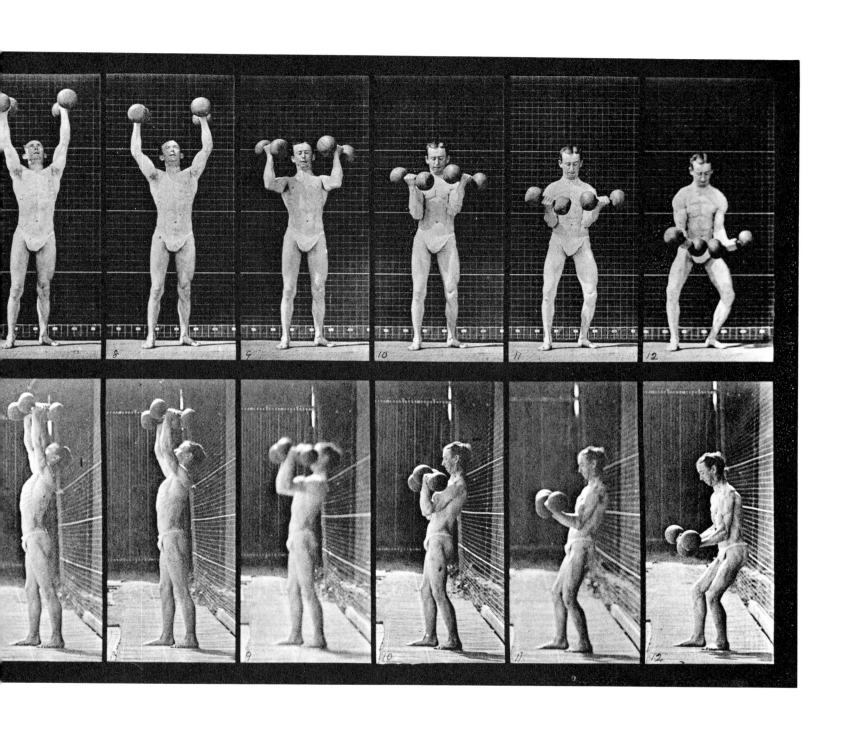

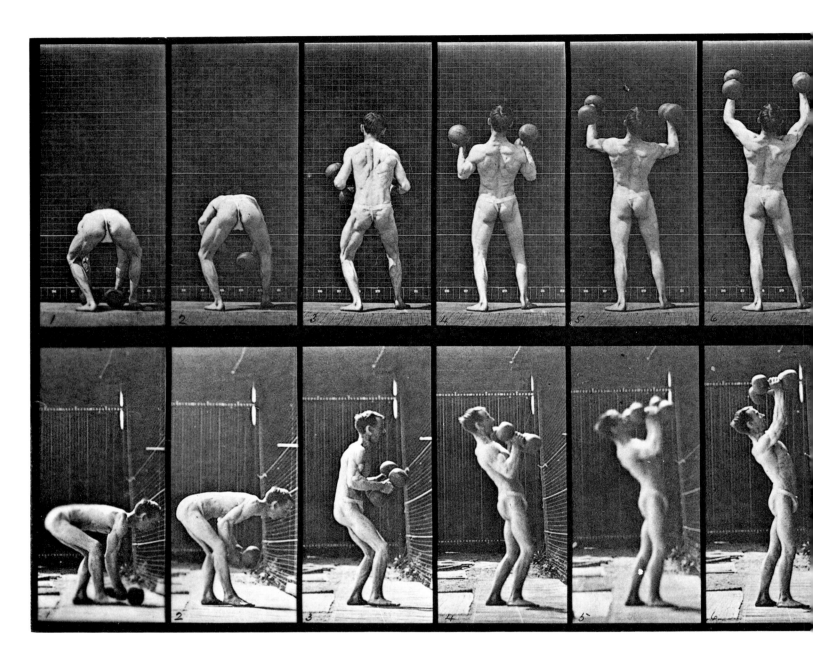

Plate 323. Lifting and letting down two 50-lb. dumbbells.

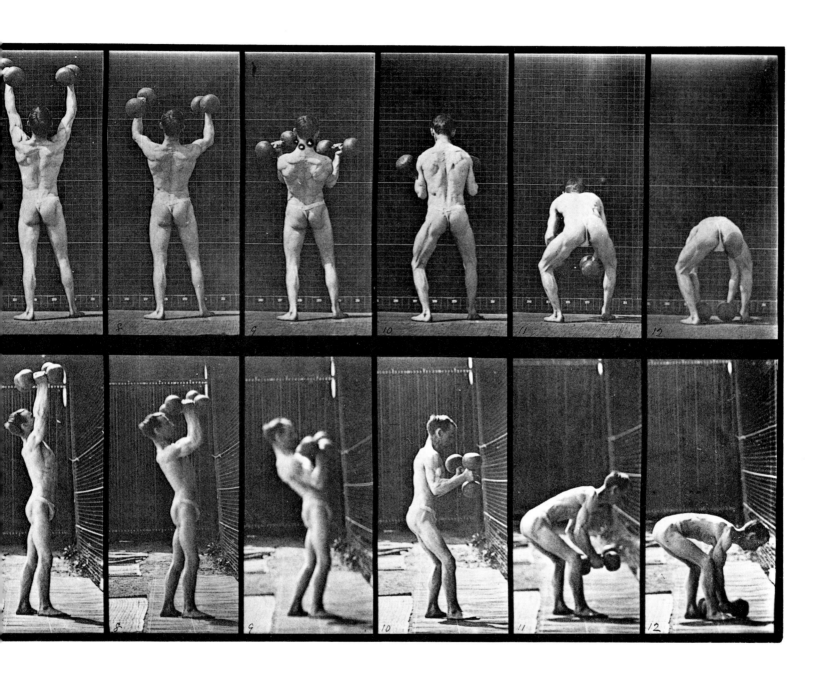

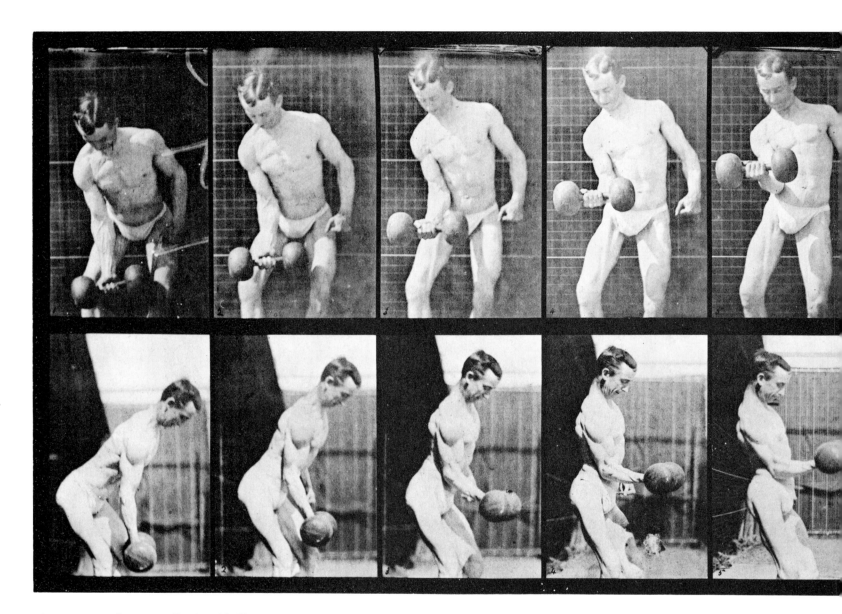

Plate 324. Curling a 50-lb. dumbbell.

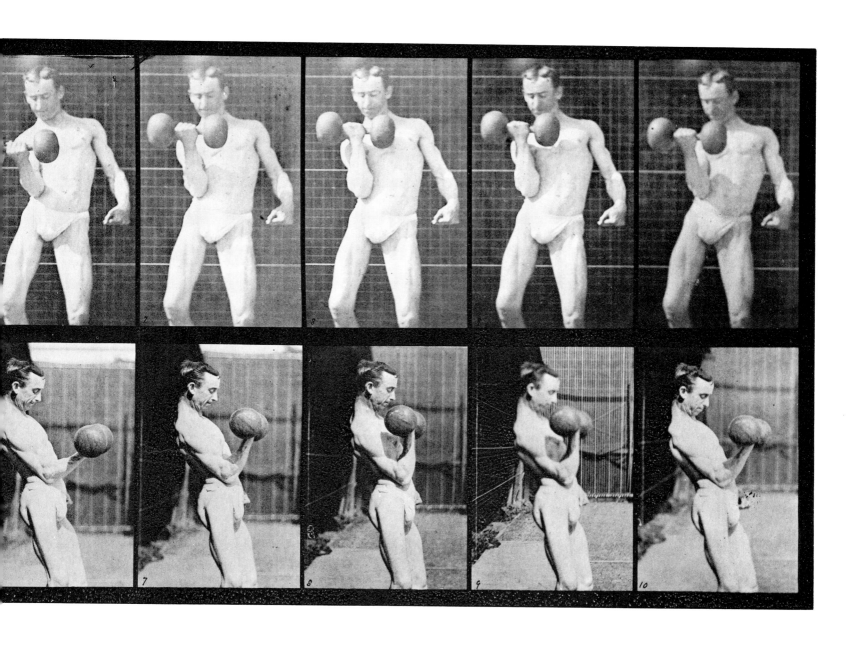

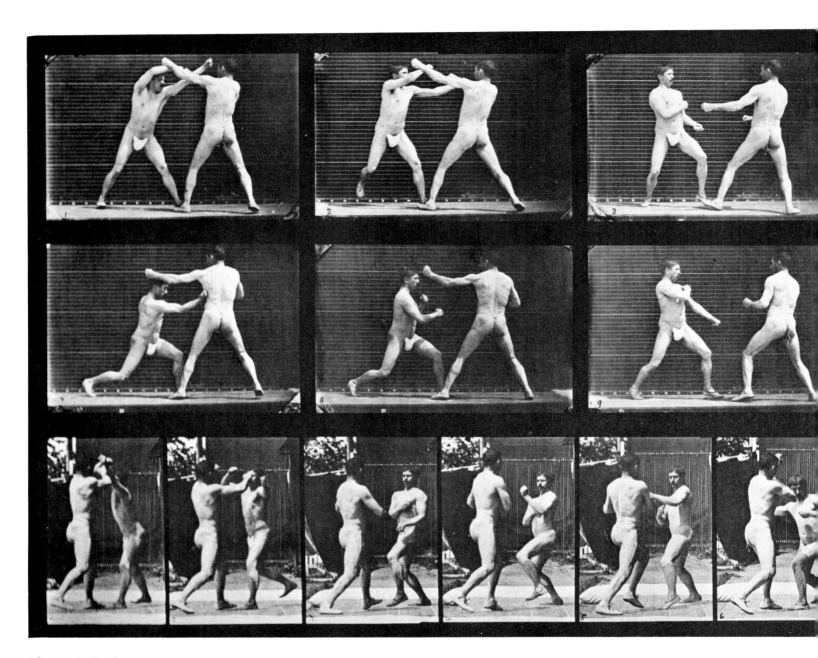

Plate 329. Boxing.

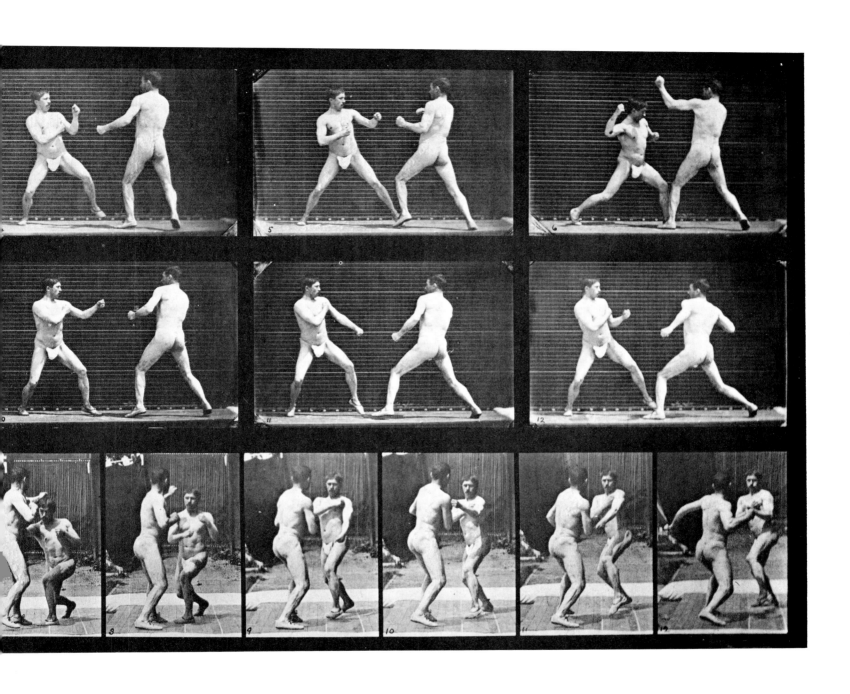

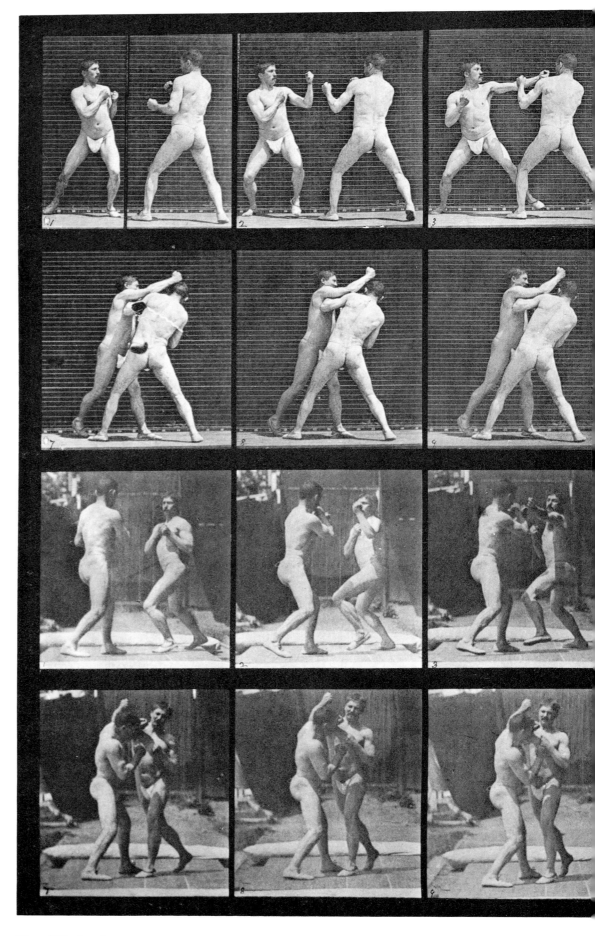

Plate 330. Boxing, cross-counter.

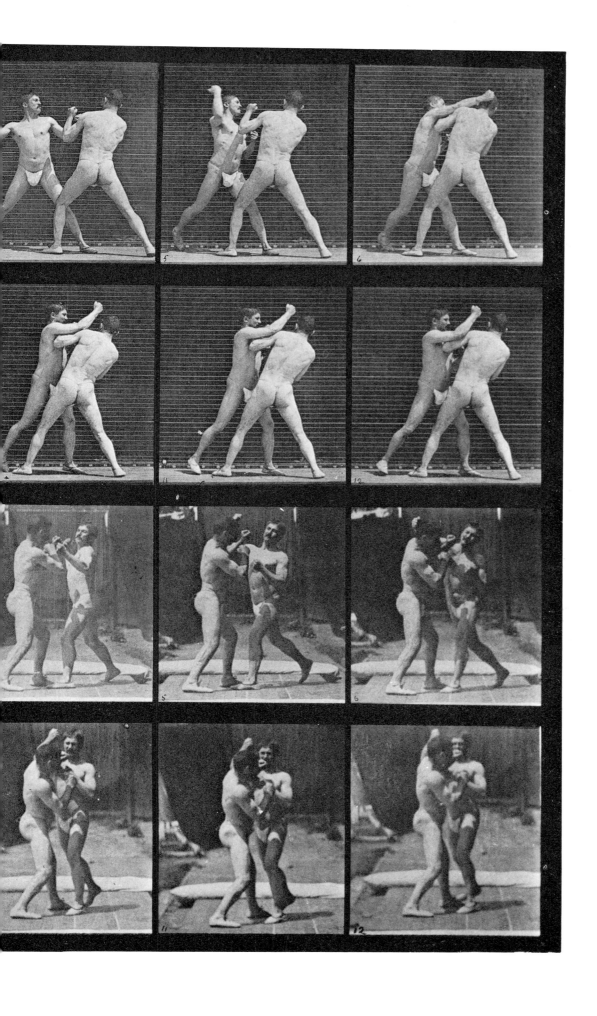

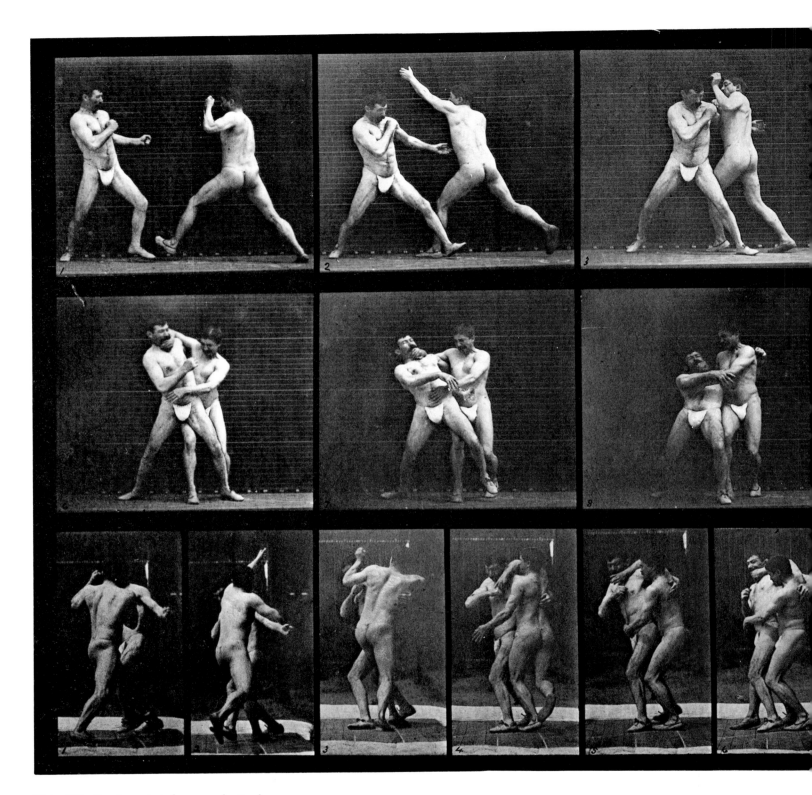

Plate 331. Boxing, stop for cross-buttocks.

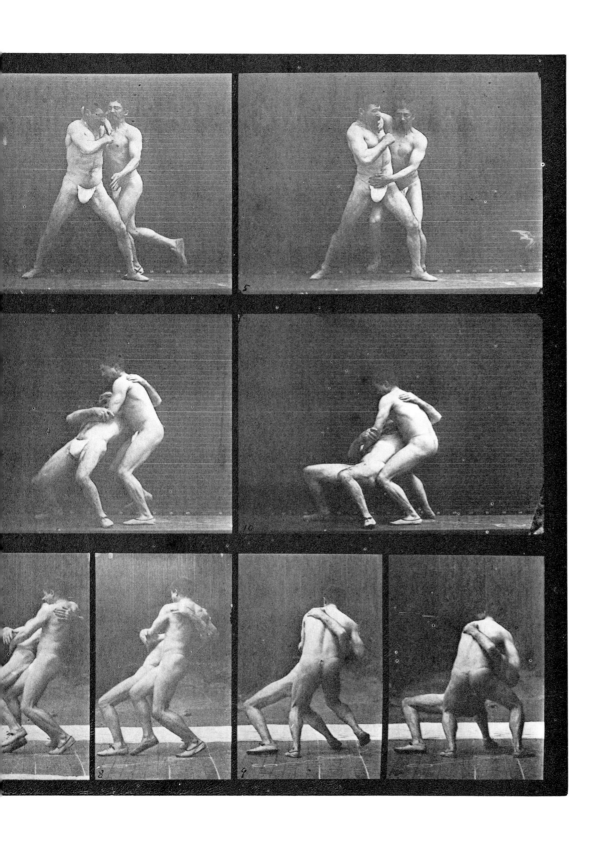

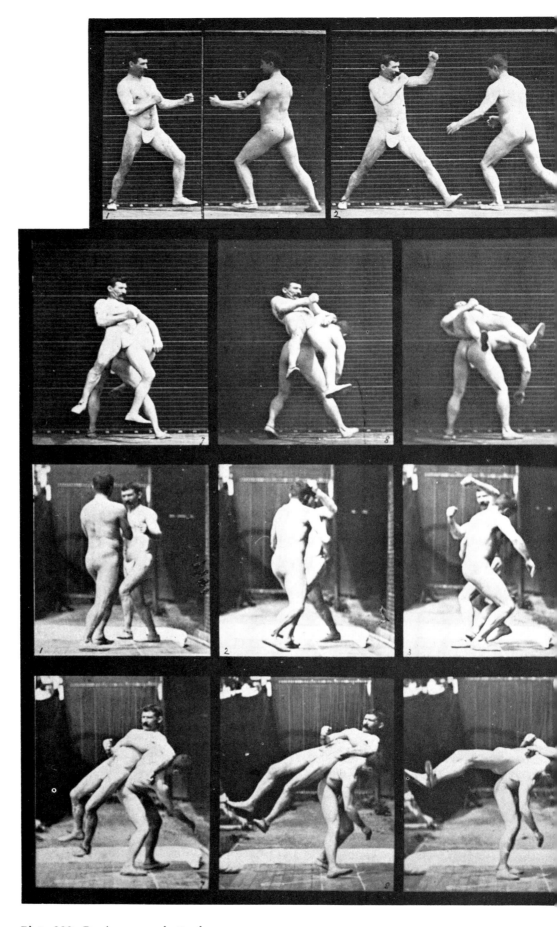

Plate 332. Boxing, cross-buttocks.

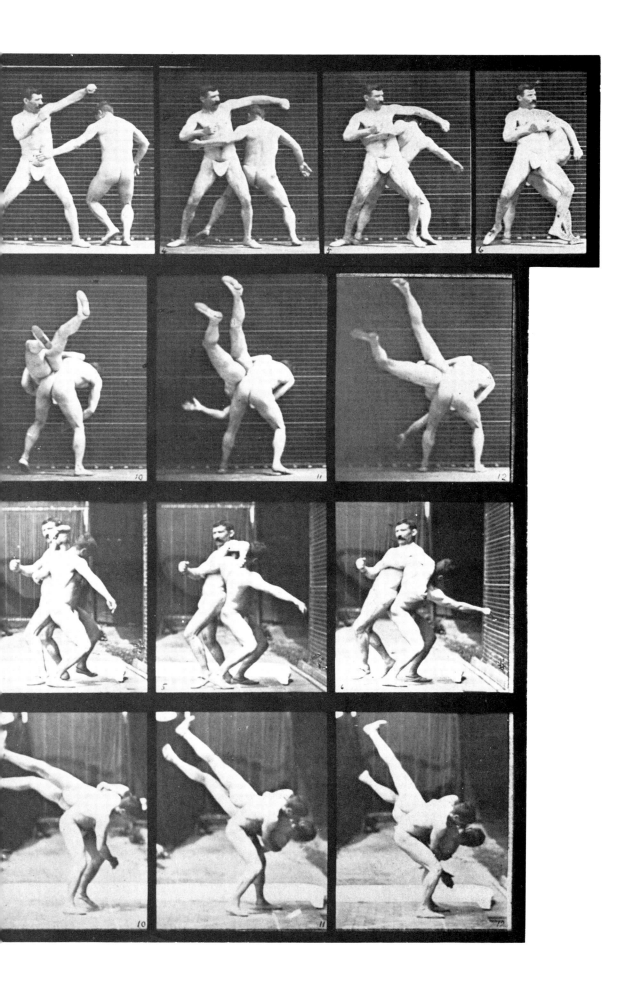

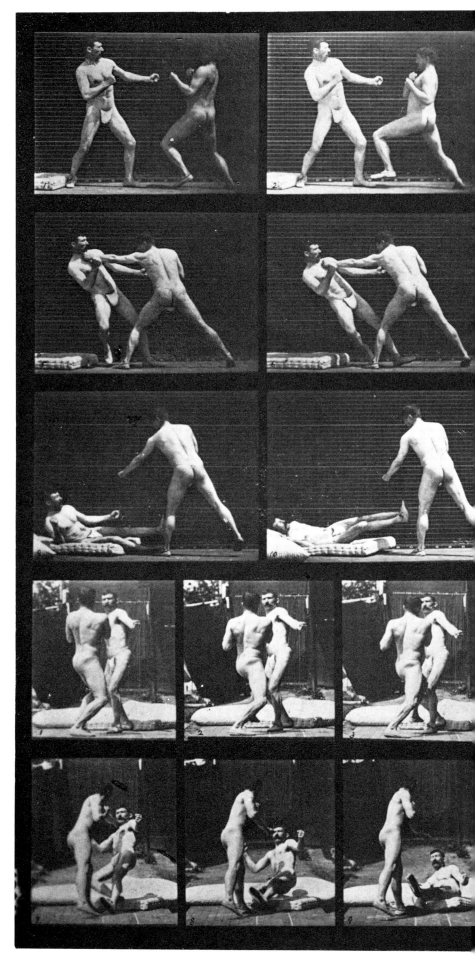

Plate 333. Boxing, one man knocking the other one down.

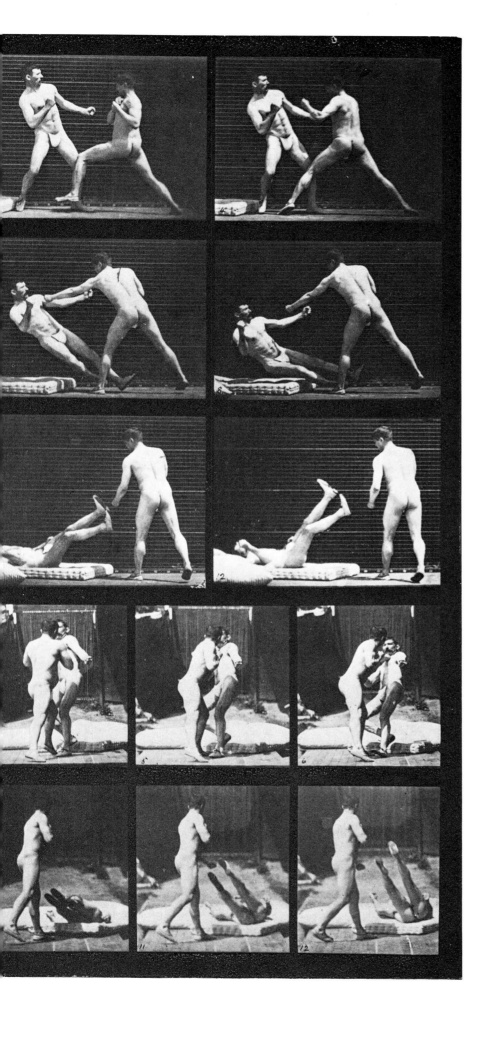

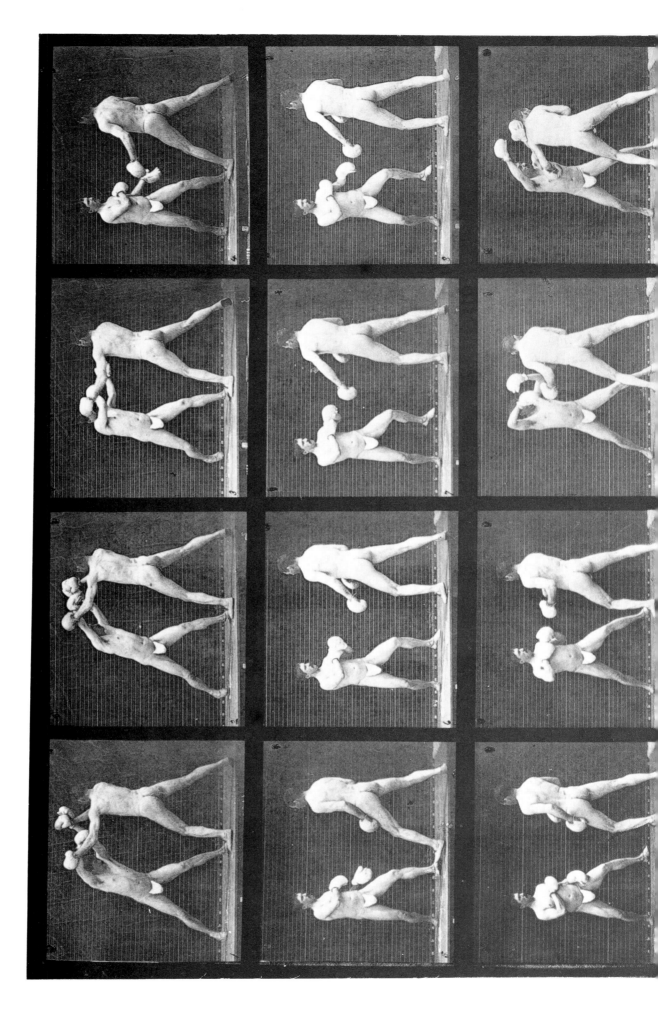

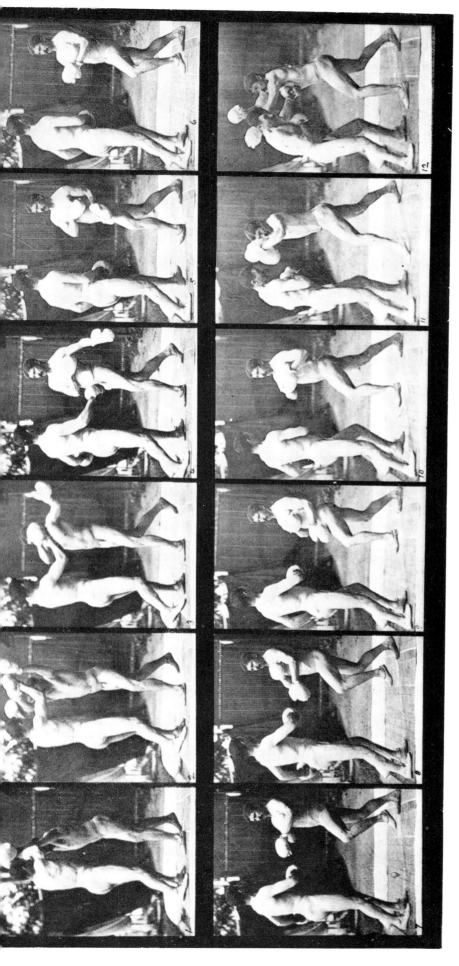

Plate 334. Boxing with gloves.

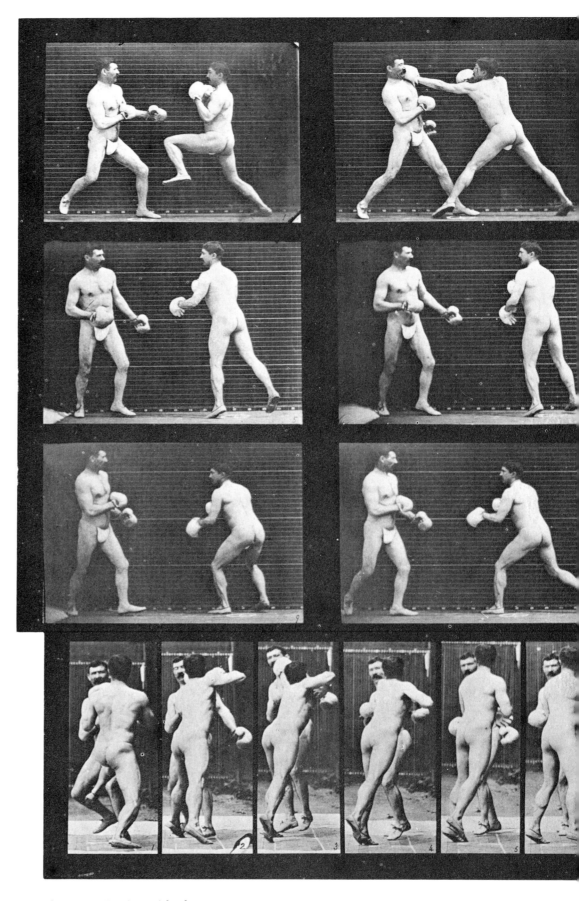

Plate 335. Boxing with gloves.

694 MALES (PELVIS CLOTH)

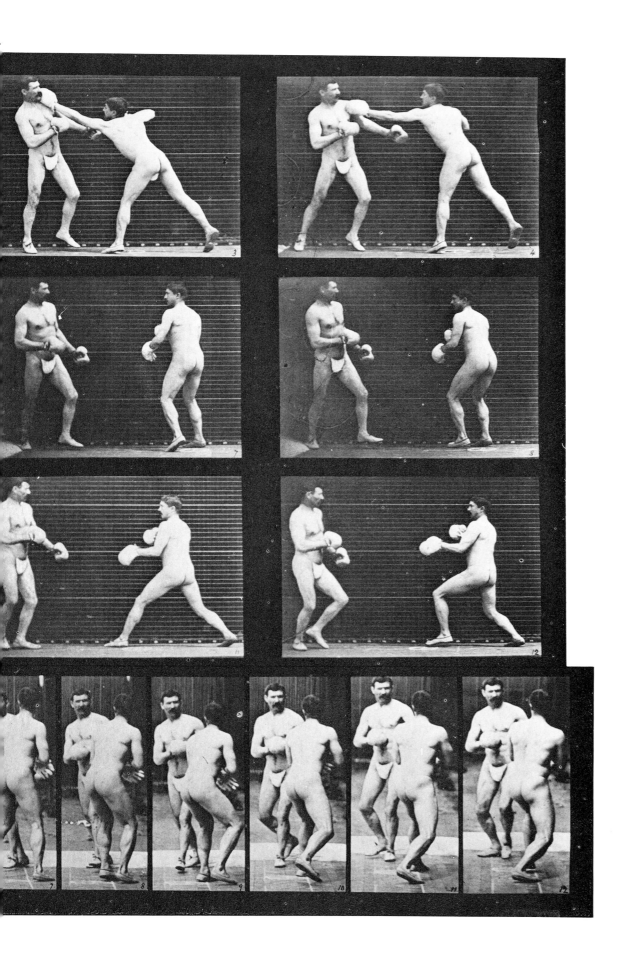

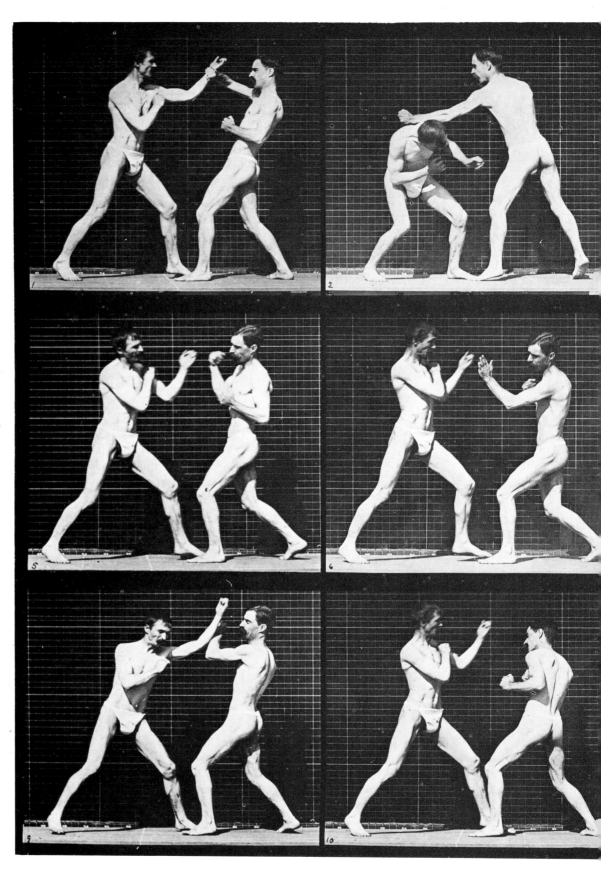

Plate 336. Boxing, open hand.

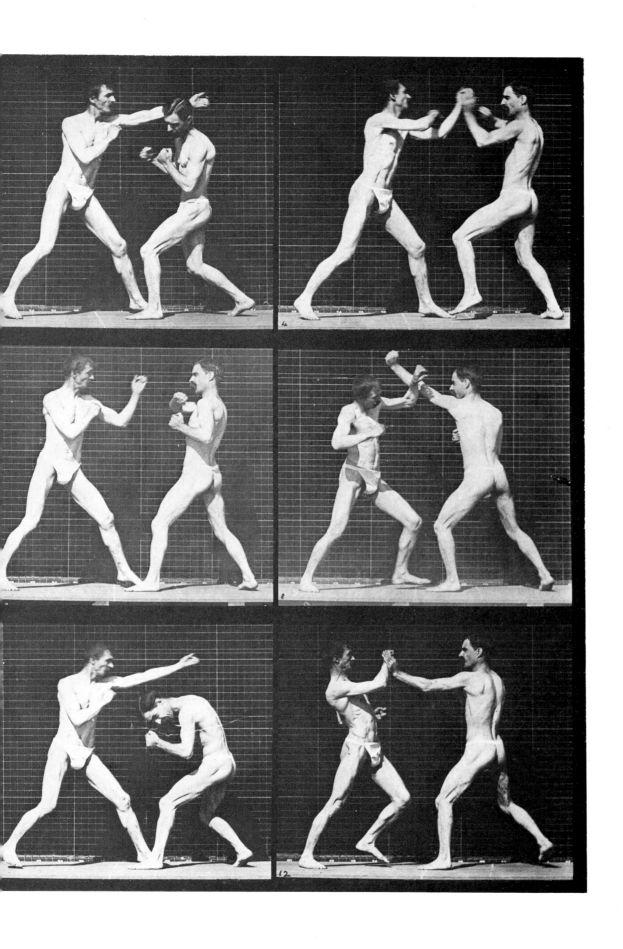

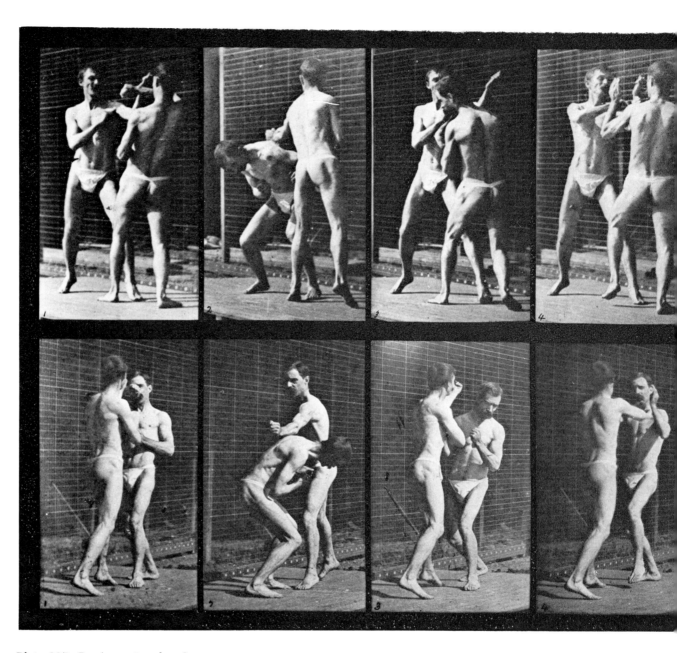

Plate 337. Boxing, open hand.

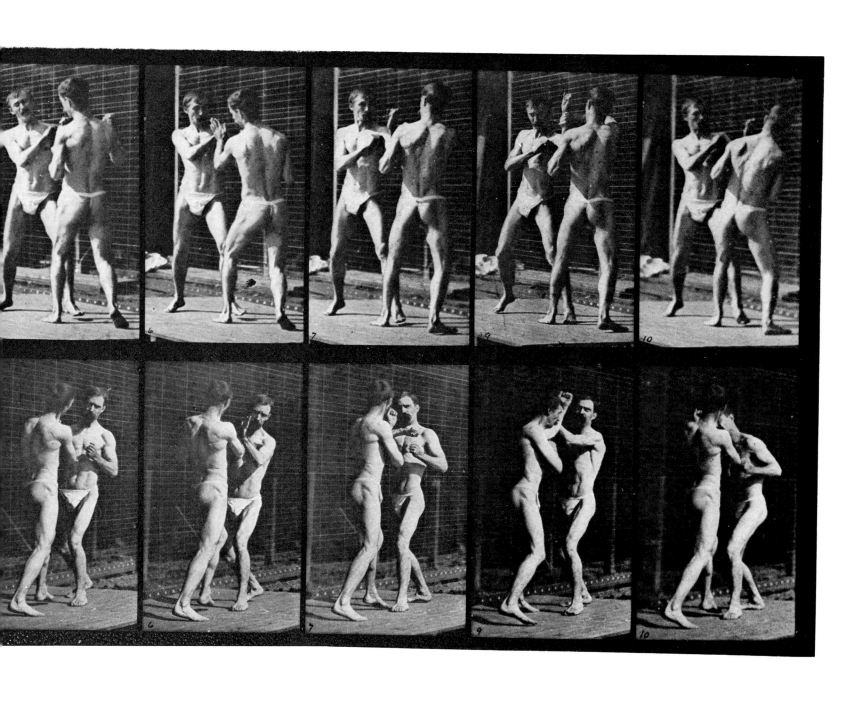

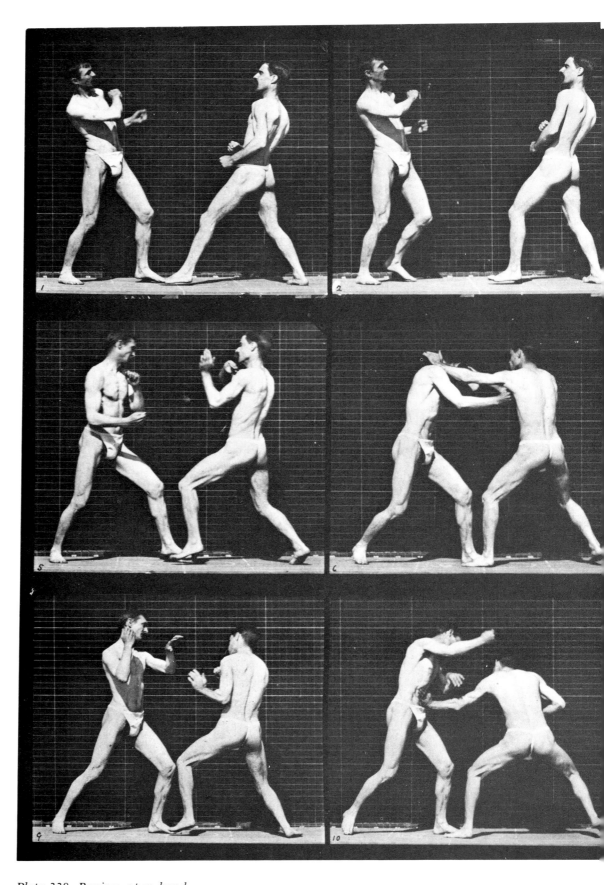

Plate 338. Boxing, open hand.

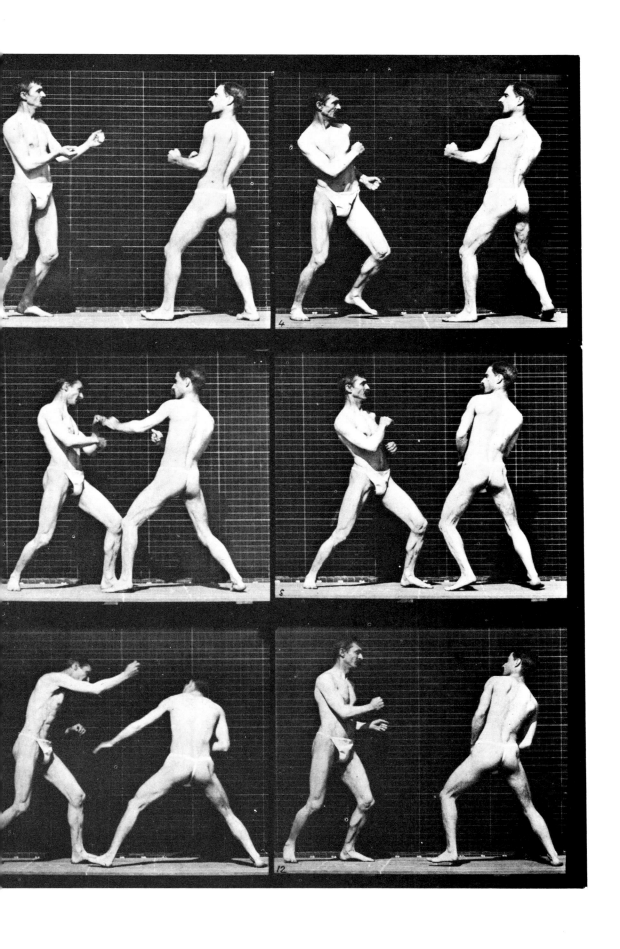

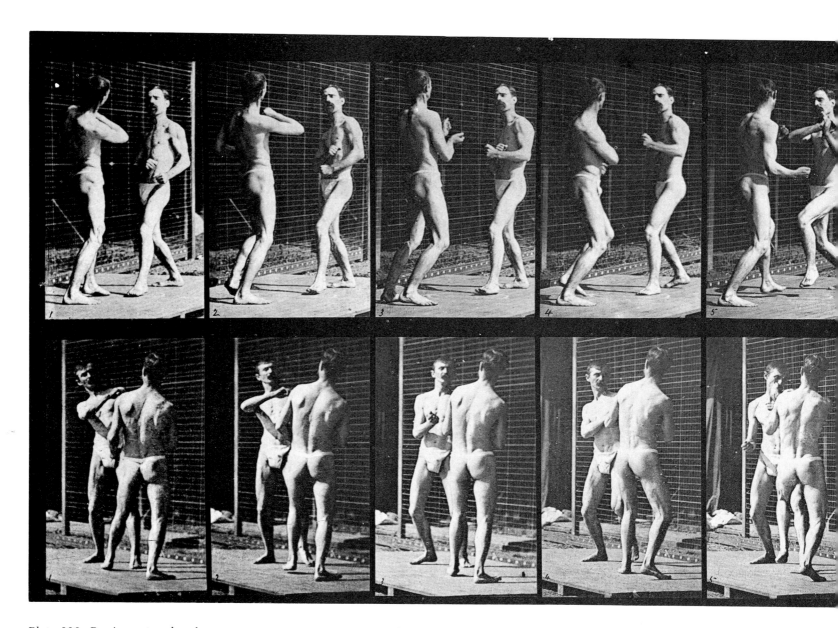

Plate 339. Boxing, open hand.

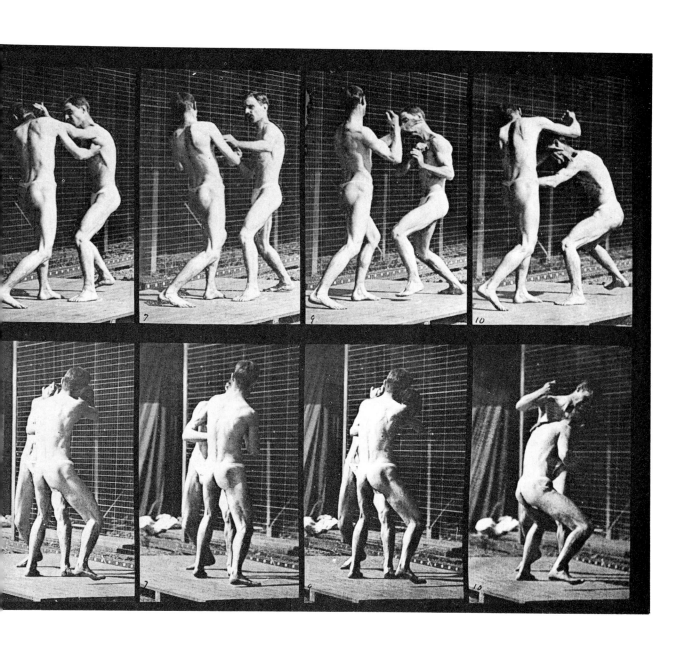

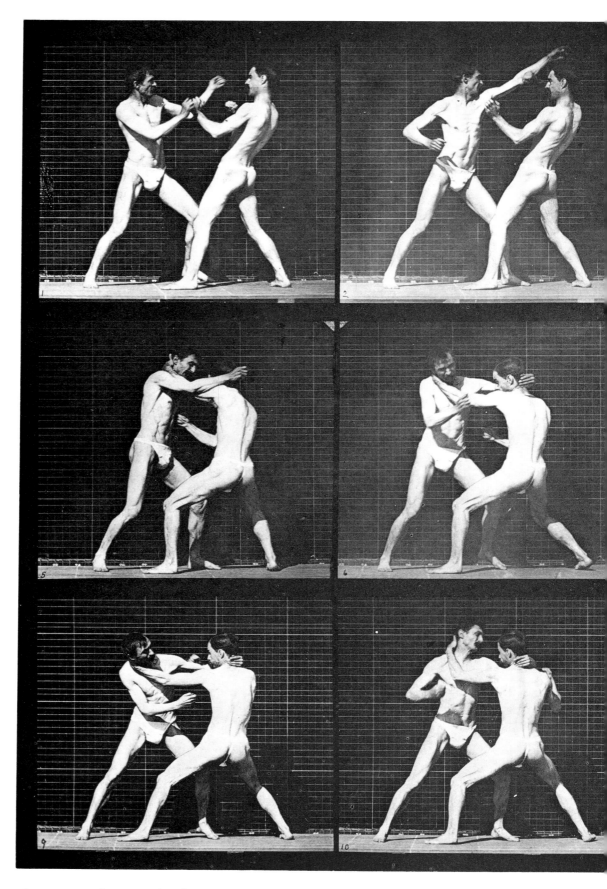

Plate 340. Boxing, open hand.

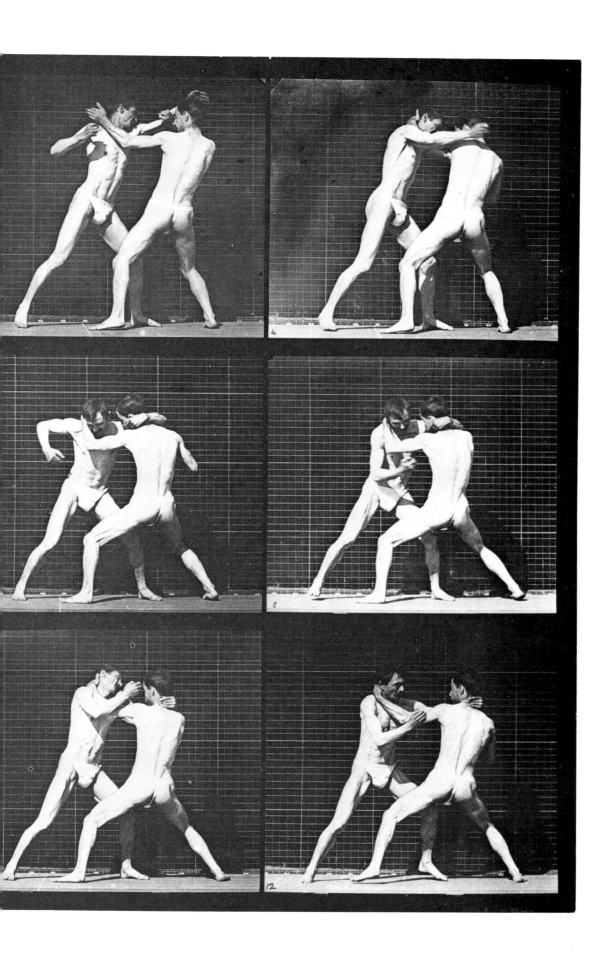

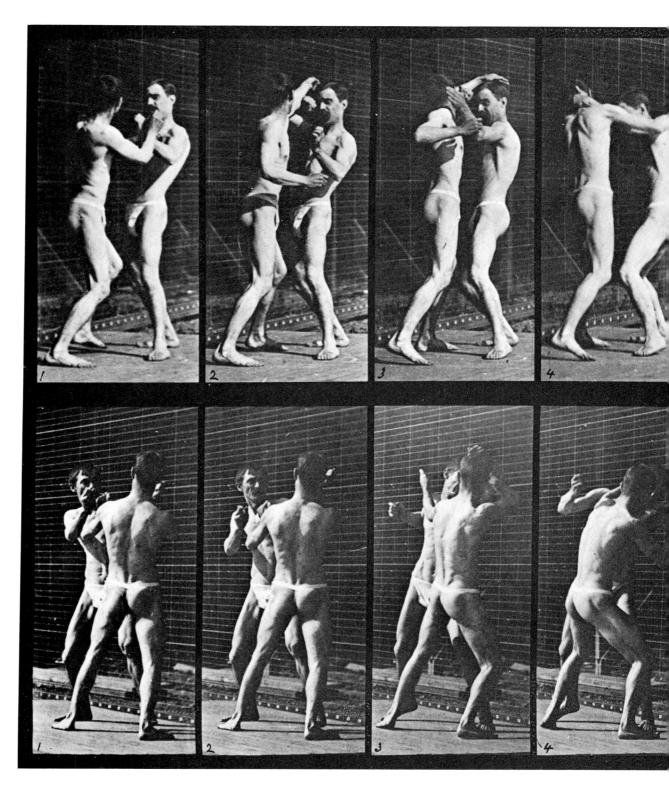

Plate 341. Boxing, open hand.

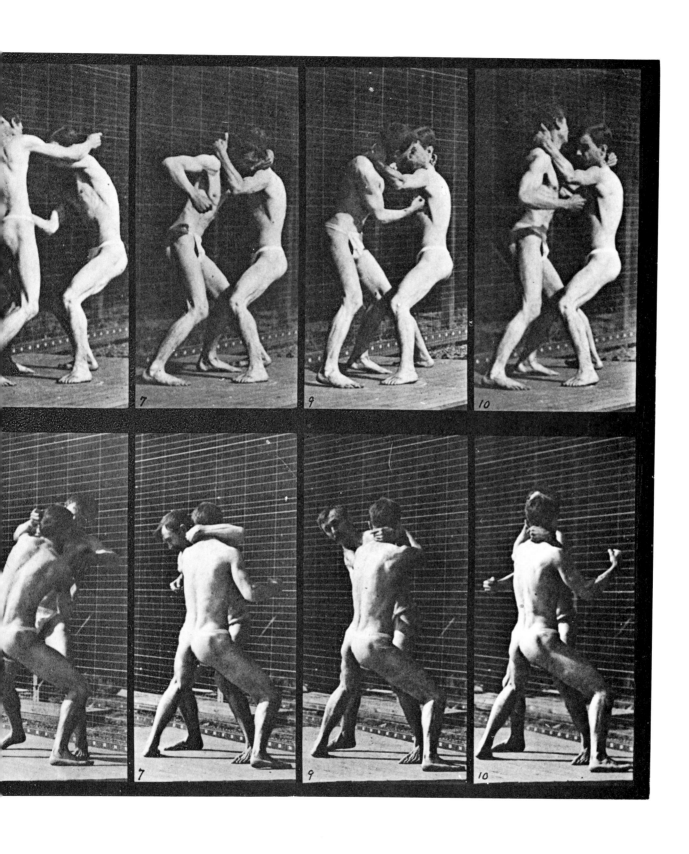

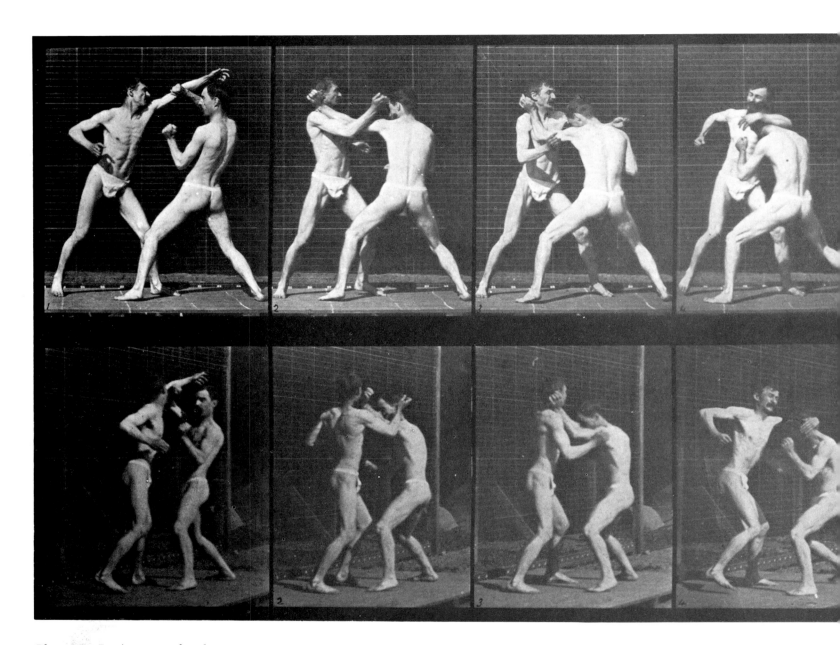

Plate 342. Boxing, open hand.

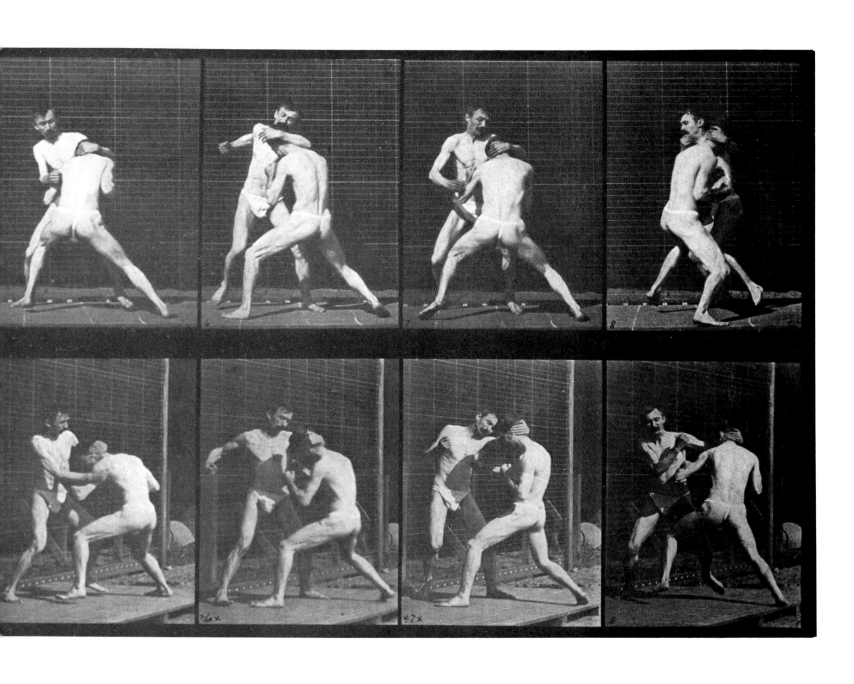

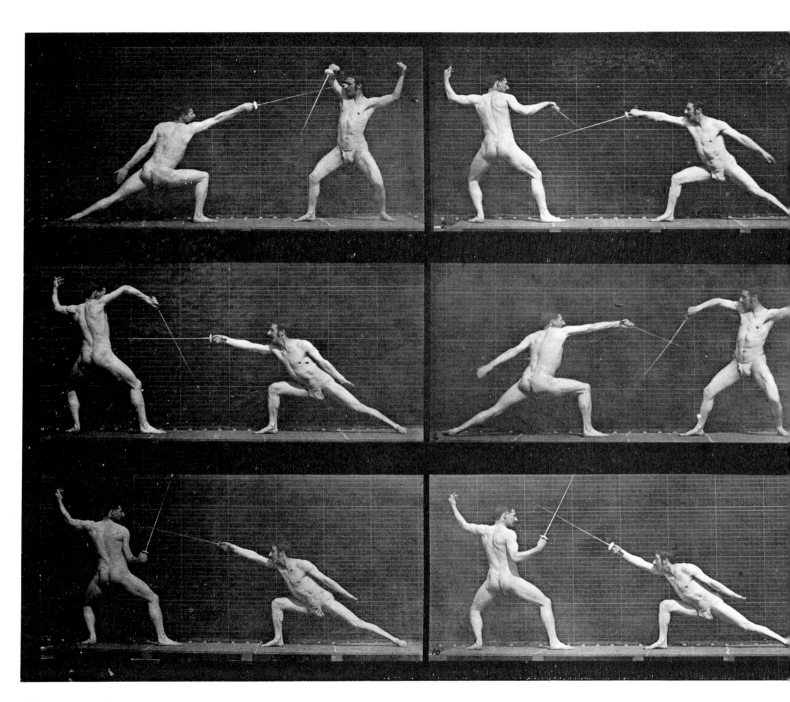

Plate 349. Fencing.

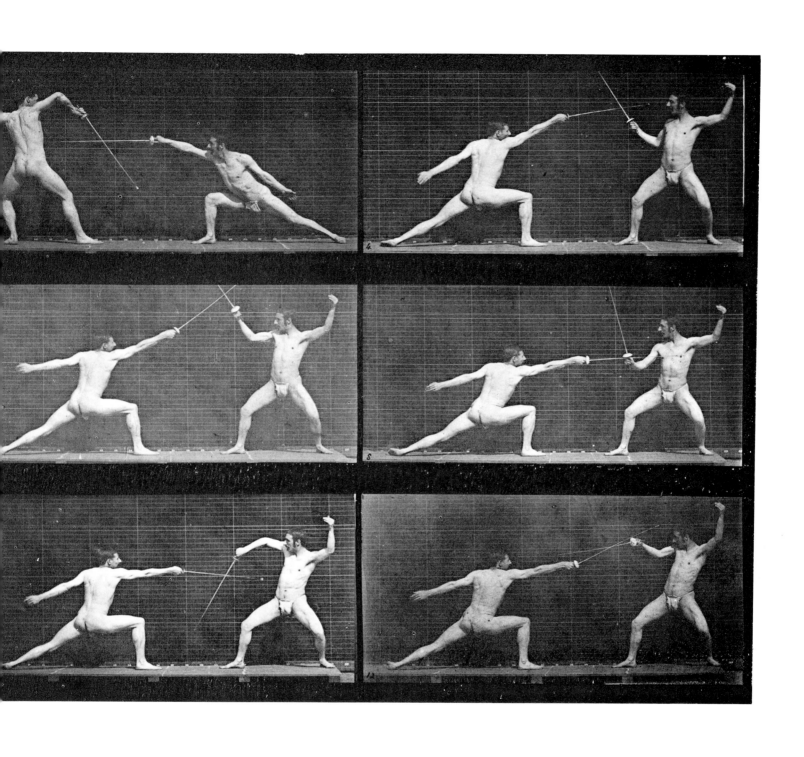

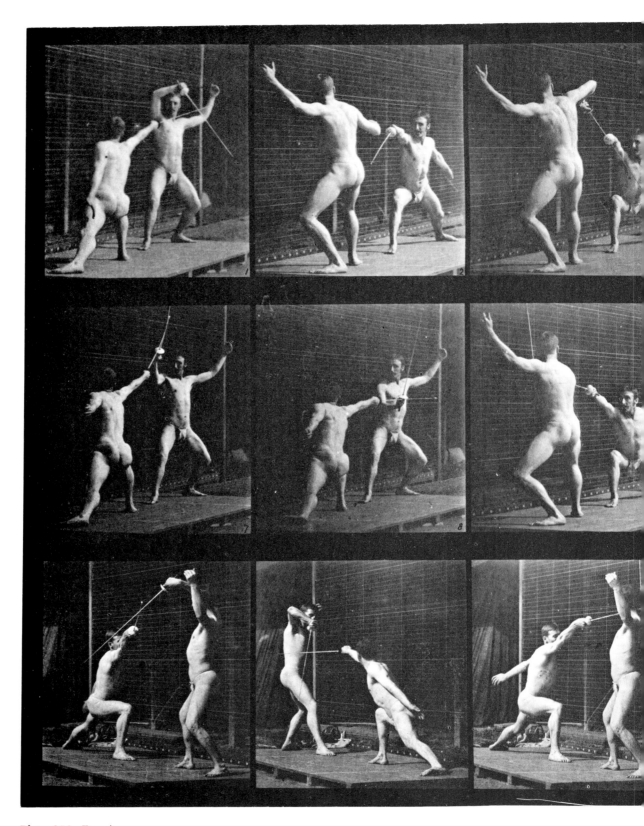

Plate 350. Fencing.

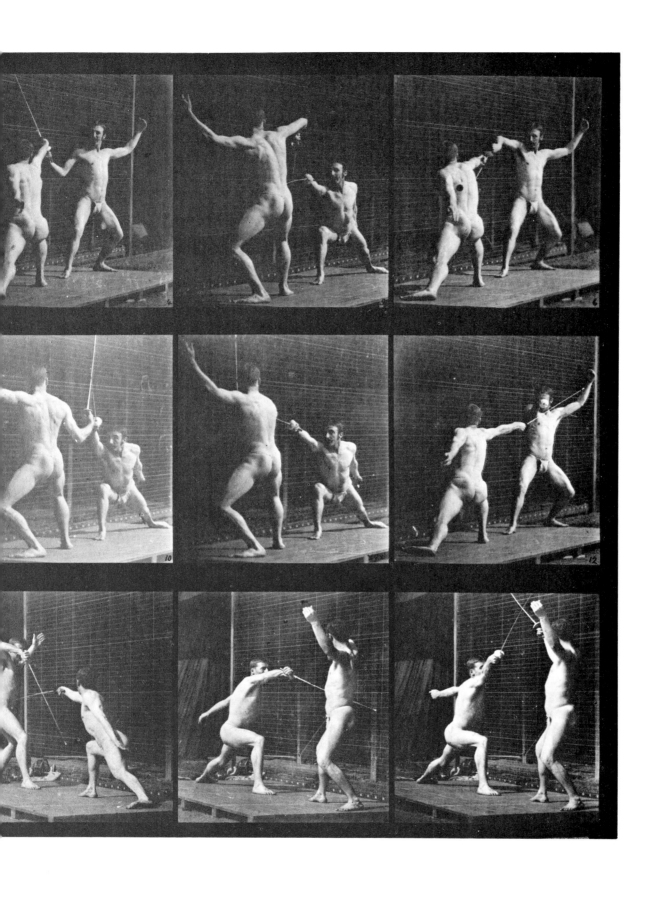

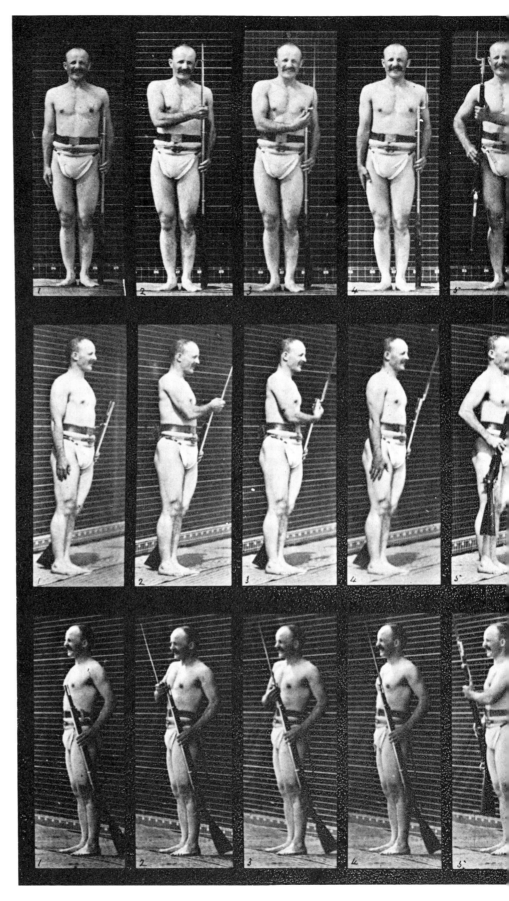

Plate 351. "Fix" and "unfix bayonets."

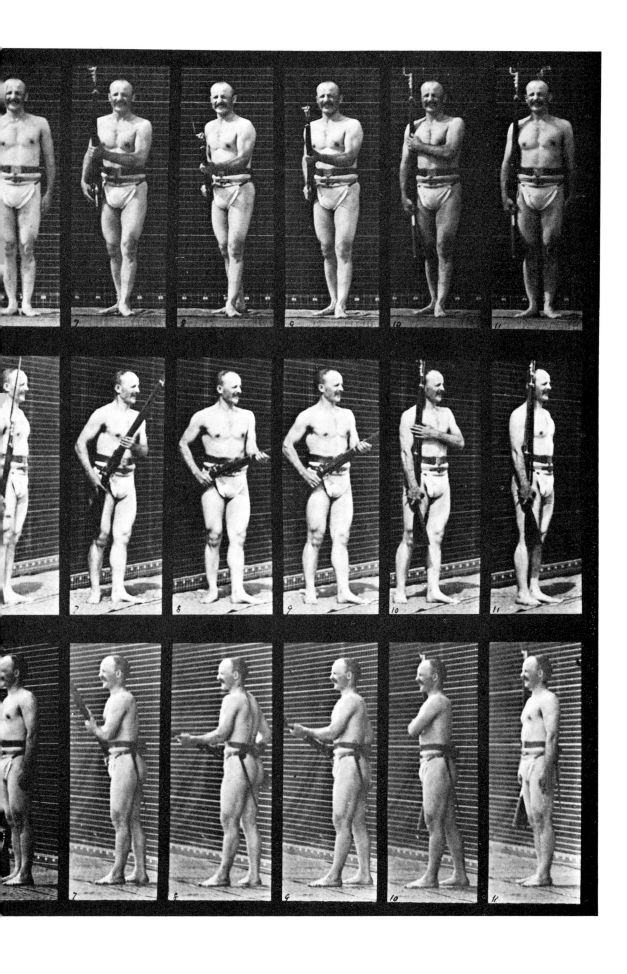

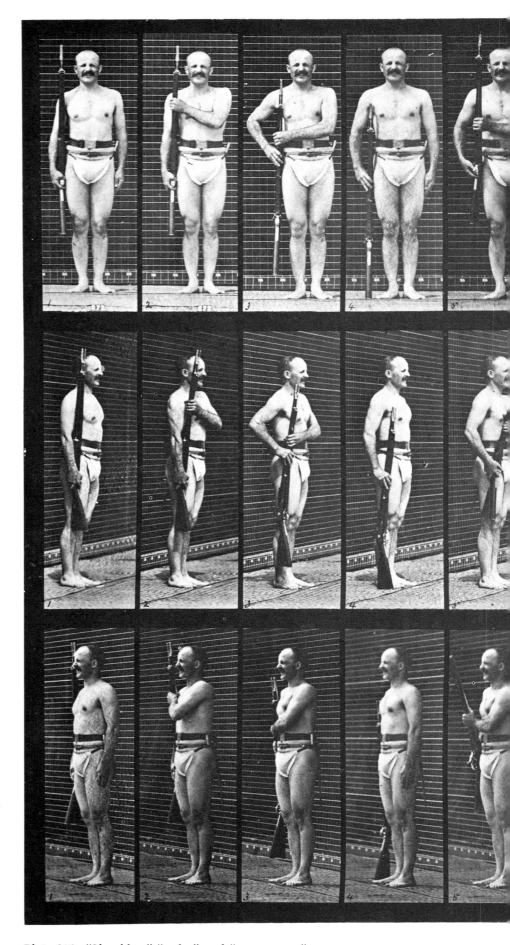

Plate 352. "Shoulder," "order" and "carry arms."

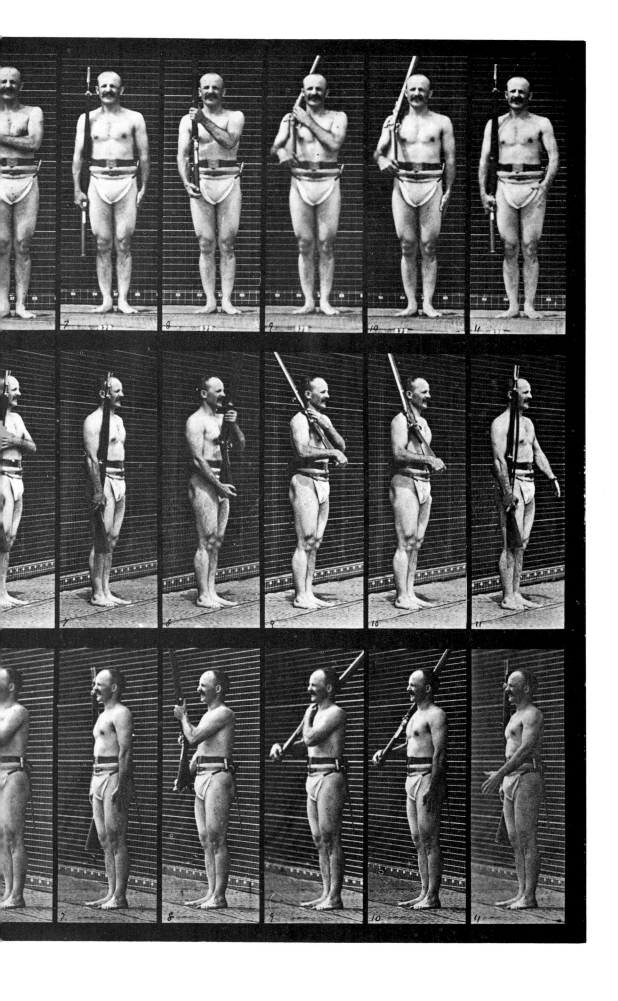

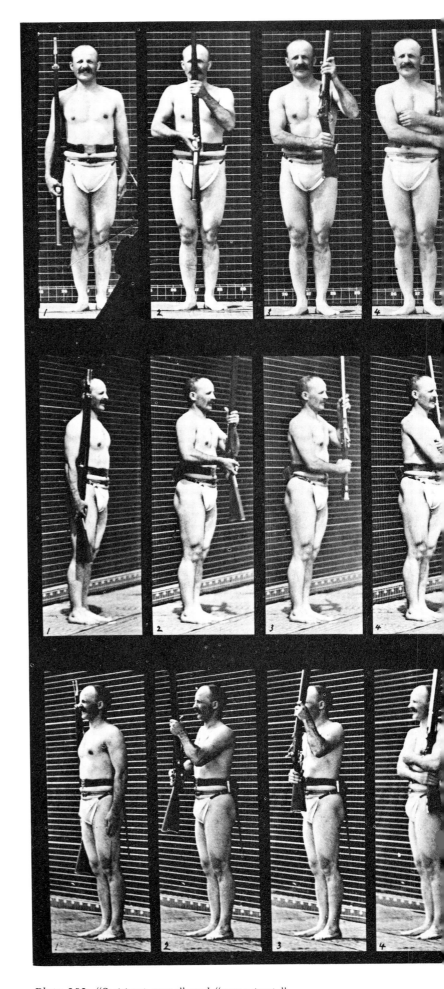

Plate 353. "Support arms" and "arms port."

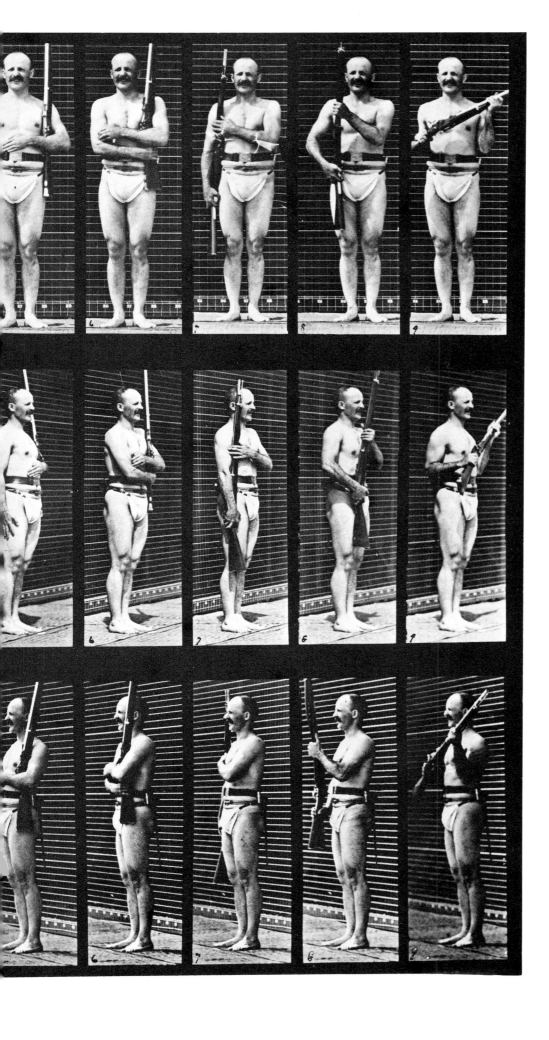

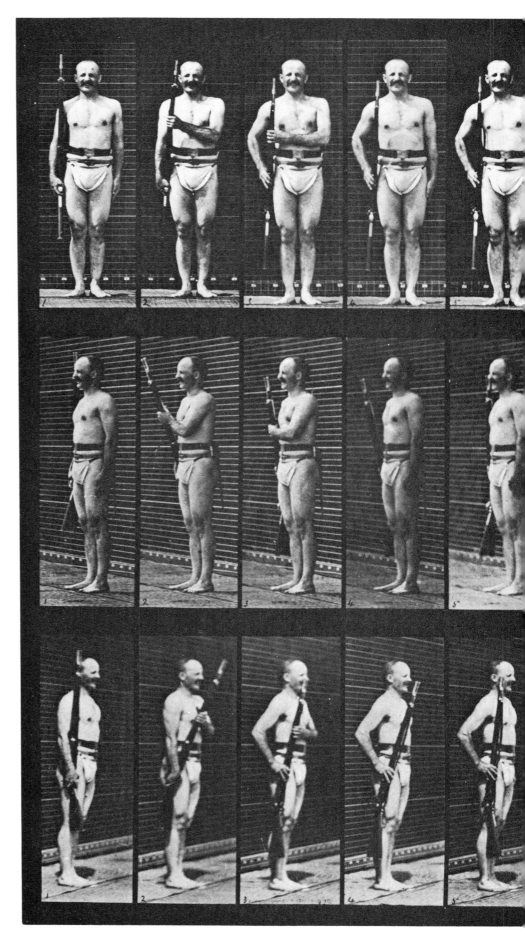

Plate 354. "Carry arms," "parade rest" and "trail arms."

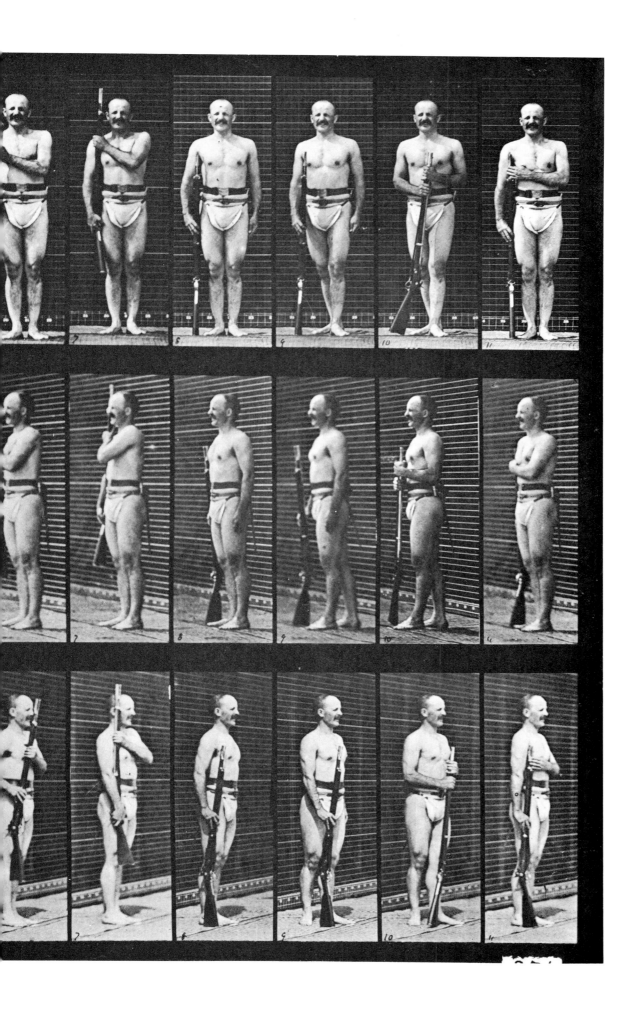

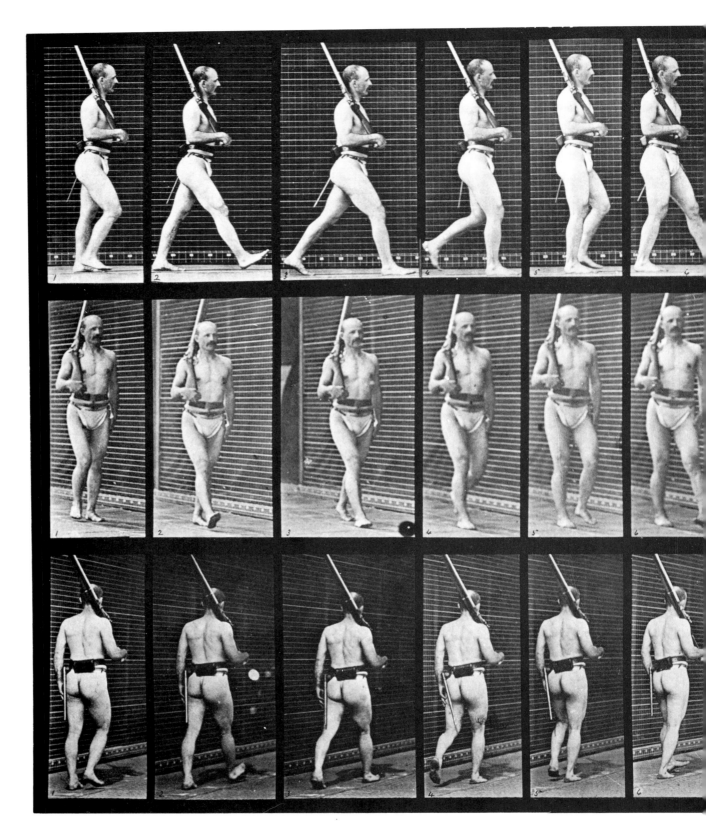

Plate 355. On guard, walking and turning around.

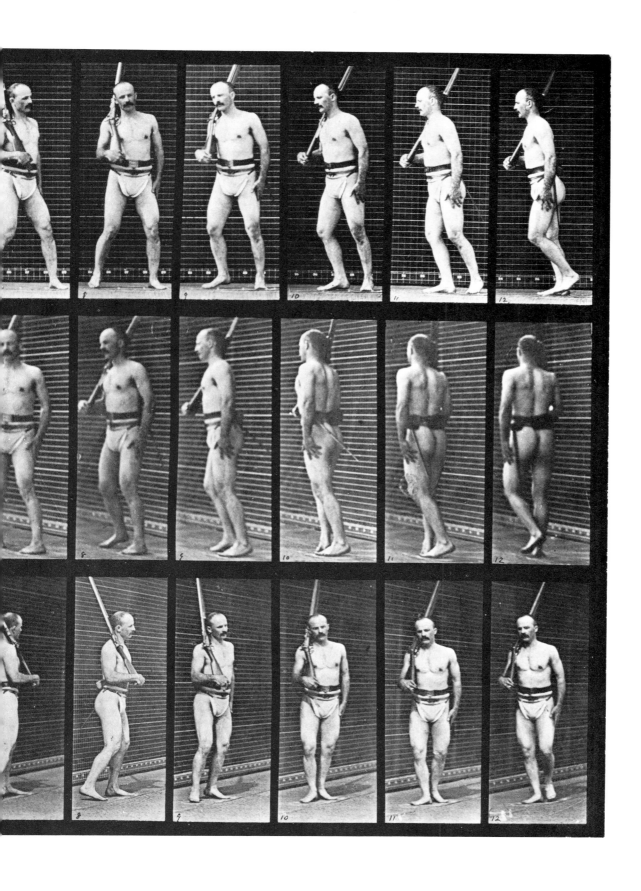

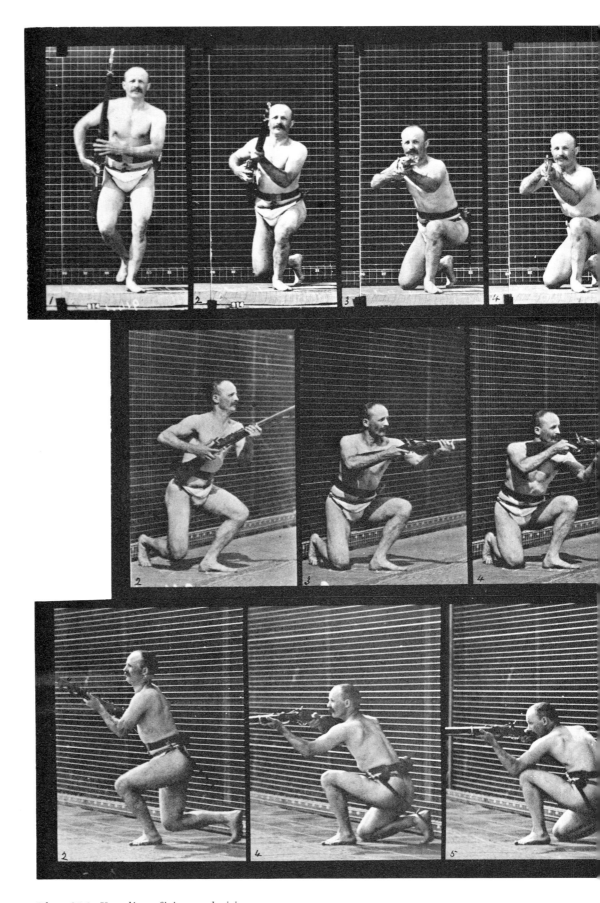

Plate 356. Kneeling, firing and rising.

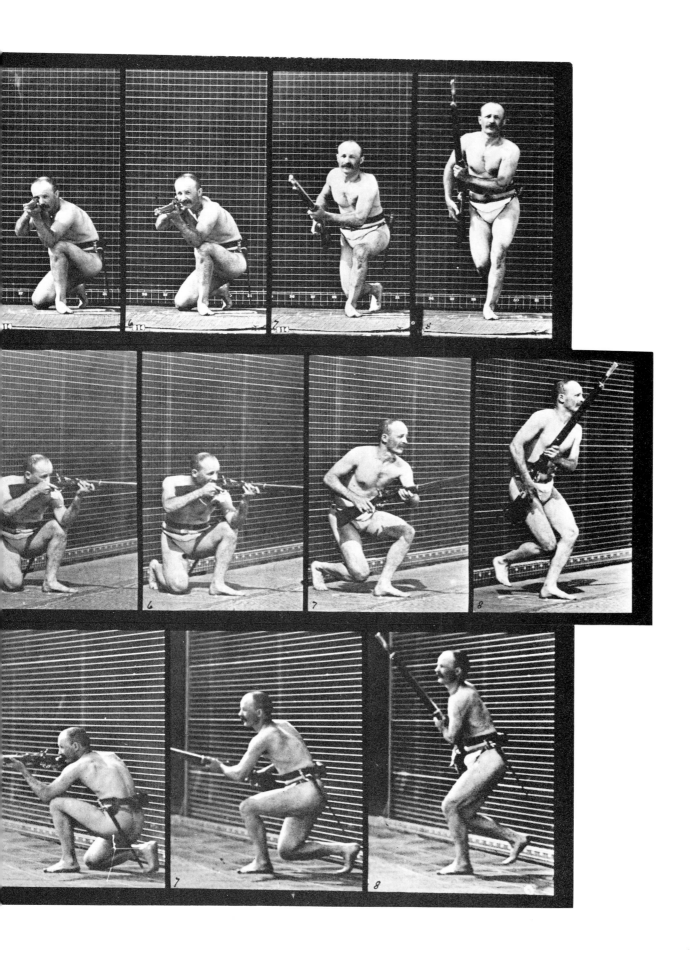

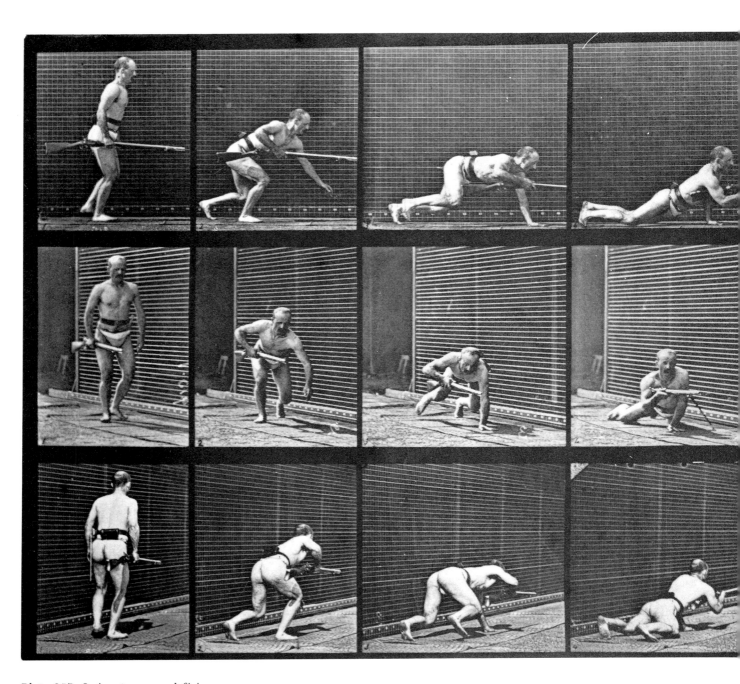

Plate 357. Lying prone and firing.

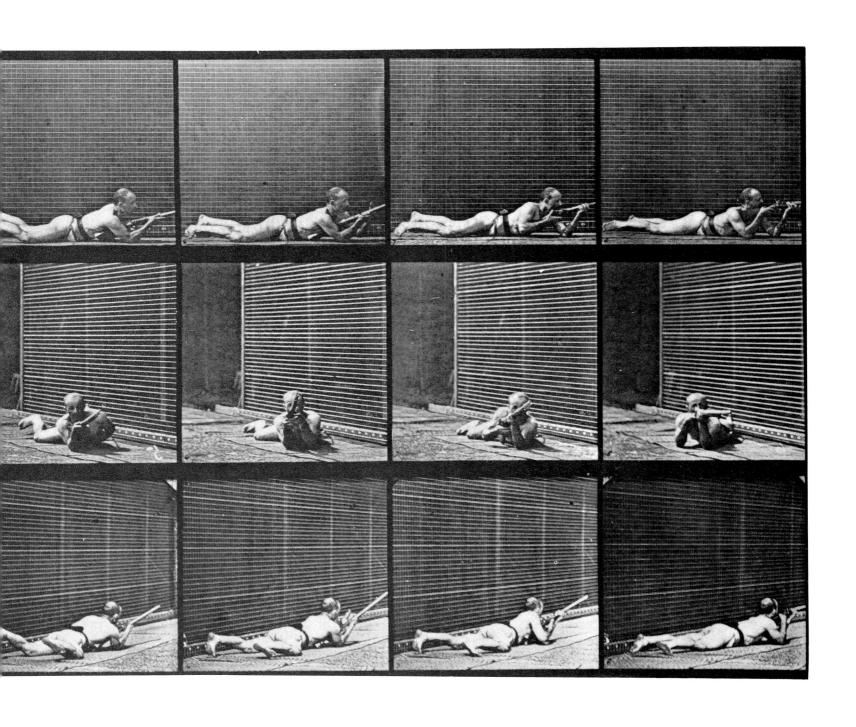

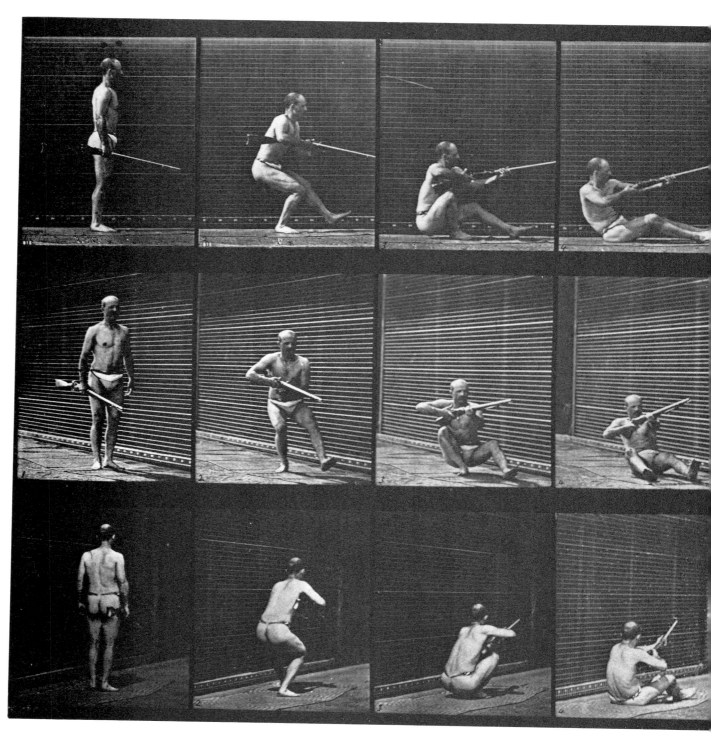

Plate 358. Lying on back and firing.

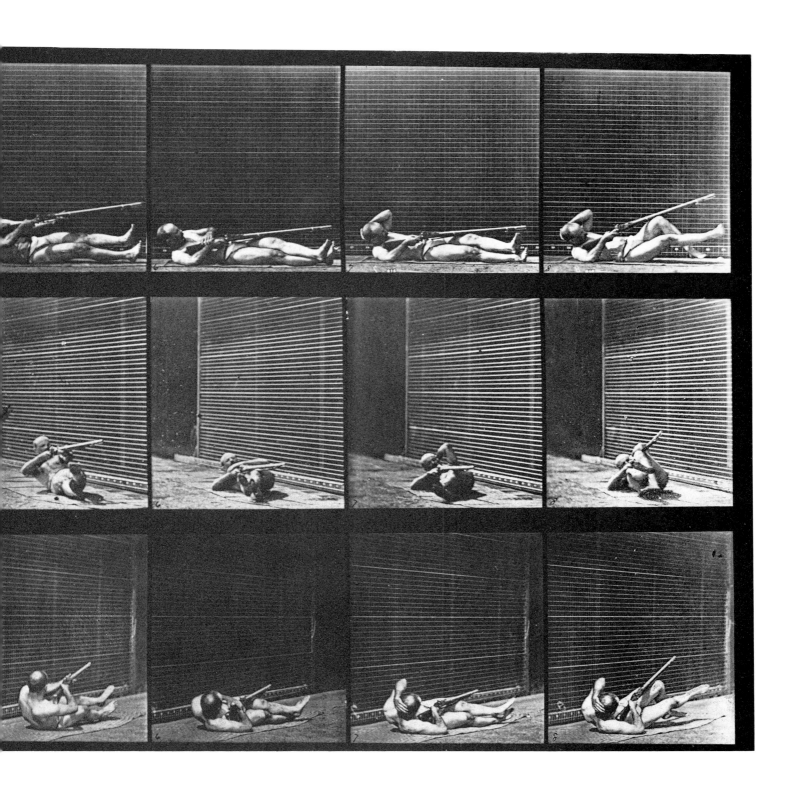

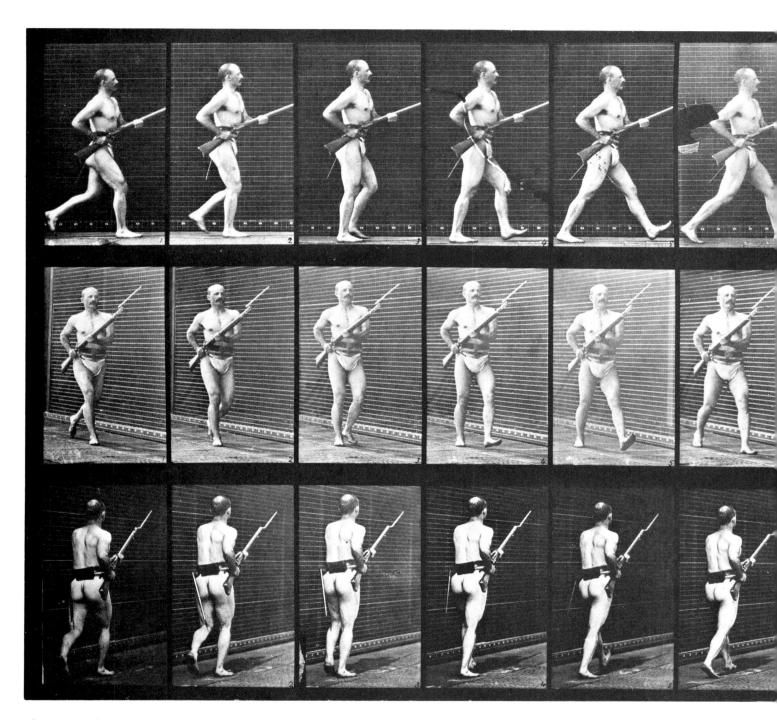

Plate 359. Charging bayonet.

730　MALES (PELVIS CLOTH)

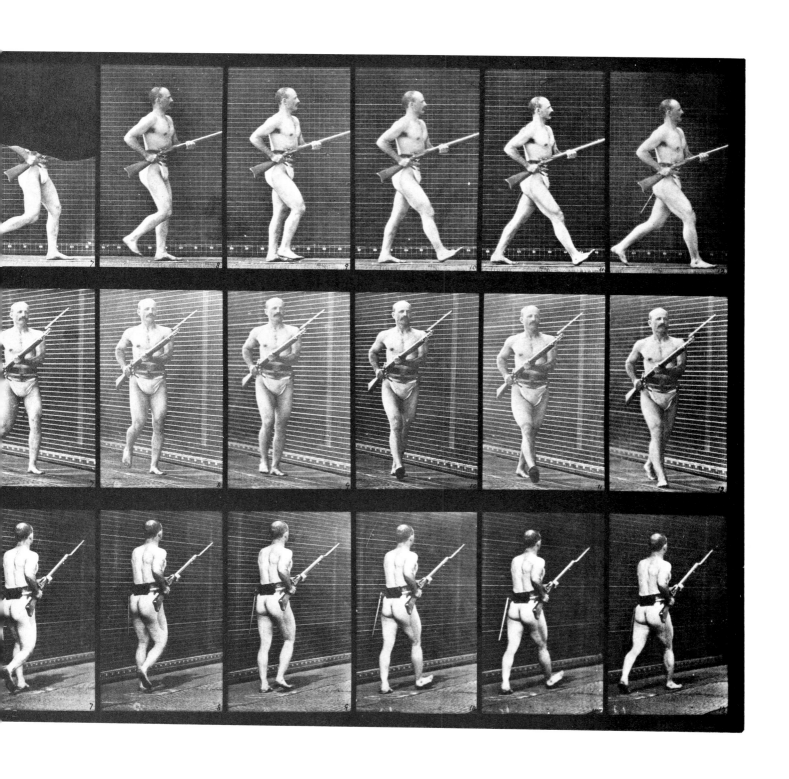

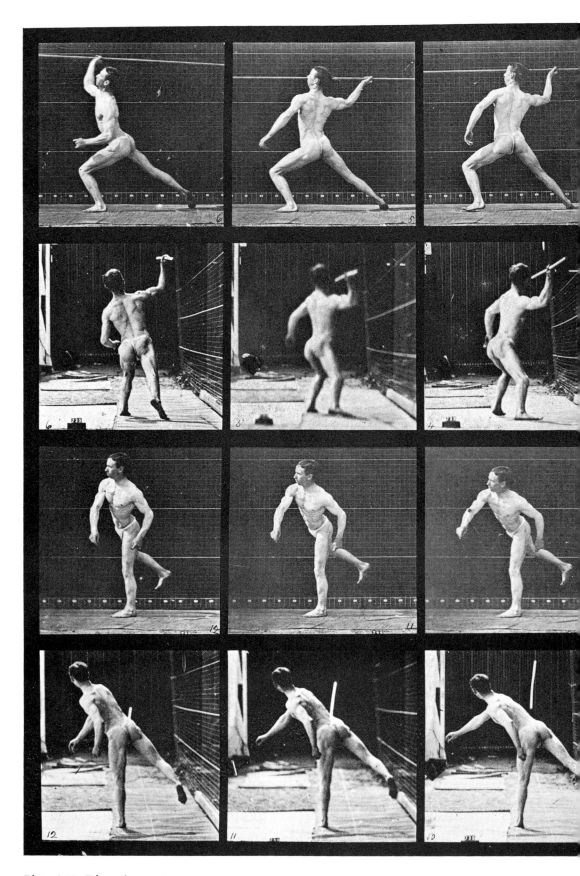

Plate 360. Throwing a spear.

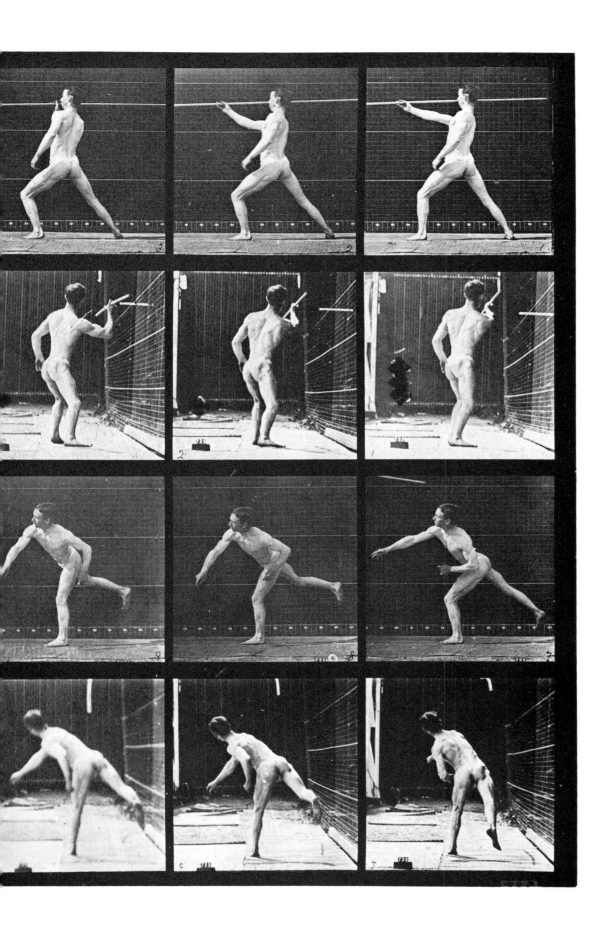

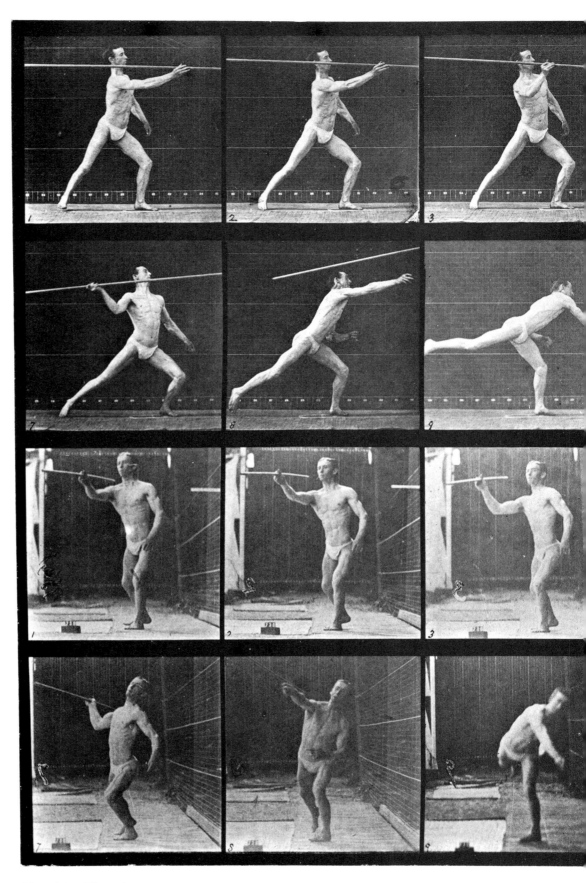

Plate 361. Throwing a spear.

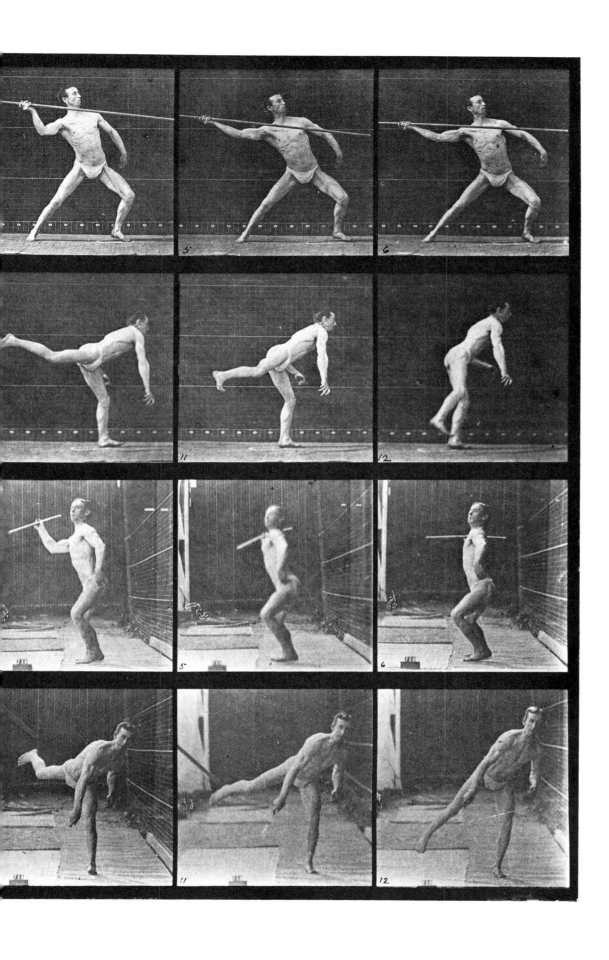

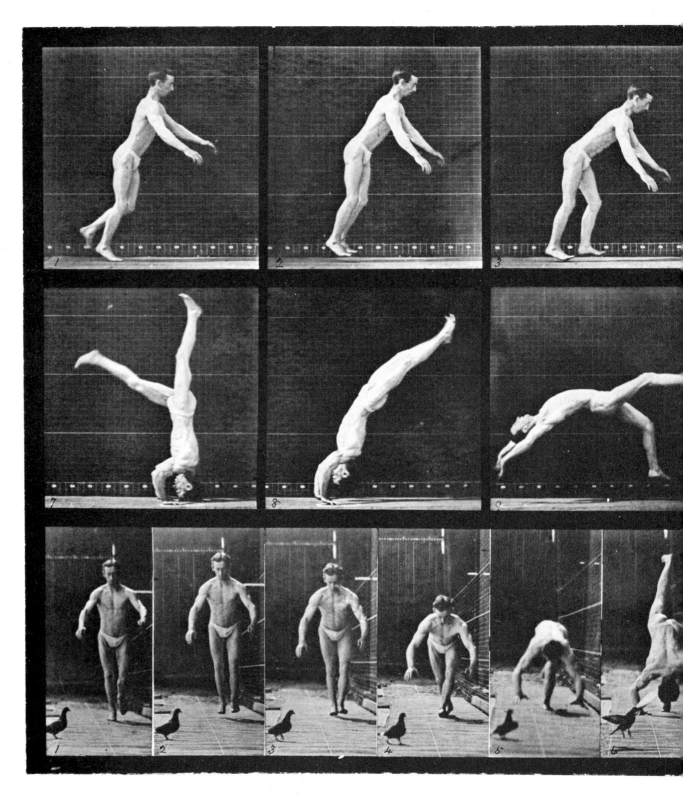

Plate 365. Head-spring, a flying pigeon interfering.

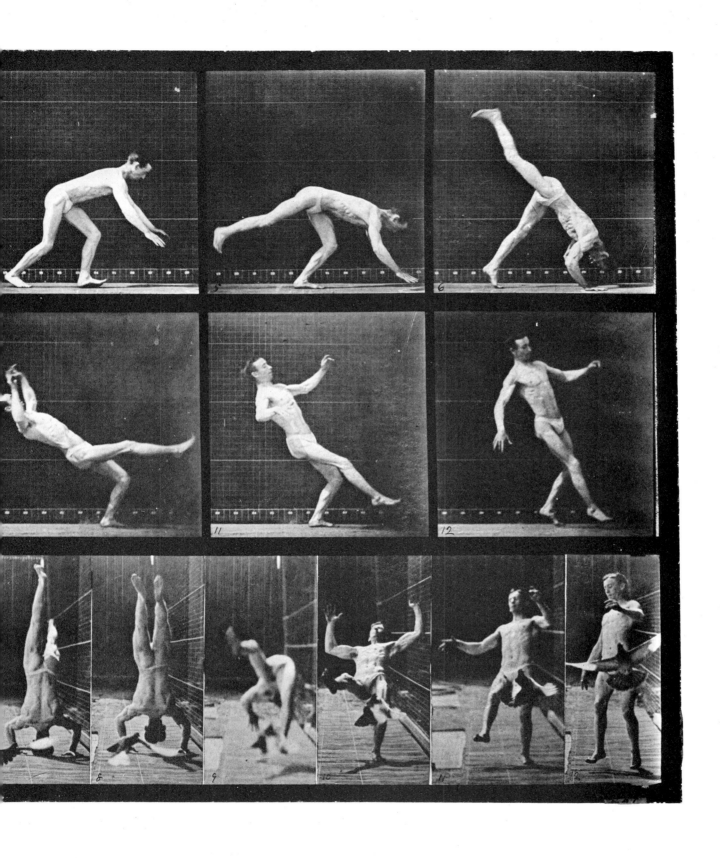

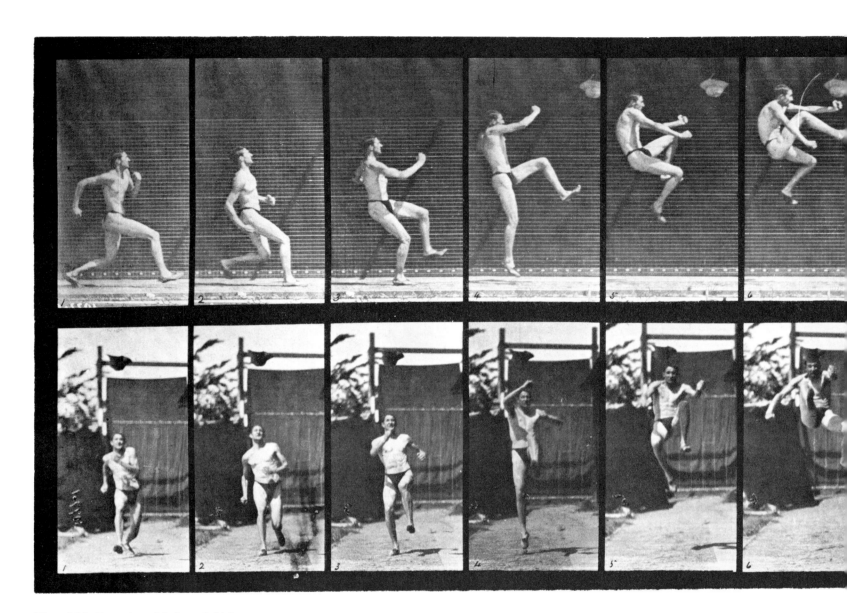

Plate 366. Running, hitch and kick.

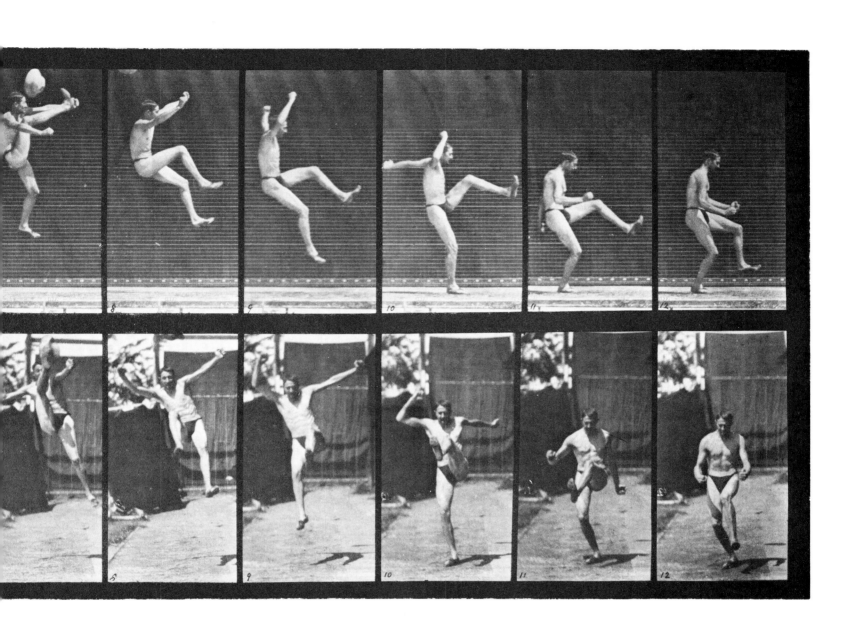

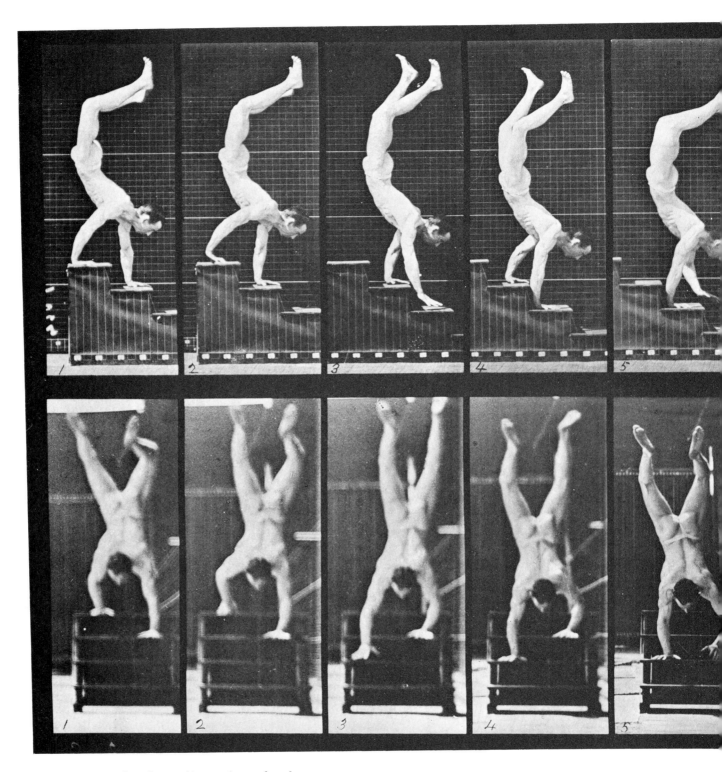

Plate 368. Acrobat descending stairs on hands.

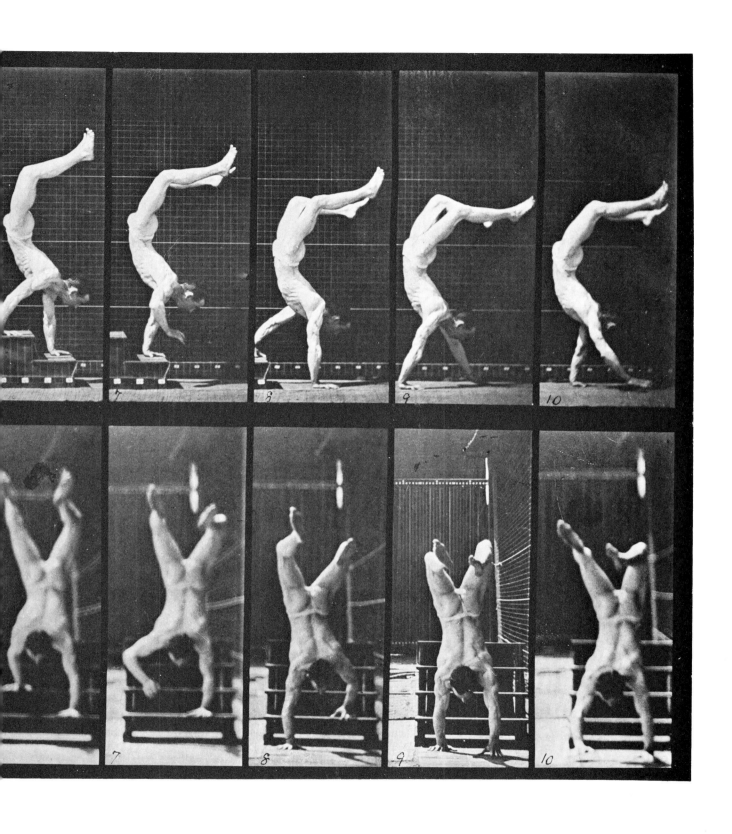

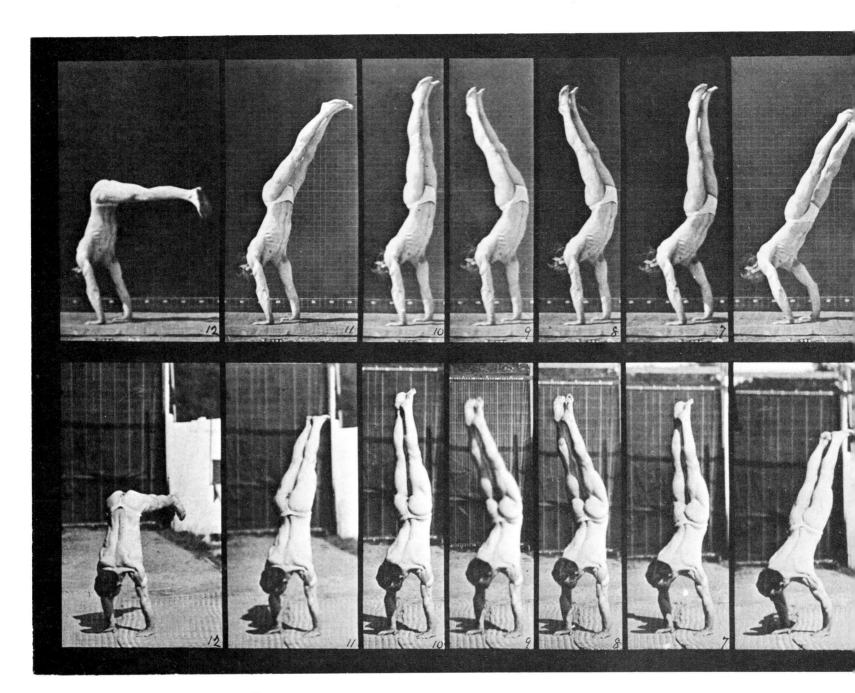

Plate 371. Acrobat, vertical "press up."

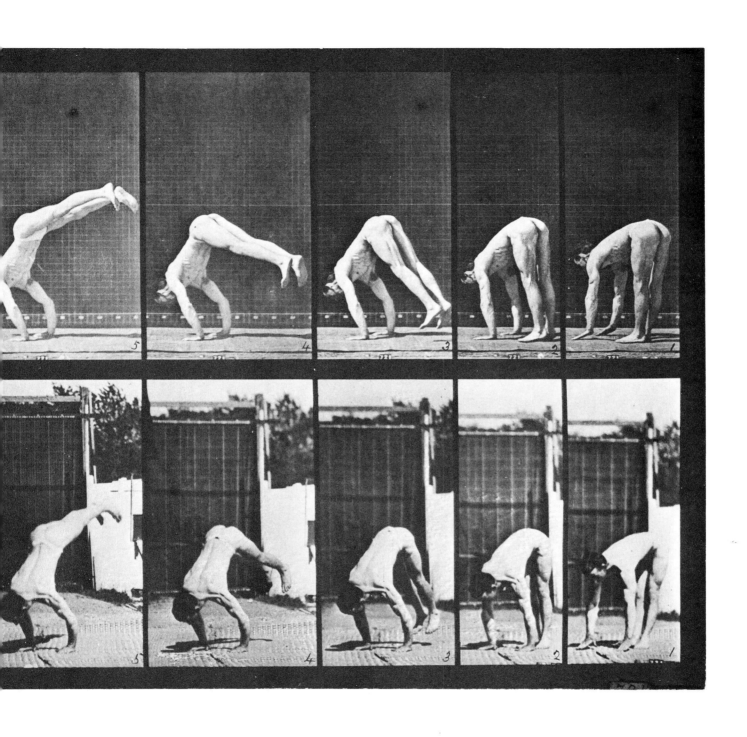

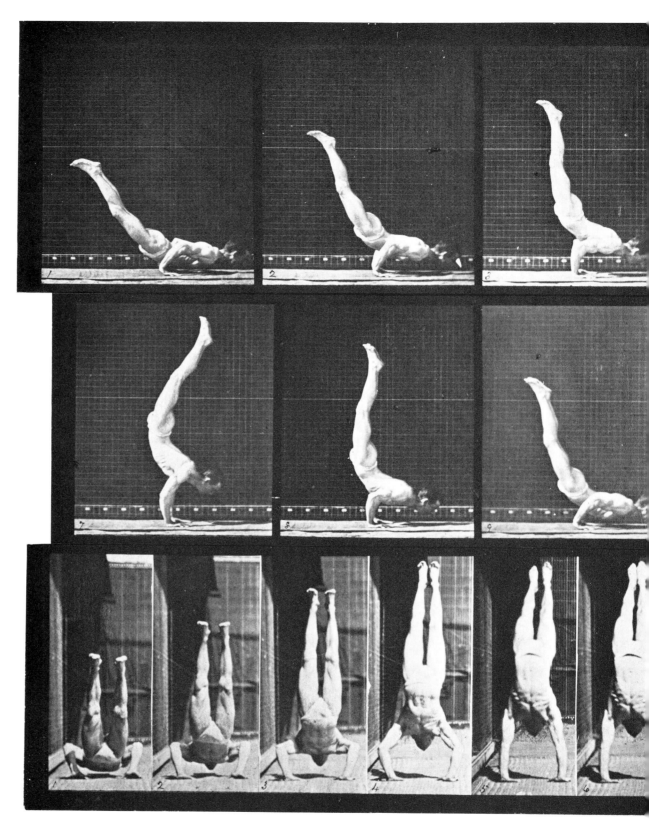

Plate 372. Acrobat, horizontal "press up."

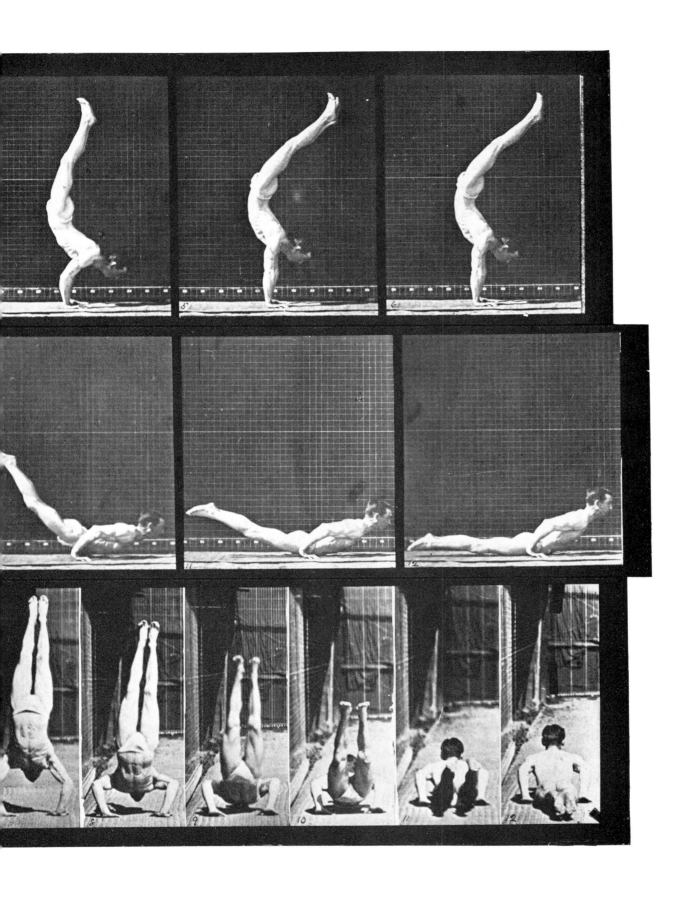

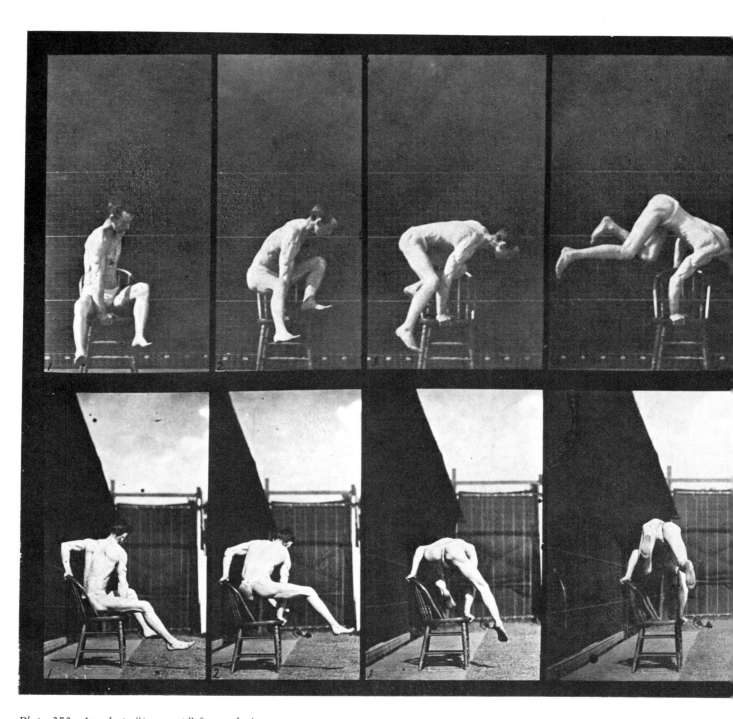

Plate 373. Acrobat, "press up" from chair.

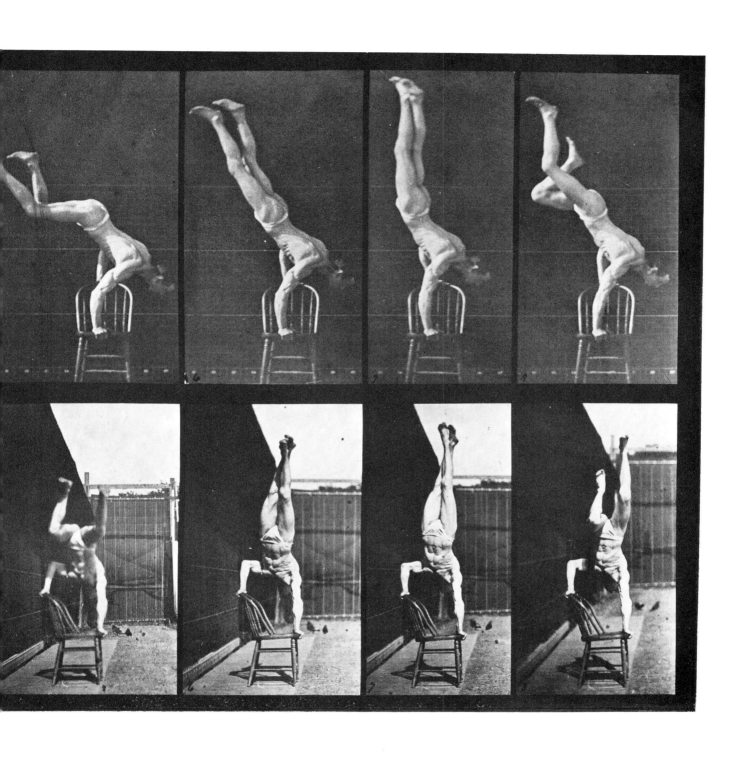

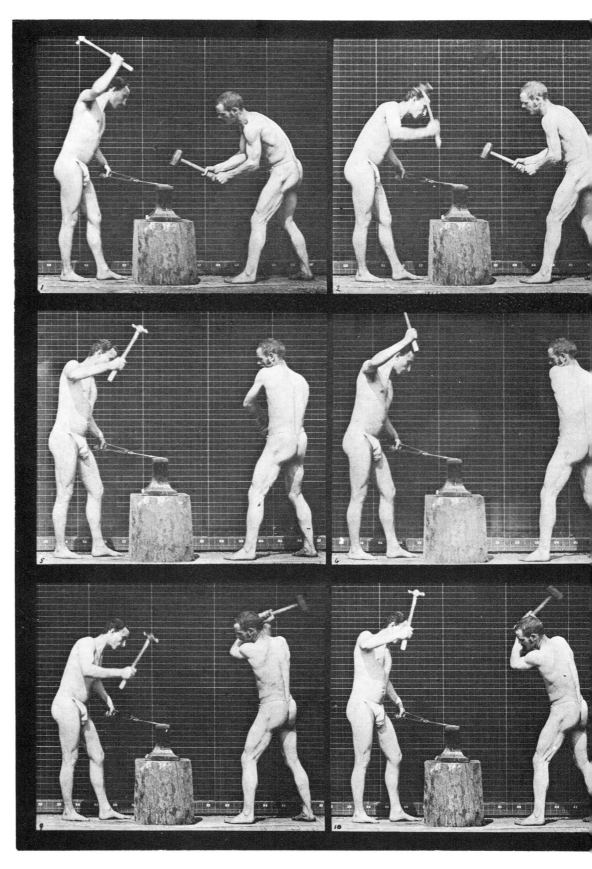

Plate 374. Blacksmiths, hammering on anvil.

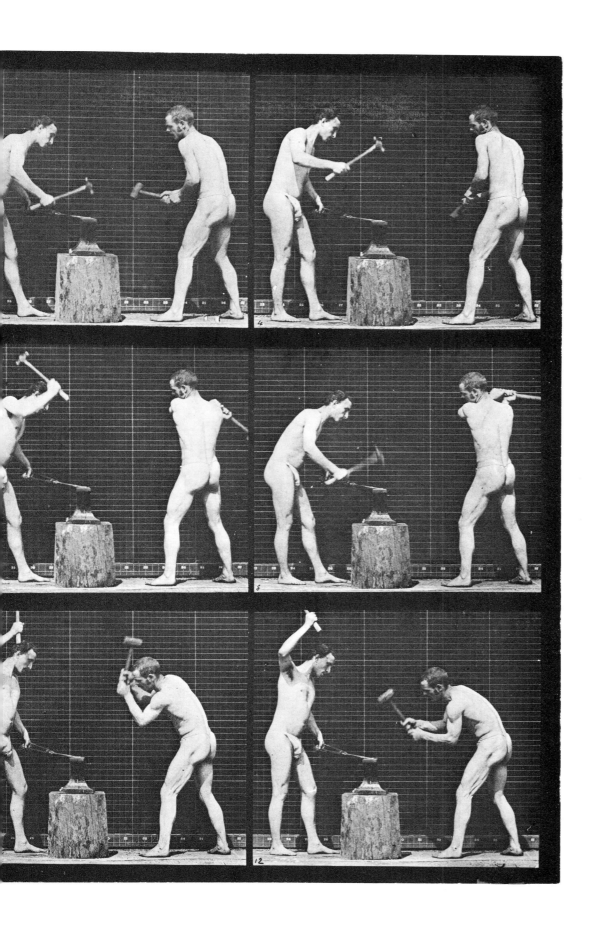

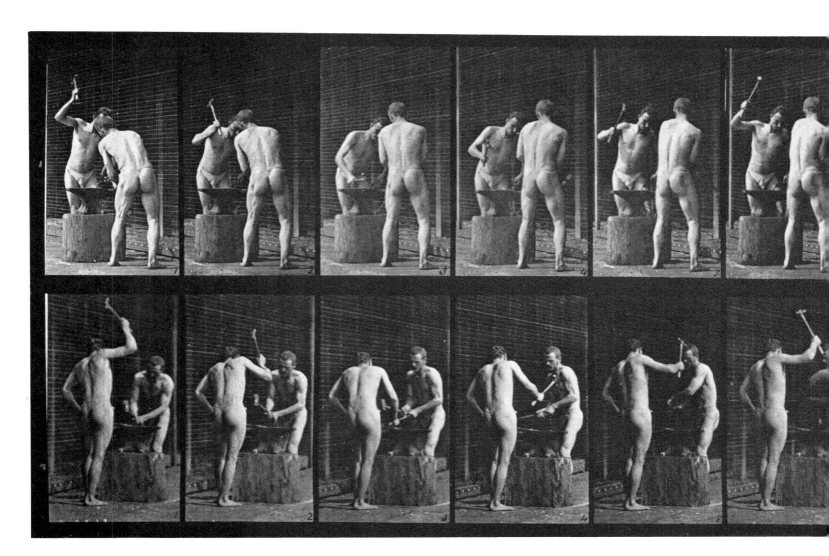

Plate 375. Blacksmiths, hammering on anvil.

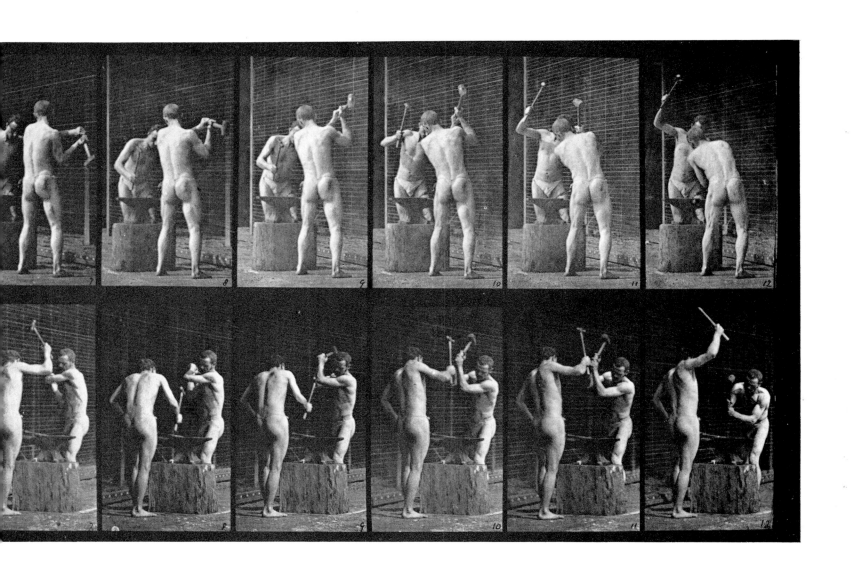

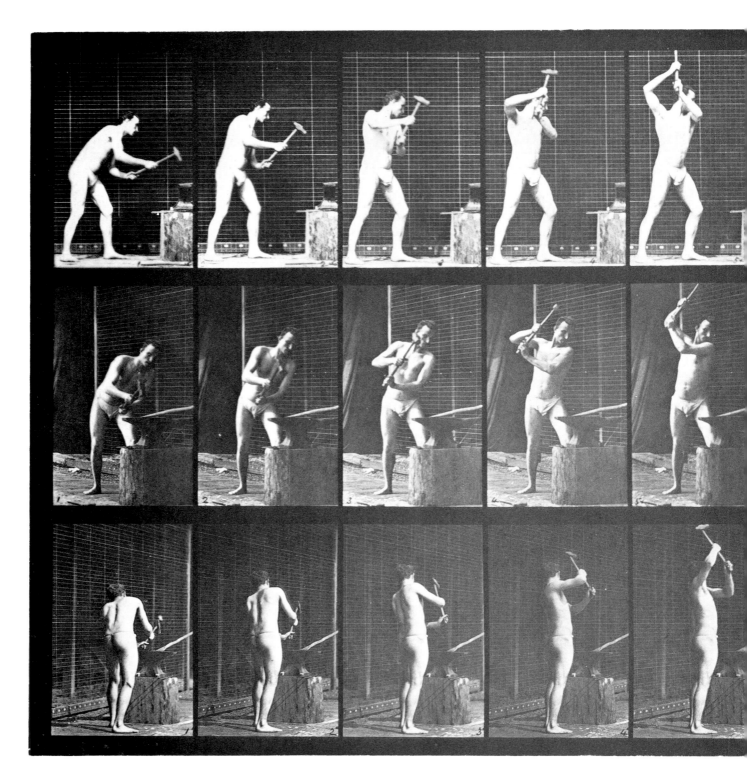

Plate 378. Blacksmith, hammering on anvil with two hands.

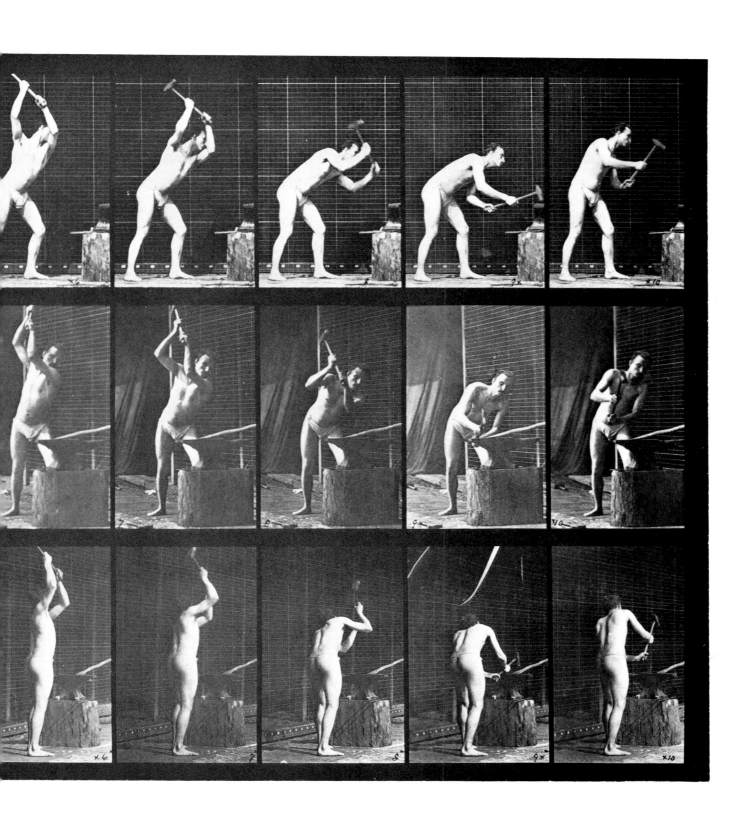

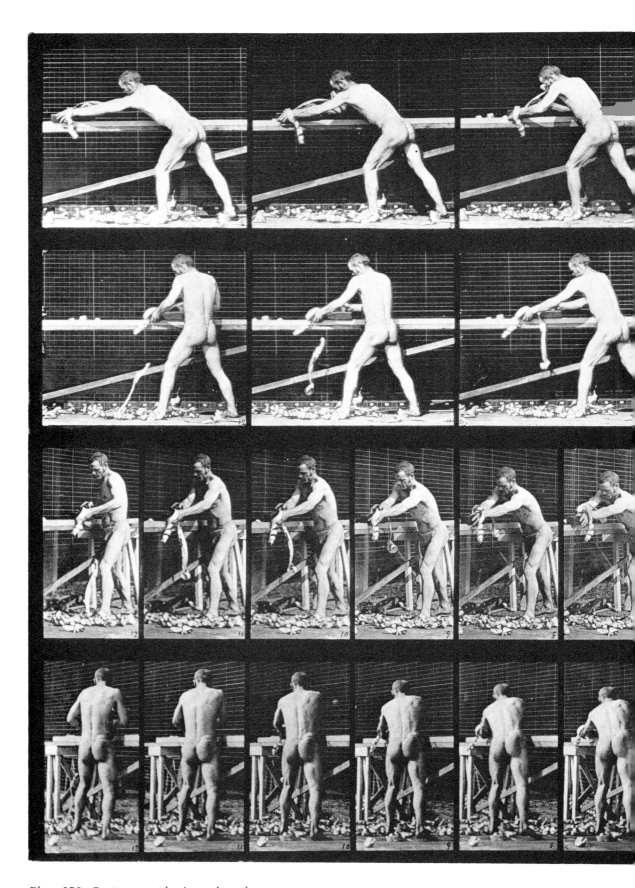

Plate 379. Carpenter, planing a board.

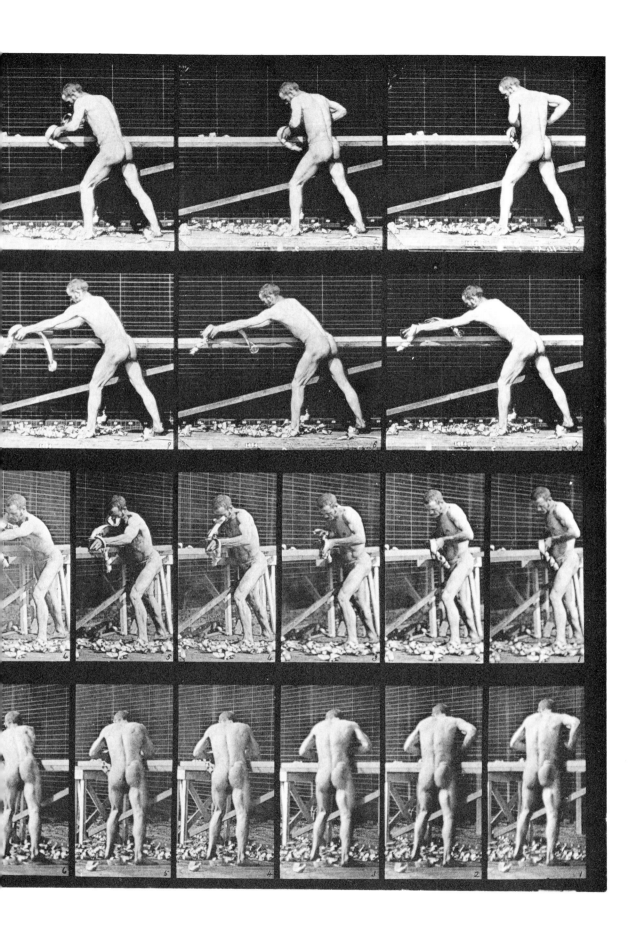

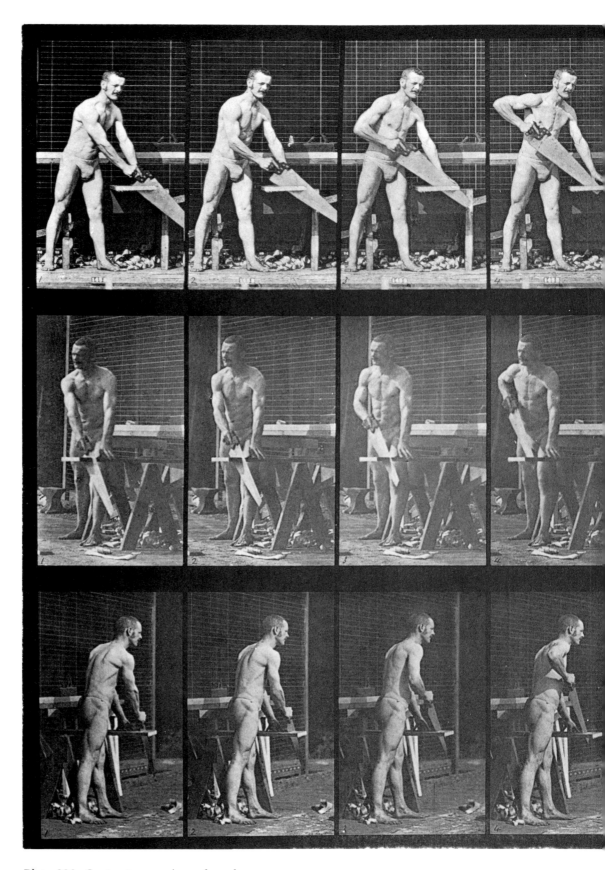

Plate 380. Carpenter, sawing a board.

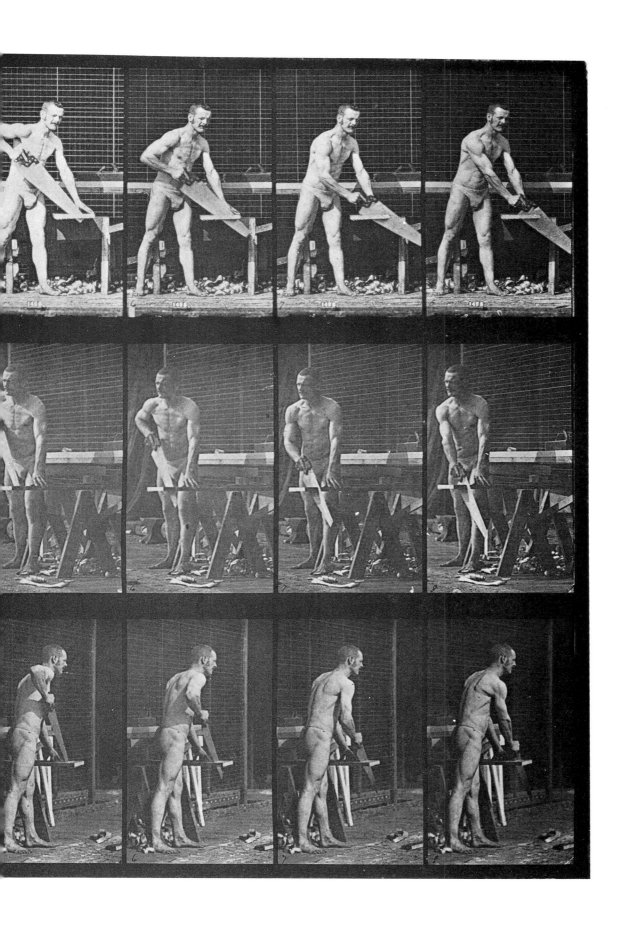

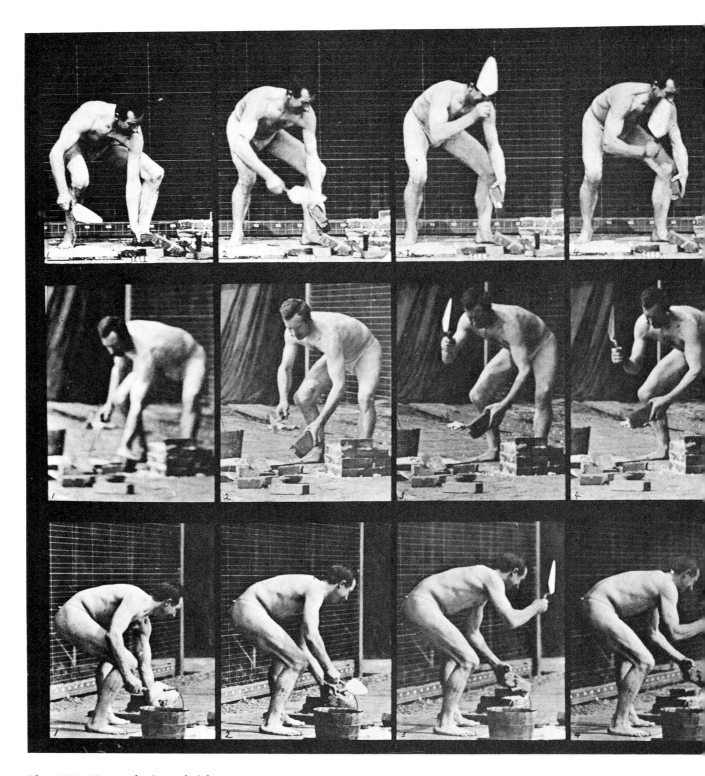

Plate 381. Mason, laying a brick.

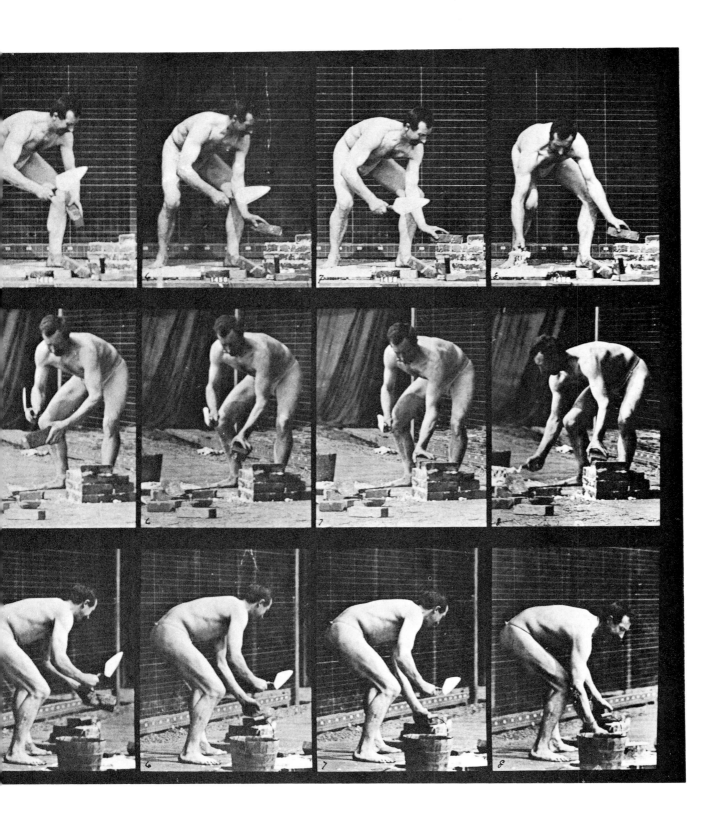

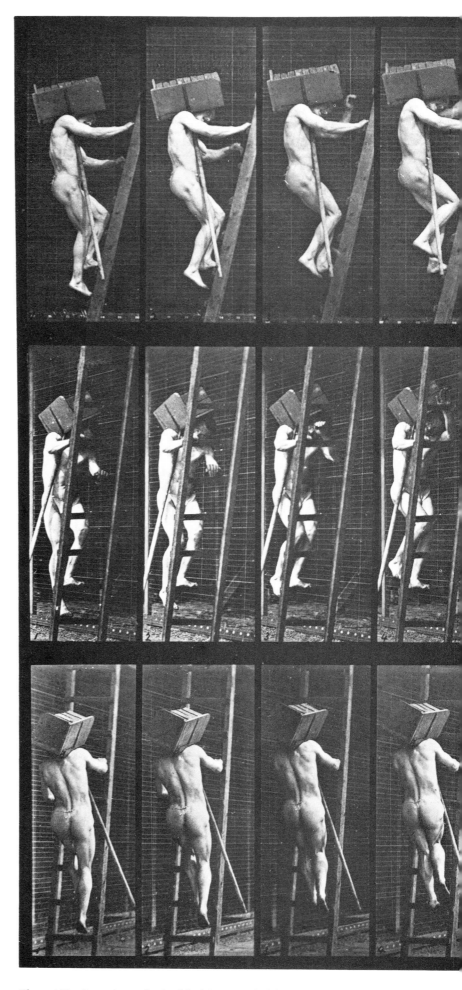

Plate 405. Carrying a hod of bricks up a ladder.

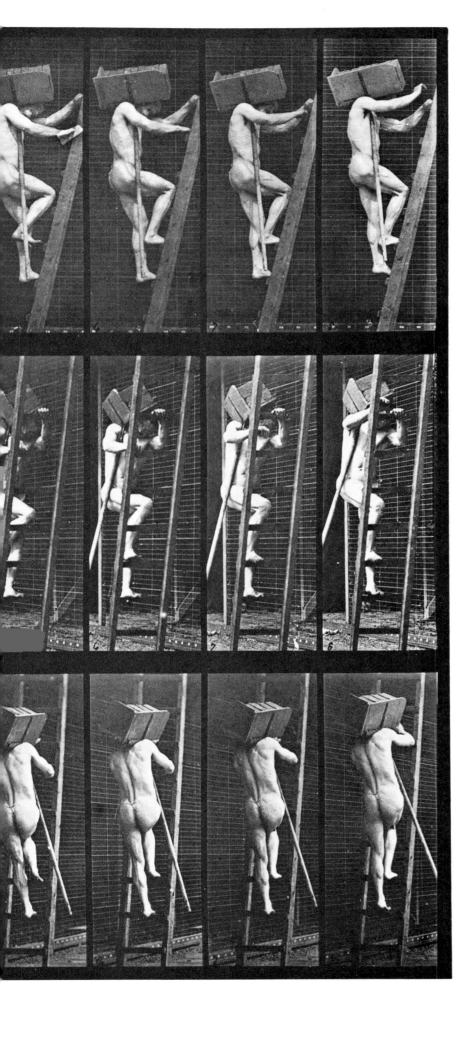

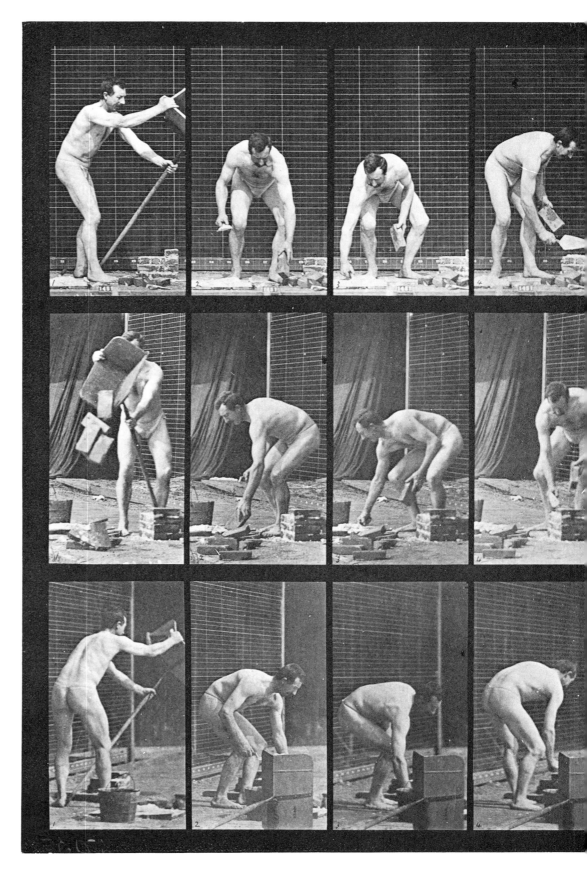

Plate 505. Bricklaying.

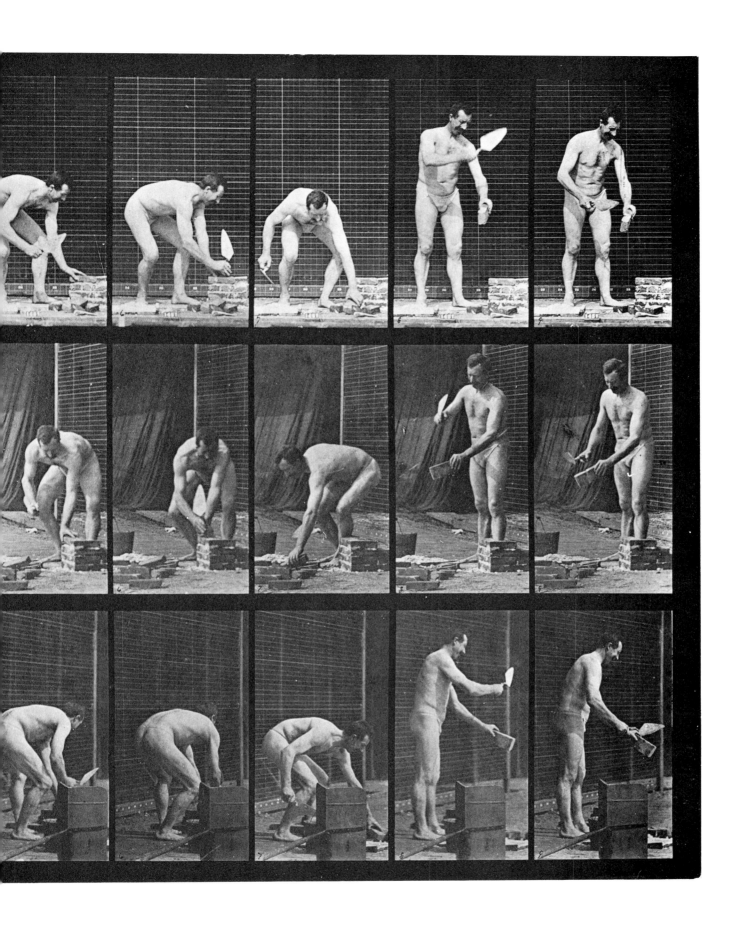

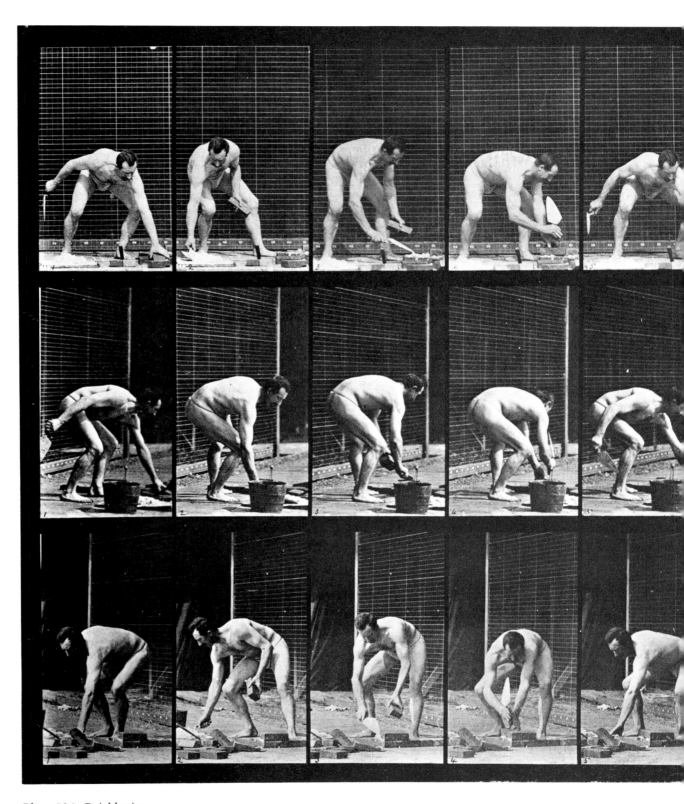

Plate 506. Bricklaying.

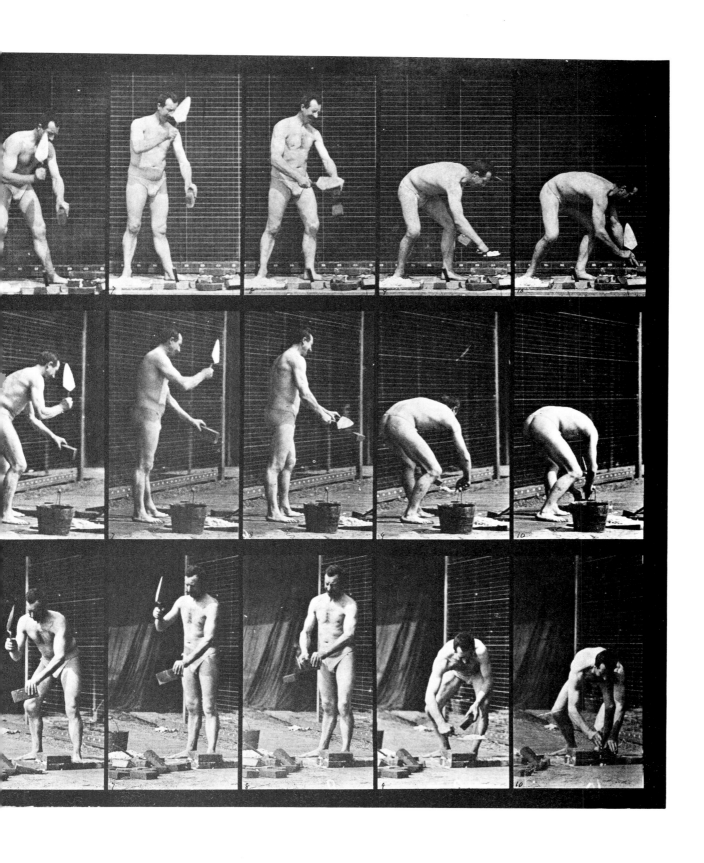

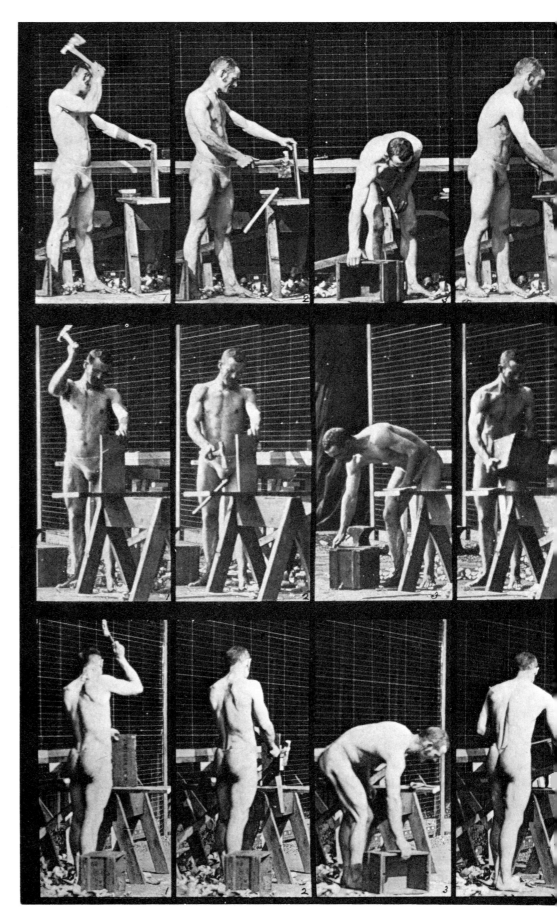

Plate 507. Carpentering.

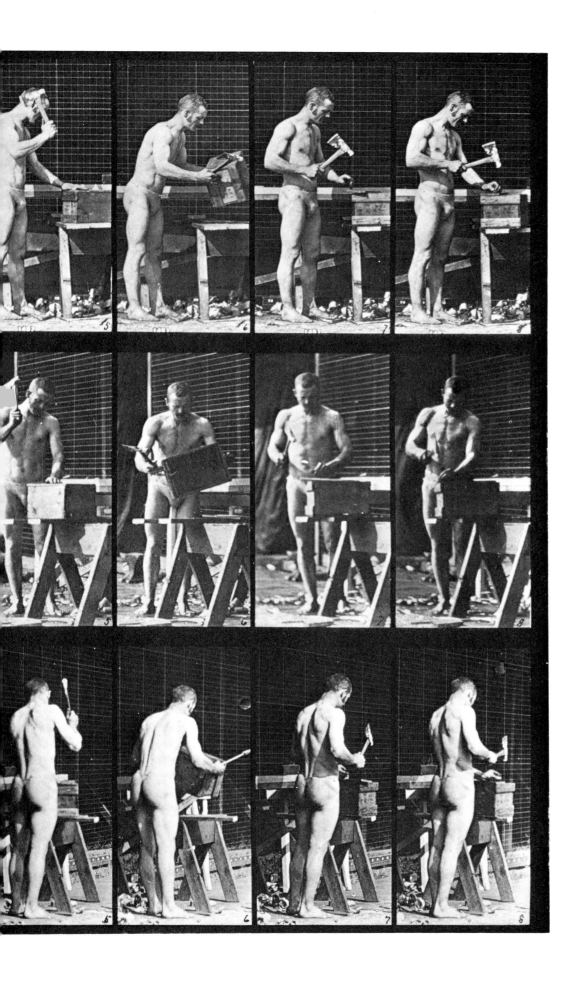

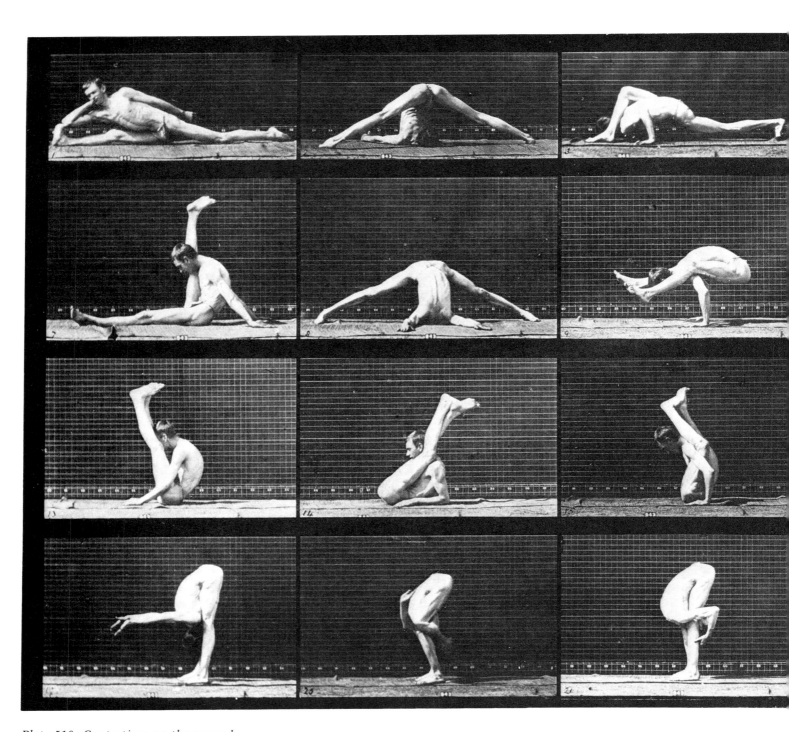

Plate 510. Contortions on the ground.

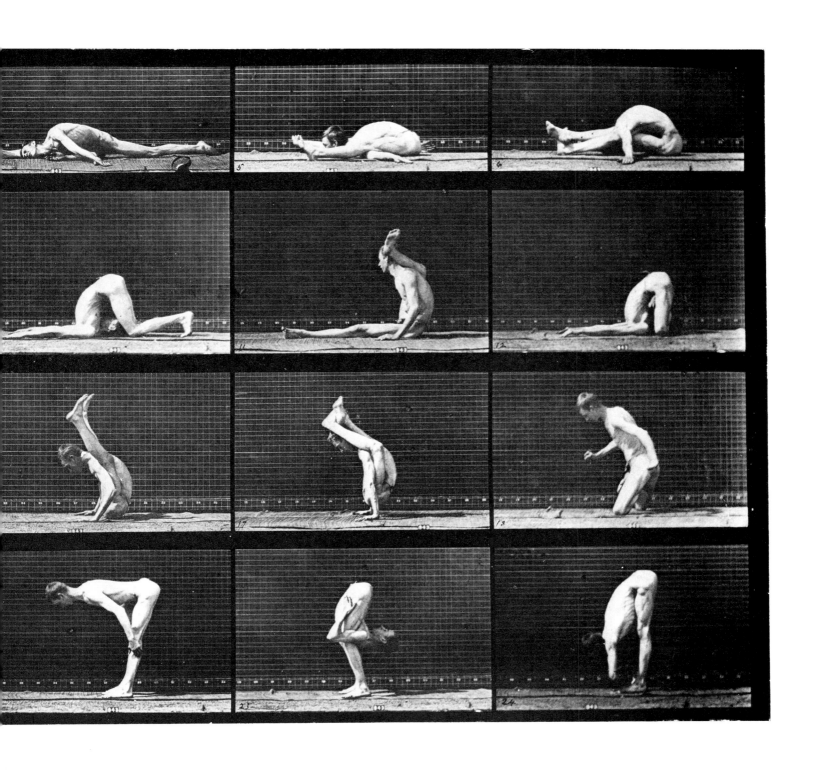

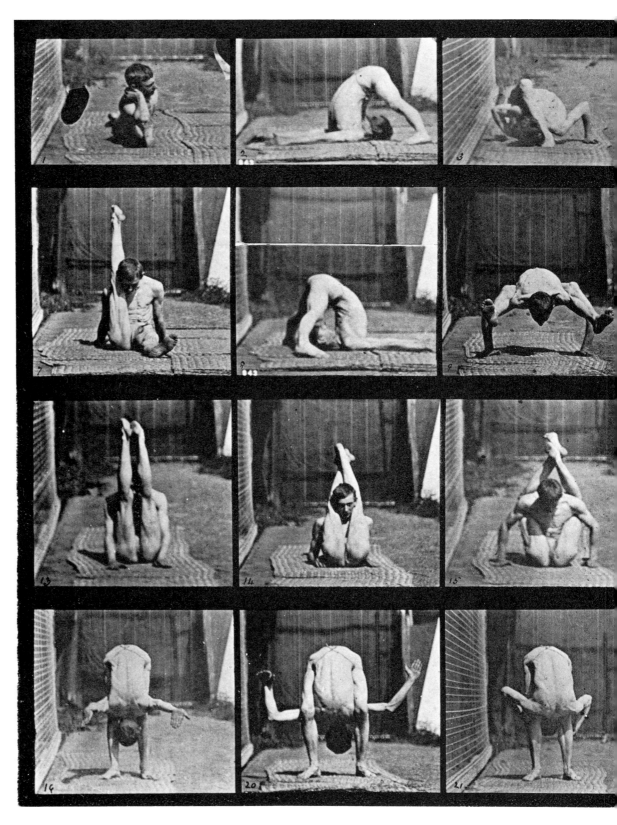

Plate 511. Contortions on the ground.

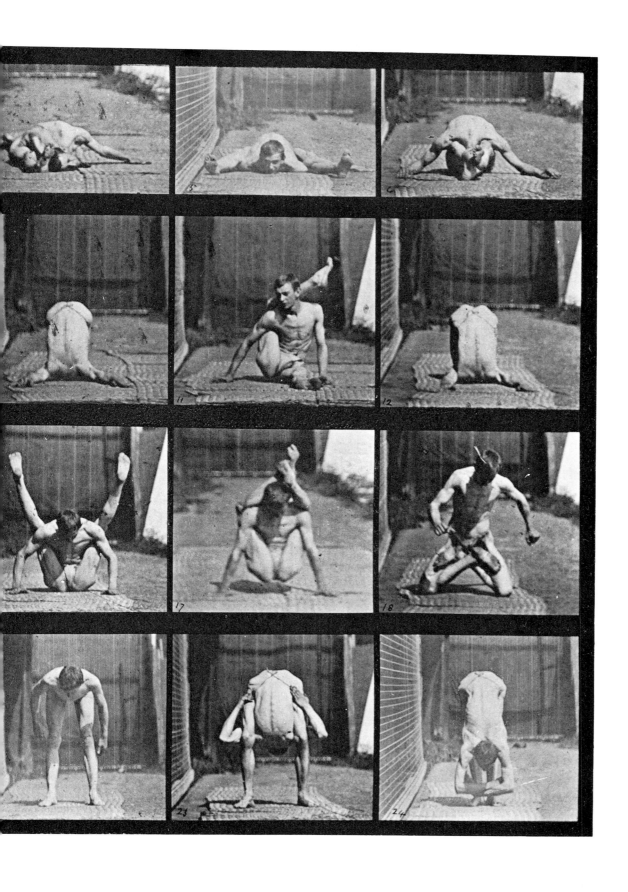

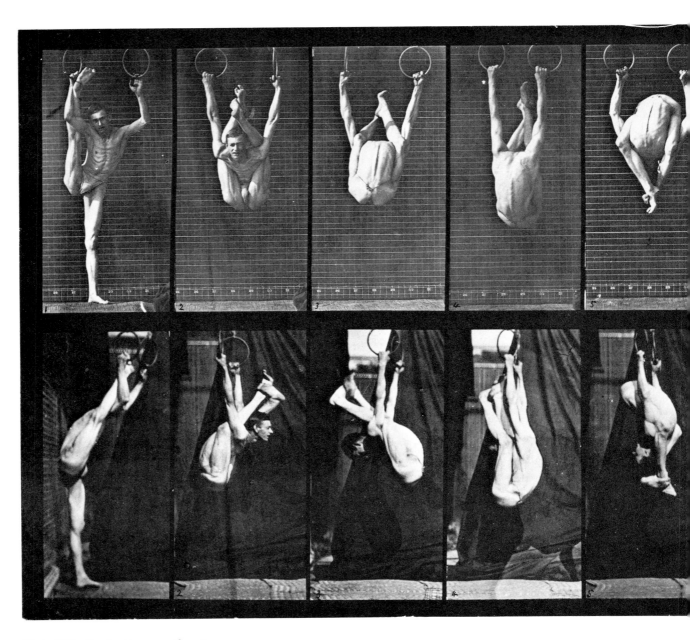

Plate 512. Contortions on the rings.

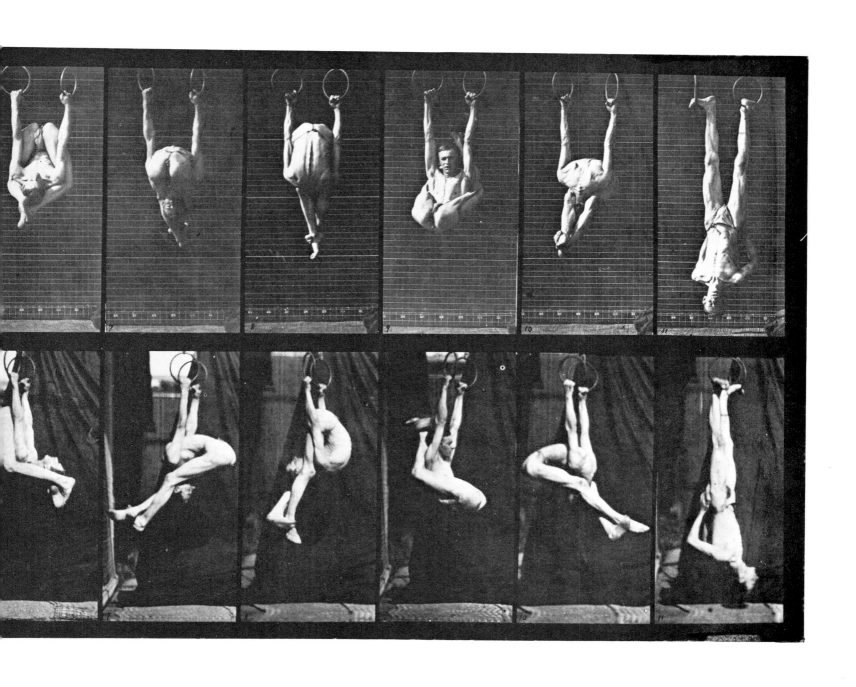

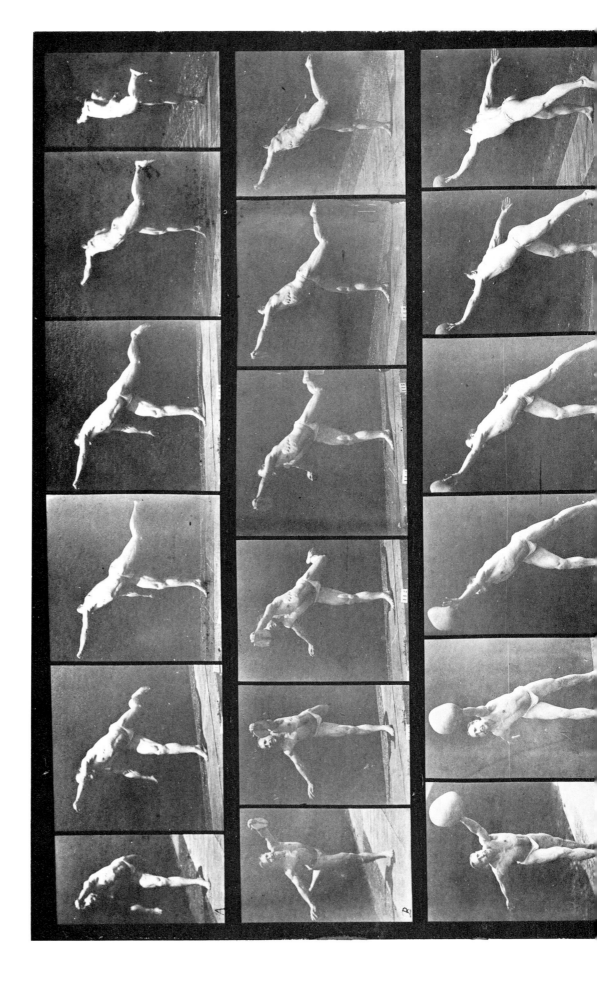

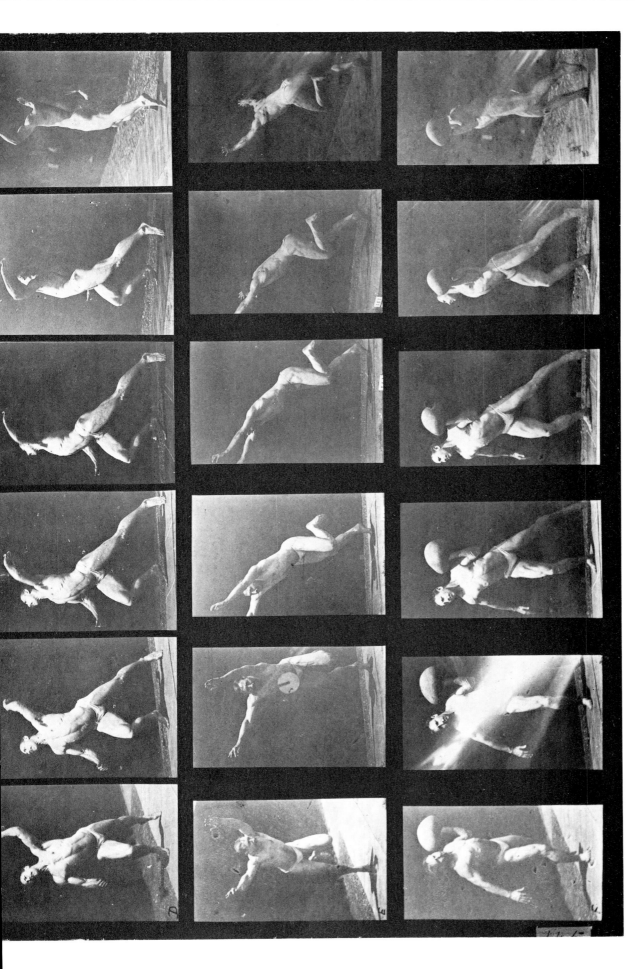

Plate 523. A: Striking a blow. B, E: Throwing a disk. C, F: Heaving a 75-lb. stone. D: Throwing a ball.

FEMALES
(Semi-Nude & Transparent Drapery)

&

CHILDREN

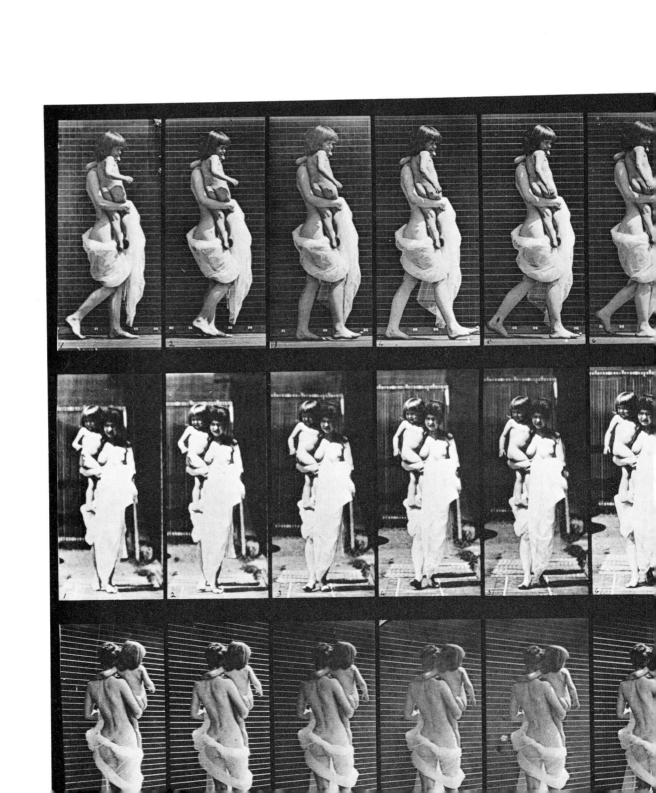

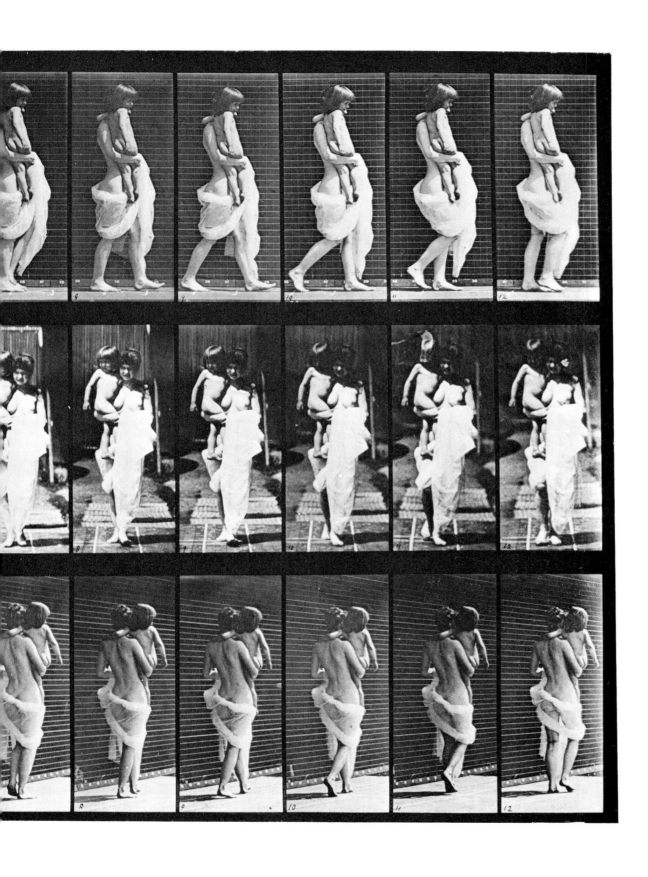

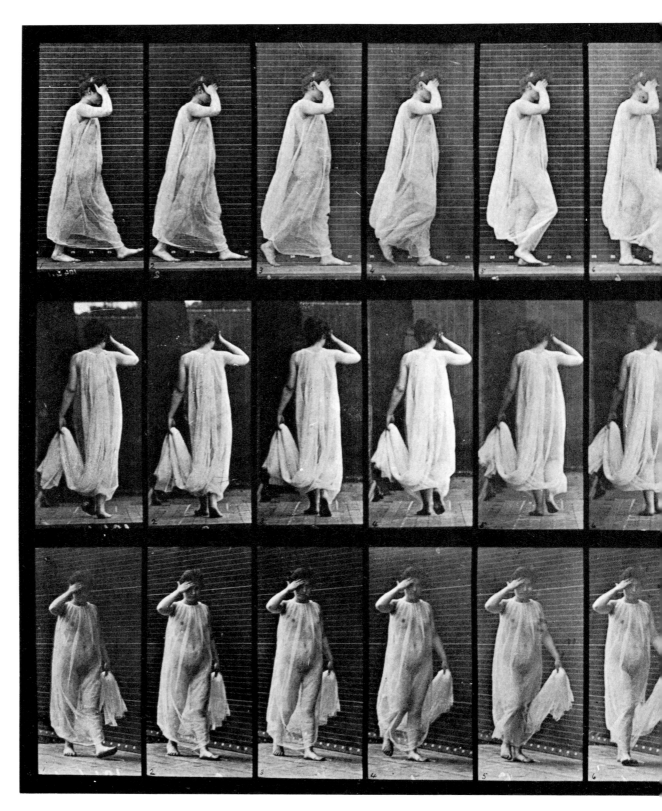

Plate 37. Walking; left hand holding dress, right hand at face.

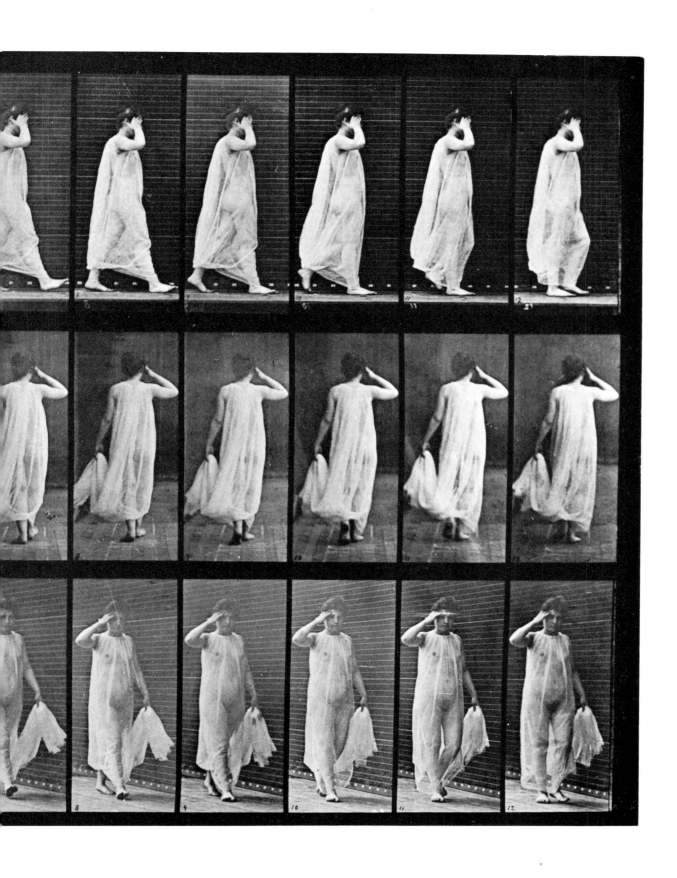

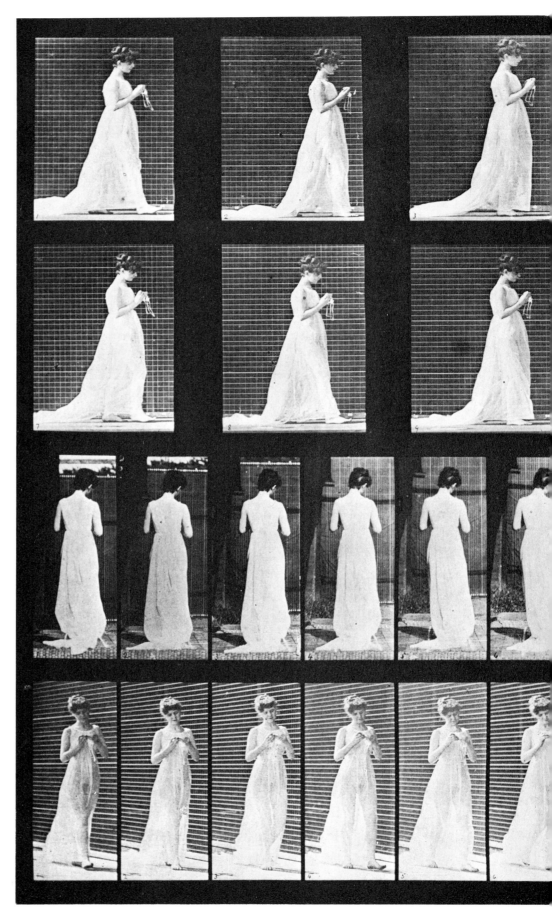

Plate 39. Walking; hands engaged in knitting.

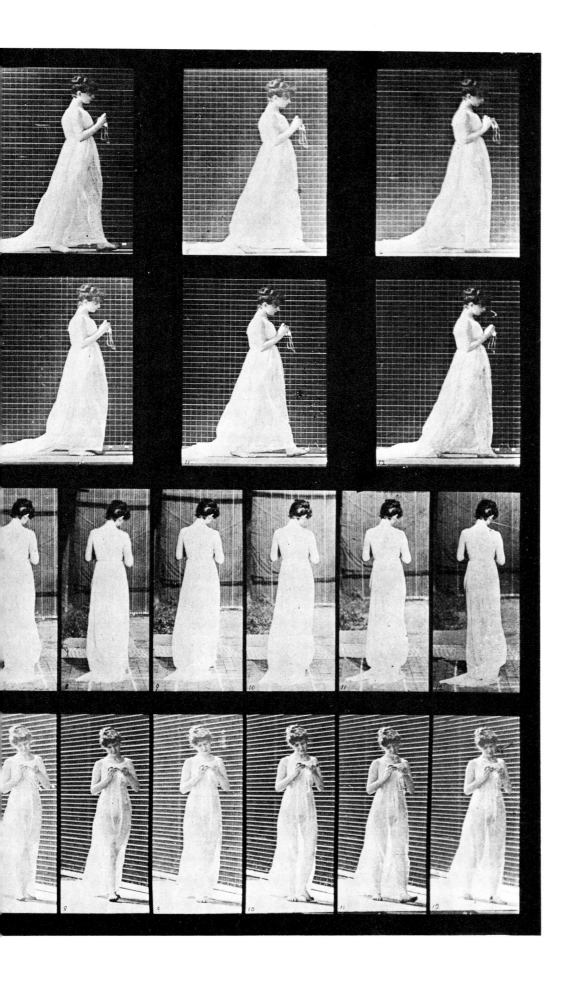

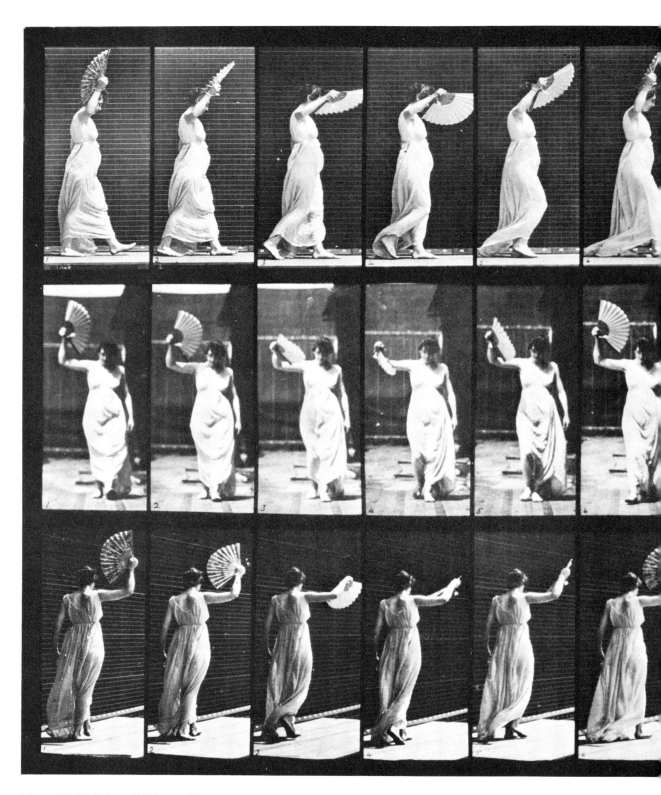

Plate 41. Walking; flirting a fan.

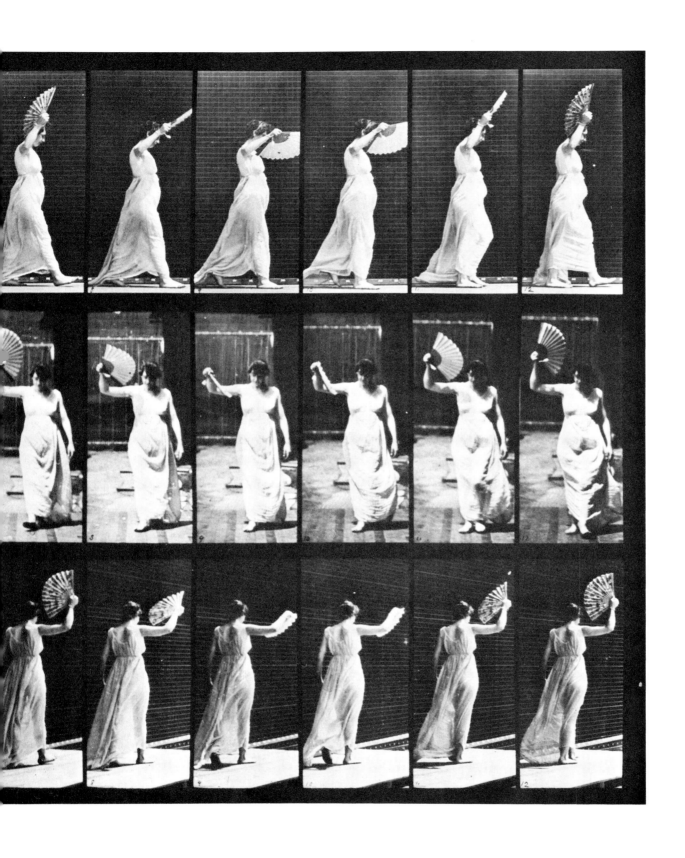

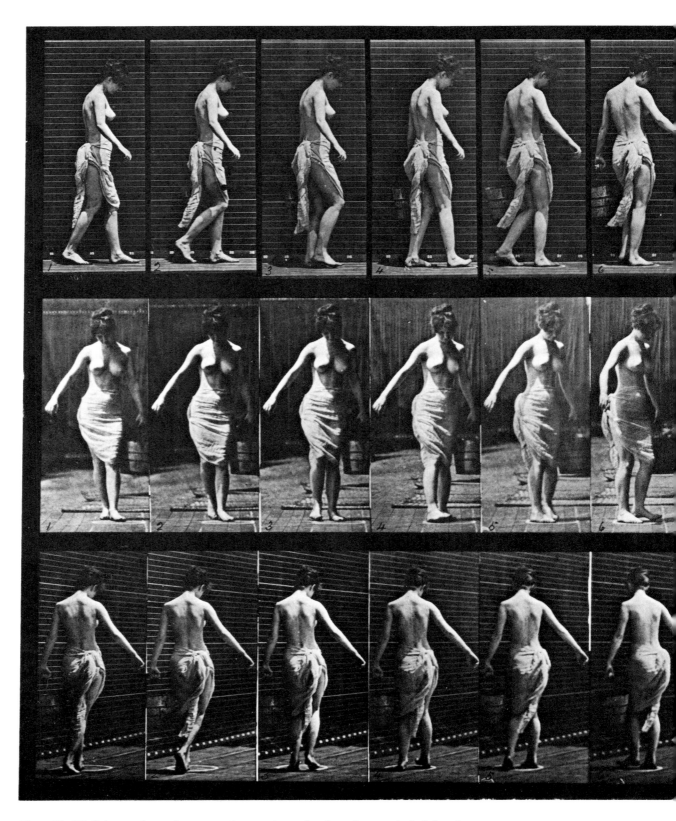

Plate 50. Walking and turning around, carrying a bucket of water in left hand.

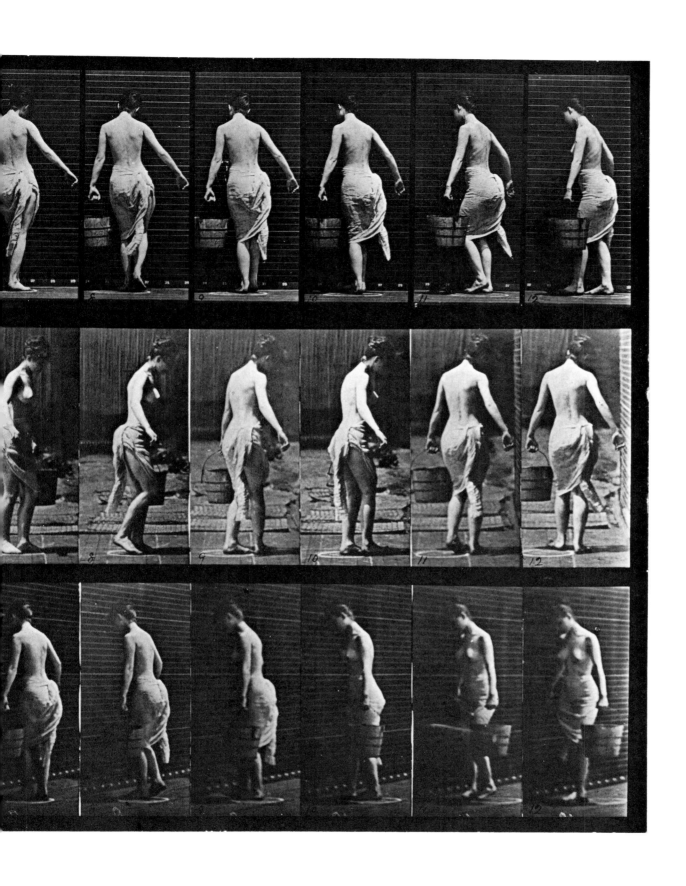

Females (Semi-Nude) & Children

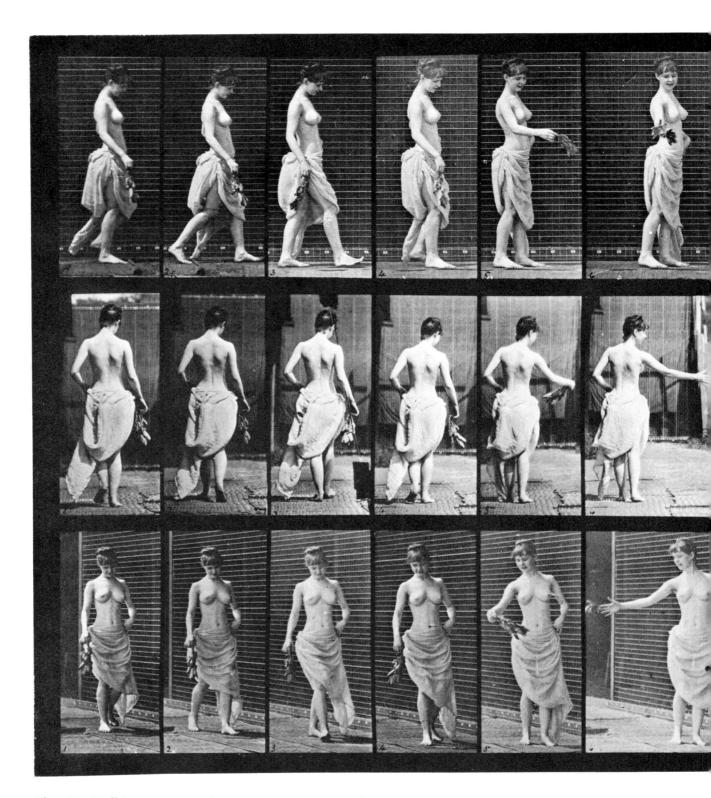

Plate 53. Walking, scattering flowers and turning around.

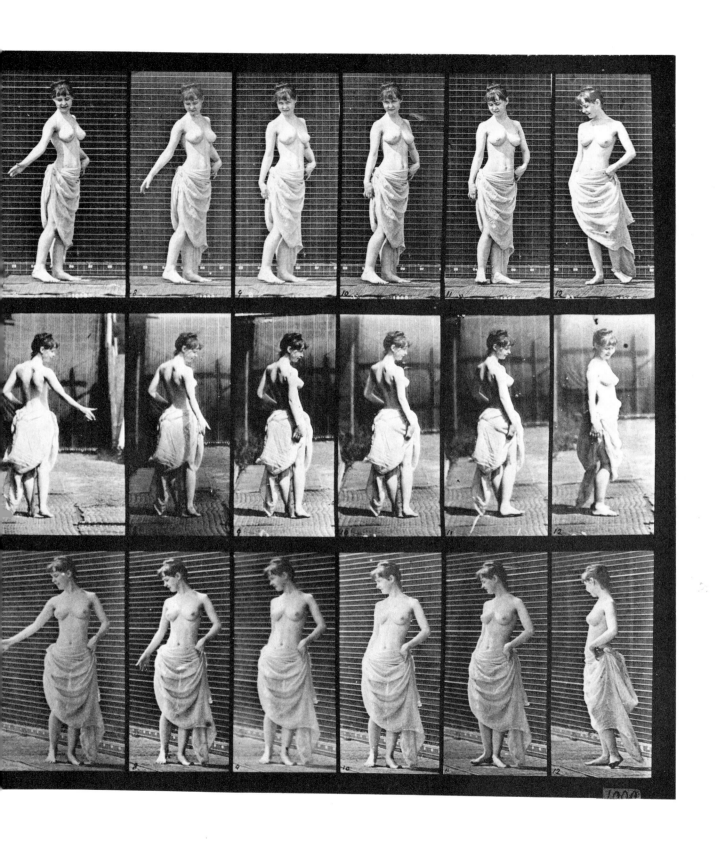

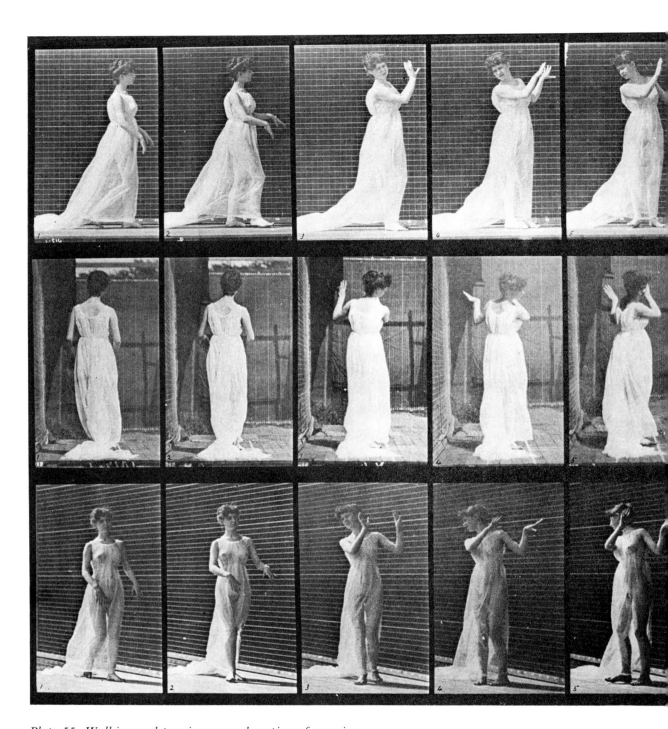

Plate 55. Walking and turning around, action of aversion.

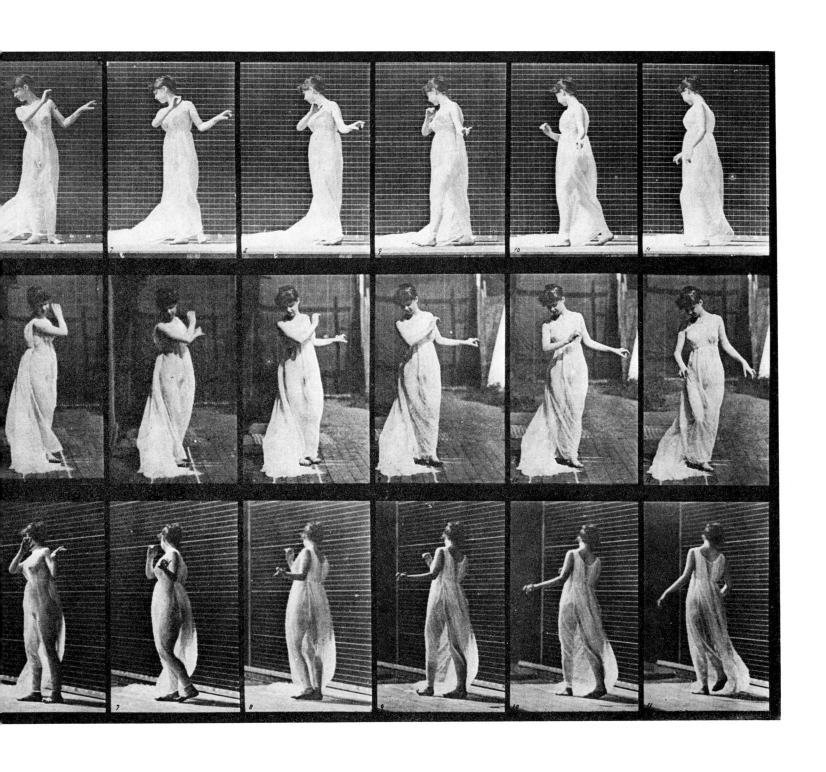

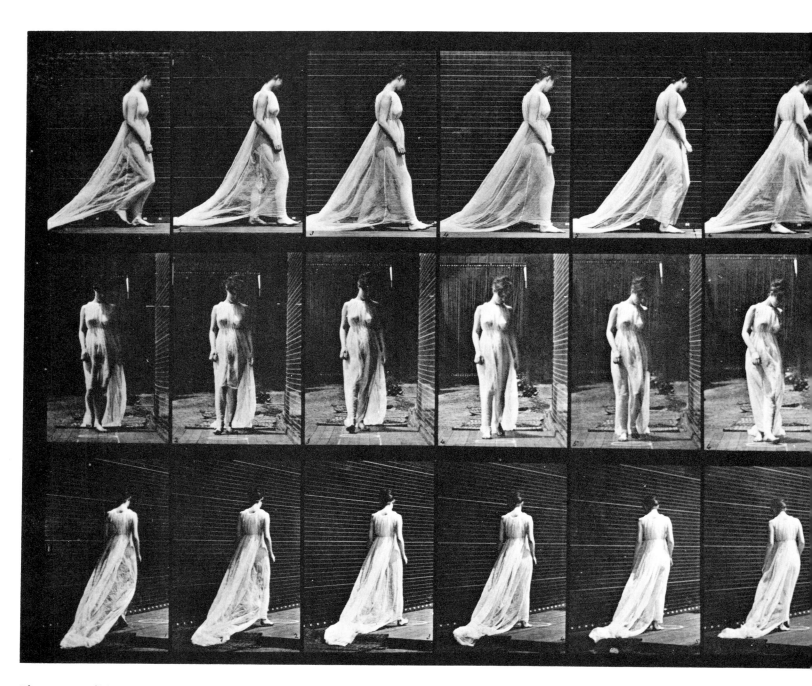

Plate 56. Walking, turning and stooping to lift train.

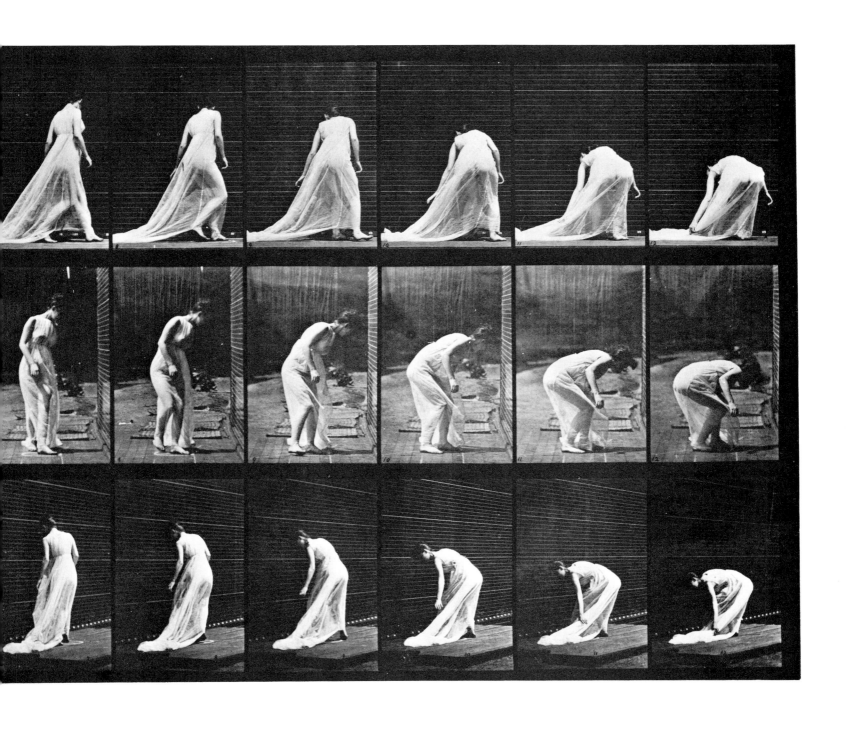

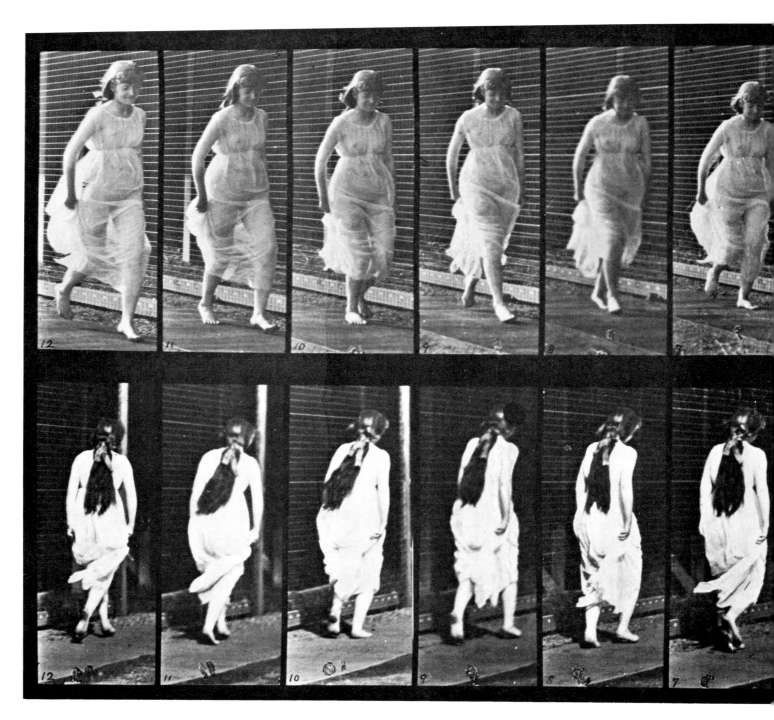

Plate 71. Running.

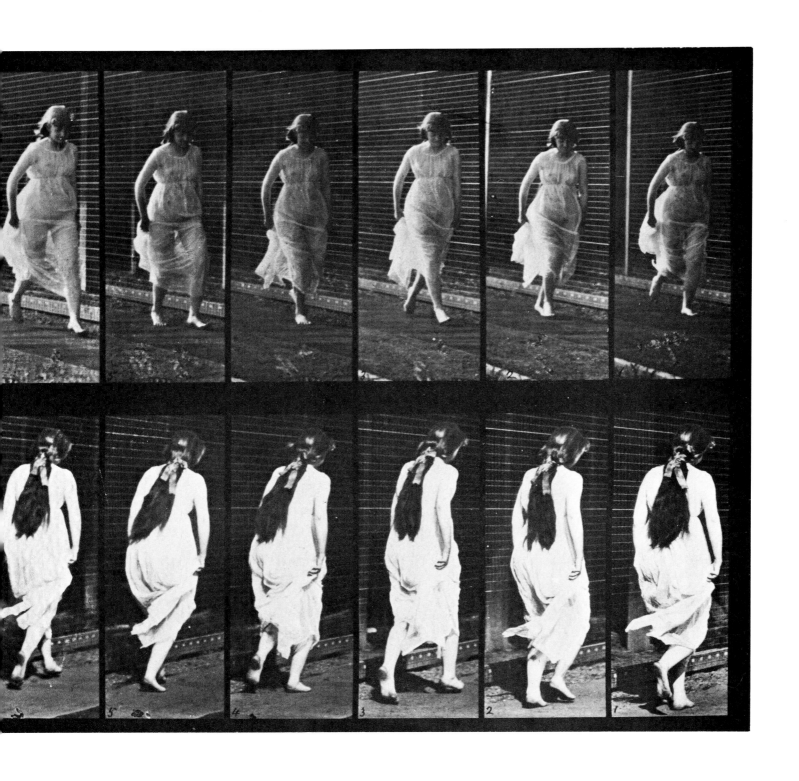

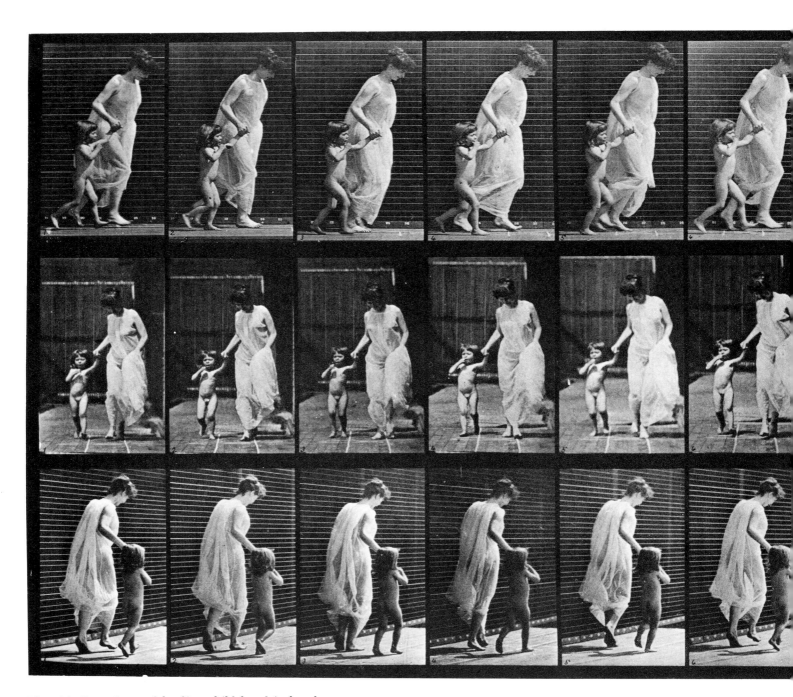

Plate 72. Running and leading child hand in hand.

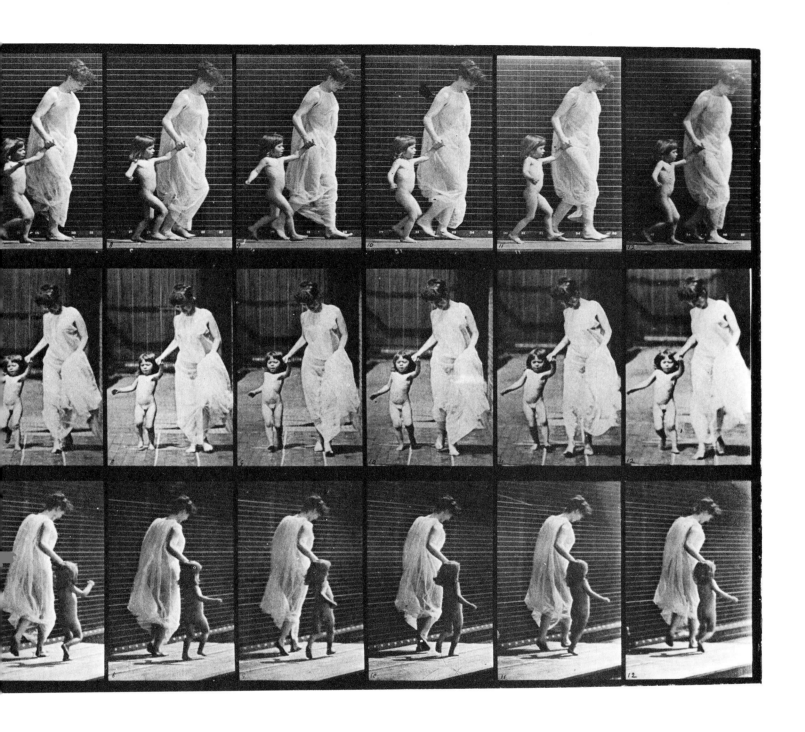

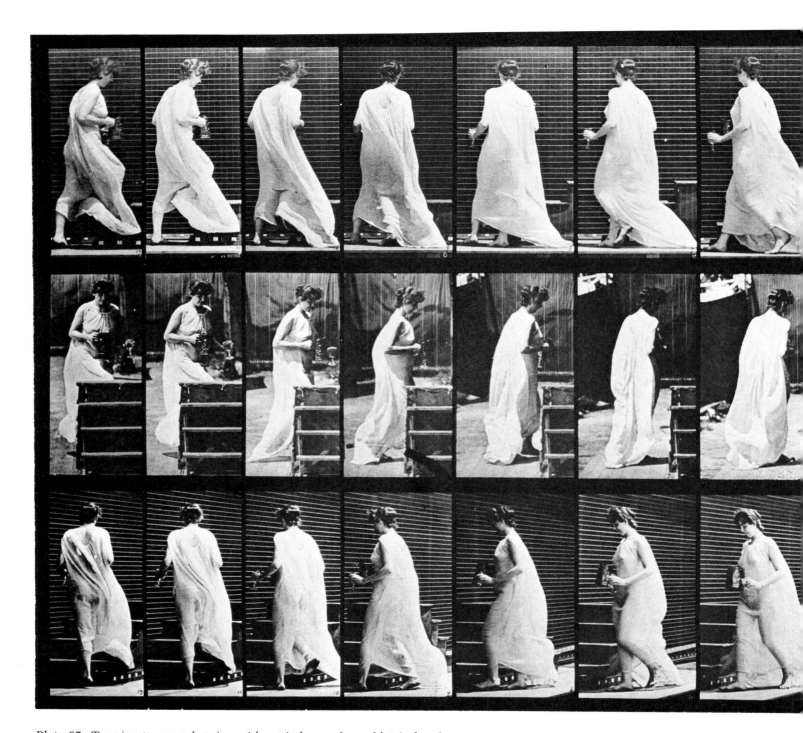

Plate 97. Turning to ascend stairs, with a pitcher and a goblet in hands.

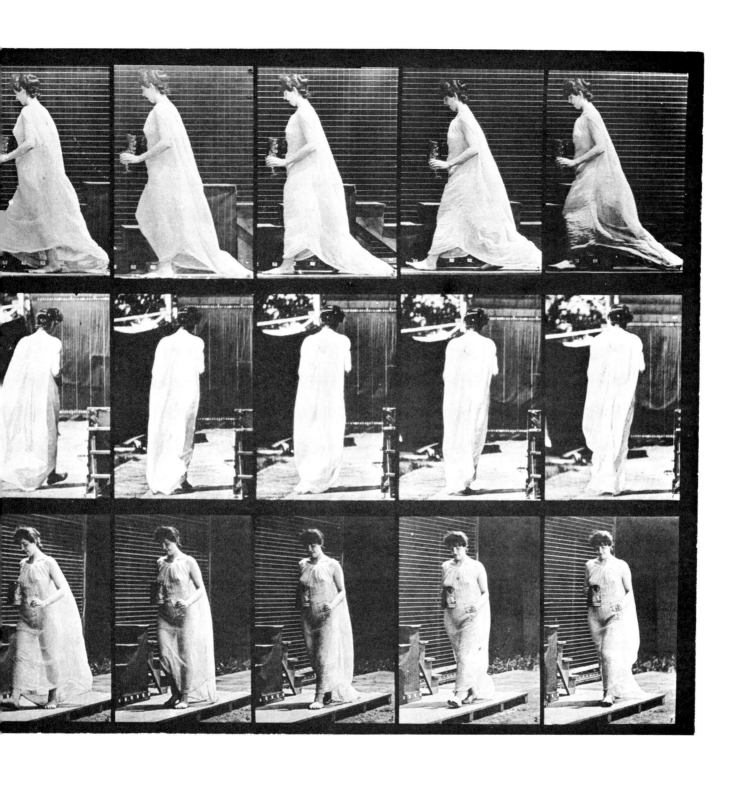

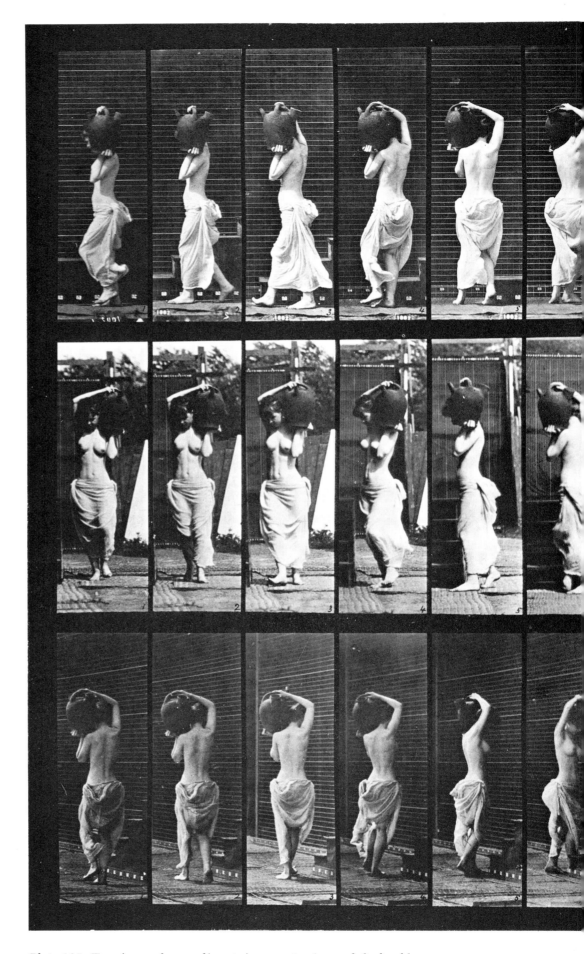

Plate 105. Turning and ascending stairs, a water jar on left shoulder.

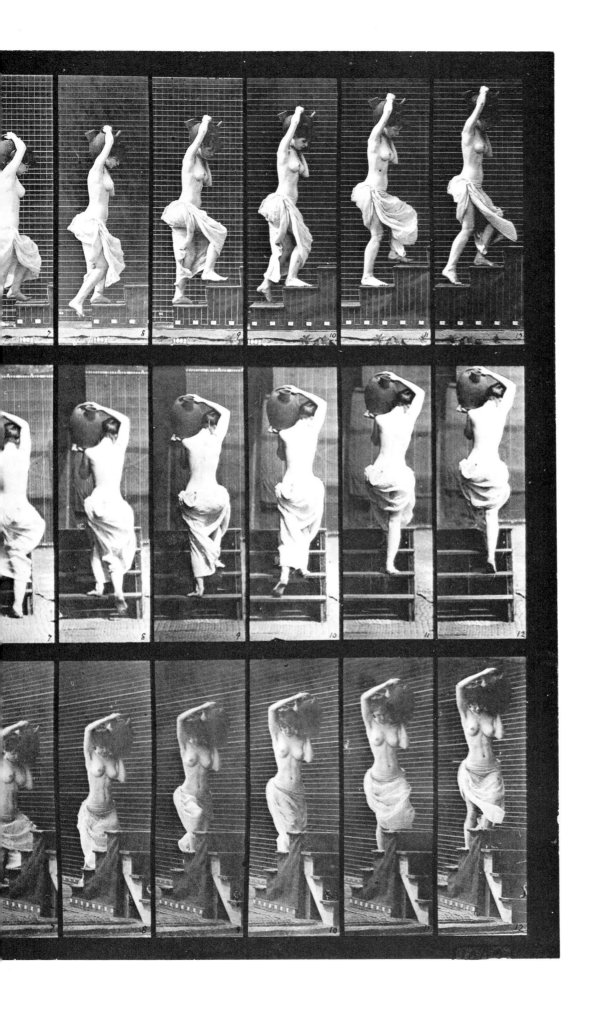

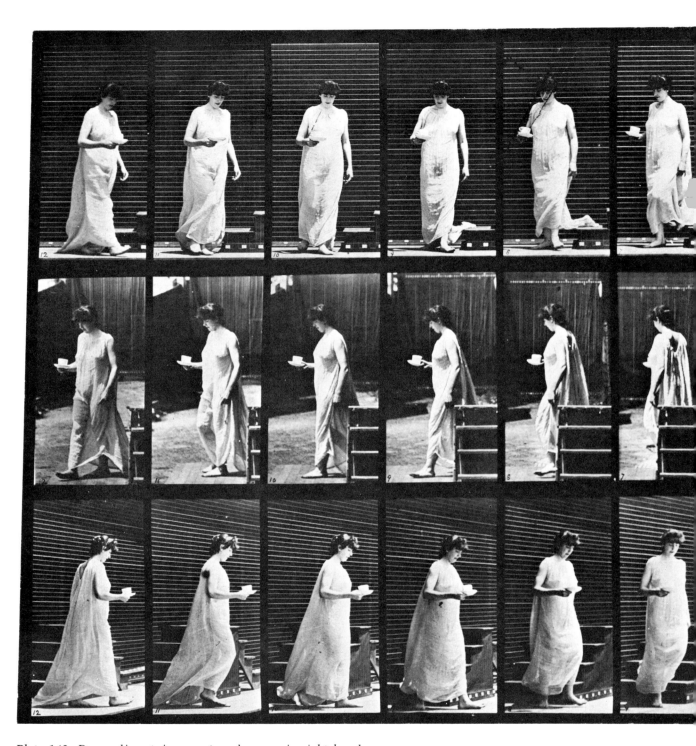

Plate 143. Descending stairs, a cup and saucer in right hand.

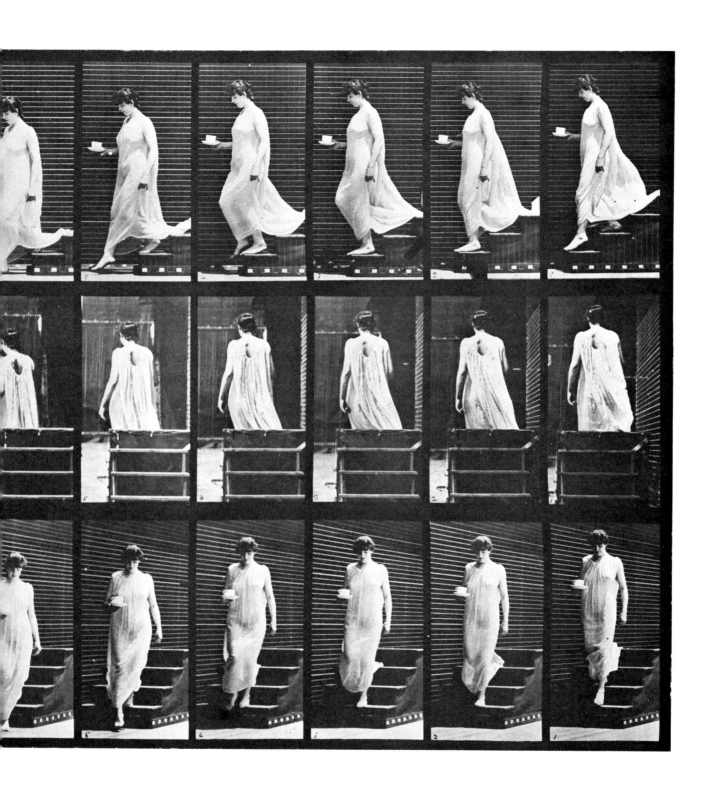

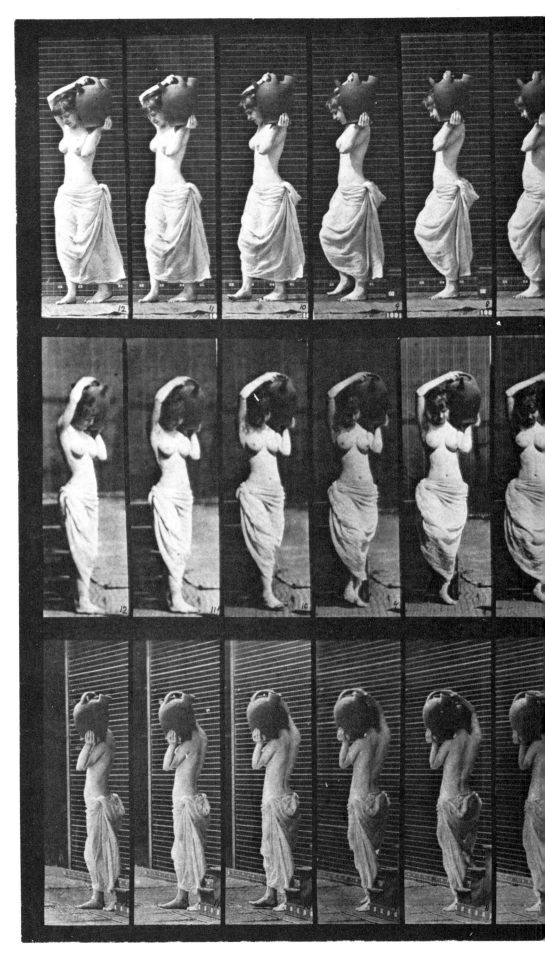

Plate 146. Descending stairs and turning, a water jar on left shoulder.

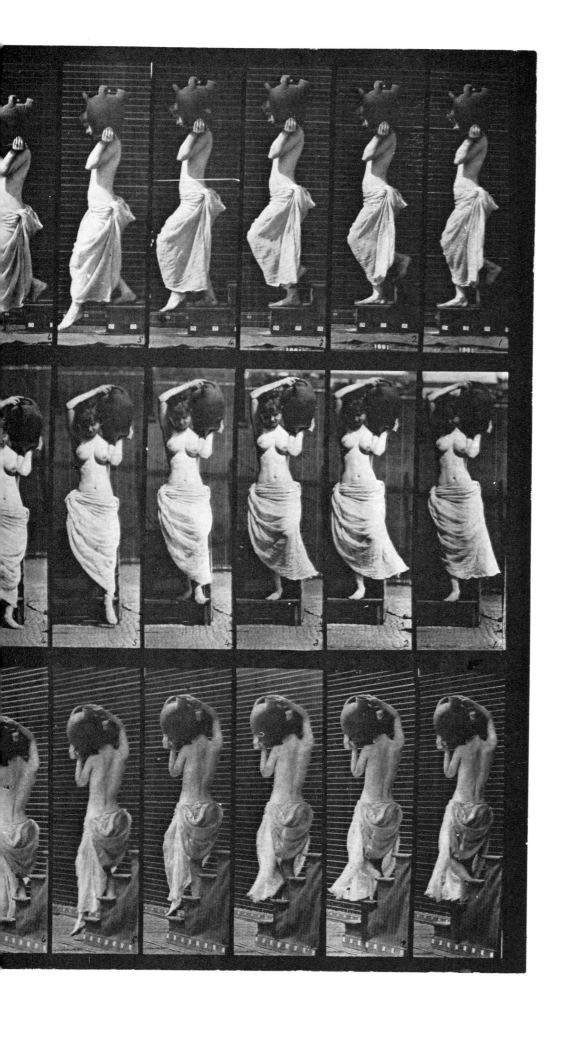

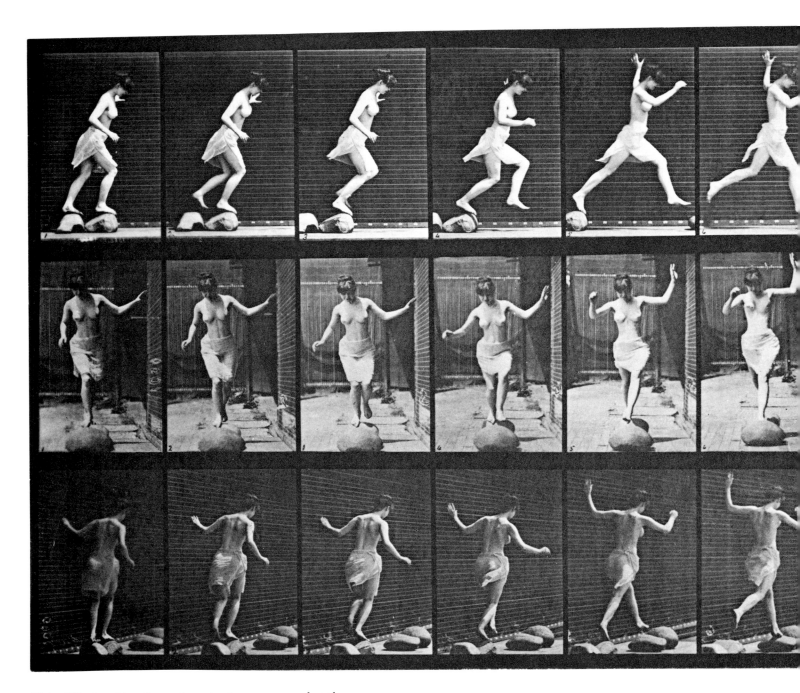

Plate 170. Jumping from stone to stone across a brook.

FEMALES (SEMI-NUDE) & CHILDREN

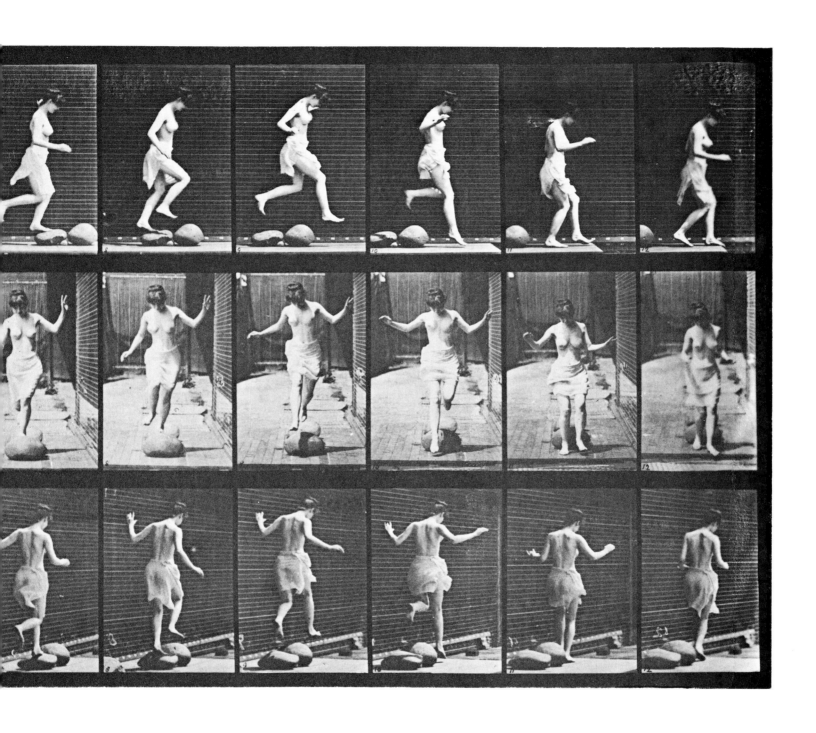

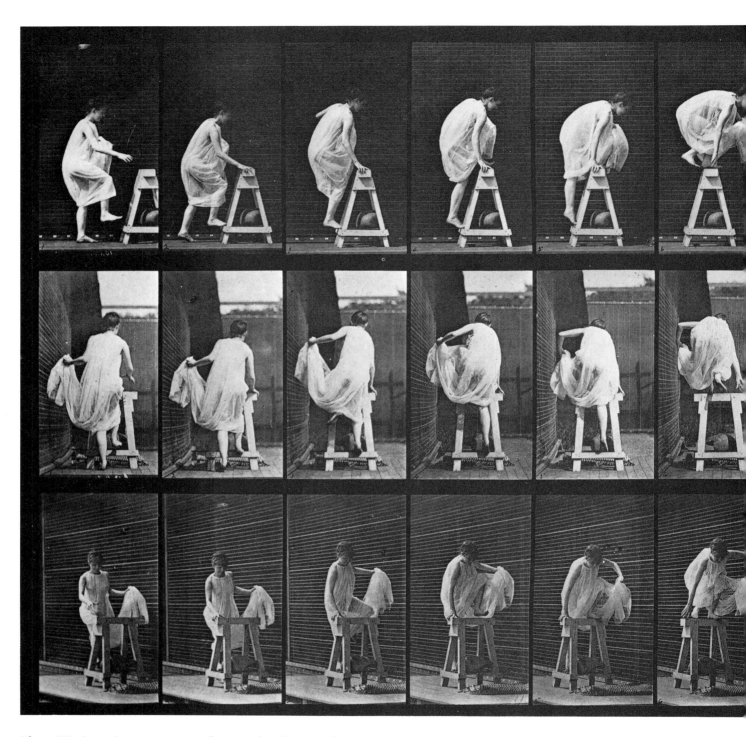

Plate 172. *Stepping up on a trestle, jumping down and turning.*

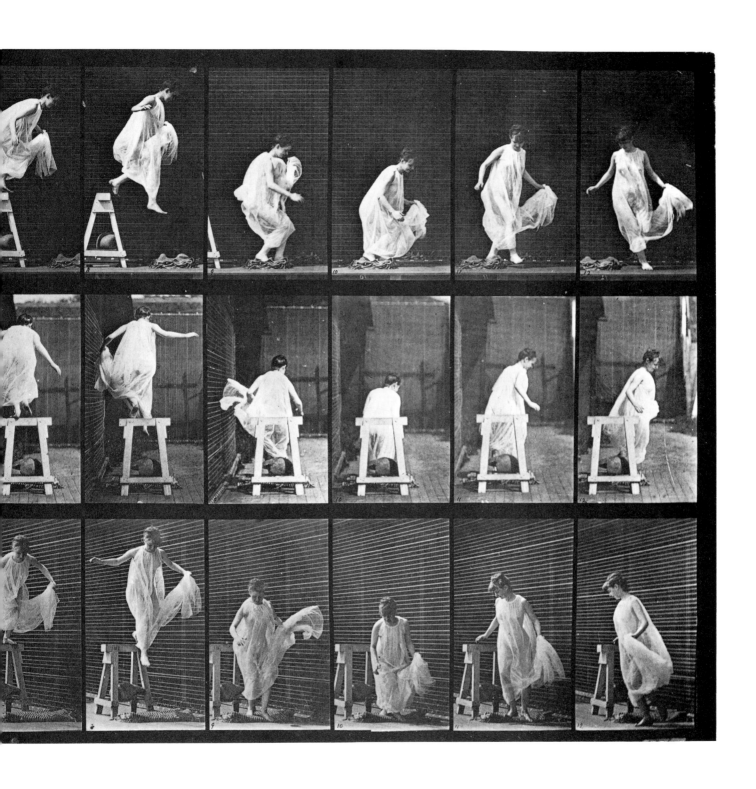

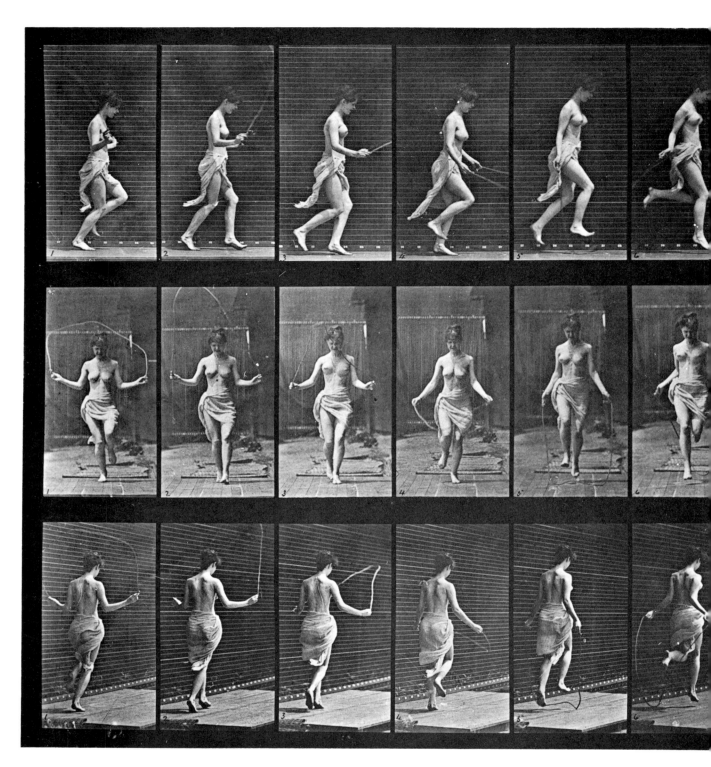

Plate 174. Running and jumping with skipping rope.

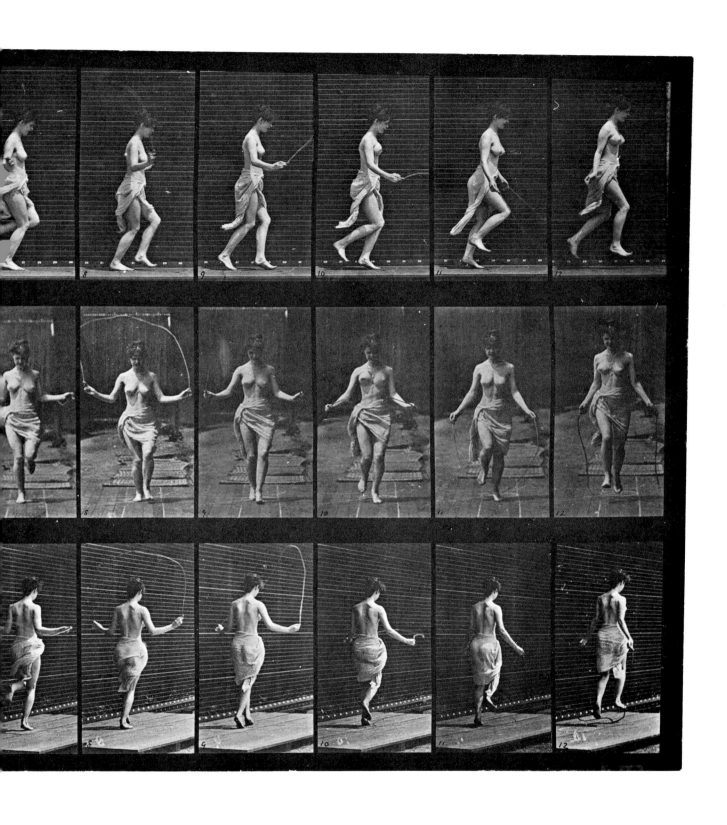

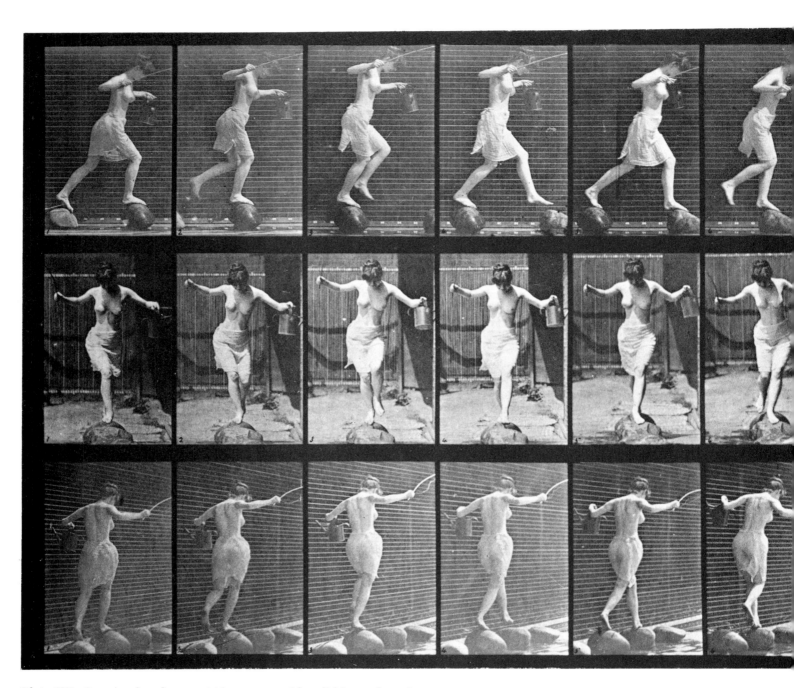

Plate 175. Crossing brook on stepping-stones with a fishing pole and can.

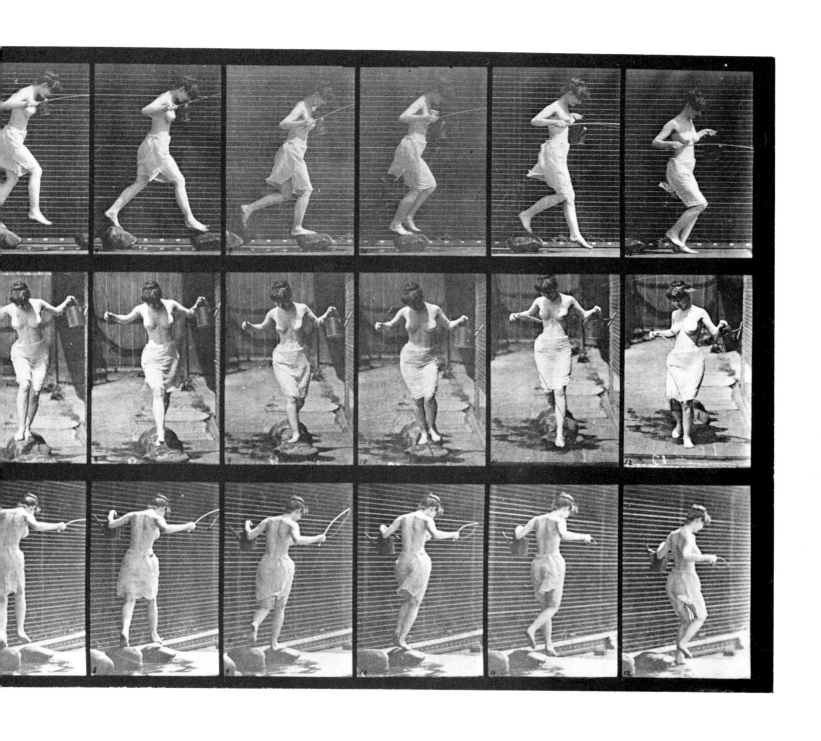

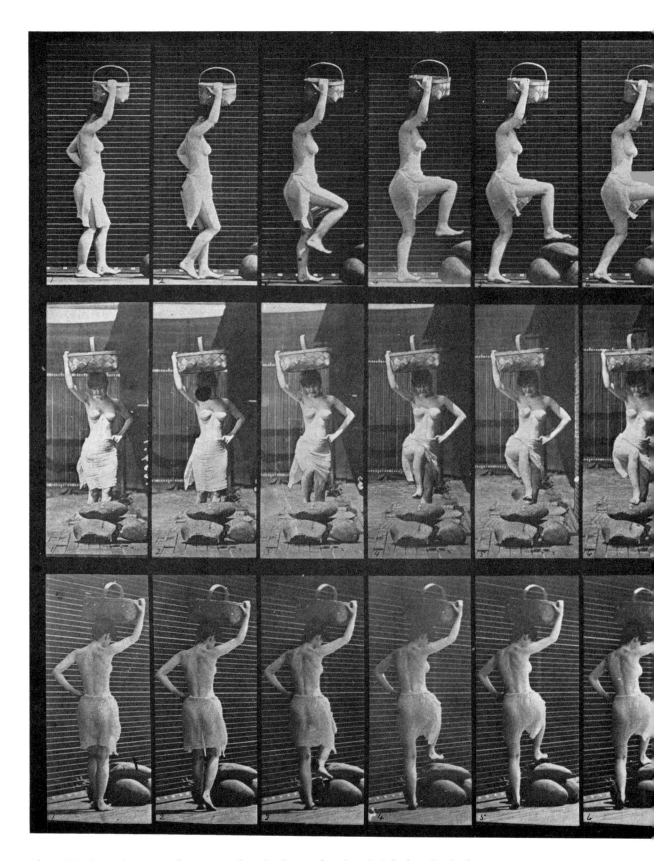

Plate 179. Stepping on and over a rock, a basket on head and right hand raised.

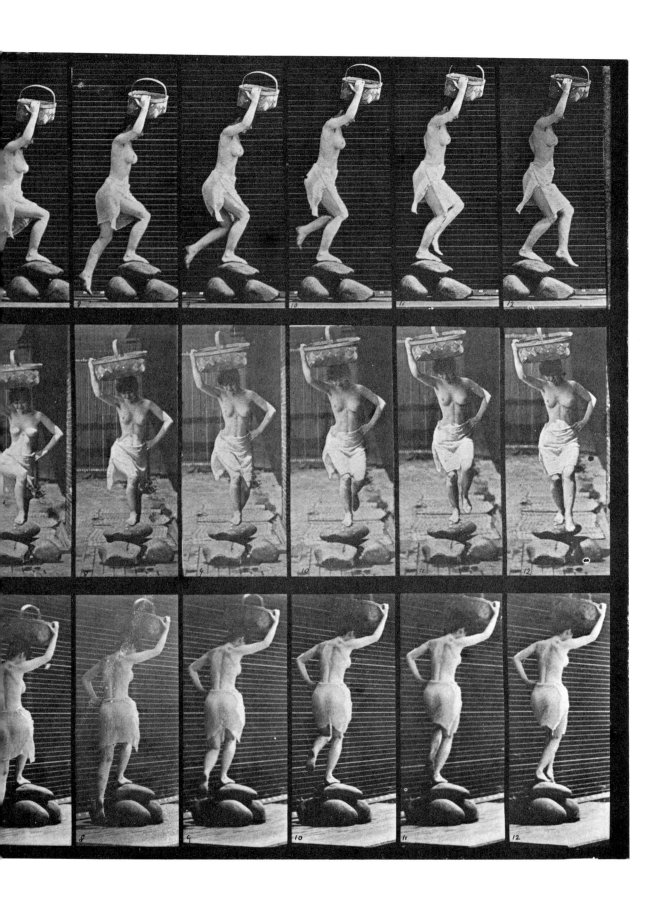

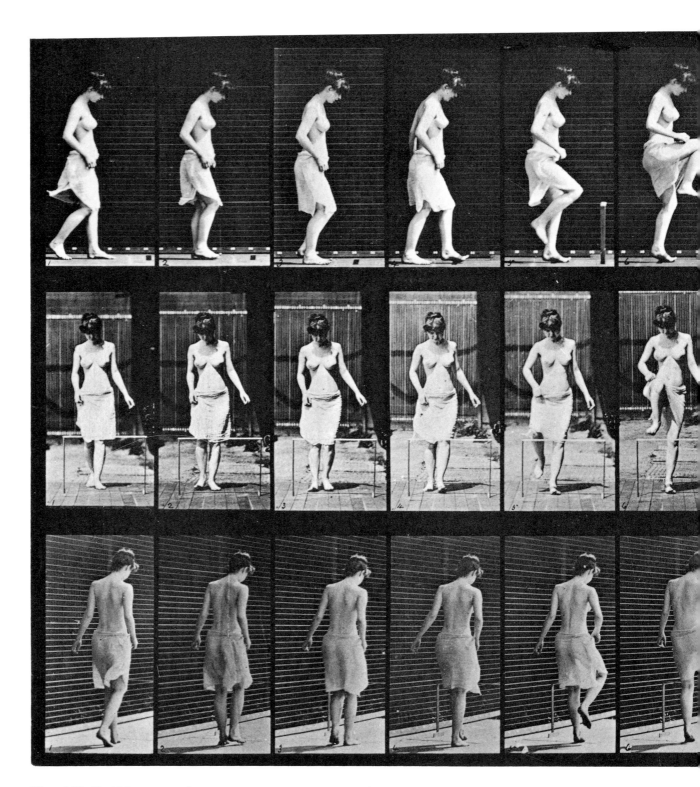

Plate 181. Stepping over a fence.

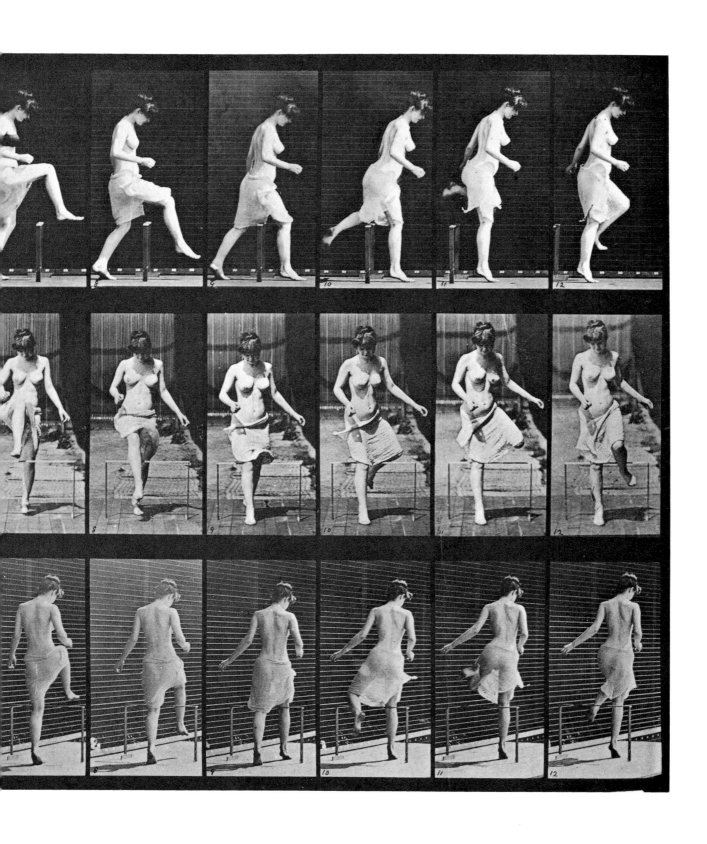

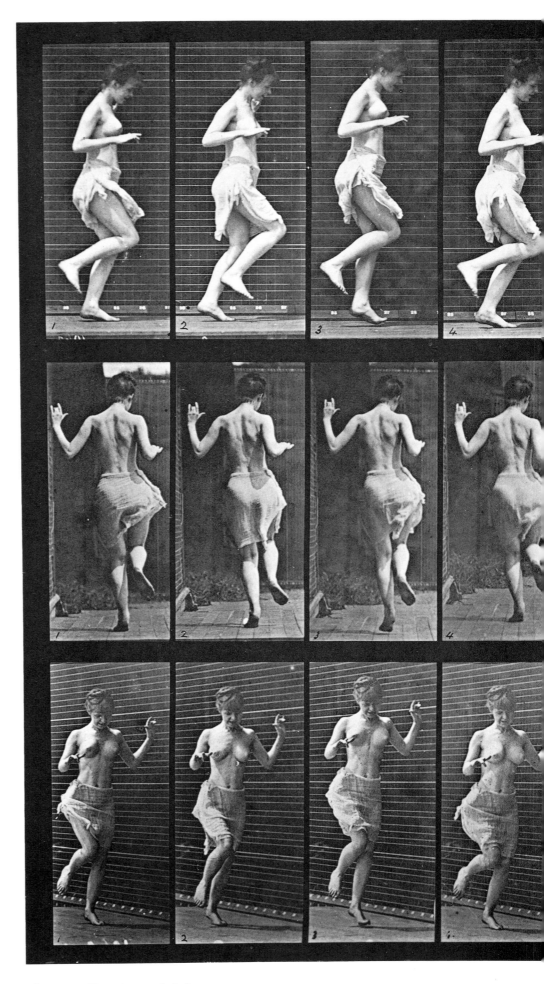

Plate 185. Hopping on left foot.

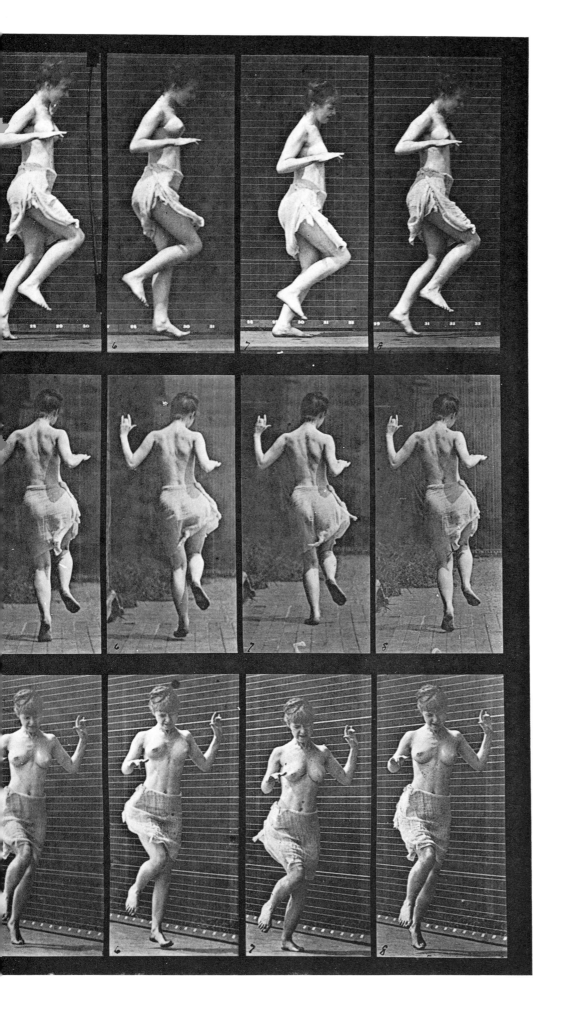

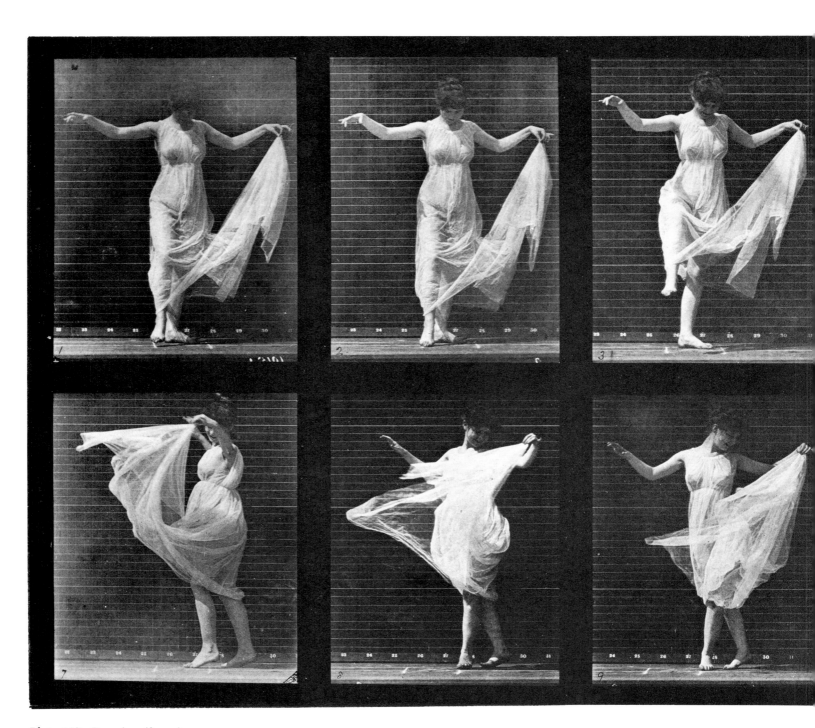

Plate 187. Dancing (fancy).

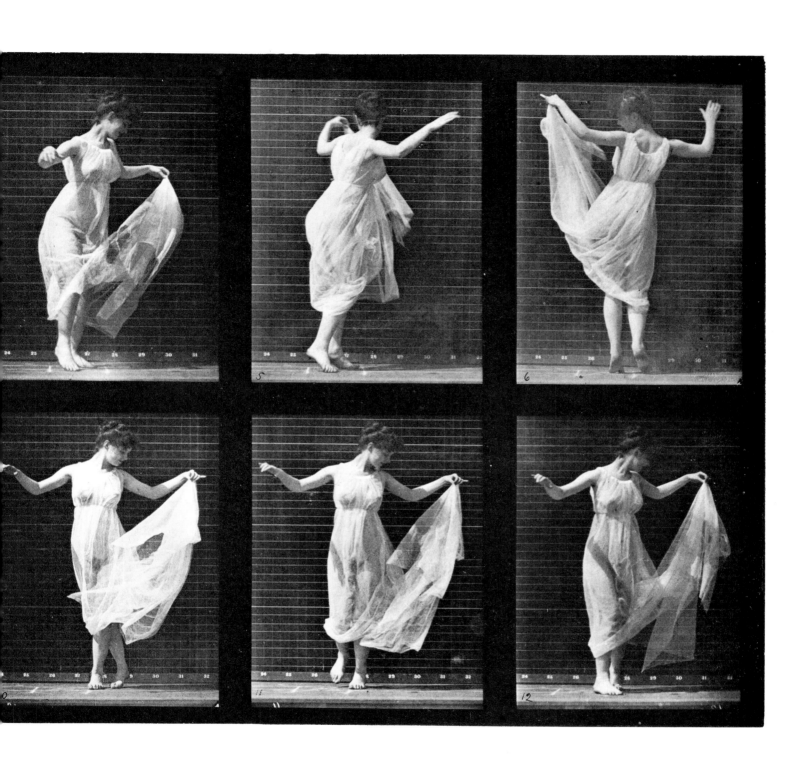

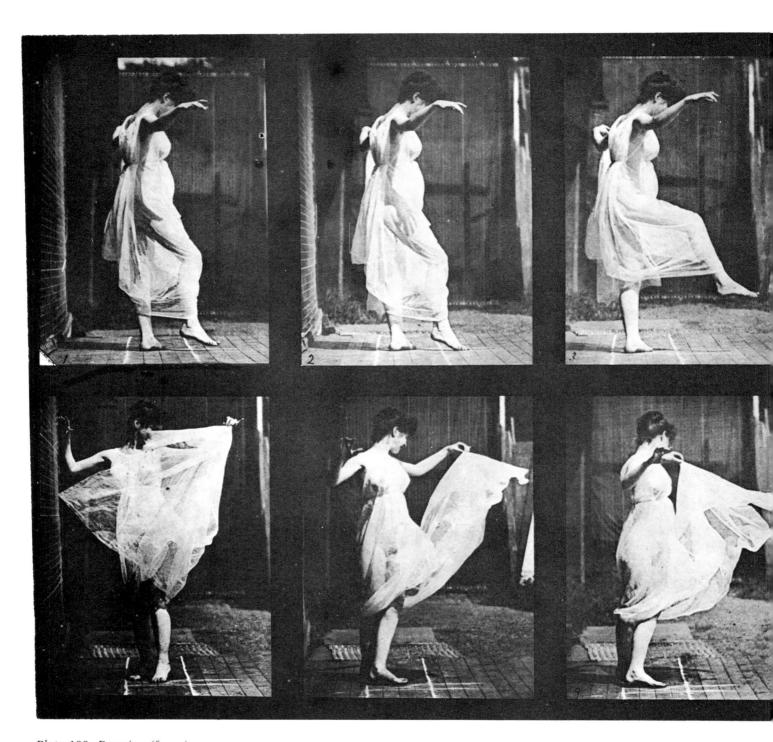

Plate 188. Dancing (fancy).

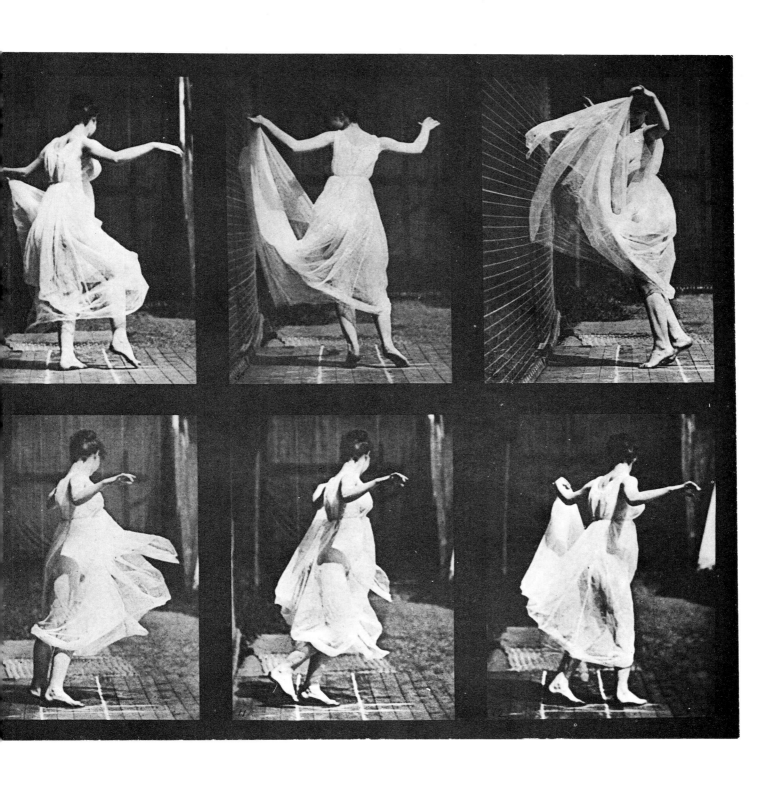

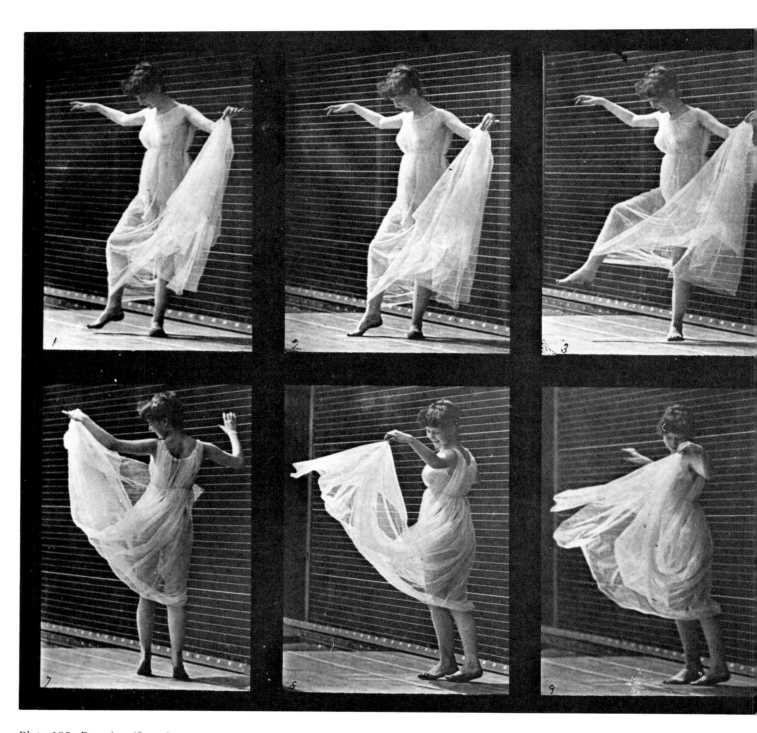

Plate 189. Dancing (fancy).

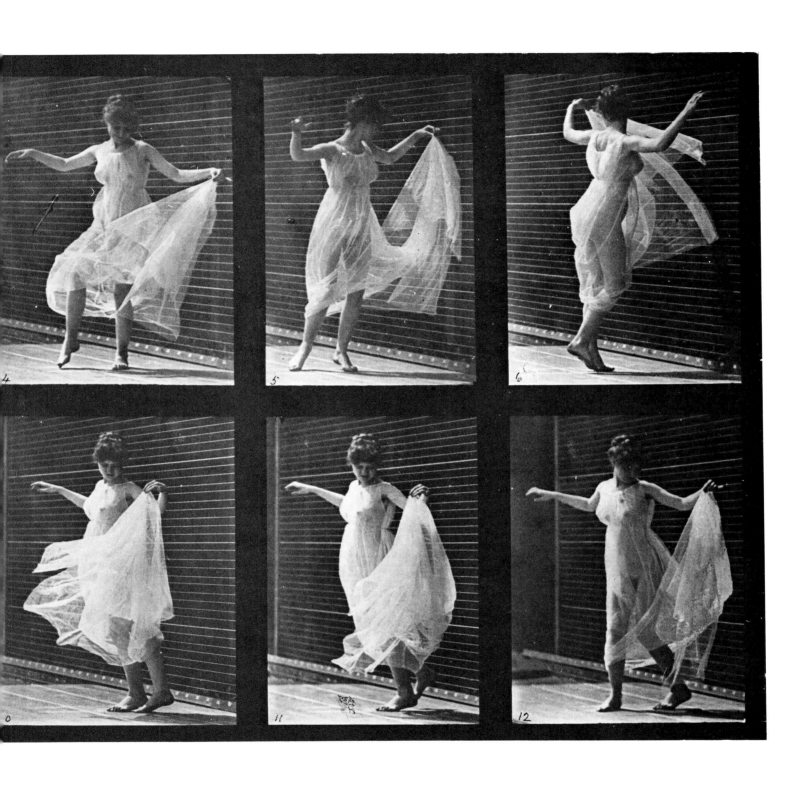

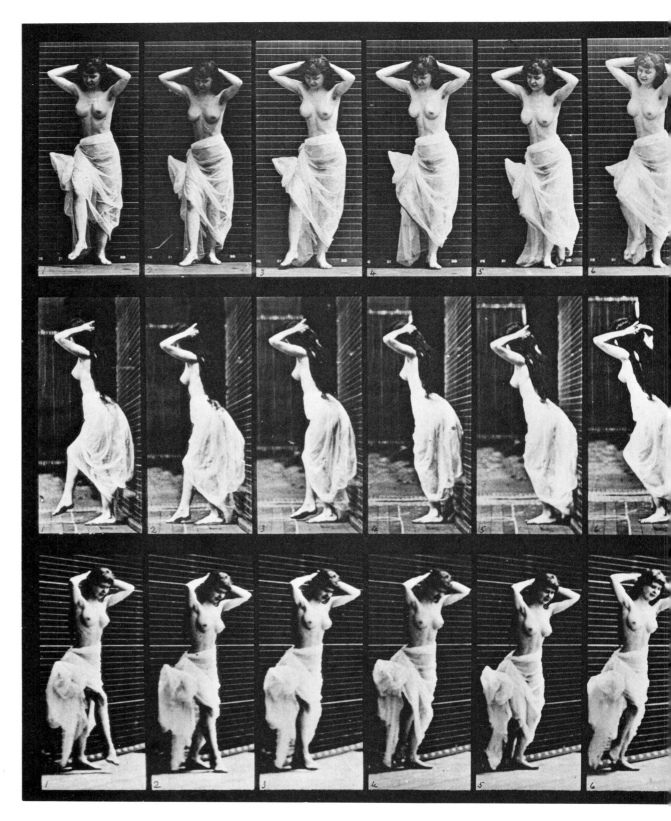

Plate 190. Dancing (nautch).

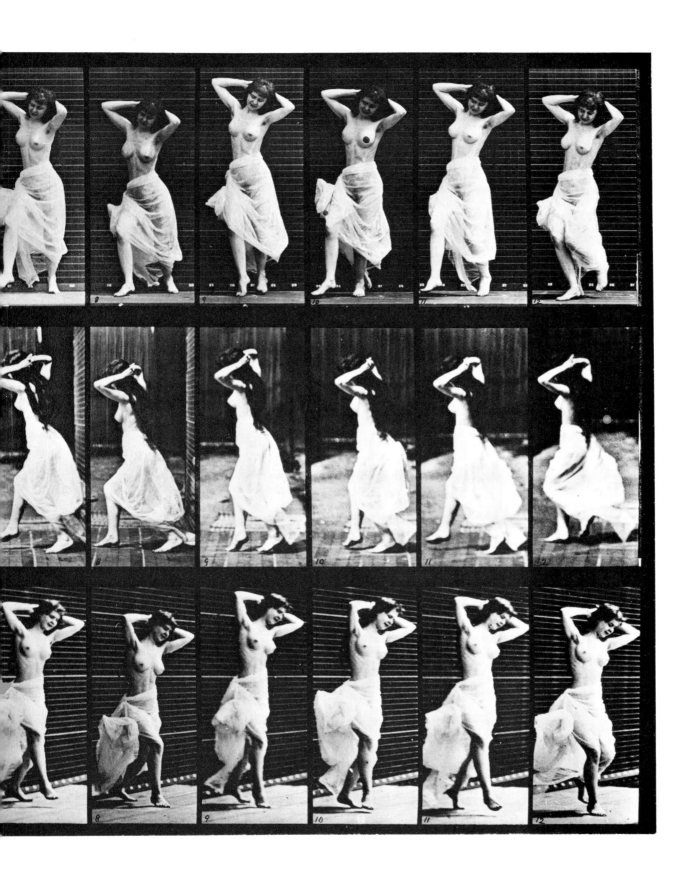

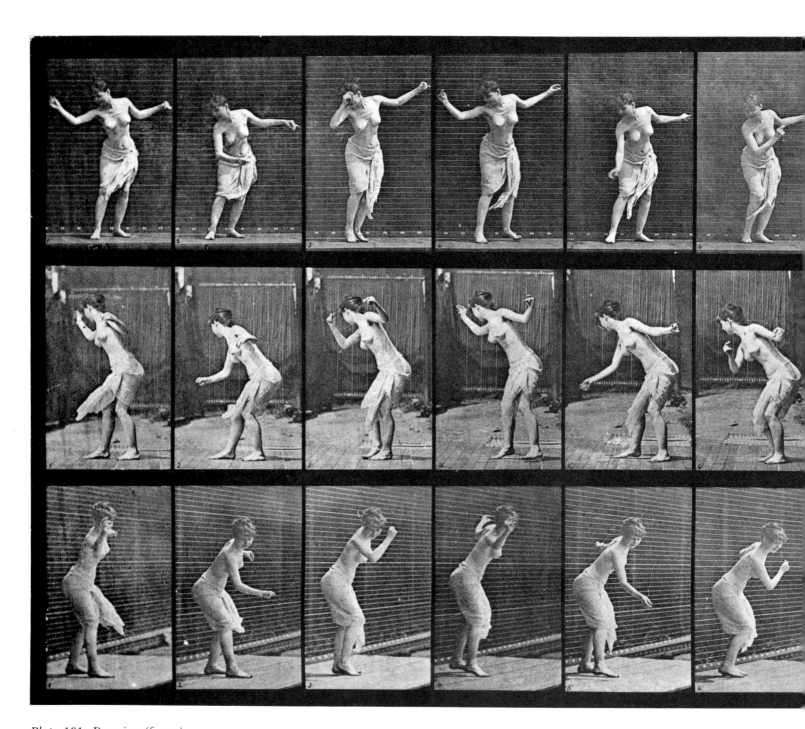

Plate 191. Dancing (fancy).

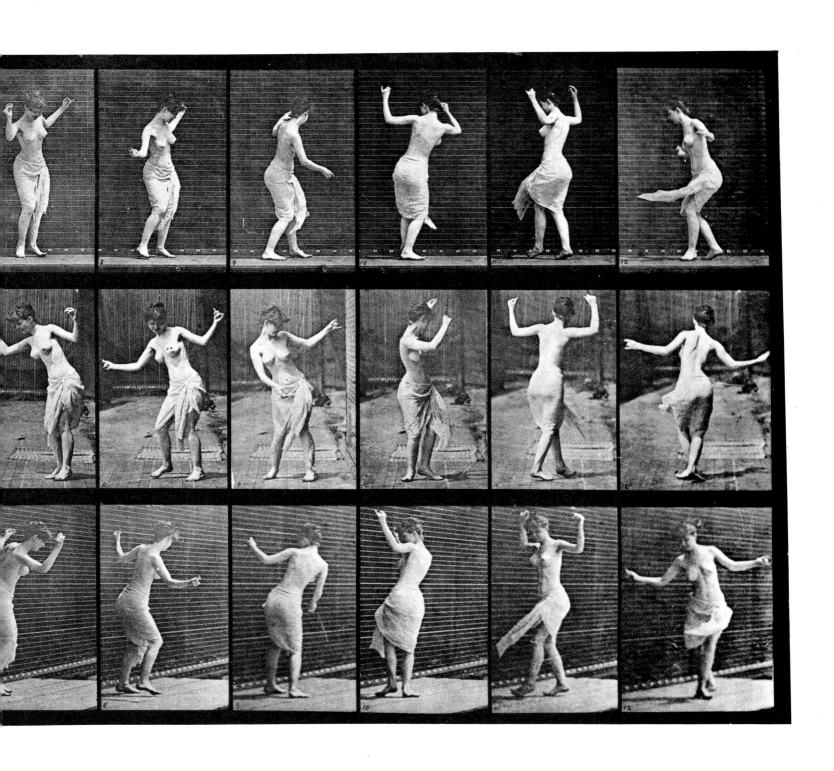

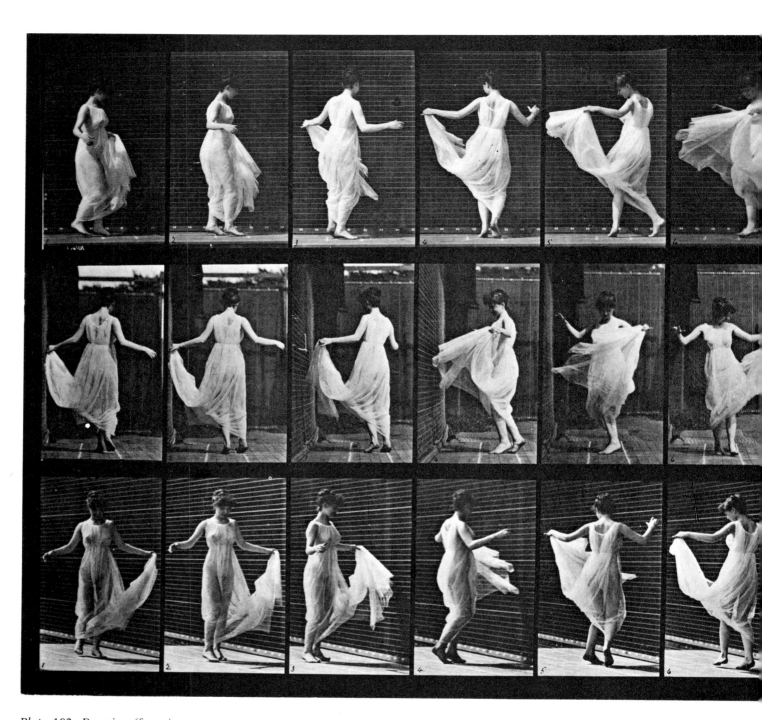

Plate 192. Dancing (fancy).

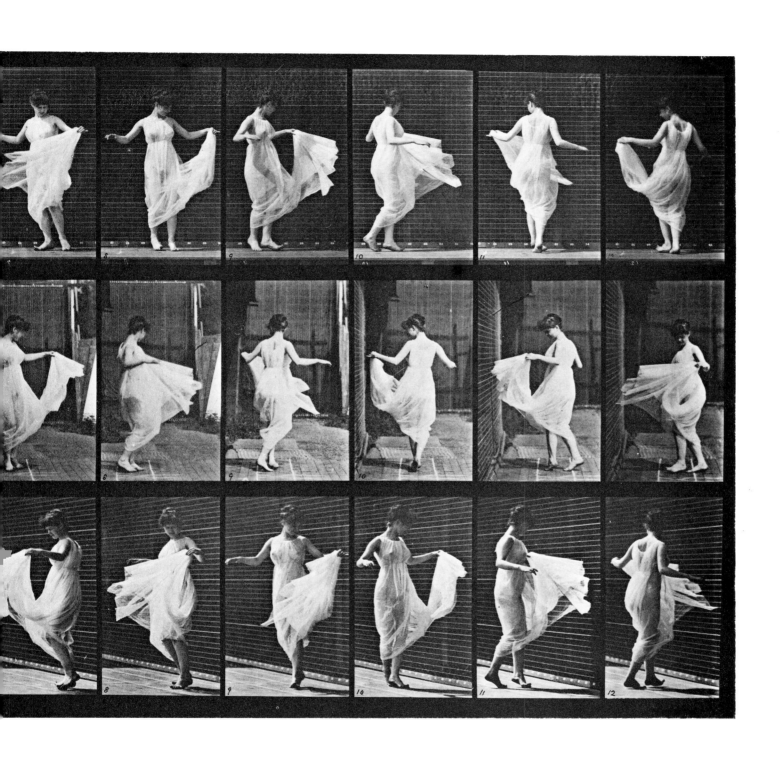

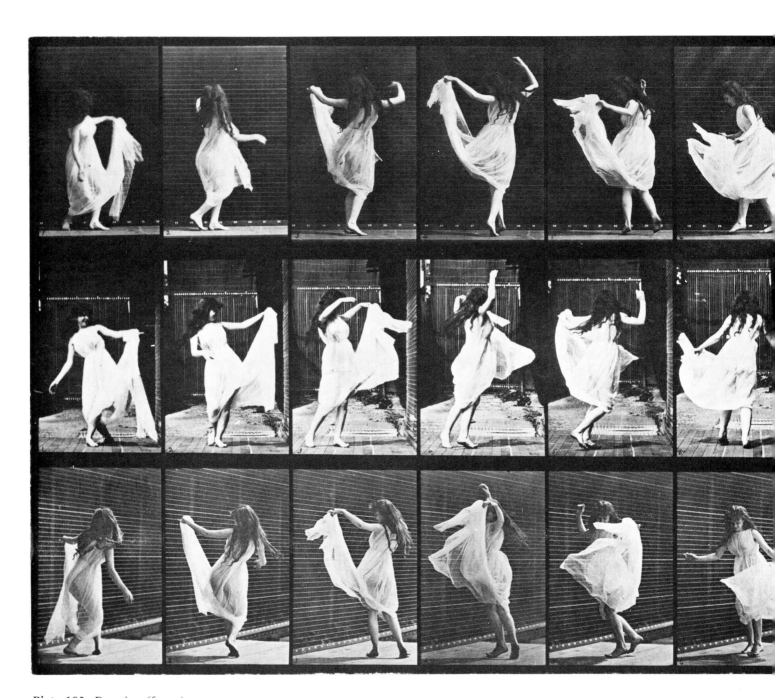

Plate 193. Dancing (fancy).

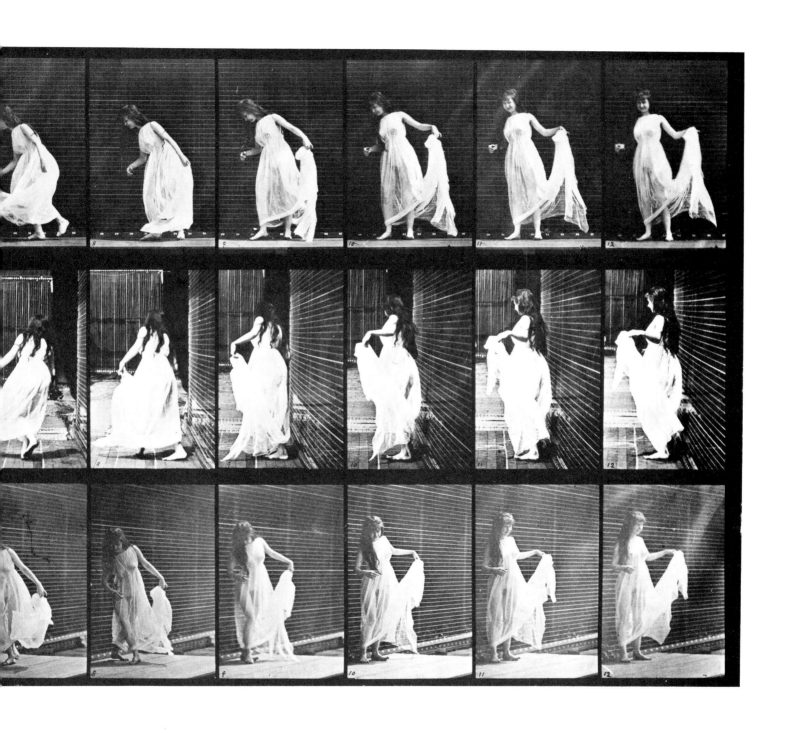

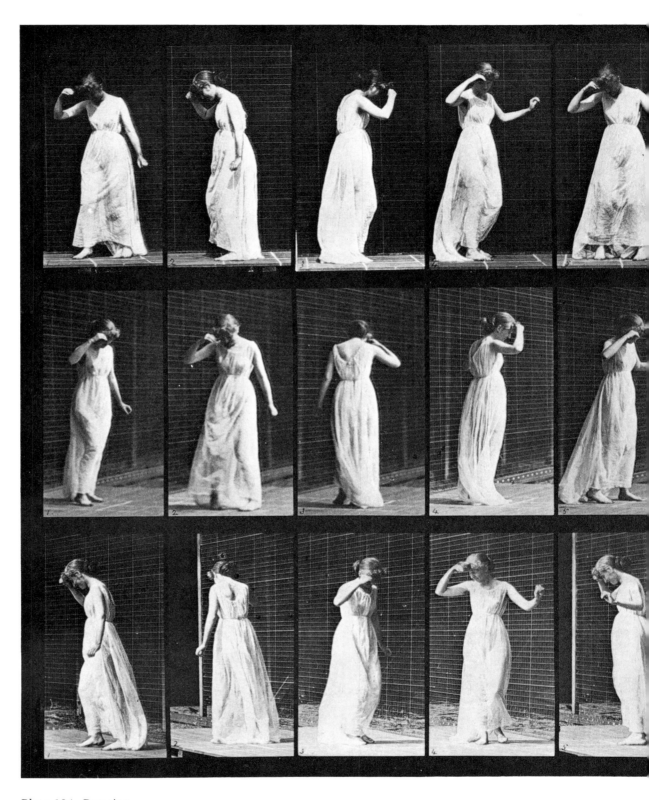

Plate 194. Dancing.

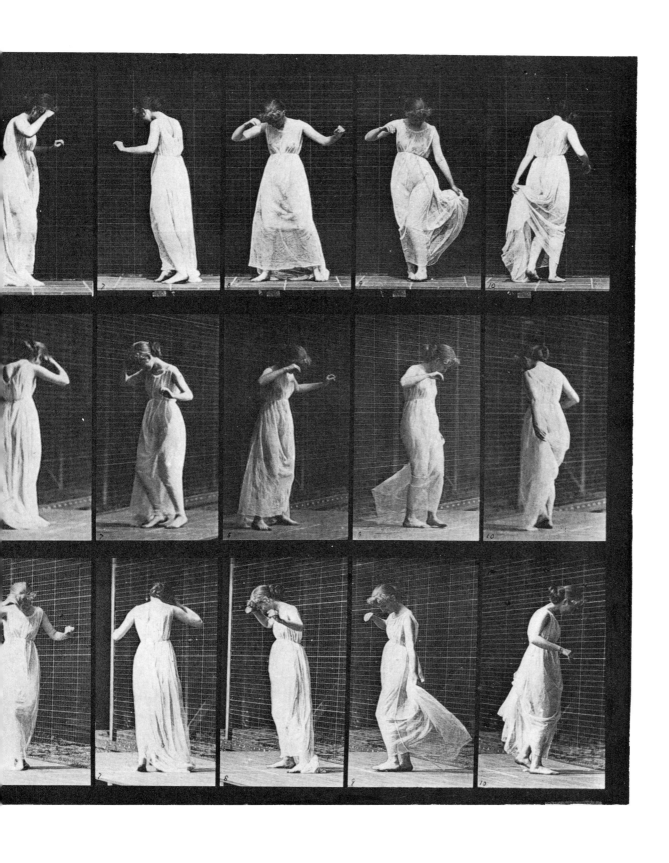

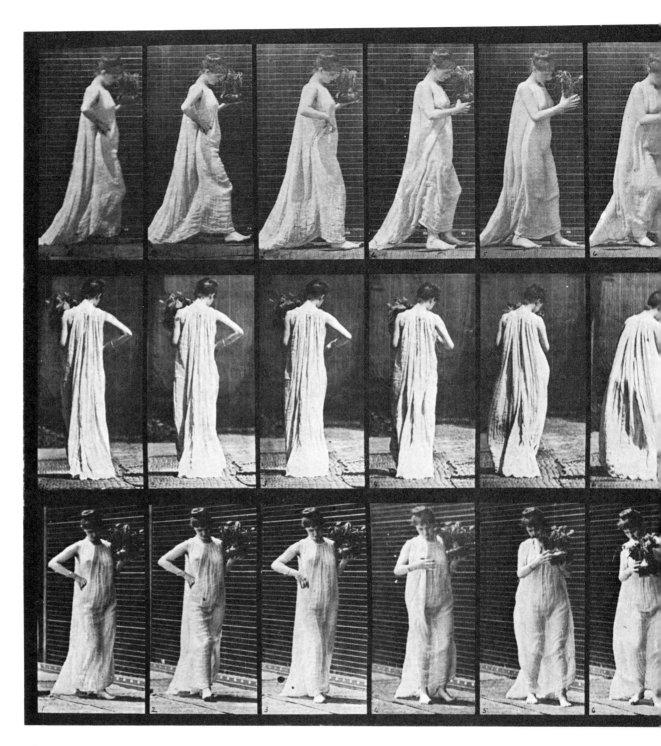

Plate 205. Carrying and stooping with a vase.

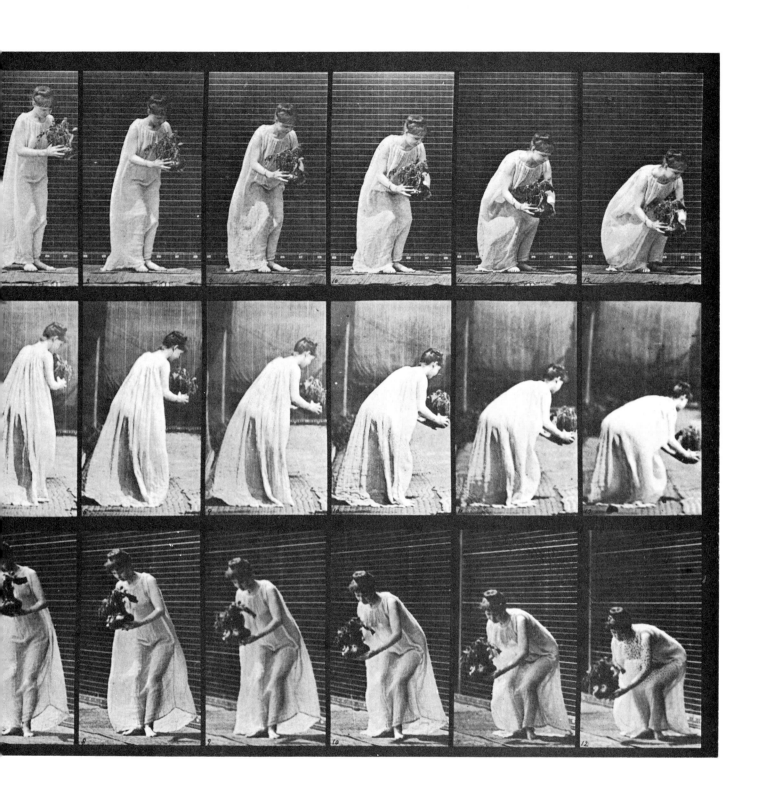

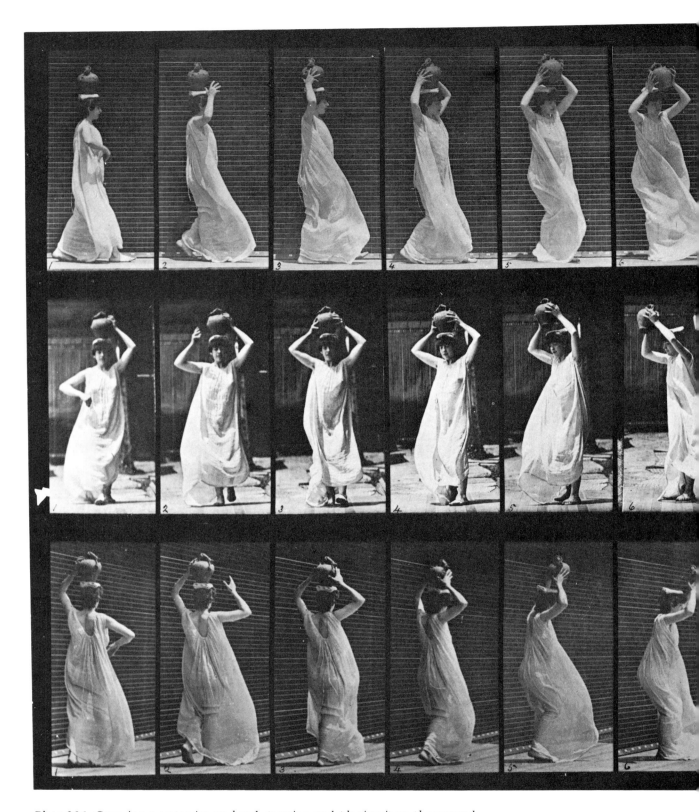

Plate 206. Carrying a water jar on head, turning and placing it on the ground.

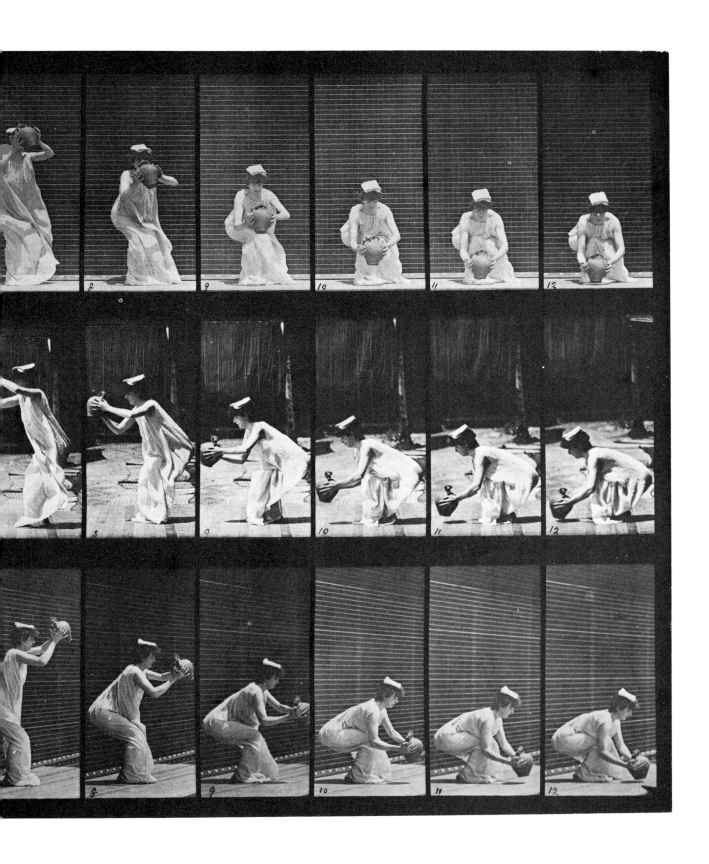

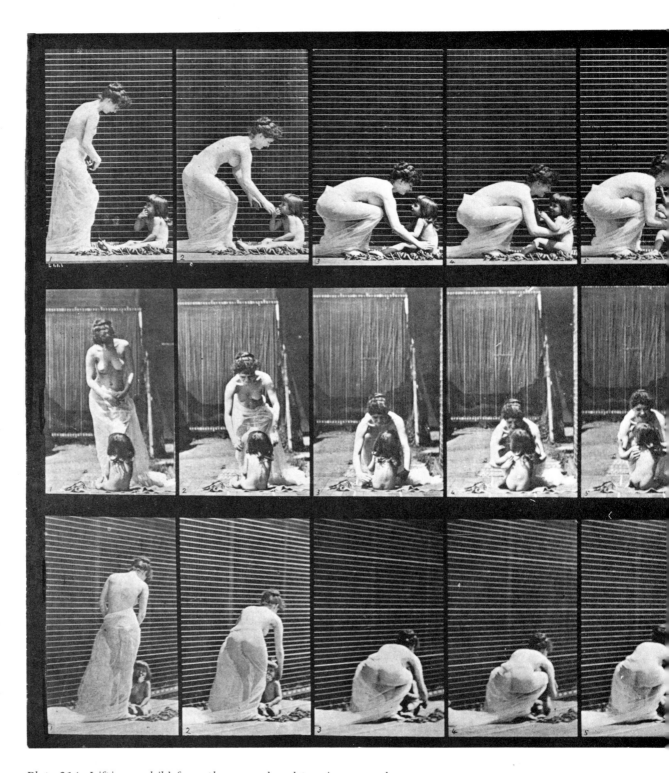

Plate 214. Lifting a child from the ground and turning around.

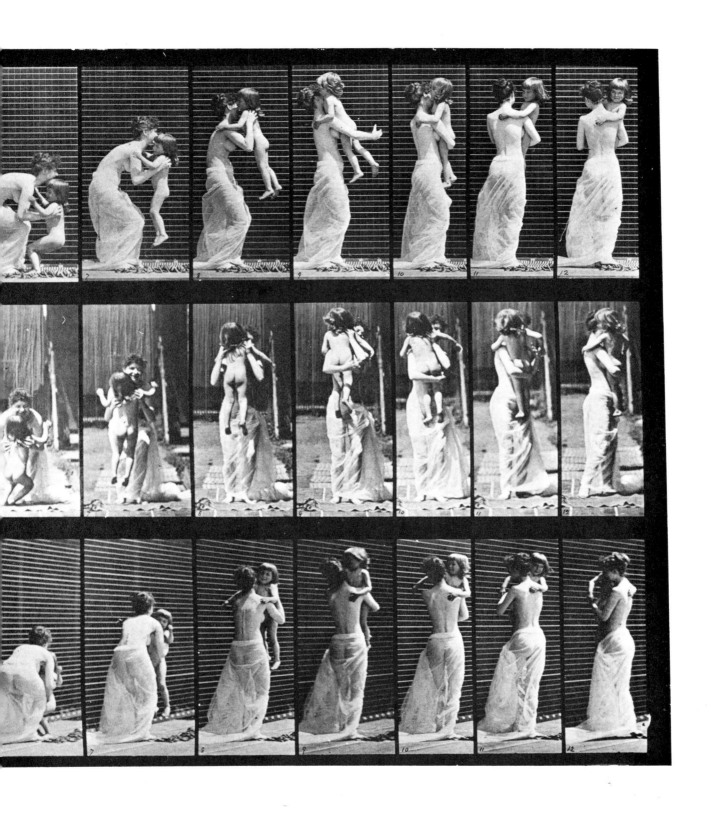

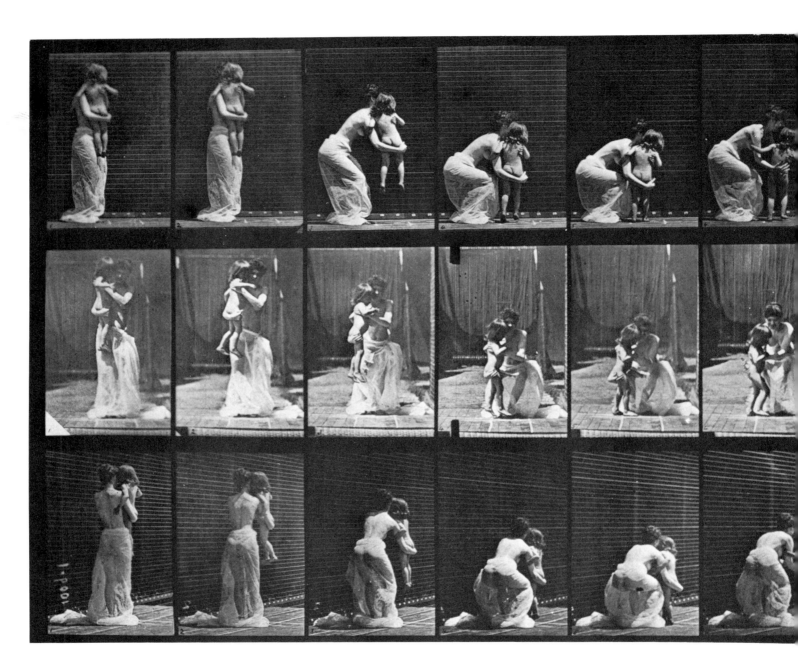

Plate 215. Placing a child on the ground; the child running off.

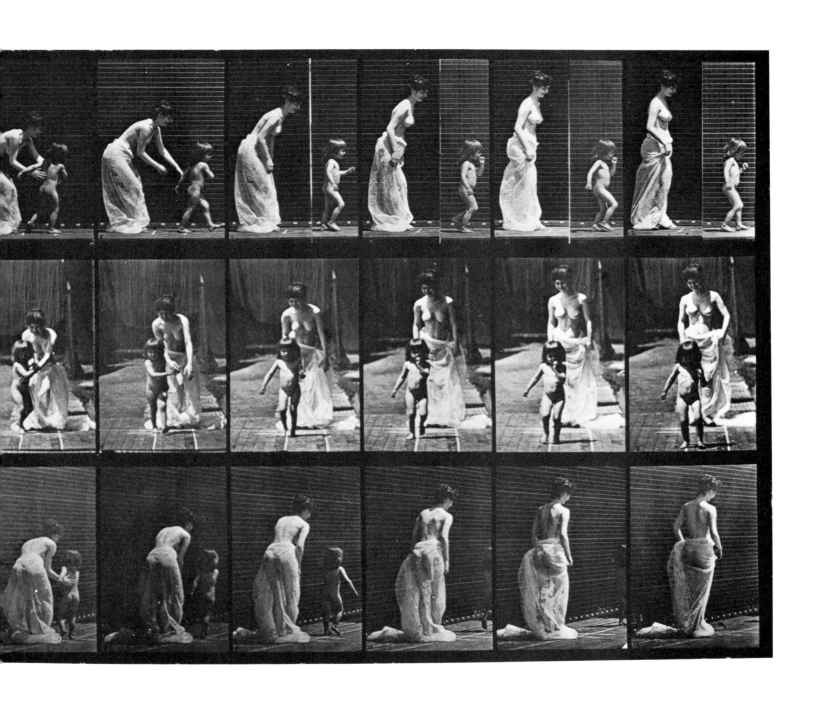

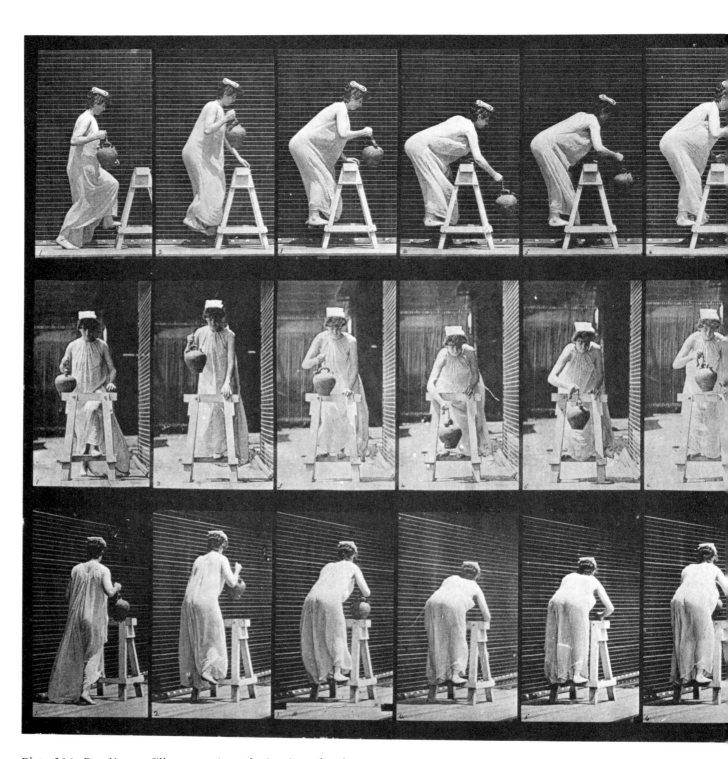

Plate 216. Bending to fill a water jar, placing it on head.

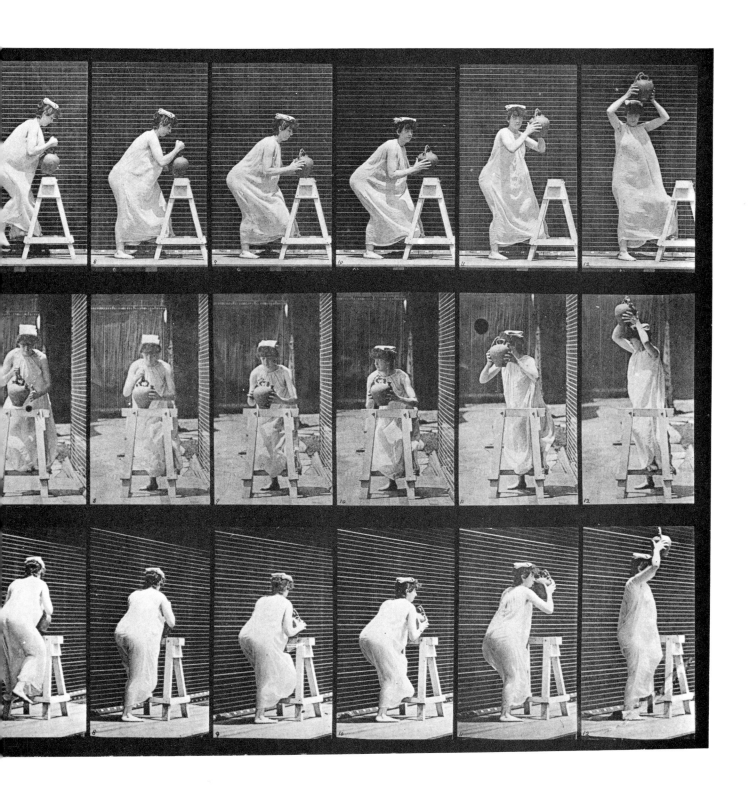

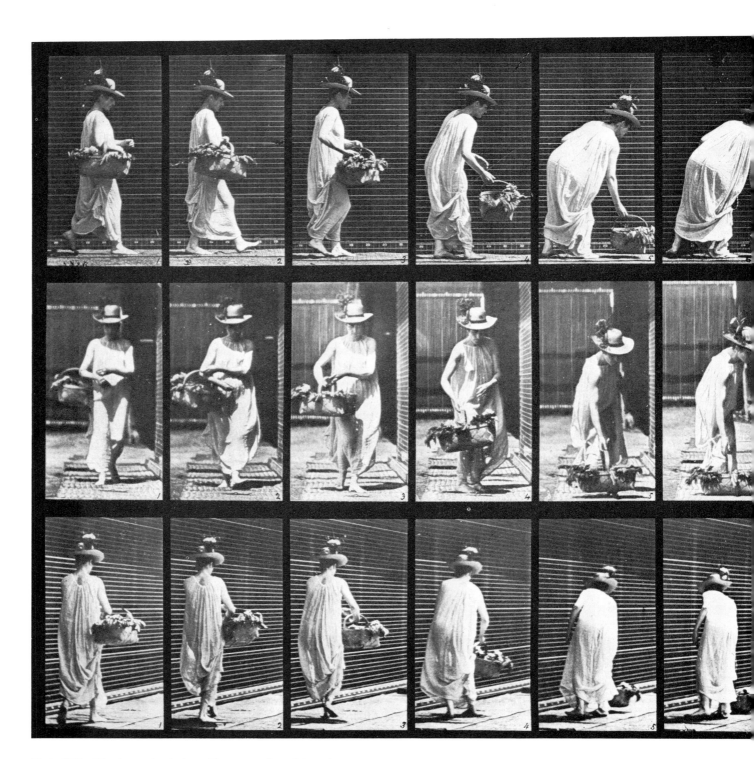

Plate 229. Placing a basket on the ground and turning.

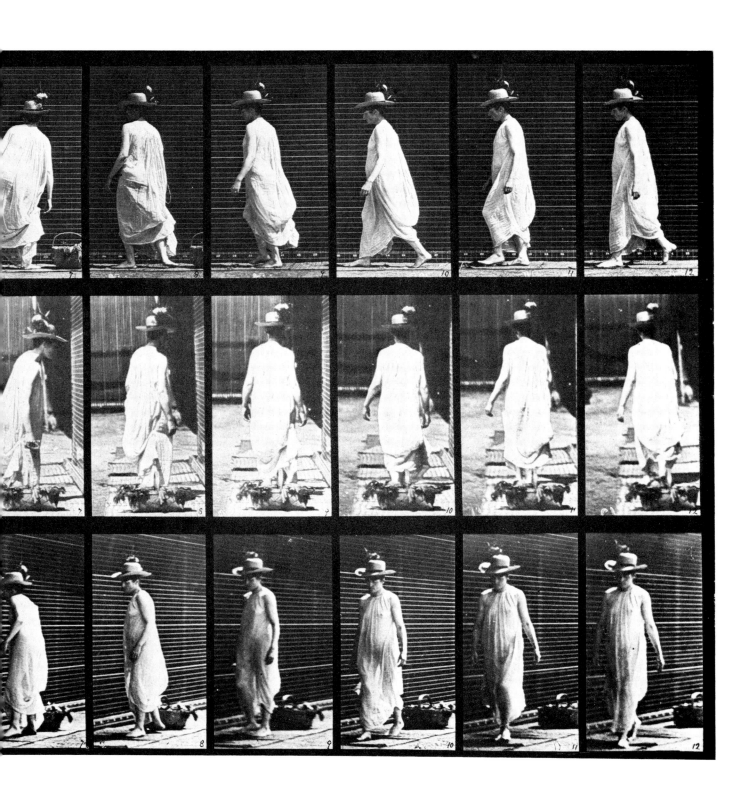

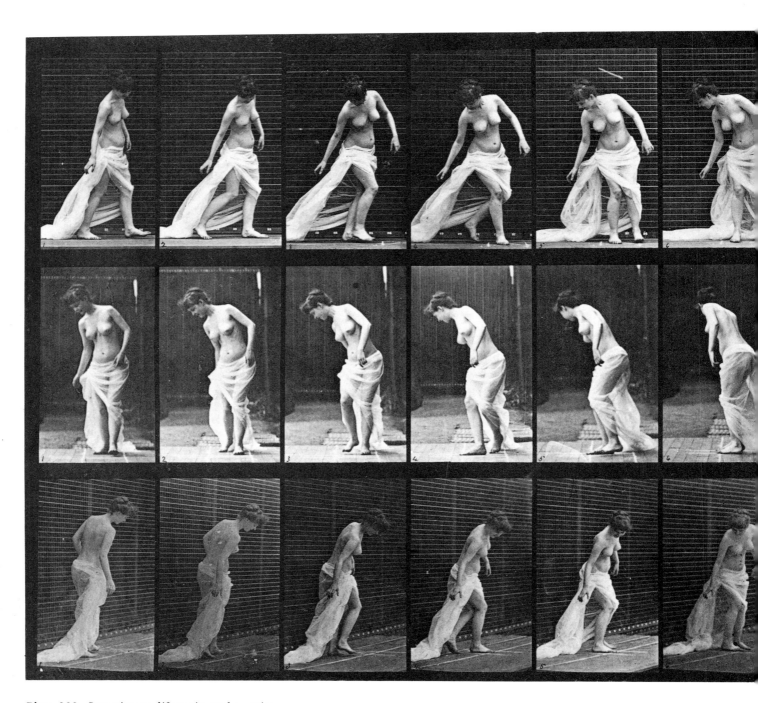

Plate 232. Stooping to lift train and turning.

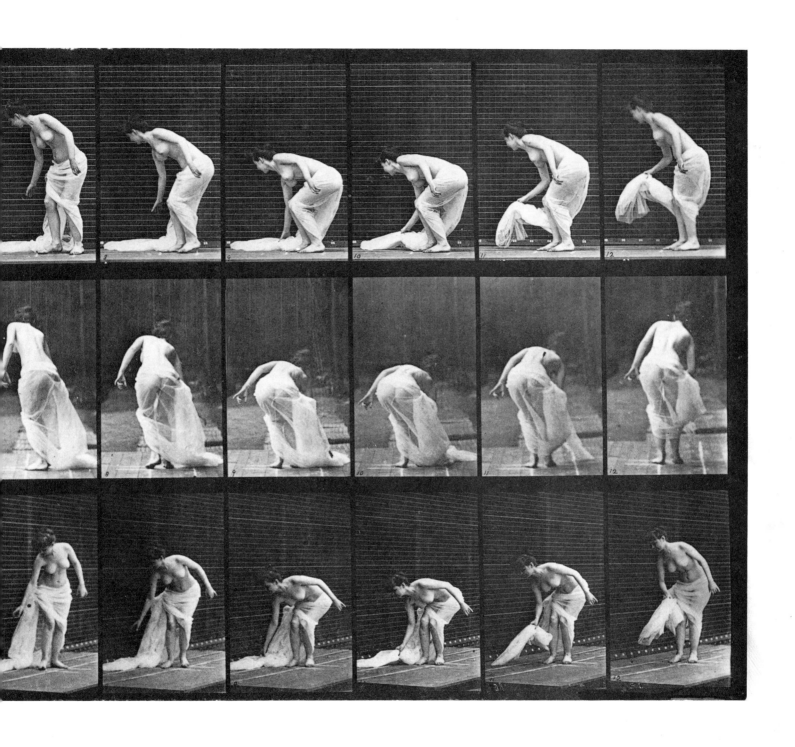

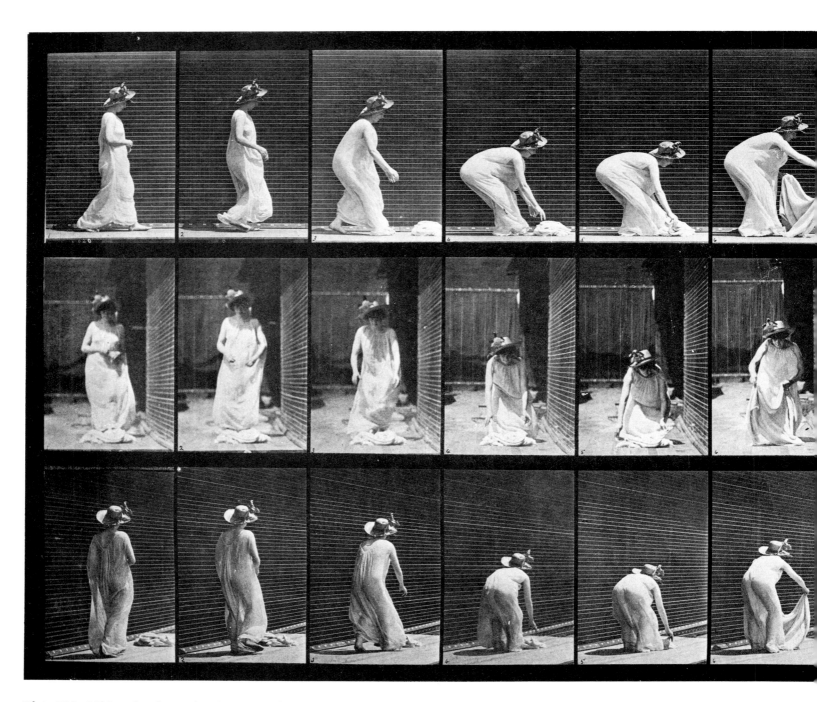

Plate 233. Lifting shawl, putting it around shoulders and turning.

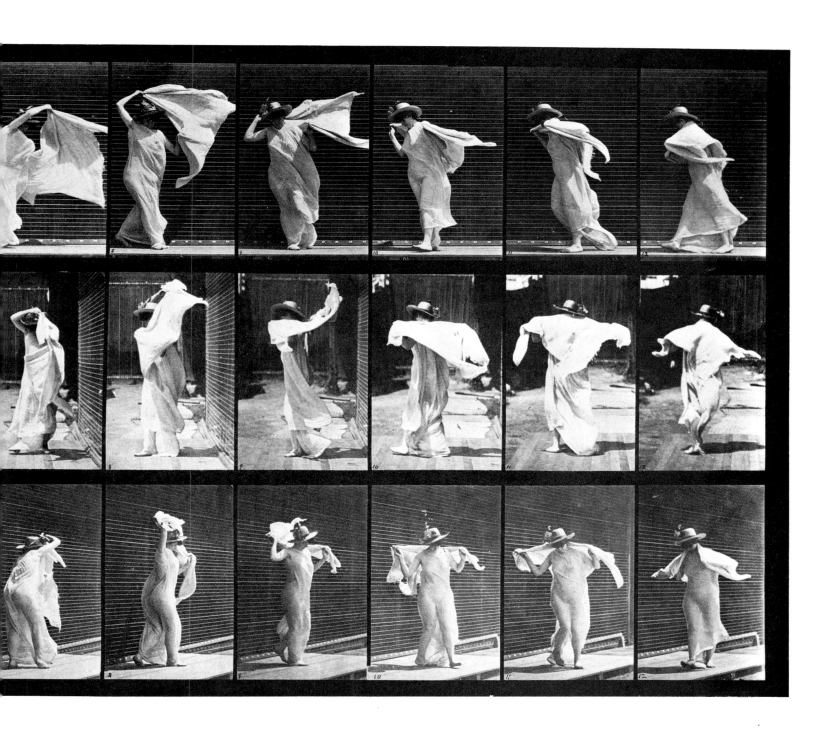

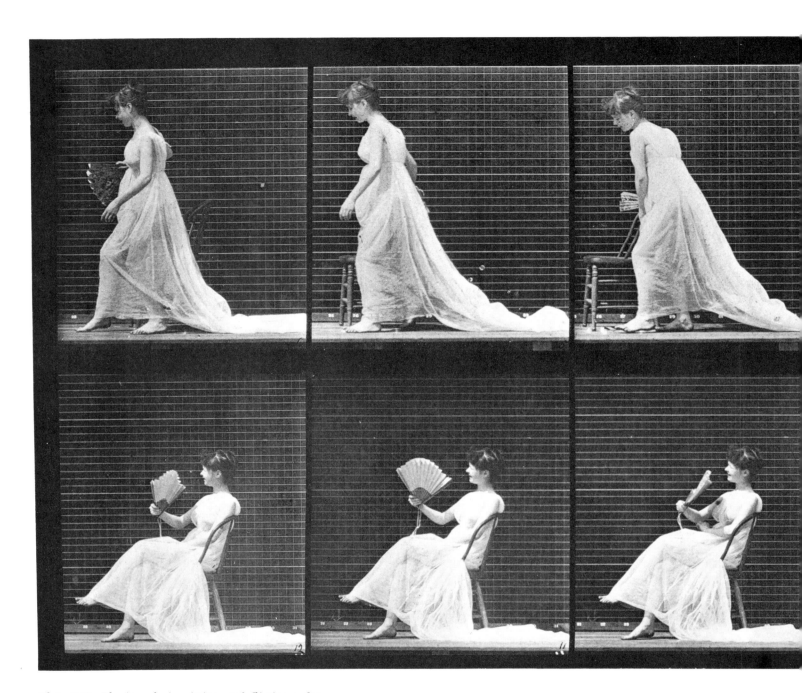

Plate 242. Placing chair, sitting and flirting a fan.

FEMALES (SEMI-NUDE) & CHILDREN

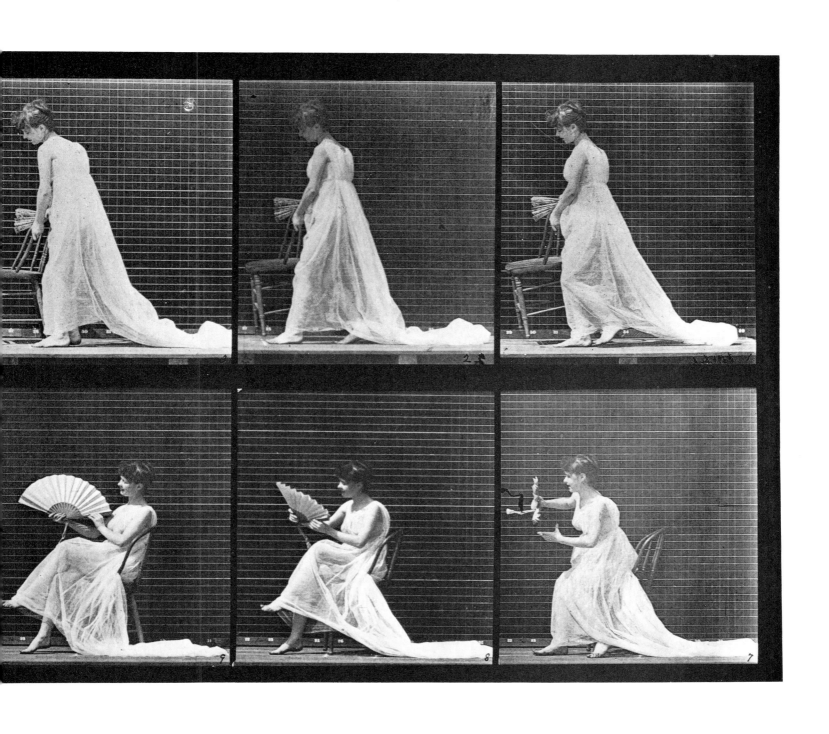

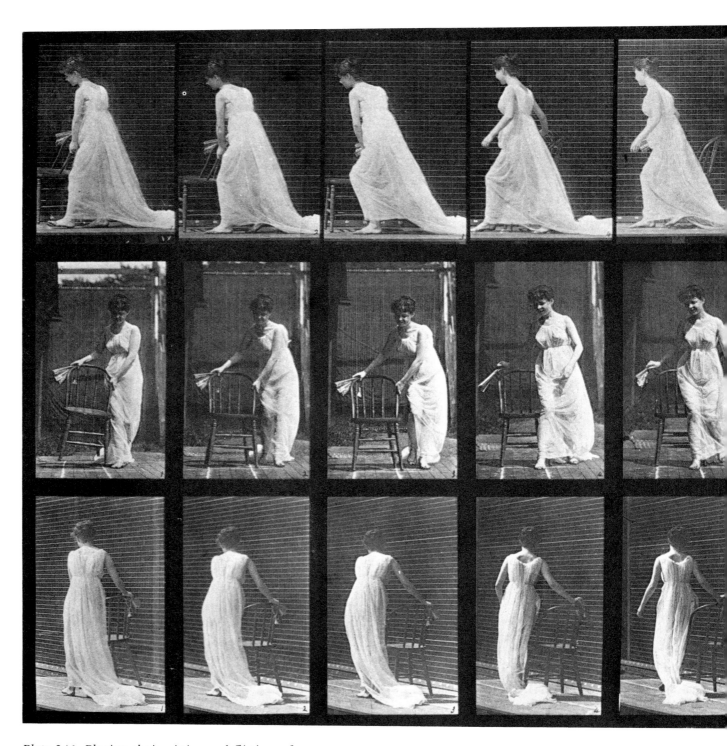

Plate 246. Placing chair, sitting and flirting a fan.

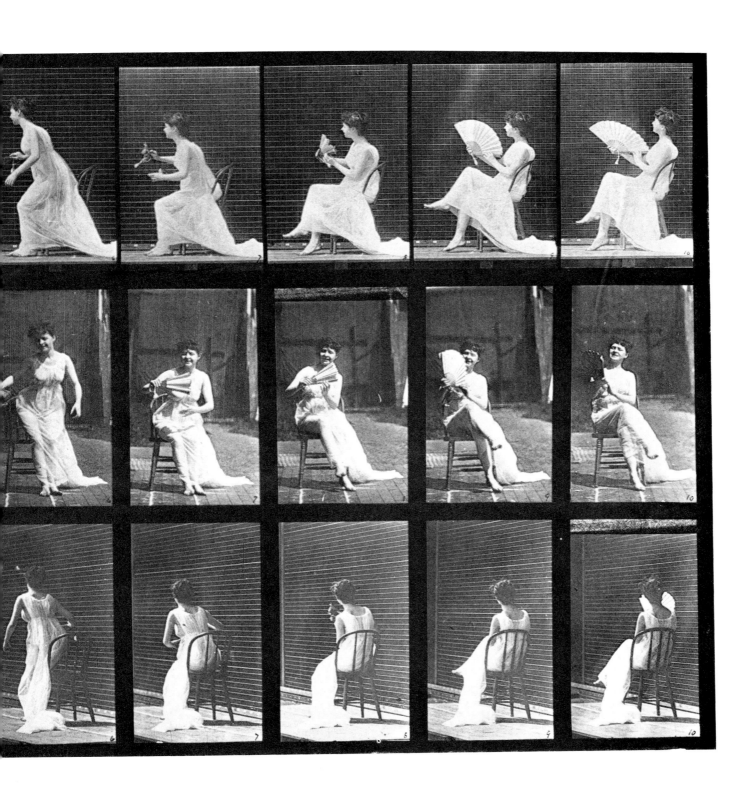

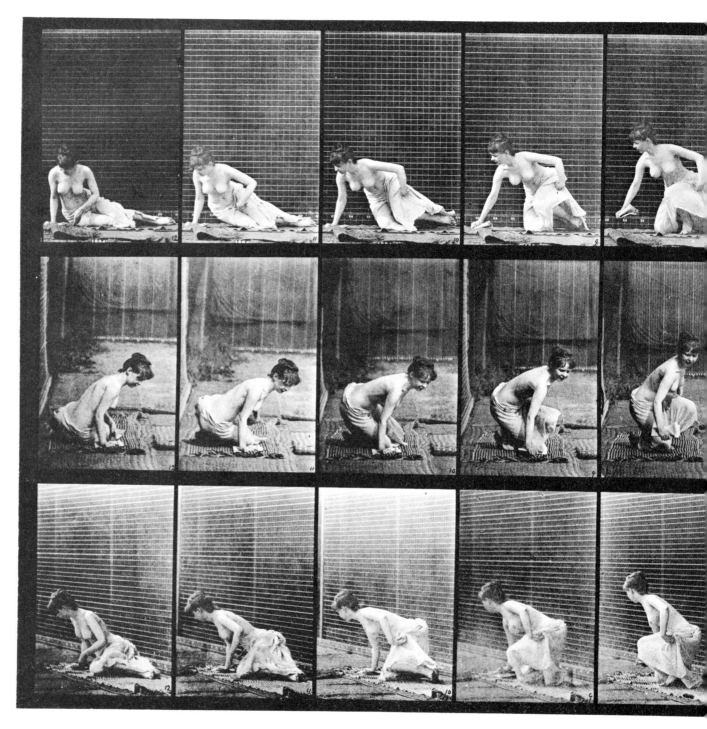

Plate 248. Sitting down on the ground.

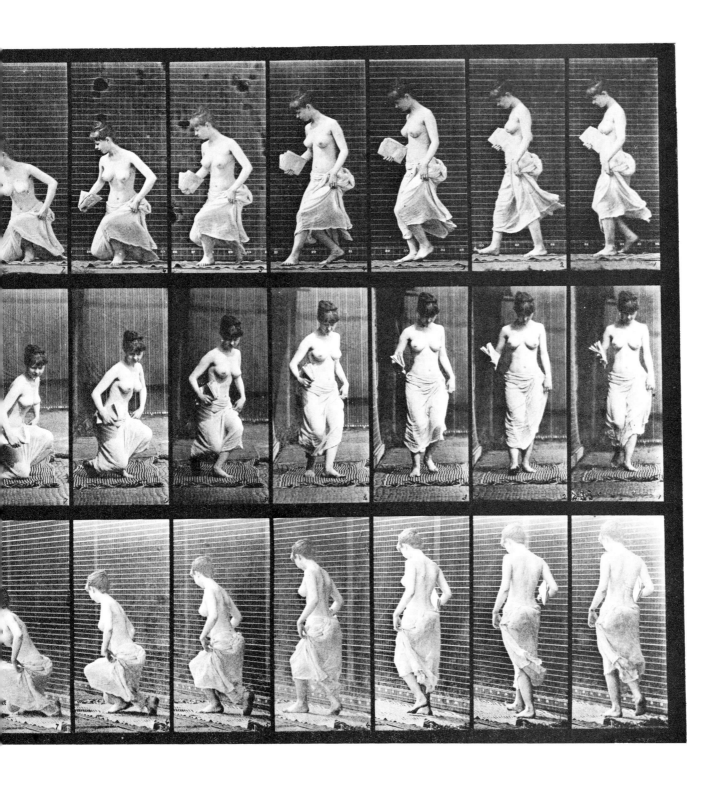

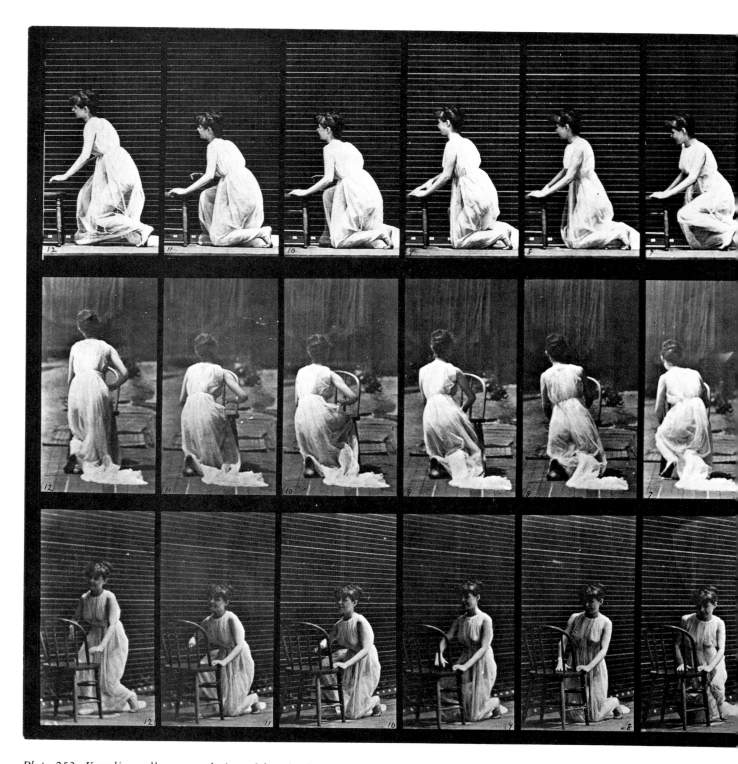

Plate 253. Kneeling; elbows on chair and hands clasped.

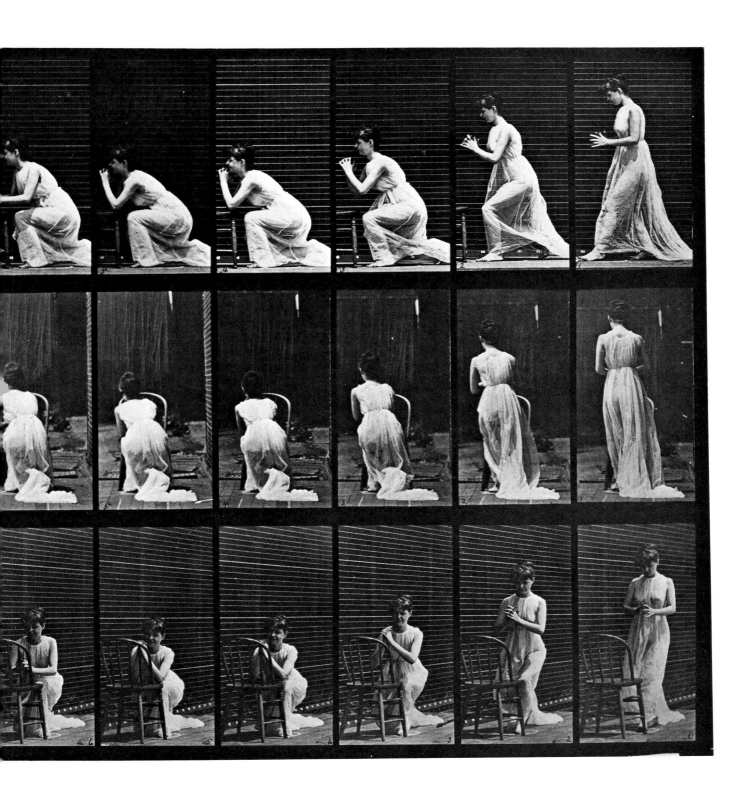

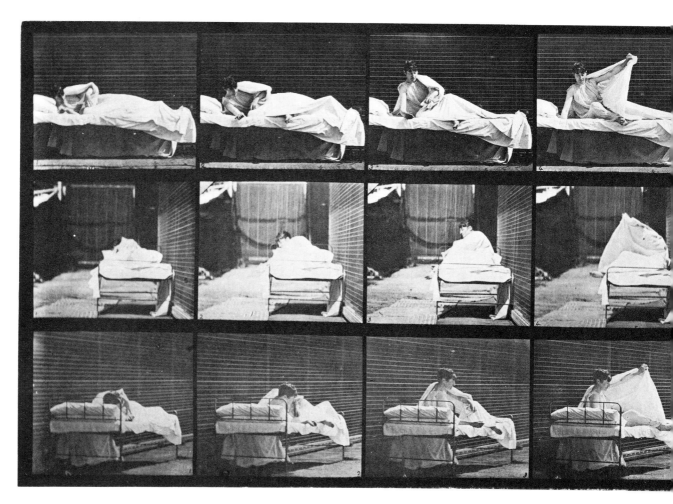

Plate 265. Getting out of bed.

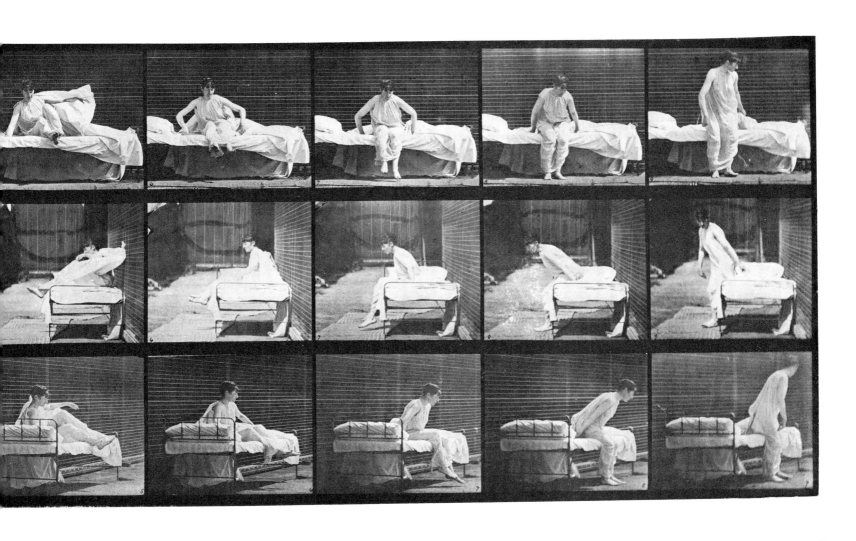

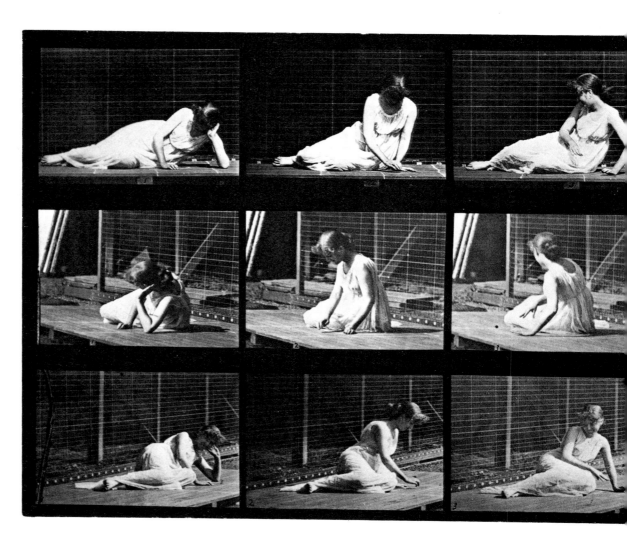

Plate 267. *Turning and changing position while on the ground.*

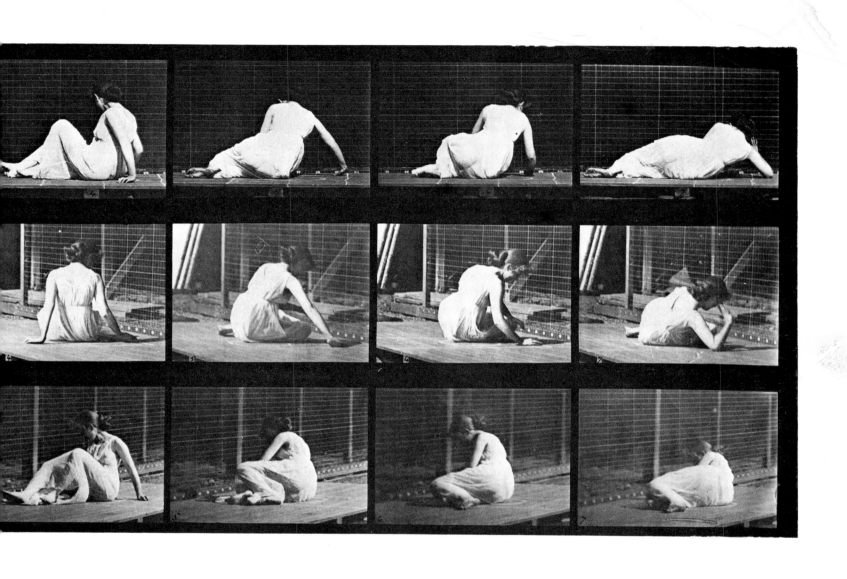

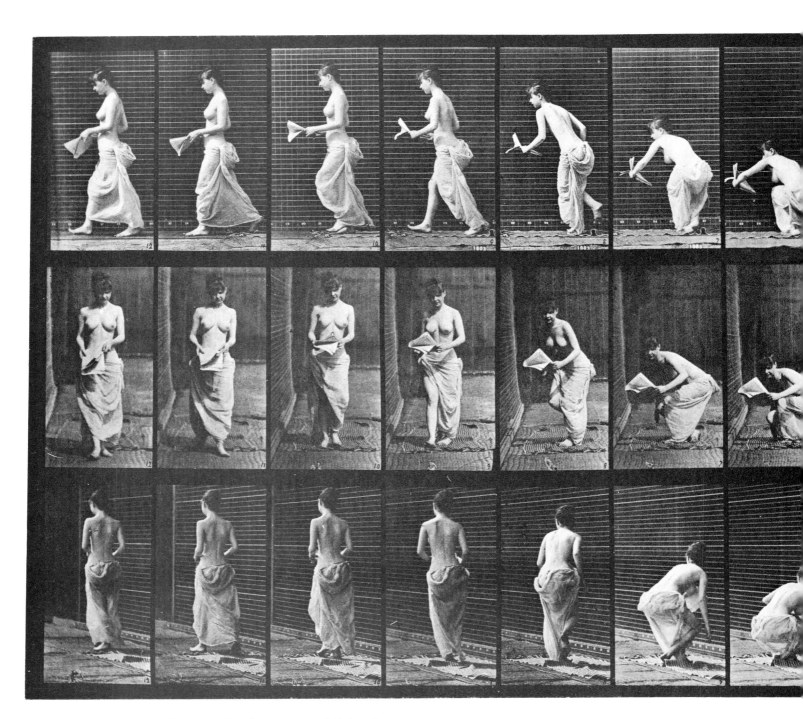

Plate 271. Arising from the ground with a paper in left hand.

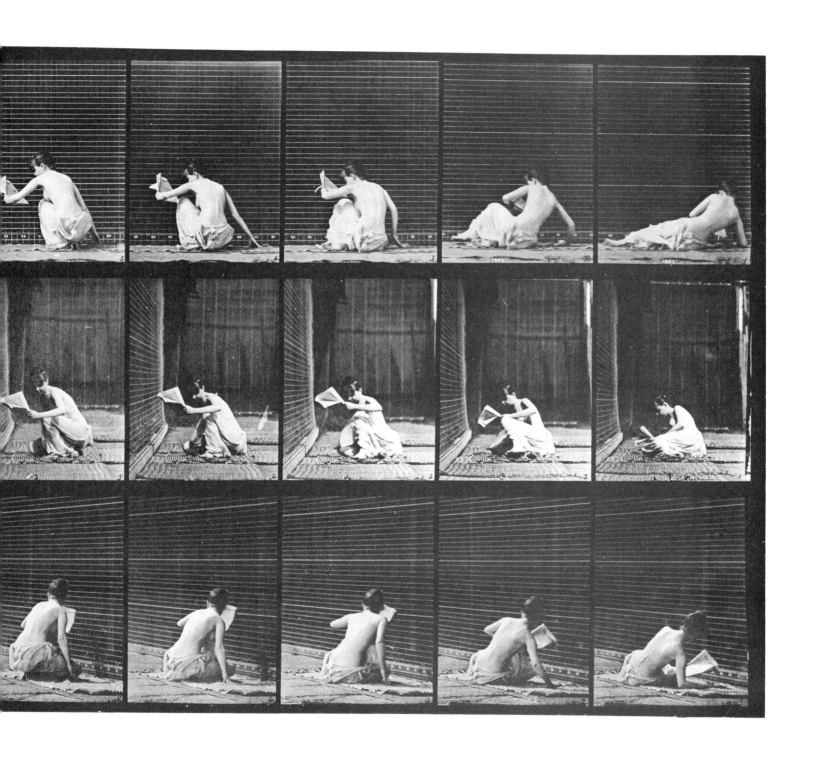

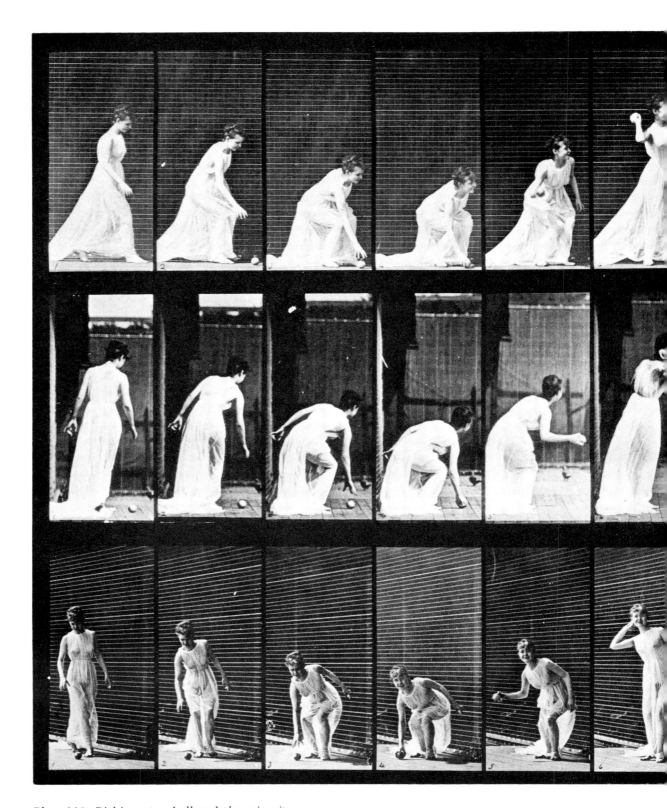

Plate 305. Picking up a ball and throwing it.

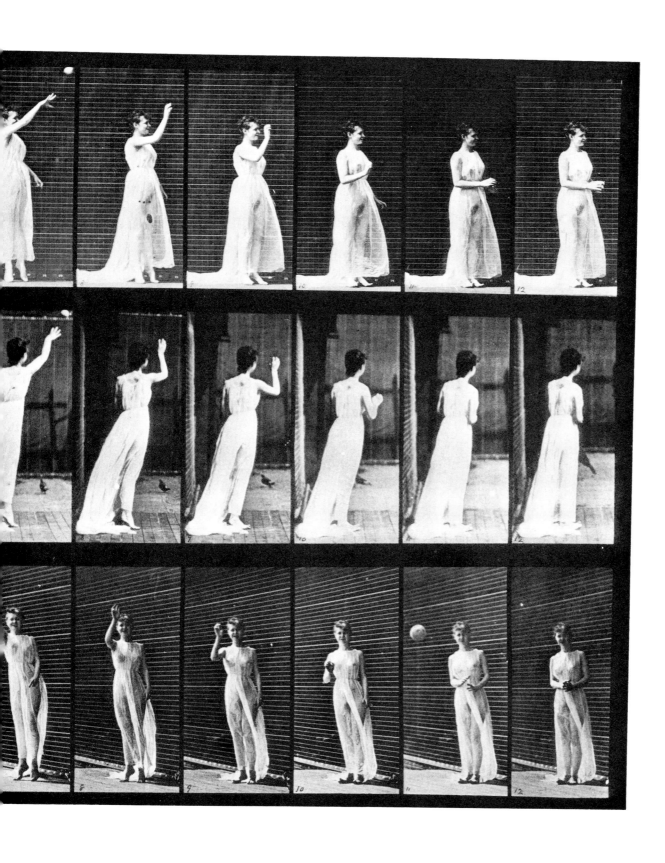

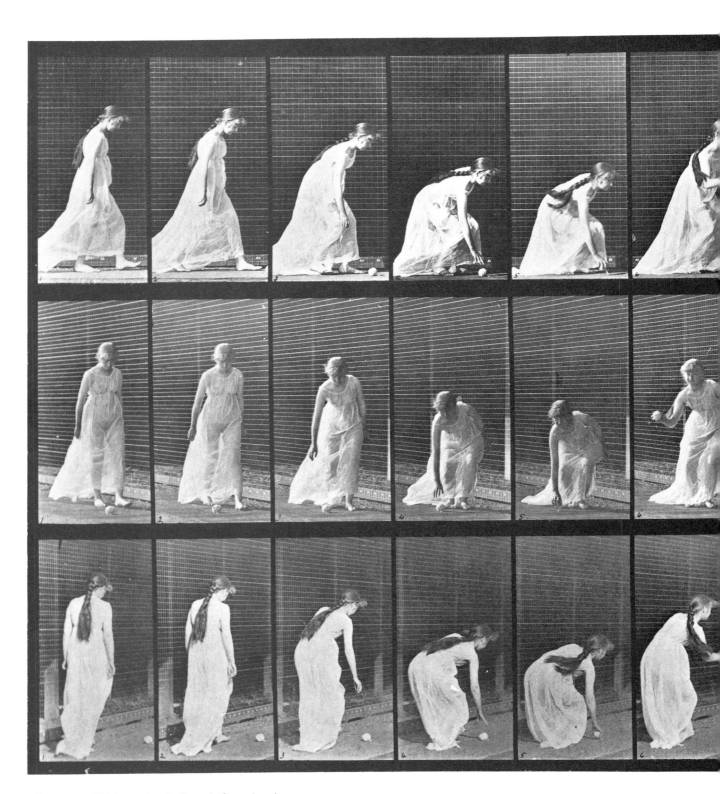

Plate 306. Picking up a ball and throwing it.

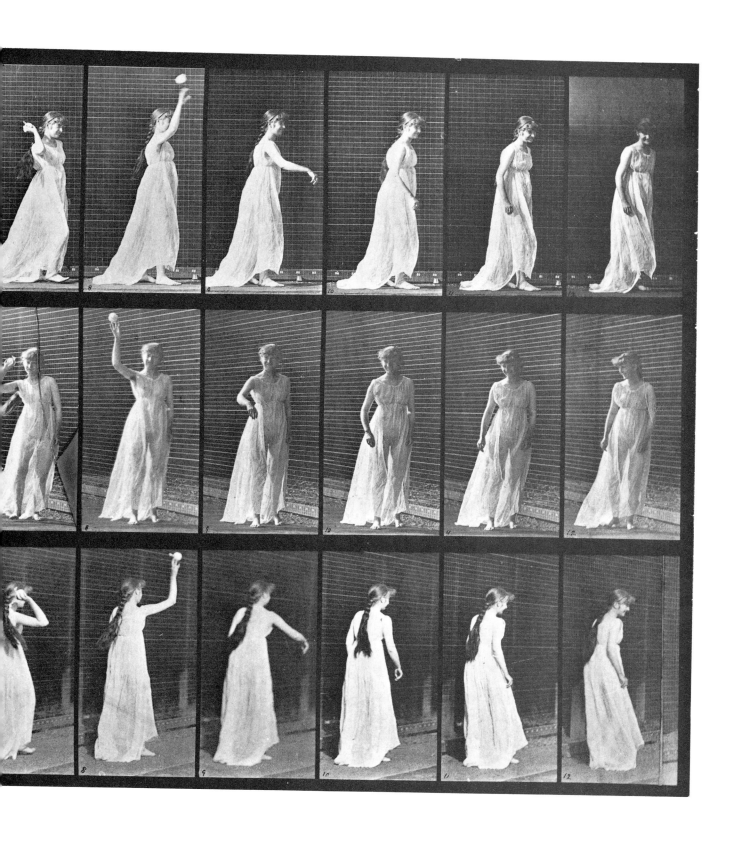

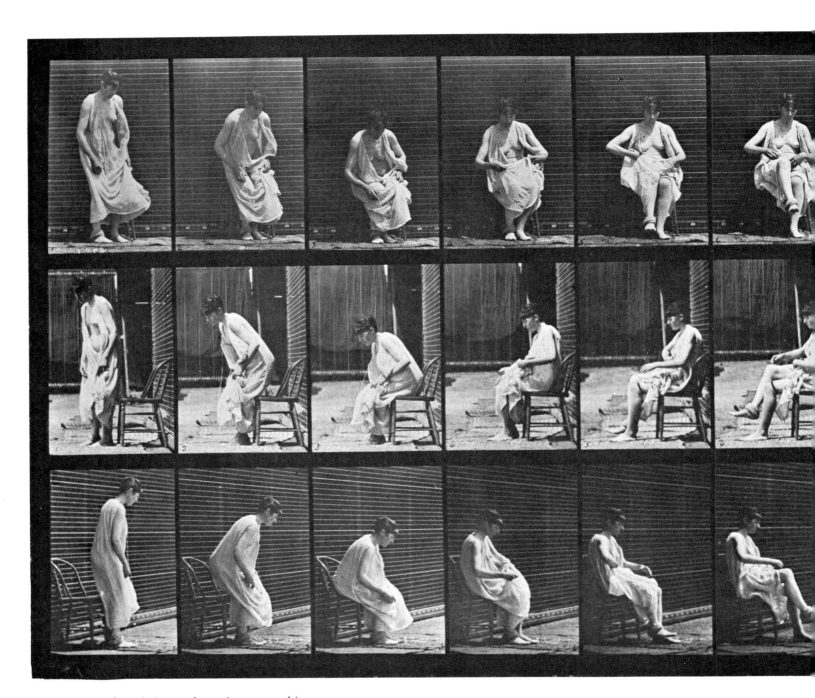

Plate 417. Toilet, sitting and putting on stockings.

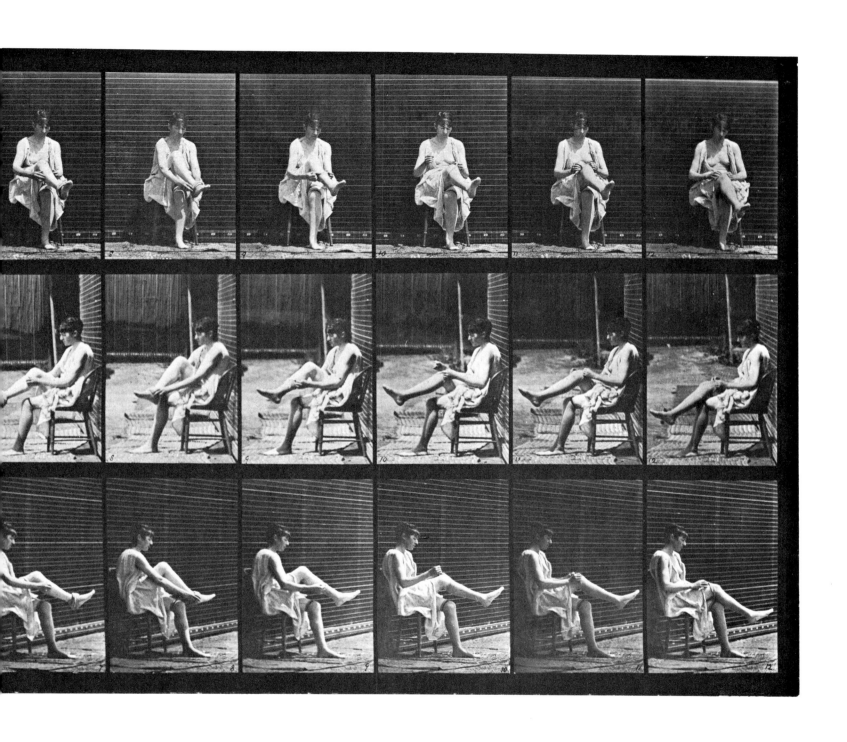

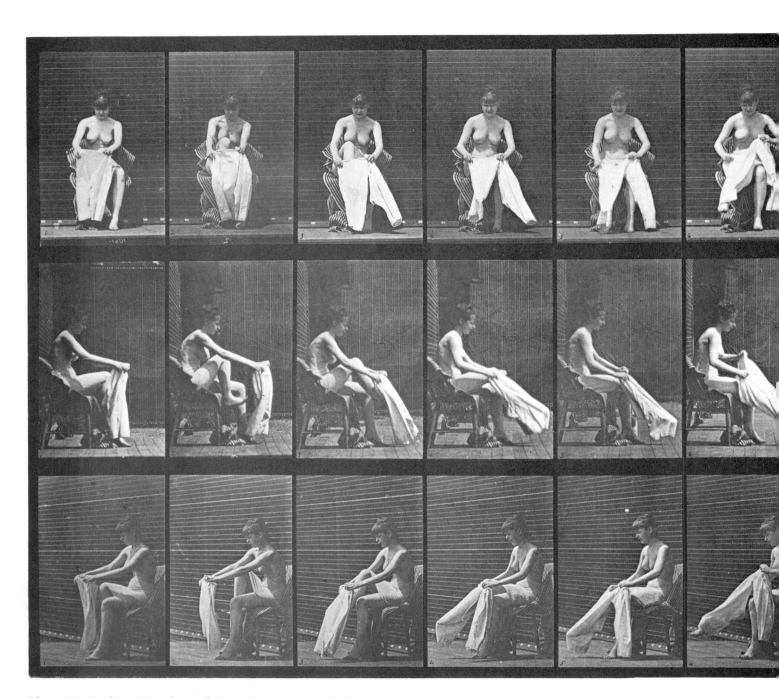

Plate 420. Toilet, rising from chair and putting on clothing.

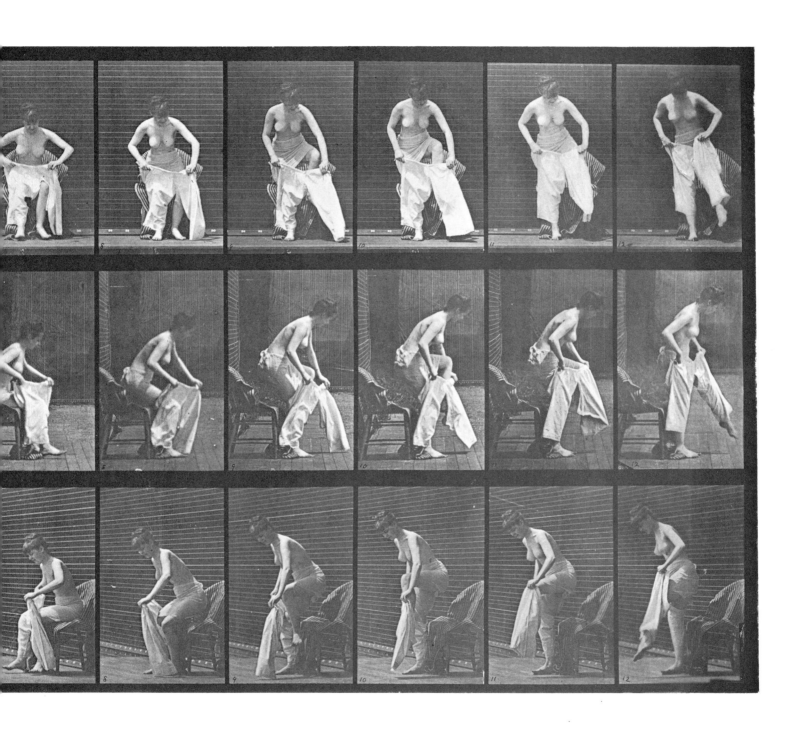

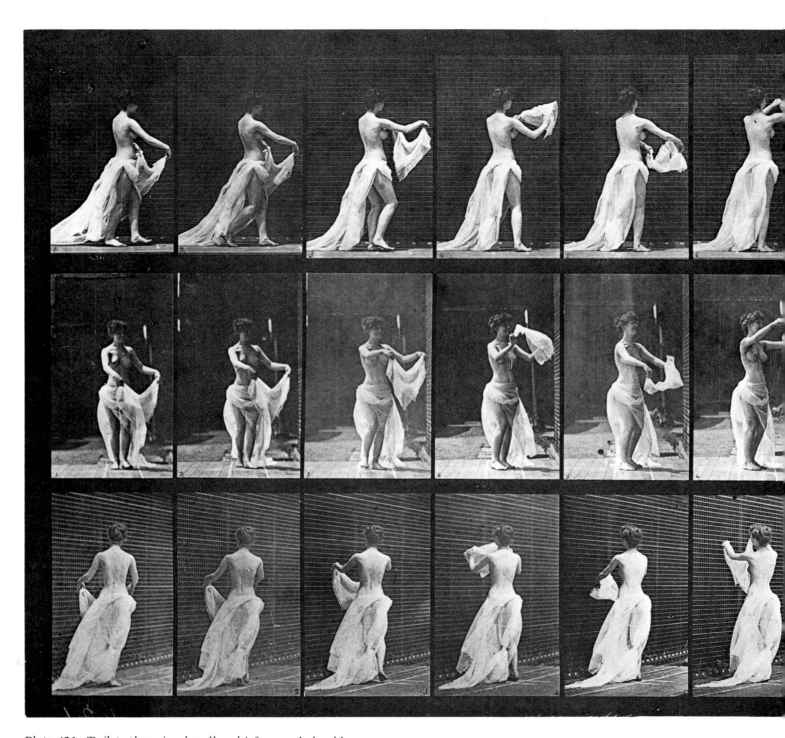

Plate 421. Toilet, throwing handkerchief around shoulders.

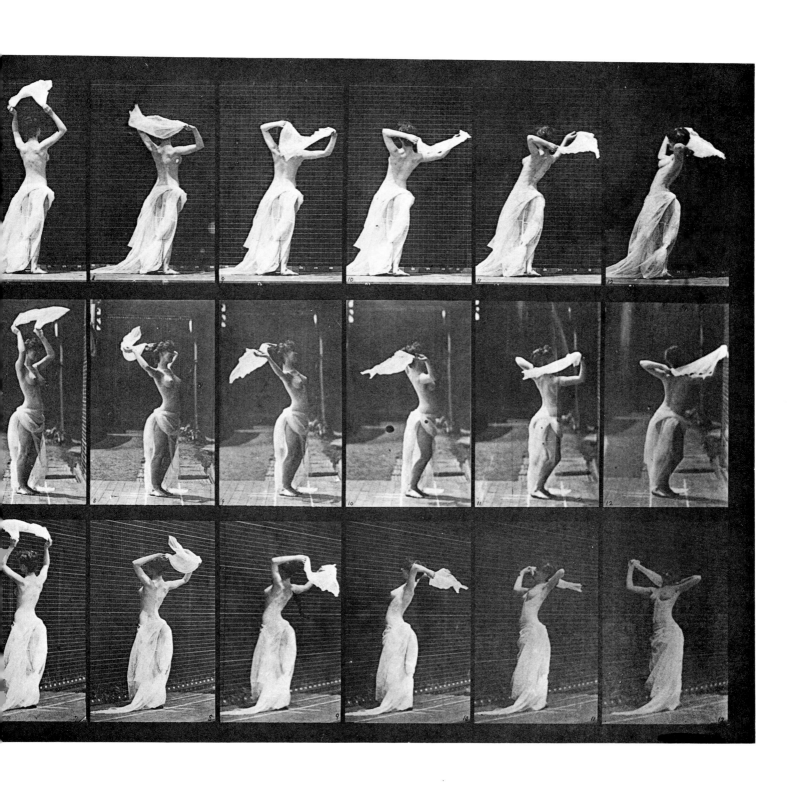

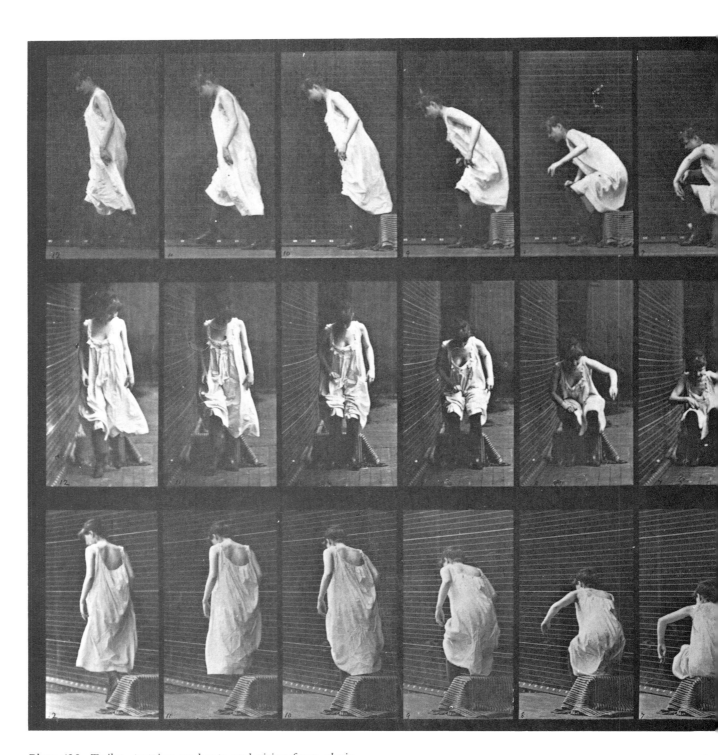

Plate 423. Toilet, putting on boots and rising from chair.

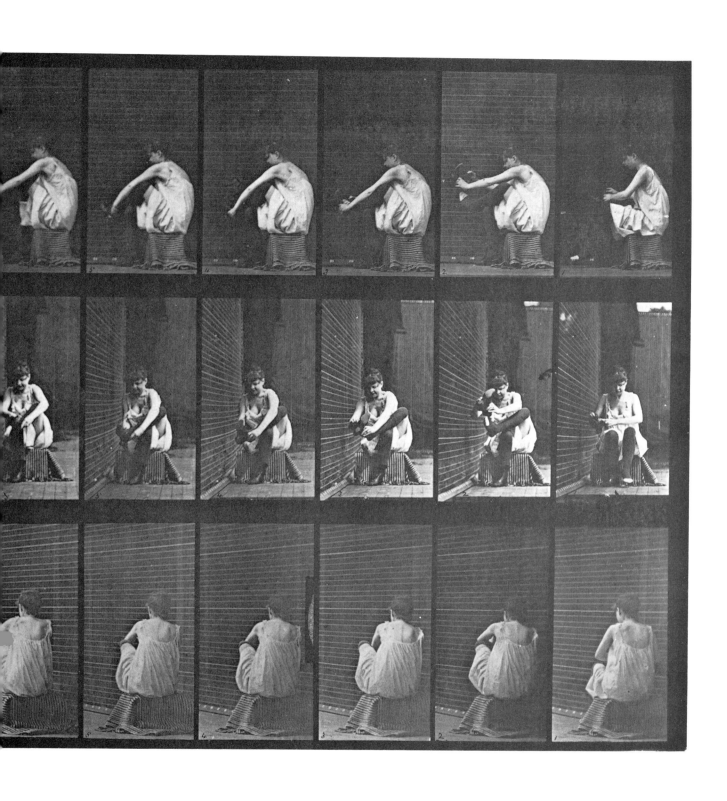

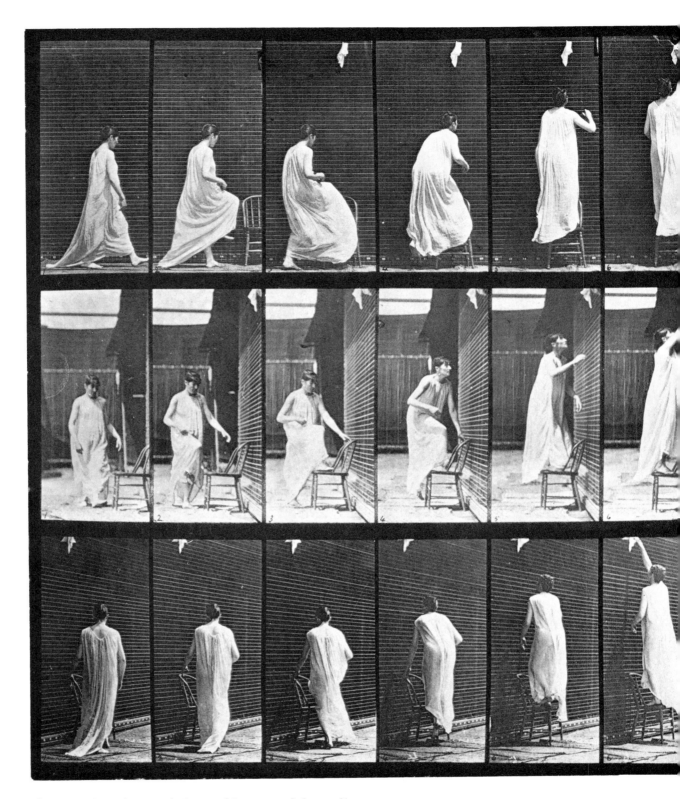

Plate 459. Stepping on chair, reaching up and descending.

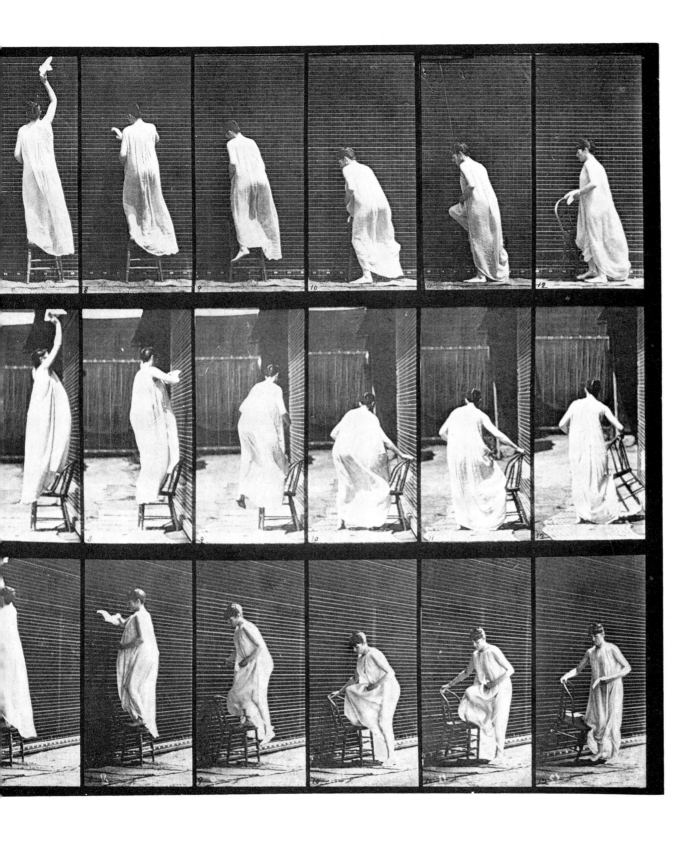

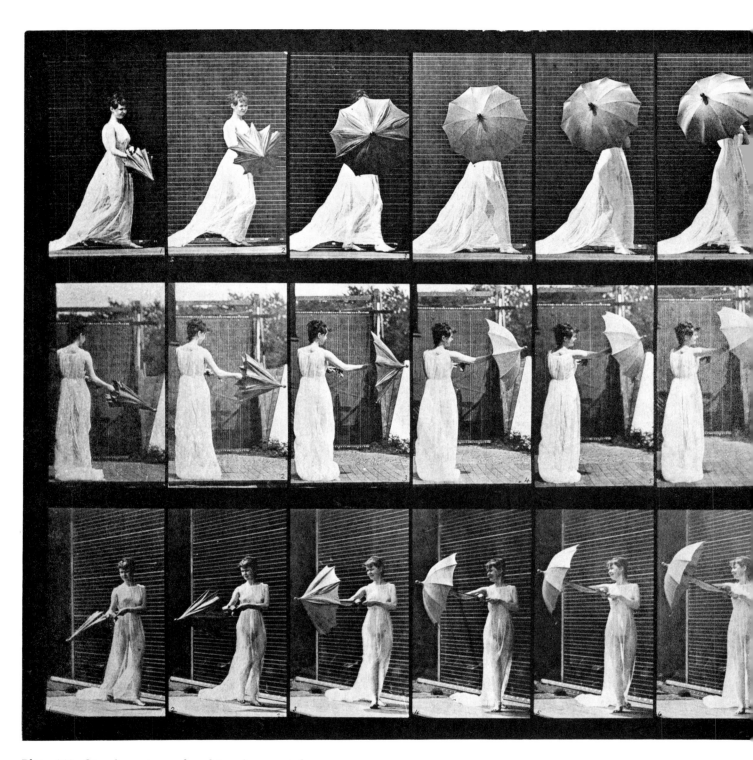

Plate 461. Opening a parasol and turning around.

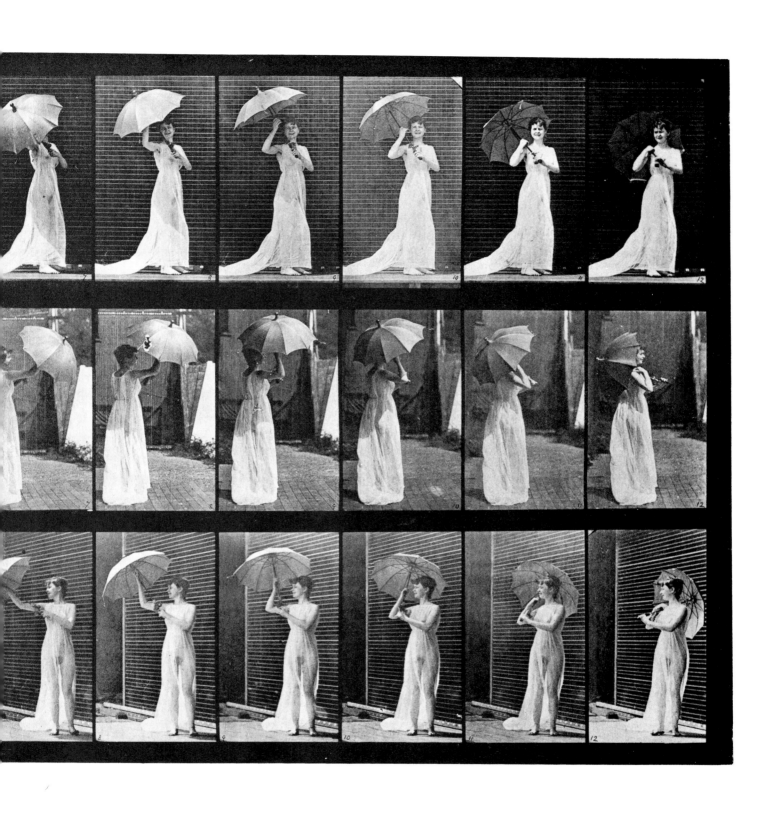

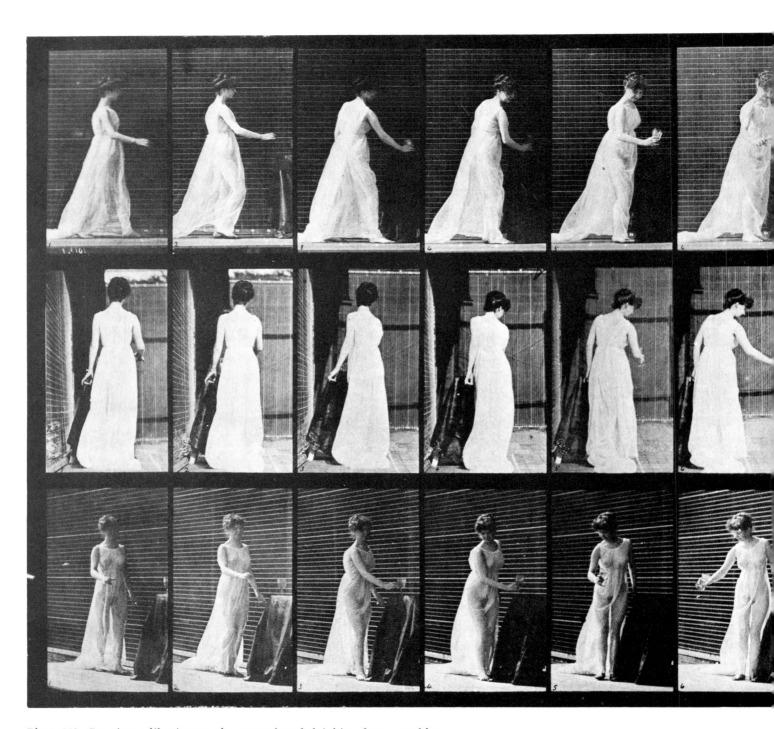

Plate 462. Pouring a libation on the ground and drinking from a goblet.

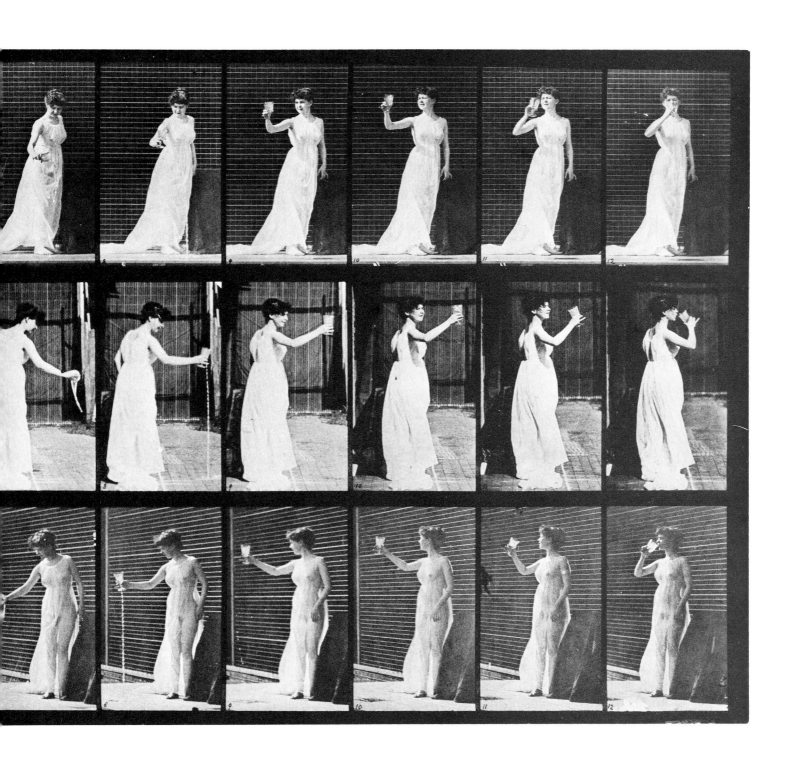

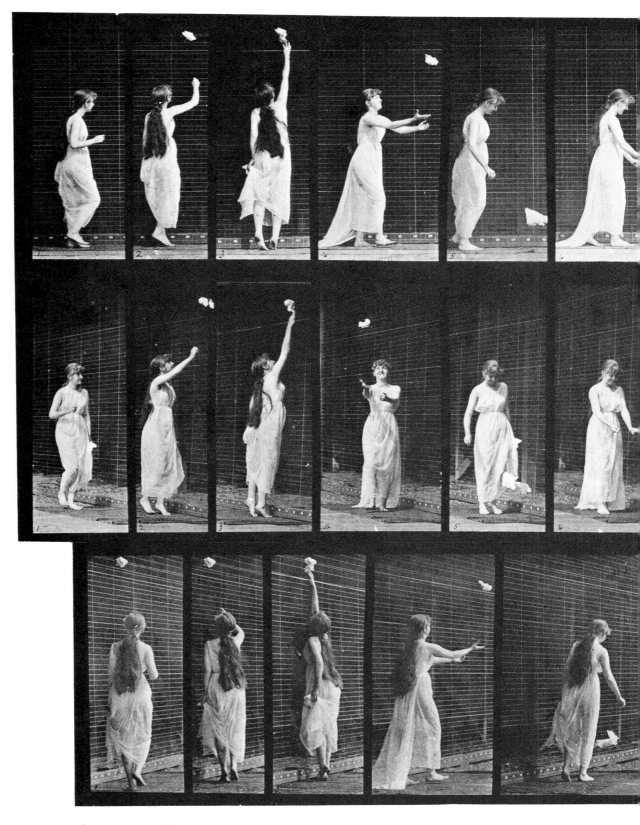

Plate 463. Reaching up, stooping and turning around.

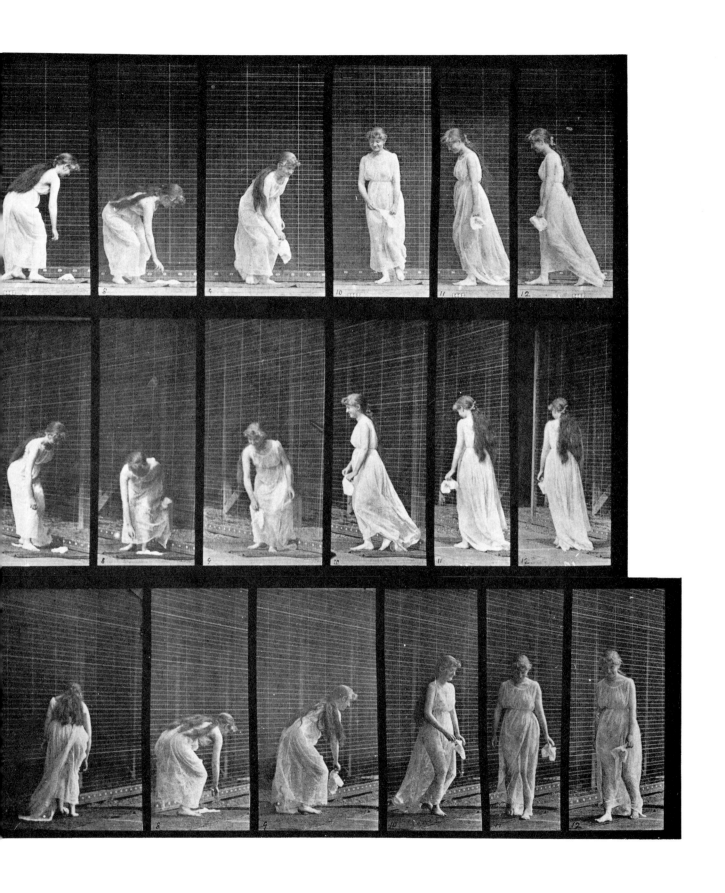

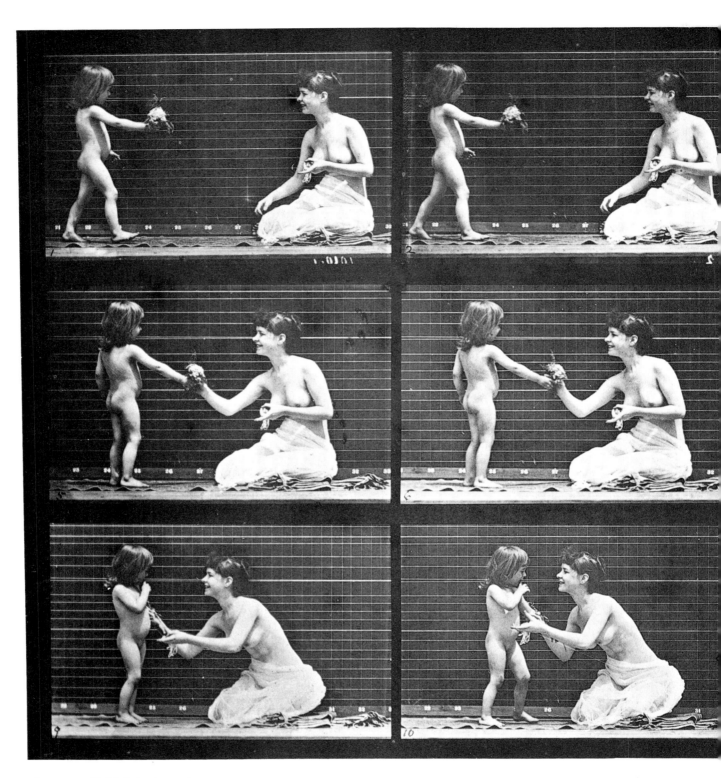

Plate 465. Child bringing a bouquet to a woman.

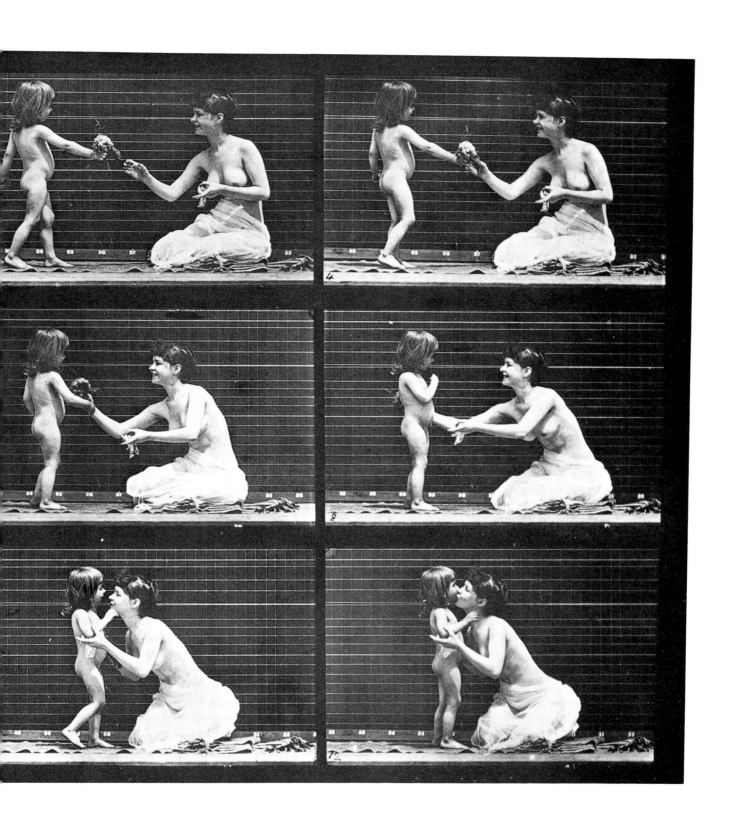

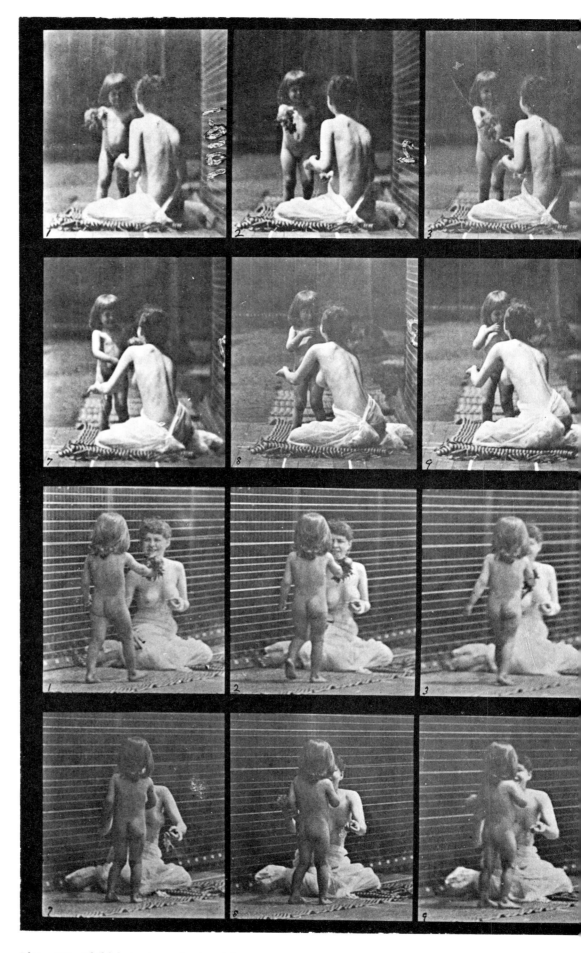

Plate 466. Child bringing a bouquet to a woman.

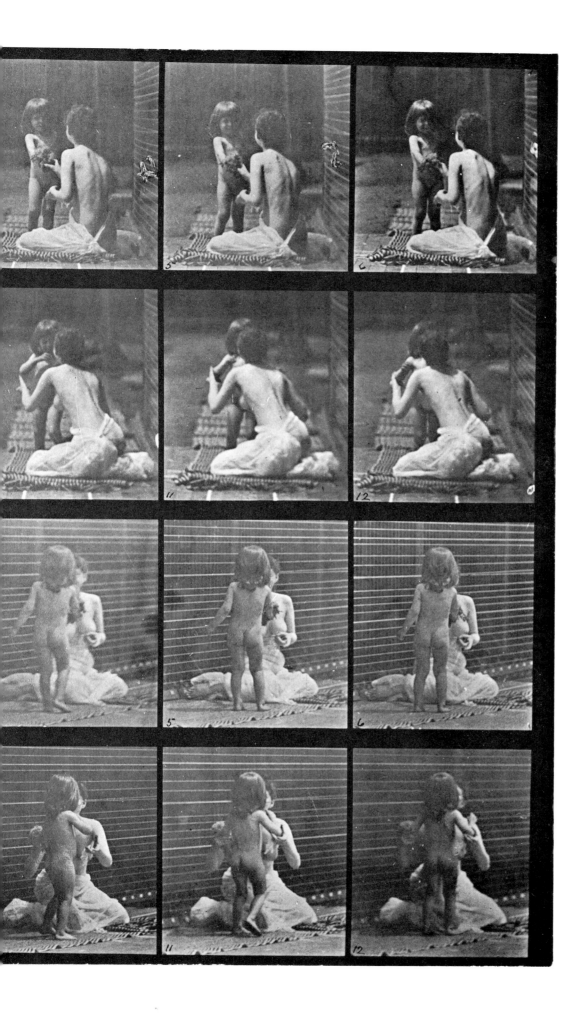

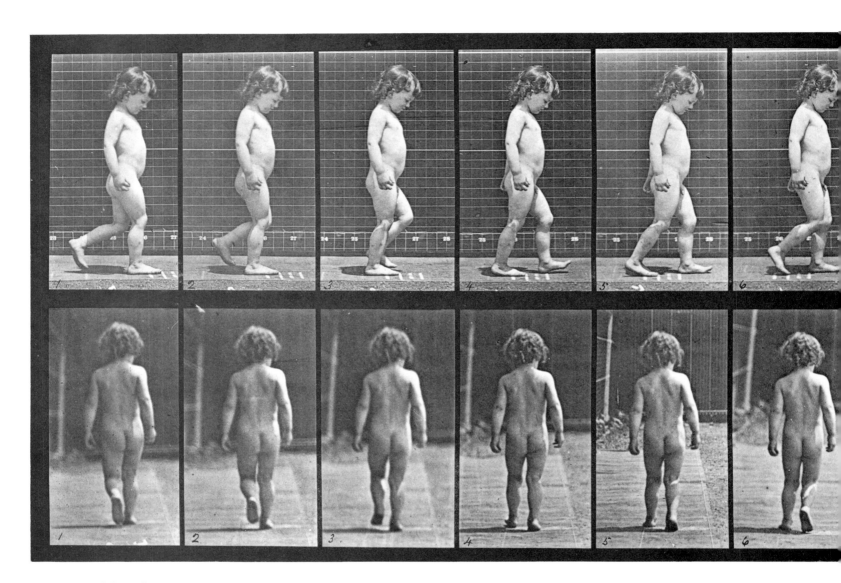

Plate 467. Child walking.

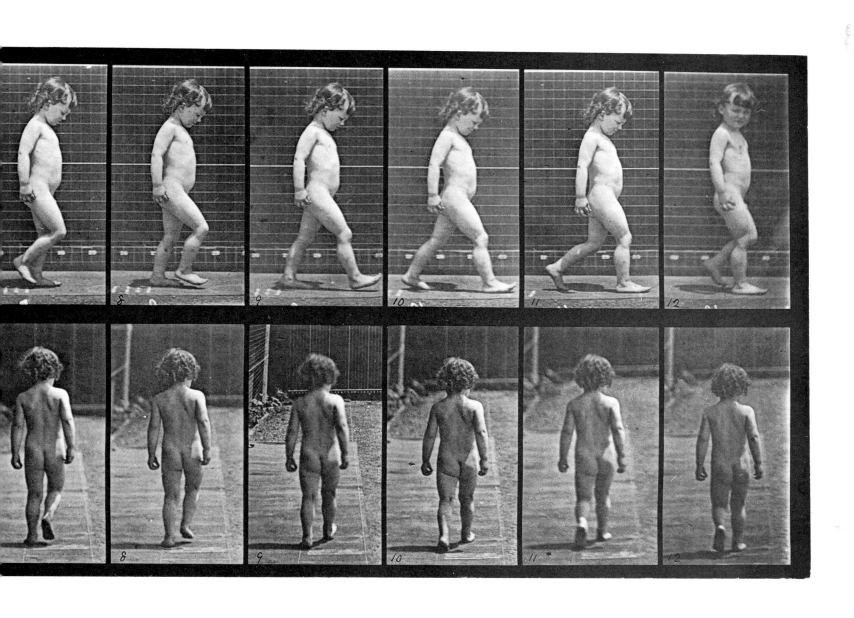

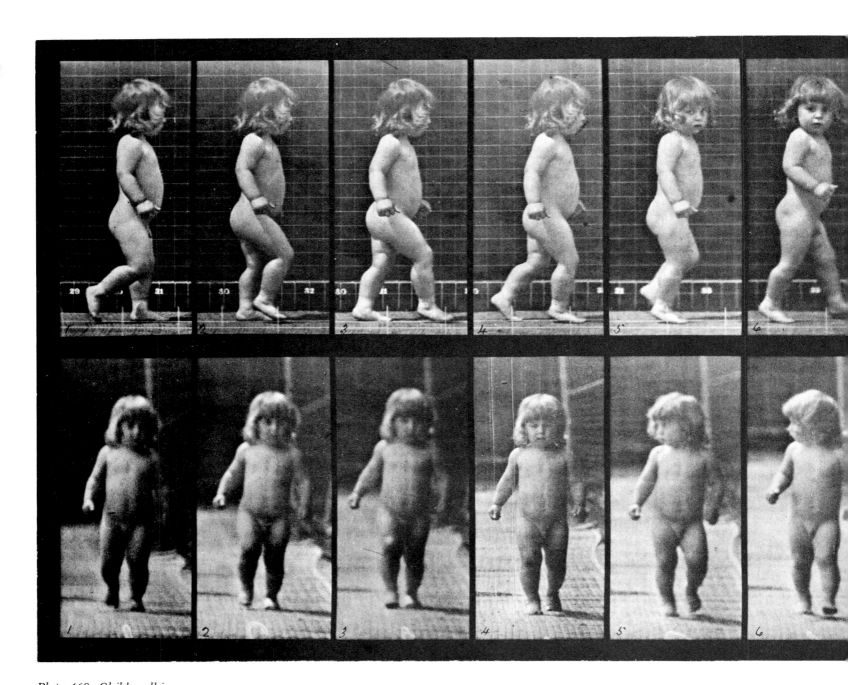

Plate 468. Child walking.

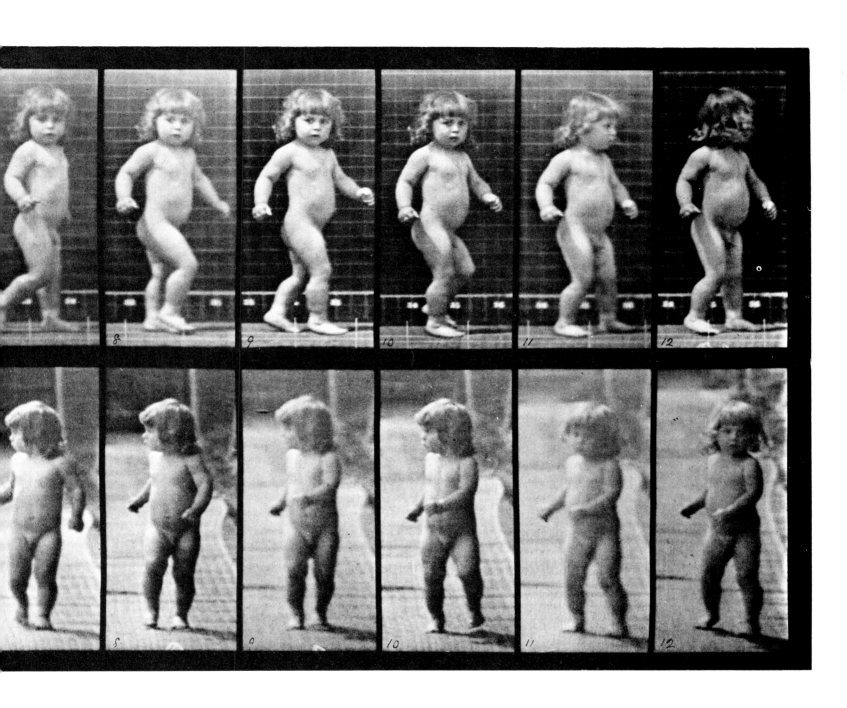

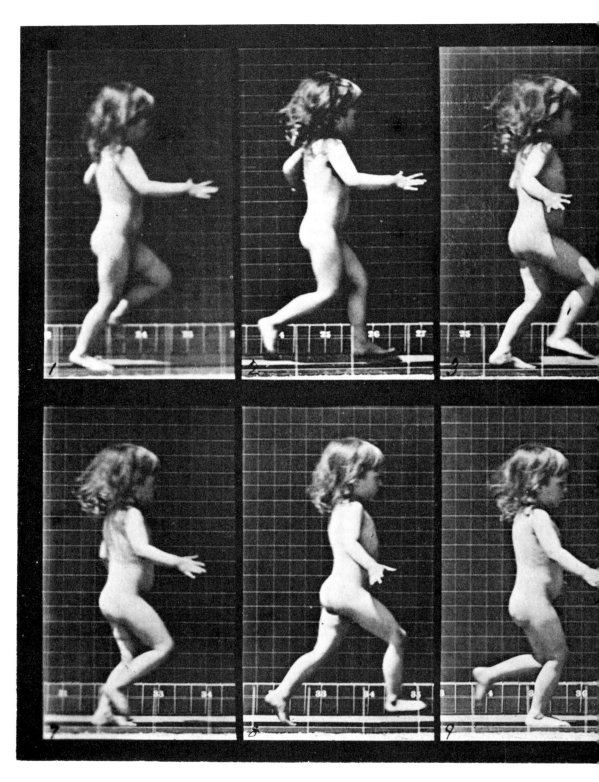

Plate 469. Child running.

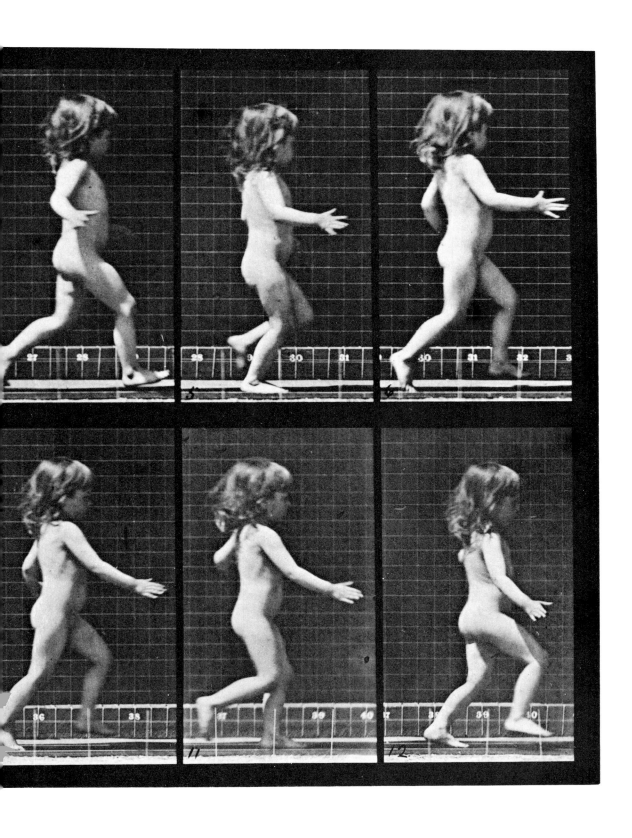

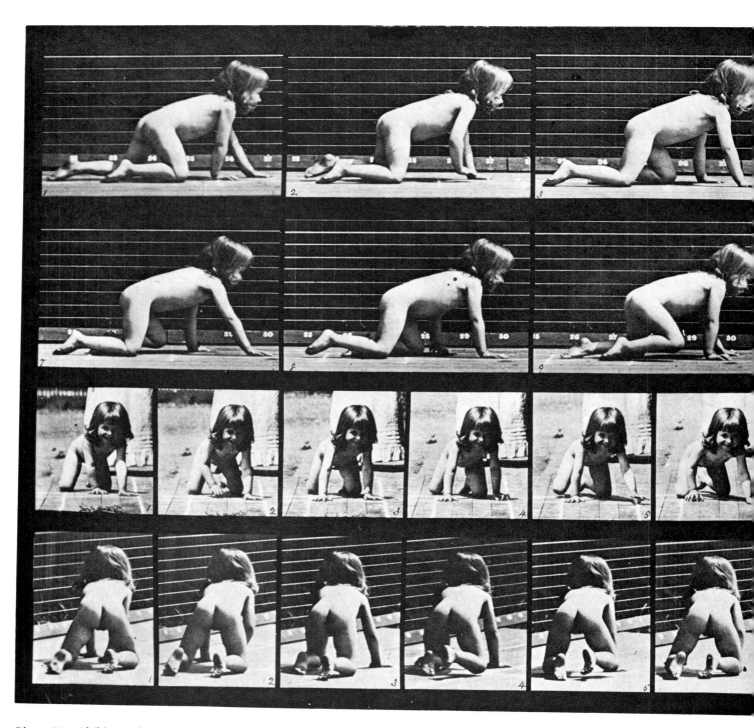

Plate 471. Child crawling on hands and knees.

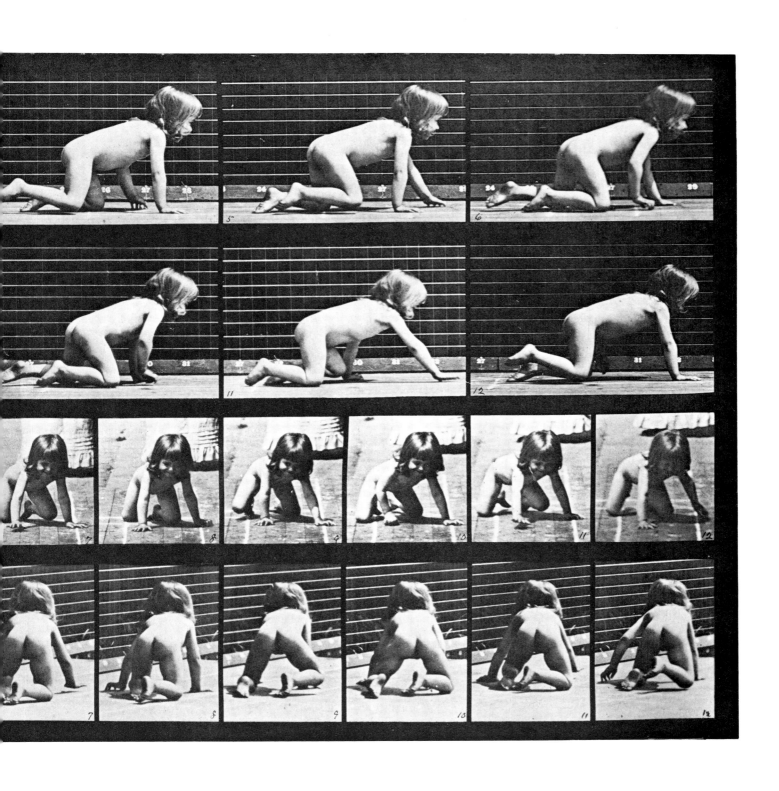

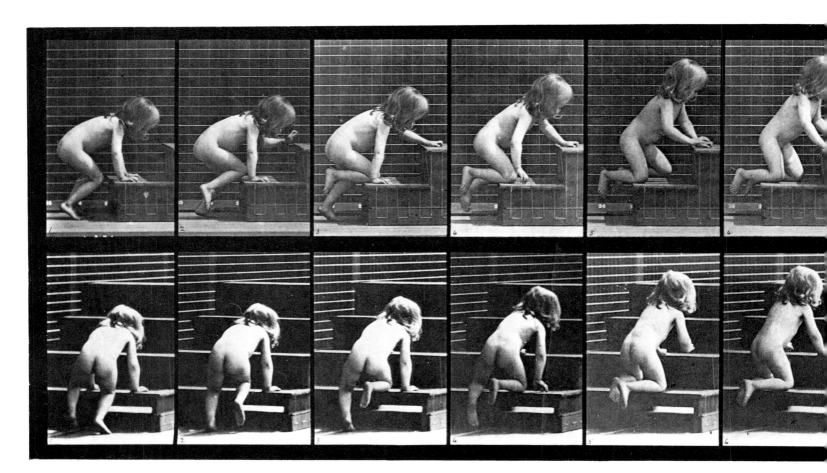

Plate 472. Child crawling up stairs.

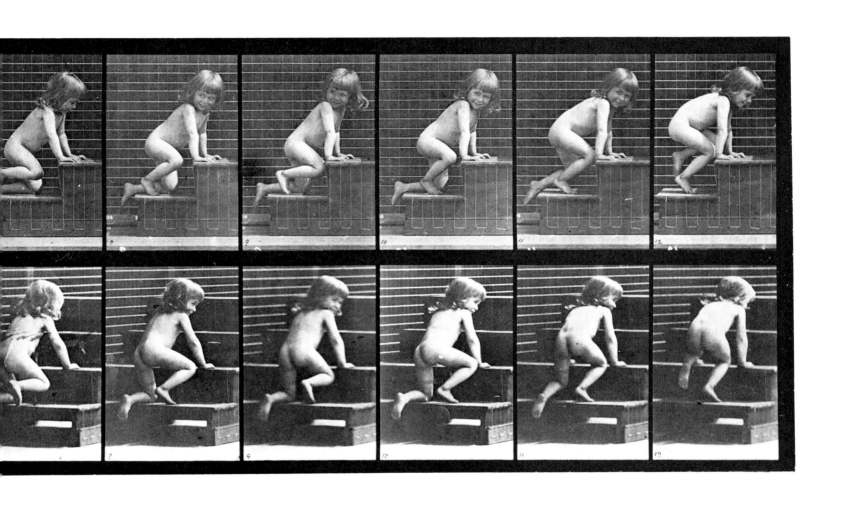

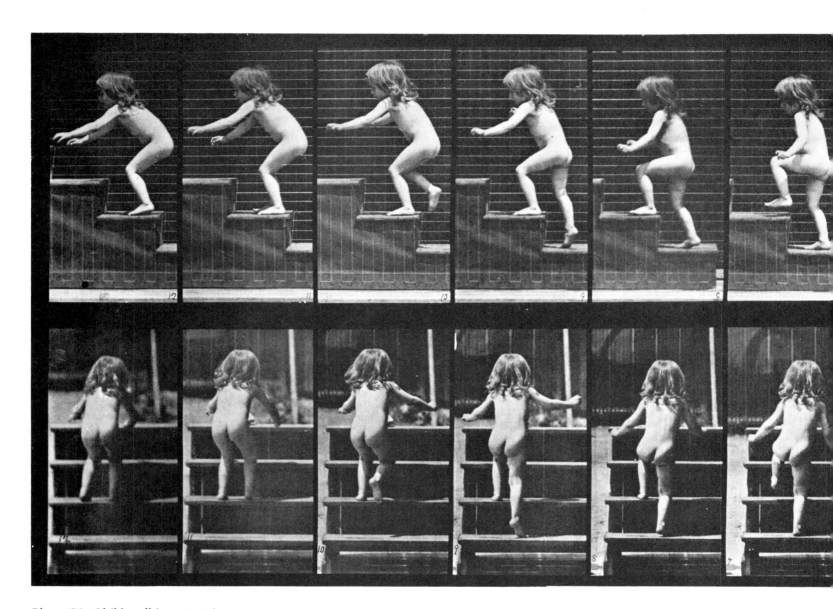

Plate 473. Child walking up stairs.

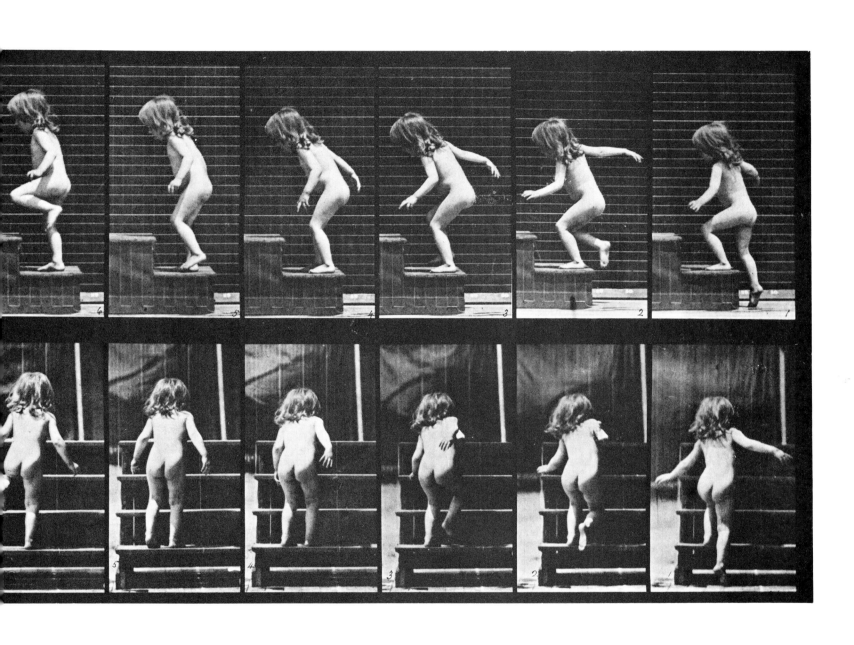

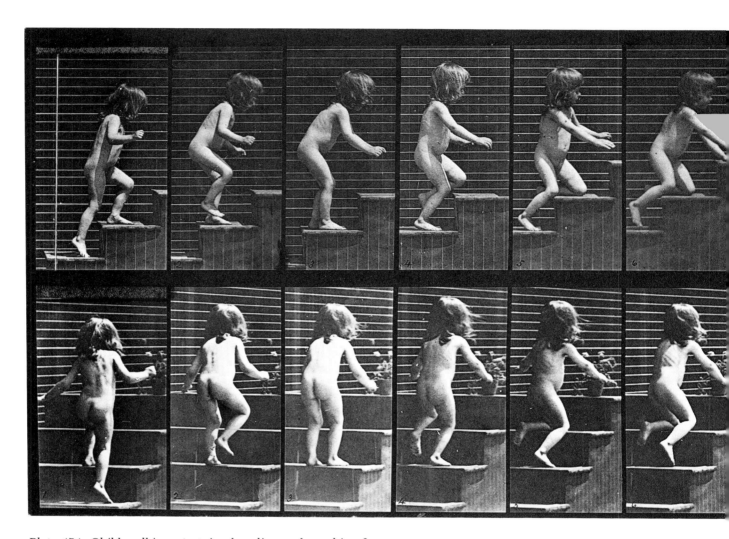

Plate 474. Child walking up stairs, kneeling and reaching for vase.

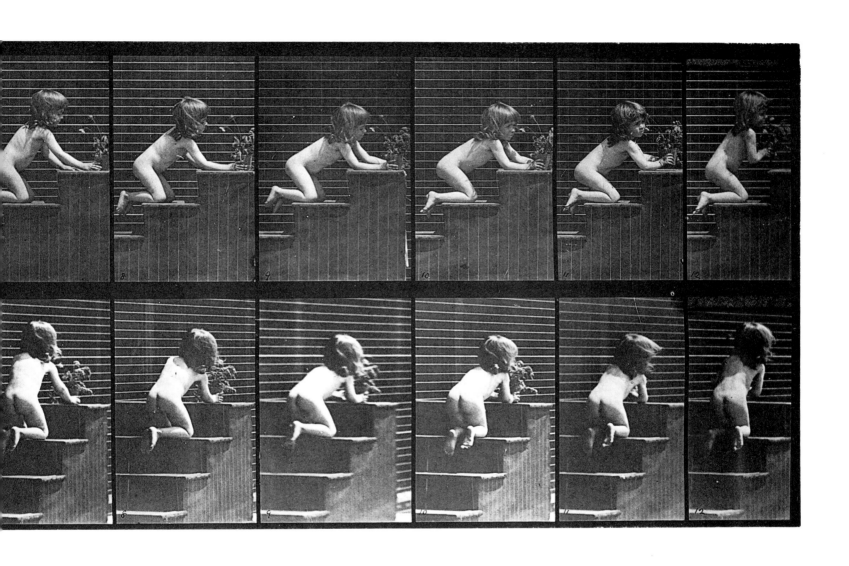

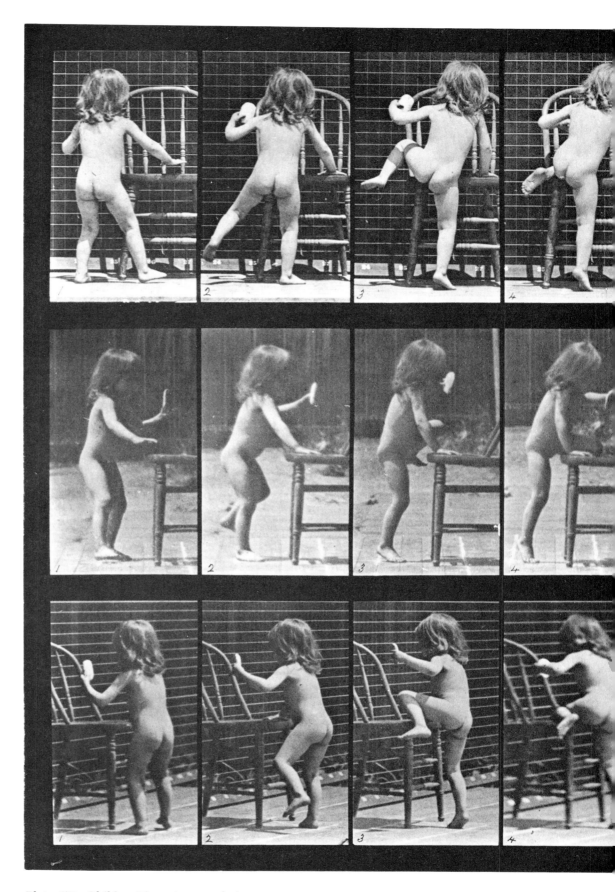

Plate 475. Child getting up on a chair.

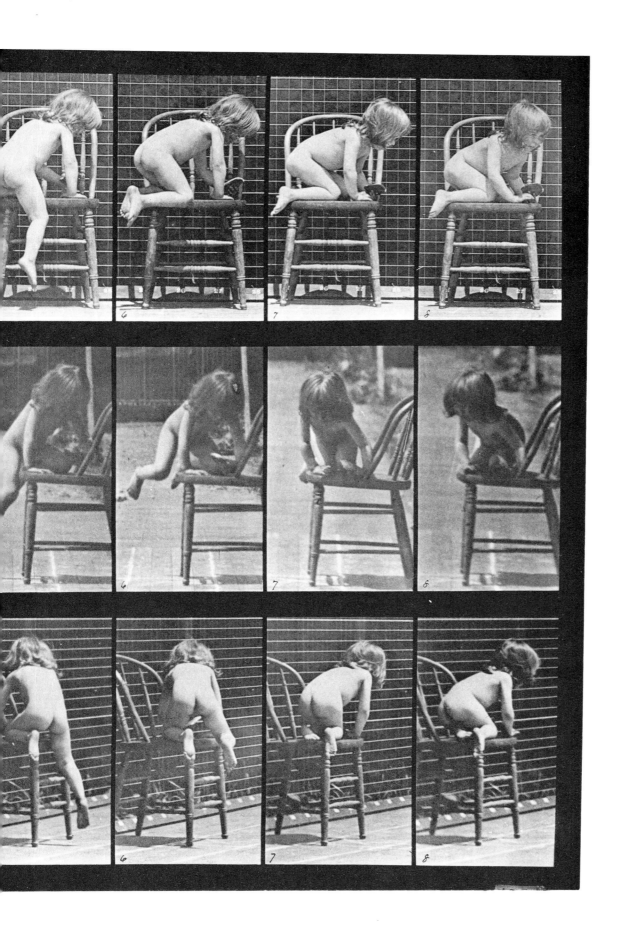

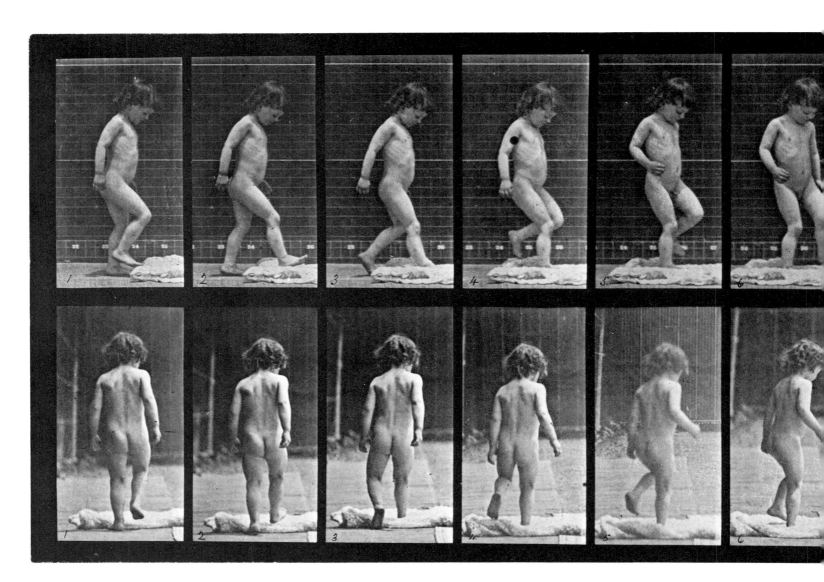

Plate 476. Child sitting down on the ground.

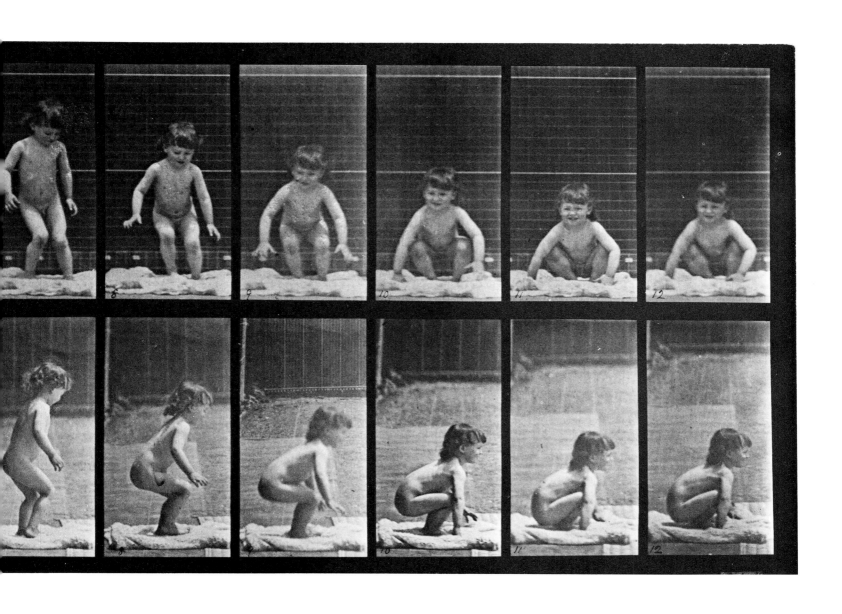

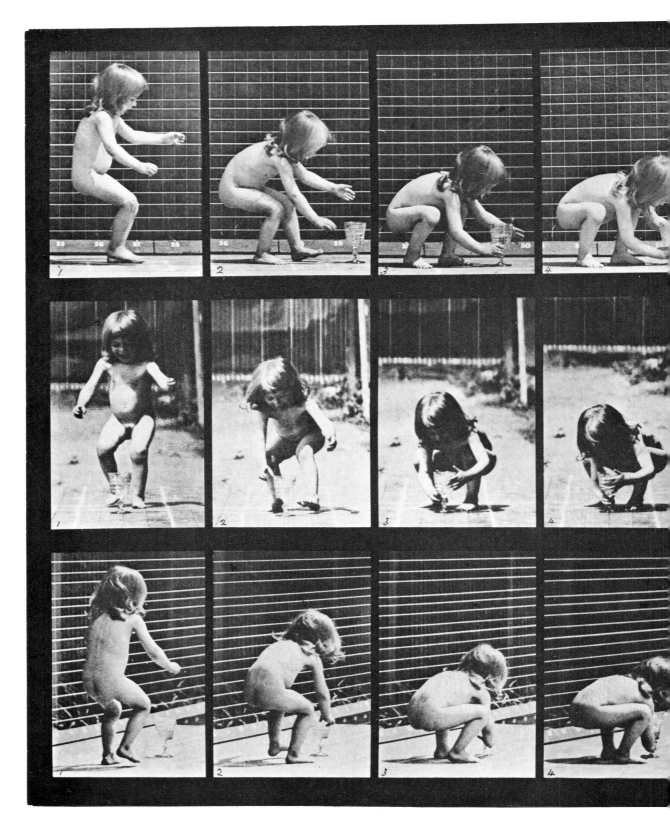

Plate 477. Child stooping, lifting a goblet and drinking.

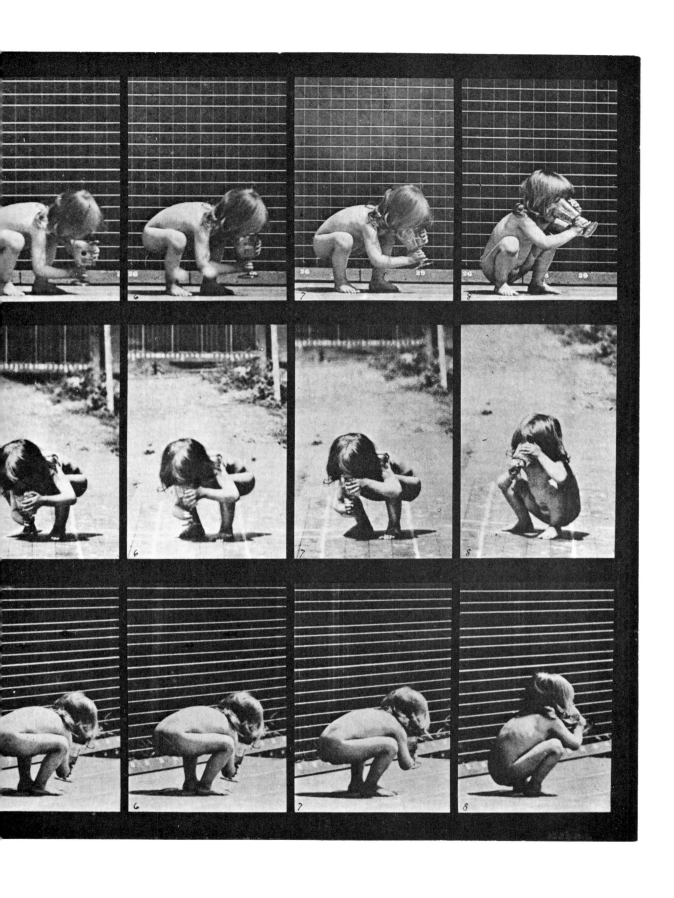

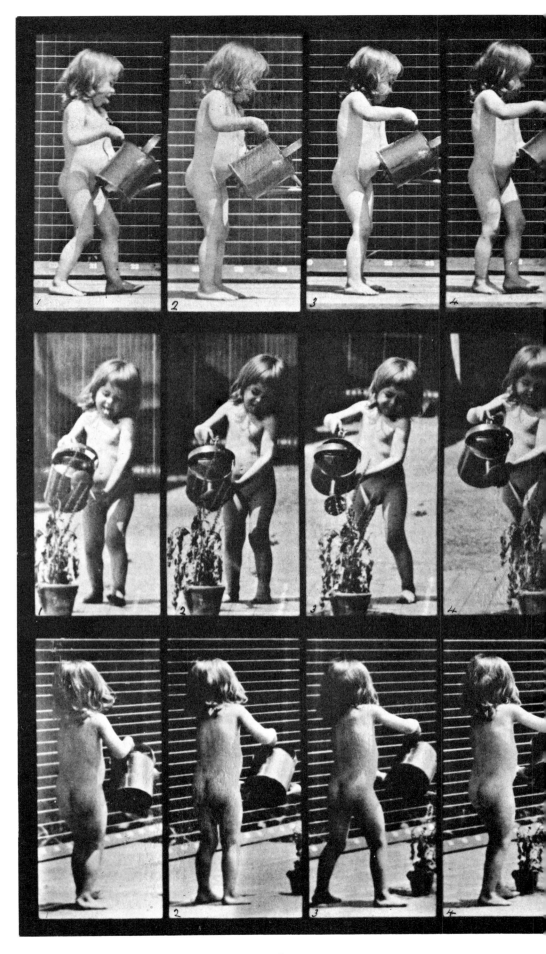

Plate 478. Child sprinkling water over some flowers.

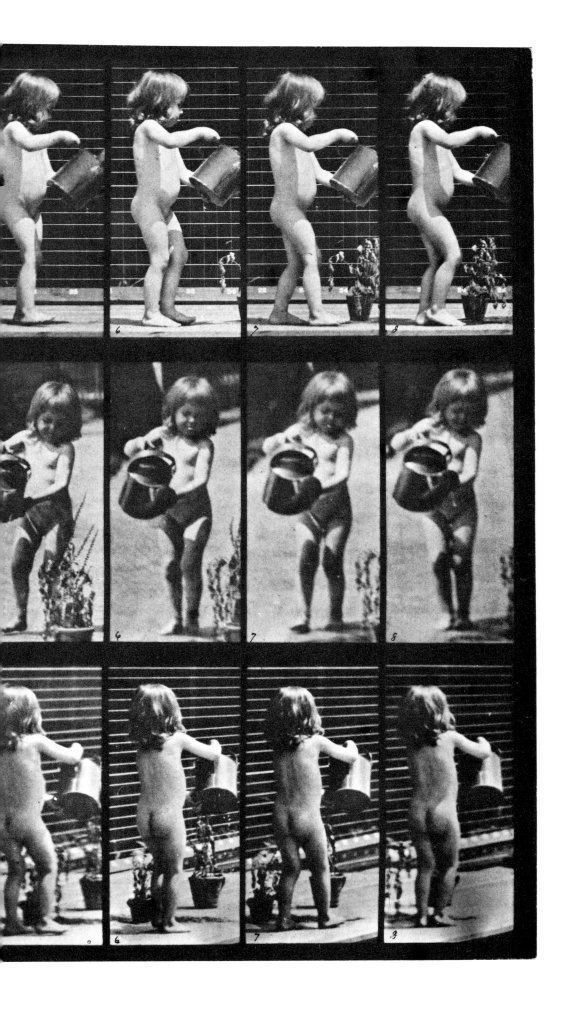

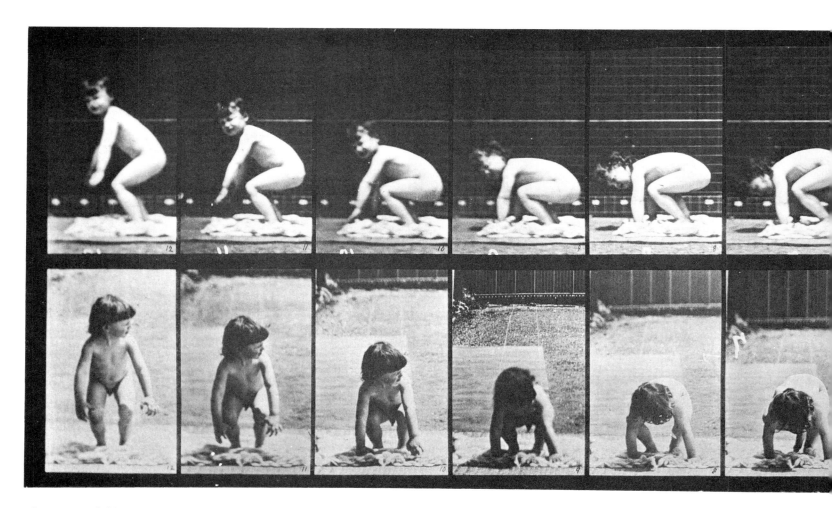

Plate 479. Child getting up from the ground.

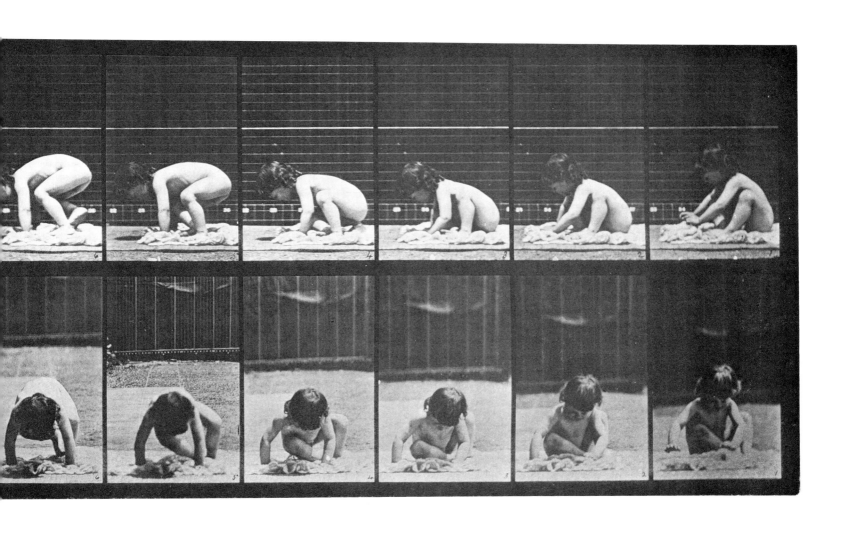

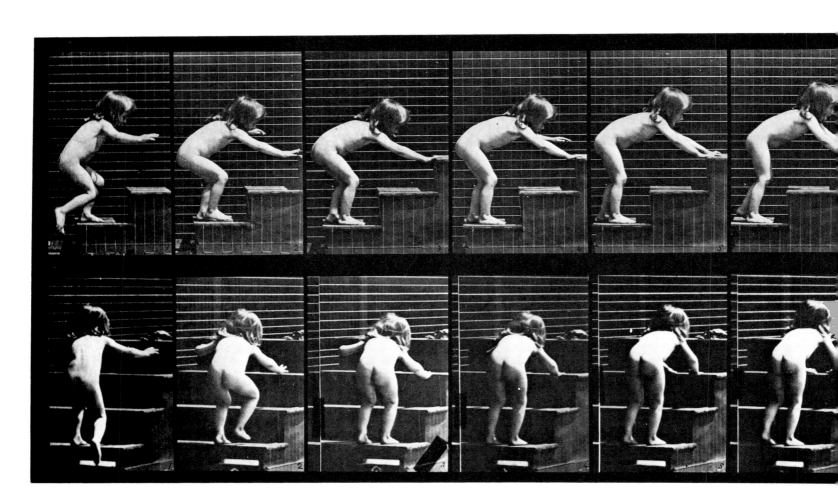

Plate 480. Child walking and crawling up stairs.

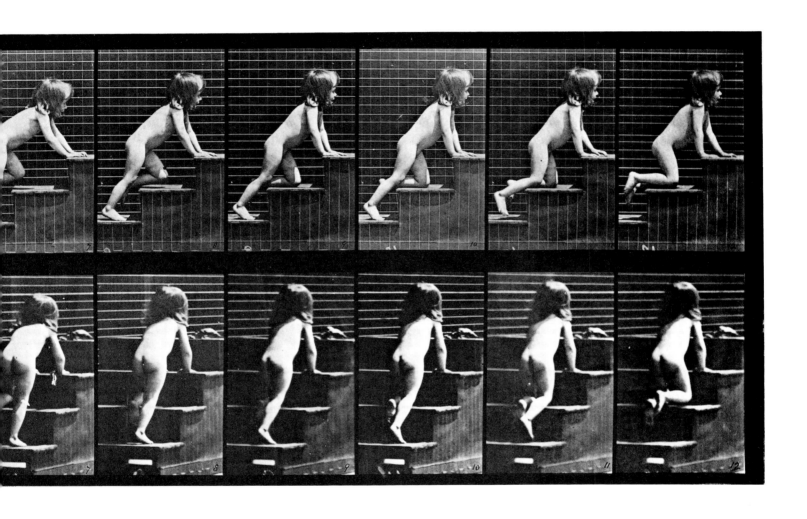

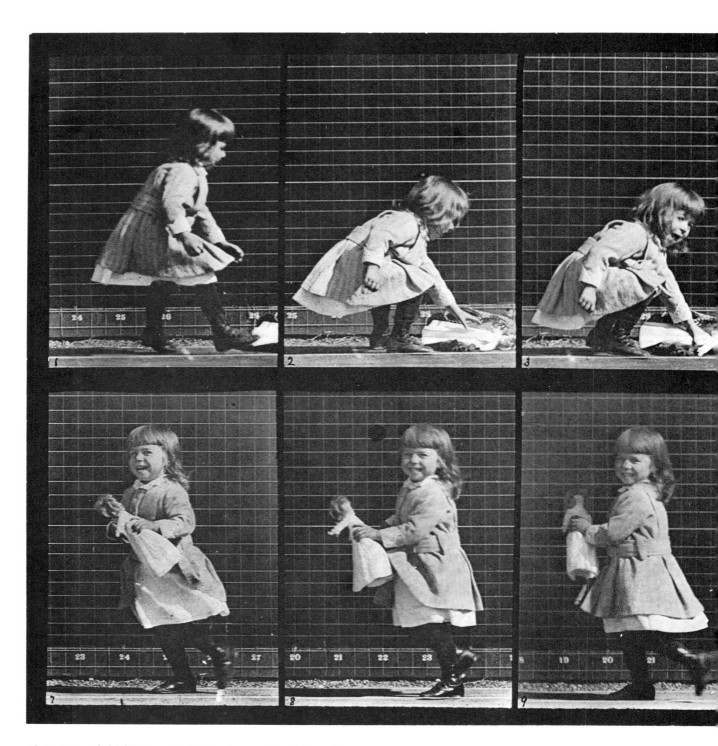

Plate 481. Child lifting a doll, turning and walking off.

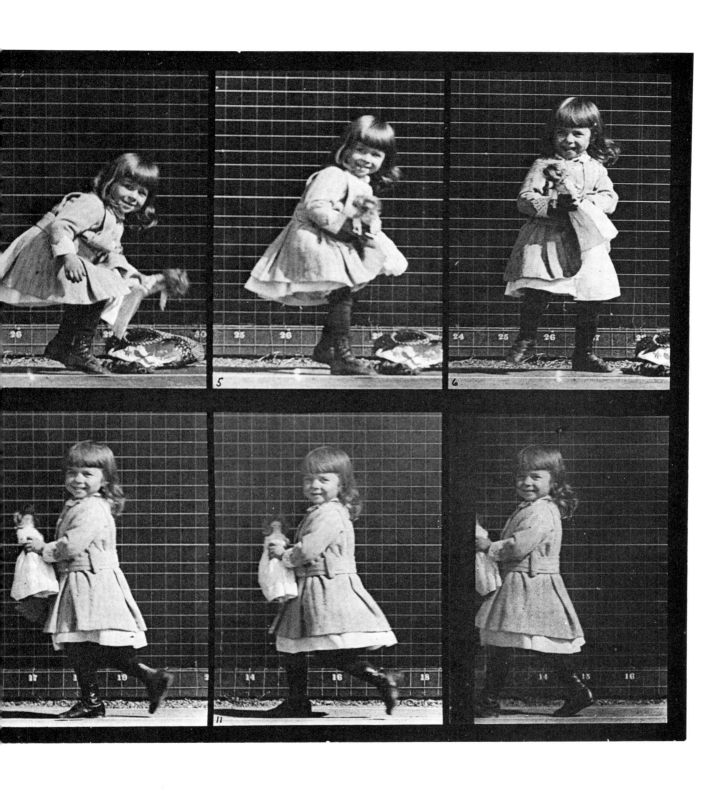

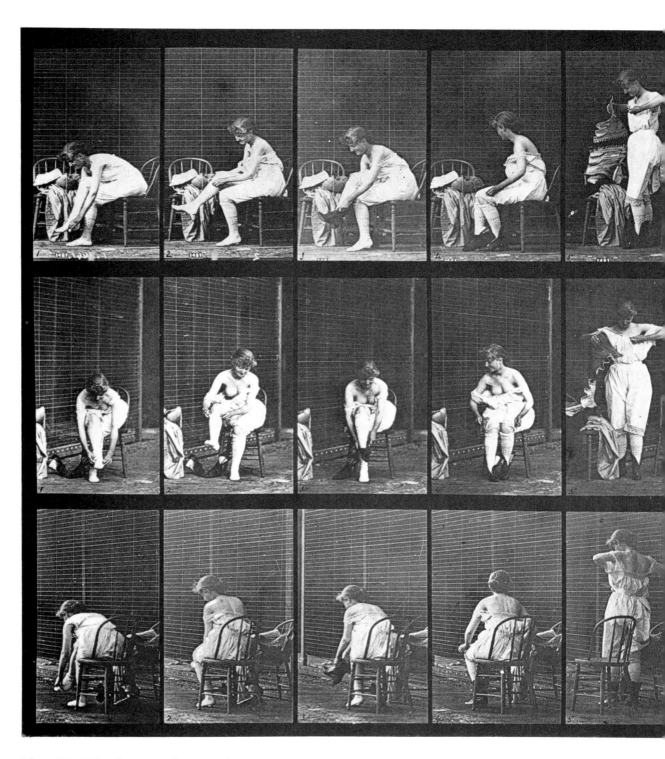

Plate 494. Miscellaneous phases of the toilet.

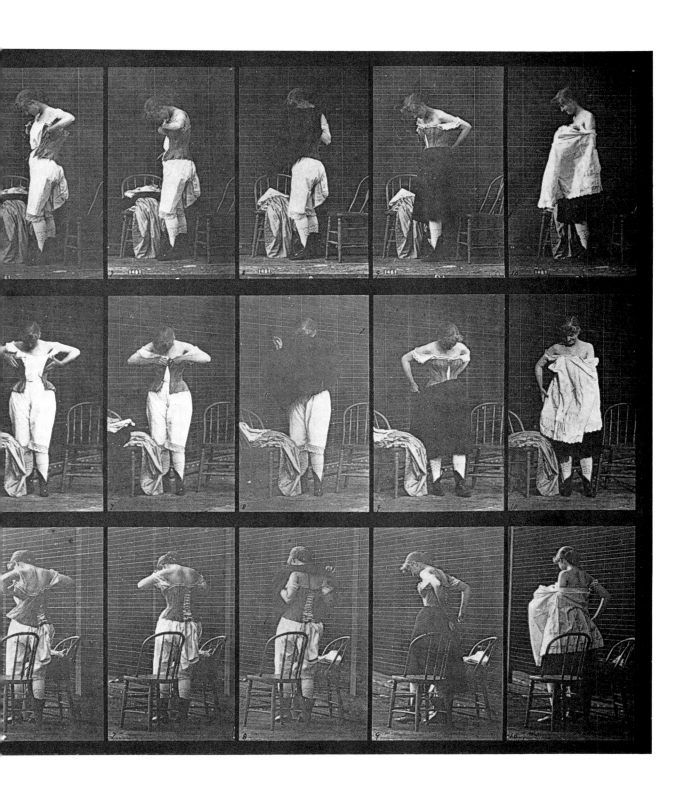

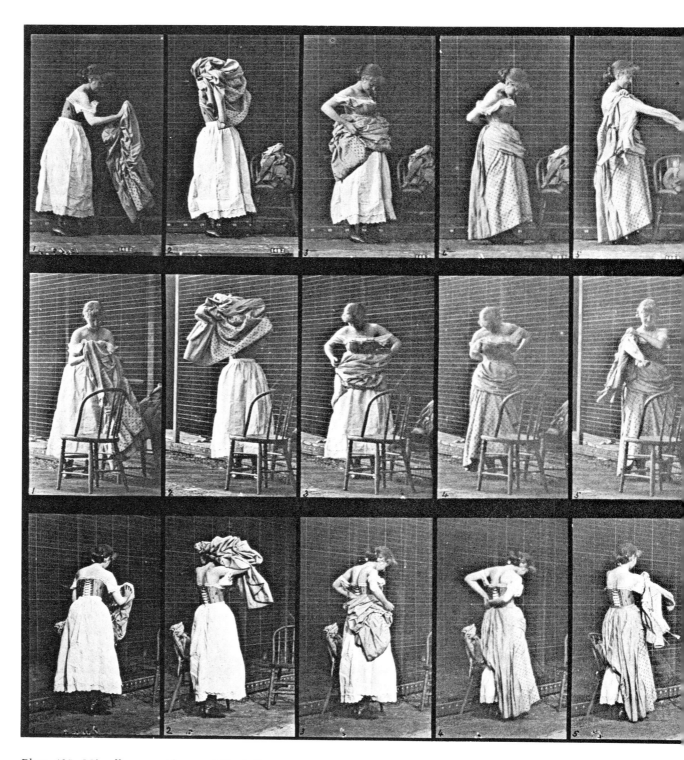

Plate 495. Miscellaneous phases of the toilet.

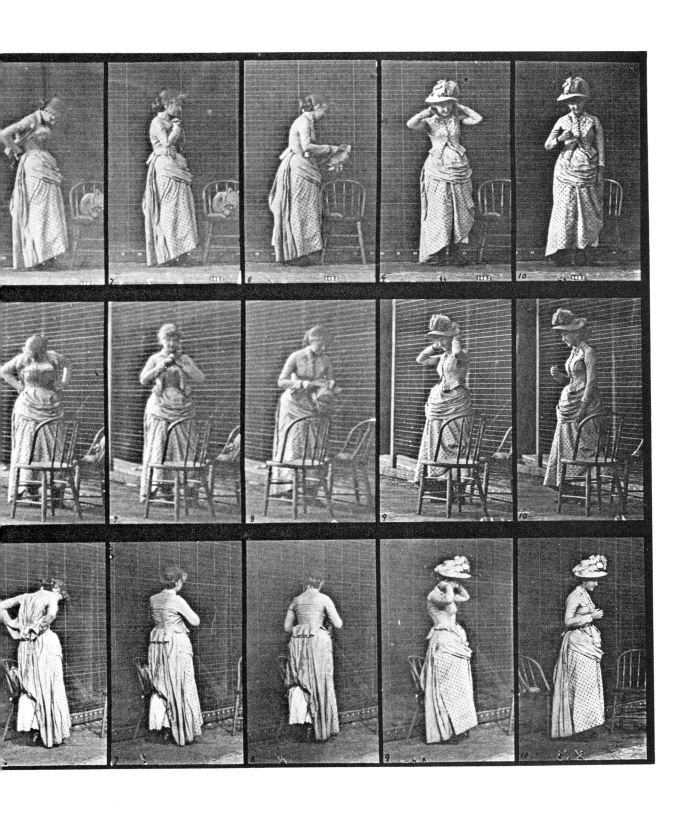

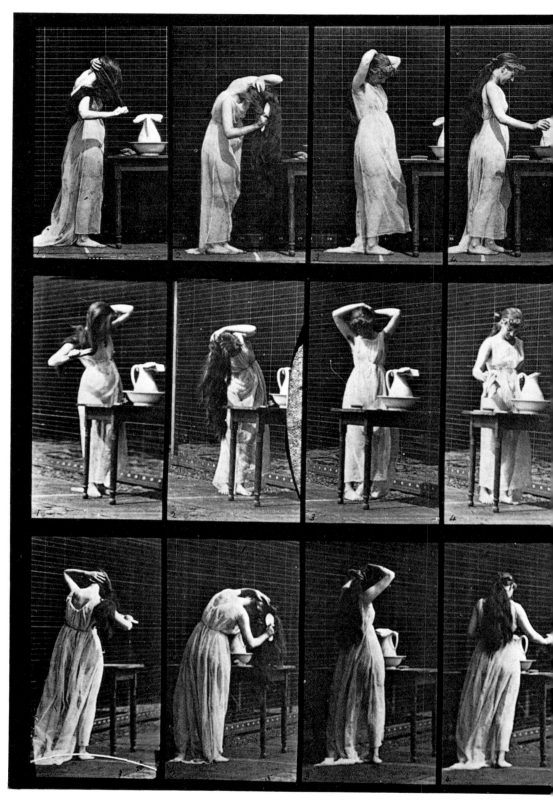

Plate 496. Miscellaneous phases of the toilet.

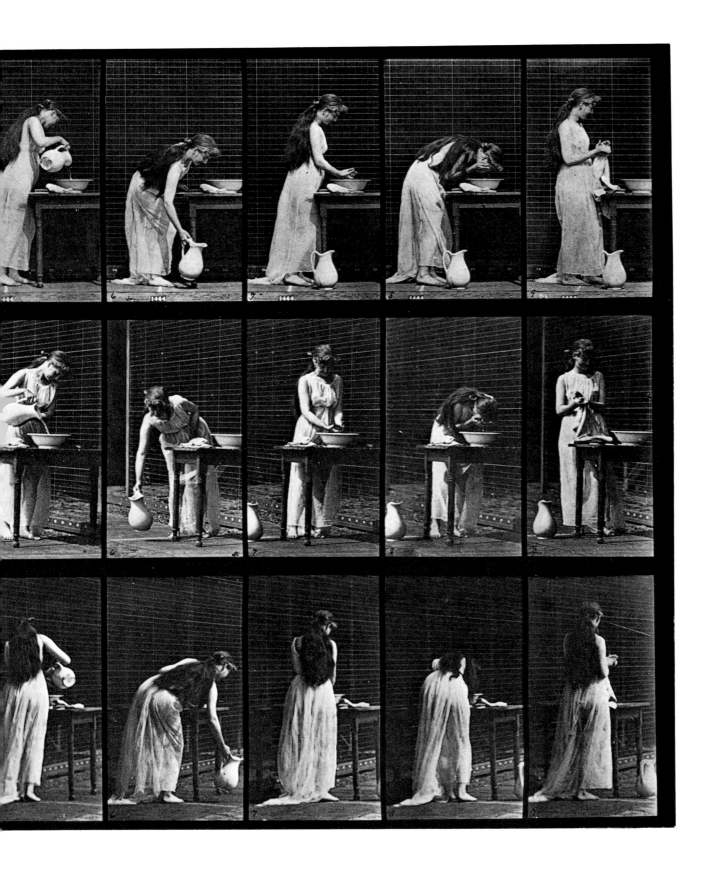

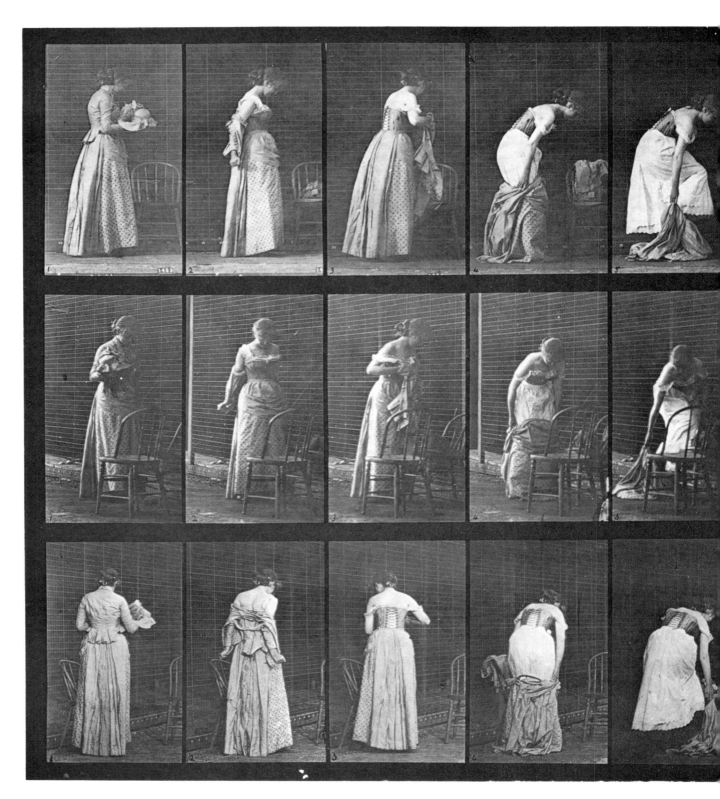

Plate 497. Miscellaneous phases of the toilet.

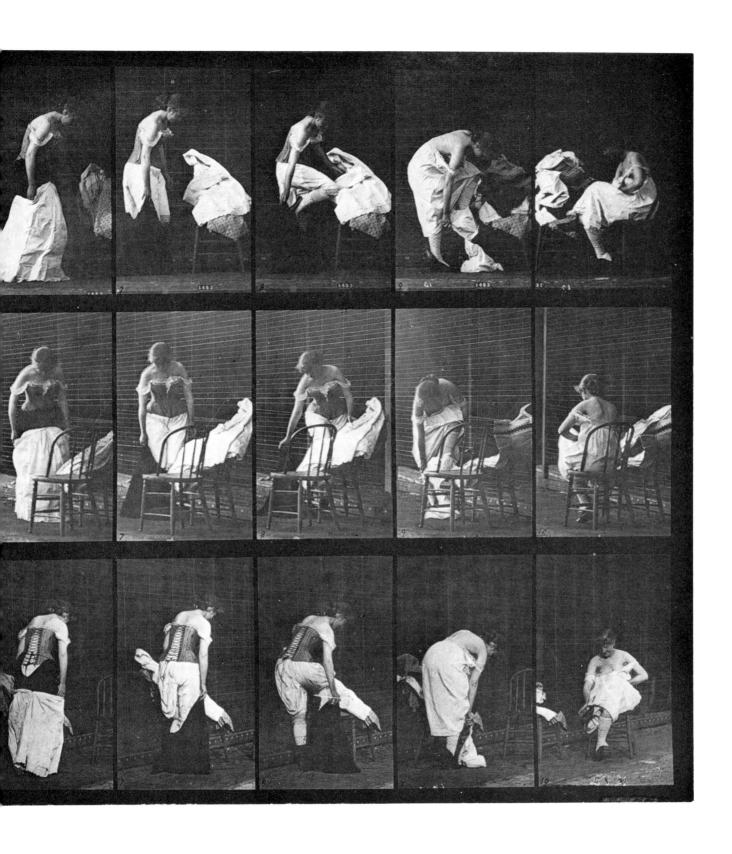

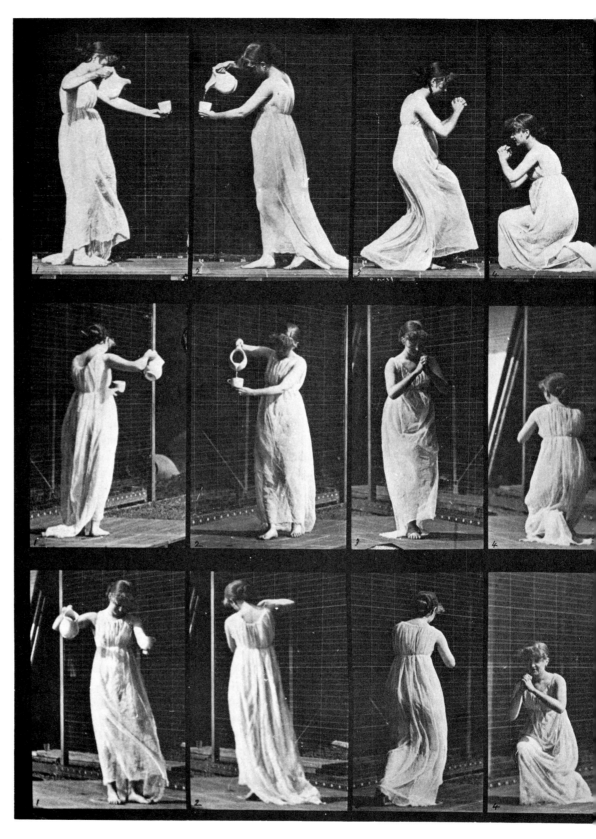

Plate 502. Miscellaneous, stooping, kneeling, etc.

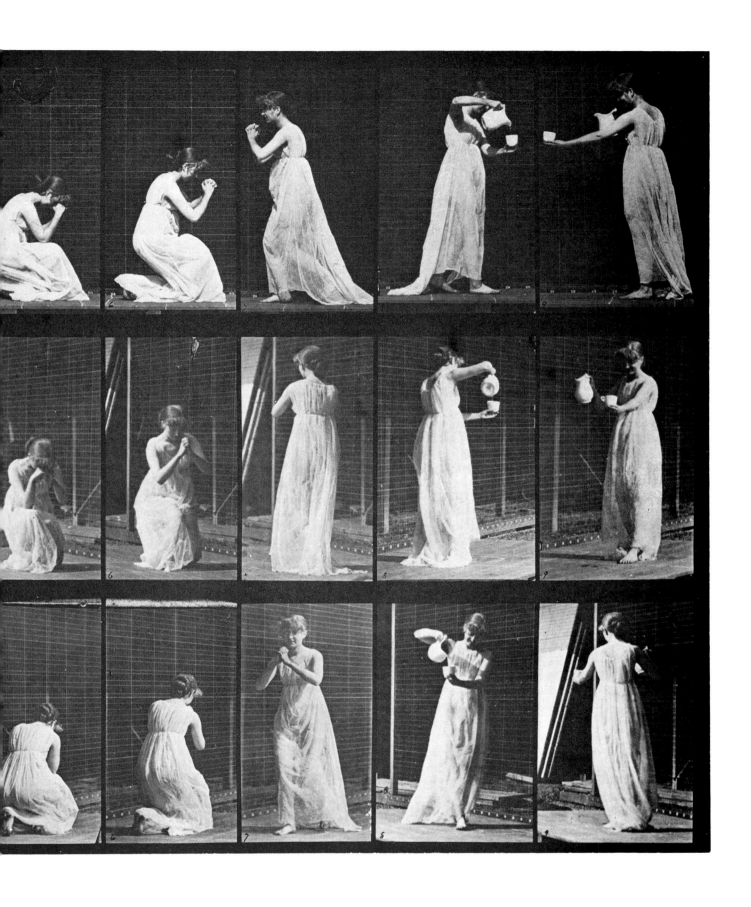

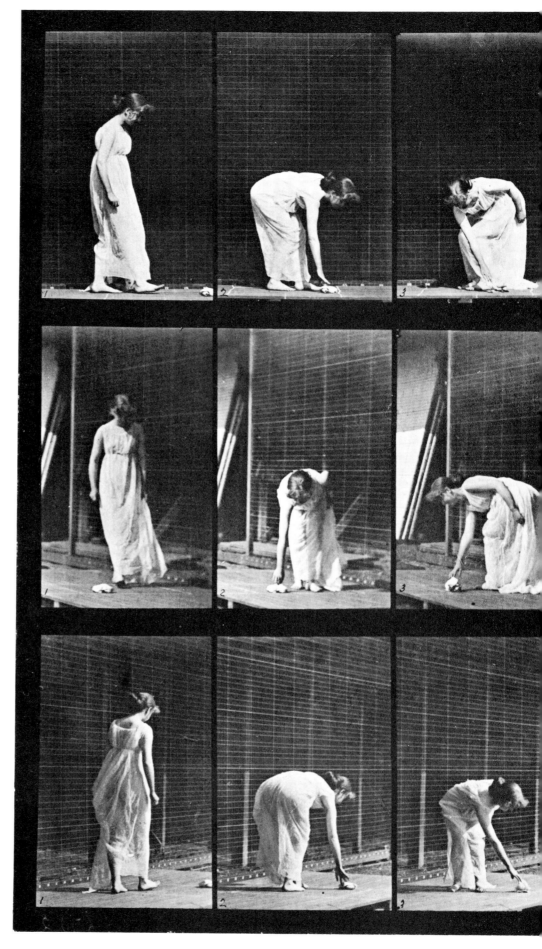

Plate 503. Miscellaneous, stooping, etc.

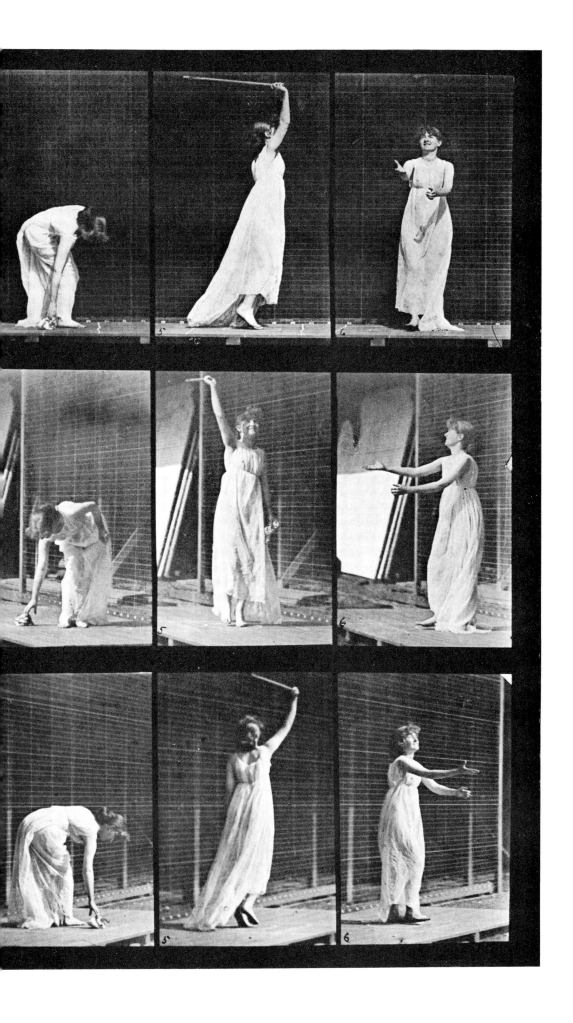

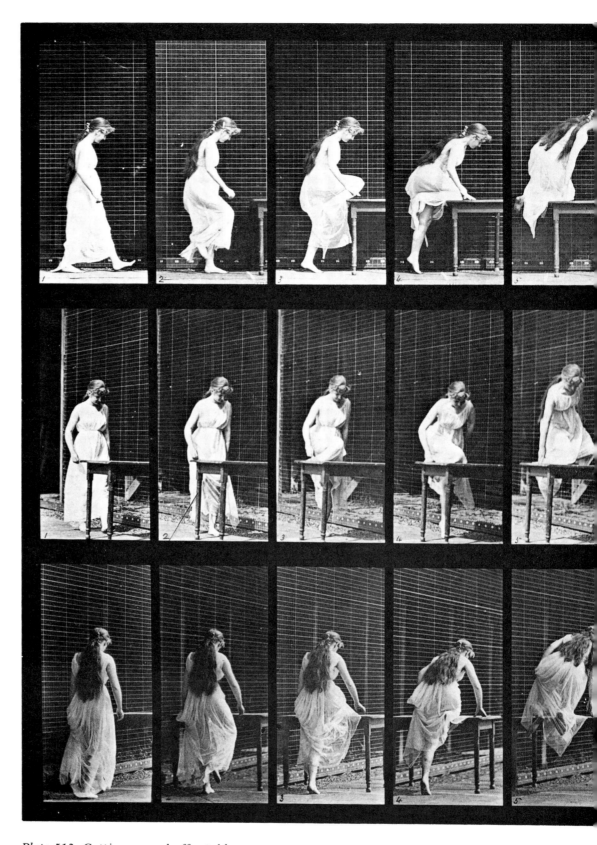

Plate 513. Getting on and off a table.

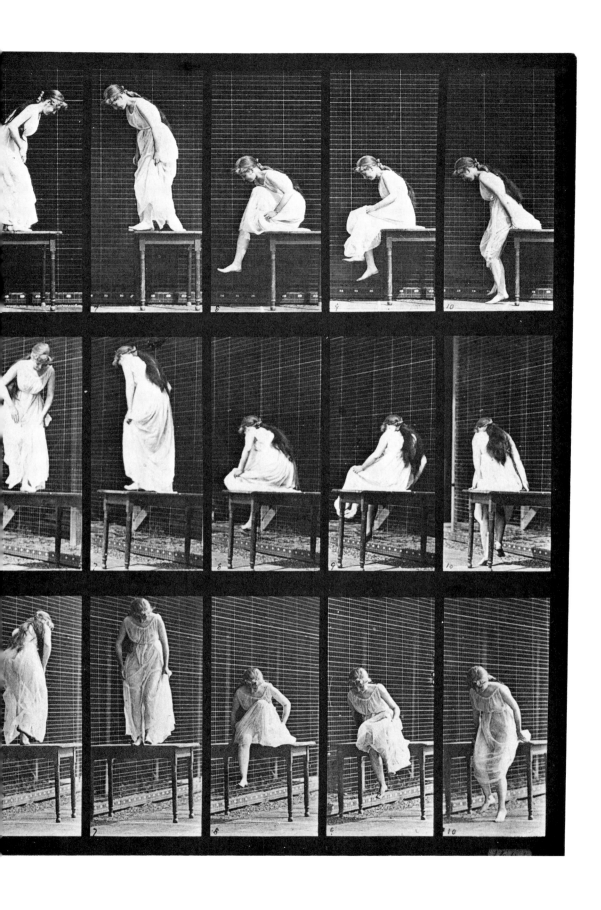

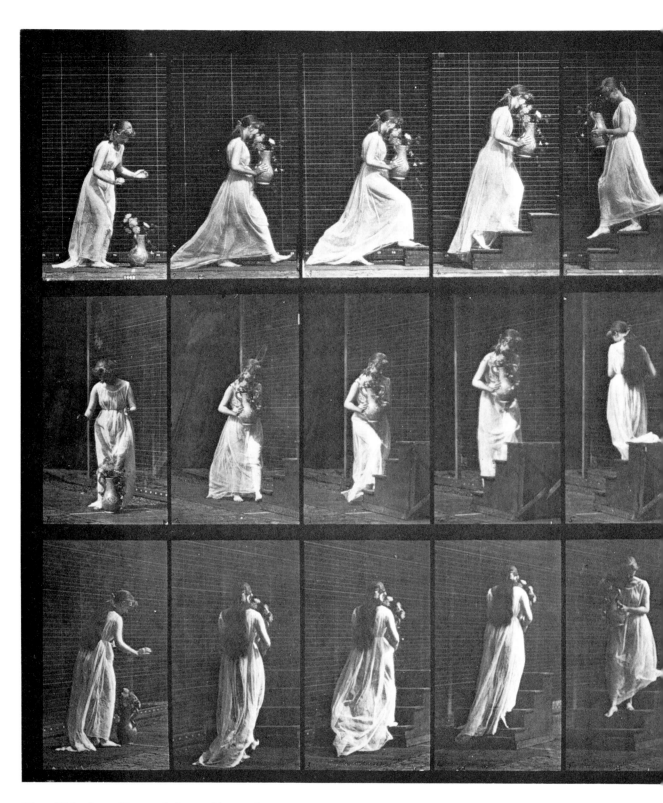

Plate 515. Ascending and descending stairs.

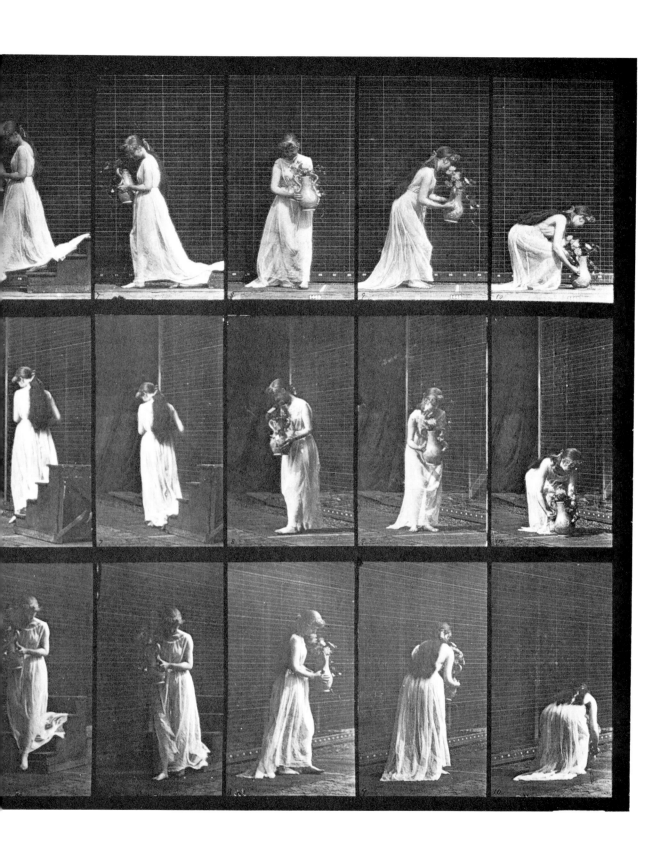

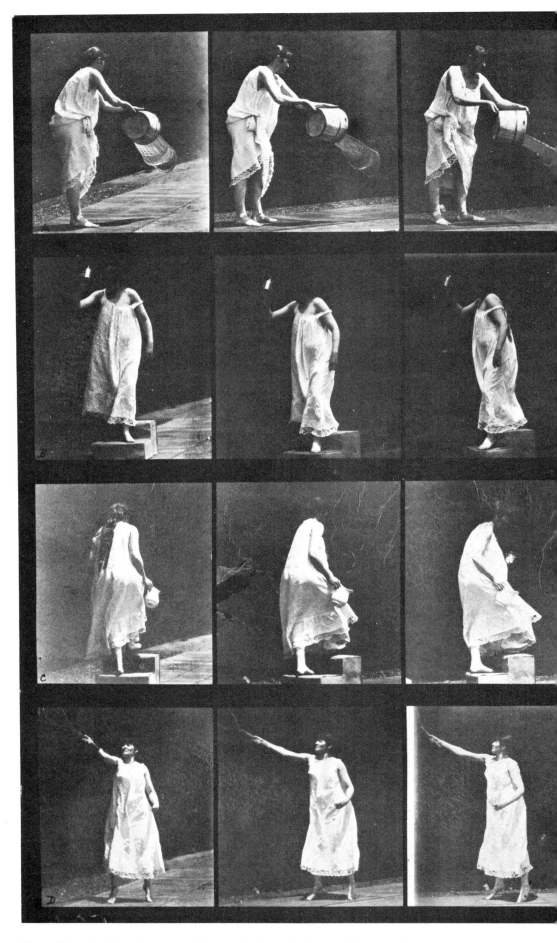

Plate 524. A: Throwing water from a bucket. B: Descending a step.
C: Ascending a step. D: Playing lawn tennis.

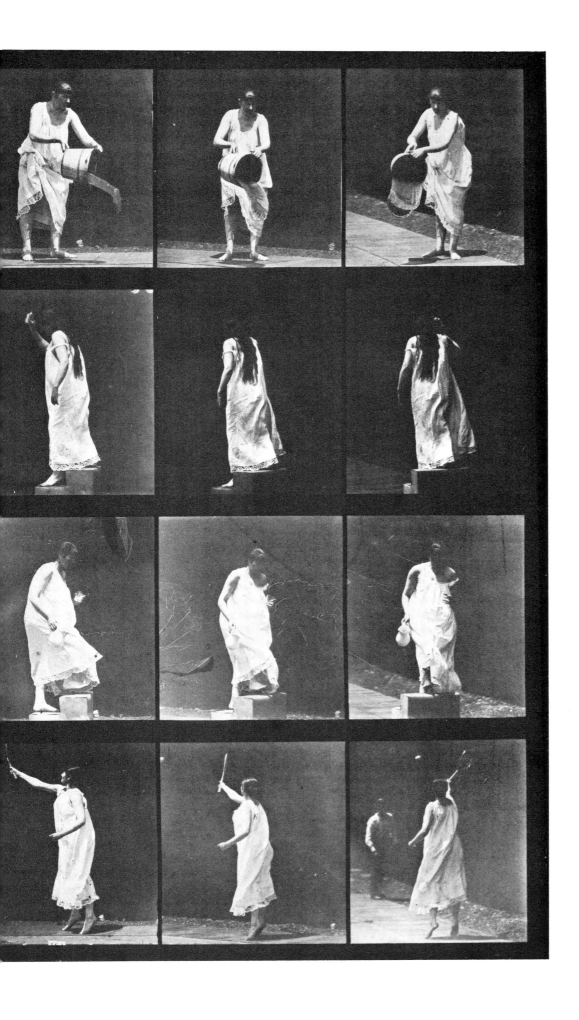

Volume 7

MALES & FEMALES
(Draped)

&

MISCELLANEOUS SUBJECTS

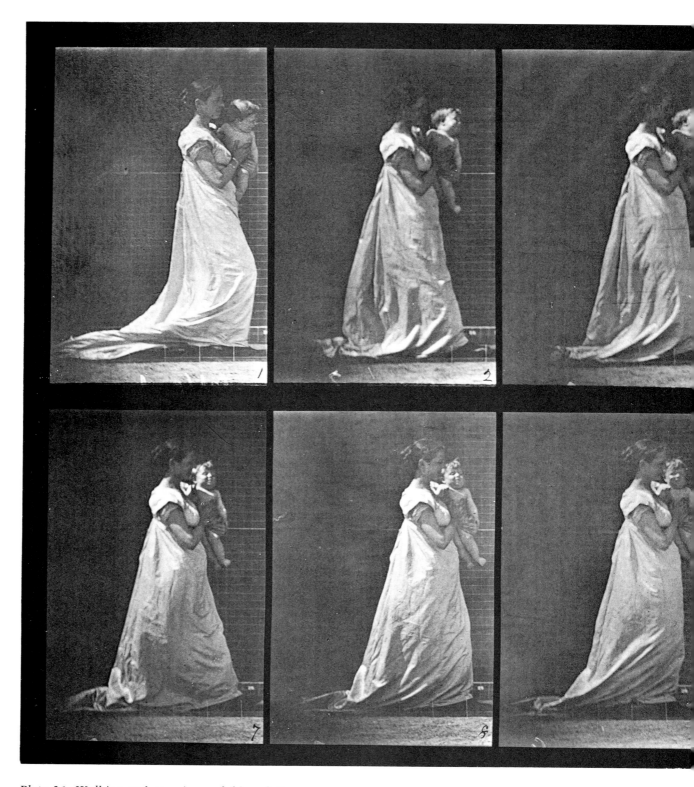

Plate 36. Walking and carrying a child on left arm.

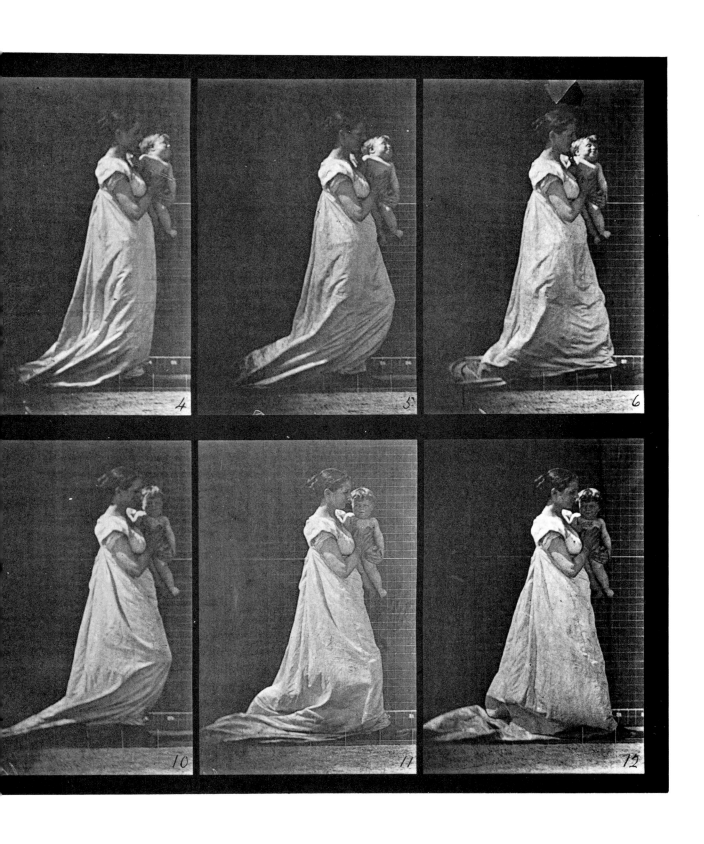

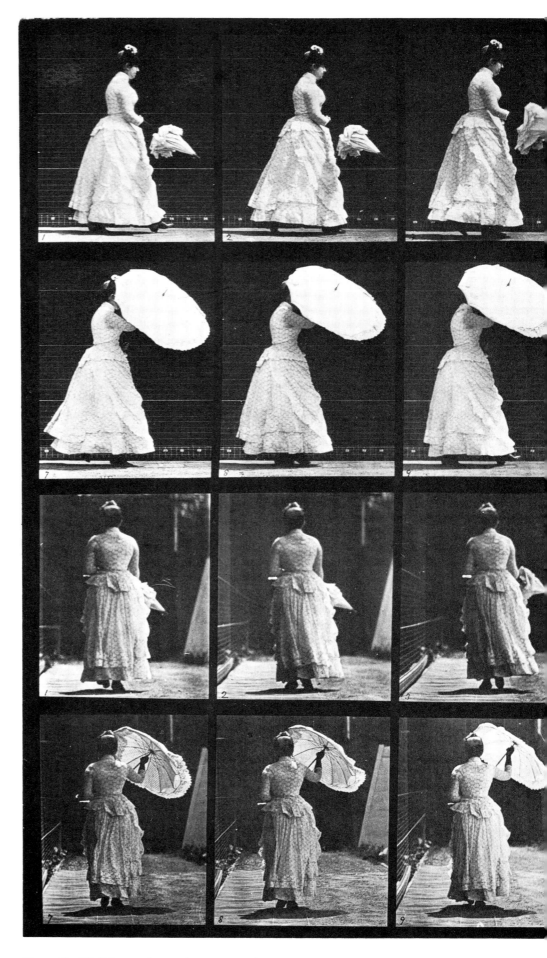

Plate 38. Walking and opening a parasol.

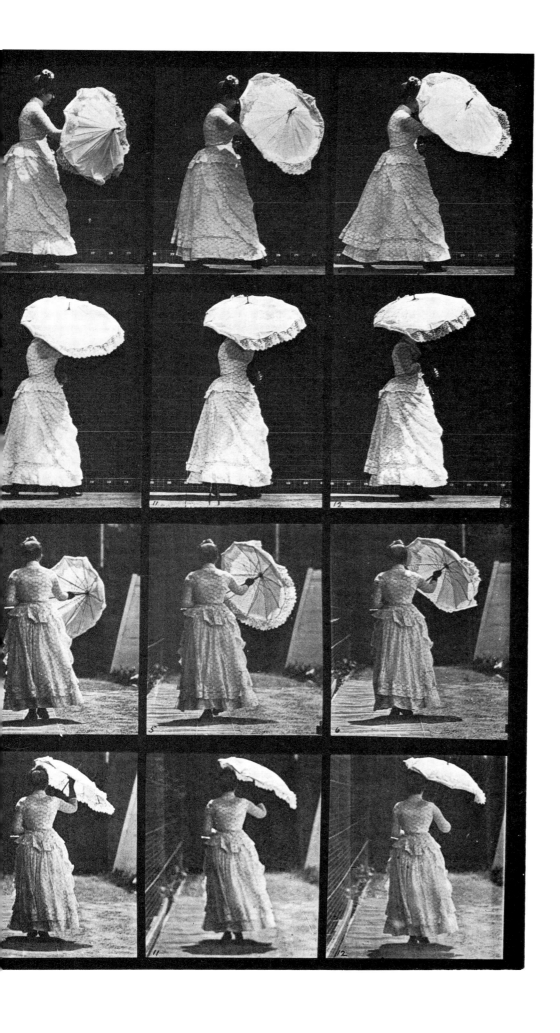

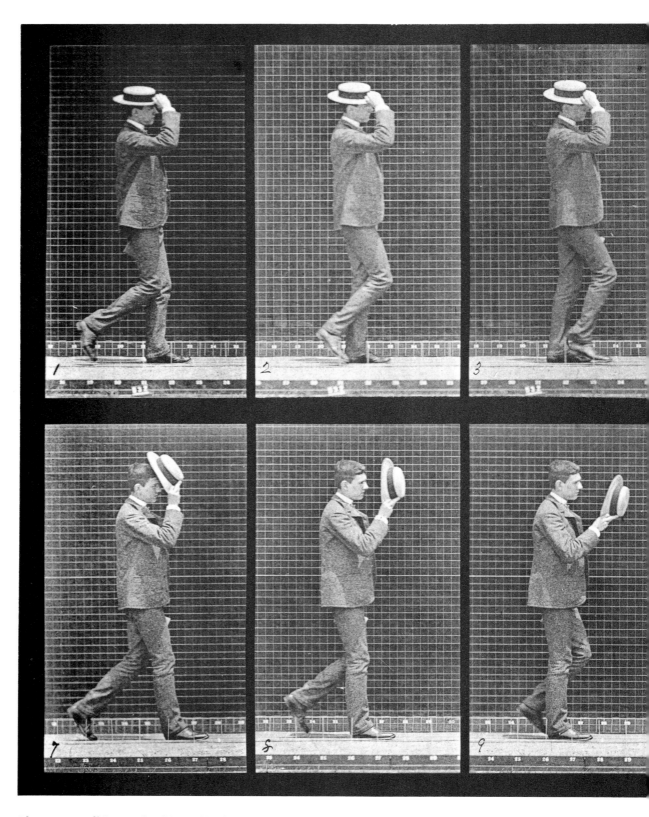

Plate 44. Walking and taking off a hat.

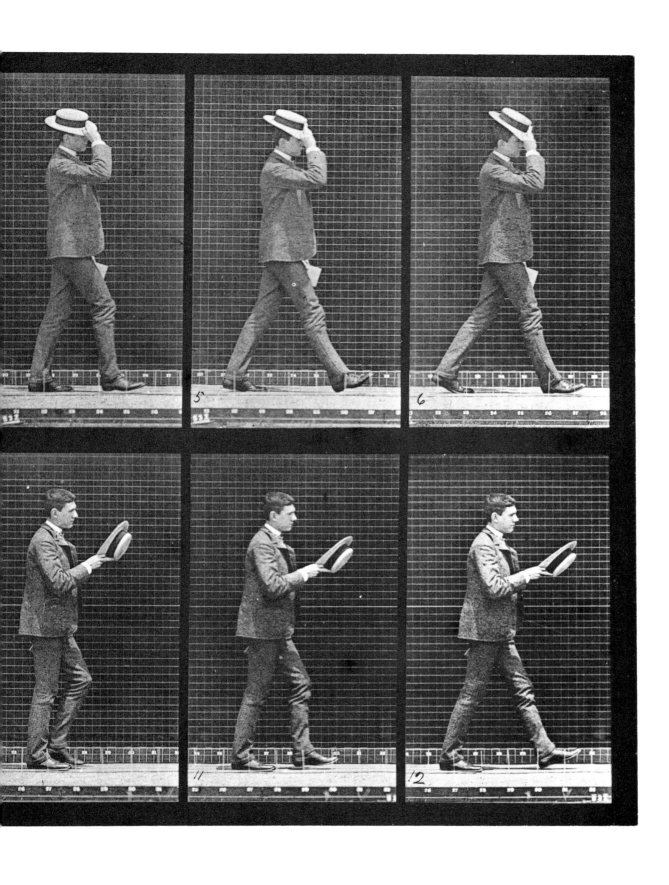

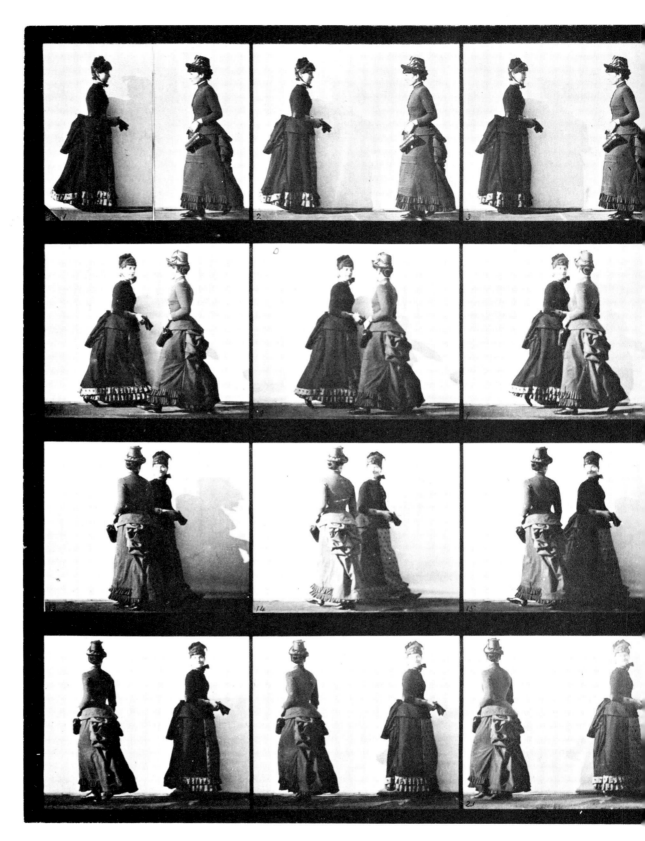

Plate 45. Two women walking, meeting and partly turning.

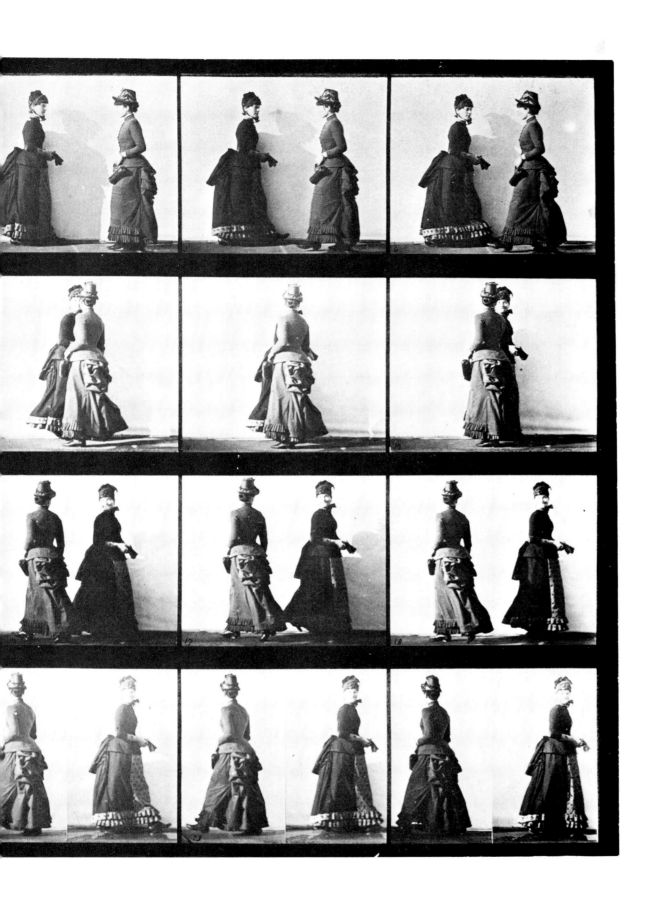

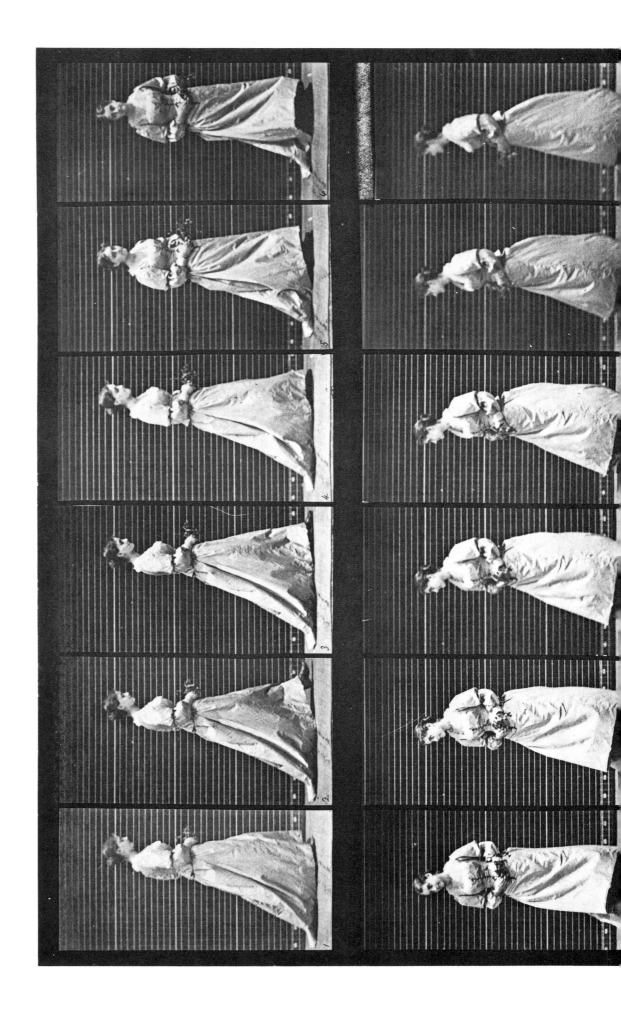

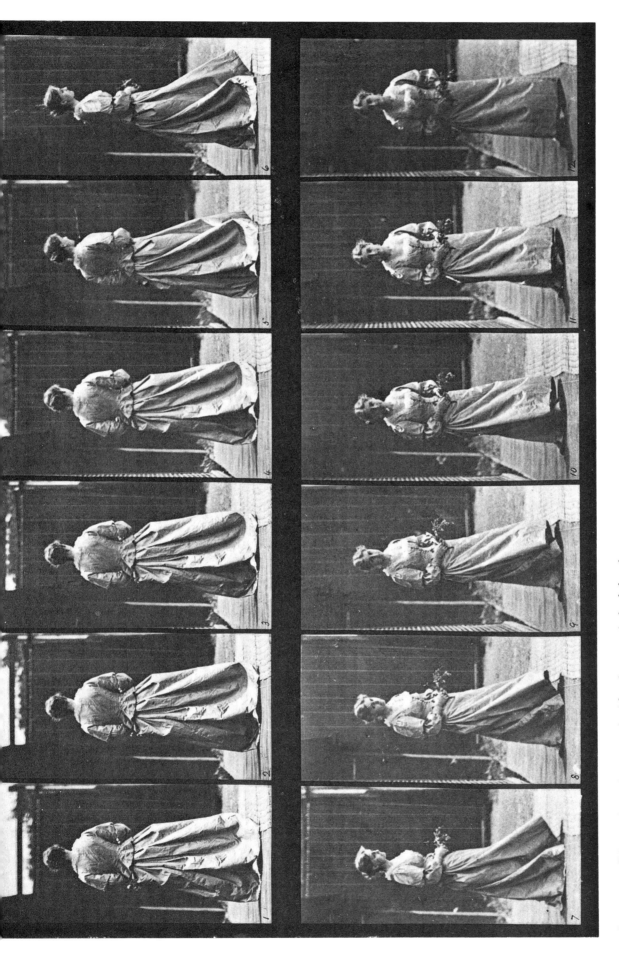

Plate 48. Walking and turning around with a bouquet in both hands.

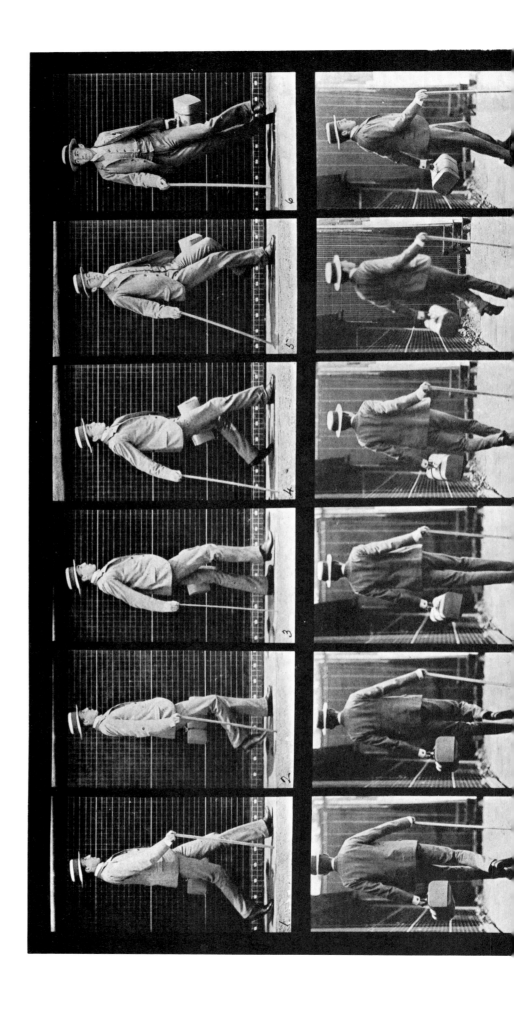

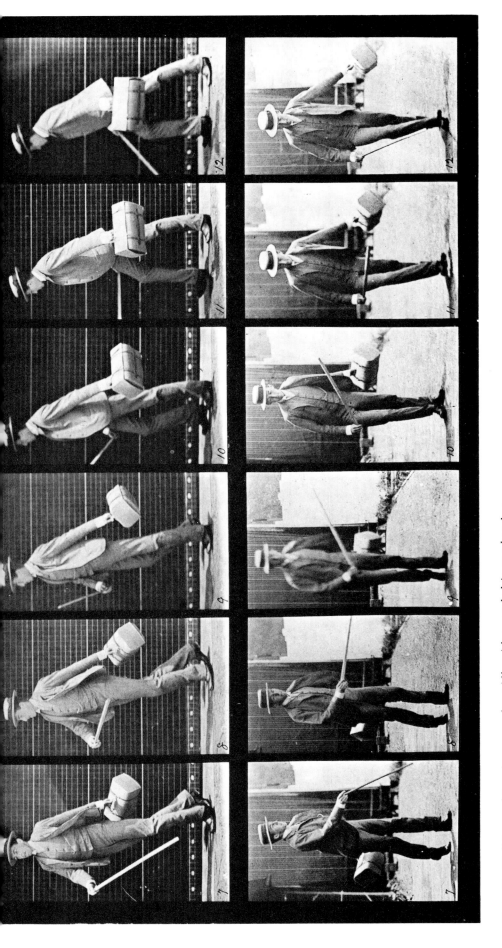

Plate 49. Walking and turning around rapidly with a satchel in one hand, a cane in the other.

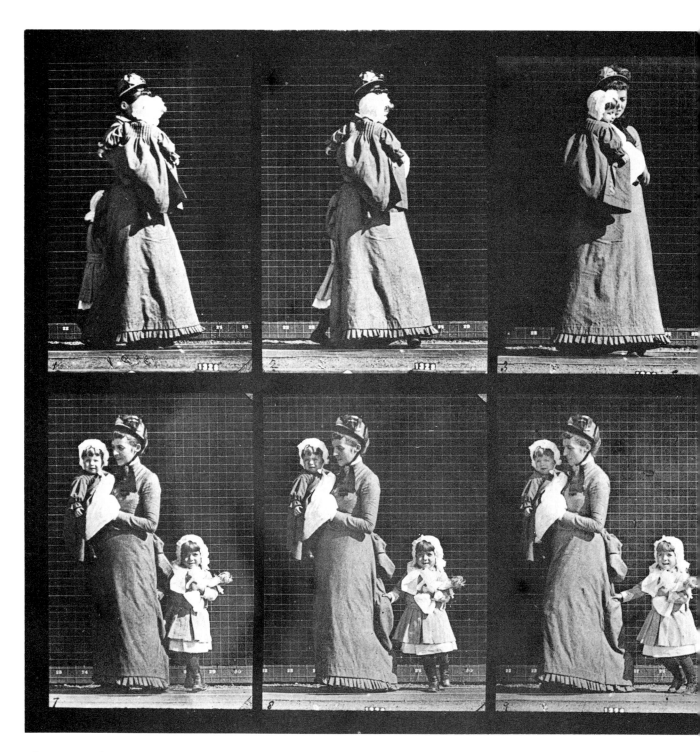

Plate 52. Walking, carrying a child, turning around; another child holding on to the woman's dress.

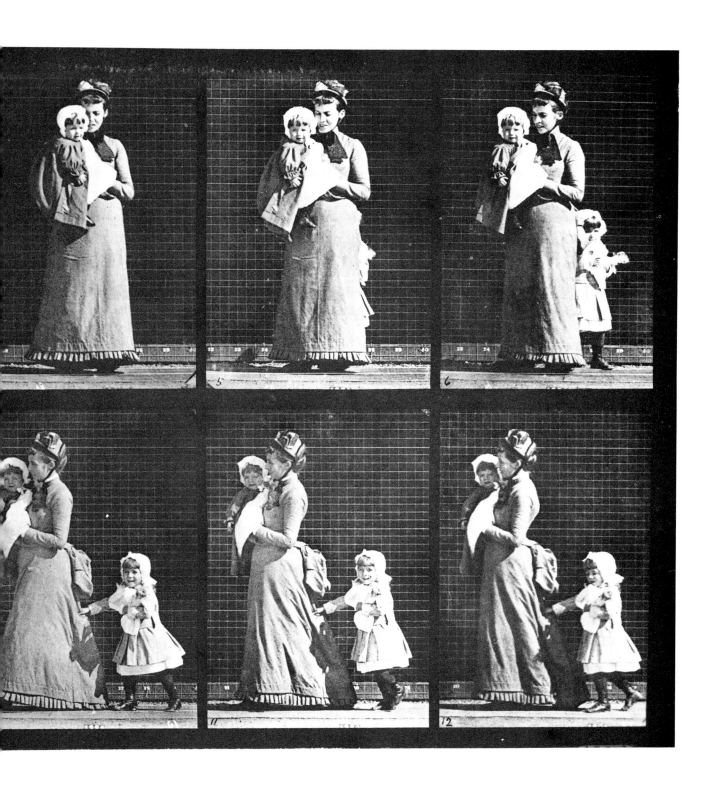

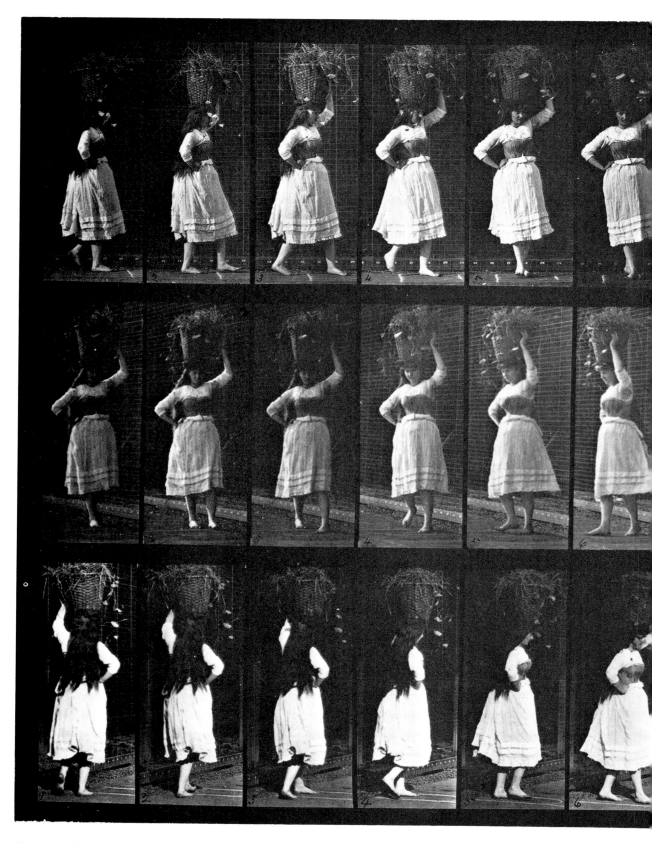

Plate 57. Walking and turning around with a 10-lb. basket on head.

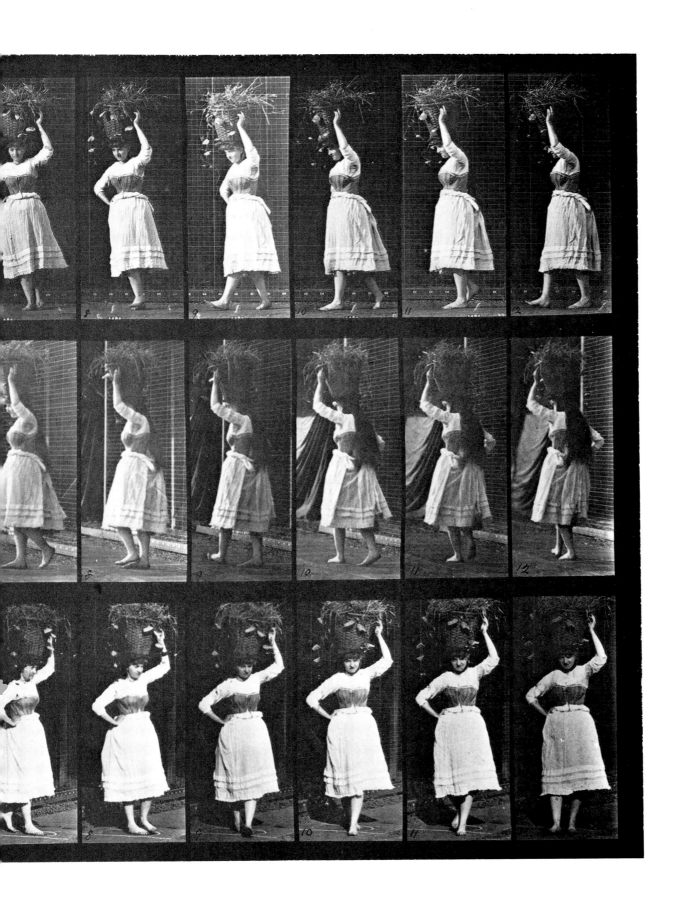

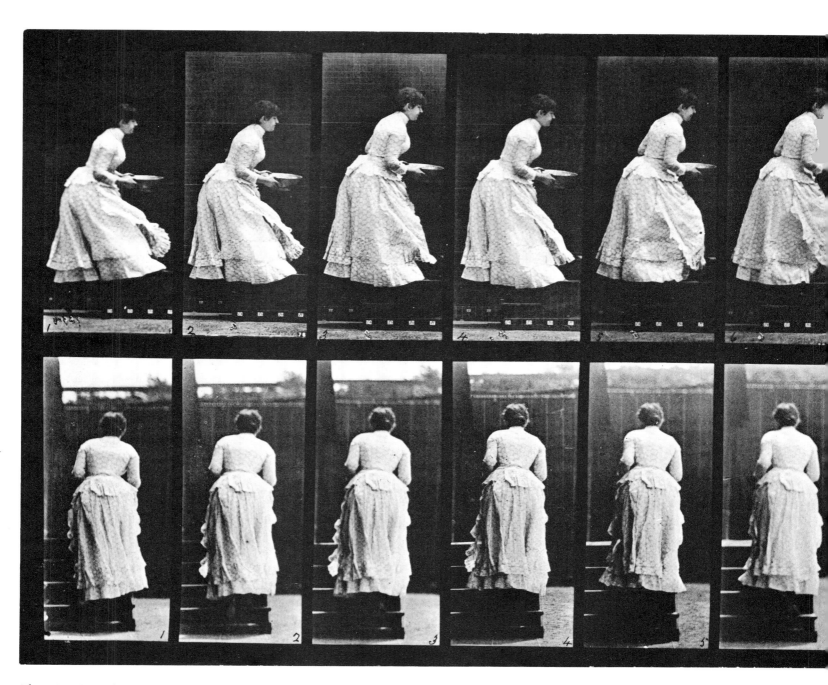

Plate 95. Ascending stairs with a basin in hands.

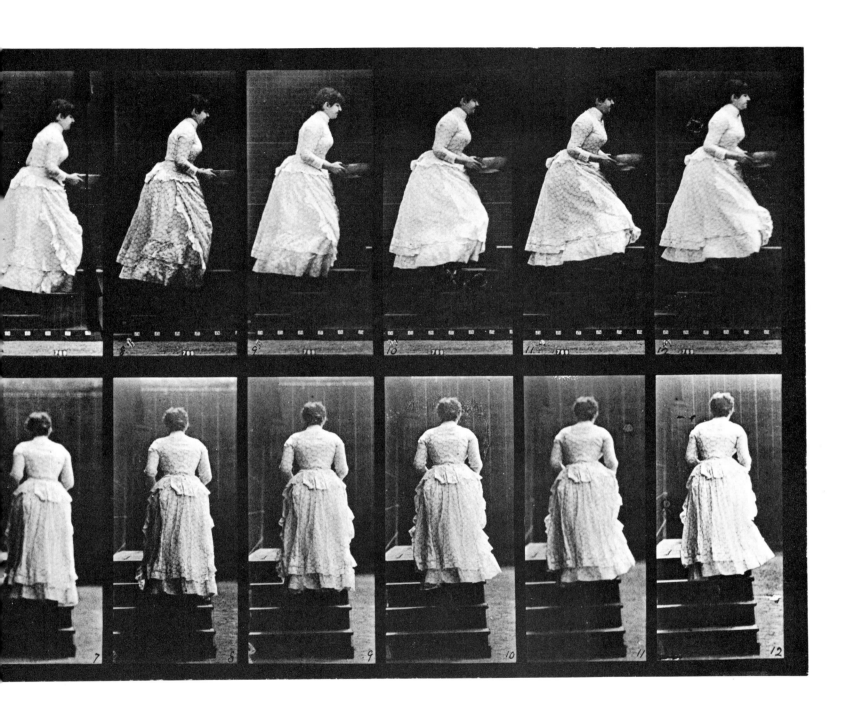

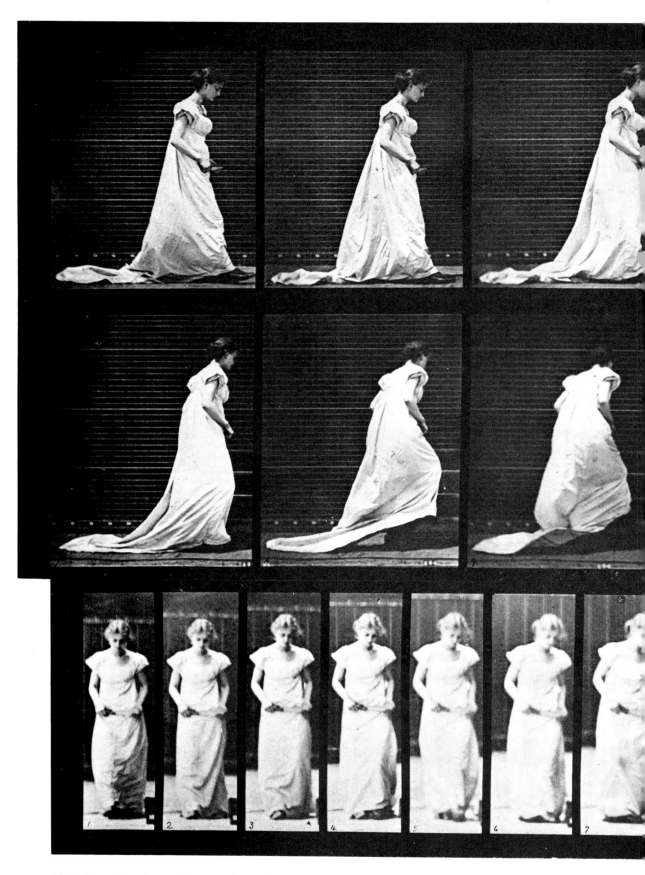

Plate 100. Turning and ascending stairs.

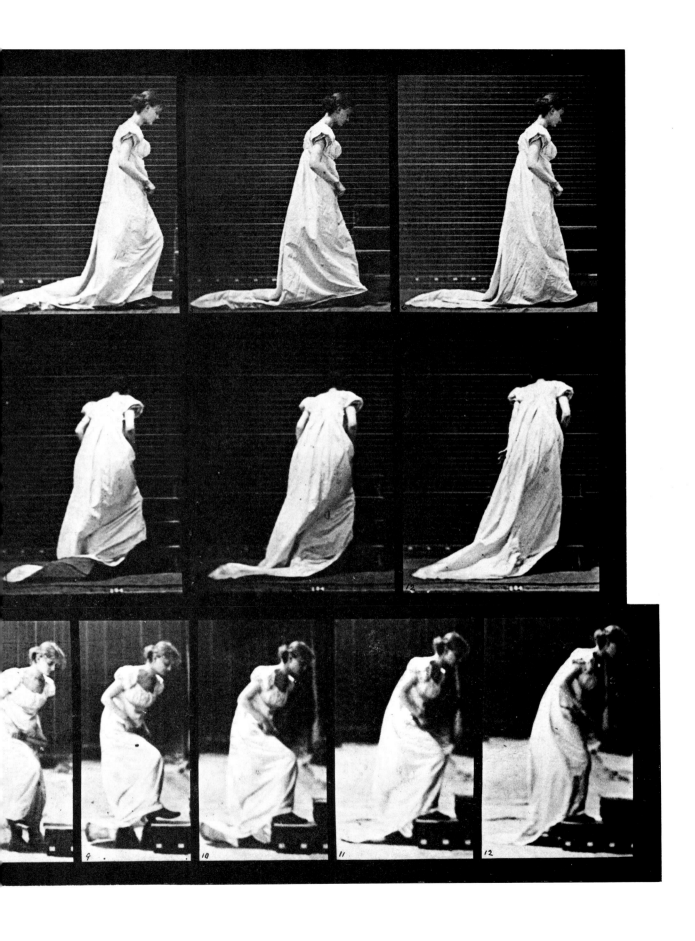

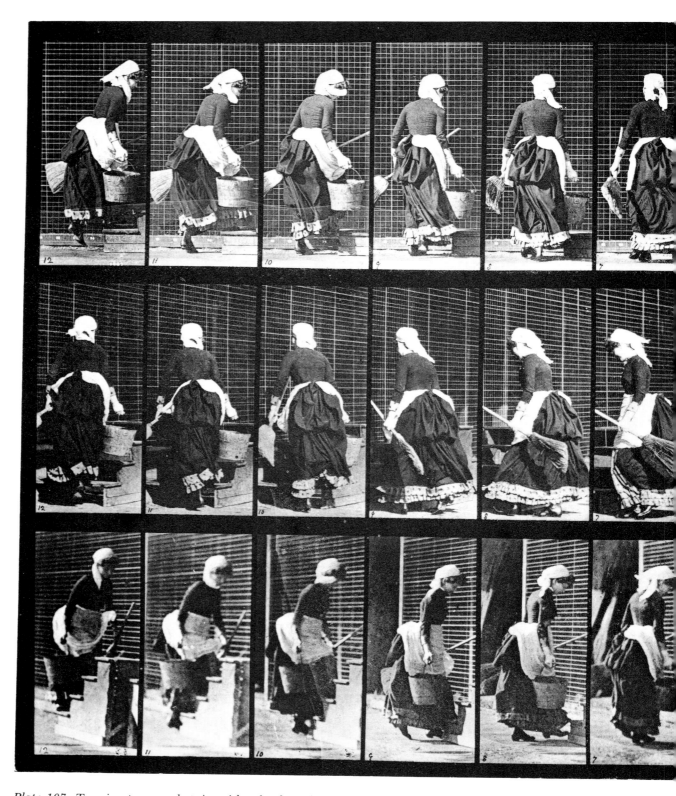

Plate 107. Turning to ascend stairs with a bucket of water and a broom in hands.

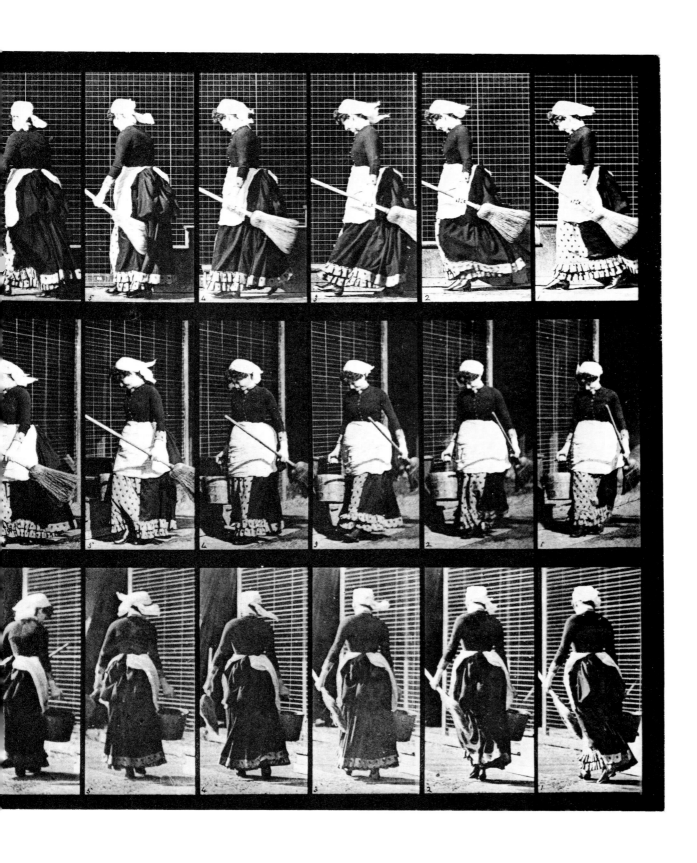

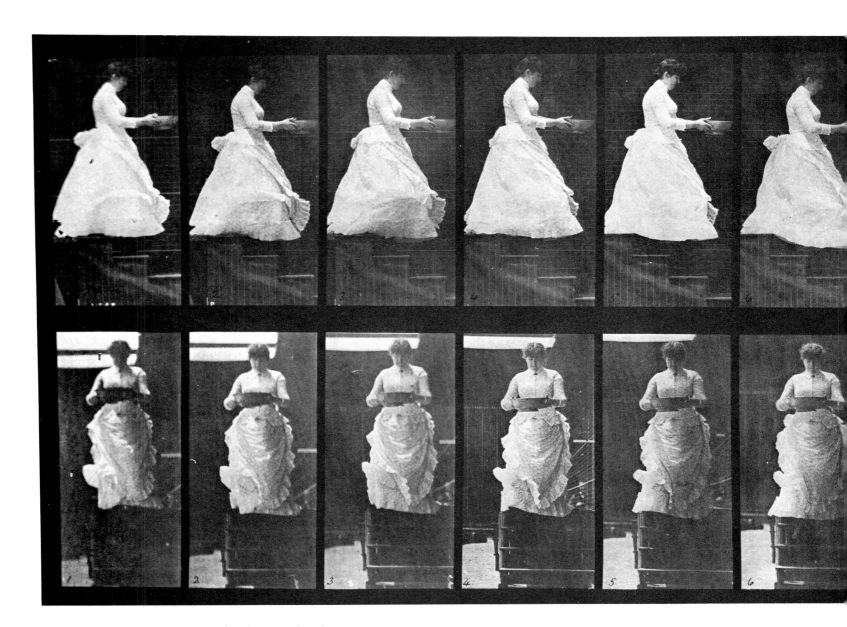

Plate 134. Descending stairs with a basin in hands.

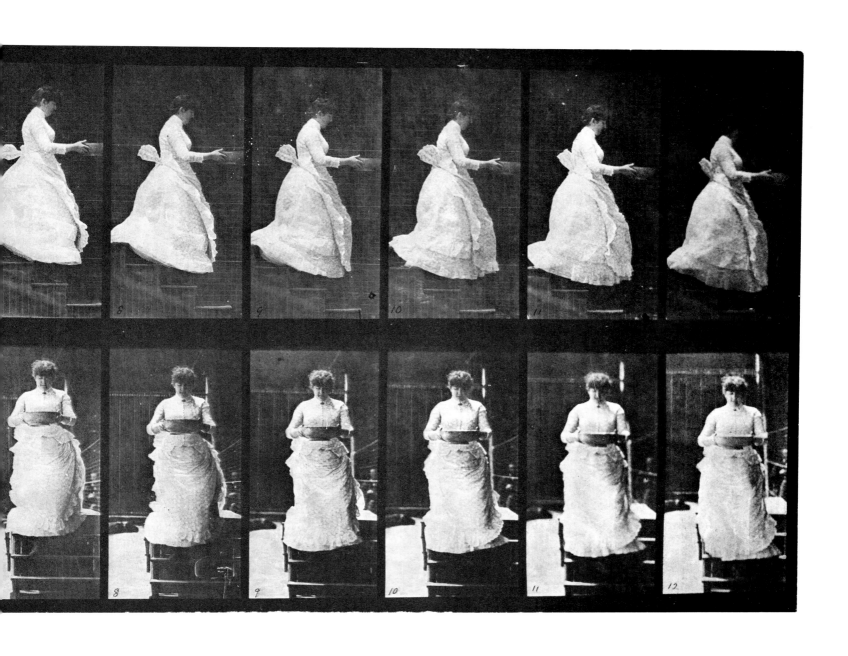

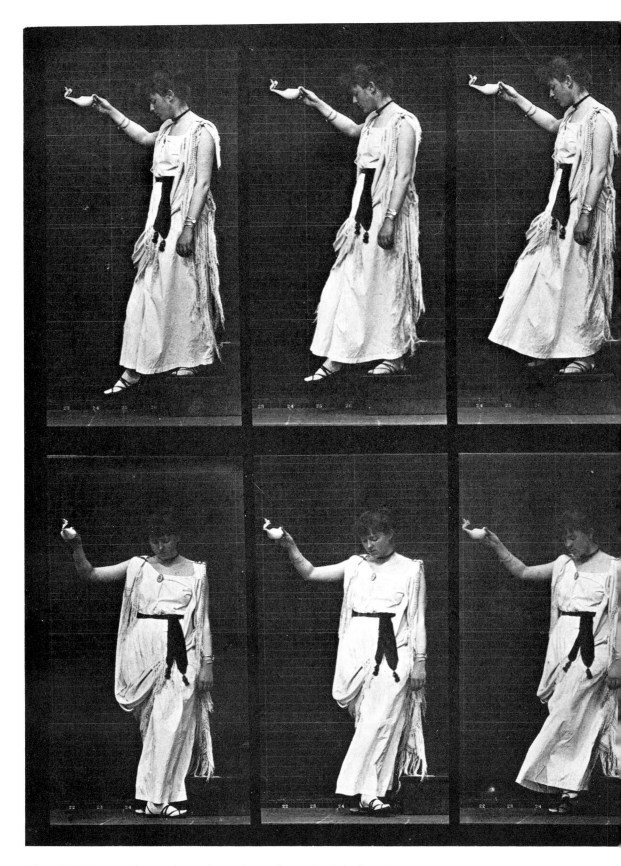

Plate 135. Descending stairs and turning, a lamp in right hand.

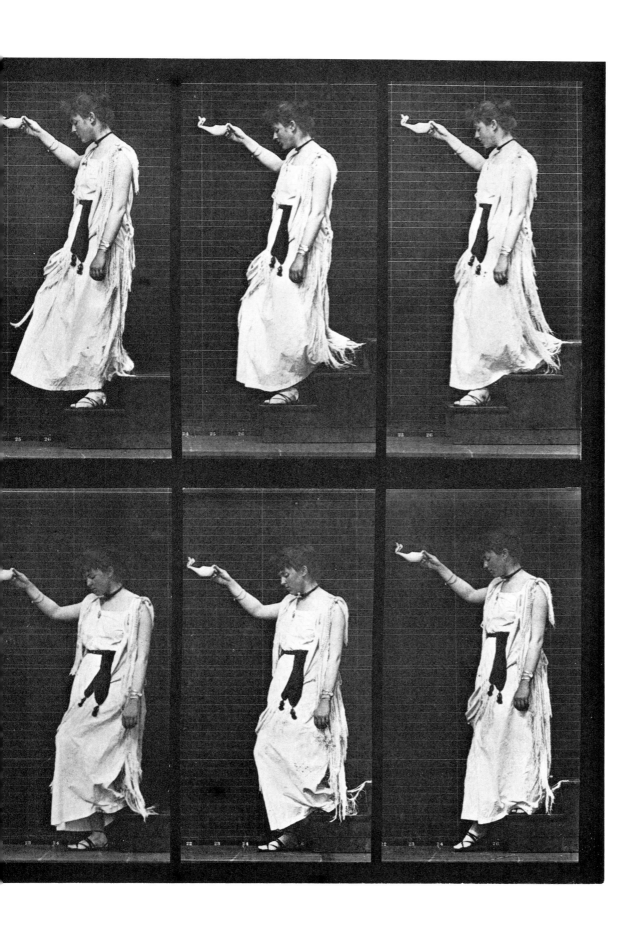

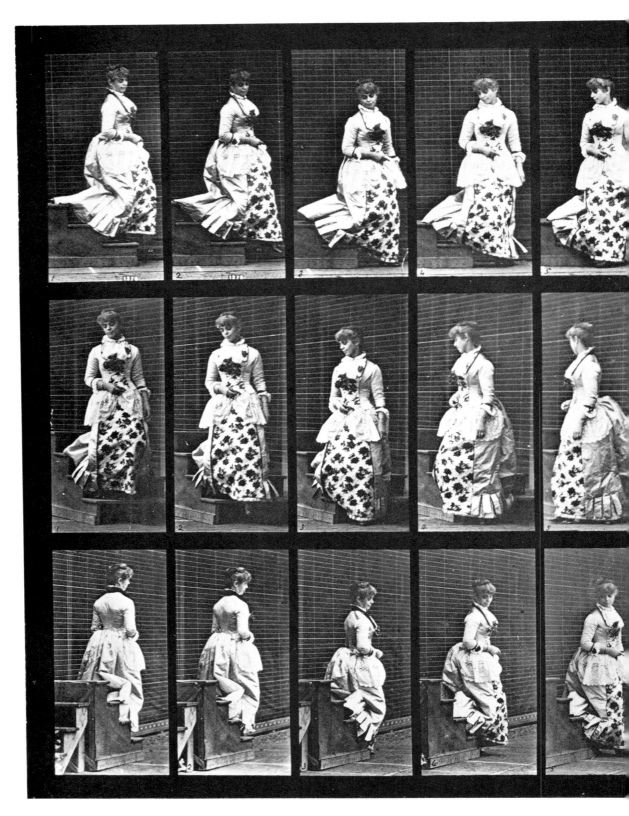

Plate 139. Descending stairs and turning.

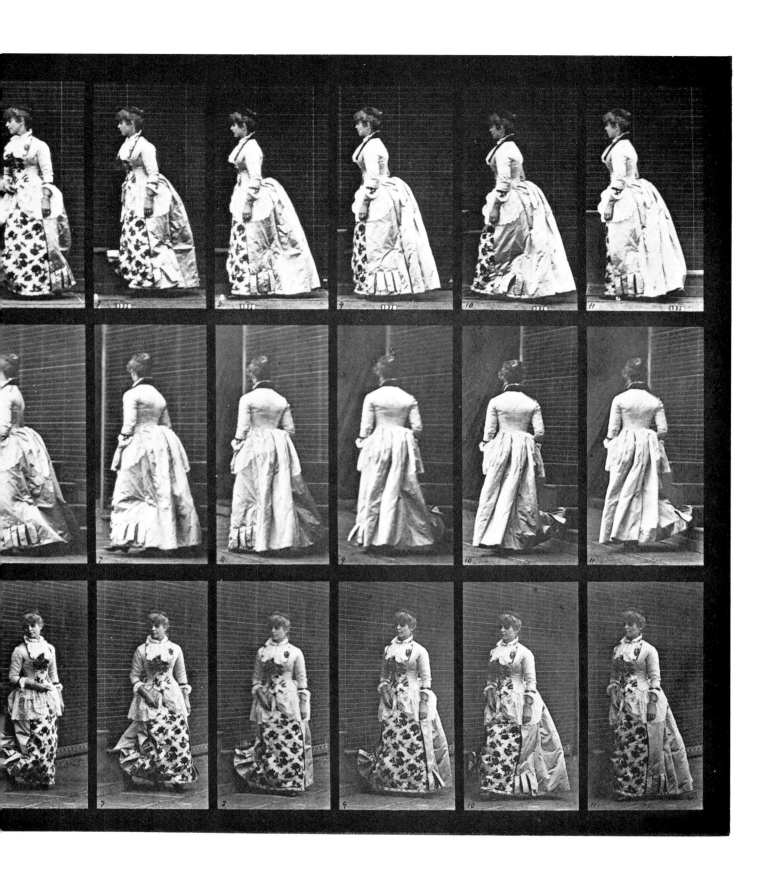

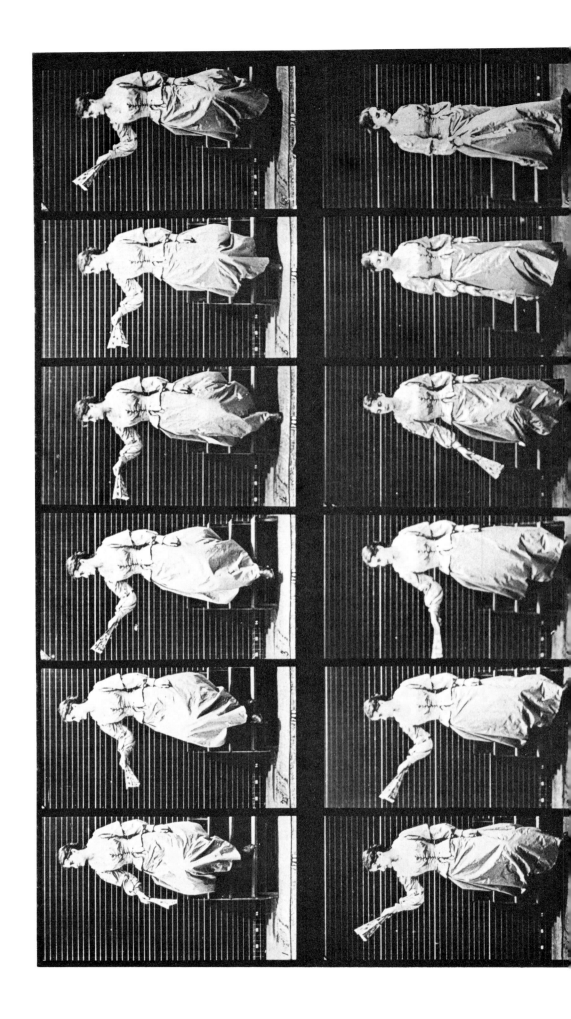

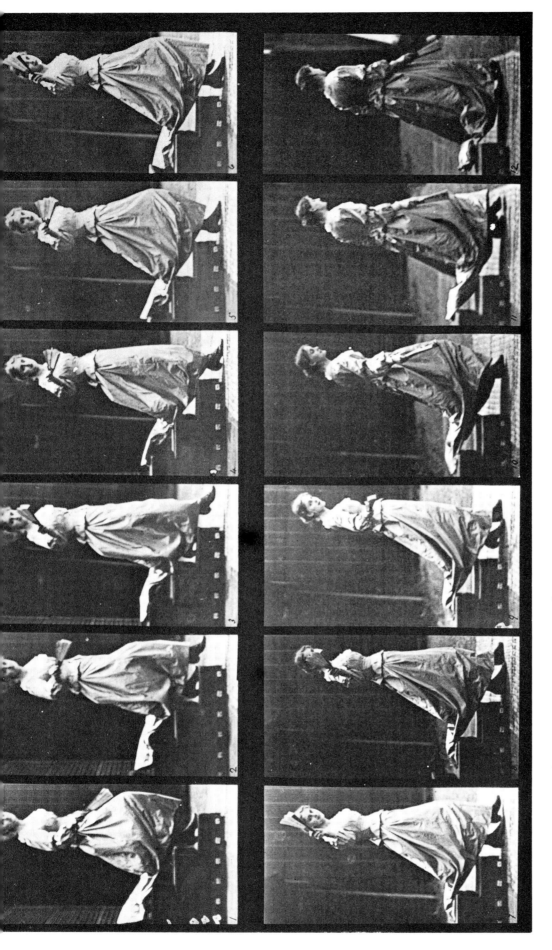

Plate 140. Descending stairs, looking around and waving a fan.

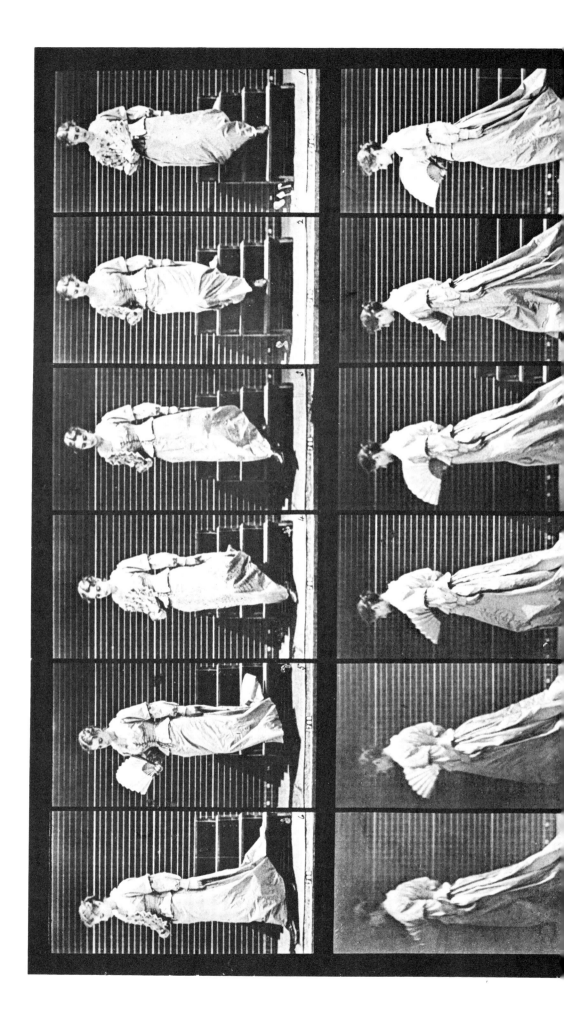

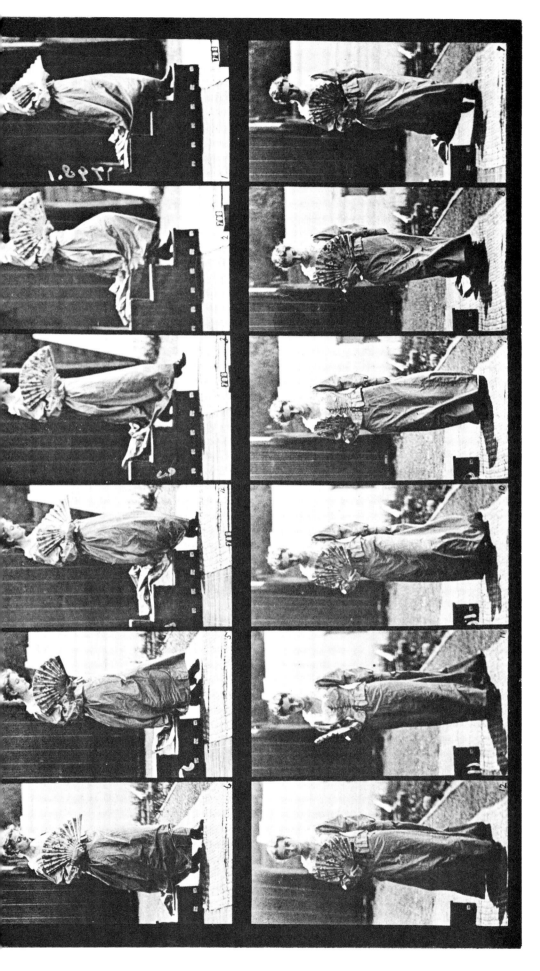

Plate 141. Descending stairs, turning and flirting a fan.

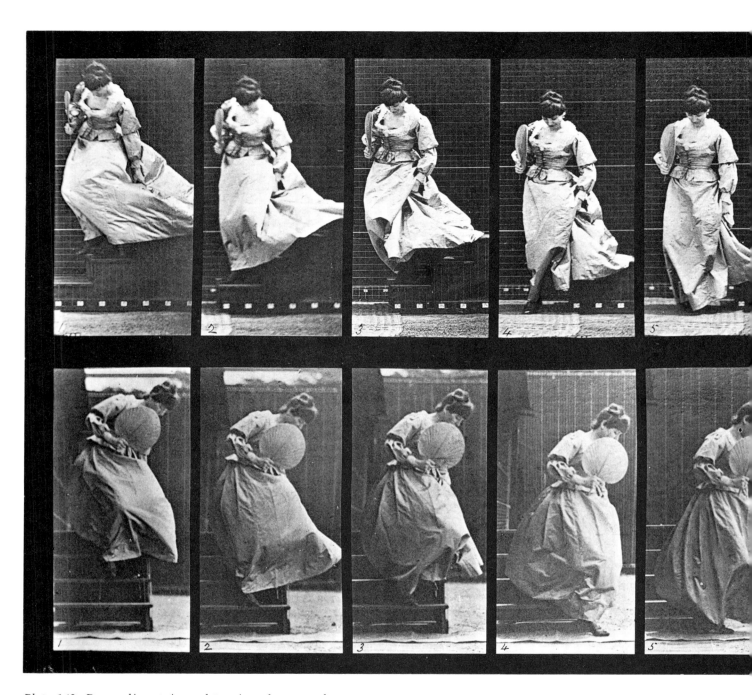

Plate 142. Descending stairs and turning, dress caught.

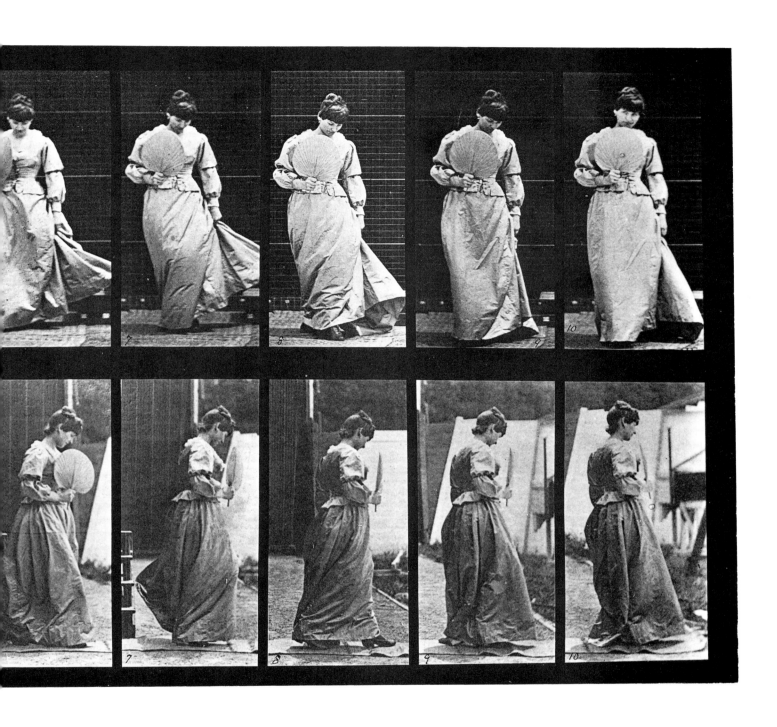

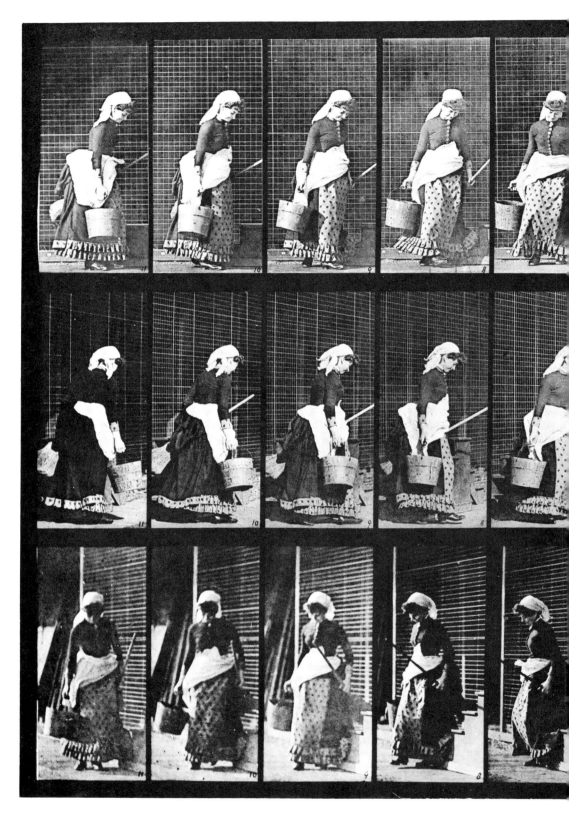

Plate 148. Descending stairs, turning and carrying a bucket of water and a broom.

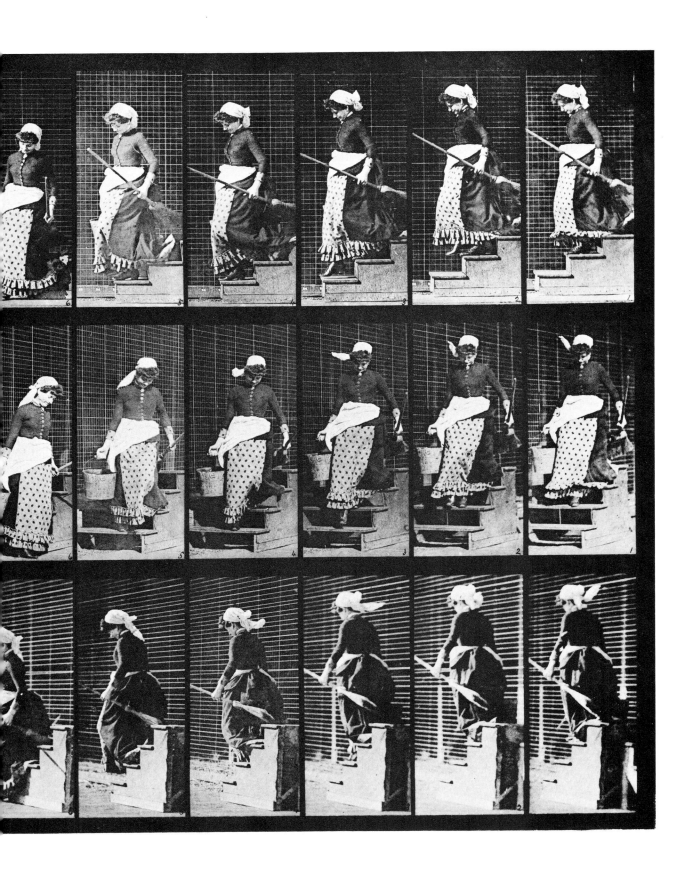

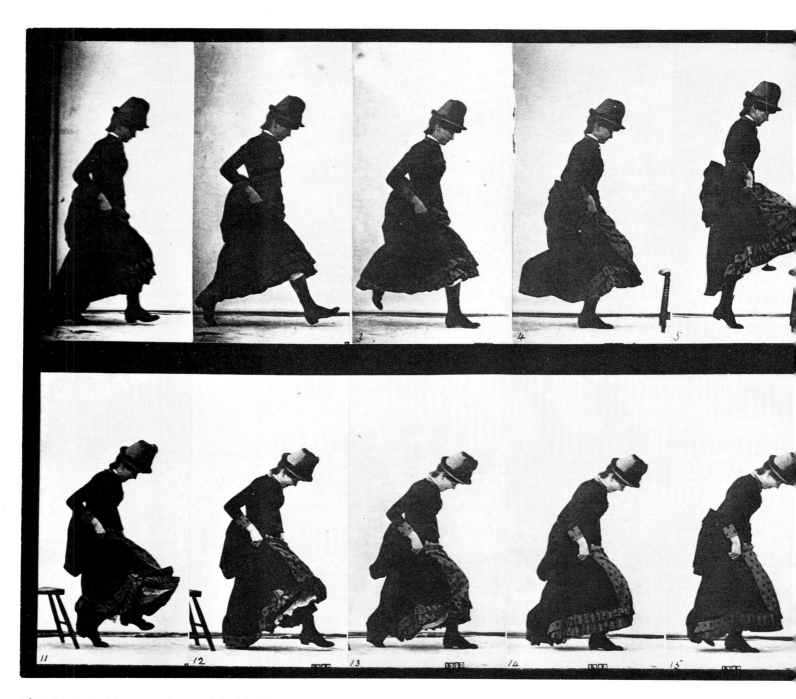

Plate 156. Jumping, running straight high jump.

974 MALES & FEMALES (DRAPED)

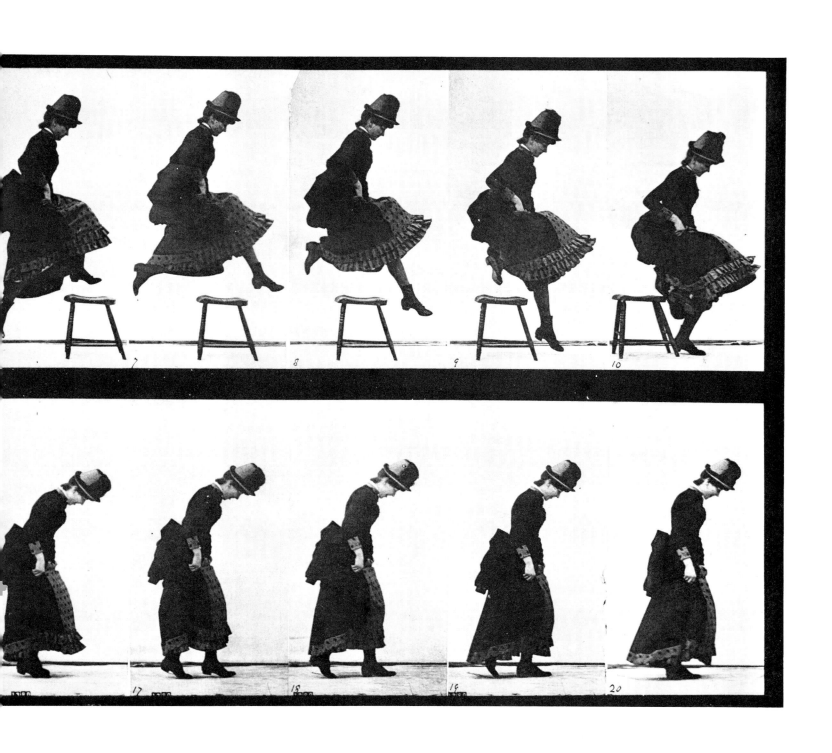

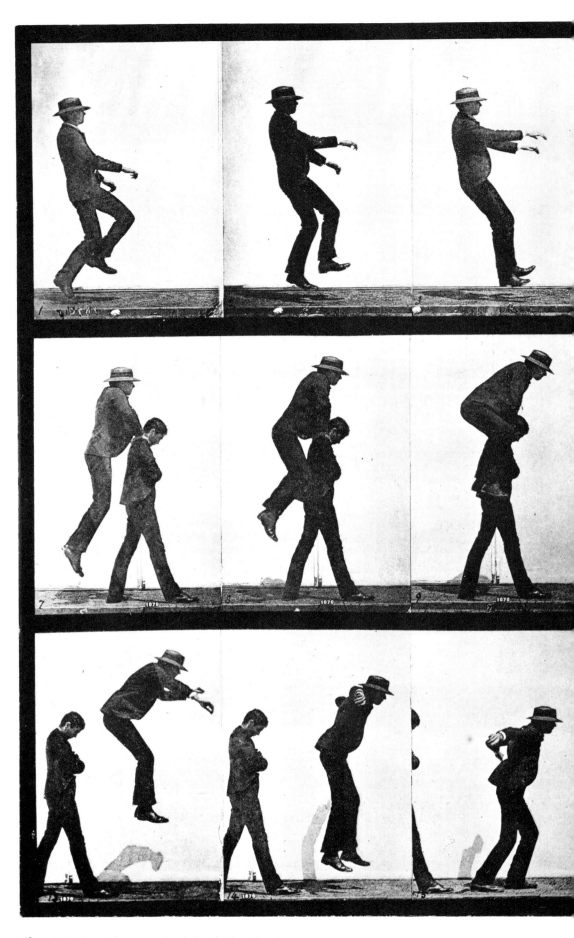

Plate 169. Jumping over boy's back (leapfrog).

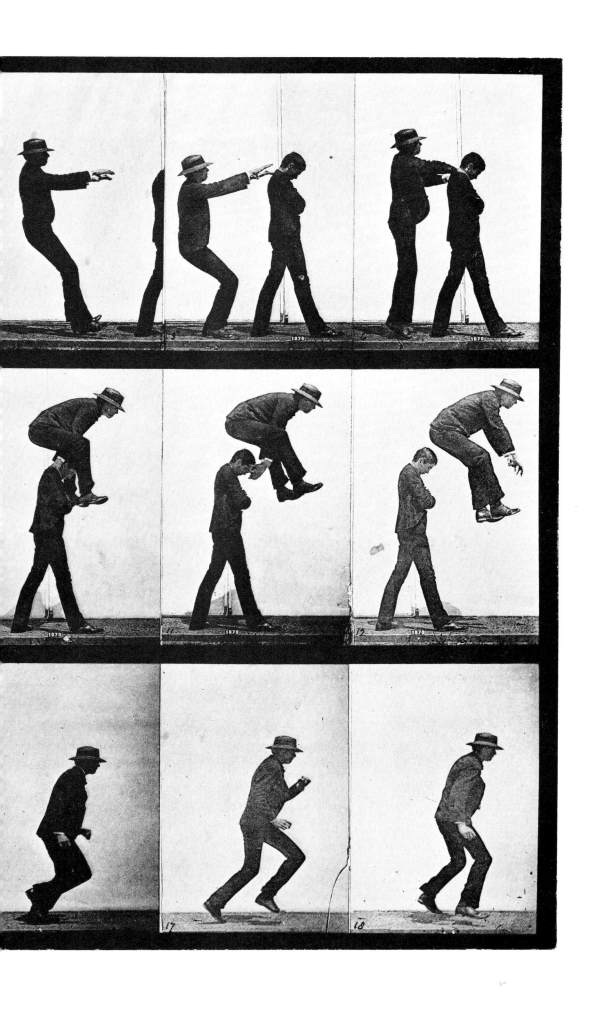

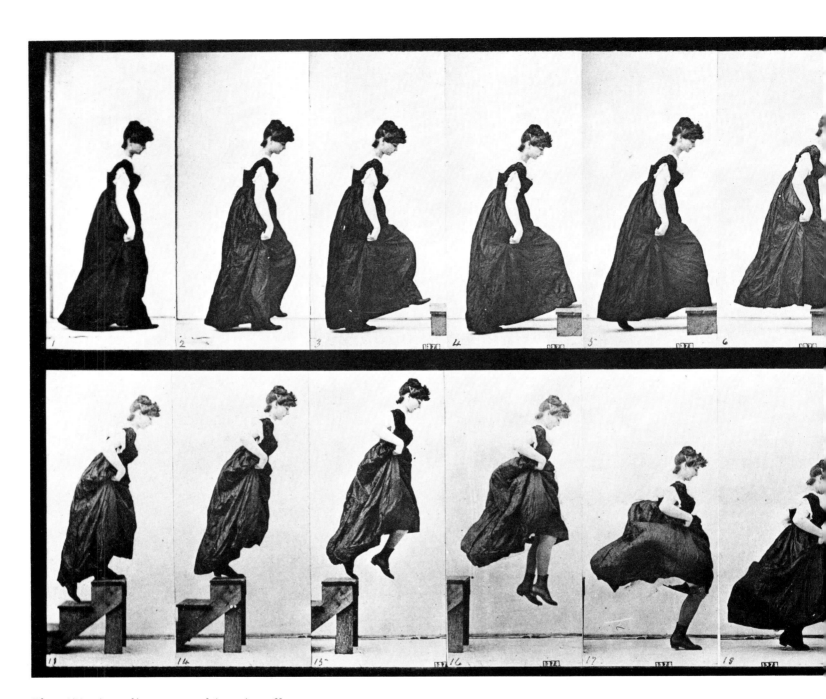

Plate 173. *Ascending steps and jumping off.*

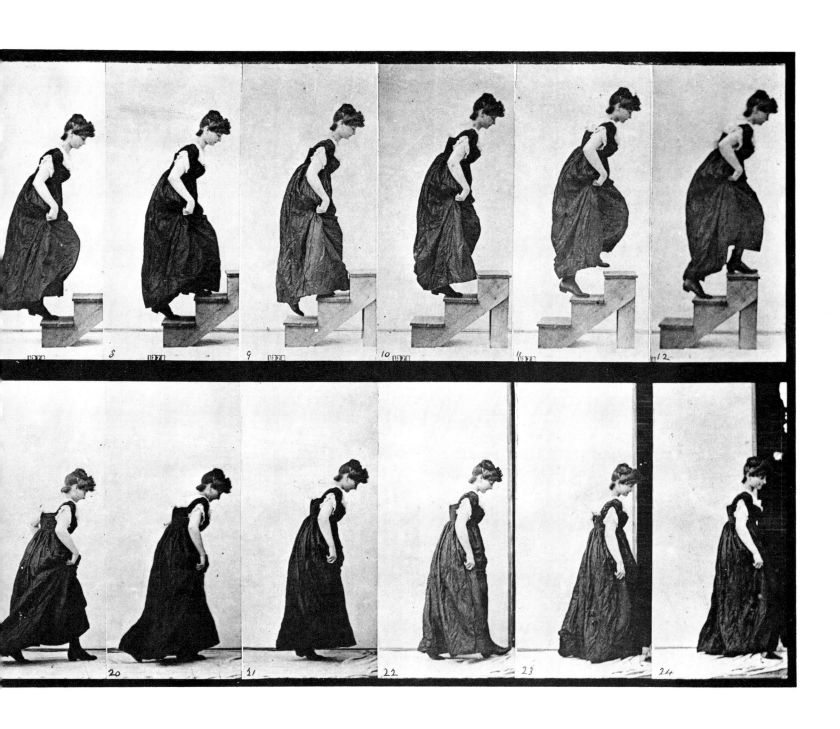

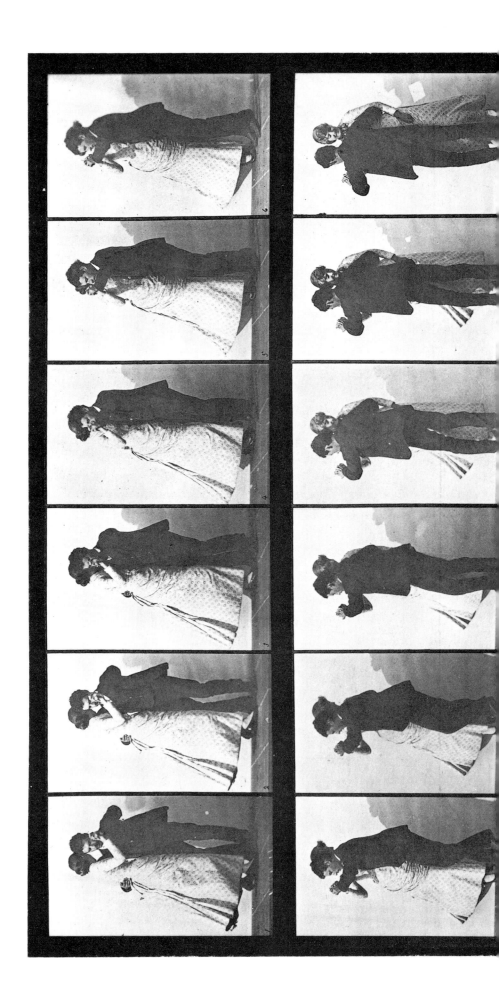

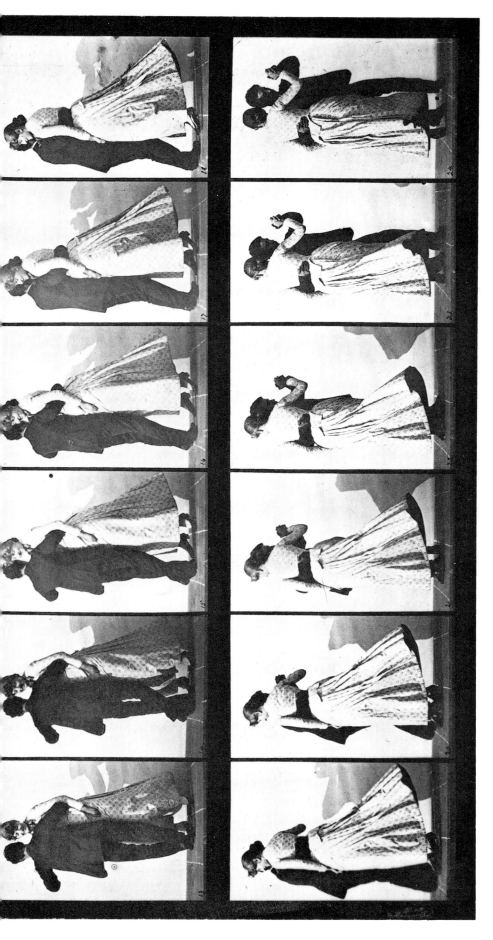

Plate 197. Man and woman dancing a waltz.

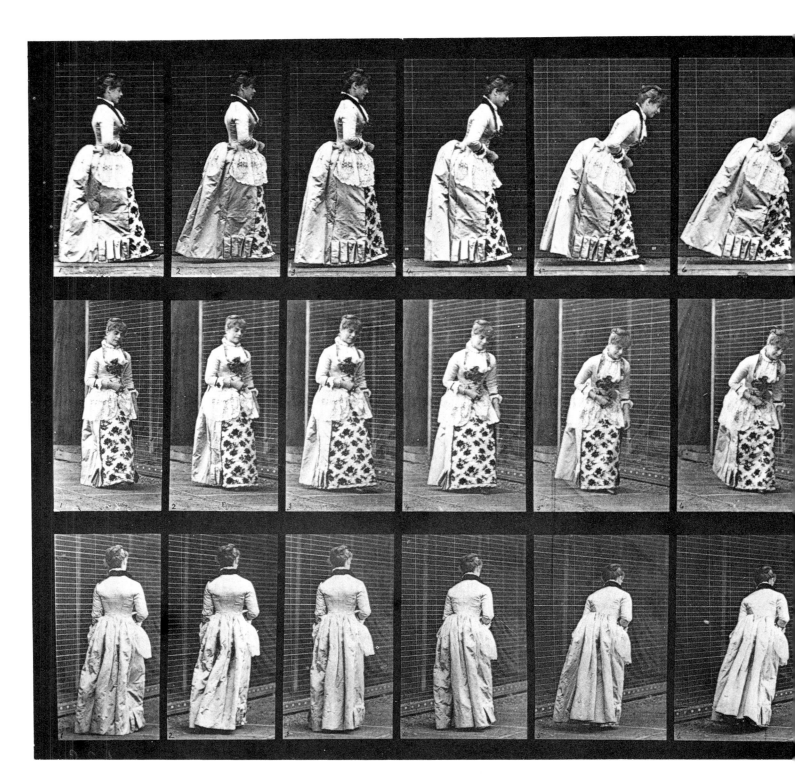

Plate 198. Curtseying.

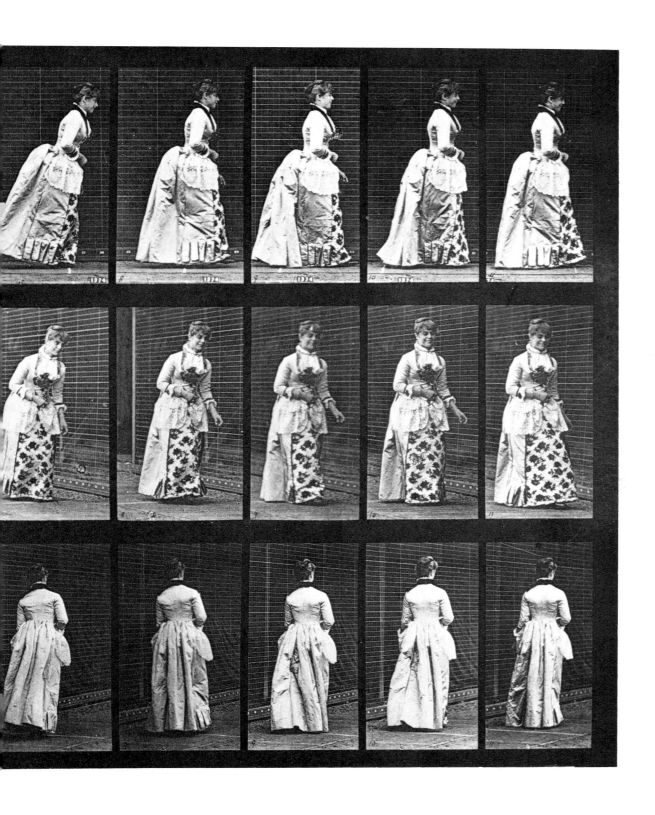

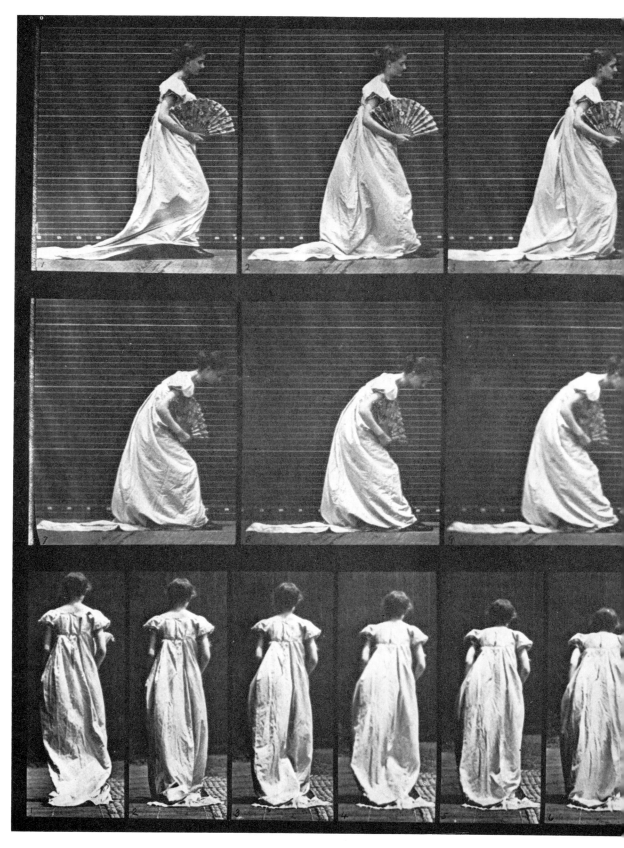

Plate 199. Curtseying, a fan in right hand.

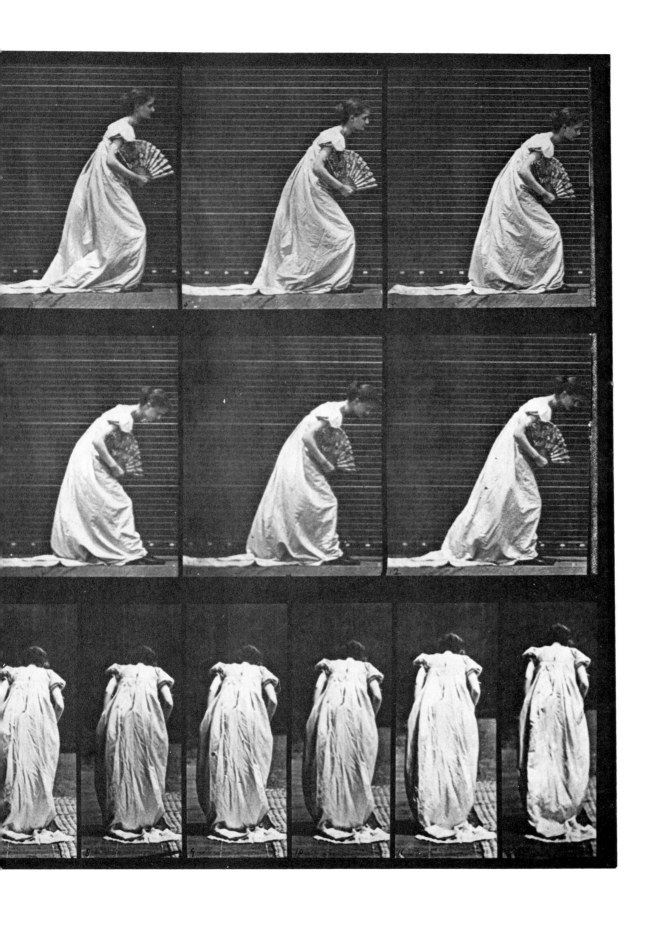

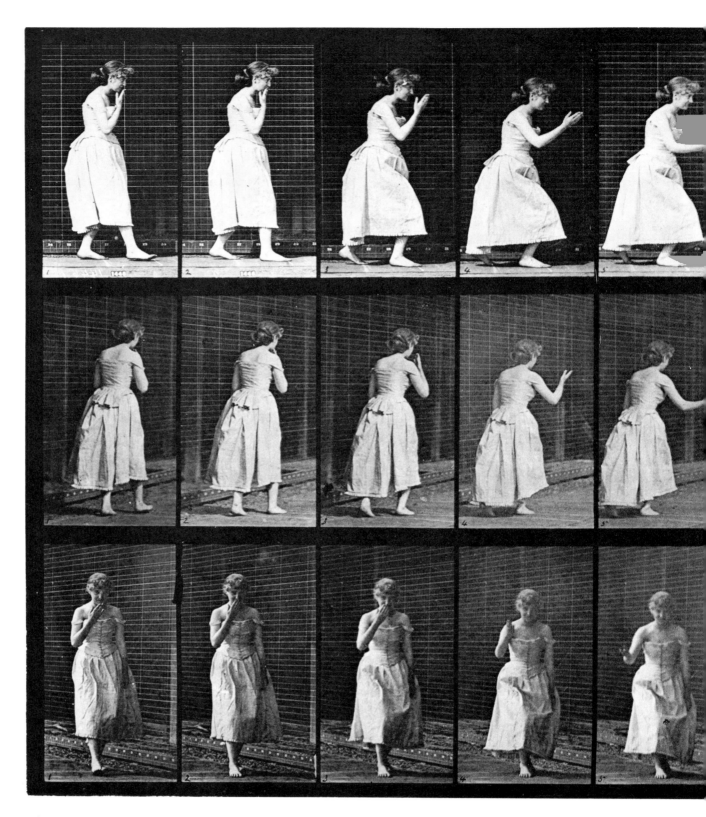

Plate 200. Curtseying, kissing hand and turning around.

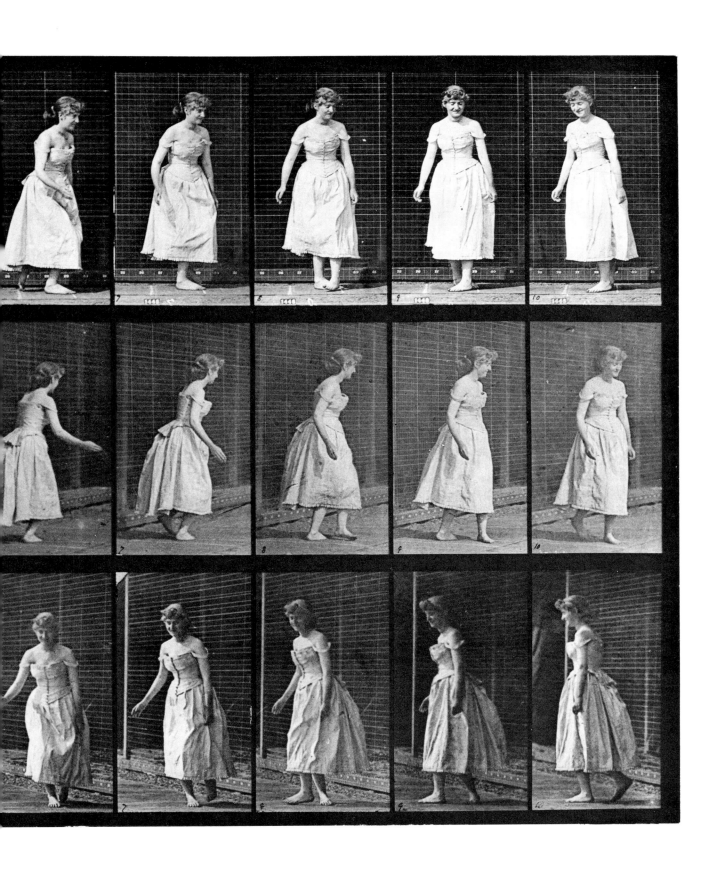

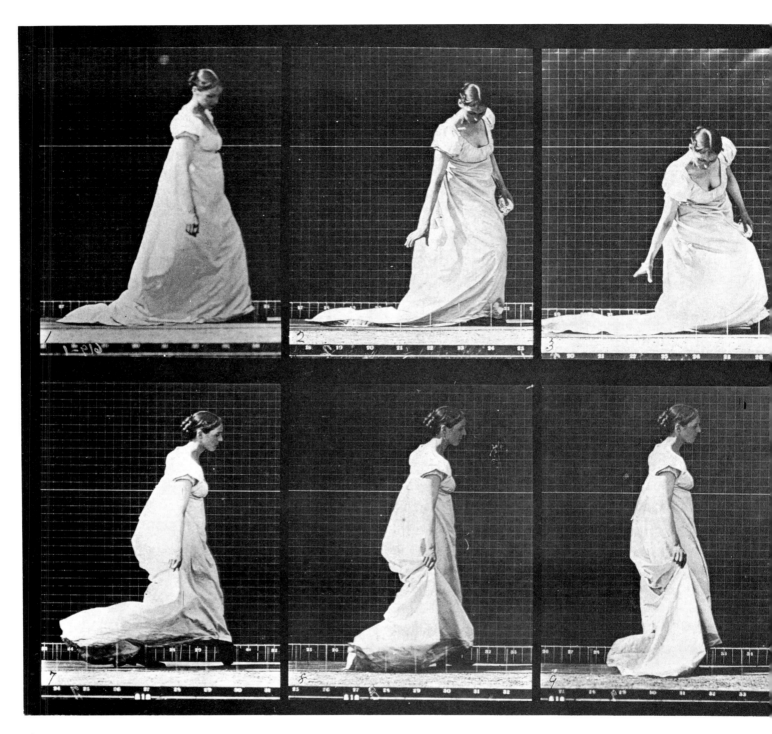

Plate 207. Stooping and lifting train.

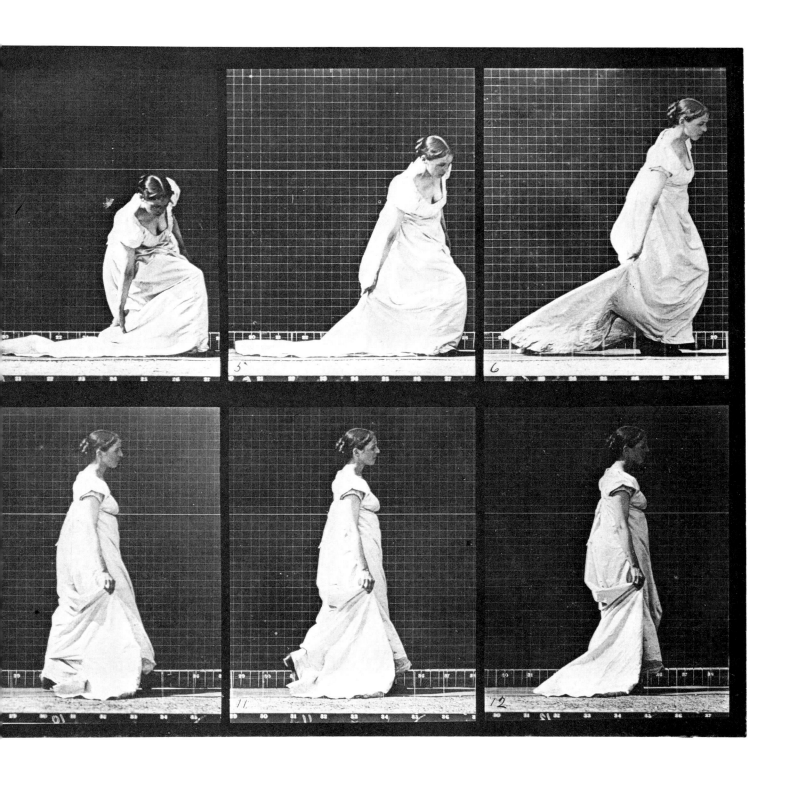

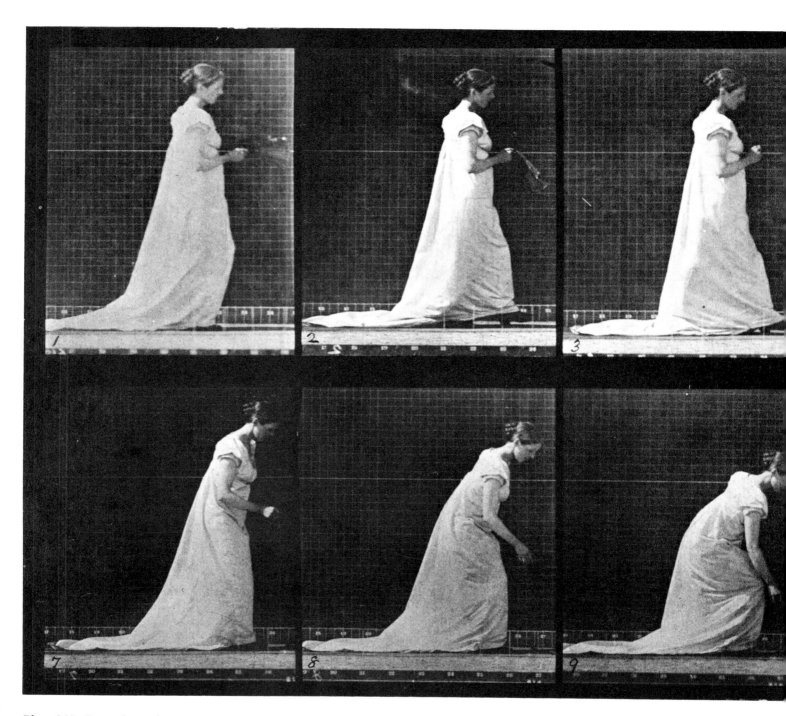

Plate 208. Dropping a fan and stooping to lift it.

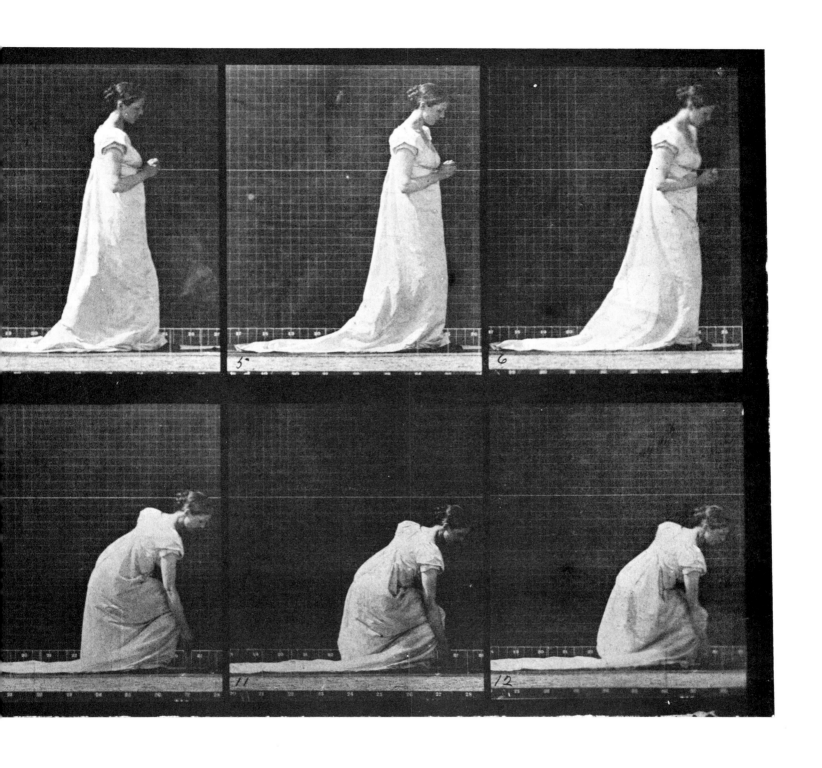

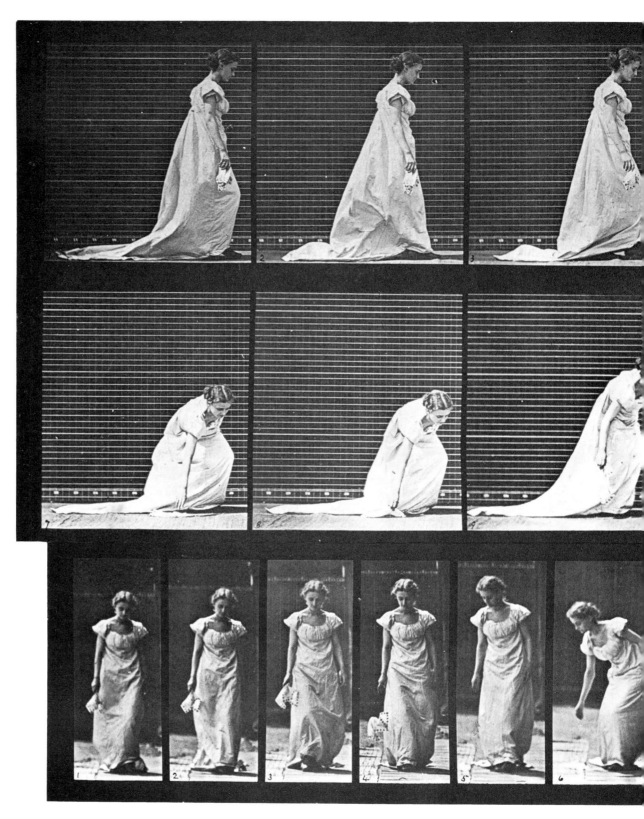

Plate 209. Stooping and lifting a handkerchief.

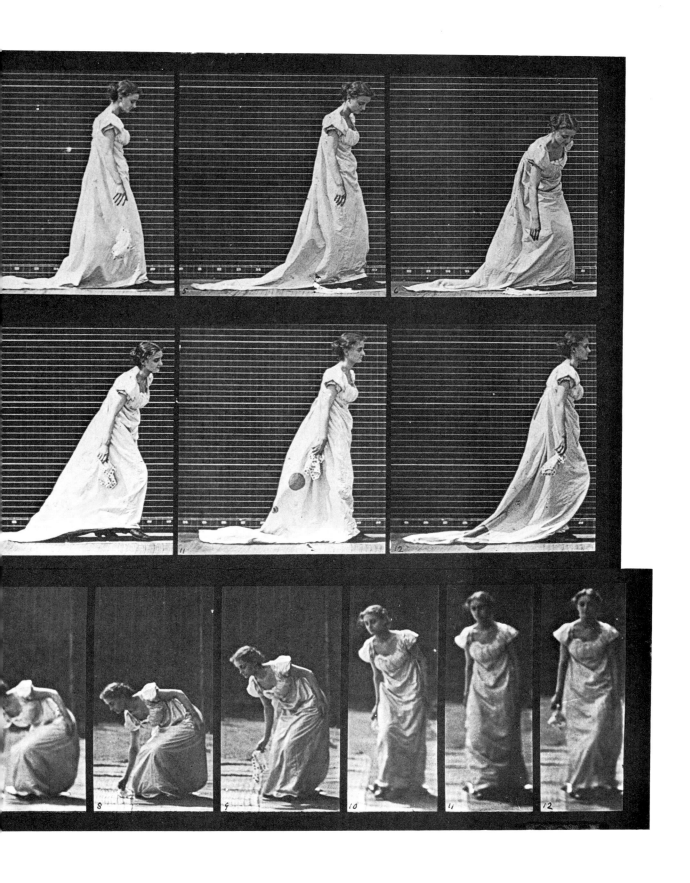

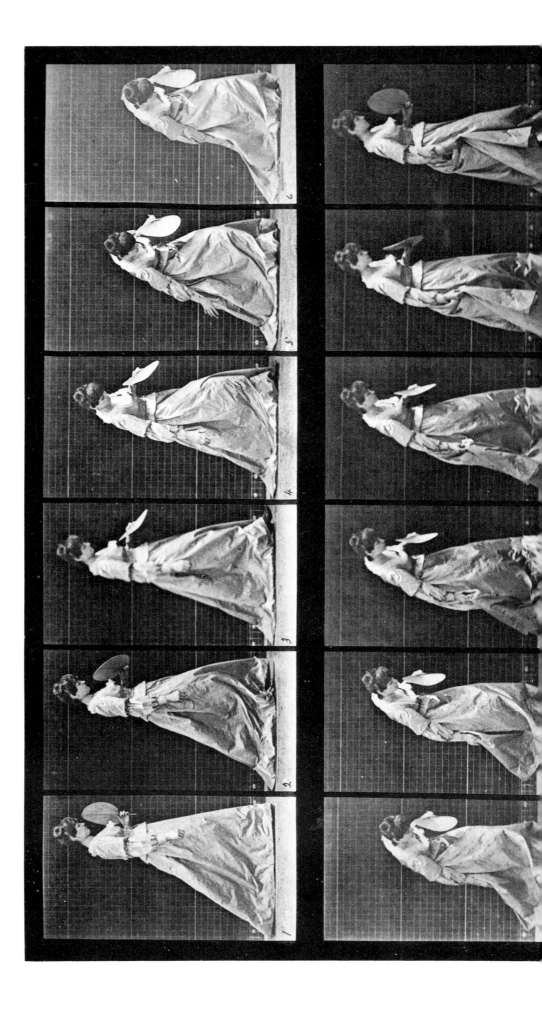

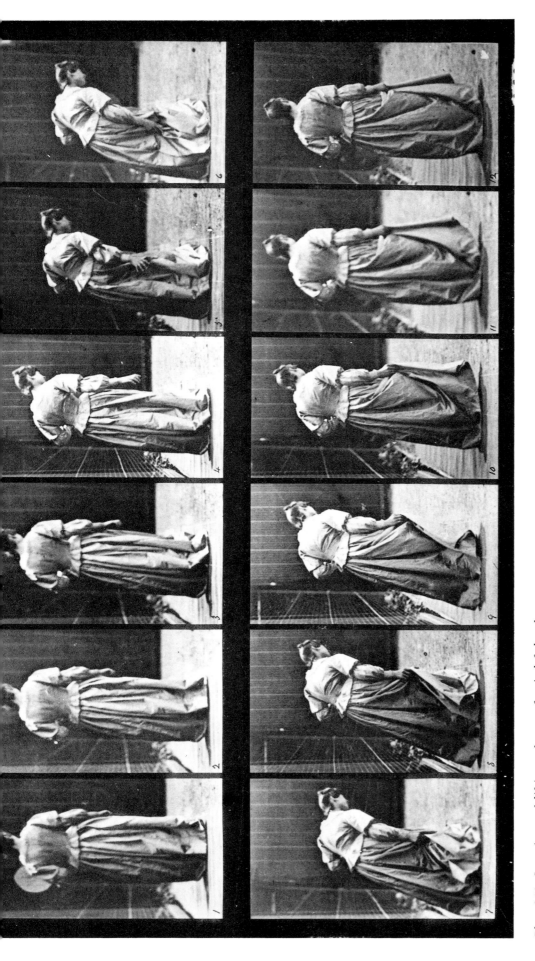

Plate 210. Stooping and lifting a dress, a fan in left hand.

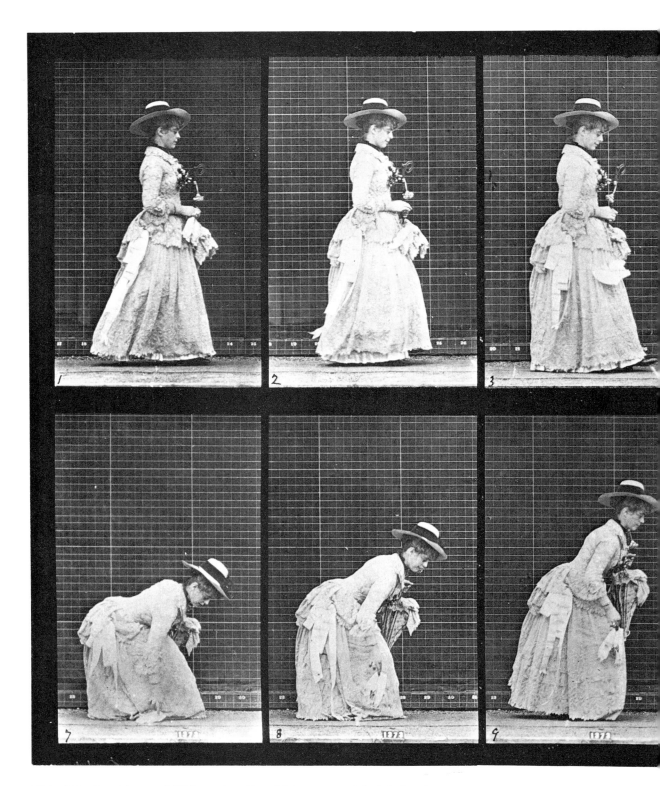

Plate 211. Stooping and lifting a handkerchief, a parasol in left hand.

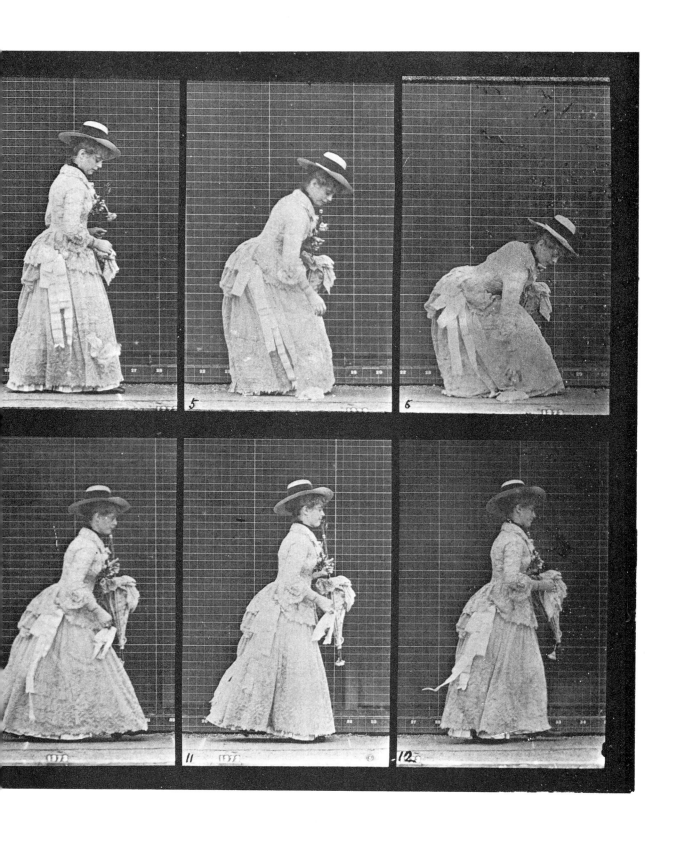

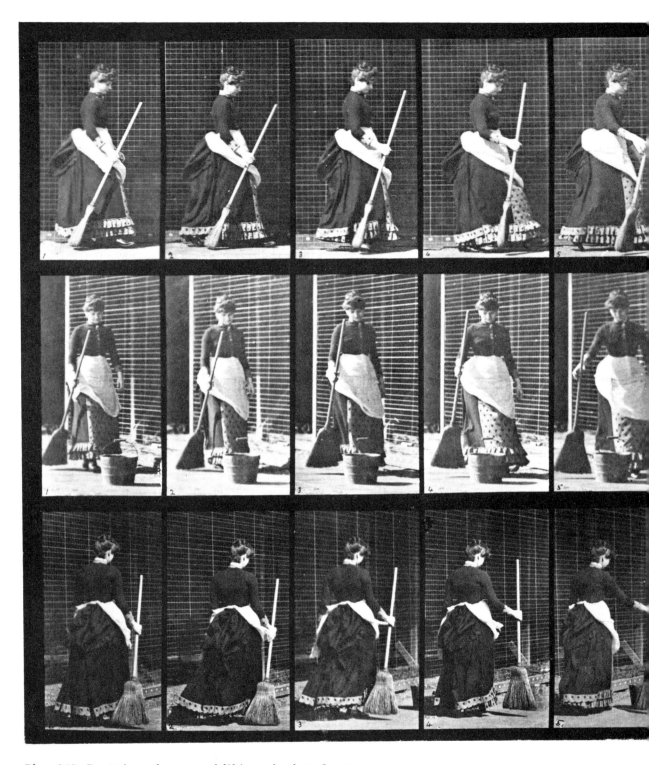

Plate 212. Dropping a broom and lifting a bucket of water.

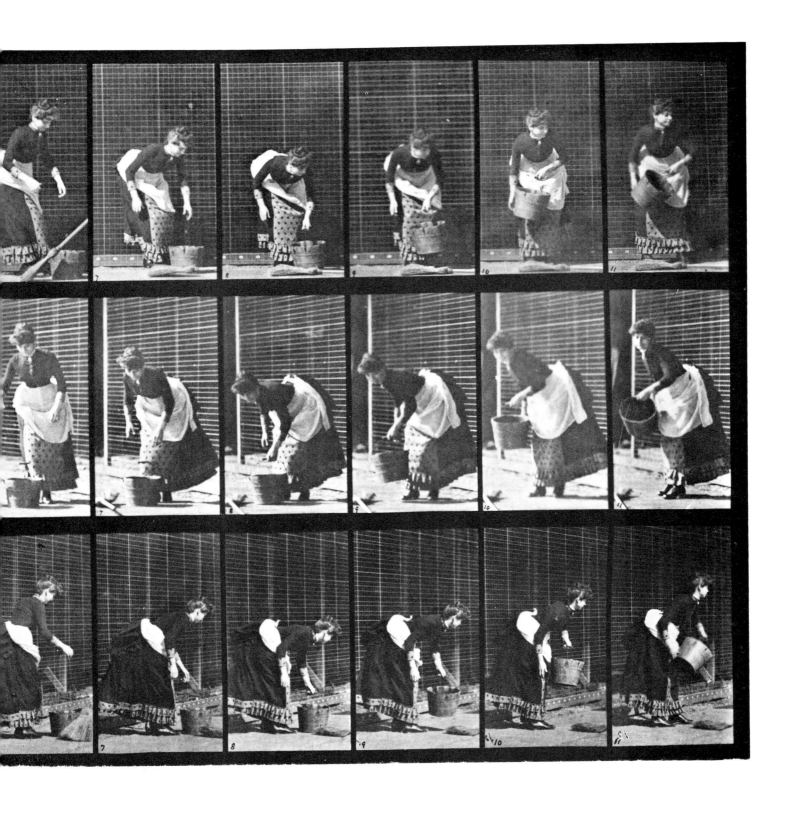

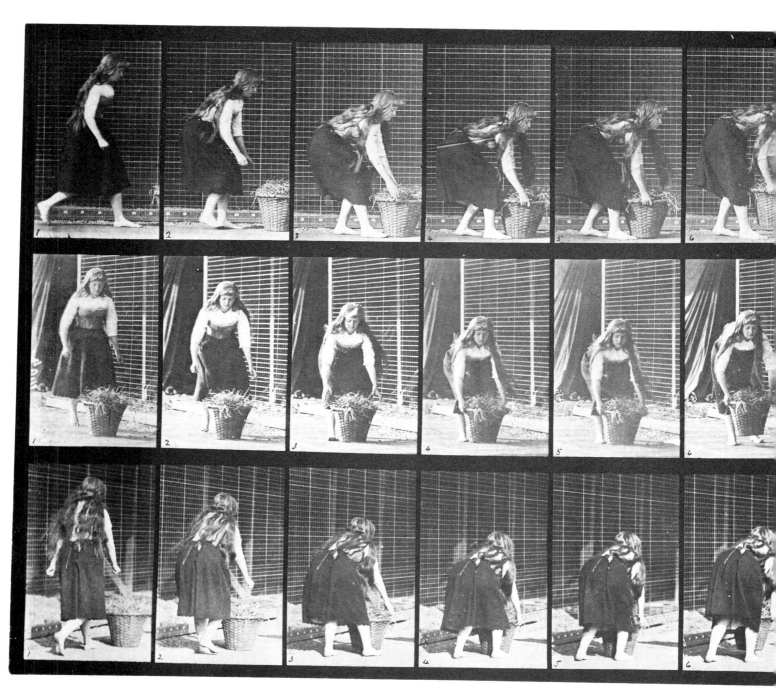

Plate 217. Stooping, lifting and carrying a 30-lb. basket.

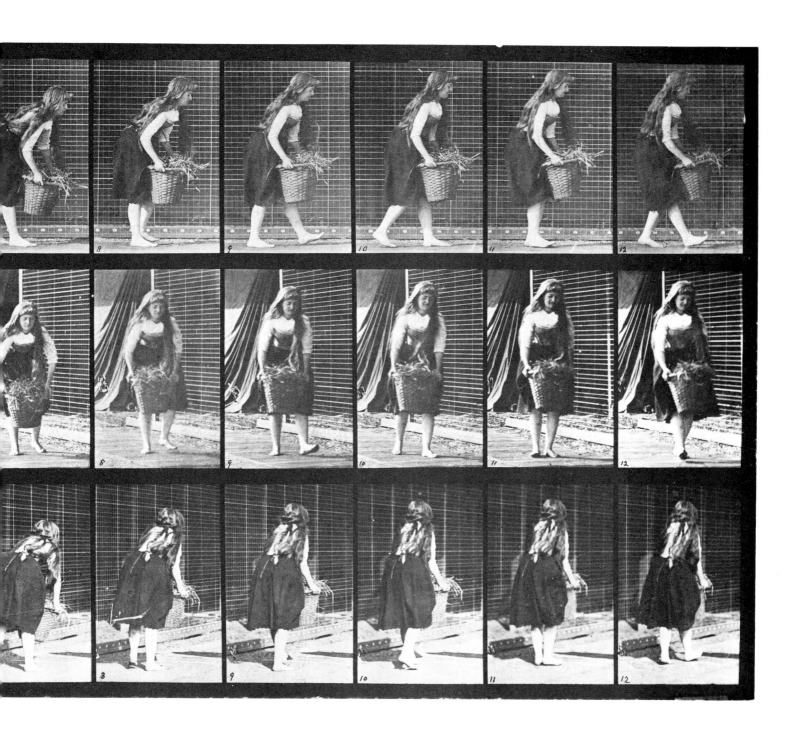

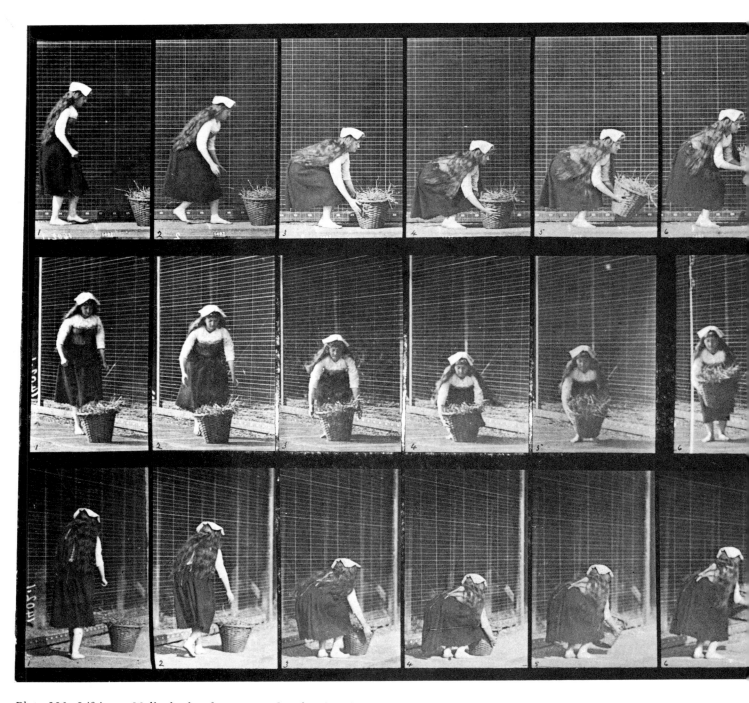

Plate 230. Lifting a 30-lb. basket from ground to head and turning.

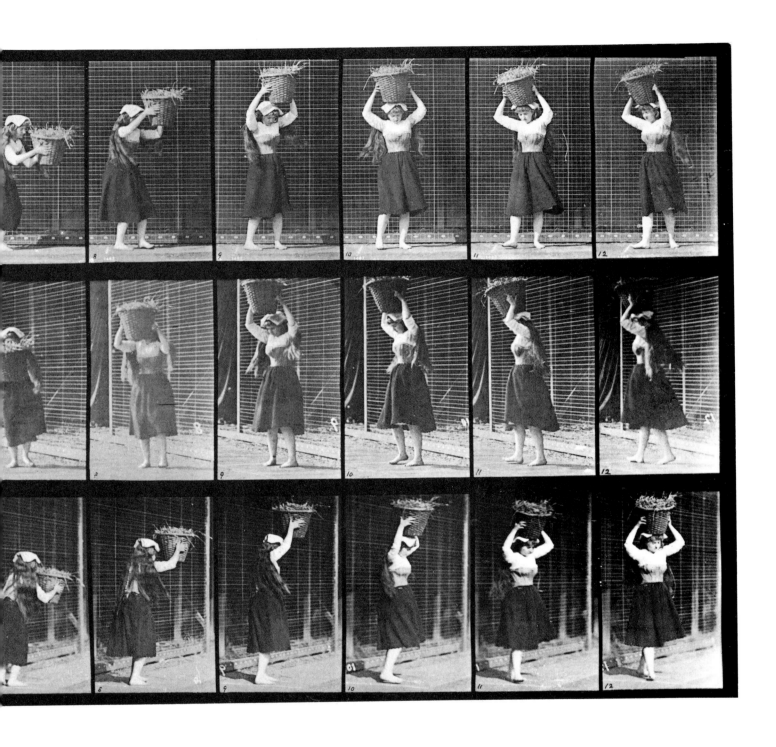

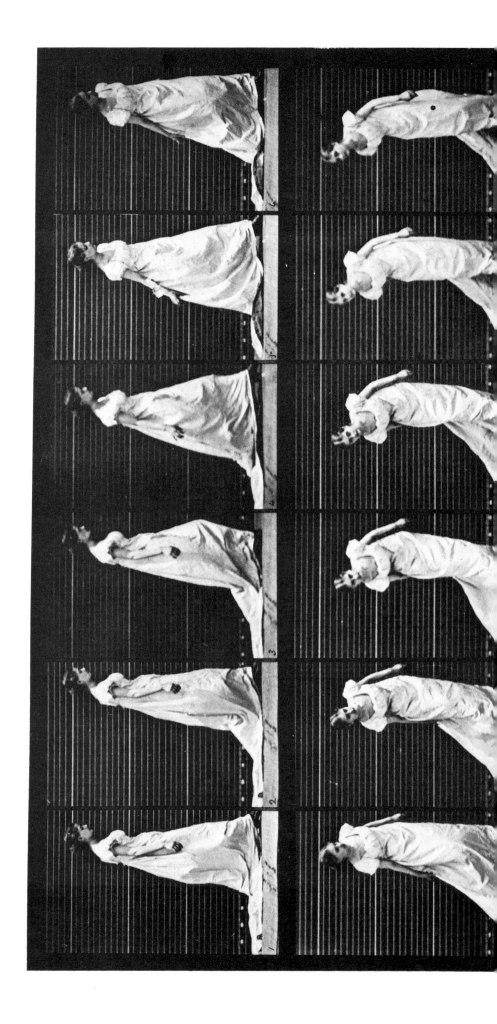

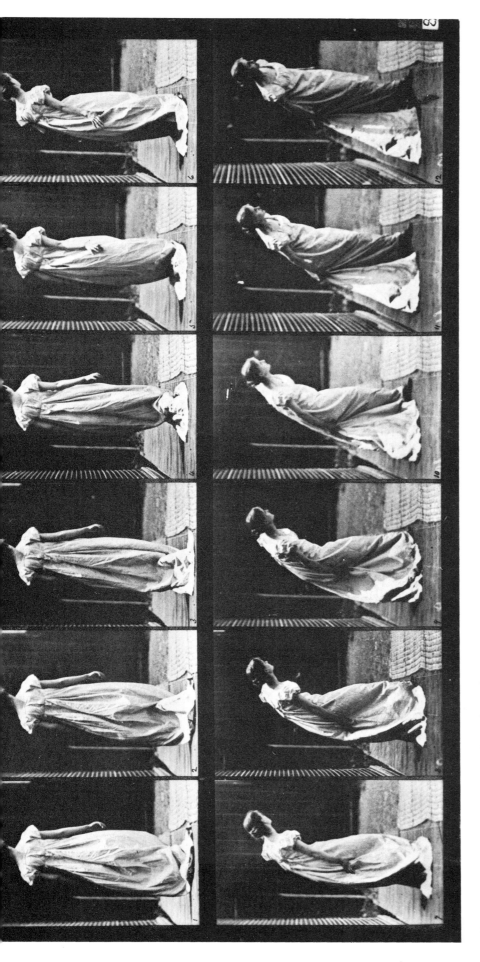

Plate 231. Stooping to arrange train and turning.

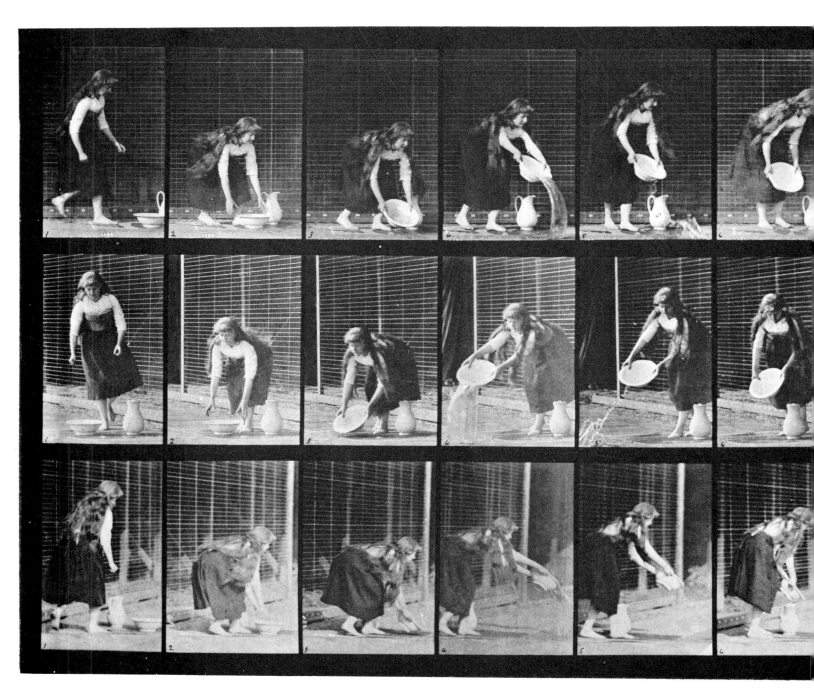

Plate 234. Lifting and emptying a basin of water and turning.

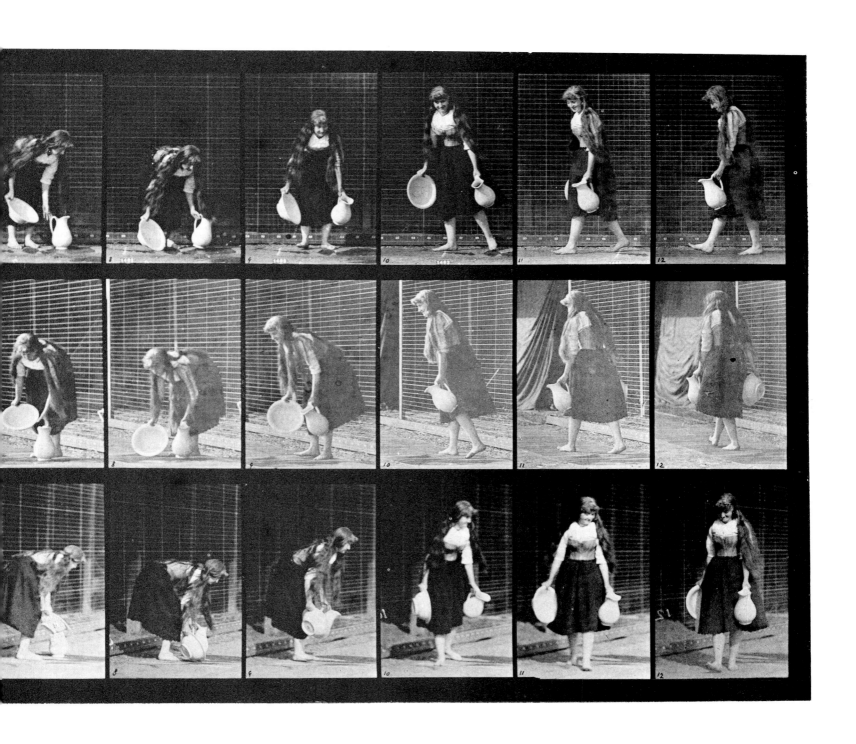

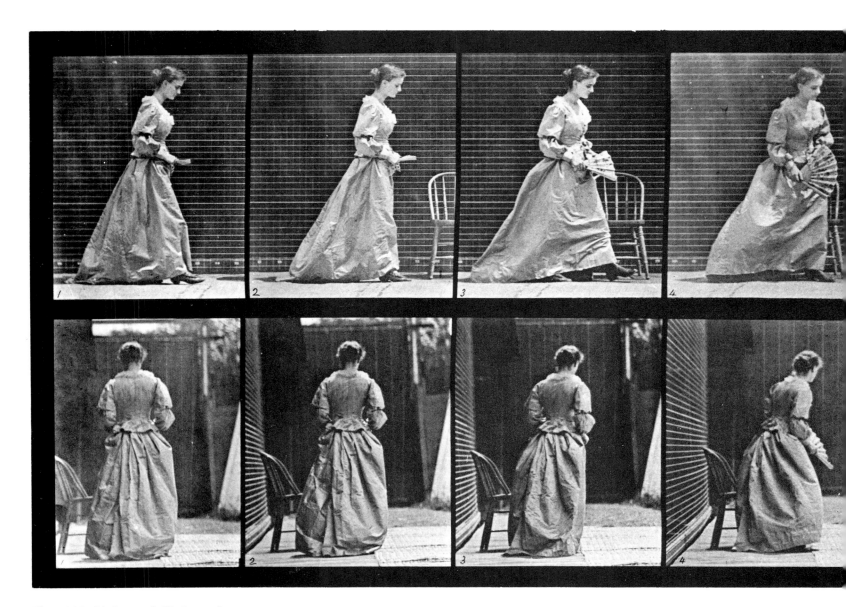

Plate 240. Sitting and flirting a fan.

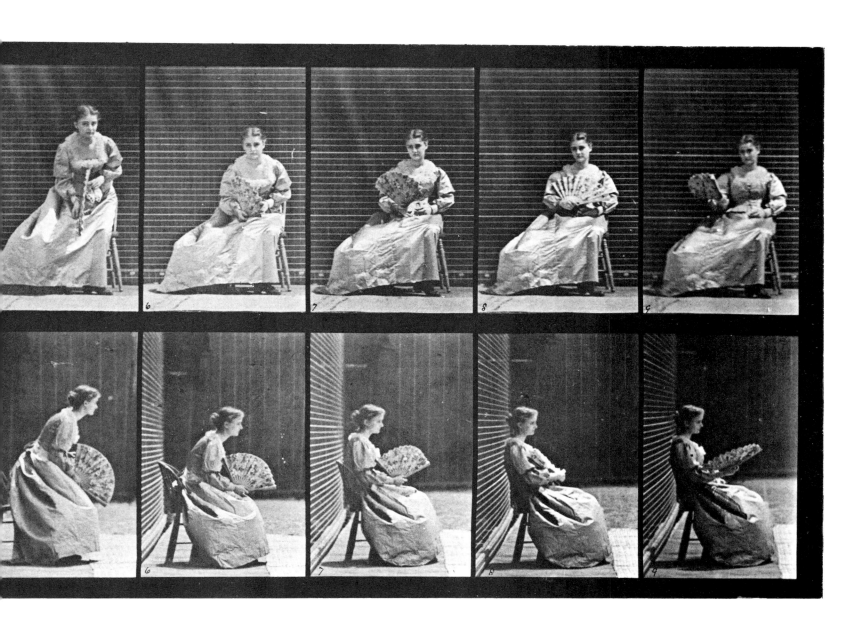

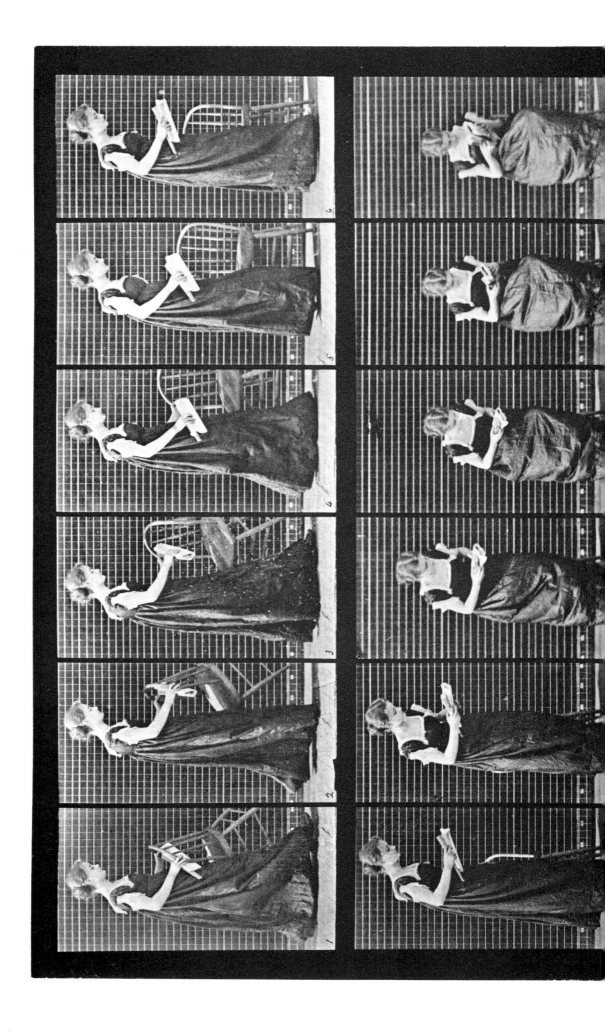

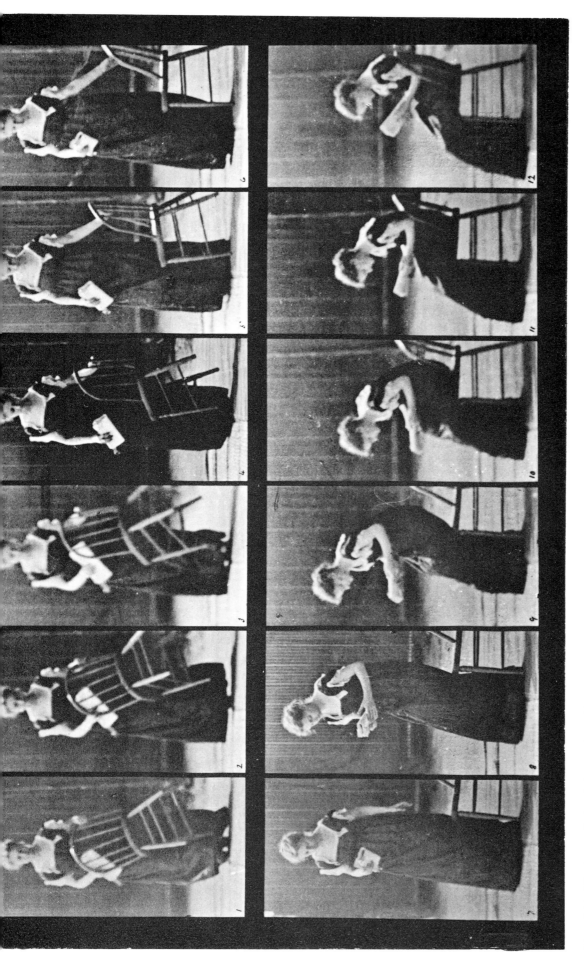

Plate 241. Placing a chair, sitting and reading.

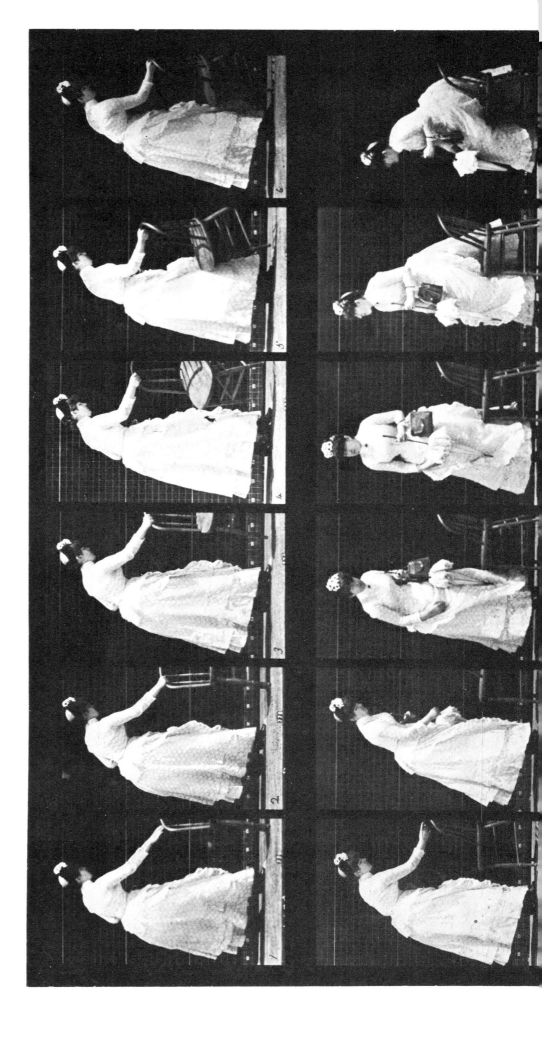

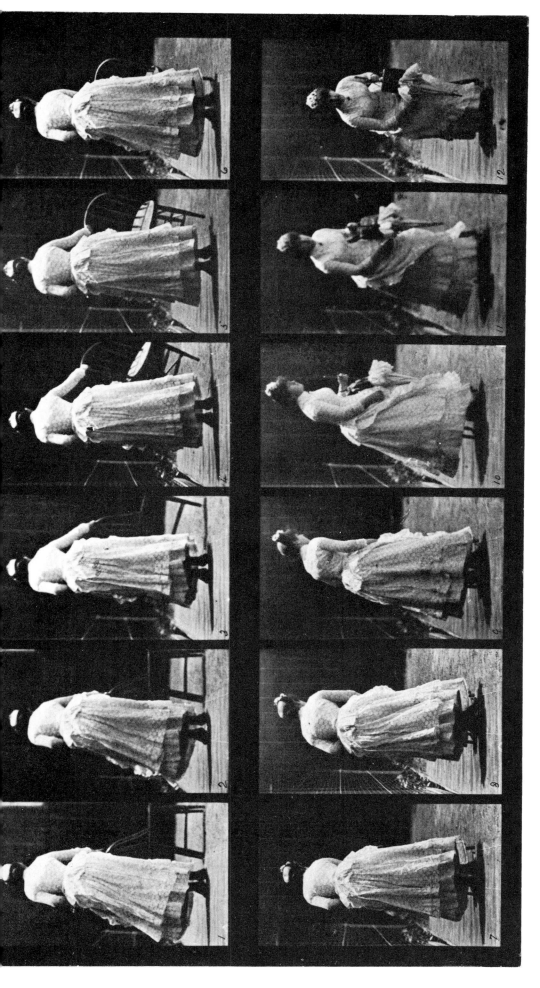

Plate 243. Placing a chair and sitting, parasol in left hand.

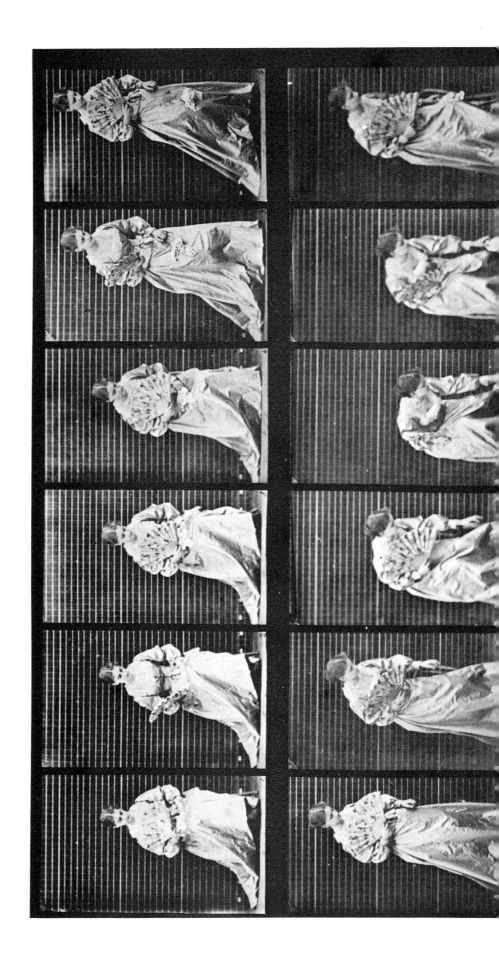

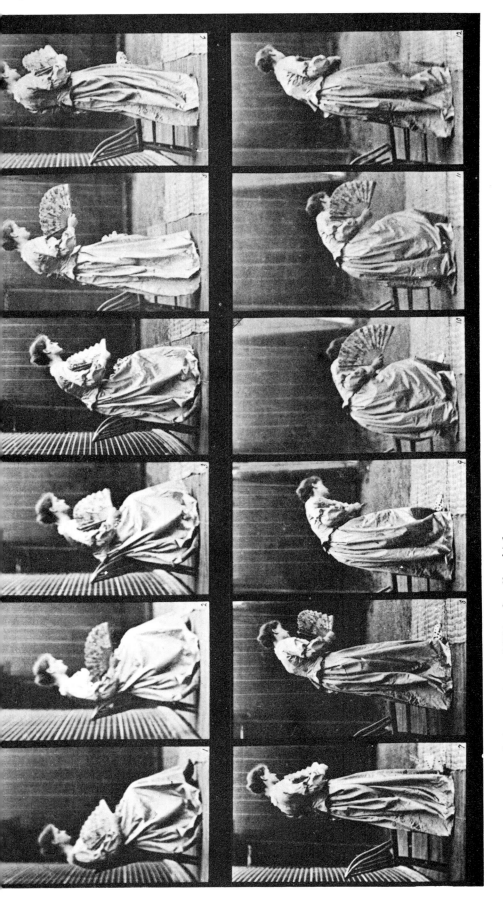

Plate 250. Rising from chair, stooping and lifting handkerchief.

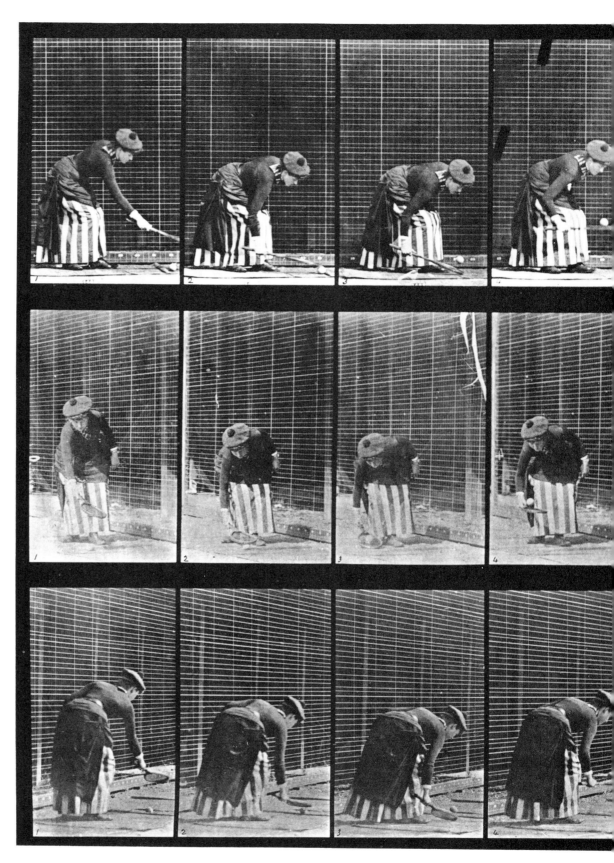

Plate 295. Lawn tennis.

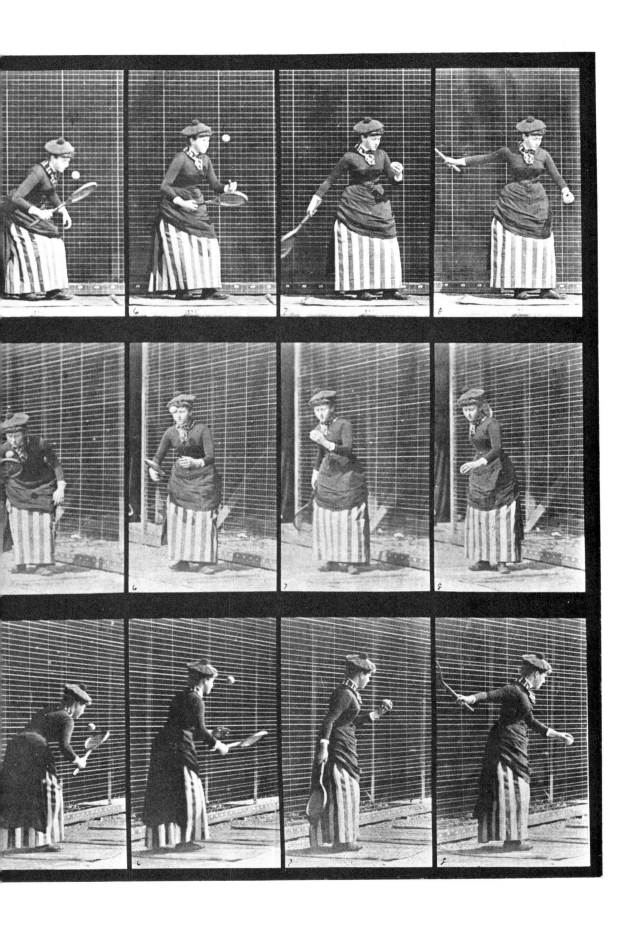

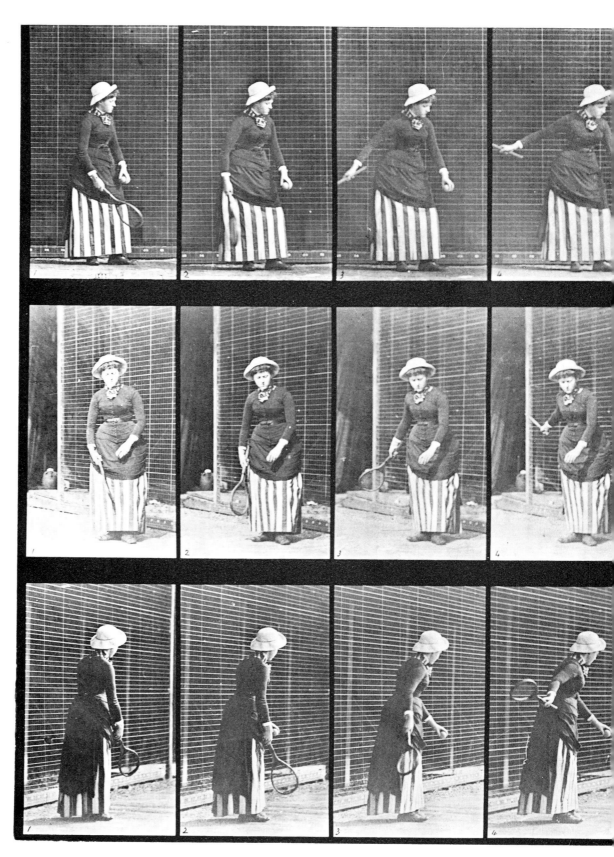

Plate 296. Lawn tennis.

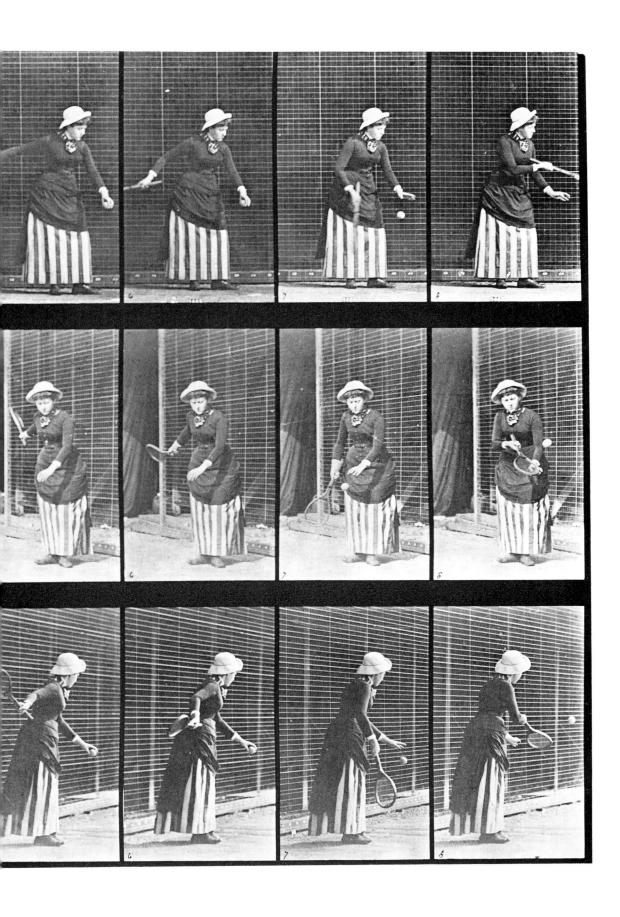

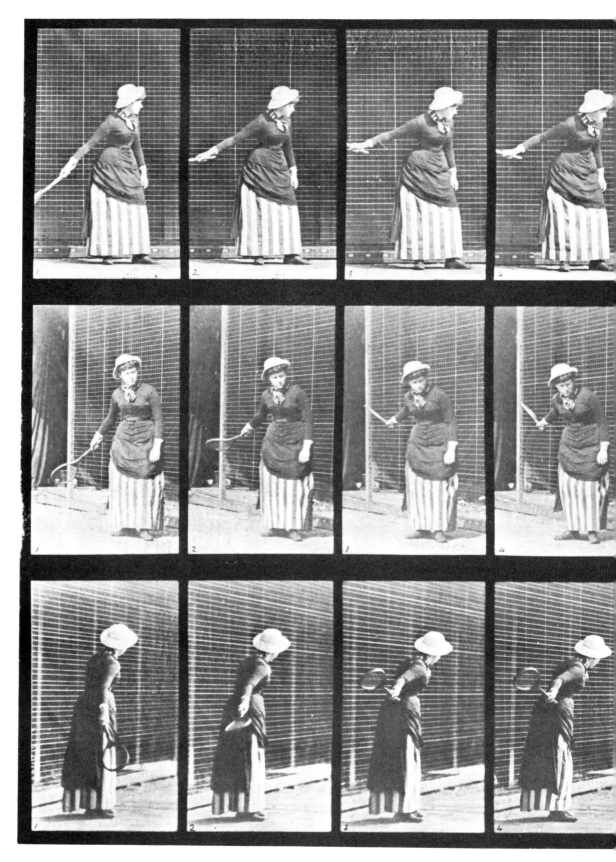

Plate 297. Lawn tennis.

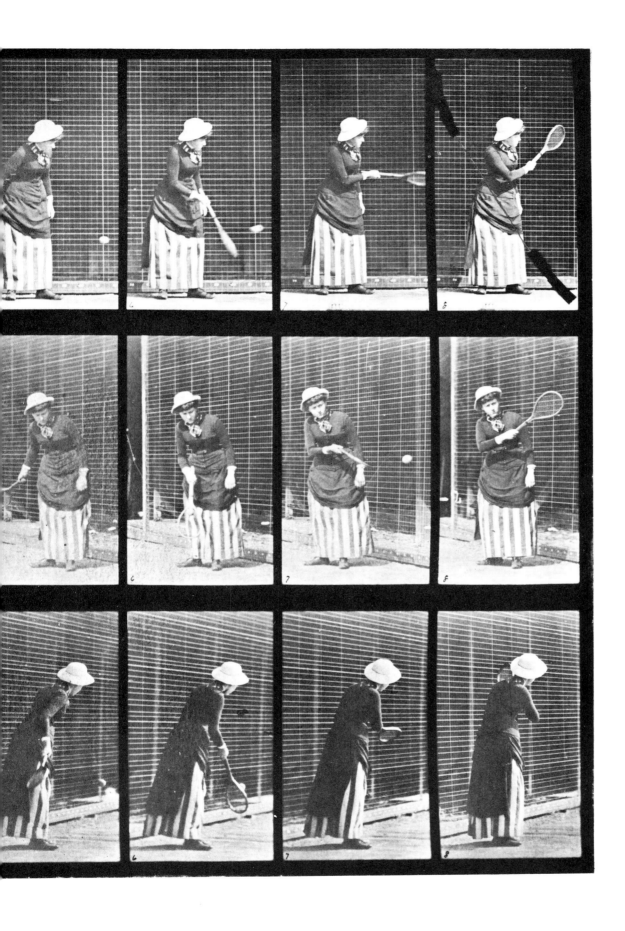

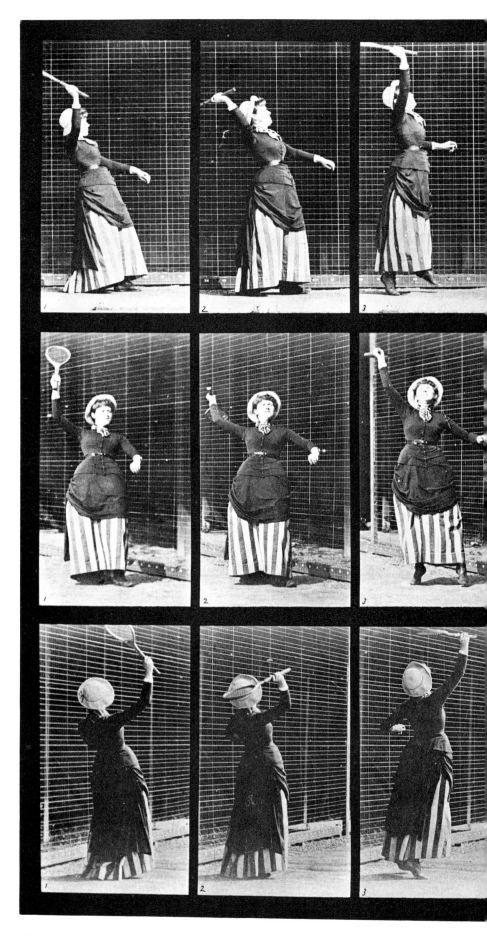

Plate 298. Lawn tennis.

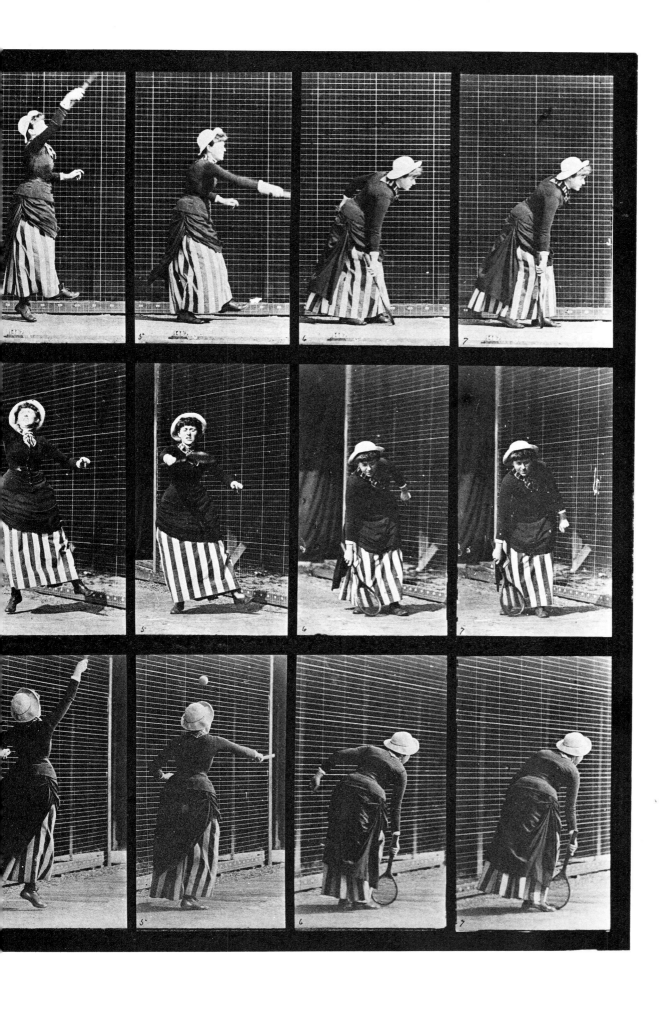

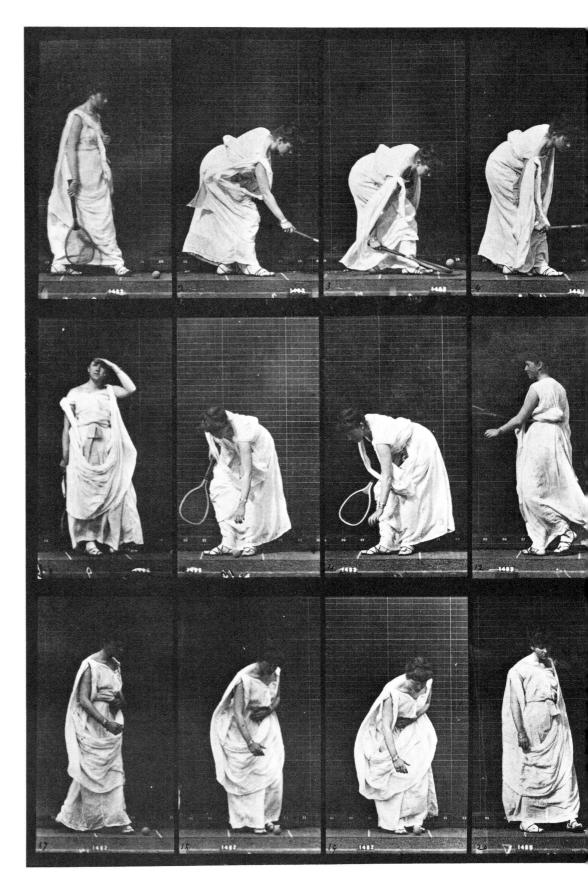

Plate 299. Playing with a ball.

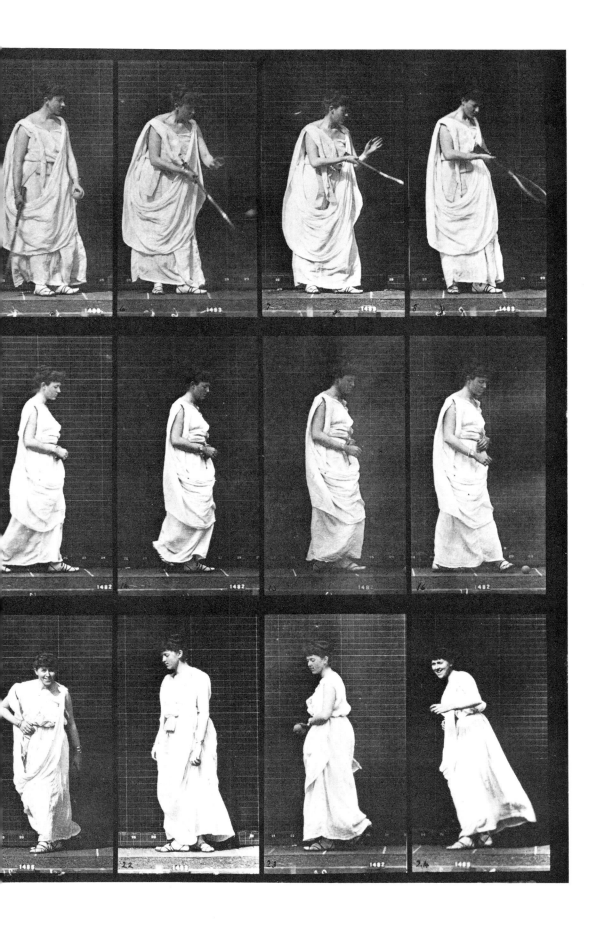

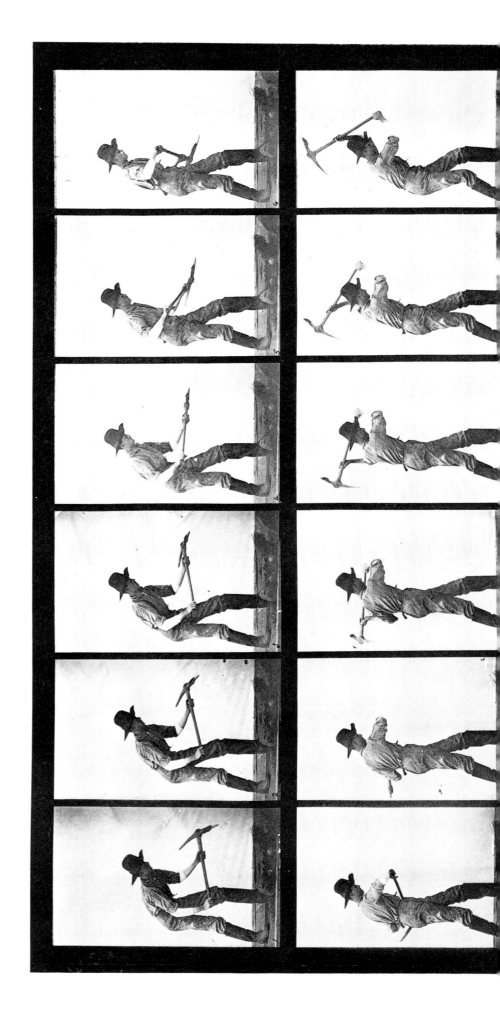

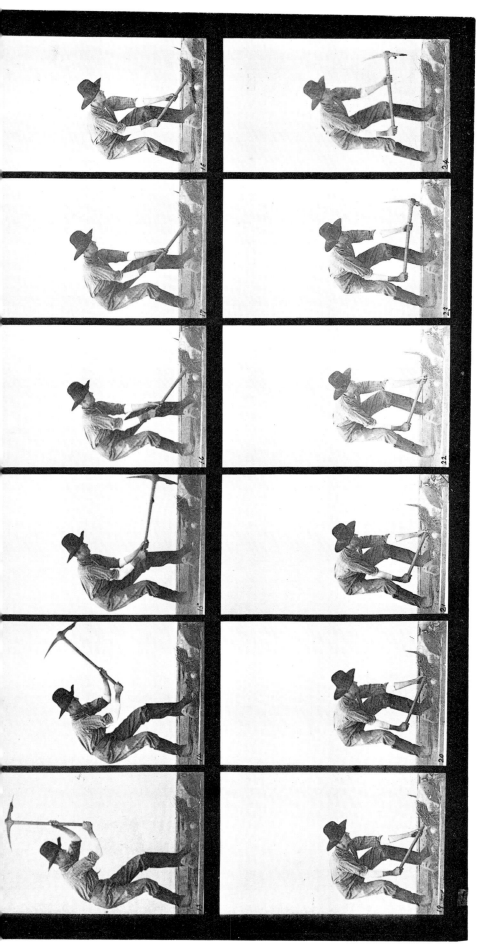

Plate 386. Miner, using a pick.

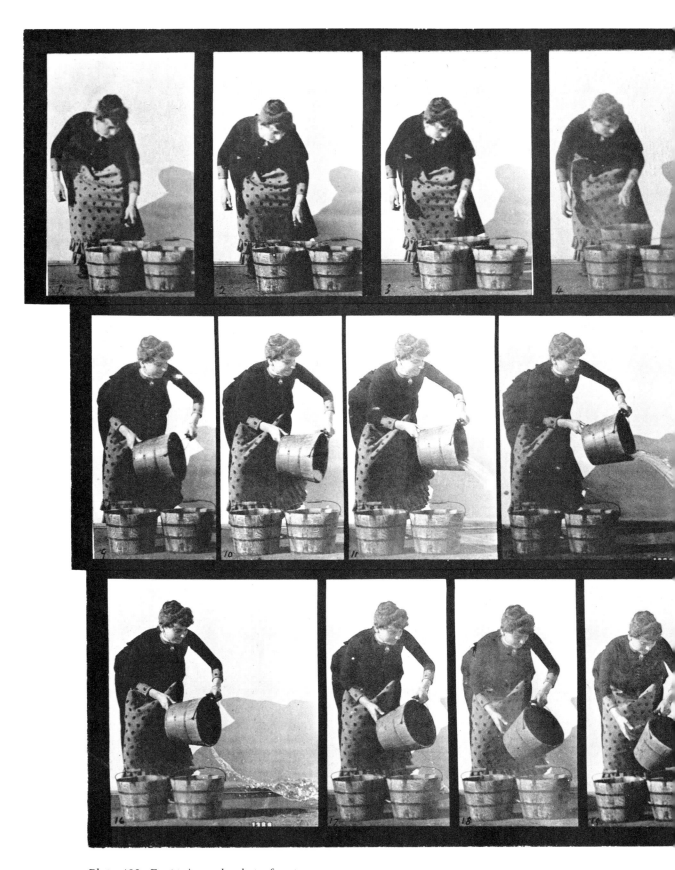

Plate 403. Emptying a bucket of water.

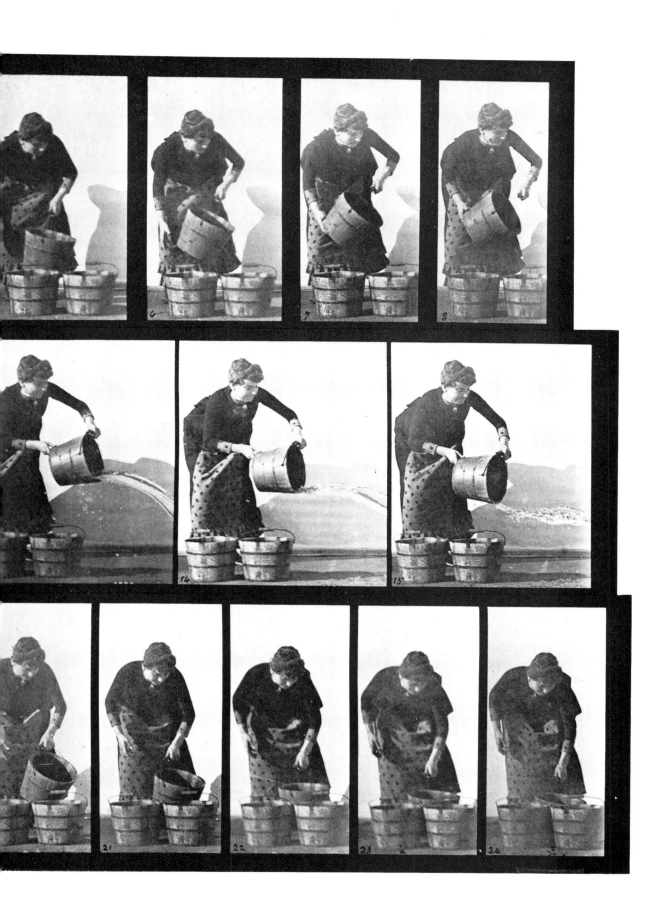

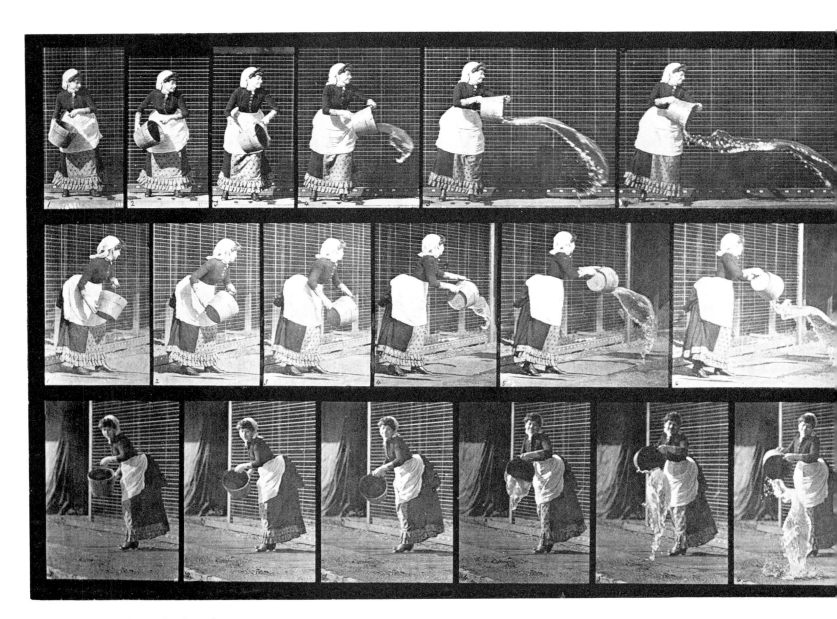

Plate 404. Emptying a bucket of water.

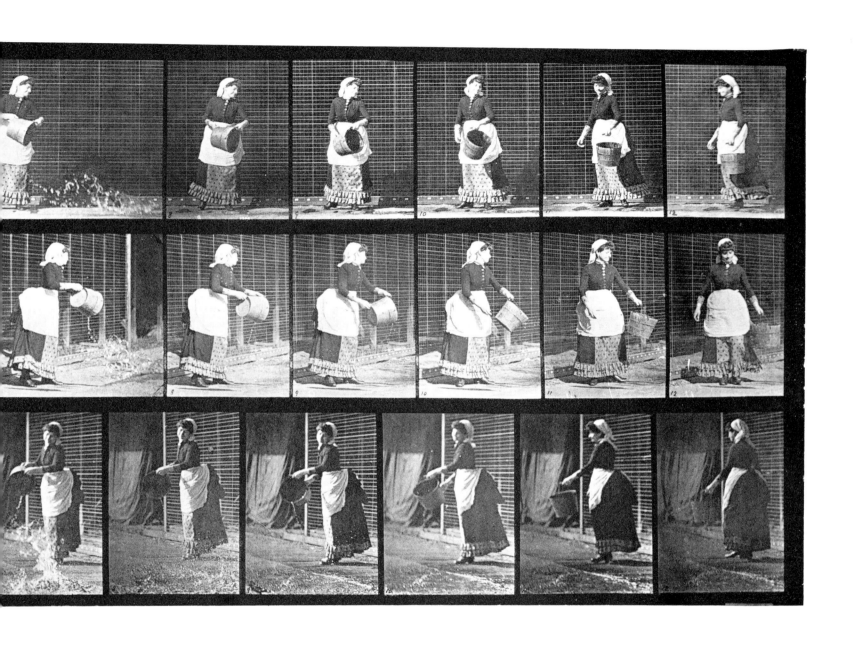

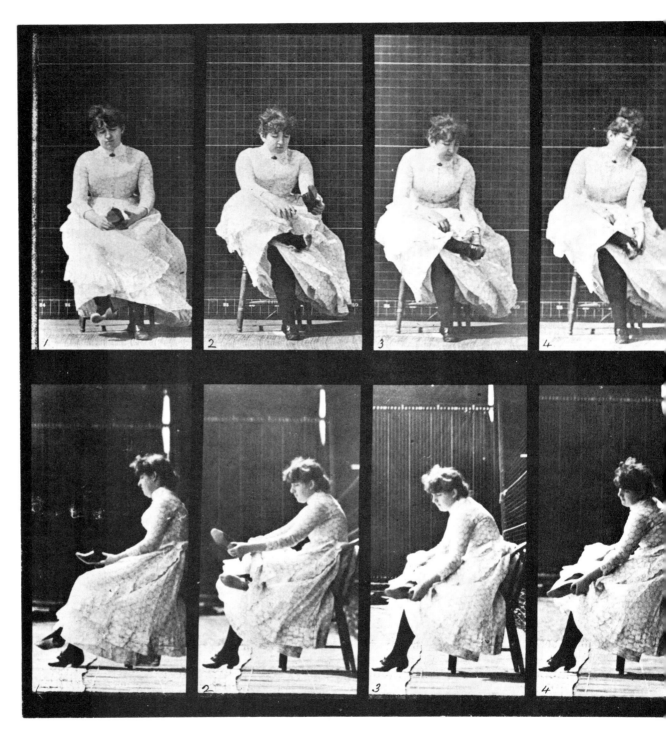

Plate 422. Toilet, putting on shoes and rising from chair.

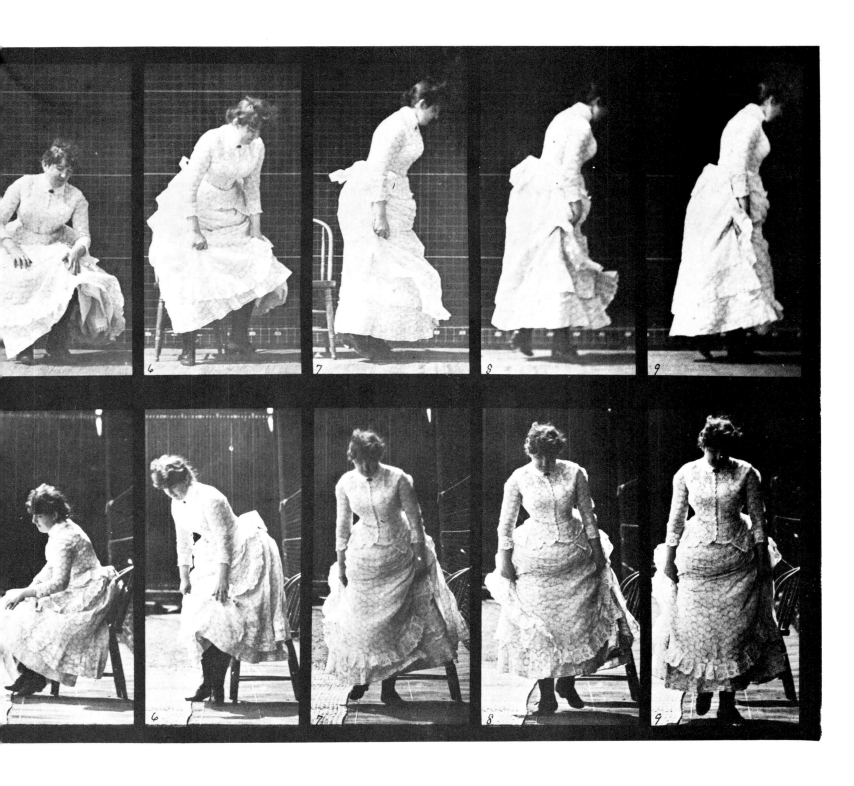

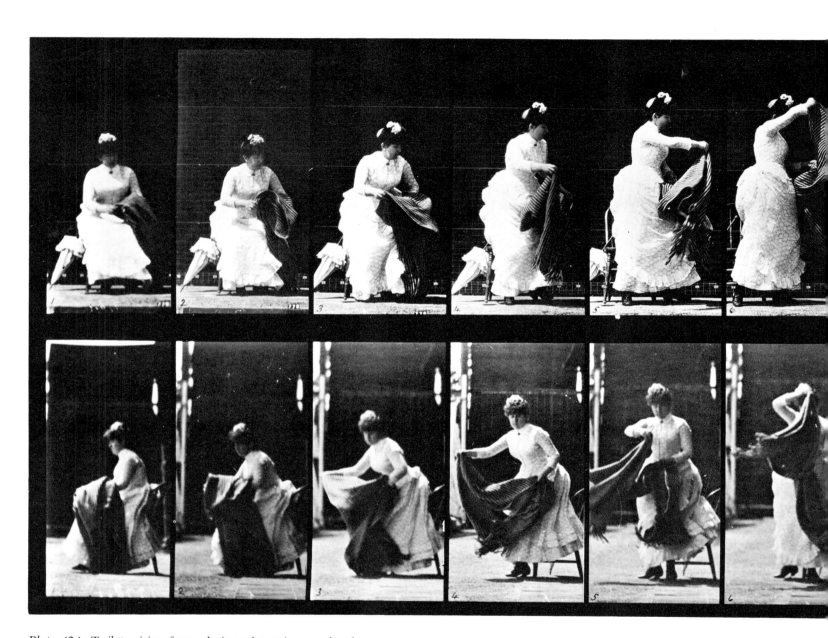

Plate 424. Toilet, rising from chair and putting on shawl.

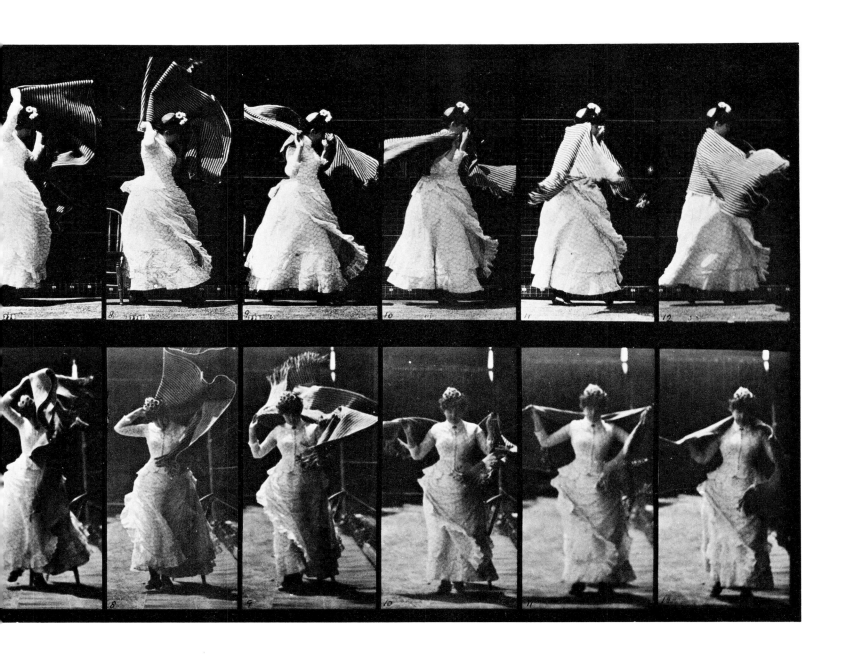

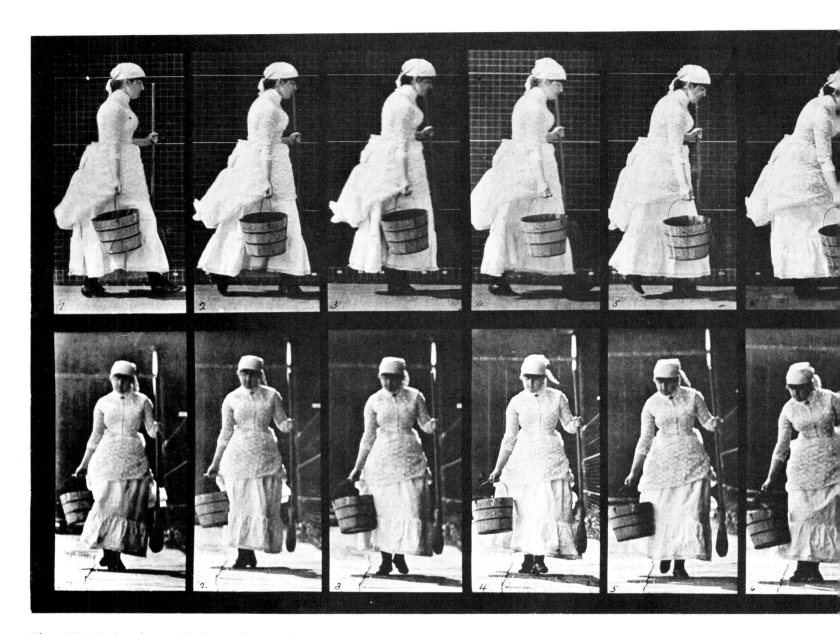

Plate 437. Setting down a bucket and preparing to sweep.

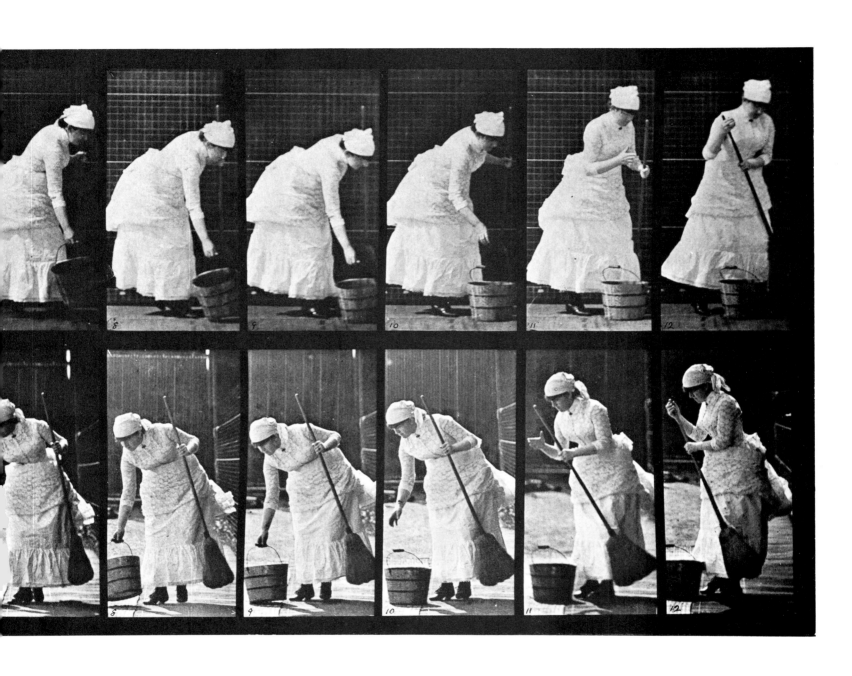

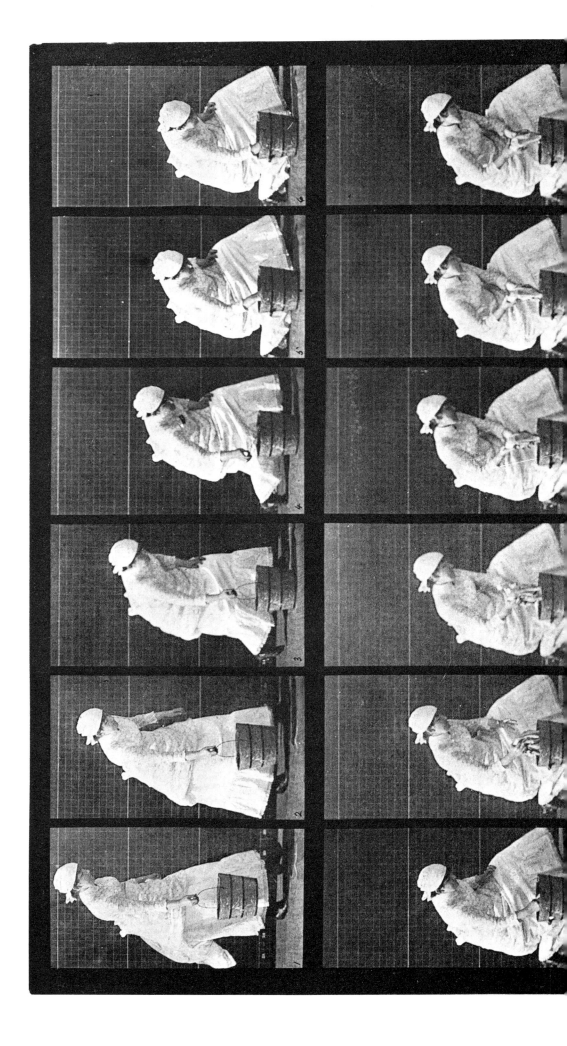

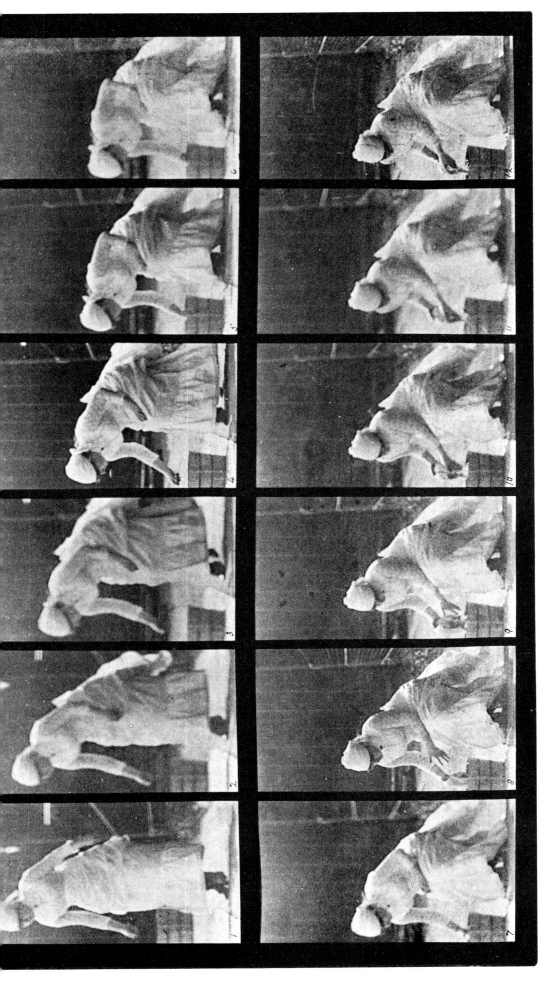

Plate 438. Setting down a bucket and preparing to scrub.

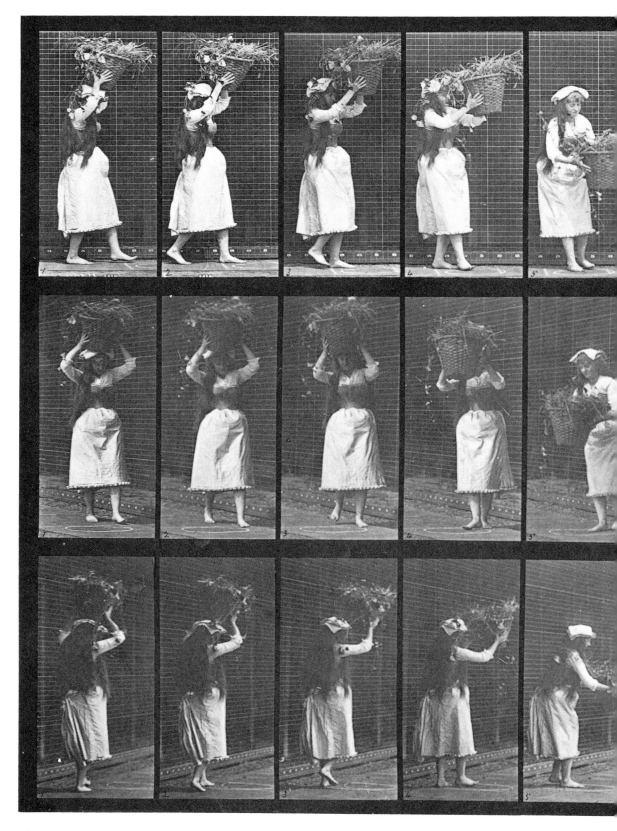

Plate 454. Taking a 12-lb. basket from head and placing it on the ground.

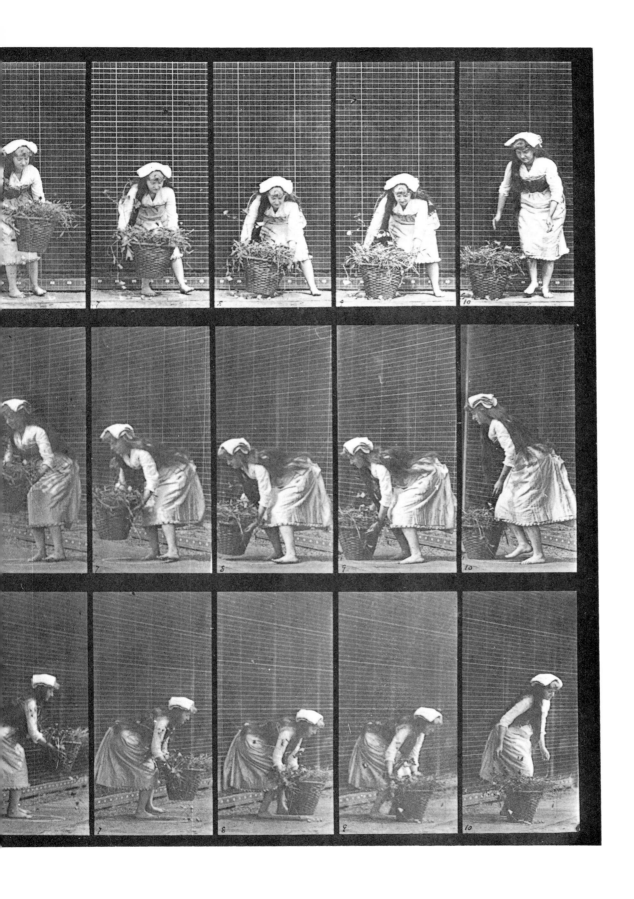

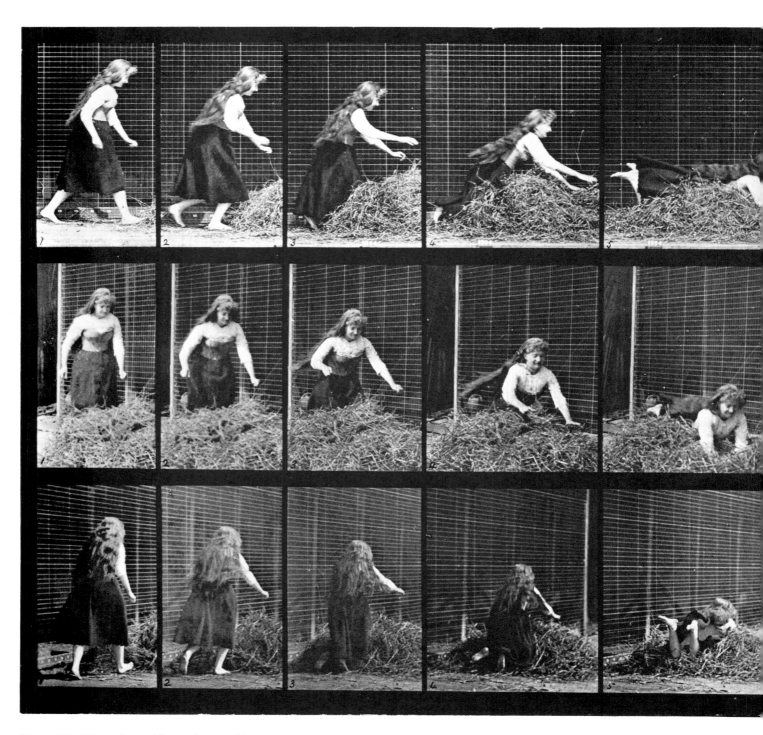

Plate 455. Throwing self on a heap of hay.

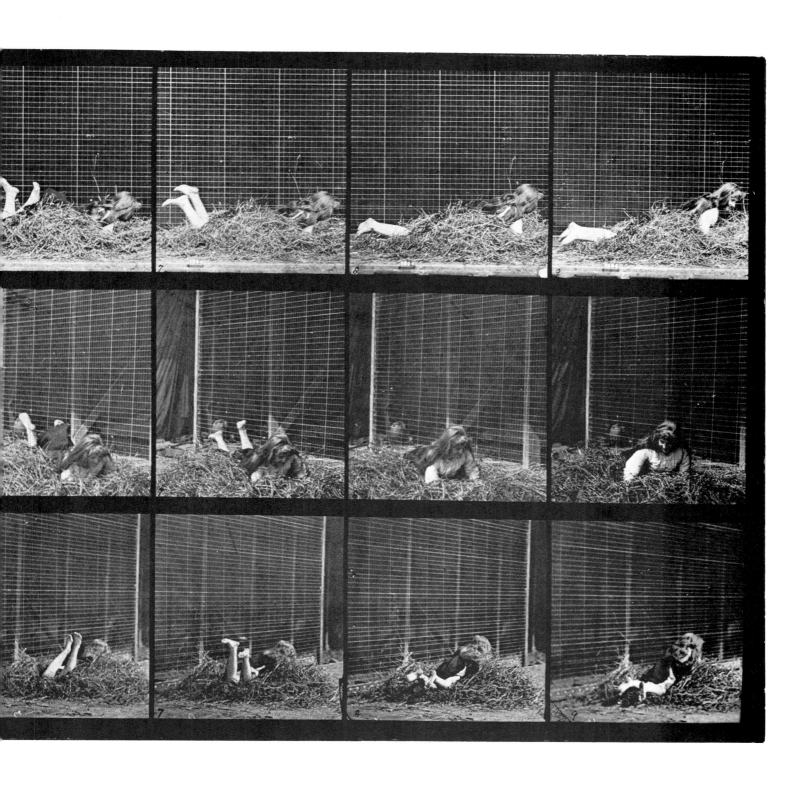

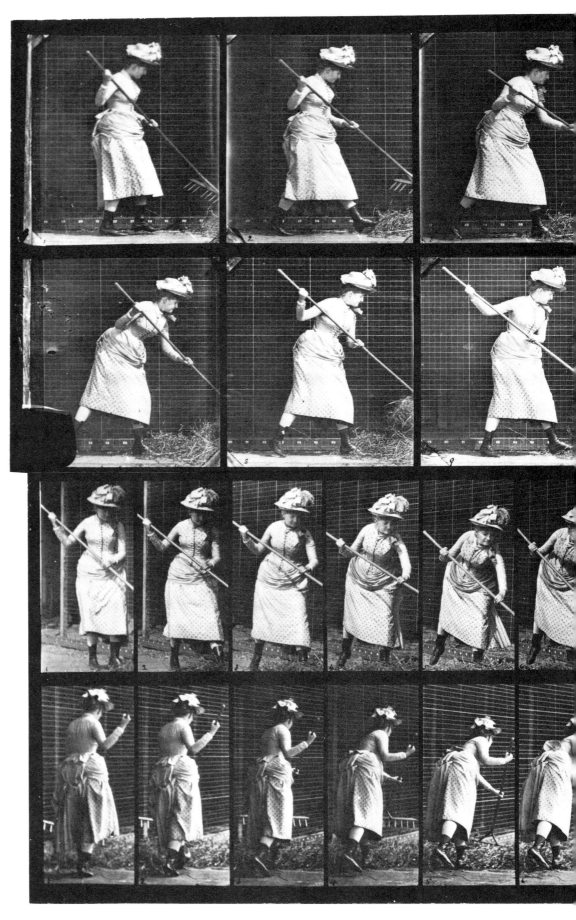

Plate 456. Raking hay.

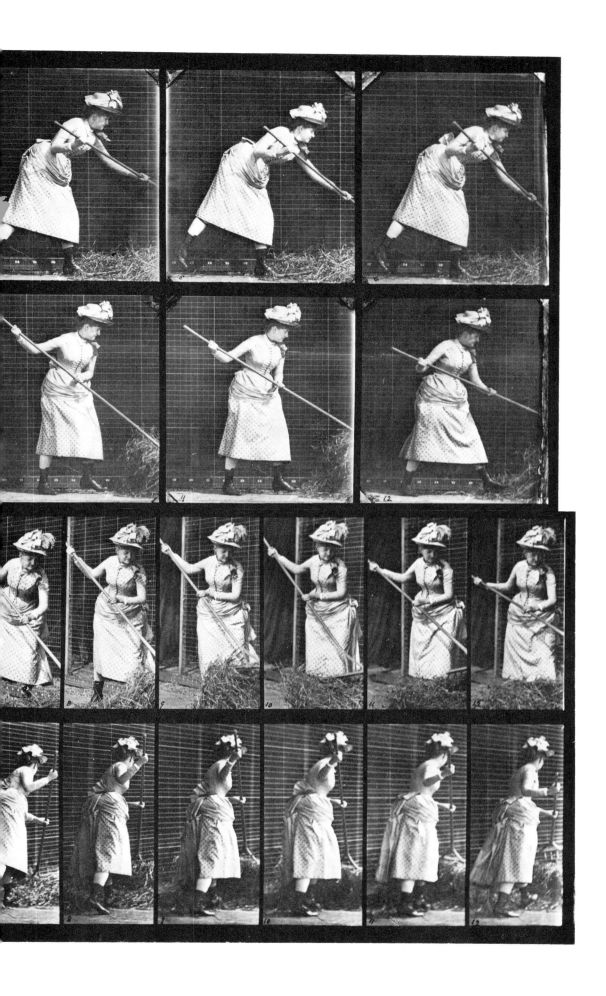

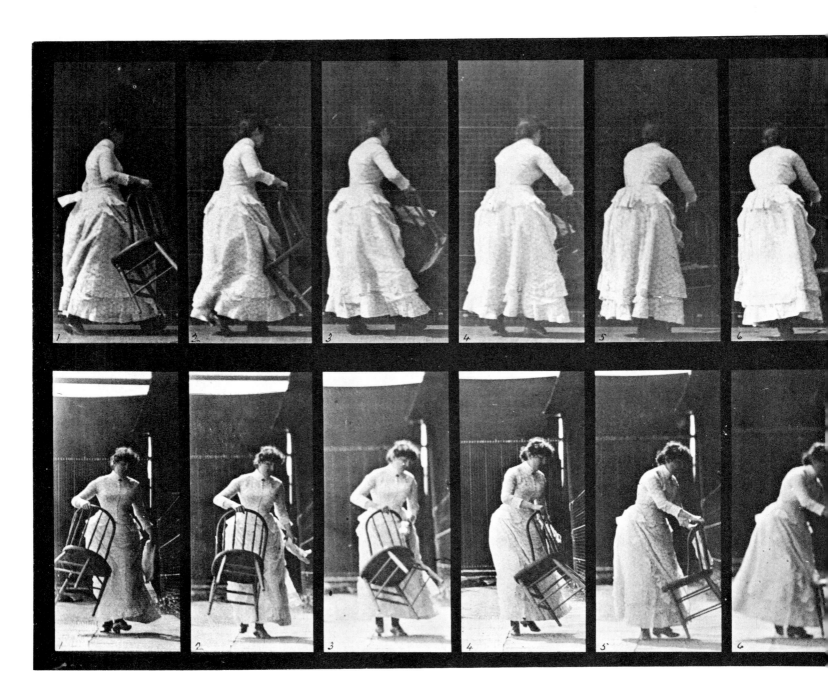

Plate 457. Stepping on a chair and reaching up.

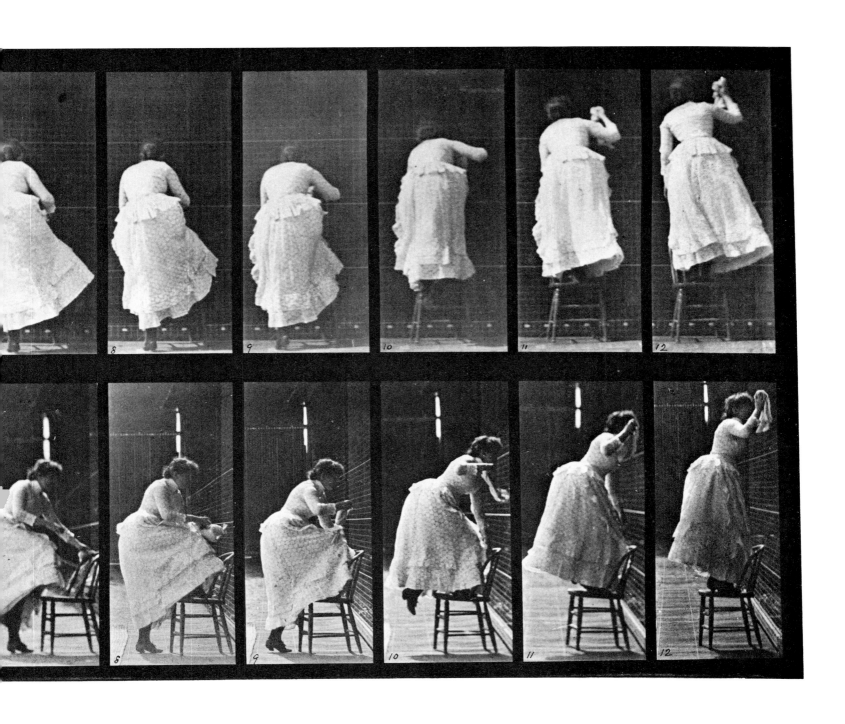

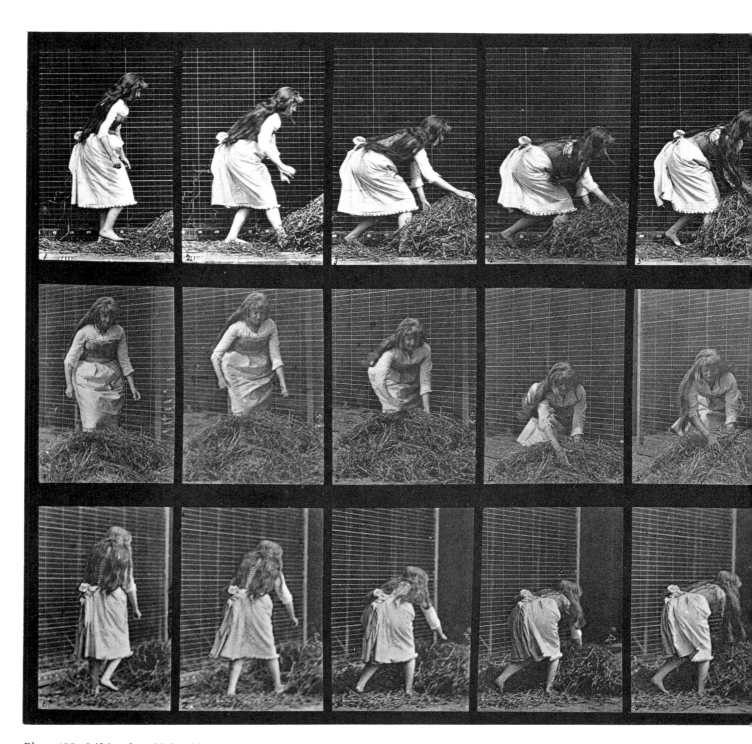

Plate 458. Lifting handfuls of hay, turning and throwing it down.

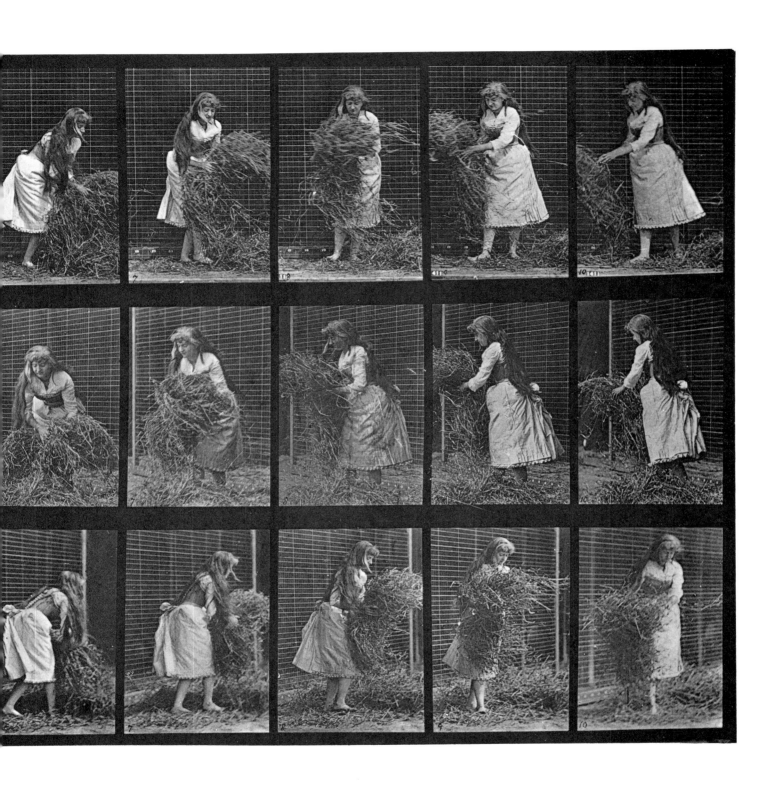

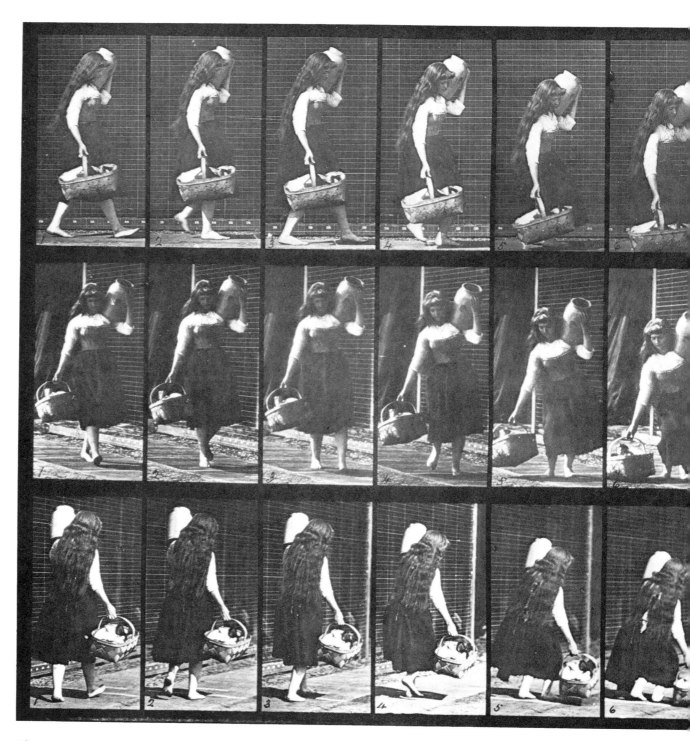

Plate 460. *Carrying a jar on shoulder and basket in hand and placing them on the ground.*

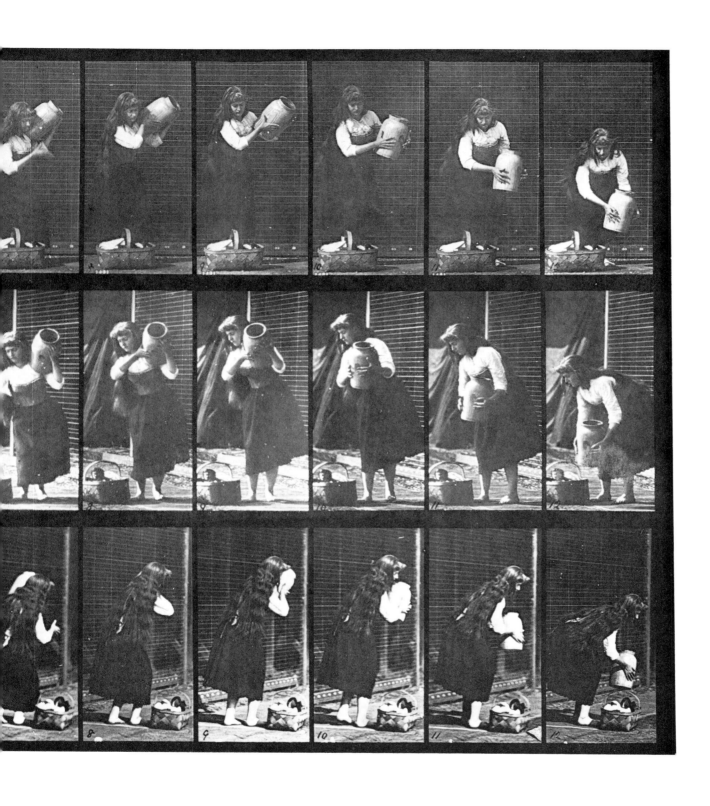

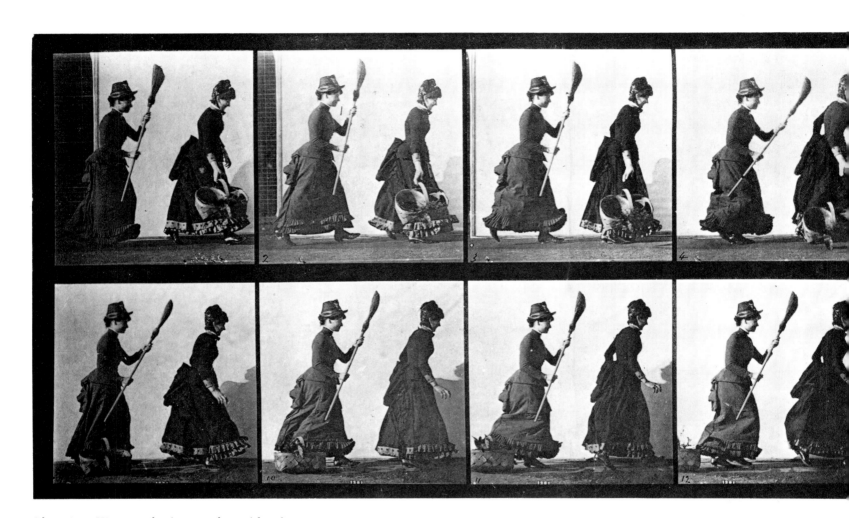

Plate 464. Woman chasing another with a broom.

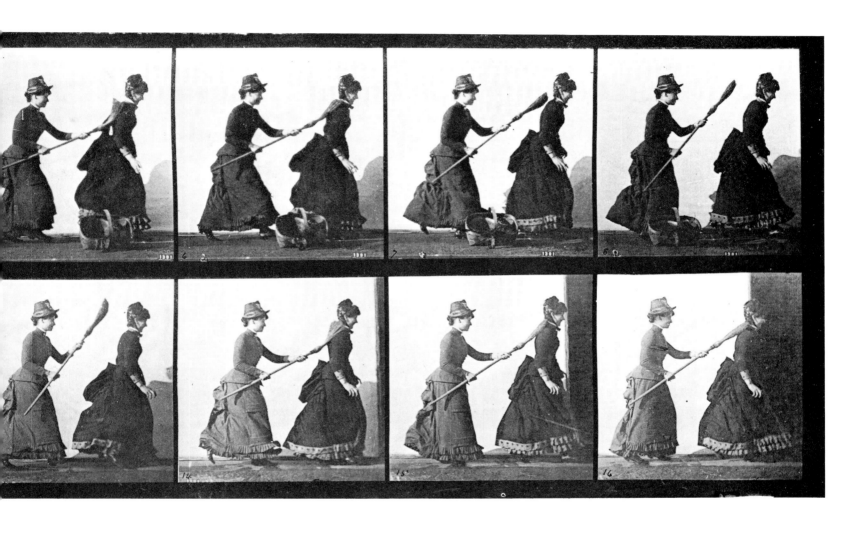

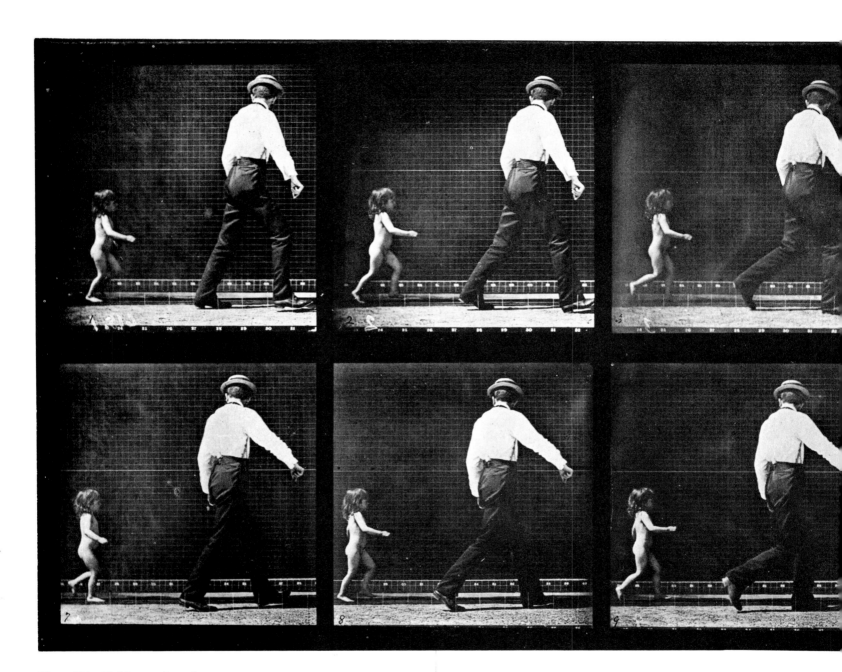

Plate 470. Child running after a man.

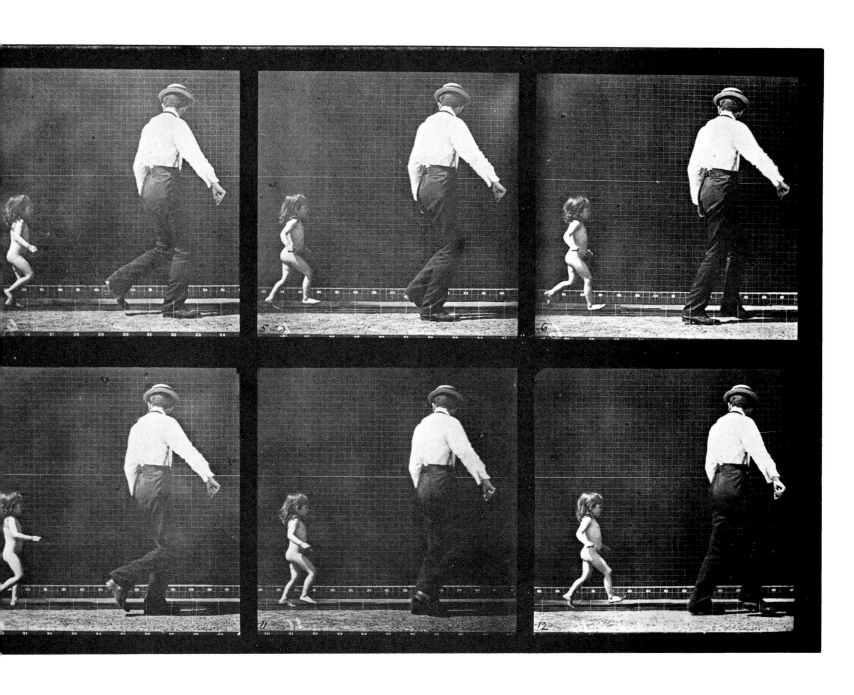

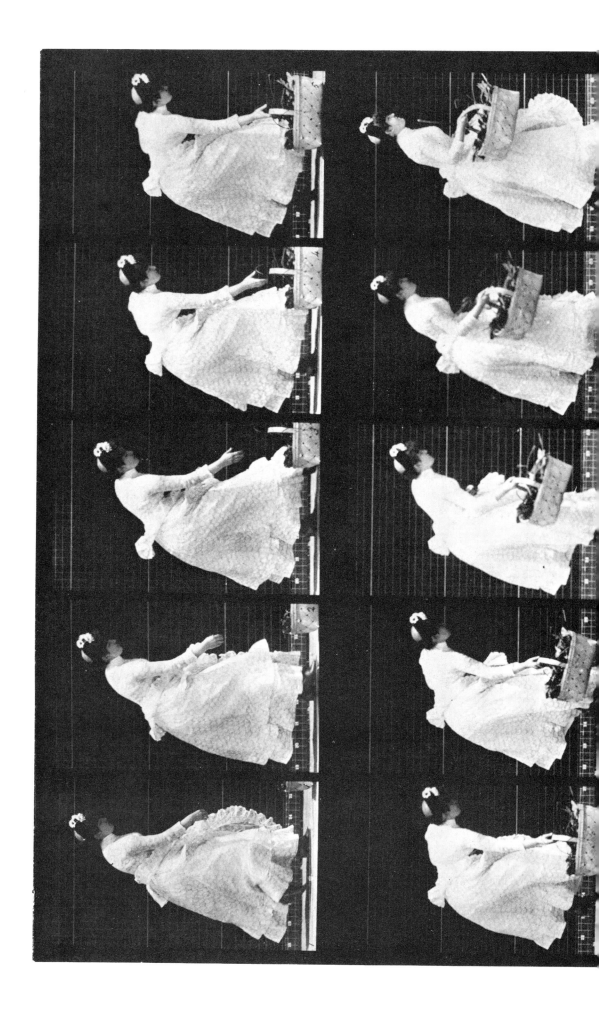

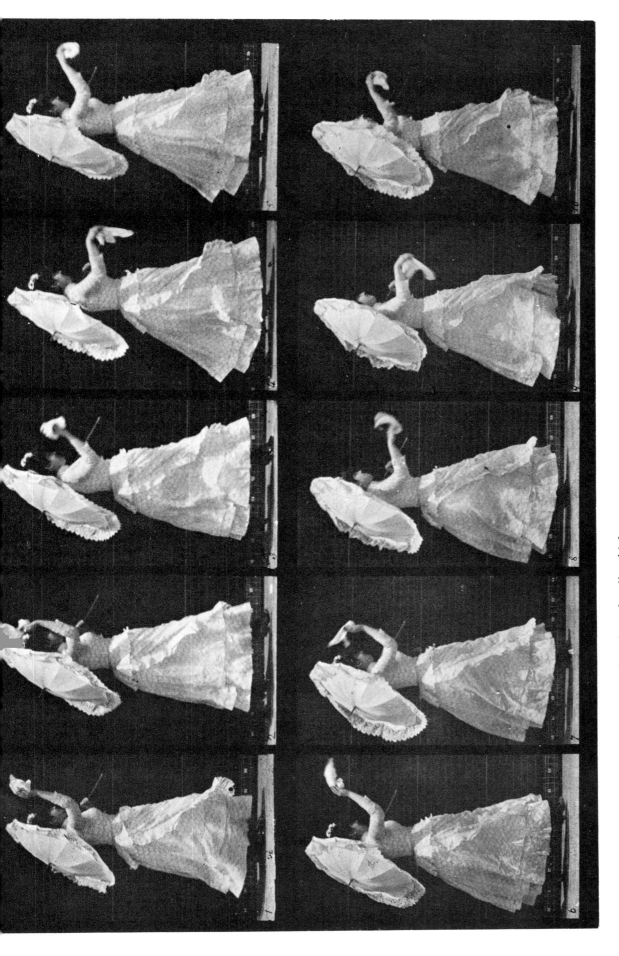

Plate 483. A: Lifting a basket. B: Running and waving a handkerchief.

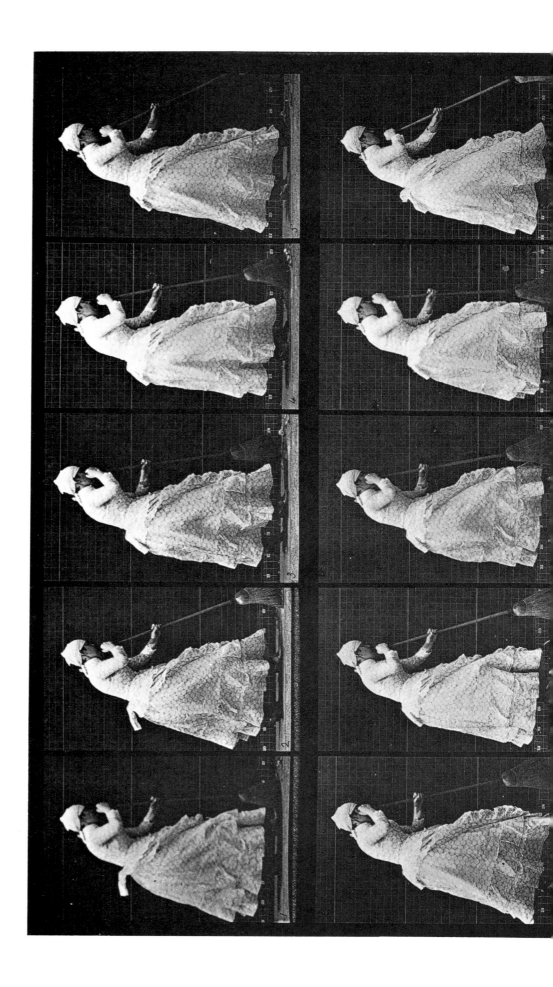

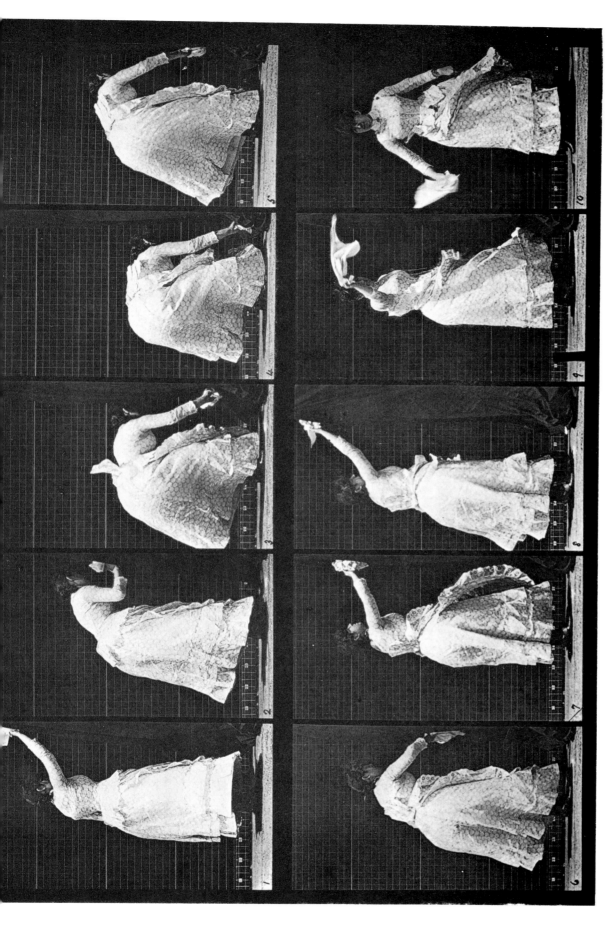

Plate 484. A: Sweeping. B: Dusting a room.

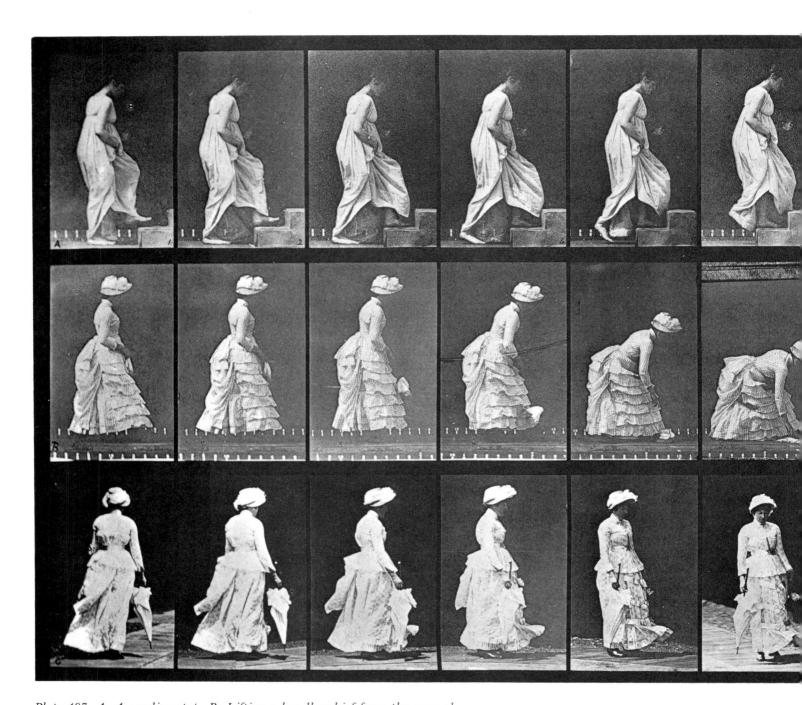

Plate 487. A: Ascending step. B: Lifting a handkerchief from the ground.
C: Walking. D: Running.

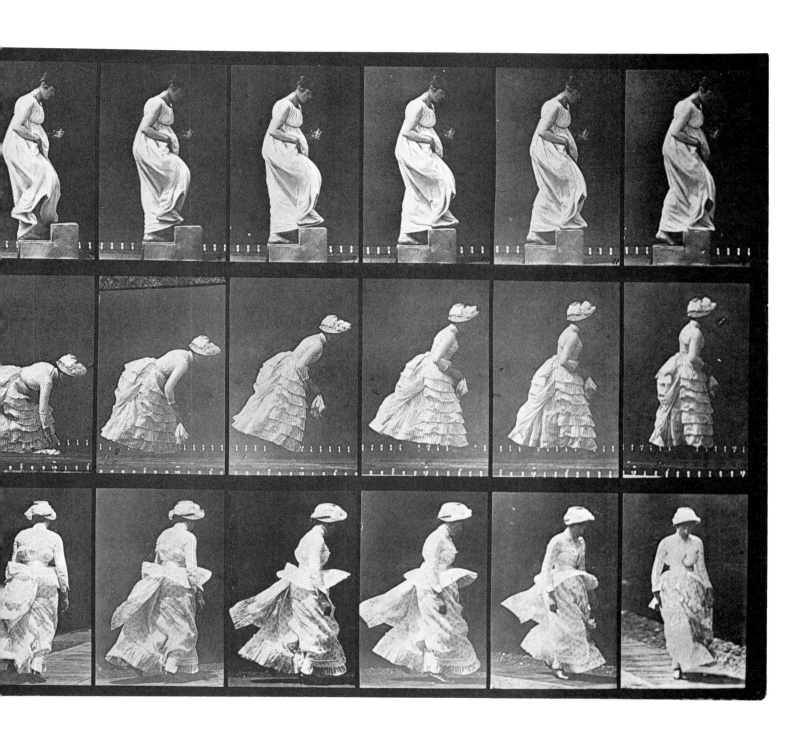

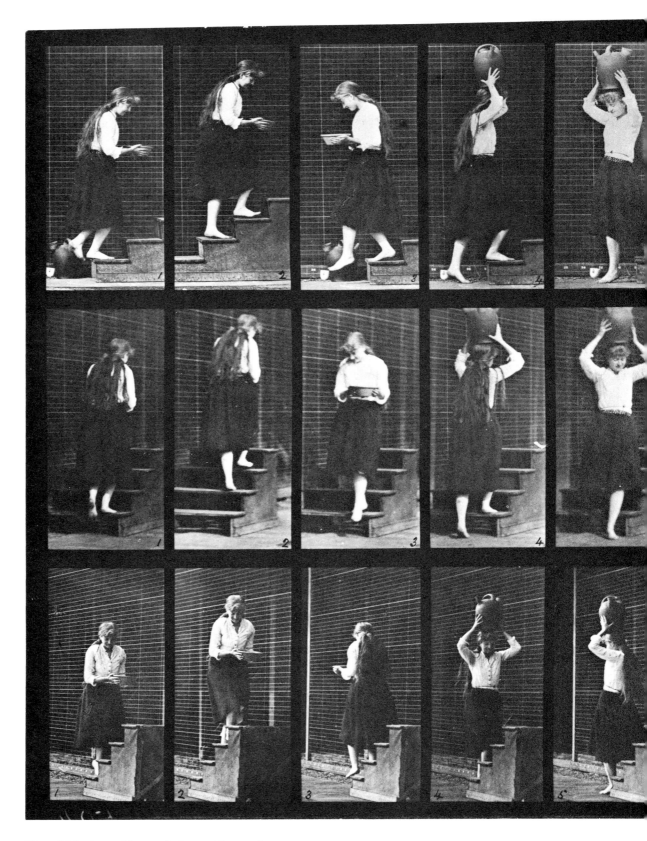

Plate 504. Ascending and descending stairs.

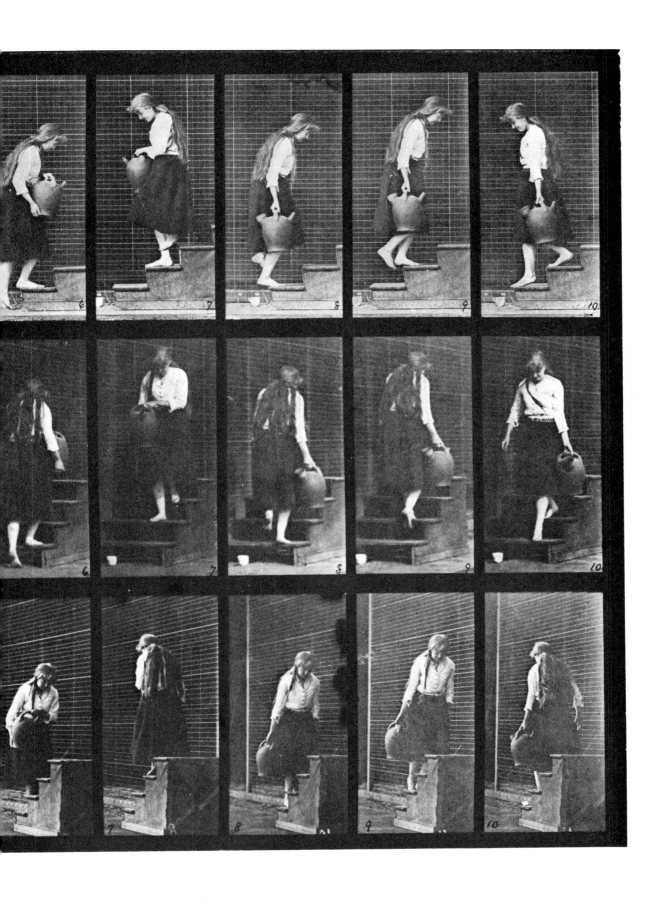

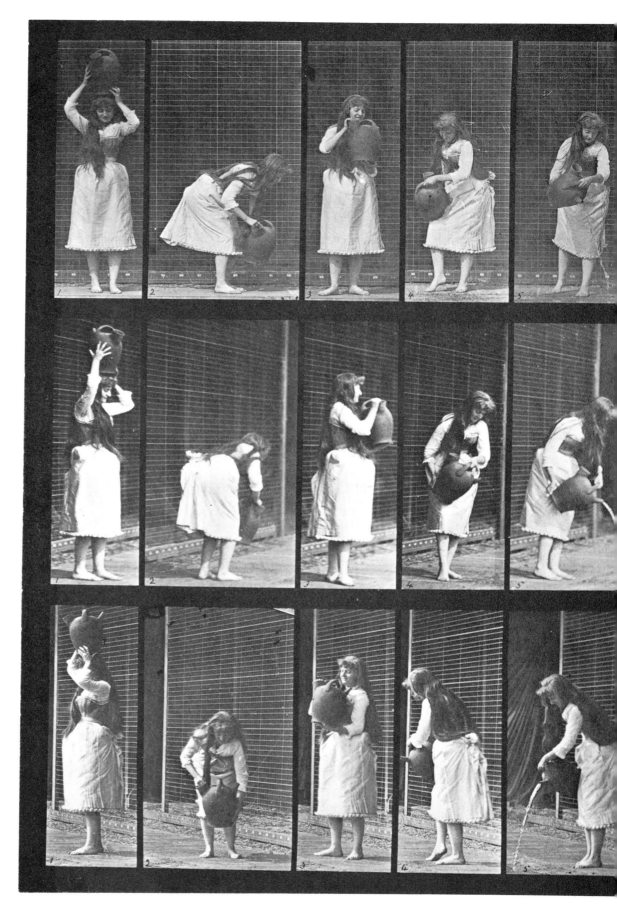

Plate 516. Miscellaneous movements with a water jar.

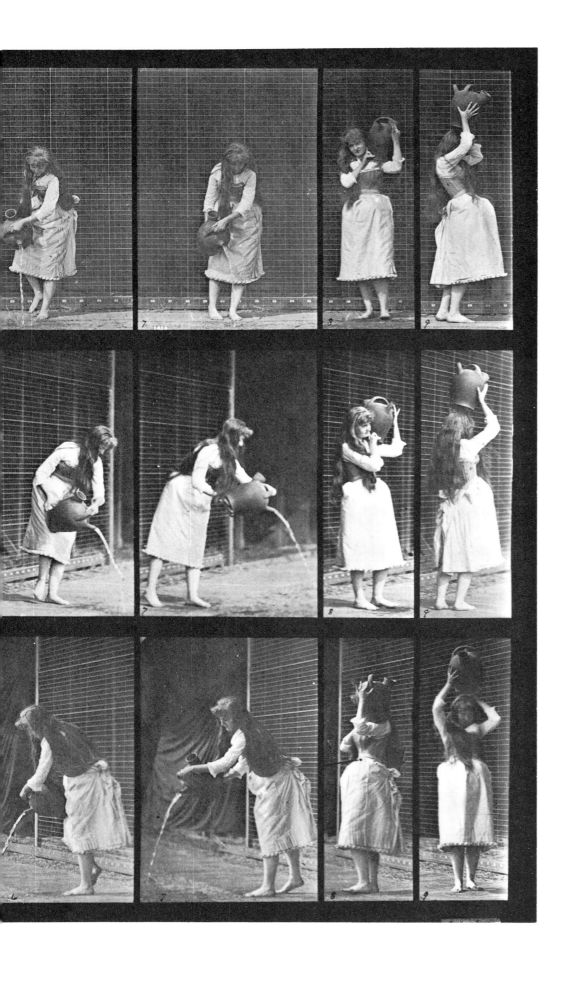

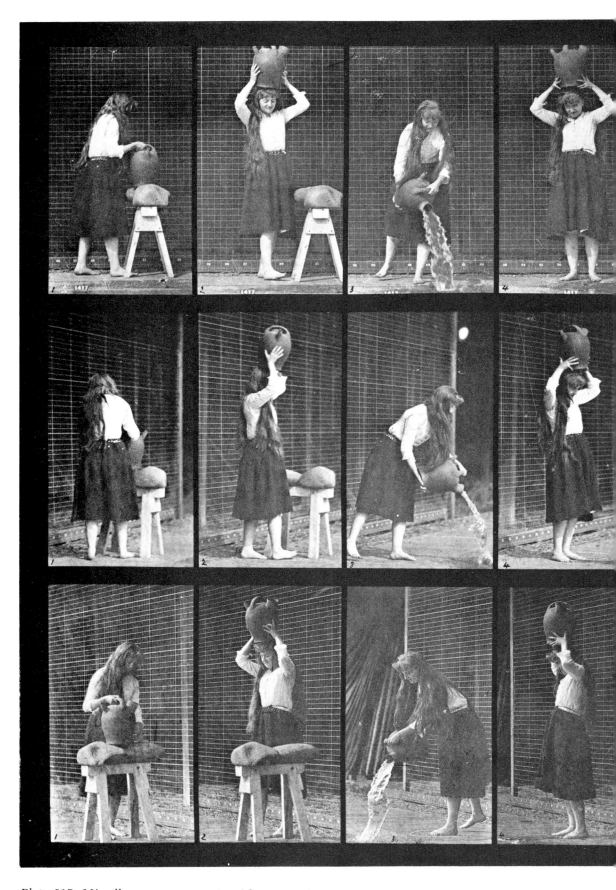

Plate 517. Miscellaneous movements with a water jar.

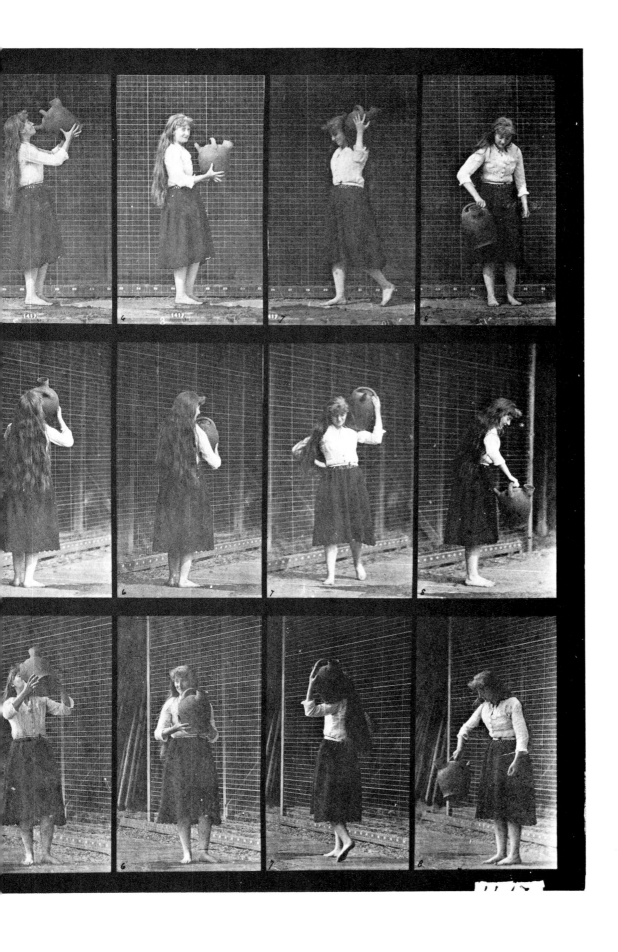

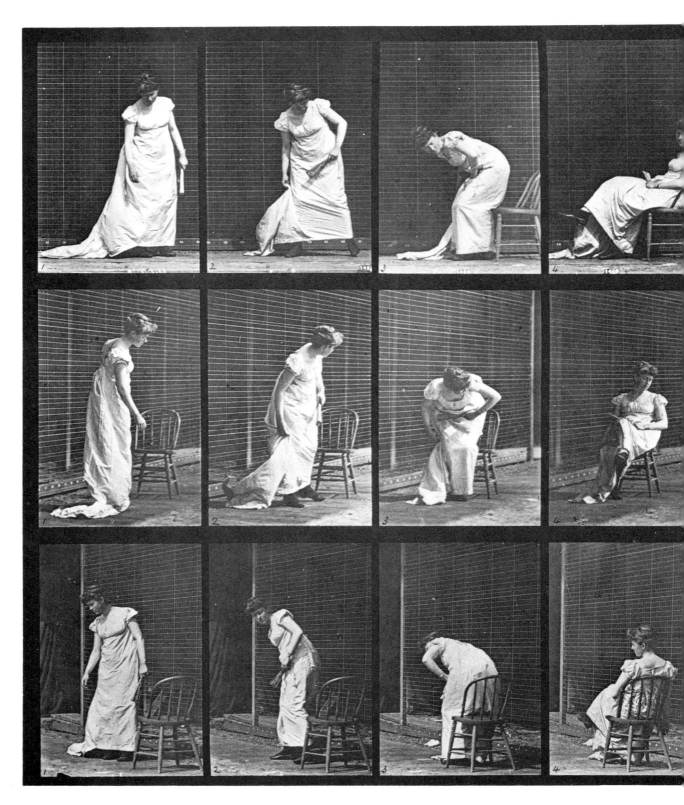

Plate 518. Sitting down, rising, etc.

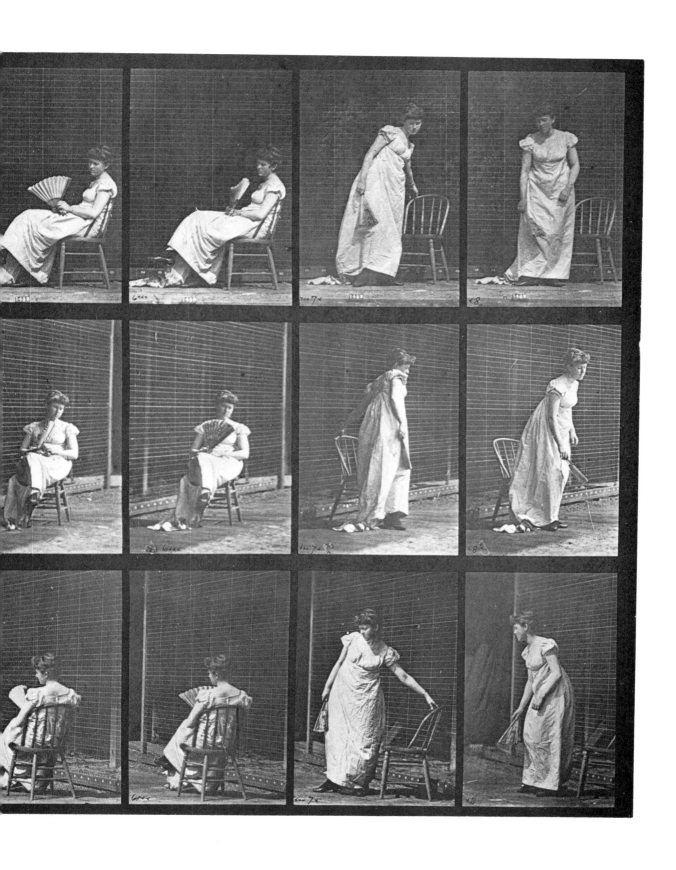

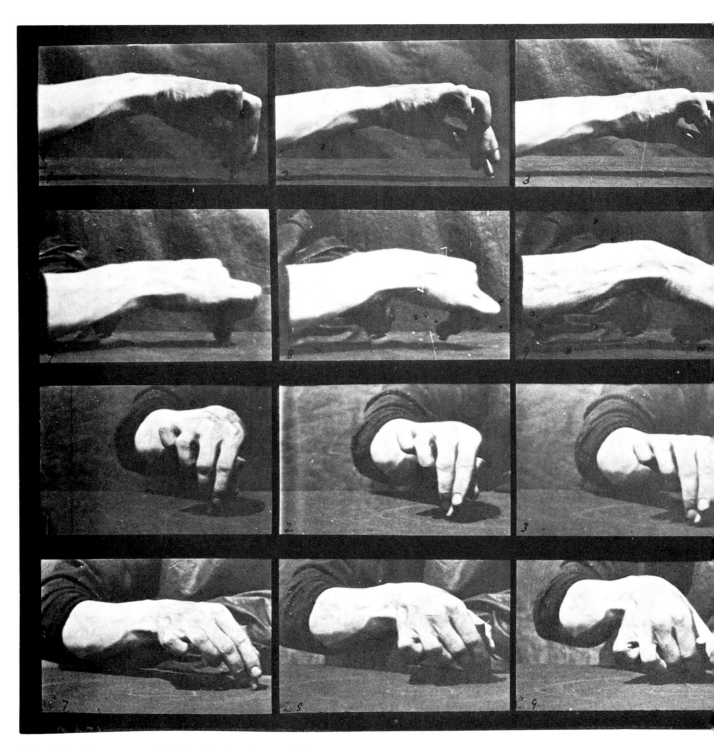

Plate 532. Movement of the hand, drawing a circle.

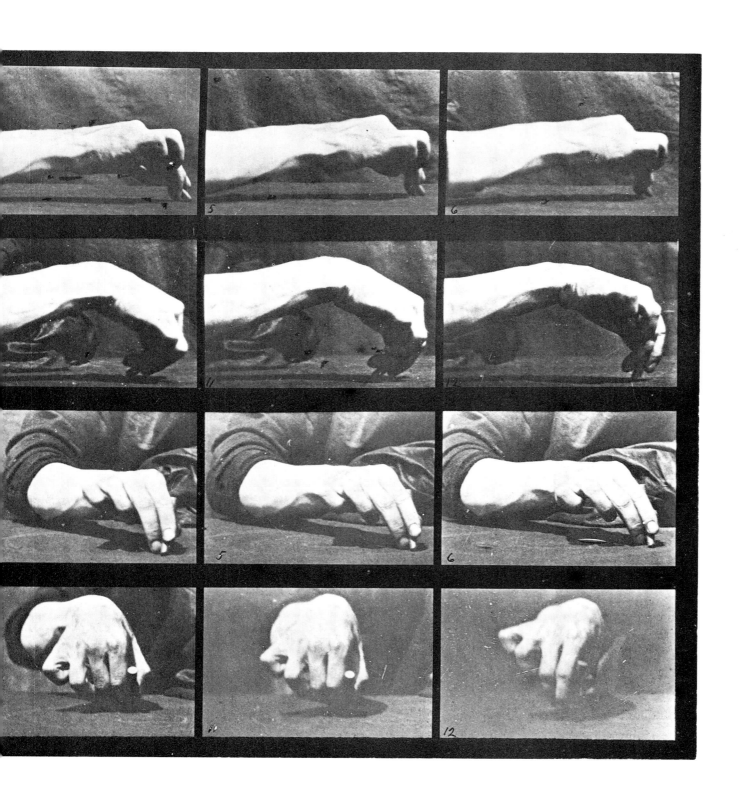

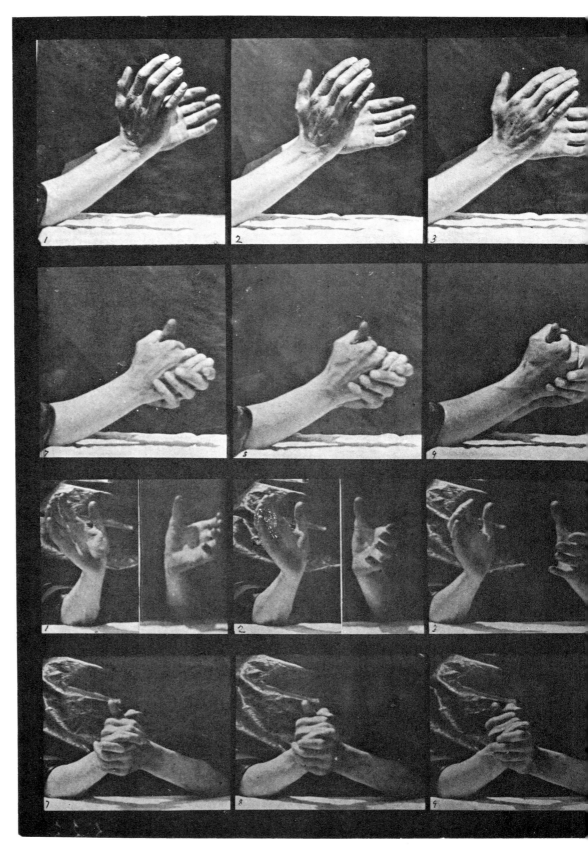

Plate 533. Movement of the hand, clasping hands.

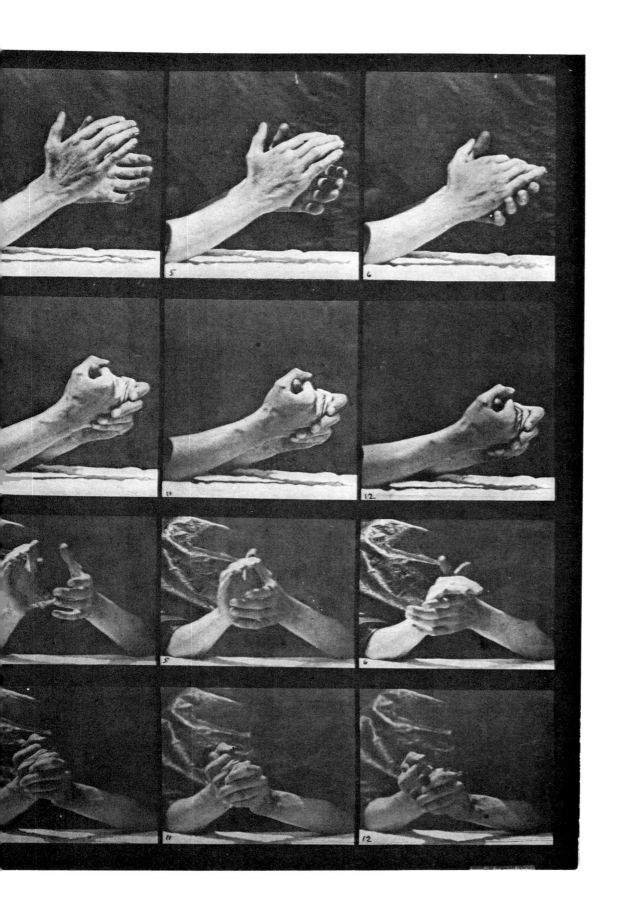

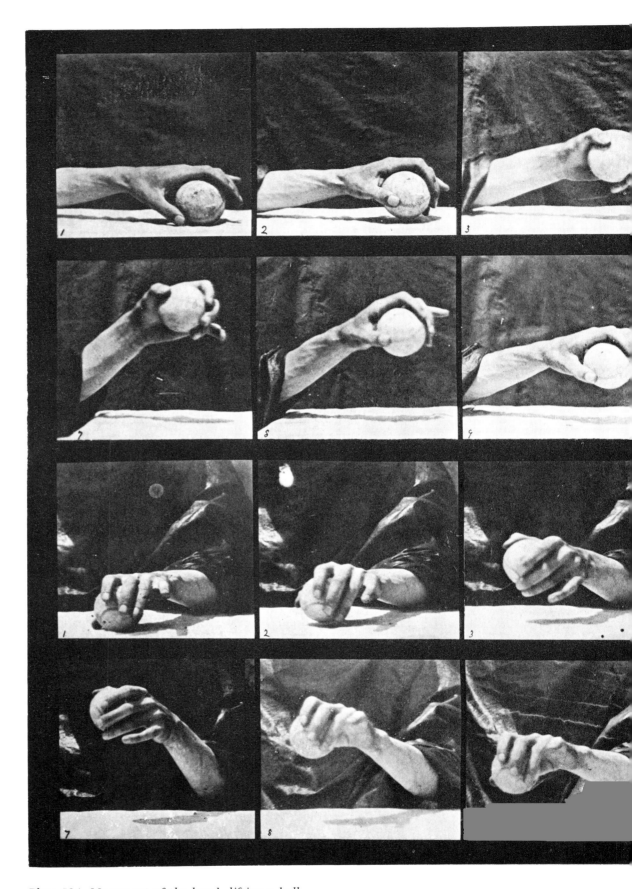

Plate 534. Movement of the hand, lifting a ball.

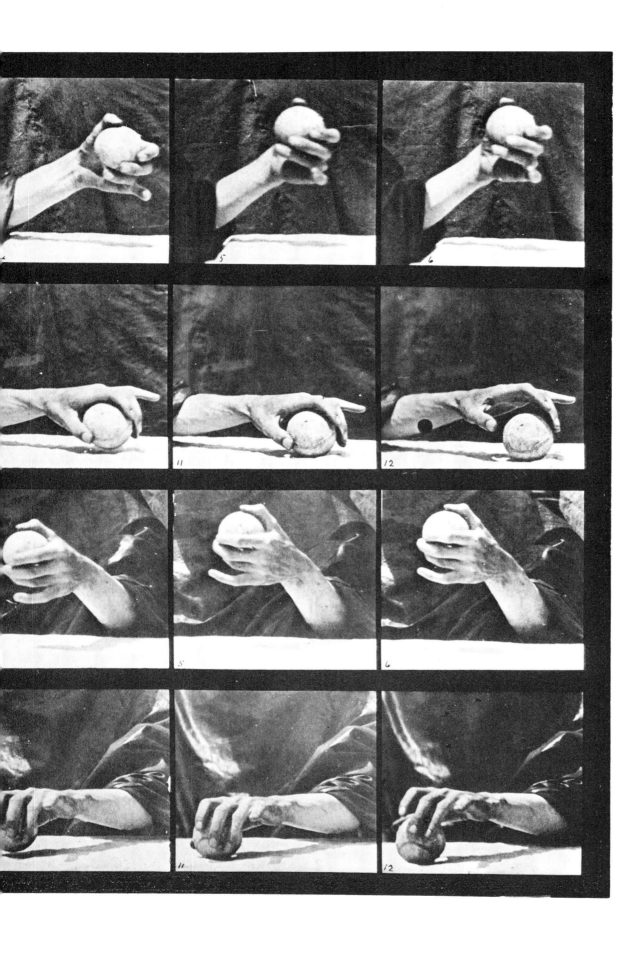

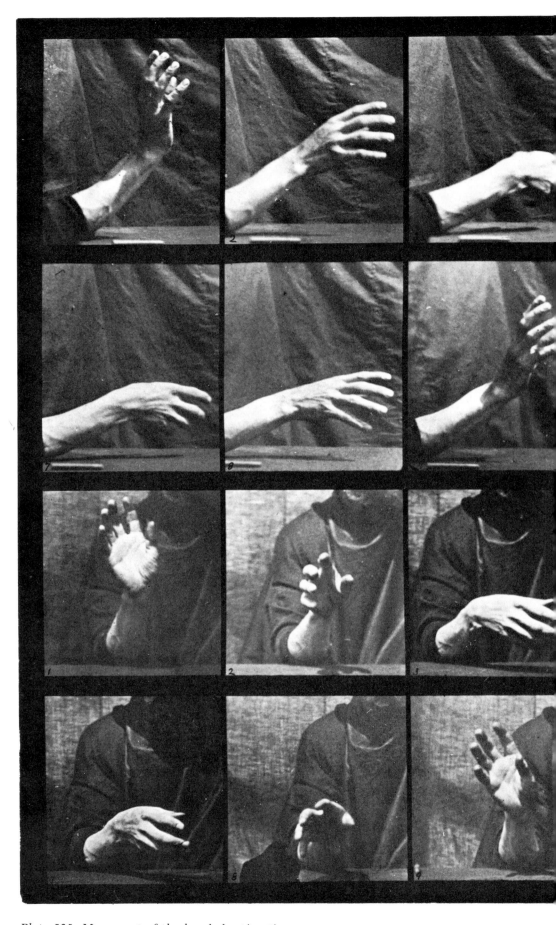

Plate 535. Movement of the hand, beating time.

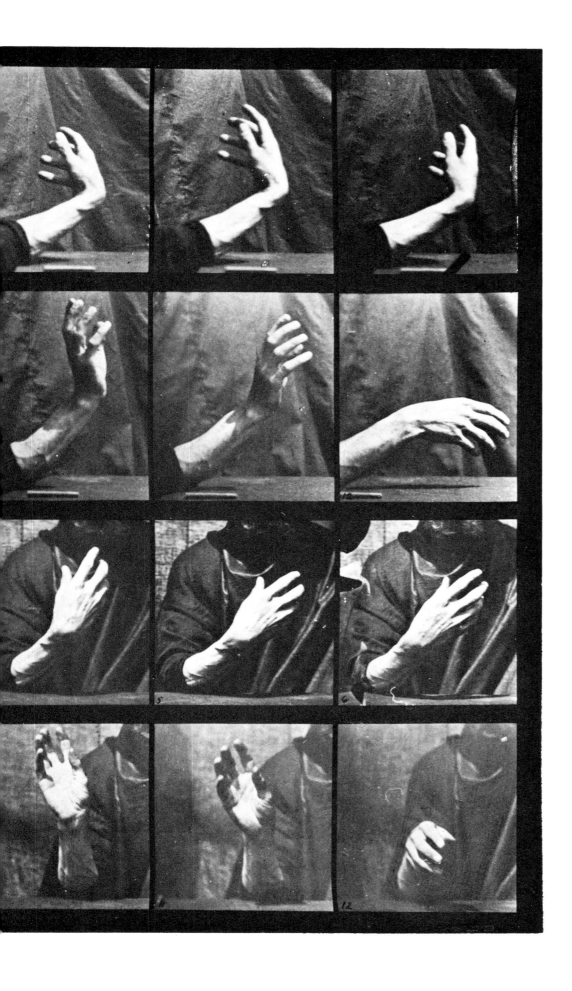

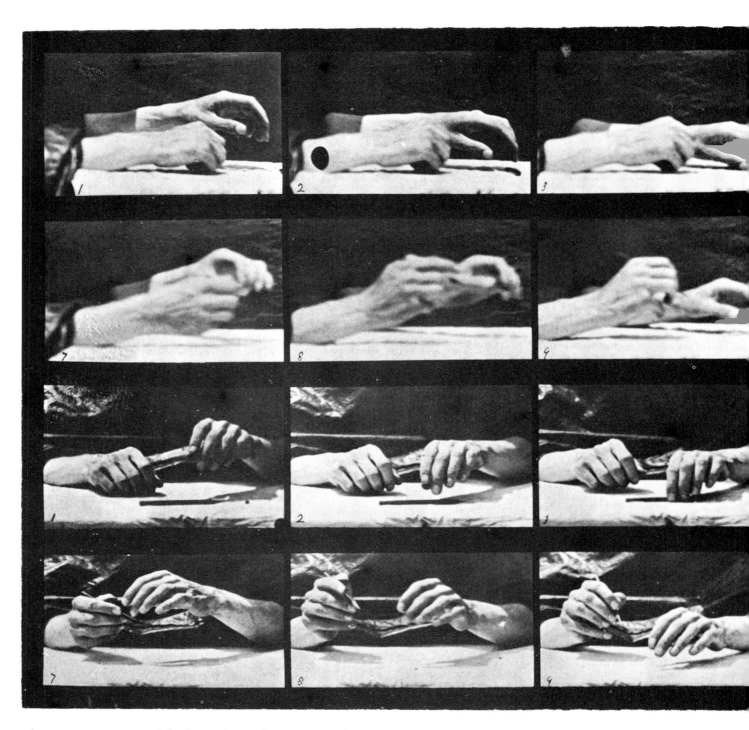

Plate 536. Movement of the hand, hand changing pencil.

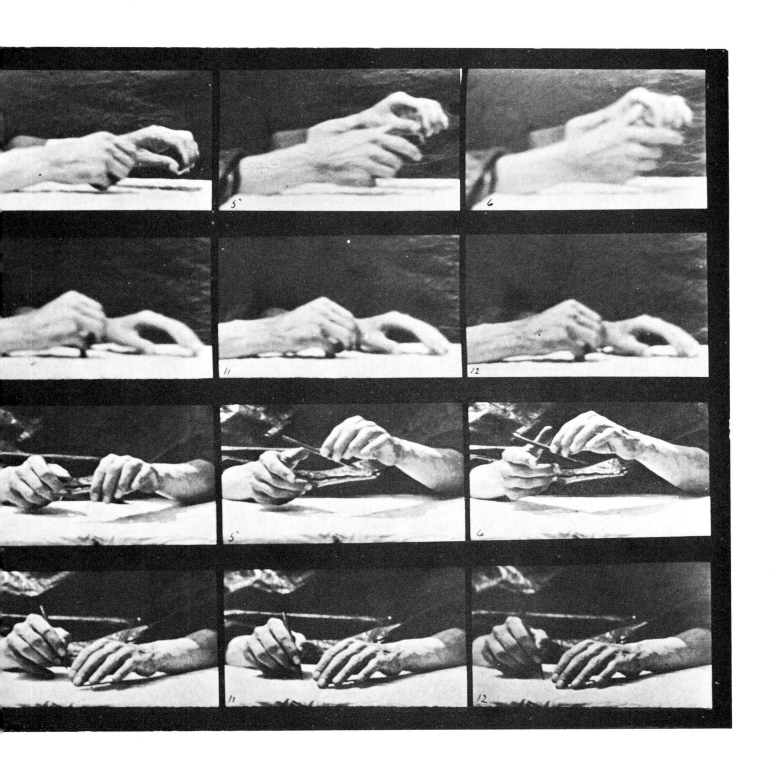

Volume 8

ABNORMAL MOVEMENTS, MALES & FEMALES
(Nude & Semi-Nude)

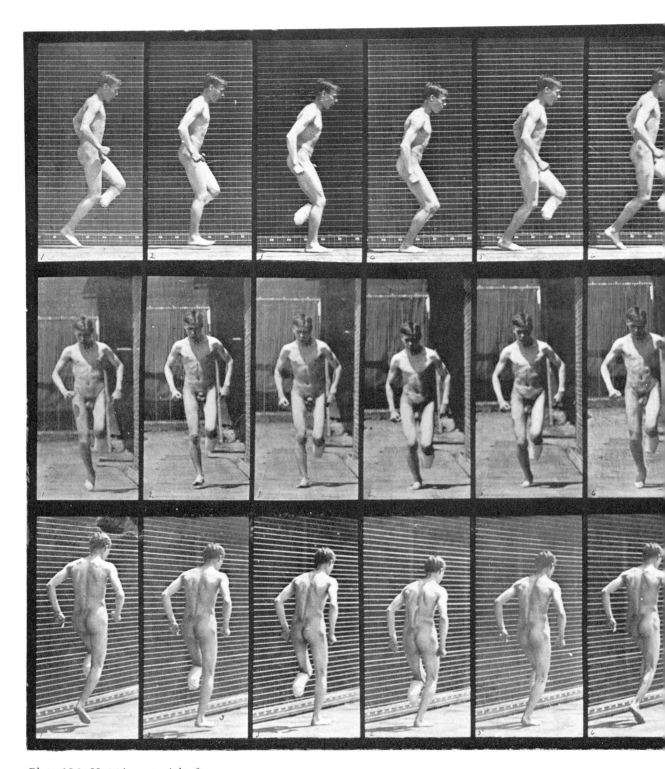

Plate 186. Hopping on right foot.

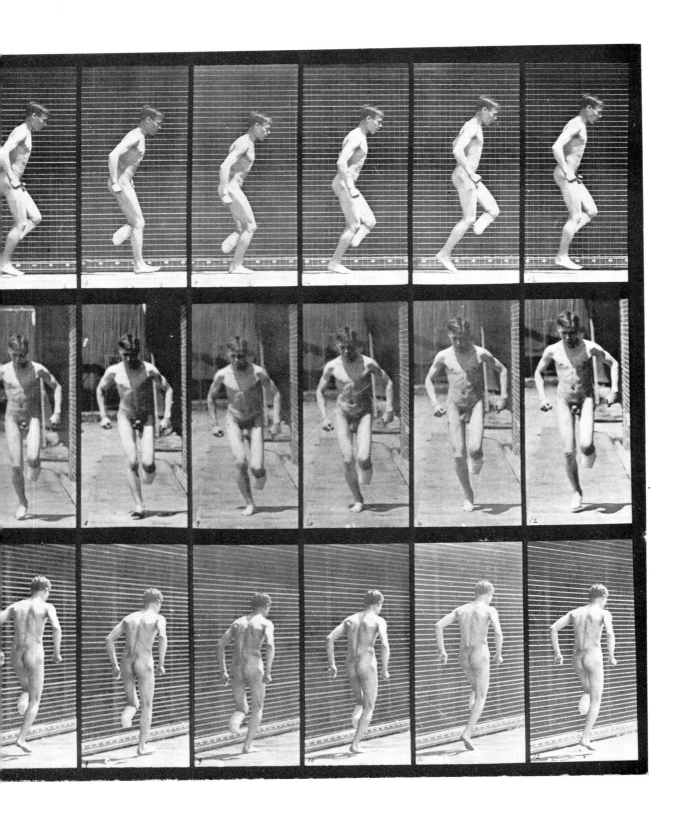

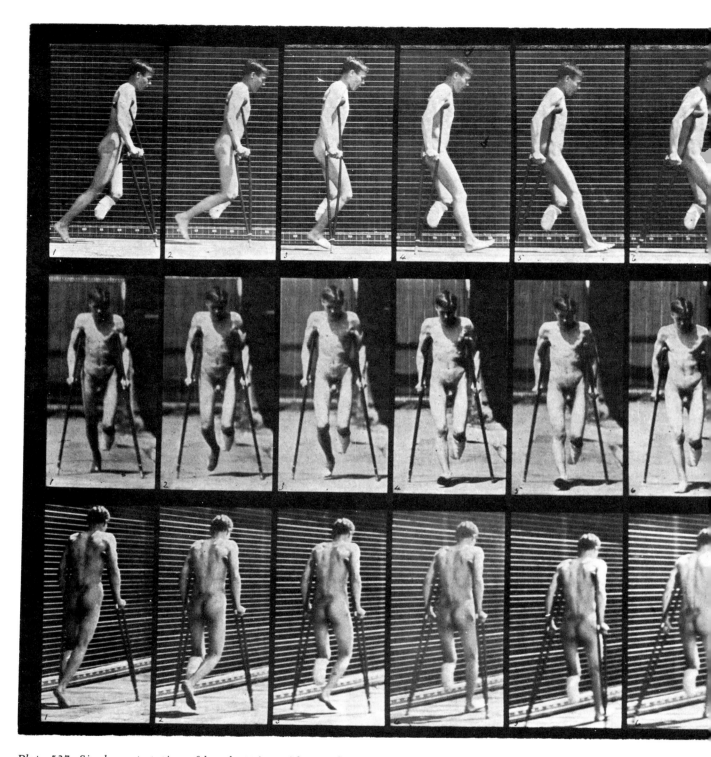

Plate 537. Single amputation of leg, hopping with crutches.

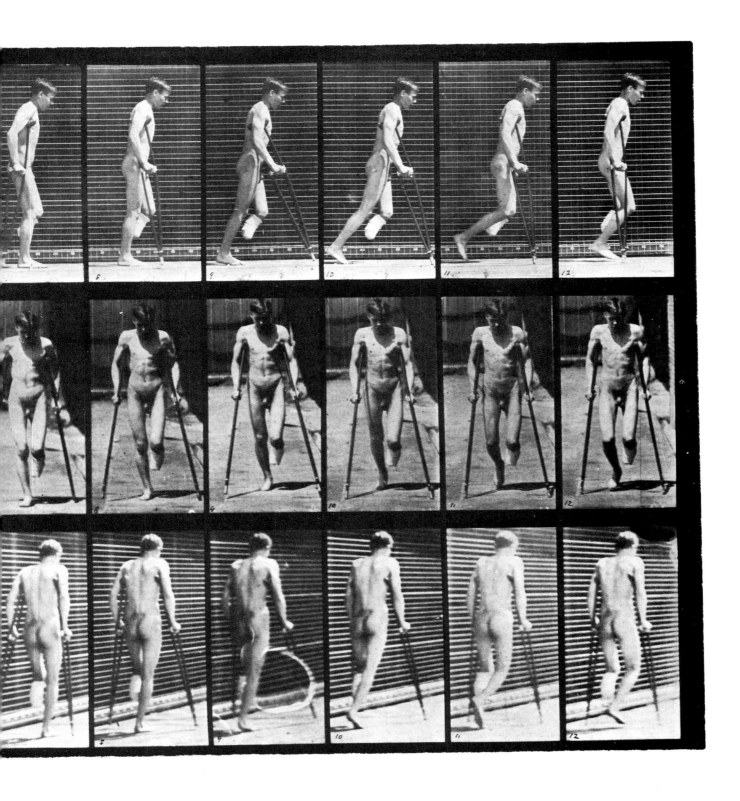

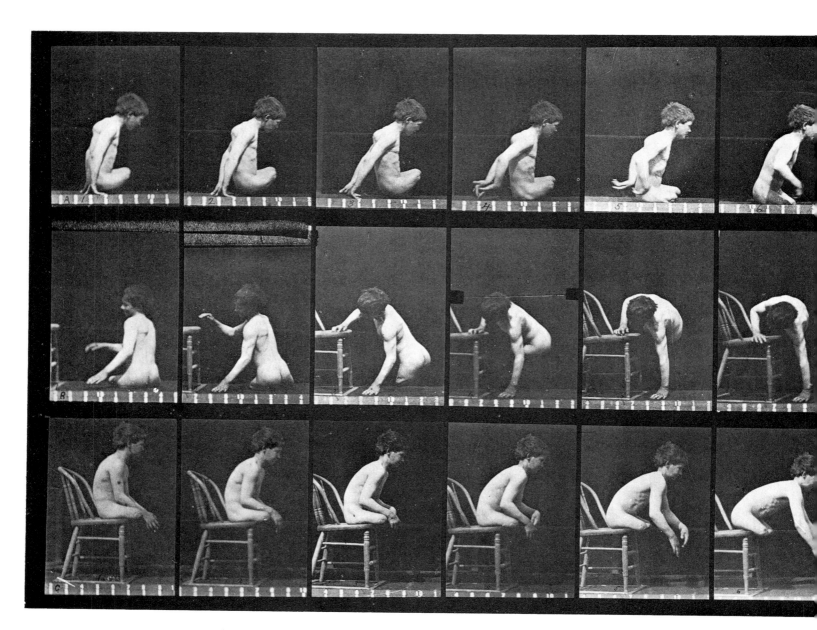

Plate 538. Double amputation of thighs, boy. A: Moving forward. B: Getting on chair. C: Getting down from chair.

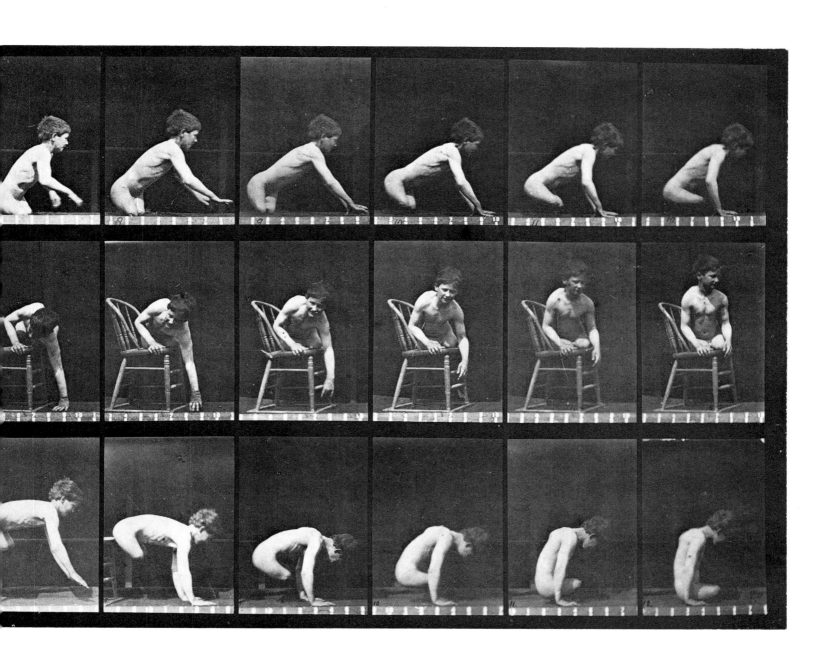

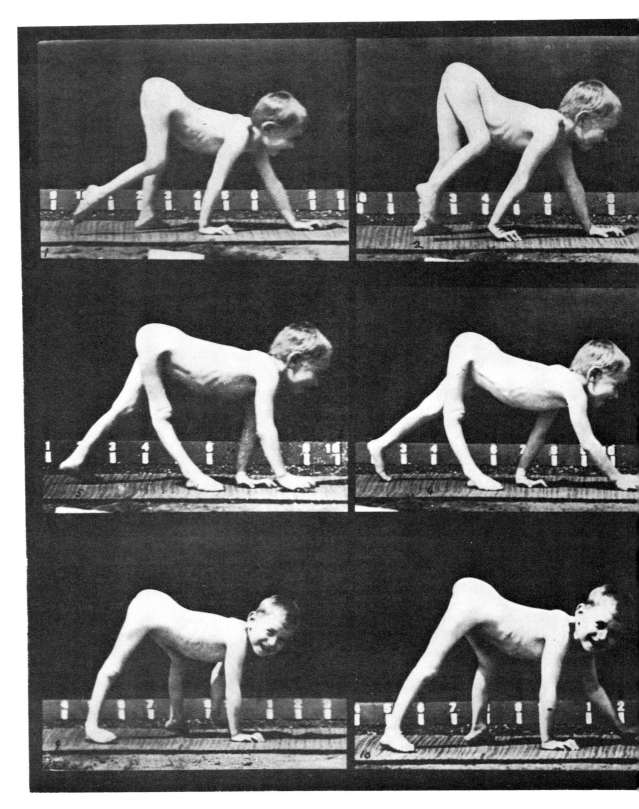

Plate 539. Infantile paralysis, child walking on hands and feet.

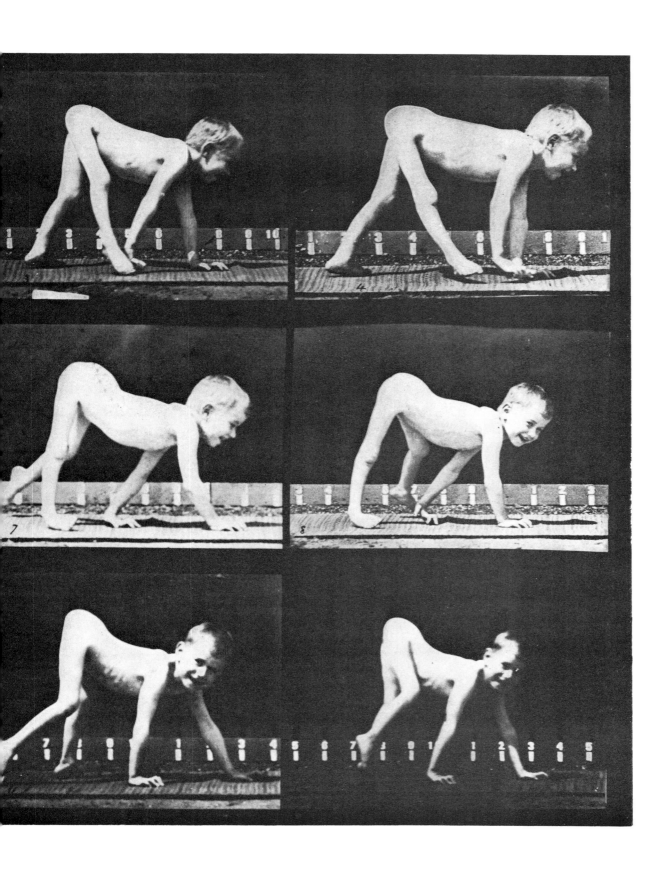

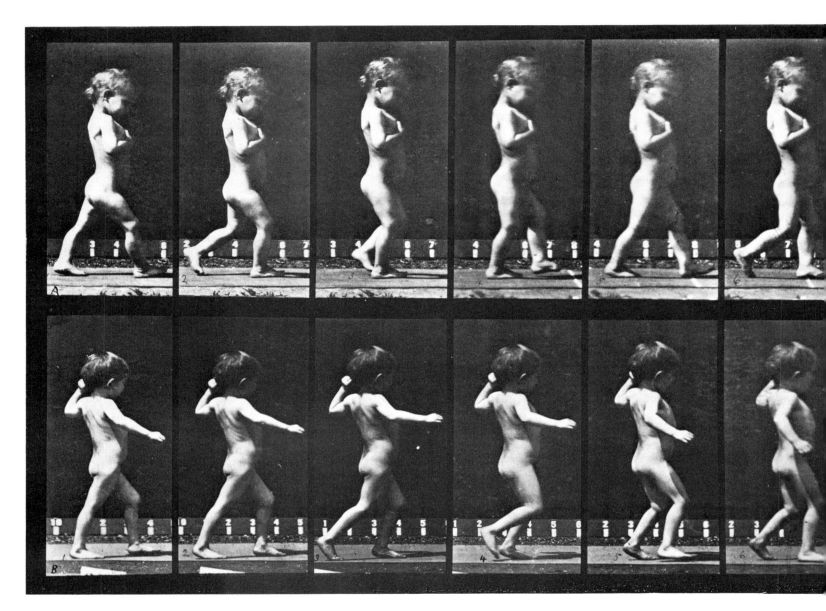

Plate 540. A: Bowlegs, boy. B: Spinal caries, girl walking.

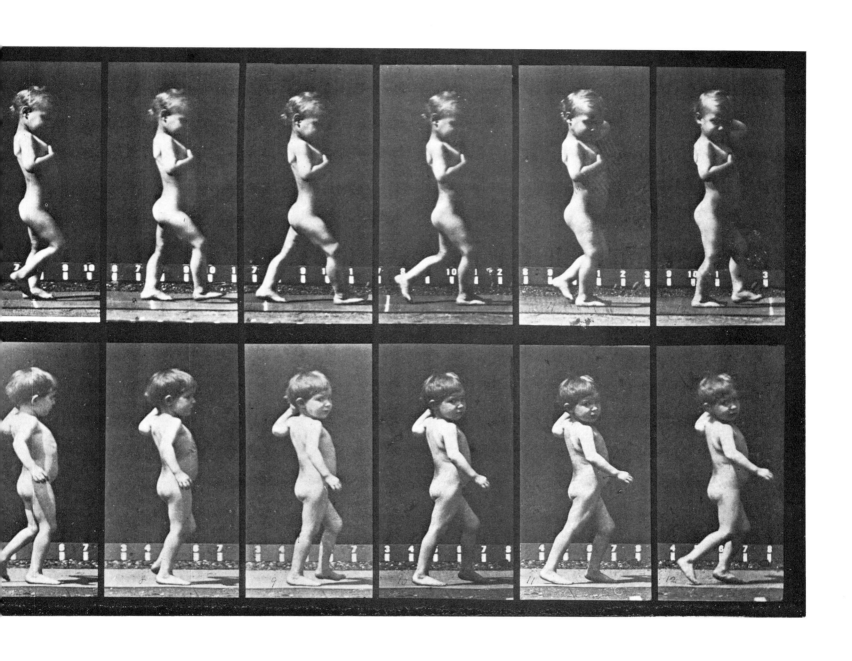

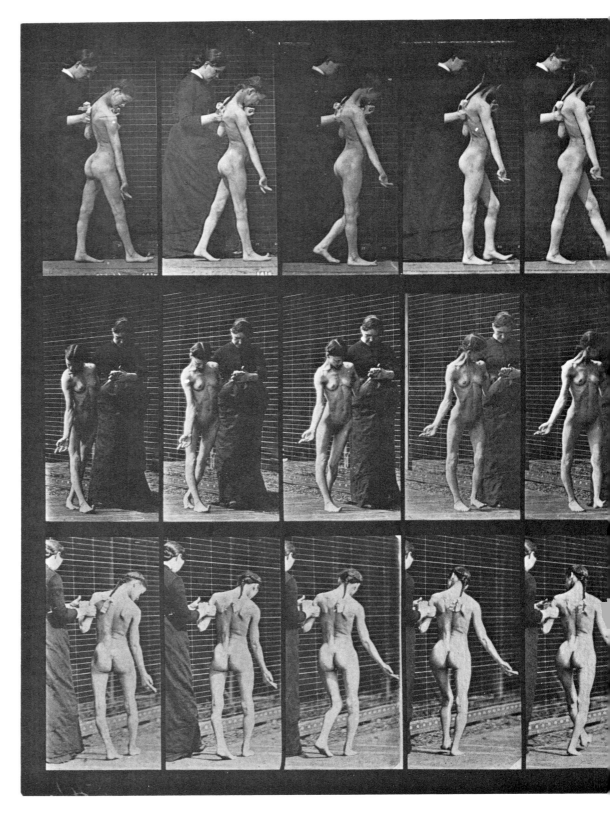

Plate 541. Spastic walking.

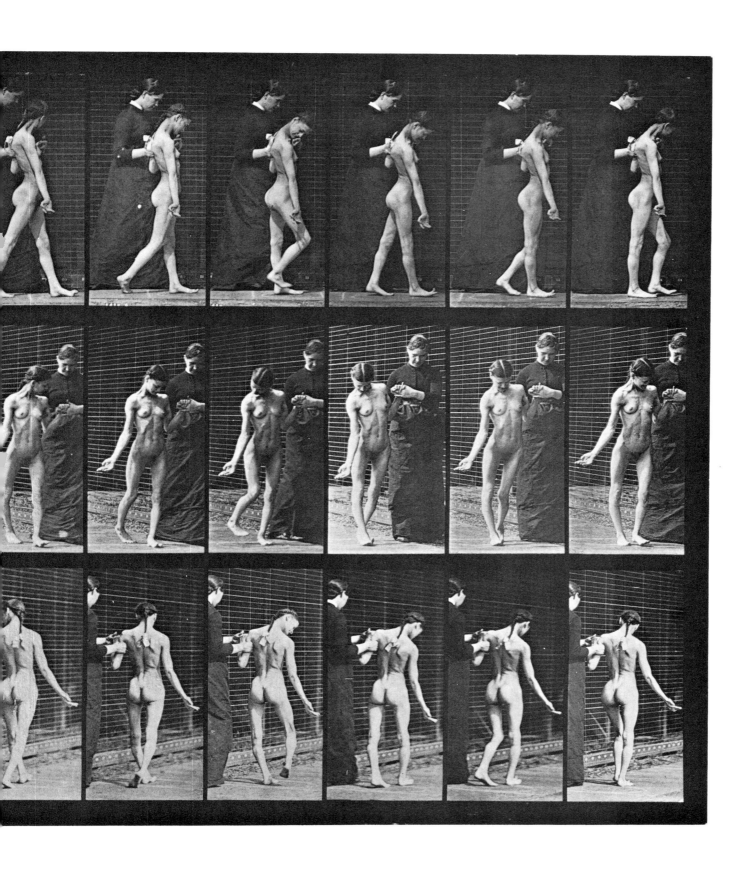

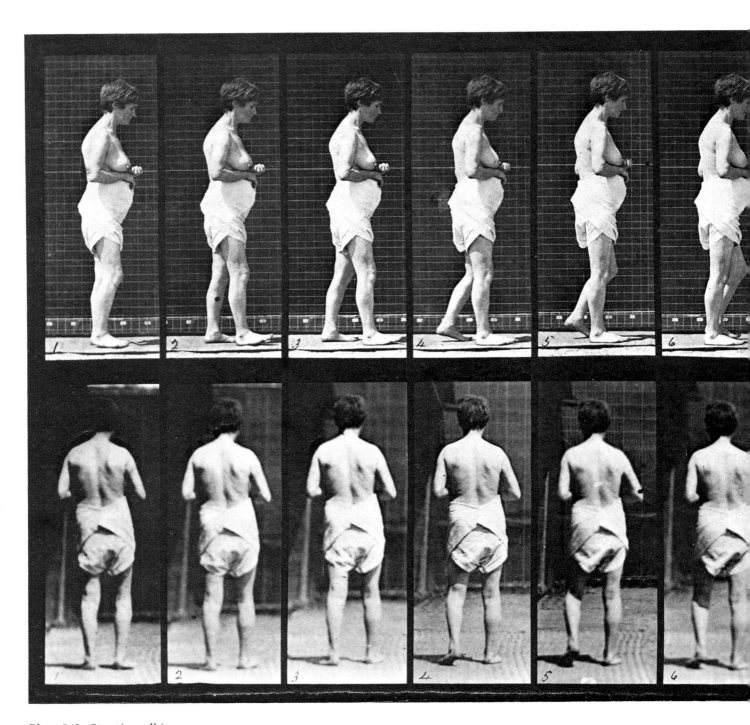

Plate 542. Spastic walking.

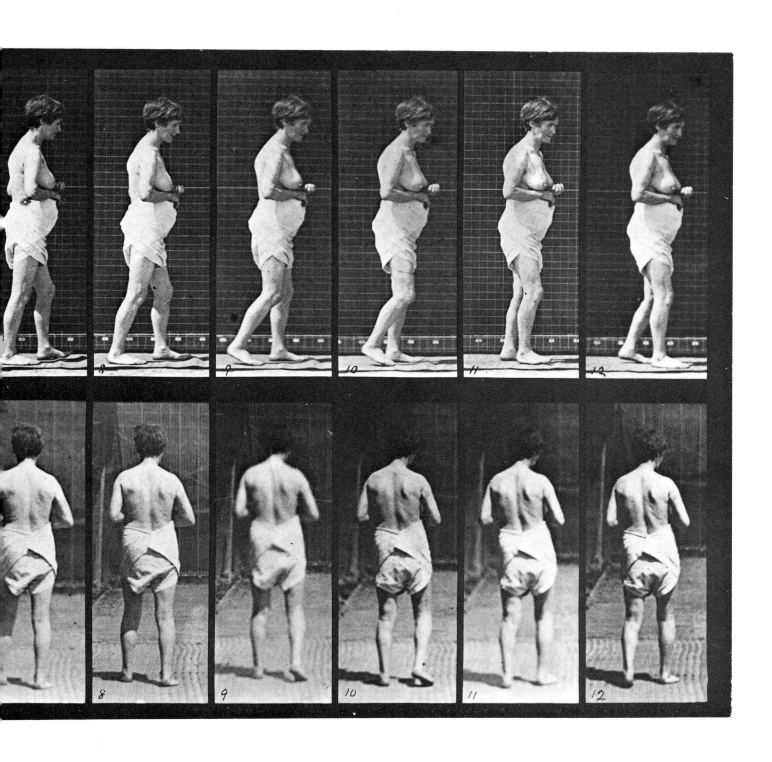

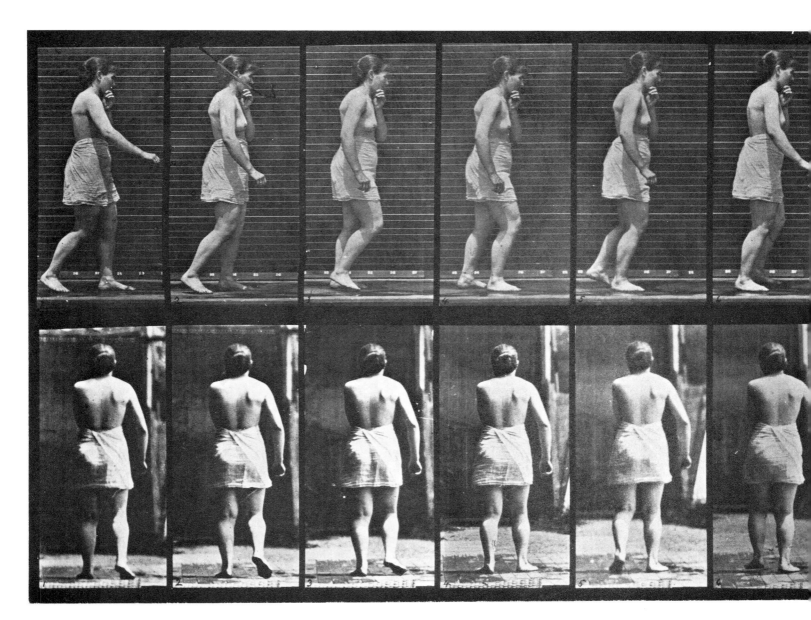

Plate 543. Spastic walking.

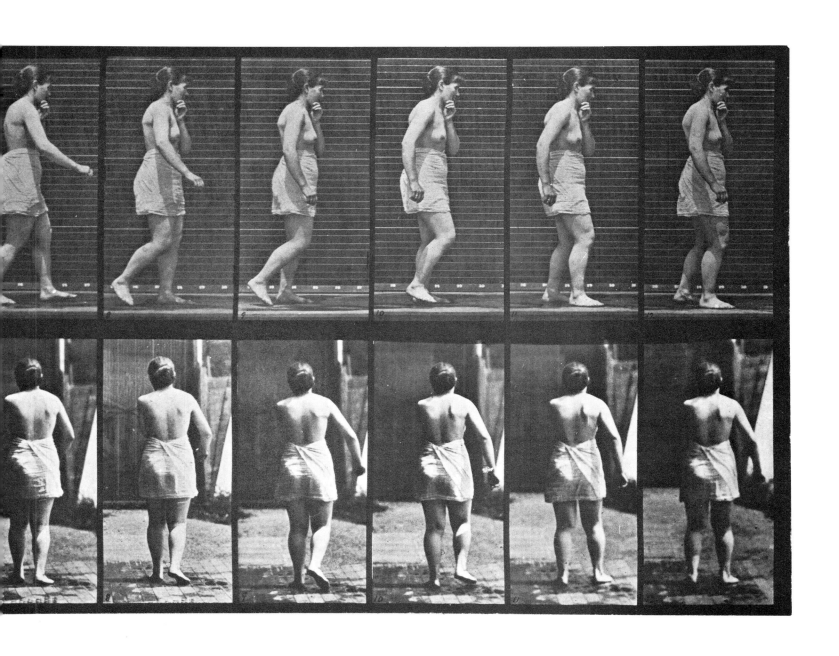

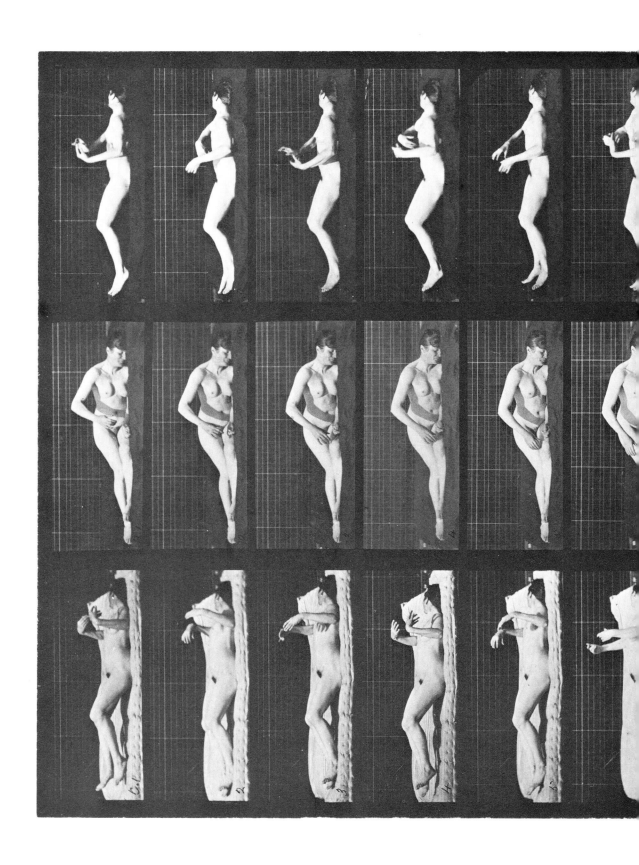

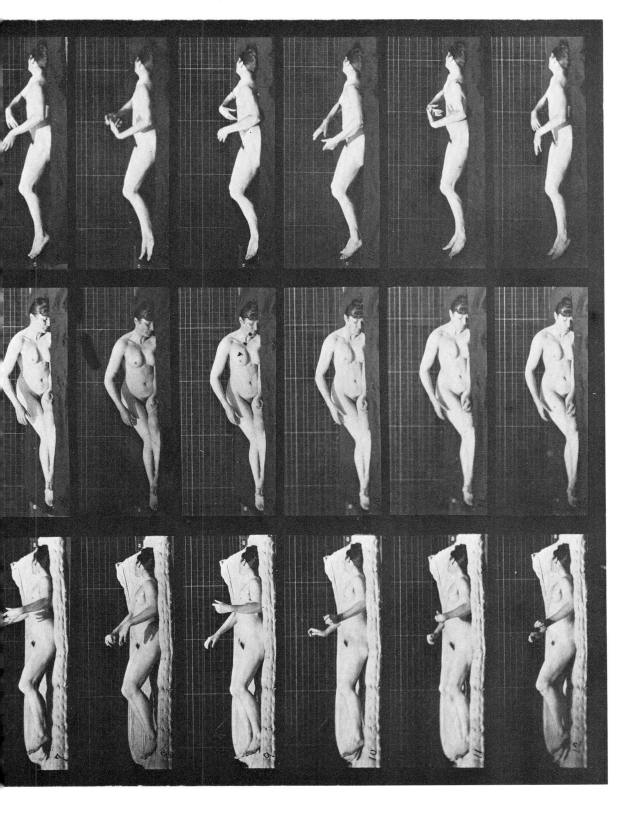

Plate 544. Artificially induced convulsions, lying down.

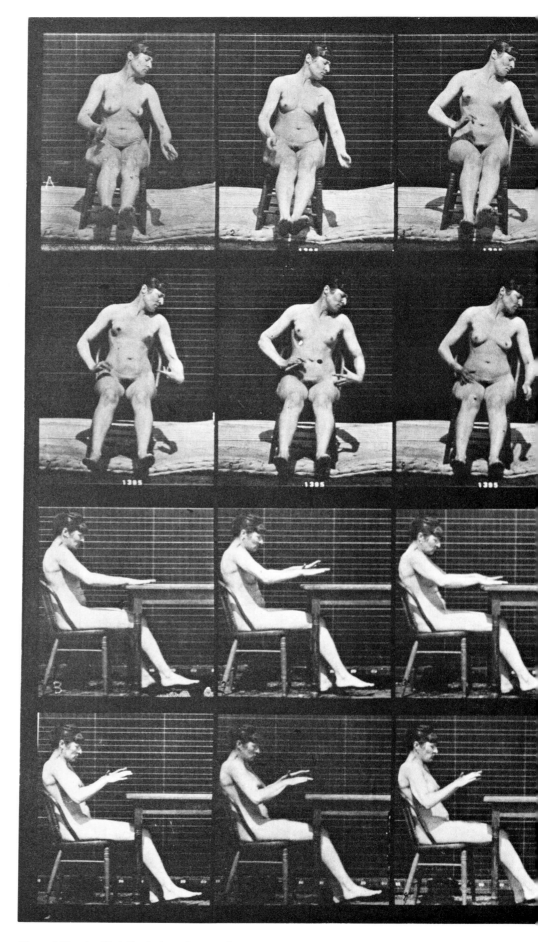

Plate 545. Artificially induced convulsions, sitting.

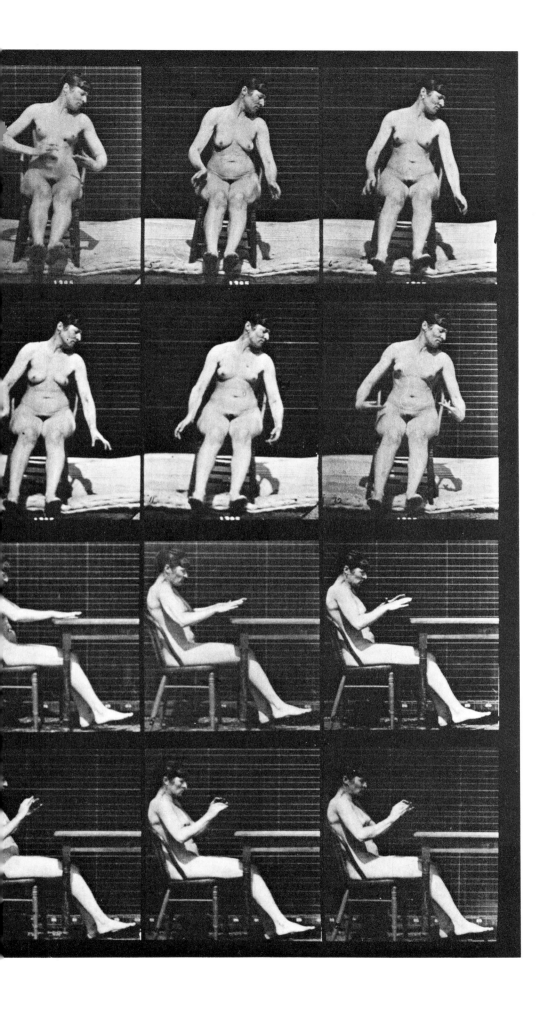

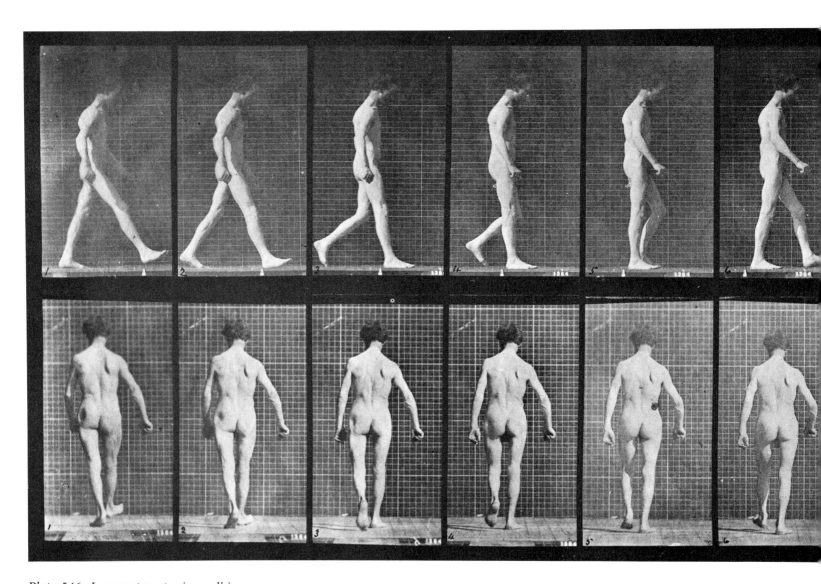

Plate 546. Locomotor ataxia, walking.

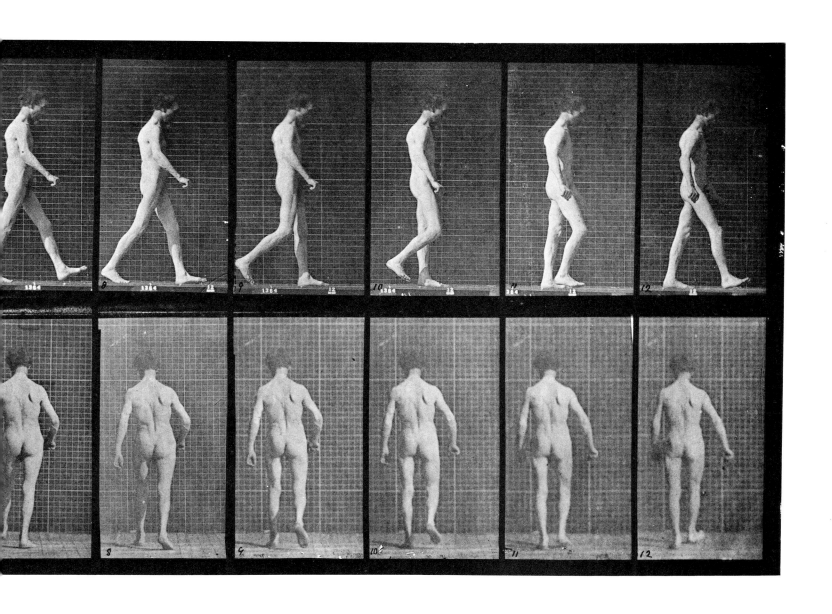

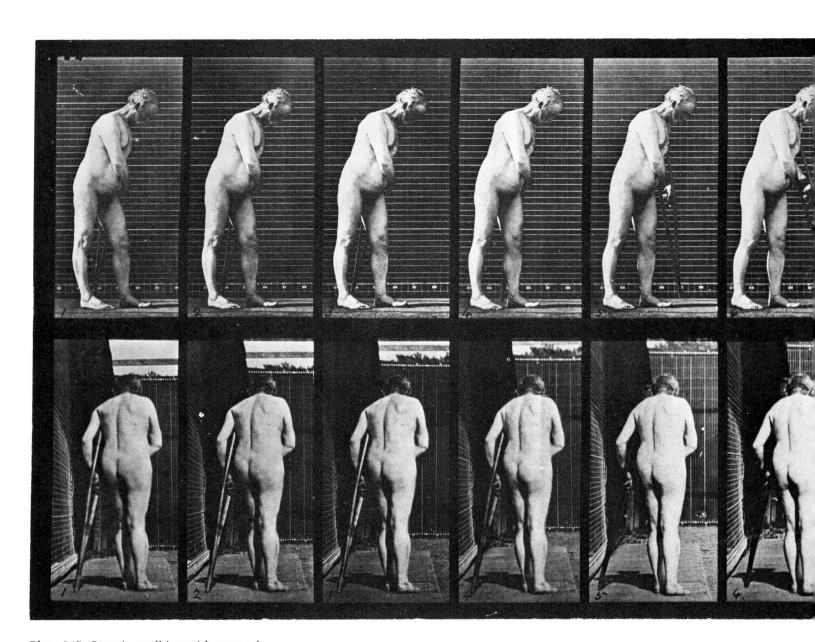

Plate 547. Spastic, walking with a crutch.

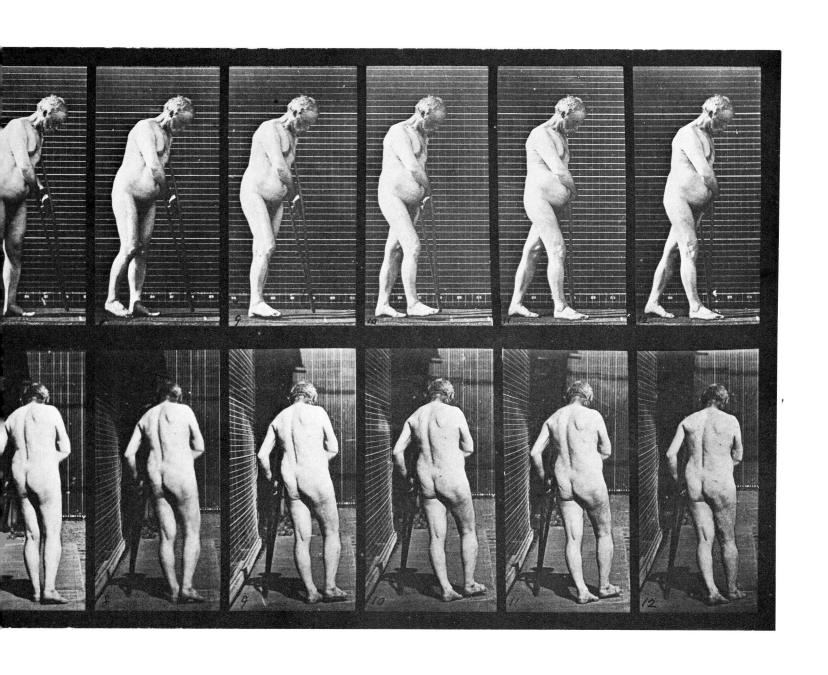

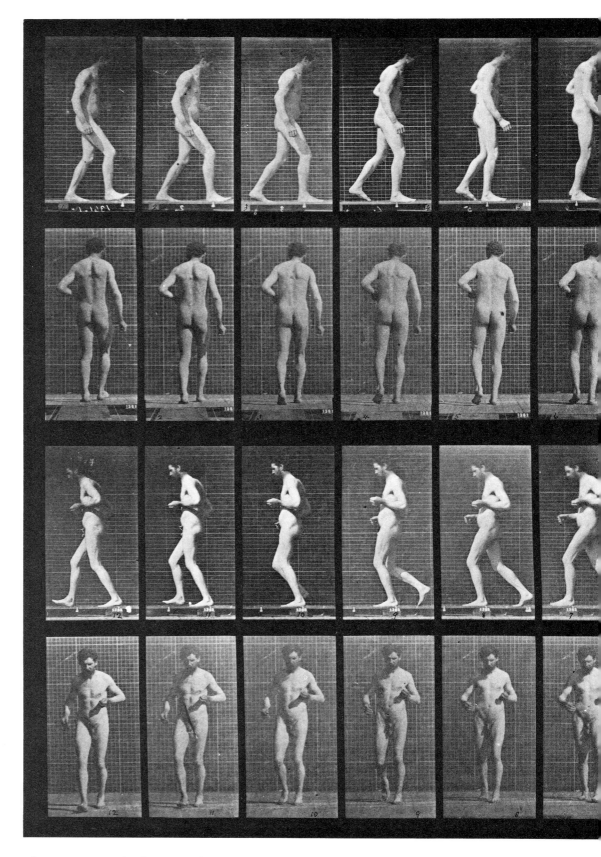

Plate 548. Lateral sclerosis, walking.

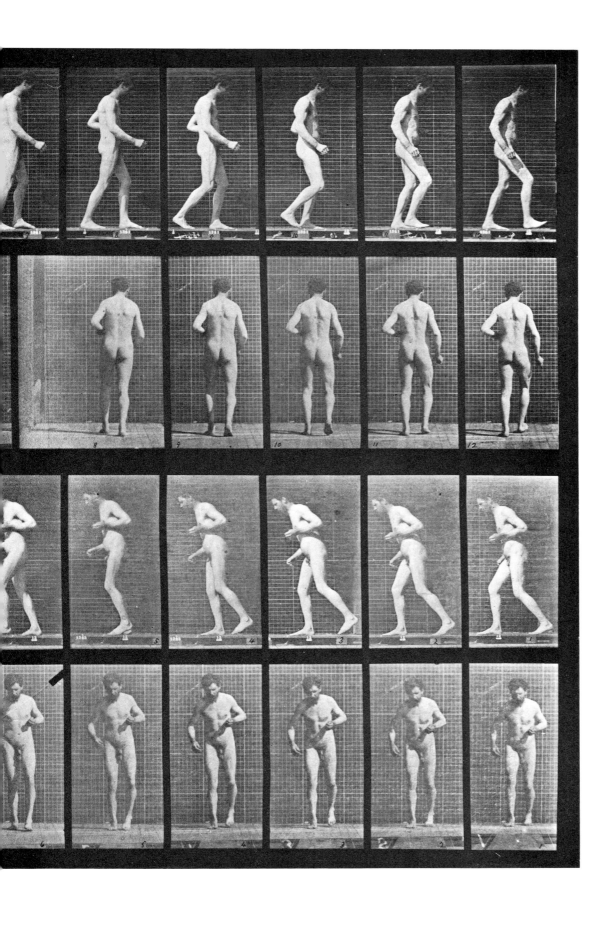

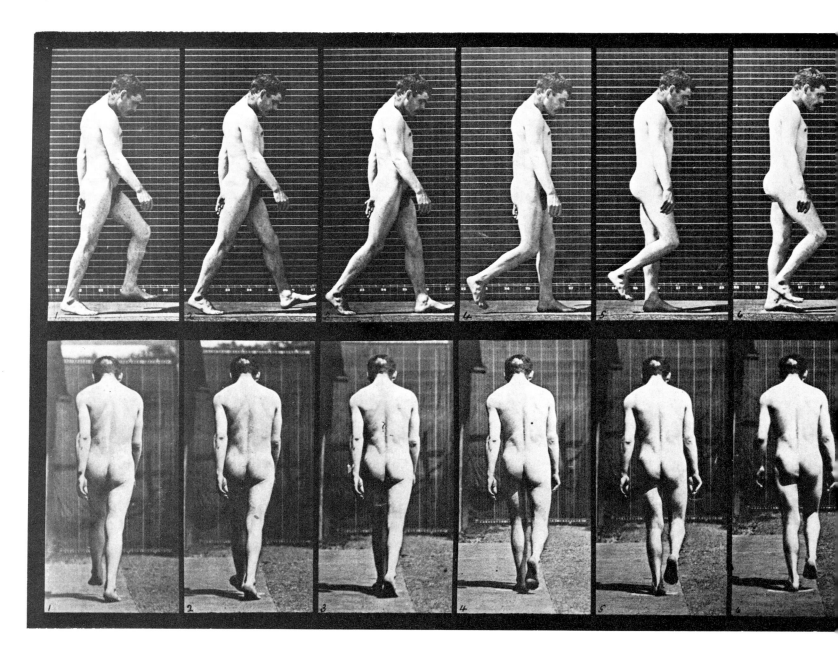

Plate 549. Locomotor ataxia, walking.

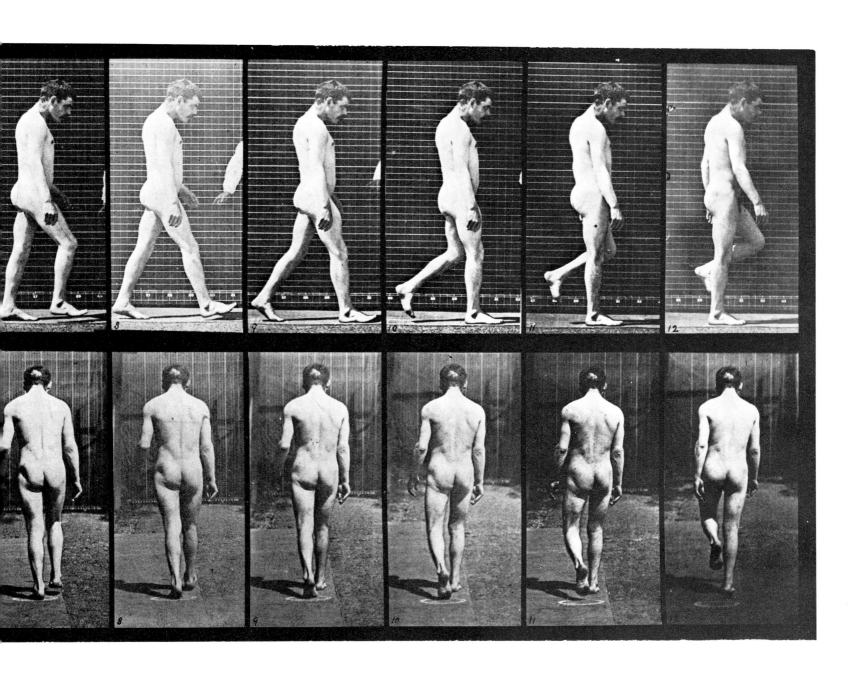

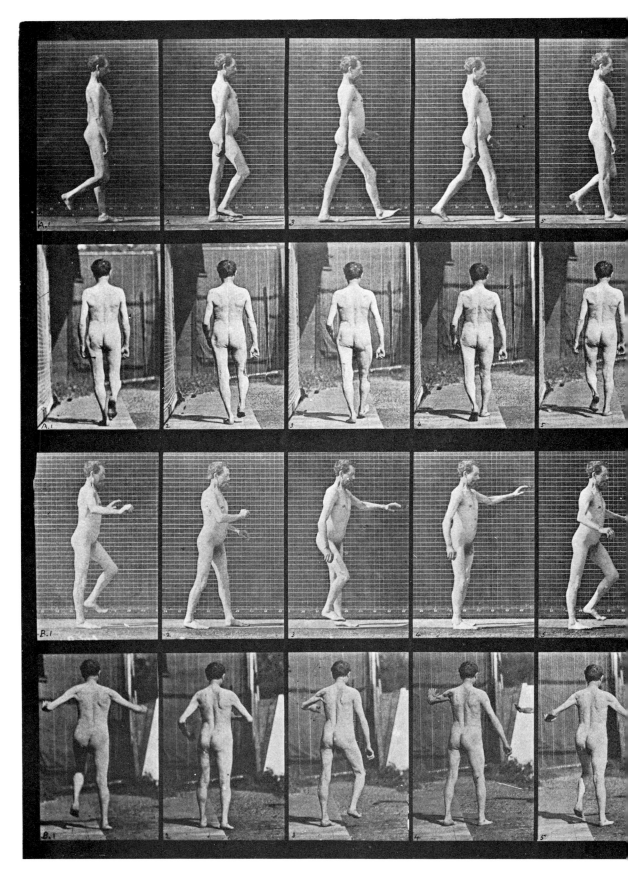

Plate 550. Locomotor ataxia, walking. A: Arms down. B: Arms up.

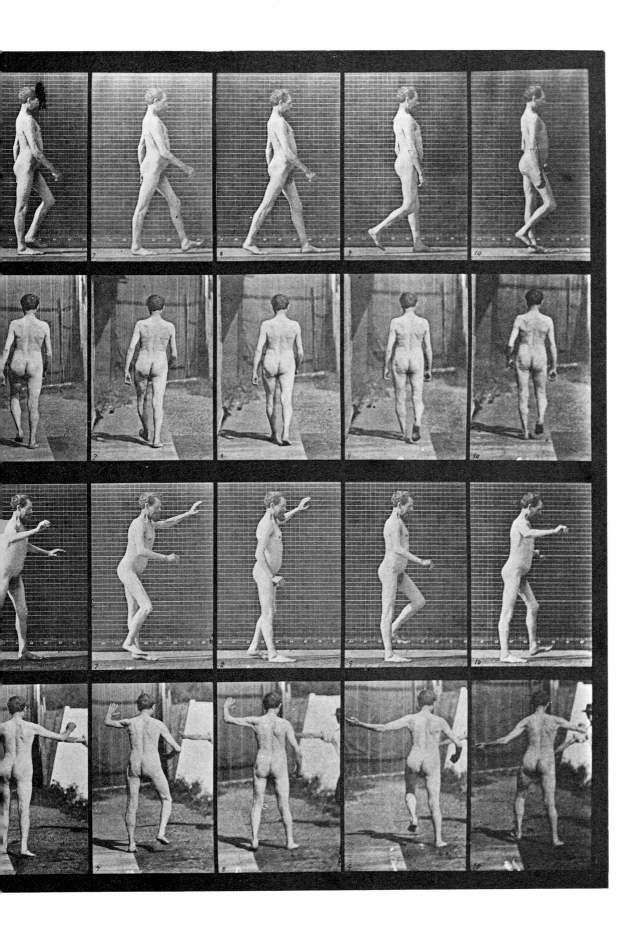

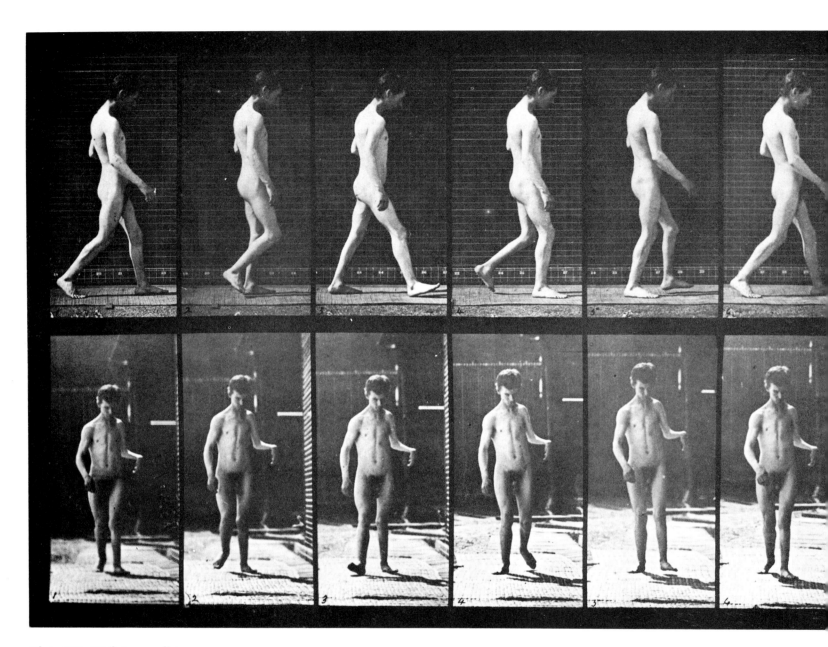

Plate 551. Epilepsy, walking.

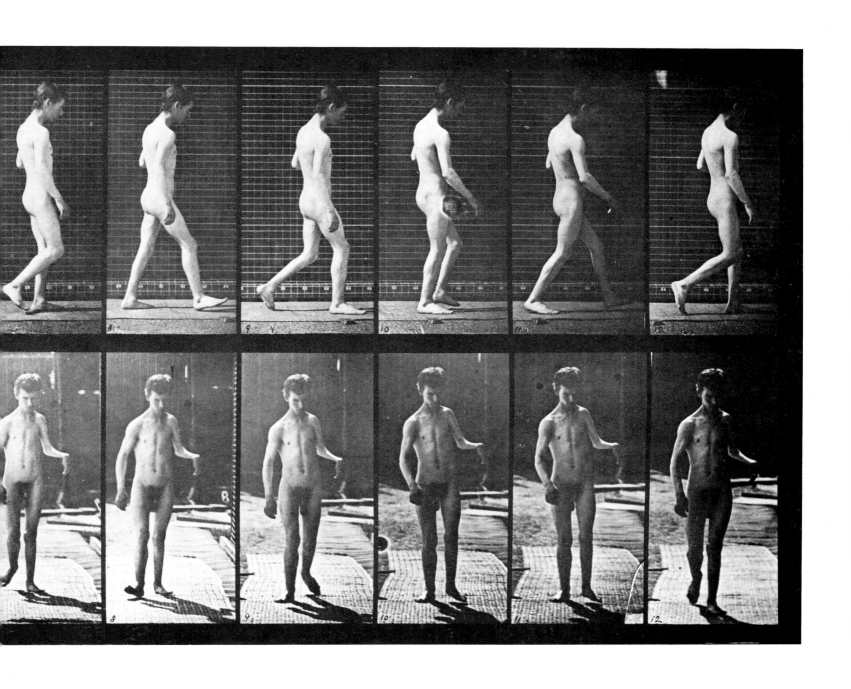

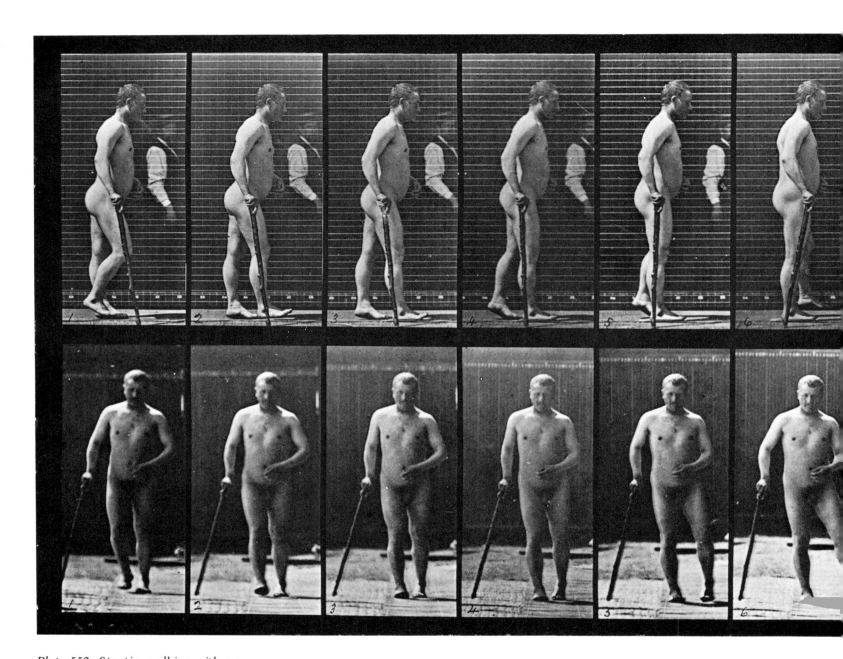

Plate 552. Spastic, walking with cane.

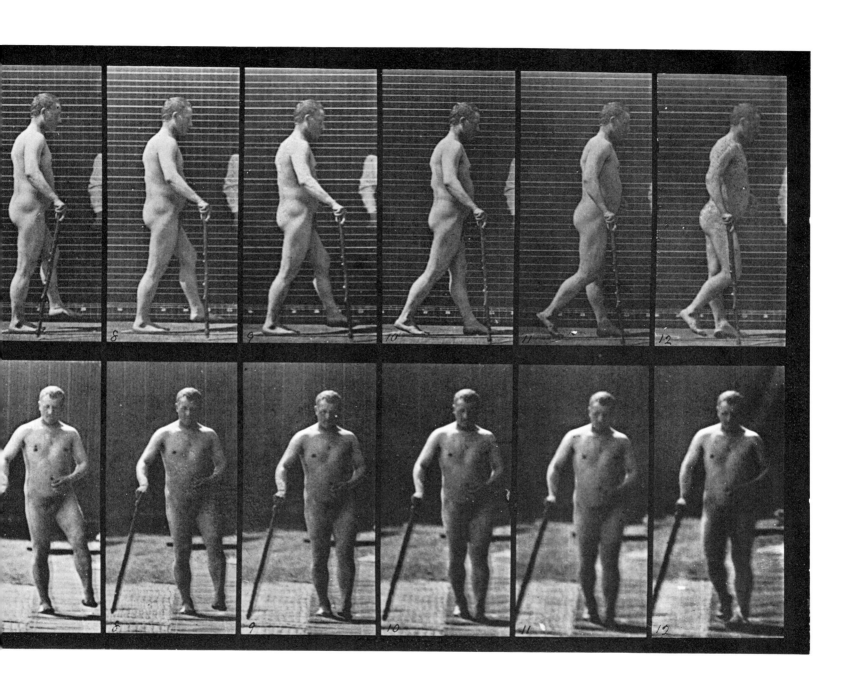

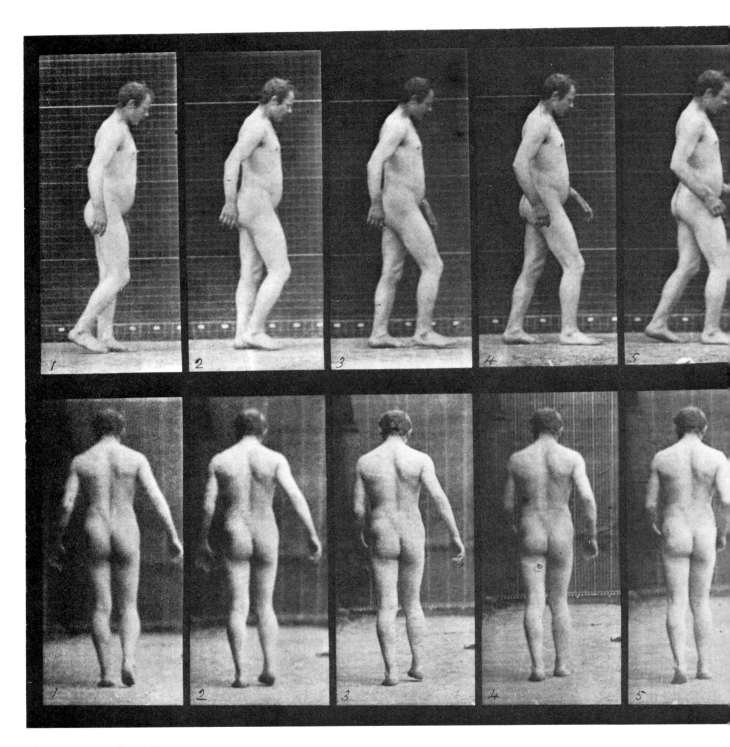

Plate 553. Spastic, walking.

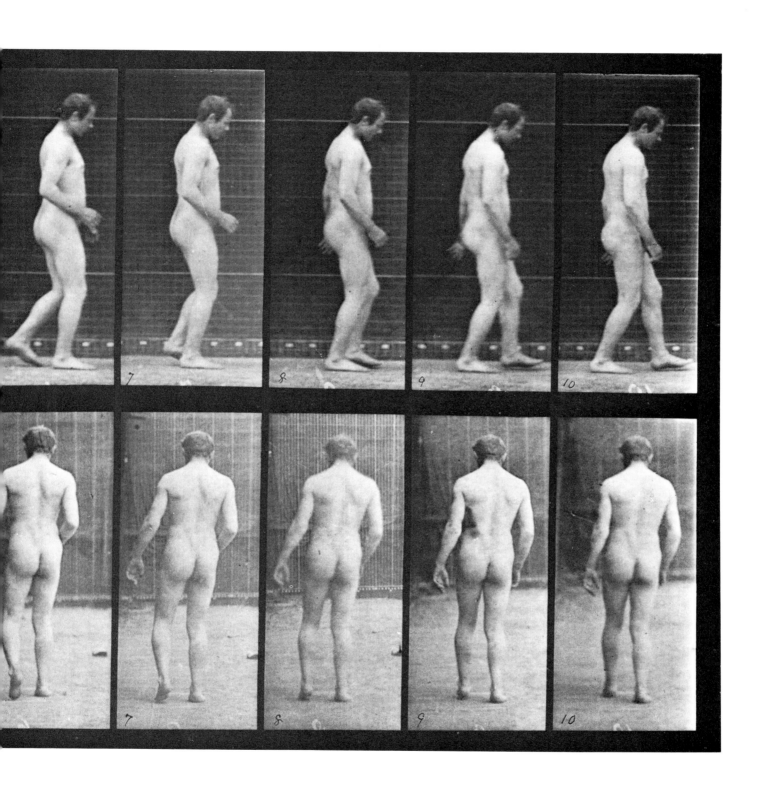

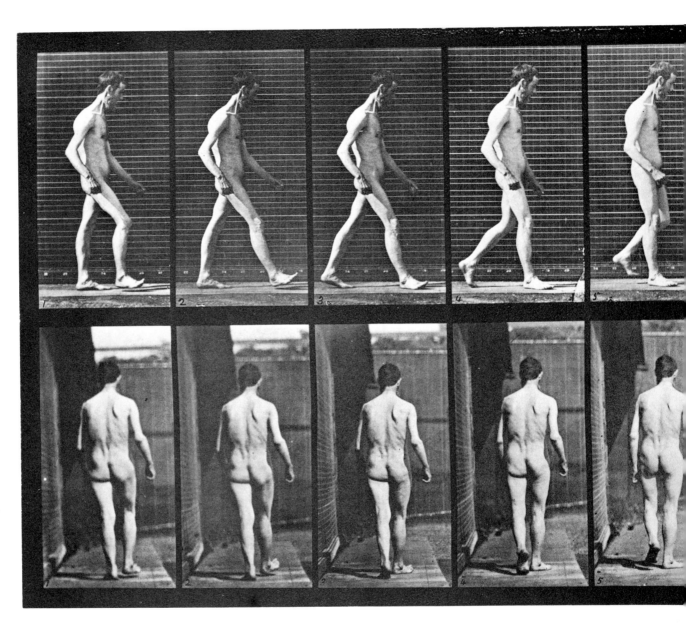

Plate 554. Locomotor ataxia, walking.

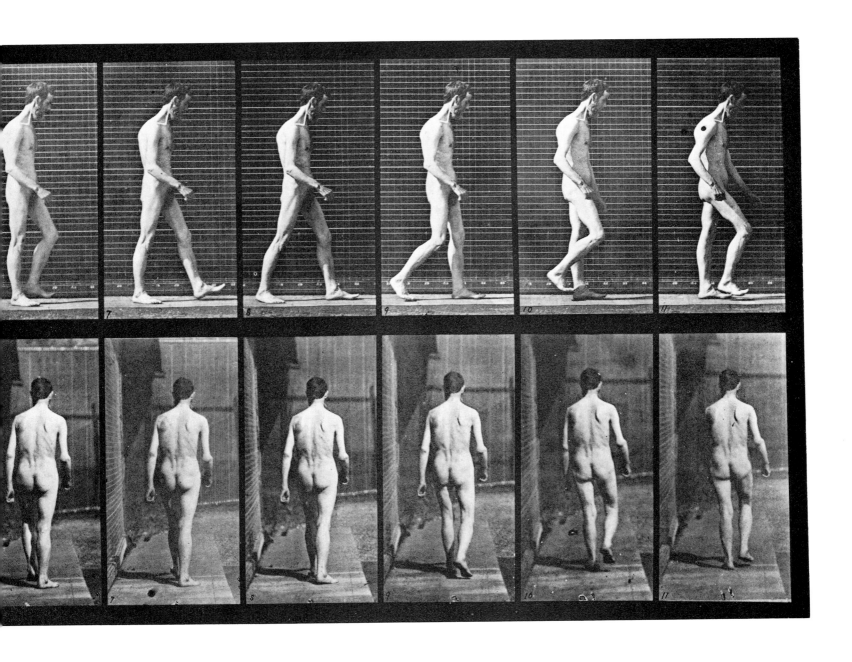

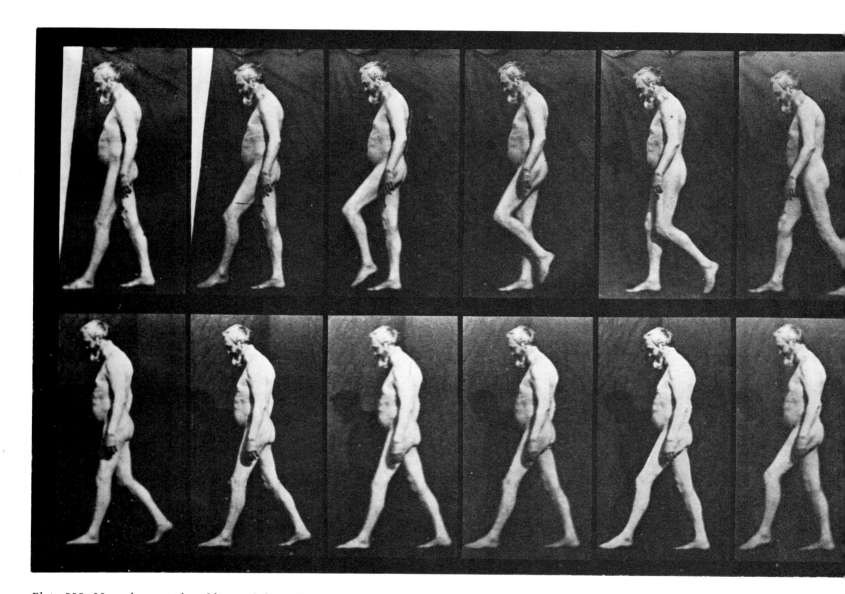

Plate 555. Muscular atrophy of legs, adult, walking.

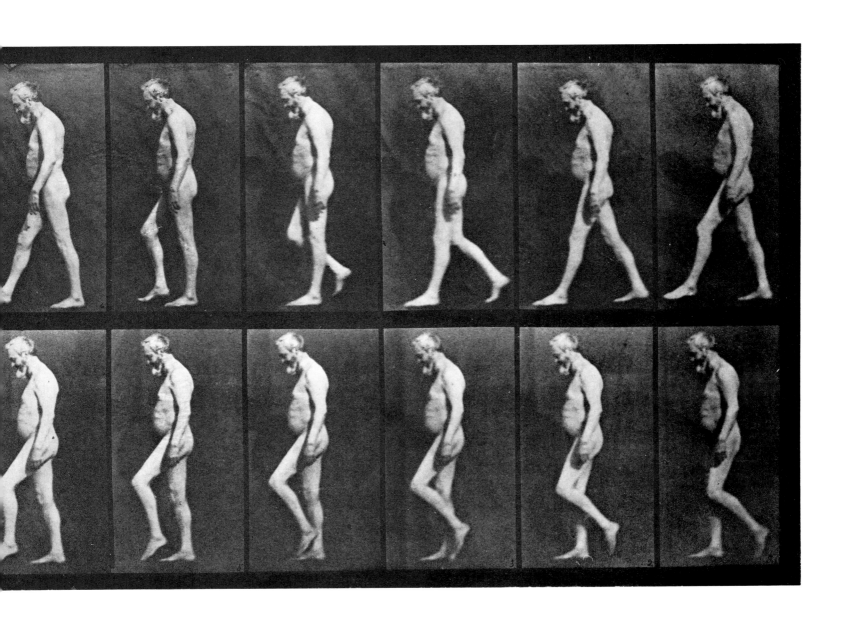

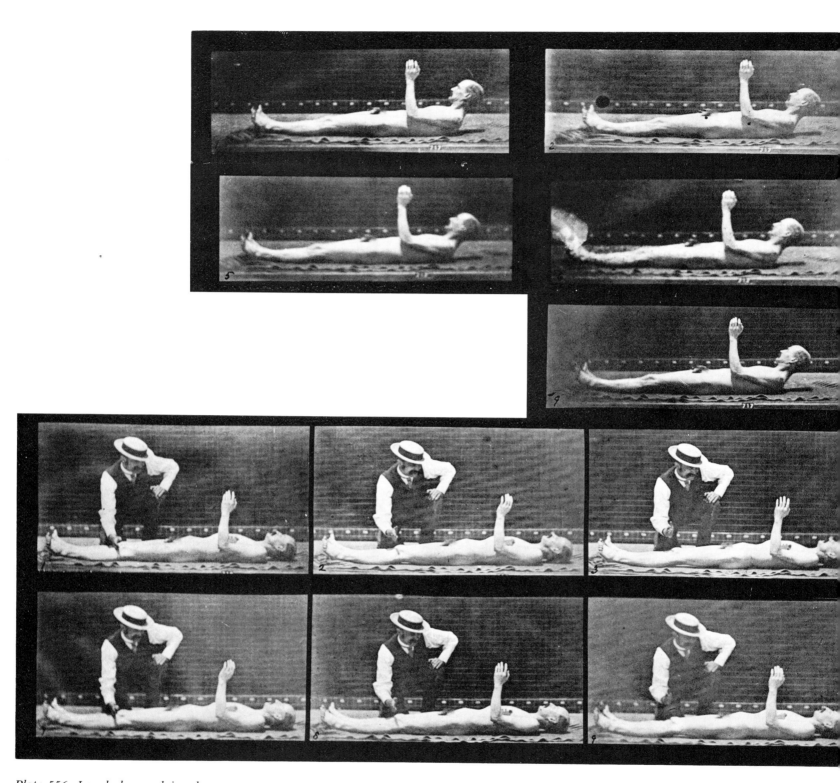

Plate 556. *Local chorea, lying down.*

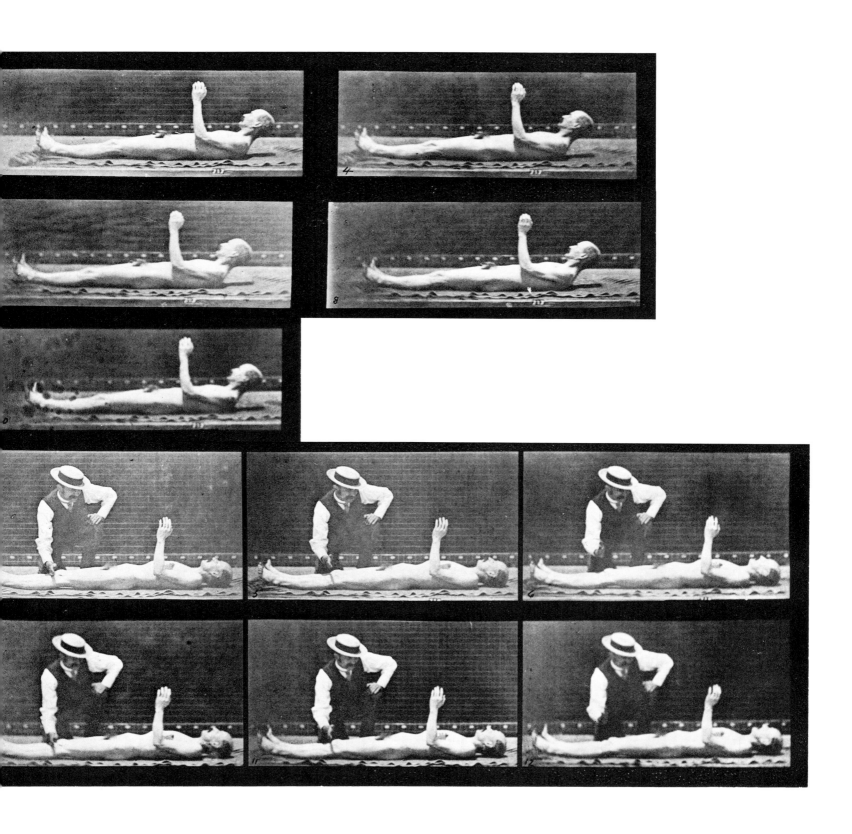

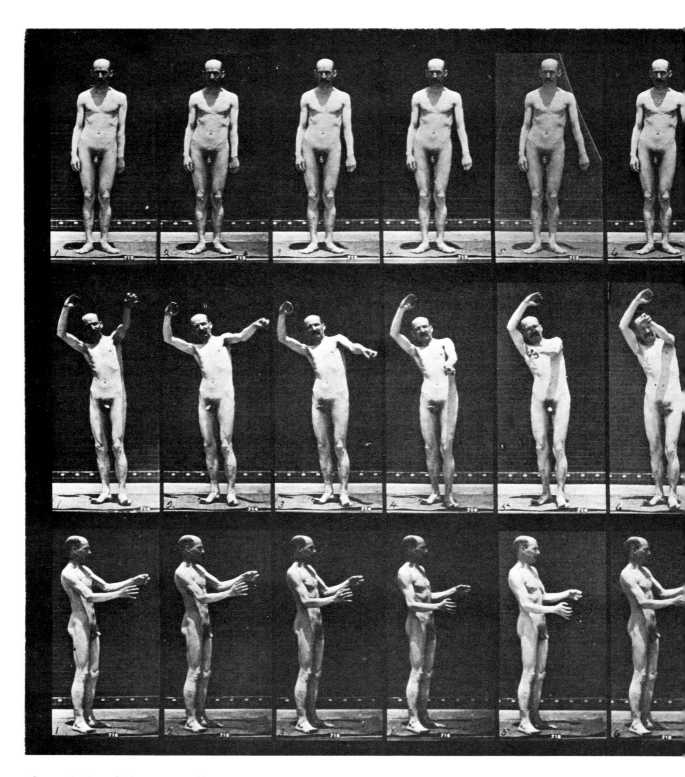

Plate 557. Local chorea, standing.

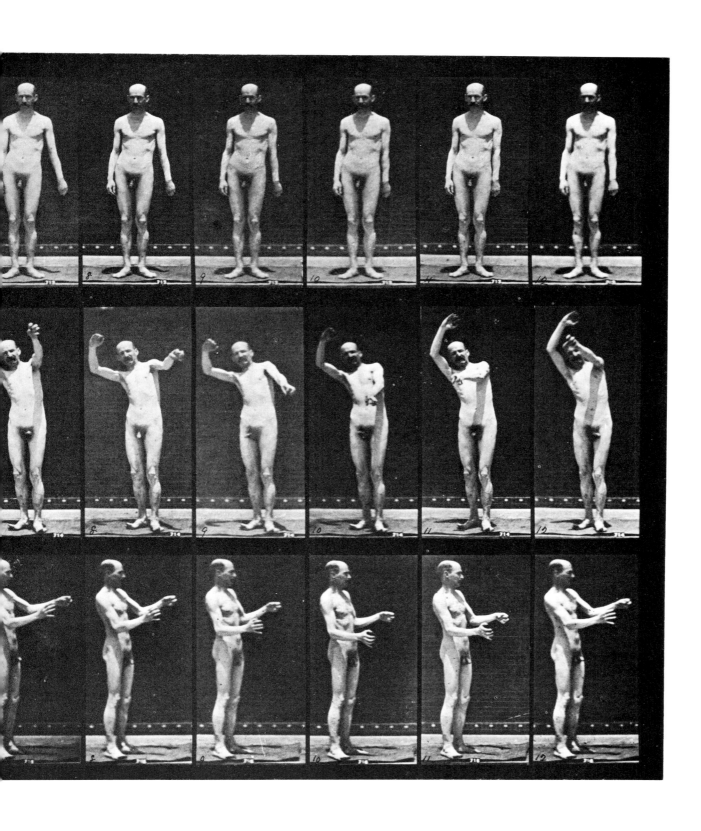

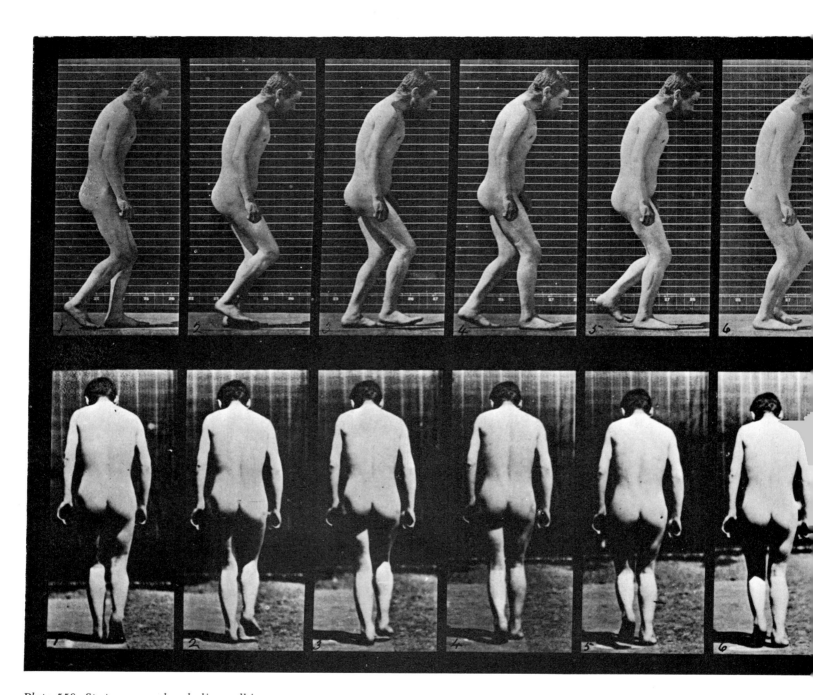

Plate 558. Stuporous melancholia, walking.

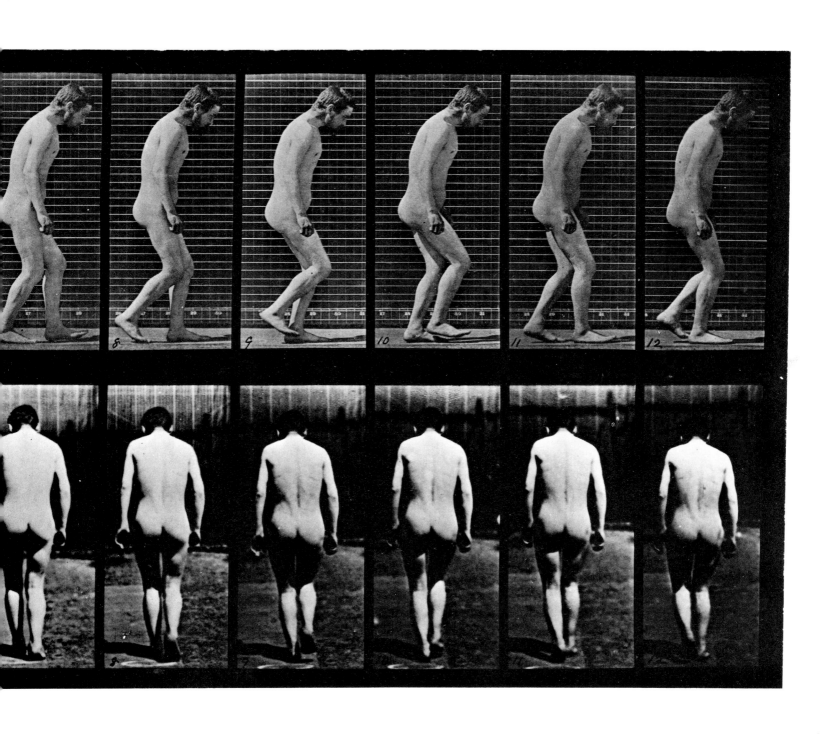

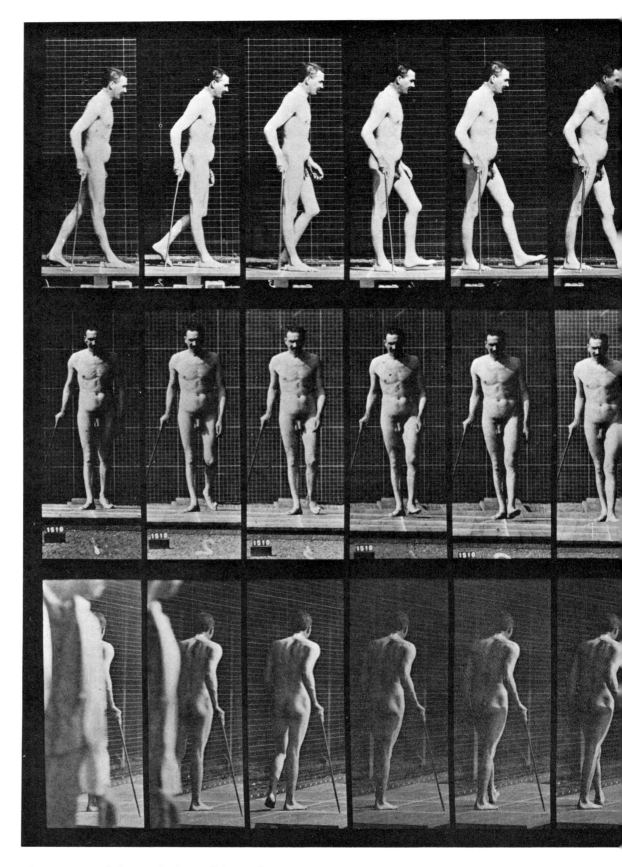

Plate 559. Partial paraplegia, walking with cane.

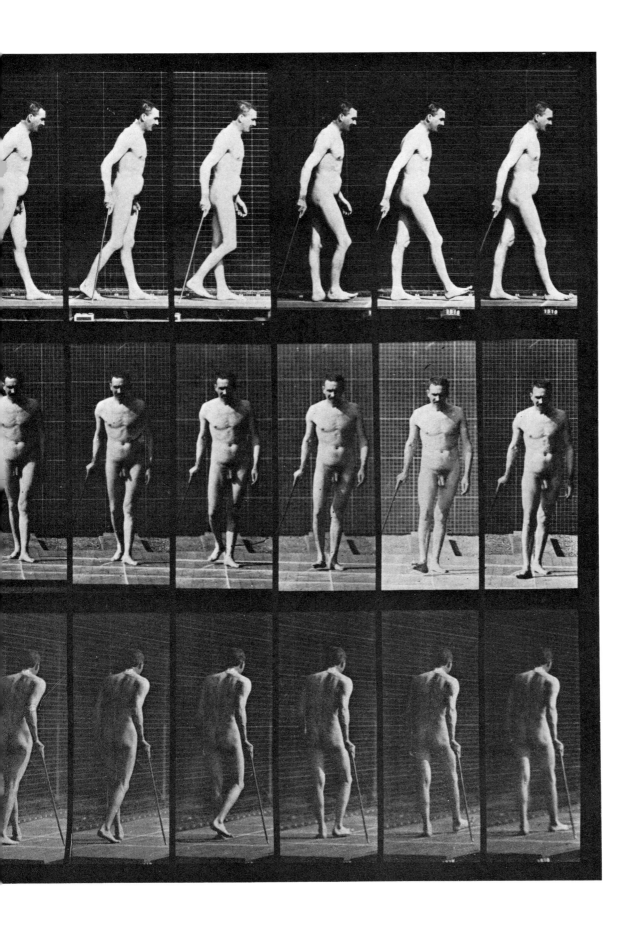

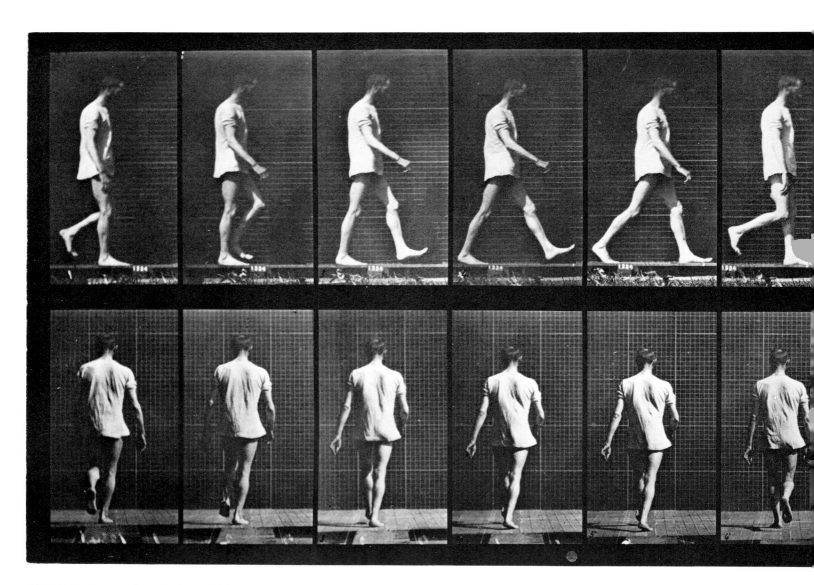

Plate 560. Locomotor ataxia, walking.

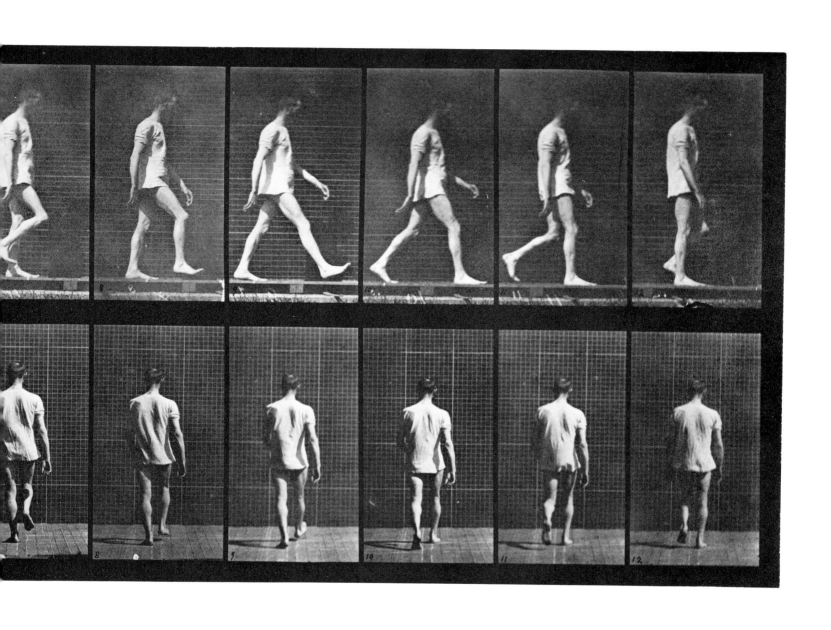

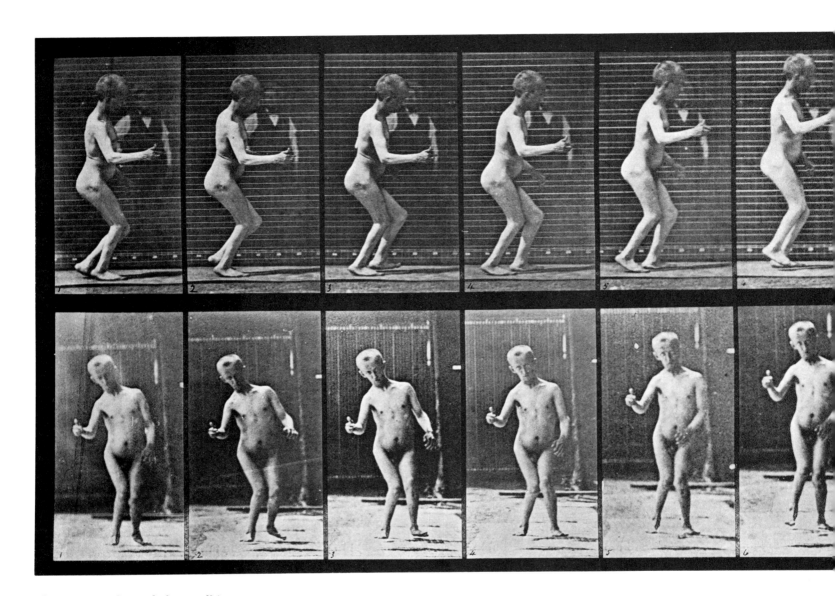

Plate 561. Hydrocephalus, walking.

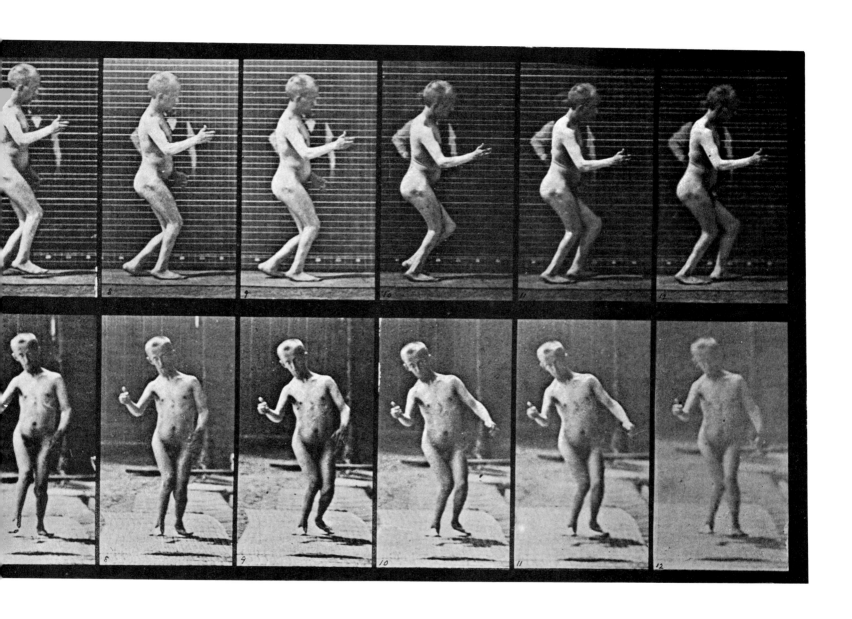

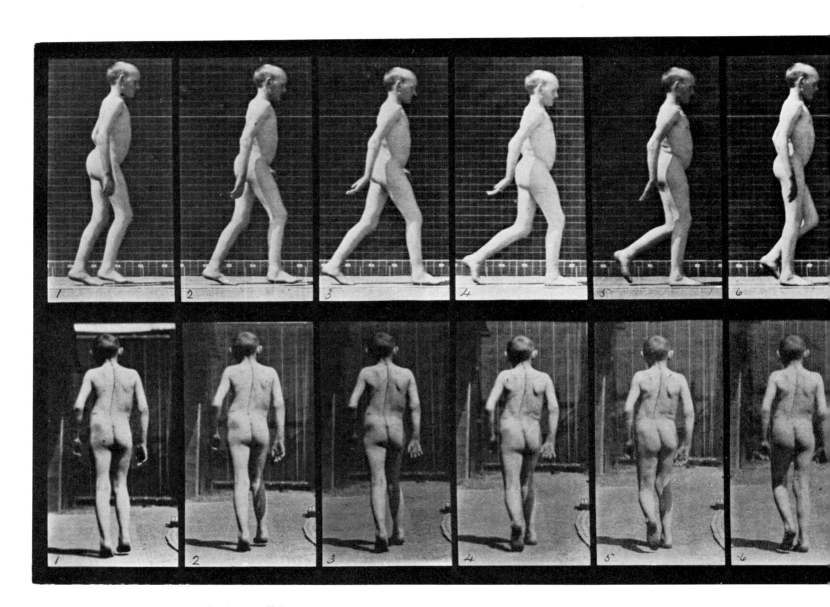

Plate 562. Lateral curvature of spine, walking.

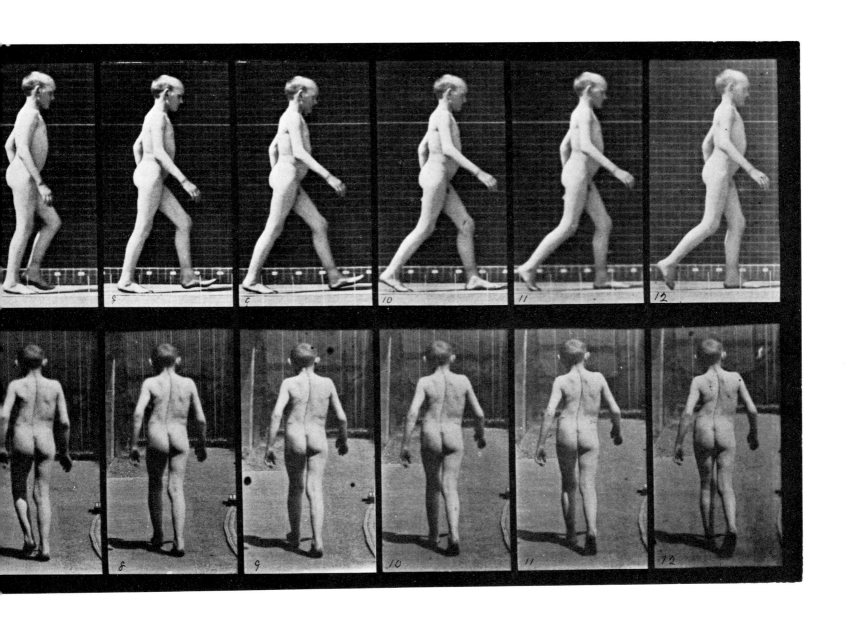

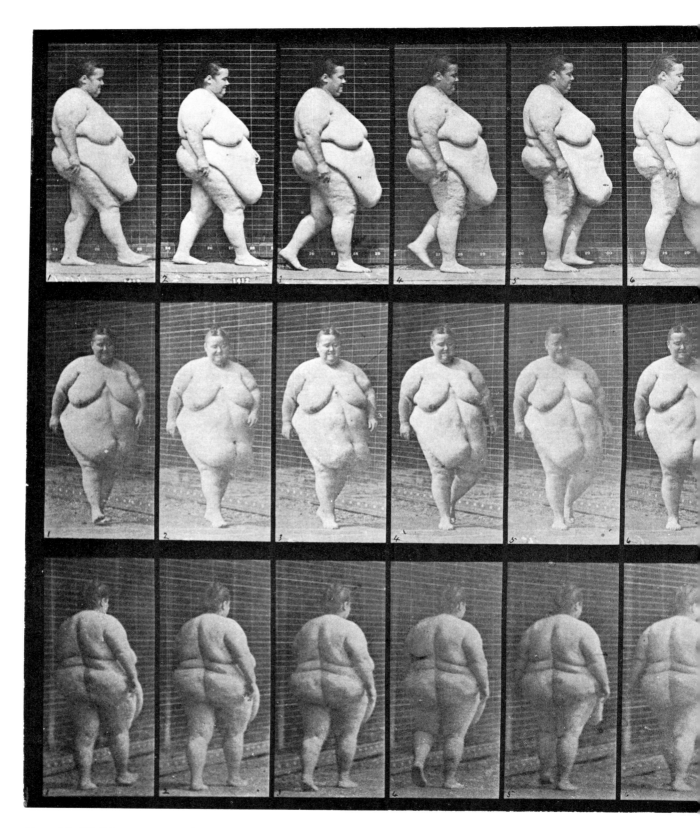

Plate 19. Walking, commencing to turn around.

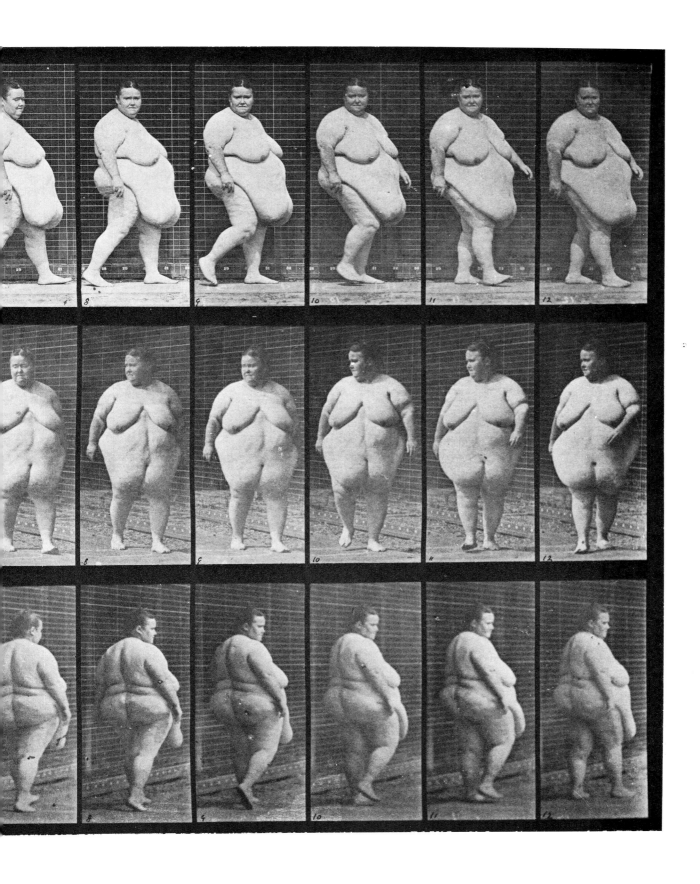

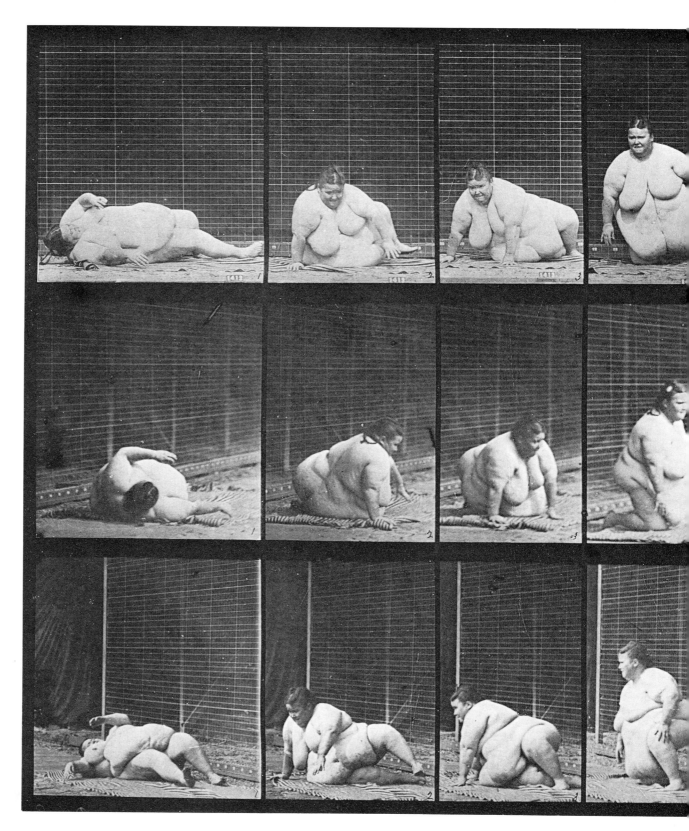

Plate 268. Arising from the ground.

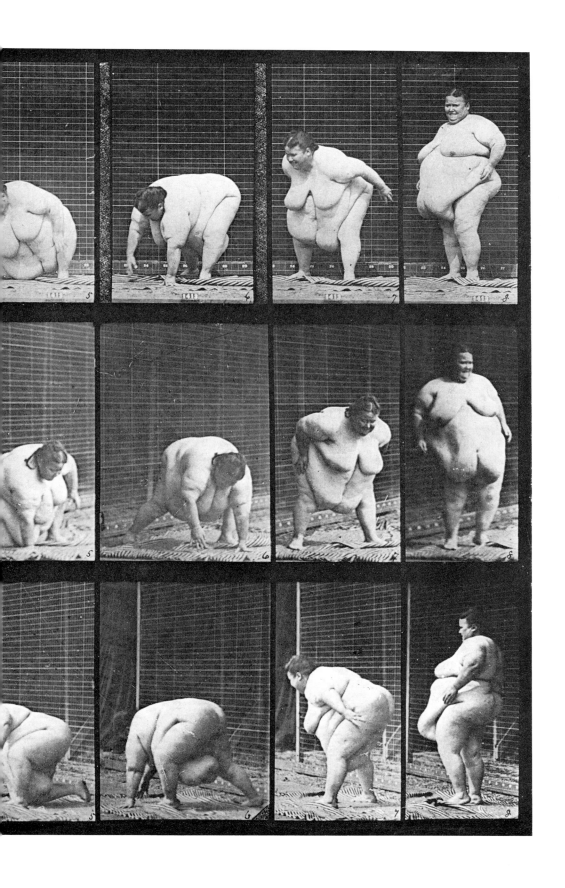